IMAGES IN IVORY

Precious Objects of the Gothic Age

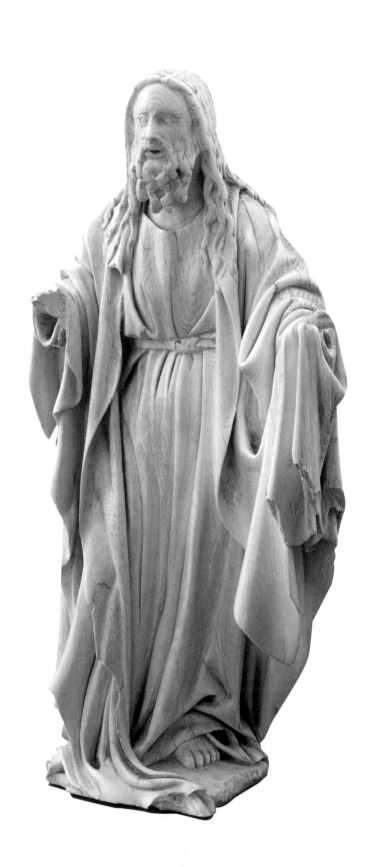

IMAGES IN
IVORY

Precious Objects of the Gothic Age

PETER BARNET, EDITOR

Essays by Peter Barnet, Danielle Gaborit-Chopin,
Charles T. Little, Richard H. Randall, Jr.,
Elizabeth Sears, Harvey Stahl, and Paul Williamson

THE DETROIT INSTITUTE OF ARTS

in association with

PRINCETON UNIVERSITY PRESS
PRINCETON, NEW JERSEY

Published on the occasion of "Images in Ivory: Precious Objects of the Gothic Age," an exhibition organized by the Detroit Institute of Arts

The Detroit Institute of Arts
March 9–May 11, 1997

Walters Art Gallery
Baltimore, Maryland
June 22–August 31, 1997

This exhibition was organized by the Detroit Institute of Arts and is made possible with the support of the National Endowment for the Humanities, the National Endowment for the Arts, an indemnity from the Federal Council on the Arts and Humanities, the Florence Gould Foundation, the Samuel H. Kress Foundation, the Michigan Council for Arts and Cultural Affairs, and the Detroit Institute of Arts Founders Society.

In Detroit, the exhibition is sponsored by Cadillac and the Detroit Cadillac Dealers.

© 1997 by The Detroit Institute of Arts Founders Society
5200 Woodward Avenue
Detroit, Michigan 48202

Director of Publications: Julia P. Henshaw

Assistant Editor: Maya Hoptman

Designed by Three Communication Design, Chicago

Printed by CS Graphics, Singapore

Library of Congress Cataloging-in-Publication Data

Images in Ivory: precious objects of the Gothic Age / Peter Barnet, editor; essays by Peter Barnet . . . [et al.].
 p. cm.
 "In association with Princeton University Press, Princeton, New Jersey."
 Includes bibliographical references and index.

 ISBN 0-691-01611-9 (cloth)
 ISBN 0-691-01610-0 (paper)

1. Ivories, Gothic—Exhibitions. I. Barnet, Peter. II. Detroit Institute of Arts

NK5875.I45 1997 96-52331
736'.62'07477434—dc21 CIP

Published in association with
Princeton University Press
41 William Street
Princeton, New Jersey 08540

Distributed in the United Kingdom by Princeton University Press, Chichester, West Sussex

ISBN 0-691-01611-9 cloth

ISBN 0-691-01610-0 paper

Cover and dust jacket:
Angel of the Annunciation (no. 16, detail), ca. 1280–1300, French, Musée du Louvre, Paris

Frontispiece:
God the Father (no. 65), ca. 1480–1530, French, Museum of Fine Arts, Houston

Contents

vi Foreword

ix Acknowledgments

IMAGES IN IVORY ESSAYS

2 I| Gothic Sculpture in Ivory: An Introduction
 Peter Barnet

18 II| Ivory and Ivory Workers in Medieval Paris
 Elizabeth Sears

38 III| Symbiosis across Scale: Gothic Ivories and Sculpture
 in Stone and Wood in the Thirteenth Century
 Paul Williamson

46 IV| The Polychrome Decoration of Gothic Ivories
 Danielle Gaborit-Chopin

62 V| Popular Romances Carved in Ivory
 Richard H. Randall, Jr.

80 VI| Gothic Ivory Carving in Germany
 Charles T. Little

94 VII| Narrative Structure and Content in Some Gothic
 Ivories of the Life of Christ
 Harvey Stahl

CATALOGUE OF THE EXHIBITION

115 The First Gothic Ivories (nos. 1–17)

147 Paris and Other Centers: Devotional Objects (nos. 18–50)

217 Secular Objects and the Romance Tradition (nos. 51–64)

249 New Developments in Ivory and Bone Carving
 (nos. 65–79)

279 Epilogue: Pastiches, Revivals, Forgeries, and Open
 Questions (nos. 80–93)

308 Bibliography

321 Index

Foreword

The very material of ivory is intriguingly attractive: it is a rare, exotic, sensuous, smoothly fine-grained substance. While many cultures have used it to create luxurious objects of various sorts, it became a major medium for artistic expression in Europe during the thirteenth century. African elephant ivory was widely available through trade across the Mediterranean at this time, the height of the Gothic era. Ivory is intrinsically so beautiful that its desirability has tragically led to its status as contraband today, as the elephants whose tusks produce the finest ivory have been hunted to the point of endangering the species.

Ivory lends itself to intricate, virtuoso carving; the limitations of size imposed by the dimensions of usable ivory in a tusk serve as a challenge to the ivory carver to create works of art that are perforce miniature in their scale. Indeed, the swaying curve characteristic of so many Gothic figures of the Virgin and Child in all media may have become standardized as a result of the ivory carvers' utilization of the natural curve of the material. When colors or gilding were applied to medieval ivories, these additions were usually made sparingly so as not to obscure the natural rich sheen of polished ivory.

Rightly or wrongly, the Middle Ages represents for us that intensely religious and romantic era in Europe, just before the humanist rationality of the Renaissance and the beginning of what is often called modern times. While as many as two thousand Gothic ivory carvings survive in public and private collections, there has been relatively little study devoted to them, and there has never before been a comprehensive major loan exhibition of ivory sculpture. These delicate works of art show that the people of medieval Europe shared our desire for beautiful and functional objects that reflect an expression of spirituality or idealized romance. Many of these elegant ivories display the intimate tenderness of a mother and child; others depict the high drama of the life and death of the teacher and prophet Jesus Christ, with amazingly complex narrative scenes presented in intricate, almost microscopic detail.

Presenting an international loan exhibition of this type is one of the great pleasures afforded those of us who work in muse-

ums. We can offer our public the rare pleasure of seeing first-hand these magnificent works of art brought together from many of the best-known museums of Europe and America. Leaves of diptychs that have long been divided are reunited here for the first time in modern history (nos. 10 and 11, 13 and 14, and 22 and 23). Scholars from around the world can make close comparisons of stylistically and iconographically similar ivories, testing the correctness of specific workshop attributions. And, as an added bonus that appeals to our human curiosity and challenges our eyes, the last section of this exhibition focuses on a number of ivories that present various problems of authenticity, including several that are blatant modern fakes. The present handsome catalogue advances our knowledge and appreciation of ivories.

My most sincere thanks go to Peter Barnet, Associate Curator of European Sculpture and Decorative Arts, for his vision in planning this exhibition, as well as his skill in guiding it to such a successful completion. The list of other catalogue authors, who also served as the scientific committee, reads like a compendium of the most prominent scholars in this field. To Danielle Gaborit-Chopin, Conservateur général, Musée du Louvre; Viviane Huchard, Conservateur général chargé du Musée National du Moyen Age, Thermes de Cluny; Norbert Jopek, Assistant Curator, the Victoria and Albert Museum; Charles T. Little, Curator, the Metropolitan Museum of Art; Pierre Yves le Pogam, Conservateur, Musée National du Moyen Age, Thermes de Cluny; Rebecca Price-Wilkin, Exhibition Assistant, the Detroit Institute of Arts; Richard H. Randall, Jr., former Director, the Walters Art Gallery; Elizabeth Sears, Associate Professor, the University of Michigan; Harvey Stahl, Associate Professor, University of California, Berkeley; Neil Stratford, Keeper, the British Museum; and Paul Williamson, Chief Curator of Sculpture, the Victoria and Albert Museum, goes my deepest gratitude for their many substantial contributions. The enthusiastic support of Gary Vikan, Director of the Walters Art Gallery, and his able staff has aided us considerably. The survival of these precious images in ivory is a testimony to the fact that they have been so highly valued, and it is therefore with special appreciation that we thank the institutions which have so generously loaned these exquisite and

delicate pieces, allowing this exhibition to present a comprehensive survey of ivories representing the finest work of the Gothic period.

Without the generous support of the National Endowment for the Humanities, the National Endowment for the Arts, an indemnity from the Federal Council on the Arts and Humanities, the Florence Gould Foundation, the Samuel H. Kress Foundation, the Michigan Council for Arts and Cultural Affairs, Cadillac and the Detroit Cadillac Dealers, and the Detroit Institute of Arts Founders Society, the presentation of this wonderful exhibition would have been impossible. I thank them all for their essential ongoing contributions to the arts and cultural life in America.

SAMUEL SACHS II
Director
The Detroit Institute of Arts

Acknowledgments

This exhibition devoted to Gothic ivory carving is the result of the cooperation and encouragement of many individuals. Richard H. Randall, Jr. introduced me to the rewards and problems inherent in studying Gothic ivories, and I am deeply grateful to him for his advice and good humor. At his suggestion, I joined a distinguished group of scholars who had already devoted years to the subject. They are Danielle Gaborit-Chopin, Charles T. Little, Neil Stratford, and Paul Williamson, and I am grateful to each of them for accepting a beginner in their midst and for their initial enthusiastic response to my suggestion of an exhibition devoted to this material. Those mentioned above, with the additions of Elizabeth Sears and Harvey Stahl, became the advisory group that saw the exhibition through the crucial planning stages. In addition to these, Viviane Huchard, Norbert Jopek, Pierre Yves Le Pogam, and Rebecca Price-Wilkin have made significant contributions to the catalogue. Nancy Netzer provided wise counsel during the implementation phase of the exhibition. Many other colleagues and museum professionals, of course, provided valuable assistance during the organization of the exhibition and the catalogue. I am especially grateful to Ellenor Alcorn, Daniel Alcouffe, Anthony Blumka, Pete Dandridge, Stephen Fliegel, Bernhard Heitmann, Mark Horton, Timothy Husband, David Torbet Johnson, Alison Luchs, Susanne Merz, Philip Myers, Judith Neiswander, Lawrence Nickels, Anne Poulet, Betsy Rosasco, Margaret Schwartz, Max Seidel, Karen Serota, Marianna Shreve Simpson, Jack Soultanian, John W. Steyaert, Gary Vikan, Roger Ward, Ian Wardropper, William D. Wixom, and Ghenete Zelleke.

Elizabeth Sears graciously asked me to co-direct with her a graduate seminar on Gothic ivories at the University of Michigan in Ann Arbor in 1995. The seminar was a valuable opportunity to test a number of approaches to the problems associated with the study of ivories, and I am grateful to Professor Sears as well as the impressive group of students that included Kirk Ambrose, Diana Goodwin, Melanie Holcomb, Catherine McCurrach, and Christina Waugh.

The lenders of the extraordinary objects in the exhibition were exceptionally cooperative throughout the long organization process, and I am grateful to the many museum directors,

conservators, curators, photographers, and registrars for their help in this project.

The exhibition has naturally involved a great number of staff members at the Detroit Institute of Arts. Samuel Sachs II, Director, Jan van der Marck, former Chief Curator, Alan Darr, Curator, and Tara Robinson, Exhibitions Curator, all provided crucial initial support of the exhibition concept. Among the many others who provided key support are Joseph P. Bianco, Jr., Executive Vice President of the DIA Founders Society; Julia Henshaw, Director of Publications, and Maya Hoptman, Assistant Editor; Dirk Bakker and Eric Wheeler in photography; Louis Gauci and Robert Loew, exhibition designers; Barbara Heller, Carol Forsythe, James Leacock, and John Steele in conservation; Pam Watson and Kim Dziurman in the registrar's office; Jim Huntley, Jennifer Czajkowski, and Marianne DePalma in the development department; Nancy Jones, Sarah Hufford, and Linda Margolin in the education department; Jennifer Moldwin, Mary Galvin, and Ryan Wieber in the research library; and Cyndi Summers and Pamela Phillips in marketing and public relations. Tracey Albainy, Assistant Curator of European Sculpture and Decorative Arts, was always available for sound advice, and Melanie Holcomb, Intern, and Maria Santangelo, Curatorial Coordinator, were also great assets. Rebecca Price-Wilkin, Assistant for the Exhibition, was invaluable in all facets of the project, and I am especially grateful to her. My colleagues in the department of European Paintings, George Keyes and Iva Lisikewycz, have also been supportive. The creative work of Three Communication Design, Chicago, has resulted in the fresh clarity of the catalogue design. Especially generous financial support for the project came from many government, foundation, and corporate sources, and we are all grateful to them.

PETER BARNET
Associate Curator
European Sculpture and Decorative Arts

Lenders to the Exhibition

FRANCE

Paris
Musée du Louvre
Musée National du Moyen Age,
Thermes de Cluny

Rouen
Trésor de la cathédrale

GERMANY

Hamburg
Museum für Kunst und Gewerbe

GREAT BRITAIN

London
British Museum
Victoria and Albert Museum

SWITZERLAND

Bern
Dr. Ernst and Sonya Boehlen

UNITED STATES

Baltimore, Maryland
Walters Art Gallery

Bloomfield Hills, Michigan
Cranbrook Art Museum

Boston, Massachusetts
Museum of Fine Arts, Boston

Chicago, Illinois
The Art Institute of Chicago

Cincinnati, Ohio
The Taft Museum

Cleveland, Ohio
The Cleveland Museum of Art

Detroit, Michigan
The Detroit Institute of Arts

Houston, Texas
The Museum of Fine Arts,
Houston

Kansas City, Missouri
The Nelson-Atkins Museum of Art

Los Angeles, California
Los Angeles County Museum of Art

Minneapolis, Minnesota
The Minneapolis Institute of Arts

New York, New York
The Metropolitan Museum of Art

Princeton, New Jersey
The Art Museum, Princeton
University

Richmond, Virginia
Virginia Museum of Fine Arts

Saint Louis, Missouri
The Saint Louis Art Museum

Toledo, Ohio
The Toledo Museum of Art

Washington, D.C.
National Gallery of Art

Worcester, Massachusetts
Worcester Art Museum

Contributors to the Catalogue

PB PETER BARNET
Associate Curator
European Sculpture and
Decorative Arts
The Detroit Institute of Arts

DGC DANIELLE GABORIT-CHOPIN
Conservateur général
Département des Objets d'art
Musée du Louvre

VH VIVIANE HUCHARD
Conservateur général chargée
du Musée National du Moyen
Age, Thermes de Cluny

NJ NORBERT JOPEK
Assistant Curator
Sculpture Department
Victoria and Albert Museum

PYLP PIERRE YVES LE POGAM
Conservateur
Musée National du Moyen
Age, Thermes de Cluny

CTL CHARLES T. LITTLE
Curator
Department of Medieval Art
The Metropolitan Museum
of Art

RPW REBECCA PRICE-WILKIN
Exhibition Assistant
The Detroit Institute of Arts

RHR RICHARD H. RANDALL, JR.
Former Director
Walters Art Gallery

ES ELIZABETH SEARS
Associate Professor
Department of the History
of Art, The University of
Michigan, Ann Arbor

HS HARVEY STAHL
Associate Professor
Department of History of
Art, University of California,
Berkeley

NS NEIL STRATFORD
Keeper of Mediaeval and
Later Antiquities
British Museum

PW PAUL WILLIAMSON
Chief Curator of Sculpture
Victoria and Albert Museum

NOTE TO THE READER

Maximum dimensions for height and width are given. Unless otherwise noted, dimensions reflect those of the object as illustrated here.

The Douai version of the Bible is used for references.

In some cases, early references to works of art in the exhibition have been omitted in favor of more recent and widely available ones.

The essay and entries by Danielle Gaborit-Chopin and entries by Viviane Huchard and Pierre Yves Le Pogam were translated from the French by Jean-Patrice Marandel.

Due to the fragility of the works of art, no. 35 will be exhibited only in Detroit and nos. 13 and 83 only in Baltimore.

IMAGES IN IVORY

ESSAYS

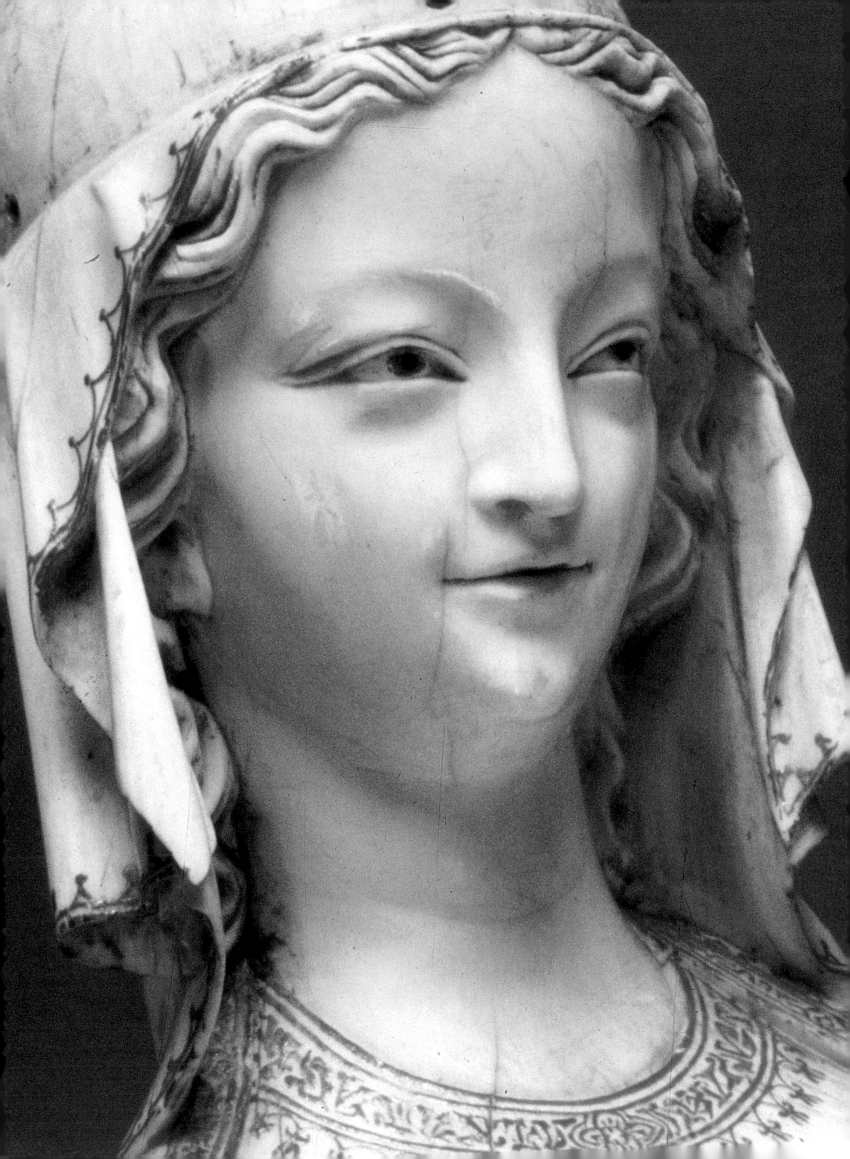

I | Gothic Sculpture in Ivory: An Introduction

PETER BARNET

ELEPHANT IVORY HAS LONG BEEN A RARE AND VALUED MATERIAL FOR CARVING. IVORY WAS A FAVORITE MATERIAL OF THE ANCIENT CIVILIZATIONS OF THE MEDITERRANEAN, AND ITS POPULARITY CONTINUED IN ROMAN ART AND IN THE ART OF BYZANTIUM.

Detail, fig. I-4

In the early medieval west prior to the Gothic period, carved ivory plaques were used to decorate book covers, reliquary caskets, and portable altars. Crosses and crosiers were also sometimes made of ivory. In the early Middle Ages African elephant ivory was often not available in Europe, and less fine-grained substitutes, notably whalebone as well as walrus tusks and narwhal tusks, were frequently used in its place. The increased popularity of ivory in western Europe during the Gothic period, beginning in the thirteenth century, coincides with a time when the horizons of western Europe were expanding. This was a period of increased contact with the eastern Mediterranean through military campaigns, trade, and other avenues. The First Crusade (1095–99) led to the establishment of the long-lived Latin Kingdom of Jerusalem in 1099. During the Fourth Crusade (1202–04) Europeans led by Venetian forces sacked Constantinople and ruled there until 1261. This was the beginning as well of a period of travel to the far east: Marco Polo returned to Italy from Asia in 1285.

Only recently, however, archaeologist Mark Horton has demonstrated in detail precisely how precious raw materials such as gold, rock crystal, and elephant ivory were obtained in Africa during the Middle Ages and subsequently brought to the West (see Horton 1987 and forthcoming). Excavation of seaports and settlements along three thousand kilometers of the East African coastline (especially in modern Kenya, Tanzania, and Mozambique) has revealed a sophisticated international trade network that had its beginnings in the tenth century. The key element in facilitating the East African trade was the activity of the seafaring Swahili people. Horton has called the long stretch of African coast dominated by the skillful sailing of this Islamic people the "Swahili corridor."

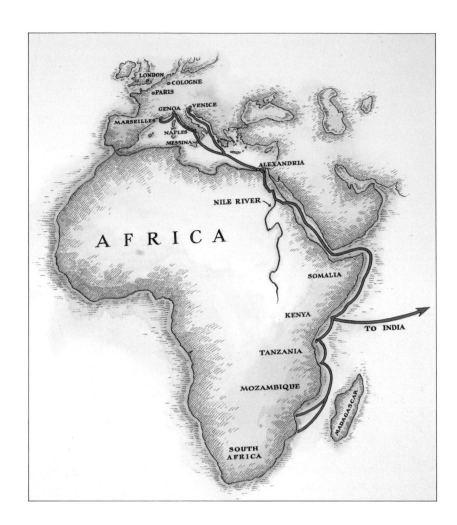

Fig. I-1. Map of East African trade routes during the Middle Ages

Fig. I-2. Diagram of an elephant tusk

The Swahili trade network led not only north to Europe but east ultimately to India and China (see fig. I-1).

Elephant ivory was obtained in the African interior, as far as one thousand kilometers inland, by local hunting peoples who traded it to herders in settlements on the east coast. There the Swahili people exchanged such goods as cloth (both cotton and silk) for the ivory tusks and other precious commodities. As Horton has demonstrated, the Swahili corridor emerged in the tenth century and lasted until the sixteenth. Through this network, ivory was taken from the south African interior and brought to the Mediterranean through the Red Sea to Sicily and into Europe. It is significant for our study of Gothic ivory carving to note that Horton has documented that "the period of 1250–1350 is one of great prosperity on the East African coast" and that "from around 1350 the African towns seem to be in decline."[1] As we shall see, the period of greatest success in the African ivory trade not surprisingly corresponds closely to the dominance of ivory as a luxury material in western Europe.

The elephant's ivory tusks are the animal's upper incisor teeth, embedded in bone sockets of the skull and growing from the inside out.[2] At the socket, the tusk has a hollow pulp cavity that narrows toward the midpoint to a small channel or nerve cavity that extends nearly to the point of the tusk (fig. I-2). The tusks of African elephants, both male and female, are larger than those of the Asian species, making the African variety the most desirable for carving. African elephant tusks are known to exceed ten feet in length and can weigh 150 pounds or more each. The material near the pulp cavity is relatively soft and not desirable for carving, while the outermost layer, cementum, is brittle and likewise of little use. The ivory carver valued the dense layer of dentin that forms the main part of the tusk. The thick dentin layer is made up of a vascular network of minuscule channels radiating from the central cavity. The density of the network accounts for the fine grain of ivory, making it an ideal substance to carve. Furthermore, the collagen contained in the dentin yields an oily substance that gives the ivory a sheen when polished.

Given the artistic importance of the ivory derived from the African elephant, it is interesting to note that the elephant's tusk itself plays a role of little importance in contemporary medieval art and thought. The elephant is accorded a great deal of space in the illustrated bestiaries of the twelfth and thirteenth centuries.[3] These moralizing texts are drawn largely from early Christian and early medieval sources. The elephant is usually viewed as an important animal for its military function, and many of the bestiaries depict the elephant with a howdah or tower fitted on its back. Often castellated, the howdah is populated with knights armed for battle. While perhaps inspired by the Crusades, this image of the elephant as a martial animal derives ultimately from classical sources. The tusk is mentioned only briefly in the bestiaries as a means of protection for the elephant.

It is interesting to note the unusual appearance of a live elephant in western Europe in the thirteenth century. This was a ten-year-old elephant from the Holy Land given to Henry III of England by Louis IX of France in 1255. Housed at the Tower of London for four years, the king's elephant was observed and illustrated by the English monk Matthew Paris

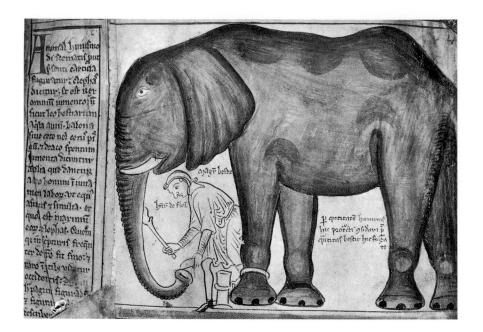

Fig. I-3. Elephant given to Henry III of England by Louis IX of France, *Chronica Majora* by Matthew Paris, English, mid-13th century, Cambridge, Corpus Christi College, MS 16, fol. iv

(d. 1259).[4] The full-page drawing that appears as a prefatory illustration in Matthew Paris's *Chronica Majora* (fig. I-3) is notable as a documented drawing done from life and by Paris's own hand. The chronicle relates that the elephant was the only one of its kind to have been seen north of the Alps and that it was a popular attraction. Paris describes the elephant in generally accurate terms, remarking on its size and color, the texture of its hide, and the method by which it feeds itself. The drawing, showing the elephant in profile, is also a faithful record, particularly when contrasted with some of the fanciful contemporary images in bestiary manuscripts.[5] Like the bestiaries, however, Matthew Paris places little emphasis on the tusk in both his text and illustration.

We have little documentary evidence of the working methods of the medieval carver, and the well-known treatise of the twelfth-century monk Theophilus concentrates on metalwork and other crafts, devoting only a brief discussion to carving ivory and bone as materials for knife handles. Theophilus instructed:

> When you are going to carve ivory, first shape a tablet of the size you want, put chalk on it and draw figures with a piece of lead according to your fancy. Then mark out the lines with a slender tool so that they are clearly visible. Next cut the grounds with various tools as deeply as you wish and carve figures or anything

else you like according to your skill and knowledge. If you want to ornament your work with gold leaf, put an undercoat of glue from the bladder of a fish called the sturgeon, cut the leaf into pieces and lay them on as you wish (Hawthorne and Smith 1976).

Theophilus uses the words *os* (bone) and *ebur* (ivory) almost interchangeably, and it is likely that the methods and tools employed in carving these materials were similar to those used by wood carvers. It is clear, for instance, from examining medieval ivories, that ivory carvers, like woodworkers, preferred to go with the grain. In other words the long axes of ivories, vertical and horizontal, follow the length of the tusk. Another step in the production of ivories was the addition of polychromy, which is discussed here by Danielle Gaborit-Chopin in her essay (pp. 46–61).

Paris and the Gothic Style

The moment of the arrival of Louis IX's elephant in Europe in 1255 coincides nearly exactly with the emergence of ivory carving as a major art form in Paris as seen in the earliest works included in this exhibition (nos. 1–17). A center of regional importance throughout the early Middle Ages, during the twelfth century Paris began to emerge as a preeminent city in Europe. When Louis VII (1137–80) departed France for the Holy Land in the Second Crusade, he appointed Abbot Suger of the royal abbey of Saint-Denis, just outside Paris, to serve as regent. The oriflamme, a banner carried in battle by the French kings, was kept at Saint-Denis.

Traditionally the burial place of the French monarchs, under the leadership of Suger, Saint-Denis emerged as the center of the new Gothic style of architecture. There, from 1137 to 1144, creative experiments in architecture led to the building of the new west facade and choir. Both of these are characterized by innovative forms that remained defining characteristics of Gothic architecture: pointed arches, ribbed vaults, and a central rose window on the west facade. The three portals of the west facade at Saint-Denis were decorated with column statues of Old Testament kings and prophets that ushered in a

new sculptural form. The walls of the choir, supported by the new Gothic structural systems, were pierced by stained-glass windows in the first large-scale use of this form of monumental painting. These achievements at Saint-Denis in the middle of the twelfth century did not, of course, emerge fully formed from Suger's imagination but were based on earlier experiments. The renovated royal abbey, however, emerged as the model for monuments in the new Gothic style.

During the reign of Philippe Auguste (1180–1223) Paris became a major capital city. Philippe Auguste was able to expand his kingdom well beyond the Ile-de-France (see Baldwin 1986). For example, at the Battle of Bouvines in 1214 the French king defeated the combined forces of the Holy Roman Emperor Otto IV; William, earl of Salisbury; Ferrand, count of Holland; Henri I, duke of Brabant; and a group of rebellious French nobles. Consequently, France retained the Angevin territory in the west that had been claimed by the English and gained control of the Netherlands. Philippe Auguste centralized the administration of the monarchy in Paris, establishing a permanent treasury, archives, and other bureaucracies in the city. He also ordered the marshes within the city drained and paved many of the major streets. Philippe Auguste was the first to enclose Paris within a protective wall built on the right bank in 1190 and then in 1210–11 on the less densely populated left bank of the Seine. This fortification and the permanent presence of the royal administration were key elements in the development of the city of Paris. Population increased greatly in the early thirteenth century, reaching sixty thousand inhabitants by about 1225.

In addition to the royal court, other Parisian institutions played key roles in the rise of the city to its status as a cultural center for all of western Europe. The cathedral of Notre-Dame shared the small island of the Cité in the Seine with the royal palace, underscoring the central role of the cathedral and its bishop. Like the abbey of Saint-Denis, the cathedral had its origins in the Merovingian period (ca. 500–751) and underwent a major transformation during the twelfth century. Rising 108 feet to the roof, with four stories and double side aisles, the nave and chevet were completed about 1180, making the cathedral the largest structure in the region (see

Bruzelius 1987). The west facade followed the three-portal scheme of Saint-Denis, placing a monumental "gallery of kings" across the upper facade. Traditionally assumed to represent the kings of France, these sculptures further emphasize the importance of Notre-Dame in the consolidation of the monarchy in Paris. In addition to its great scale, the renovated cathedral was built to the highest artistic and architectural standards. From the time Maurice de Sully became bishop of Paris in 1160, Notre-Dame was also noted for the musical innovations of its cathedral school. Polyphonic music developed for the liturgy at Notre-Dame spread throughout Europe, and by the end of the thirteenth century Paris was also noted for the development of the vernacular motet (see Wright 1989).

Equally important as the king, court, and cathedral to the cultural primacy of Paris was the development of its university. Begun informally in the twelfth century by scholars such as Peter Abelard who abandoned established cathedral schools and monasteries, the university developed on the city's left bank as an alternative place of learning. The success of the university was a result of an exemption from civil authority granted to the associations of students and masters. As the reputation of the university grew, students came from all over Europe, and by about 1200 Paris was preeminent in Europe for the study of theology and the liberal arts.[6]

All of these institutions—court, cathedral, and university— contributed to making Paris the leading center of manuscript production in Europe. Students required good quality textbooks and a small, compact manuscript of the Bible became a noted Parisian product. The ecclesiastical institutions, the cathedral, and the many monasteries in Paris created a steady demand for beautifully decorated liturgical books, and, of course, the court commissioned lavishly illuminated psalters and other manuscripts. Recent studies (see Rouse and Rouse 1990) have revealed the complex nature of the book trade in Paris by the time of Louis IX's reign (1226–70). Blanche of Castille, Louis's mother, was one of the first great royal patrons of Parisian illuminators, and by 1270 Paris had become the European center of illuminated manuscript production as well as of Gothic art and architecture.

The increasingly specialized nature of the book trade is of interest for the study of ivory carving in the same period because the production of manuscripts is better documented than other trades and crafts of the period. In the Gothic period the distinct stages of manuscript production were handled by separate artisans and tradesmen. A *librarius,* or bookseller, was generally involved in the sale of a manuscript. The *librarius* therefore was responsible for acquiring parchment from a specialized dealer, obtaining the model text to be copied, and finding scribes, rubricators, illuminators, and binders to complete the book. Students with limited means often rented texts from *librarii,* while more affluent customers commissioned new books from the same dealer. One can imagine a similar organization in the production of ivories that were carved, polychromed, gilded, hinged, and often sold in leather cases.

The activities of the booksellers constituted but one of many trades for which Paris became noted. We are fortunate to have preserved the manuscript of Etienne Boileau's compendium of Parisian guild regulations, known as the *Livre des métiers,* which was compiled at the request of the king in the 1260s. Boileau set down the regulations of an enormous range of craft guilds, from those producing mundane articles to those producing the luxury arts; 101 corporations in all are described. Elizabeth Sears's essay (pp. 18–37) explores Boileau's text for information on the production of and trade in ivory carvings that were just emerging at this time.

The life of Louis IX (1214–70) reveals a great deal about the thirteenth century in France, when Paris was emerging as the center of ivory carving. Crowned at the age of twelve, Louis proved to be a strong political leader, consolidating territory held by the previous Capetian kings by denying claims made on it by the English king and some French barons. For all his political acumen, however, Louis IX is best remembered as an exceedingly pious king. He was canonized as Saint Louis in 1297. In all things, Louis was heavily influenced by his mother, Blanche of Castille, a deeply religious woman. He was an ardent supporter of the friars, the new urban mendicant religious orders such as the Franciscans and the Dominicans, founded in Italy in about 1210 and 1216, respectively. Louis emulated the friars' tunic in his own dress, and some friars

Fig. I-4. Virgin and Child from the Sainte-Chapelle, French (Paris), ca. 1250–60, elephant ivory, 41 cm, Paris, Musée du Louvre (OA 57)

even became officials in the government, provoking the displeasure of many. Louis also expressed his piety by embarking on the Seventh Crusade in 1248. After some initial success in the Middle East, he was eventually defeated and captured in Egypt, unable to return to France until 1254. The failed venture deepened Louis's religious devotion. He left for another Crusade in 1270 and died near Tunis that summer.

Louis IX's monumental contribution to Paris was his royal chapel, the Sainte-Chapelle. The Gothic style, born at Saint-Denis in the twelfth century, was developed in the construction of cathedrals in Paris and in the surrounding regions in cities such as Chartres, Amiens, and Reims. But with the construction of the Sainte-Chapelle, Gothic art and architecture achieved new levels of accomplishment (see Branner 1965). Dedicated in 1248, the chapel was built by Louis IX to house the sacred relics of the Passion of Christ that he had obtained earlier in Constantinople and Venice. The lavish two-story chapel, with a series of interior sculptures integrated with an unprecedented expanse of stained glass, was part of the royal palace complex on the Ile de la Cité. A fourteenth-century observer wrote of "the choice of its radiant colors, the images standing out against a gold background, the transparency and brilliance of its windows, its altar frontals, and its reliquaries sparkling with precious stones."[7]

Private Devotional Art

From about the time of its dedication, among the glorious "images" of the Sainte-Chapelle referred to in the quotation above was the splendid statuette of the Virgin and Child now in the Musée du Louvre (fig. I-4, III-3, IV-2). At forty-one centimeters tall, this exquisitely carved statuette is among the earliest of the important Gothic ivory sculptures.[8] Documented in an inventory of the Sainte-Chapelle that was prepared between 1265 and 1279, the sculpture can be dated stylistically to the decade after 1250.

If not commissioned by Louis IX himself, the statuette was most likely a gift to the king. Reflecting the style of Louis's court at mid-century, the sculpture is one of the first great

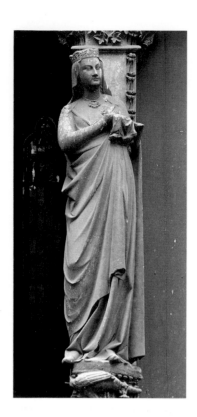

Fig. I-5. Virgin and Child on the trumeau of the north transept of Notre-Dame cathedral, Paris, ca. 1245–50, limestone

Fig. I-6. Legend of Theophilus on the tympanum of the north transept of Notre-Dame cathedral, Paris, ca. 1245–50, limestone

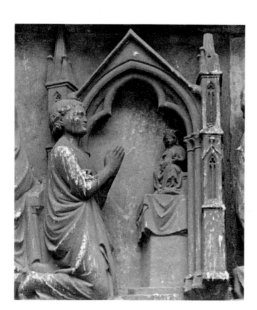

Parisian products made in the newly popular material of elephant ivory. As has often been remarked, the Sainte-Chapelle ivory Virgin and other thirteenth-century examples can be compared to the monumental limestone sculpture of the Virgin and Child on the trumeau of the north transept of Notre-Dame (fig. I-5). The north transept of the cathedral can be dated to about 1245–50, and it is likely that the trumeau of Notre-Dame exercised an influence over the carver of the Sainte-Chapelle Virgin. Paul Williamson explores in this volume (pp. 38–45) the complex relationship between small-scale sculpture in ivory and monumental sculpture of the Gothic period.

In its large size and extraordinary quality, the Sainte-Chapelle statuette is no more typical of thirteenth-century ivory carving than the royal chapel is typical of medieval buildings in Paris. In one important respect, however, both monuments reveal a great deal about the changing function of art at this time and the proliferation of ivory sculptures used in worship. The Sainte-Chapelle was built as a place for private devotion of the king and court, and it provided a model for many smaller chapels. The wealthiest members of society were able to construct chapels attached to or separate from their residences, while others dedicated a chamber within the house to devotional use. As private devotion increased from the thirteenth century onward, so, too, did the works of art created for personal use within these smaller chapels. Although we do not know the circumstances of the commission for the Sainte-Chapelle ivory, nor its exact location in the church, a monumental sculpture on the north transept of Notre-Dame suggests the placement of many contemporary ivory statuettes. This image can be found on the tympanum directly above the trumeau sculpture mentioned above. The three registers show commonly represented scenes from the Infancy of Christ in conjunction with the much rarer legend of the priest Theophilus. To the right of center in the middle register we see Theophilus at prayer calling upon the Virgin Mary to intercede on his behalf in his struggle with Satan (fig. I-6).[9] He kneels before a

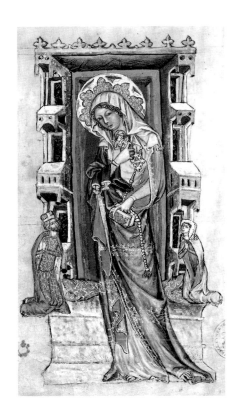

Fig. I–7. Saint Hedwig holding an ivory statuette, from the Hedwig Codex, Silesia, 1353, Malibu, The J. Paul Getty Museum, MS Ludwig XI.7, fol. 12v

simple altar on which is an image of the Virgin enthroned with the Christ child. Theophilus's sculpture is not, of course, necessarily to be taken as an ivory, as devotional images existed in many materials ranging from wood sculptures to statuettes of gold and silver. The relief does convey, however, that such small statuettes as the example from the Sainte-Chapelle served an important new purpose, different from the Romanesque ivories that were principally used to decorate book covers, portable altars, and caskets.

A painted image from the fourteenth century reinforces this interpretation. The Hedwig Codex (*Legenda maior*) of 1353 at the J. Paul Getty Museum, Malibu, is devoted to the life of Saint Hedwig of Silesia, who died in 1243.[10] The text relates that Saint Hedwig had a small ivory sculpture of the Virgin and Child, which she carried with her at all times and which was ultimately buried with her. When visiting the sick, she blessed the afflicted persons with the statuette, and they were miraculously healed. The richly illustrated manuscript contains a full-page miniature of Saint Hedwig flanked by the patron Ludwig I of Liegnitz and Brieg and his wife, Agnes von Glogau (fig. I-7). The standing saint is represented barefoot with her shoes held in her right arm. She carries a prayer book and a rosary in addition to the ivory statuette. Saint Hedwig clutches the white image of the Virgin and Child to her chest with her right hand in a rare contemporary depiction of a Gothic ivory statuette.

There were many changes in religion and society that can account for the burgeoning of private devotional art in the Gothic period (see Oakley 1979). Hans Belting has even referred to the late Middle Ages as "the era of the private image."[11] The Virgin came to occupy a central role in late medieval spirituality. She was increasingly seen as an accessible figure to whom the faithful could appeal for help, and as such she was frequently represented in art. In the thirteenth century the Book of Hours, a prayer book for the laity largely dedicated to the Virgin, became the most popular book across Europe.[12] We have seen that by the early thirteenth century friars of the mendicant orders became an important presence in urban areas. Around 1300 a Franciscan wrote a new version of the life of Christ, adapted from the Gospels. The

Meditationes vitae Christi (Meditations on the Life of Christ) was originally intended for a nun of the Poor Clares, the Franciscans' sister order, and it rapidly became a popular text. The writer encourages the reader to become an imaginary participant in the stories of the Gospels, to stand beside the Magi, for example, and adore the newborn Christ child. The growing popularity of ivory diptychs in this period can be seen as a response to this emphasis on personal worship. The small scale of devotional ivories provided imagery for private prayer and contemplation, and, like the Book of Hours, ivory carvings were popular with both the clergy and the laity. Harvey Stahl's essay (pp. 94–114) gives new insights into the nature of narrative in the context of the devotional function of Gothic ivories.

Raymond Koechlin and the Study of Gothic Ivories

The Alsatian Raymond Koechlin (1860–1931), an amateur scholar, was the first to study systematically the vast quantity of ivory carvings that survive from the Gothic period.[13] His seminal three-volume catalogue *Les ivoires gothiques français* was published in 1924 (Koechlin 1924). Heir to a prominent family in Mulhouse, Koechlin was a knowledgeable collector in a wide range of fields but never served on a museum or university staff. In 1900 he collaborated with J.-J. Marquet de Vasselot (1871–1946), curator at the Musée du Louvre, on a study of late Gothic sculpture in Champagne (Koechlin and Marquet de Vasselot 1900). Marquet de Vasselot is best known for his pioneering studies of Limoges champlevé enamels, which he grouped according to ornamental motifs found in the backgrounds, such as stars, foliate scrolls, and flowers. (Michel 1906, 941–42)[14] Koechlin was apparently heavily influenced by his colleague's approach. Like Marquet de Vasselot, he relied primarily on intrinsic criteria rather than comparison with works in other media.

Koechlin's catalogue contains 1,328 numbered entries, preceded by a volume of historical and methodological discussion. He assumed that nearly all Gothic ivories are Parisian with few exceptions, such as the bone objects attributed to the northern Italian workshops of the Embriachi. Koechlin separated

ivories with religious themes from the secular examples and then subdivided each group according to function and format. Statuettes are thus isolated from diptychs and triptychs, and the writing tablets and caskets are divided from mirror cases. Within the large group of diptychs, Koechlin subdivided his examples further using details of their enframement. His group of "diptyques à décor des roses," for example, comprises the many diptychs with rosettes decorating the horizontal borders between the bands of narrative. Likewise the scenes in the group of "diptyques à frise d'arcatures" are framed by arcades, and the "diptyques à colonnettes" use colonnetes to separate scenes. While he admitted that his groups do not necessarily reflect distinctions between the workshops that produced the ivories during the Gothic period, Koechlin at times referred to the rose group diptychs as products of the same atelier. Koechlin incorporated some discussion of documentary information about the ivory carvers, largely drawn from Boileau's *Livre des métiers*, and he included an appendix listing carvers named in the documents as well as a brief appendix listing ivories with known dates. None of the named carvers, however, can be associated with a known ivory.

It is perhaps a testimony to Koechlin's monumental achievement that the study of Gothic ivories did not receive a thorough reevaluation for more than fifty years after the publication of *Les ivoires gothiques français*. Danielle Gaborit-Chopin's *Ivoires du moyen age* examines the development of Gothic ivories within the context of medieval ivory carving from late antiquity into the fifteenth century (Gaborit-Chopin 1978). Taking a broader approach than Koechlin, her discussion of the major thirteenth-century examples makes frequent reference to contemporary monumental Gothic sculpture in Paris and the Ile-de-France. While acknowledging that Gothic ivory carving emerged in Paris, Gaborit-Chopin carefully reviews the evidence for other centers of ivory carving in such regions as the Rhineland, England, and Italy. In an article published in 1979, Charles Little further explores the broader artistic context for thirteenth-century ivory carving, introducing evidence from metalwork and monumental sculpture (Little 1979). His essay on German ivory production (pp. 80–93) adds depth to our understanding of works from this important area. John

Beckwith, Géza Jászai, Neil Stratford, Paul Williamson, William Wixom, and others have made further contributions to the localization of ivories outside France.[15] Richard H. Randall, Jr., has contributed greatly to the localization of ivories and many other aspects of their study in his extensive writings on the subject. His essay (pp. 62–79) on secular ivories explores the imagery drawn from romance literature used to decorate these luxury products.

The present exhibition and catalogue build on the foundation created by Koechlin and developed by the more recent scholarship cited above. Following a chronological organization beginning in the early thirteenth century, the exhibition documents the emergence of such devotional images as statuettes of the Virgin and Child and diptychs and triptychs carved in relief. The exhibition continues into the fourteenth century to examine the serial production of devotional ivories, which emerged first in Paris and later in other centers. After an exploration of the secular caskets, mirror cases, and combs decorated with scenes of courtly love drawn from romance literature, the exhibition moves into the fifteenth century. By this time Paris was no longer preeminent in ivory carving and, indeed, ivory itself was scarce. Many of the objects in this section utilize bone in place of elephant ivory.

An epilogue to this chronological study of Gothic ivories examines works posing problems of questionable authenticity, introducing some works once dismissed as forgeries but now established as genuine Gothic works of art, others that are pastiches made up of old pieces assembled in modern times. Some are perhaps works created in the late eighteenth or nineteenth century in the spirit of Gothic revival and not intended as forgeries.

In addition to providing a rewarding opportunity to assemble a large group of extraordinarily beautiful objects, this exhibition synthesizes much of the significant research that has been devoted to the subject since Raymond Koechlin's early work. Each of the essays in this volume contributes new information in a variety of important areas of research, and the objects themselves provide a valuable opportunity to study issues related to style and workshop. Perhaps inevitably, however,

one is acutely aware of how little is known about the circumstances in which the ivories were created and used. Science, with such tools as radiocarbon dating and nondestructive spectroscopic analysis, offers the possibility of many new avenues of future research. The developing history of art and culture, with ever-widening interests in such issues as narrative, religious devotion, and social and economic contexts, will undoubtedly also yield much insight in the future.

Notes

1. Undated letter to the author, 1995 (DIA curatorial files).

2. On the physical properties of ivory, see MacGregor 1985 and Cutler 1985.

3. On bestiaries, see Hassig 1995.

4. On Matthew Paris, see Lewis 1987.

5. See Hassig 1995, figs. 131-45.

6. On the development of universities, see Leff 1968.

7. Jean de Jandun, writing in 1323 in his *Tractatus de laudibus Parisius,* quoted in Ottawa 1972, 2:16–17.

8. On the Sainte-Chapelle Virgin, see Gaborit-Chopin 1972.

9. For the story of the legend of Theophilus, see Ryan 1993, 2:157.

10. On the Hedwig Codex, see Euw and Plotzek 1982, 3:74–81, figs. 25–38 with bibliography.

11. On the development of devotional art, see most recently Camille 1989; Belting 1994; and Amsterdam 1993.

12. On the Book of Hours, see Wieck 1988.

13. On Koechlin's life, see Paris 1989, 241, and Paris 1993, 1234–35, both with further bibliography.

14. See, for example, Marquet de Vasselot 1914; 1914a; 1941.

15. See Beckwith 1966; Jászai 1979; Stratford 1983; Williamson 1994; Wixom 1987.

Qviconques Cist tra[...]

ueut estre de vaer vo[...]

a pn̄. ce est a sauoir feseeu[...]

de dez a tables et a eschiez. d[...]

et dyuoire de cor et de touta[...]

maniere destoffe et de mu[...]

le puet franchement pour t[...]

II | Ivory and Ivory Workers in Medieval Paris

ELIZABETH SEARS

A CRUCIFIX OR A STATUETTE OF THE VIRGIN MARY, A SET OF KNIVES WITH CARVED HANDLES, SOME BUTTONS, A COMB, A SET OF WAX-FILLED WRITING TABLETS, A PAIR OF DICE: SUCH ARE THE SORTS OF OBJECTS IN IVORY THAT A VISITOR TO PARIS MIGHT HAVE PURCHASED AROUND THE YEAR 1270.

Detail, fig. II-1

This much can be gathered from a reading of the earliest guild regulations to survive from the city, *Li establissement des mestiers de Paris,* more commonly called the *Livre des métiers,* or the Book of Trades.[1] Containing the statutes of 101 corporations of workers in the capital, the text was compiled toward the end of the reign of Louis IX (1226–70) by a royal official, the *prévôt de Paris,* Etienne Boileau.[2] As witness to the operations of the Parisian craft guilds at the very time when Gothic ivories were beginning to be produced in number, the *Livre des métiers* is the optimal starting point for an investigation of the use of ivory and the status of the ivory worker in medieval Paris.

Boileau prepared the *Livre des métiers,* "for the profit of all," he says, in response to an untenable situation. Having seen in his time many complaints and disputes, "born of that wicked envy which is the mother of grievance and unbridled greed which consumes itself," he had determined to set out clearly the regulations of each trade, including infractions and the penalties for infractions.[3] We may imagine representatives of the various corporations coming to his headquarters in the Châtelet to deposit their statutes.[4] Boileau's self-appointed task lay in collecting, assembling, and ordering the regulations he received—many of which clearly reflect ancient practice, others of which were likely codified for the occasion. Upon completion, he reports, his work was read before many of the "wisest, best, and most venerable men of Paris, and those who had most reason to know these things," and all praised it highly. If Boileau's code—preserving the tensions and contradictions inherent in the system it mirrored—did not put an end to contention, it achieved noteworthy success. The *Livre des métiers* would serve as the basis of Parisian guild legislation for some five centuries.

Fig. II-1. Boileau's *Livre des métiers*, folio with illustration of carved dice, French, late 13th century, Paris, Bibliothèque Nationale, MS fr. 24069, fol. 175r

Vivid proof of the respect accorded the work is offered by a late-thirteenth-century copy of the text preserved in the Bibliothèque Nationale in Paris (MS fr. 24069).[5] This was a working manuscript, very possibly kept in the Châtelet, periodically updated for over a century.[6] The original scribe copied the 101 sets of regulations neatly, in double columns, providing rubrics and leaving wide margins as if in anticipation of revisions and refinements, a sensible precaution. Generations of officials would improve on the text, making additions and deletions as regulations changed and new trades defined themselves. Evidences of regular use are many. Clerks filled the margins with marks and signs to help them return rapidly to previously consulted passages. Some called attention to given regulations by means of crosses, stars, wavy lines, and pointing fingers.[7] A few added simple images to signal the contents of entries; thus, a pair of dice—with five and six spots, respectively—can be seen above the entry that opens: "Whoever wishes to be a dice maker in Paris, that is, a maker of dice and chess pieces of bone, ivory, horn, and any other kind of material and metal, can be so freely, so long as he works according to the uses and customs of the trade" (fig. II-1).

The 101 entries vary considerably in length, but all conform to a rough schema. They typically open with broad statements of the conditions for entry into a trade—statements that offer invaluable, often unique, definitions of the activities of its members. Of the sculptors *(ymagiers tailleurs)*, one of the chief ivory-working guilds, we read: "Whoever wishes to be an *ymagier* in Paris—that is, a carver of crucifixes, knife handles, and any other kind of carving, whatever it be, that one makes of bone, ivory, wood, and any other kind of material, whatever it be, can be so freely, so long as he knows the trade and works according to the uses and customs of the aforesaid trade."[8] The enumerations of uses and customs that follow, in every case, define what is acceptable practice and what not. Considerable attention is paid to the position of apprentices: how many can be had, for how long, under what conditions.[9] The *ymagier* is allowed only one (apart from family members), and he must accept this apprentice for no fewer than eight years with a payment of four Parisian pounds and ten years without payment, although he may demand more money and longer

service if he can get it.[10] Working hours are carefully regulated: it is stated on which days (normally feast days) workers may not ply their trade and at which hour they must cease working. *Ymagiers,* like many others, cannot work at night "because the light at night is not sufficient for them to practice their trade; for their trade is carving."[11] Fines for infractions are stipulated, the recipients of fines identified, and the number and sometimes the names of jurors given. It is indicated just what taxes are owed, and not owed, to the king, and, most importantly, it is stipulated whether members of the trades must perform the night watch *(guet),* an irksome task. Only the most privileged professions were exempt, the *ymagiers* among them: "for their trade belongs solely to the holy church and to princes and barons and other rich and noble men."[12]

Many entries list prohibitions specific to the trade, and these offer sometimes intimate insight into workshop practice and professional ethics. Duplicity is everywhere condemned: painters of sculpture *(ymagiers peintres),* for example, must not sell anything as gilded unless the gold is laid on silver; indeed, it is stated, if gold is laid on tin and they sell it as gilded without saying that the gold is on tin, then the work is false and the gold and tin and all the other colors must be scraped off and the piece redone and a fine set by the *prévôt* paid to the king.[13] Of the carvers of images we read: "No worker of the aforementioned trade can or should work any *ymage* which is not wholly of one piece, except for the crown—unless it is broken in carving, for then one can rejoin it—with the exception of a crucifix, which is made of three pieces, that is, the body of one piece and the arms affixed. And this was established by the wardens of the trade, for the reason that some used to make *ymages* which were not well joined, and not good and proper *[bones et loiaus],* for they were made of many pieces."[14] This regulation gives us to understand that while well-mended pieces were acceptable, composite pieces were not; it confirms that statuettes of the Virgin (characteristically crowned) were among the sculptors' chief commissions in the late thirteenth century (no. 5); and it explains, if explanation is needed, why so many crucifixes survive armless (nos. 8, 34, 36).

The assembled regulations make clear that no guild existed for the sole purpose of working ivory and confirm what we

know: that no objects crafted in ivory were made exclusively in that material. Seven trades specifically mention the exotic substance in their definitions of their craft, while claiming the right to work other carvable materials. They appear in MS fr. 24069 in the following order: makers of knife handles *(couteliers feseeurs de manches* or *enmancheeurs); makers of combs and lanterns (pingniers-lanterniers); makers of writing tablets (tabletiers); sculptors (ymagiers tailleurs); painters and carvers of sculpture (peintres et tailleurs d'ymages); makers of rosary beads, buckles, and buttons (patenostriers); and dice makers (deiciers).*[15] All take their place within a complex system that had been evolving rapidly in the previous century as groups sought to seize and hold portions of an expanding market. The craft guilds may be seen defining themselves by means of varying combinations of a constant set of factors: material, process, product, and (as a corollary) patronage.

Thus, for example, the professional identity of the goldsmiths *(orfèvres),* whose patrons were the elite, resided in the precious substances they worked. Their regulations gave them the exclusive right to manufacture any and all objects in gold and silver[16]—the same objects fashioned in different and humbler materials by members of other corporations. Thus they shared the making of statuettes with *ymagiers,* of knife handles with *enmancheeurs,* of writing tablets with *tabletiers,* of combs with *pigniers.* But in one way the goldsmiths' territory was delimited. *Batteurs d'or et d'argent à filer* (those who drew gold and silver wire to produce thread used in the fashioning of sumptuous fabrics and richly embroidered goods)[17] and *batteurs d'or en feuille* (who hammered gold and silver into the thin leaf required by furniture makers and others) maintained a separate existence by employing a particular process; these were, of course, pleased to consider themselves *orfèvres* when it came to claiming privileges.[18] The gold beaters, in turn, were distinct from those using related techniques but working different substances: Paris had corporations of beaters of *archal* (a copper alloy), who hammered leaf and drew wire,[19] as well as tin beaters *(batteurs d'étain).* The latter were separate from those tinsmiths who defined themselves by product: makers of tin vessels *(potiers d'étain)* and "makers of all small objects in tin and lead" *(ouvriers de toutes menues oeuvres que on fait d'estaim ou de plom a Paris).*[20] Indeed product most often

provided a guild's primary identity, with material and technique further delimiting the sphere of activity. Makers of various sorts of headgear *(chapeliers)* were divided according to whether they worked with flowers, felt, cotton, or peacock feathers. Four corporations of *patenostriers* supplied rosary beads: one employed bone and horn; another coral and mother of pearl; another amber and jet. The fourth produced an oddly heterogeneous group of items: rosary beads and shoe buckles of brass, *archal,* and copper, and also buttons of bone, horn, and ivory—a rare instance of a corporation manufacturing both cast and carved objects.[21]

The ivory-working industries take their place in this scheme. Carvers *(ymagiers tailleurs)* make the broadest of claims, their ambition approaching that of the *orfèvres,* or the *cristalliers,* who worked precious stones.[22] They claimed the right to manufacture any carved object of any carvable material: the sculptor, again, is "a carver of crucifixes, knife handles, and any other kind of carving, whatever it be, that one makes of bone, ivory, wood, and any other kind of material, whatever it be." Members of the linked guild of the *ymagiers peintres,* who painted carved objects with "good and proper pigment," extended the list of carvable substances to stone: "any kind of wood, stone, bone, horn, and ivory."[23] The other ivory-working trades, voluntarily limiting themselves by product, employed a similar range of substances. Knife handle makers were sanctioned to work bone, wood, and ivory; comb and lantern makers, horn and ivory; tablet makers, any kind of wood, ivory, and any kind of horn. The dice makers manufactured dice of bone, ivory, horn, or any other kind of material, or of metal—in this resembling the fourth corporation of *patenostriers* mentioned above.

Even in these seemingly straightforward definitions there are inherent tensions. Sculptors claim the right to carve knife handles, thus treading on the turf of the *couteliers feseeurs de manches;* handle makers in turn encroach upon the activities of the comb makers when they call themselves "makers of knives of bone and wood and ivory, and makers of combs of ivory." Just how the competing claims were resolved in practice, we do not know. Did, for example, *couteliers* confine themselves to simple turned products while *ymagiers* carved knife handles with figural decoration (see fig. II-2)?[24] And who then

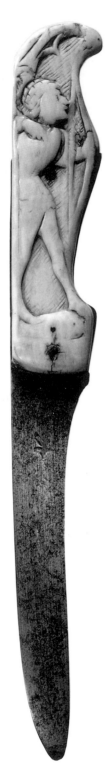

Fig. II-2. Knife with elephant ivory handle, French, late 14th–early 15th century, Paris, Musée du Louvre (OA 11113)

fashioned the ivory hair parters *(gravoirs* or *broches),* sold by comb makers, which—with figures and animals posed on platforms—closely resemble certain knife handles (fig. II-3)?[25] Were comb makers responsible for the reliefs carved on combs and mirror cases (nos. 53–60, 69)? Were makers of writing tablets trained to carve (no. 61)? Or did *pigniers* and *tabletiers* normally collaborate with *ymagiers* in the manufacture of richly embellished works?

The regulations leave much unstated. Many more kinds of objects were made in ivory than are named in the *Livre des métiers.* A high percentage of Gothic ivories in public collections, for example, are the hinged relief plaques *(tableaux)* we now call diptychs, triptychs, and polyptychs. Though already becoming common in the thirteenth century (nos. 9–14, 17), there is no hint of their existence in Boileau's compendium. And as the decades passed, an ever-wider range of ivory objects was produced. Surviving inventories reveal that boxes, in various sizes, plain and carved, with locks and fittings in precious metals, must have been common sights in both ecclesiastical and secular settings. In churches and private chapels they served as receptacles for relics, the chrism, the unconsecrated host, or corporals;[26] in the domestic sphere they held all manner of precious items (nos. 62–64).[27] Religious institutions possessed ivory croziers (nos. 28, 50) and pastoral staffs, liturgical combs, paxes (no. 72), and ceremonial fans *(flabella)* for keeping flies from the host.[28] Ivory fans *(émouchoirs)* were also useful against flies in nonreligious situations.[29] Private patrons might own ivory-handled whips, and splendid saddles decorated with ivory inlay are known.[30] Inventories are full of ivory gaming pieces and inlaid game boards (nos. 51, 74–75).[31] Musical instruments could be embellished with ivory,[32] as could astronomical devices: Jean le Bon had a quadrant of gold and ivory.[33] Spectacles of ivory existed.[34] In the sixteenth century ivory ear spoons *(cure-oreilles)* are attested.[35] Members of a number of trades must have purchased and worked the material.

In modern scholarship ivories are often treated separately from works in other media, and it is sometimes loosely assumed that a large class of specialists worked principally or exclusively in ivory. But there is no reason to think that most

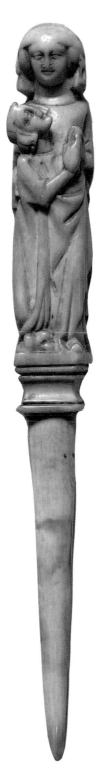

ivory carvers did not did also carve bone, horn, and wood, as
the guild regulations suggest. Too little attention has been
paid, perhaps, to the value medieval patrons placed on fine
woods, both local and exotic. *Madre* (mazer-wood), for exam-
ple, used especially in the manufacture of vessels for drinking
new wine, was highly prized for its interesting grain.[36] The
well-kept accounts of Mahaut, countess of Artois (1302–29),
reveal that this astute patron bought up cups of *madre* when
she visited Pontarlier in Burgundy, home of the best *madre.*
Moreover she regularly acquired blocks of the wood for
the future fashioning of objects, not only cups but also knife
handles.[37] Ebony, which must have been imported along
the same trade routes as ivory, was yet more highly prized.
Charles V (1364–80)—who owned a quantity of ivory objects
—possessed, too, an impressive collection of works in ebony.
He had several ebony boxes, larger and smaller (one holding
quills and ink), two inkstands, three lecterns, two mirrors, two
candleholders (one of gold with an ebony handle), a baton
with silver ferrules, several knives with ebony handles, two
diptychs and a triptych carved with religious scenes,[38] and
a whimsy: an ebony statuette of a fox in the guise of a
Franciscan, seated on his two hind legs, holding a shell with
pearls in the guise of the host.[39] Those who inventoried his
collection saw fit to record that he owned "four large pieces
of ebony": this was a valuable commodity.[40]

Specialization demands a steady supply of a particular materi-
al, and we have no way of knowing just how reliable the ivory
trade was. We may wonder if individual craftsmen had stand-
ing arrangements with merchants, or if *ymagiers, tabletiers,
pigniers,* and the rest bought against the future whenever a
shipment came in. In 1377, when Philip the Bold of Burgundy
asked his "sculptor of small works," Jean de Marville, to fash-
ion some items for him, it was a Parisian *tabletier,* Jean Girart,
who provided twenty-six pounds of ivory.[41] Certain artisans
may well have stockpiled the material in order to ensure the
regular production of ivory wares. But it is likely that blocks of
other carvable substances lined the walls of ateliers as well, for
ivory was often used in combination with other materials.
Charles V, for example, owned an ivory statuette of the Virgin
sitting on a throne of ebony, a Coronation of the Virgin in
which Christ, the Virgin, and three angels were carved in ivory

and the bench was of cedar, and a diptych of *brésil* (a red wood) inside of which there were six relief images in ivory: Christ, Saint James and Saint John, the Virgin, Saint Catherine, and Mary Magdalen.[42]

Few specialists in ivory turn up in medieval documents. The word *ivoirier*, as signifying one who works with or deals in ivory, is strikingly rare. No such artisan is listed in the tax rolls of the city of Paris. These rolls *(livres de la taille)*, however, have much to reveal about the status of those in the ivory-working trades. Seven rolls survive, all recording payments made by residents of Paris to the French crown during the reign of Philip the Fair (1285–1314).[43] The earliest, dated 1292, is interesting because it includes considerable numbers of people paying less than five sous (*menus gens*); it is the lengthiest with some 14,500 names.[44] The next five form a continuous series from 1296 to 1300 and can be useful for tracing careers over time.[45] A last roll, dated 1313, lists those wealthier Parisians required to pay an exceptional tax for the knighting of Philip's eldest son, the future Louis X le Hutin (1314–16); it is the shortest, with approximately 6,000 names.[46]

The tax collectors did their jobs systematically: they proceeded parish by parish, *quête* by *quête*, street by street, house by house,[47] exacting sums from all those who did not manage to obtain exemptions. Individuals identify themselves in various ways: all give baptismal names and some offer family names. But this was the era in which surnames were just coming to be codified, so other qualifiers—including profession—served as well. Often it is difficult, however, to know whether an individual actually practiced a designated trade, since surnames were often derived from profession. Guillaume *le tabletier* and Richart *le tabletier* may or may not have been makers of writing tablets, although the likelihood is great, since they were neighbors of a *tabletier* with a surname, Jean de Roëm, and lived on a short street off the rue Saint-Denis, called La Tableterie.[48] Guillaume *le coutelier, porteeur d'eau,* may have been both a knife maker and a water carrier, but he could also have inherited his name Le Coutelier and carried water for a living.[49] Jehan *le peintre, ymagier,* seems to be a sculptor from a painting family,[50] although he could conceivably be a member of the guild of painters and carvers of sculpture.[51] Pierre Cornet,

feseeur de cornez, appears to have carried on a family tradition of horn making.[52]

If the tax rolls cannot furnish reliable statistics, they do allow us to observe distinctions in status between and within the trades. Dice makers, for example, are not well represented: the 1292 roll lists seven who are asked to contribute insignificant sums: two are assessed at 12 deniers; four at 2 sous; and one at 8 sous. None at all appear in the 1313 roll where more prominent citizens are listed. Sculptors *(ymagiers, entailléeurs, entailléeurs d'ymages),* in contrast, number twenty-four in 1292. If the most humble of this corporation are no better off than the dice makers, paying 12 deniers, many pay more. In the 1313 roll, seventeen sculptors are listed, two of whom contribute substantial sums: 4 pounds 10 sous and 6 pounds.

The rolls tell us a good deal about professional identities. Rosary bead makers, although divided into four guilds in Boileau's text, are never distinguished from one another: all are simply *patenostrers.* Comb and lantern makers, on the other hand, though joined in a single trade, invariably appear separately: there are nine *pigniers* and three *lanterniers* in the 1292 list. When identities change over time, interesting issues about mobility within the medieval workforce come to the fore. A certain Jehan de Taverni appears in five tax rolls at the same address:

> *1296. Jehan de Taverni, coutelier. 48 sous.*
>
> *1297. Jehan de Taverni, coutelier. 58 sous.*
>
> *1298. Jehan de Taverni, coutelier. 62 sous.*
>
> *1299. Jehan de Taverni, coutelier. 62 sous.*
>
> *1300. Jehan de Taverni, ymagier, enmancheeur.*
> *62 sous.*[53]

The fifth entry surprises: a prominent knife maker, paying a substantial tax, decides in a given year to call himself a sculptor and maker of knife handles. It seems unlikely that Jehan had suddenly joined the sculptors' guild. Was he a blade maker *(coutelier fèvre)* who had taken to handle making —a sister guild with fairly relaxed conditions for entry? Or was he a handle maker all along who had begun to carve figured handles, and thus felt justified in styling himself an *ymagier?*[54]

Sculptors, the case history implies, do something beyond the normal work of the handle makers; yet equally, it is demonstrated that knife makers did carve. When an individual in the 1292 roll, Jehan le Mestre, calls himself a "carver of knife handles" (*taillẽeur de manches à coutiaus*),[55] it is not absolutely certain that he belonged to the guild of sculptors.

There is little in the tax rolls to indicate specialization by material in any of the ivory-working trades. One handle maker listed in the 1292 roll, Yvon—an artisan paying a mere twelve deniers tax—calls himself a maker of handles of horn (*fesẽeur de manches de cor*).[56] But this voluntary delimiting of the sphere of activity cannot have been common. If we survey the amply documented career of a highly placed *coutelier,* Thomas de Fienvillier, a favorite of the royal family during the reign of Jean le Bon (1350–64), we see that this craftsman capitalized on the very variety of materials he employed.

Purchases from Thomas are recorded in a sequence of royal accounts, the *comptes de l'argenterie,* dating from the early 1350s.[57] These "wardrobe accounts"—kept by a royal official who saw to the clothing of the royal family and the furnishing of their apartments—are typically arranged by category.[58] The entries under the heading cutlery (*coutellerie*) bring to light a seemingly extravagant custom, which the royal knife makers must have done everything to encourage: that of acquiring new sets of carving knives, with differently colored handles, on a seasonal basis. In 1352, for example, Thomas was asked to supply a pair of knives with handles of ebony for Lent, another with handles of ivory for Easter, and a third with handles of pieced ivory and ebony (*à manches escartelez d'yvoire et d'ibenus*) for Pentecost—all of them accompanied by smaller bread knives (*parepains*) and embellished with silver-gilt ferrules and rings and enameled with the royal arms.[59] Both the king and the dauphin (the future Charles V) received all three sets, while seven sets of Easter knives were delivered to the other princes of the royal house and their companions. In the same term, eighteen sets of small knives with ebony handles were ordered as Easter gifts for the *valets de chambre* of the king, the dauphin, the duke of Orléans, and the duke of Anjou.[60] The seasonal rhythms continued in succeeding years. In 1353 Thomas supplied the king, the queen and her companions,

and the dauphin and his companions with sets of knives for the feast of All Saints on November 1: this time all handles were of red *brésil*.[61] In the next half-year knives were purchased for four seasons: there were handles of *madre* for Christmas; jet *(gest)* for Lent; ivory, again, for Easter; and pieced ivory and ebony, once more, for Pentecost.[62] While no strict scheme of color symbolism prevailed, ivory handles appear to have been preferred for the joyful feast of Easter, forming a contrast to the black handles deemed appropriate for the penitential season of Lent. And the custom seems to have endured. In 1387 Jean le Bon's grandson, Charles VI, acquired carving knives with handles of ivory to be used "for carving before the king" at the Easter Feast *(Grans Pasques)*.[63]

Knives are complex items. Part of Thomas de Fienvillier's job would have been to orchestrate their manufacture, ensuring that blade makers, handle makers, goldsmiths, and enamelers collaborated efficiently. Even the most humble knife required coordinated teamwork among as many as three parties, or so the guild regulations suggest: blade and handle makers had to deal with *viroliers,* whose job was to make ferrules for knives and swords.[64] Other objects in ivory were similarly complex. A statuette of the Virgin, painted and gilded, might have a crown and other accoutrements in precious metals and might stand on a splendid pedestal;[65] collaboration with a goldsmith *(orfèvre)* was necessary. Ivory boxes not only had metal fittings but also came with locks and keys: *ymagiers* had to have dealings with *boîtiers, who made brass locks for boxes.*[66] Inventories suggest that comb makers commonly sold their wares in sets consisting of ivory combs, hair parters, and mirrors—the latter possibly produced in collaboration with *miroeriers*[67]—and that these objects came in leather cases, which were manufactured by case makers *(gainiers),* who, if the case were to be suspended by a silk ribbon *(laz de soye),* would have been in contact with *laceurs de fil et de soie.*[68] Ivory writing tablets, filled with colored wax, equipped sometimes with clasps and hinges, came with a stylus, often of silver, and were sold, too, in custom-made leather cases (no. 61).[69] We know all too little about the nature and extent of collaborations between craftsmen, or just how far outside the primary definitions of their trade individuals were able to go in the manufacture of complex items.

Of the marketing of wares we are only slightly better informed. Jean de Jandun's oft-quoted description of the great covered marketplace of Paris, Les Halles, provides an evocative image of the range of luxury wares available in Paris in 1323. Piles of splendid fabrics, each more beautiful than the last, could be seen on the ground level, while in the vast upper gallery, resembling an astonishingly long street, adornments for the various parts of the body were displayed: crowns, plaits, and bonnets for the head, parters for the hair, mirrors to serve the eyes, belts for the loins, purses to hang down the sides, gloves for the hands, necklaces for the breast, and many other things. Jean's Latin failed him as he tried to find words to describe all the wonders.[70] There were also boutiques in the city proper. Walking down the rue de la Tableterie, we imagine, a visitor would have passed shops where makers of combs and writing tablets could have been seen producing ivory wares for sale.[71]

Images in a famous Parisian manuscript, the *Vie de Saint-Denis*, presented to king Philippe le Long by the abbot of Saint-Denis around 1317, offer rare views into medieval shops. Scenes from the life of the patron saint of France, martyred in Paris in early Christian times, unfold above. But below, on a smaller scale, illuminators presented a conspectus of activities in the contemporary city—the comings and goings of colorful characters, the labors of distinctive classes of artisans—set on and under the principal bridges of Paris, the Grand Pont and the Petit Pont. On one page we see, to the left, an *orfèvre* hammering an object on an anvil, possibly a gold cup like the one displayed behind him, while, to the right, we look into a shop where ivory wares might have been sold (fig. II-4).[72] A woman engages in animated exchange with a man about to purchase the knife he holds in his hand; additional knives are suspended on the wall behind her, along with purses *(bourses* or *aumônières)*—items made by the corporations of *boursiers* and *aumosniers*.[73] This is a significant detail; it suggests that what is depicted is not the boutique of a cutler but the shop of a *mercier* or *mercière*.

Merciers were merchants, well represented in Paris and sometimes very wealthy, who sold a wide range of luxury goods purchased at home and abroad. They had no ateliers of their

own and manufactured nothing, though they might dress up
items for sale. They specialized in fine fabrics and elegant
trimmings but dealt, too, in splendid hats, belts, and purses.[74]
Writing tablets, mirrors, combs, lamps, and gaming pieces were
among their wares,[75] as were knives: in 1334, for example, the
Connétable d'Eu purchased a pair of carving knives with ivory
handles from a Parisian *mercier,* Jehan Lefrison.[76] Some of the
marketing of ivory objects, perhaps a good deal of it, was owed
to the *merciers,* and certain of these tradesmen may even have
specialized in this valuable material.

The case of the Parisian Jehan le Seelleur is revealing in this
regard. Called an *ivoirier* in a document of 1322—perhaps the
earliest use of the term—he seems to have been a *mercier* by
profession. In the tax roll of 1313, in any event, a Jehan le
Seelleur, *mercier,* is listed as living in the fifth *quête* of the parish
of Saint-Germain-l'Auxerrois and paying the impressive tax of
nine pounds.[77] Jehan's name begins to appear in the accounts
of Mahaut, countess of Artois, in 1315 when he is paid for
two ivory combs "purchased in her presence" (in her hôtel in
Paris,[78] perhaps, if not in his shop), and for two leather cases
to hold the combs, for a hair parter, and for "illuminating"
Madame's mirror. In 1316 he provides a comb set for Philippe
le Long; this purchase is recorded in the earliest of the surviv-
ing wardrobe accounts, under the heading *mercerie.*[79] But

Jehan does not confine himself to combs. In 1322 Jehan (called an *ivoirier*) is paid for the repair of an ivory statuette of the Virgin that Mahaut had purchased from the estate of Marie, widow of Philippe le Hardi.[80] And in 1325 he receives a handsome sum for supplying Mahaut with an ivory statuette of the Virgin in a tabernacle and an ivory Christ on a cross of cedar—works that must have been fashioned by *ymagiers*. The evidence suggests that Jehan le Seelleur was a middleman, a *mercier* specializing in ivory wares, who purchased for resale items from comb makers and sculptors, well able to undertake or arrange for the painting or repair of ivory works when the need arose. The designation *ivoirier* does not refer to a guild affiliation but to another kind of professional identity.[81] The case history suggests that, even though the guild structure worked against specialization in ivory carving, already in the early fourteenth century buyers were beginning to desire ivories as a separate class of goods and that tradesmen were working to satisfy the demand.

Evidence that certain sculptors were becoming known for their skills in ivory carving begins to accumulate in the later Middle Ages. A notice of a royal pardon delivered in February 1376 reveals the existence of an ivory worker of high status:

> Remission for Jean Cornée, worker in ivory in Paris *[ouvrier en ivoire a Paris]*, who had been condemned by the *prévôt* of Paris and given to the pillory for having struck a servant girl of Simon de Buci whom he discovered, with another girl, in the streets at night and whom he took to be a woman of ill repute because of certain things she said. The suppliant is a good worker, who works for the king and queen, and he is rehabilitated and restored to honor.[82]

The professional identity of Jean Cornée, his guild affiliation unstated, was based on the material he worked. Similarly Jehan Aubert, a Parisian sculptor active in the following two decades, seems to have specialized in ivory carving. In the wardrobe accounts of Charles VI for 1387 he is called an *ymagier* and paid for the repair and polishing of two ivory works in the Sainte-Chapelle—a crozier and a *tableau*.[83] A few years later, in 1394, he provided for Isabelle of Bavaria an ivory candleholder *(absconse d'yvoire)* "in which to place a candle when the queen says her Hours." In this document

he is given a specialist designation: sculptor in ivory *(ymagier d'yvoire)*.[84] That a sculptor should be providing a candleholder is itself proof that guild categories were scarcely binding, at least at the upper end of the hierarchy:[85] ivory lamps are properly the territory of the *pigniers-lanterniers*. And indeed in 1396 Henry des Grès, a highly placed Parisian comb maker who supplied comb sets for royal and aristocratic clients, sold the queen "a candleholder of white ivory in the shape of a spoon," again to serve her when she said her devotions.[86] But combs and candleholders did not exhaust his professional range: in 1395 he provided the queen with a range of chess pieces, black and white (the latter in ivory); and in 1396 he supplied her with twenty-four ivory game pieces *(batonnez)*.[87]

The material ivory is what connects the activities of these individuals. And we see that our present tendency to group ivory objects and to treat them as a separate category obeys a logic not wholly alien to the period in which the works were produced. When the trades defined themselves in the third quarter of the thirteenth century, on the eve of the great era of Gothic ivory carving, ivory was not so plentiful, perhaps, and the taste for ivory objects not so well developed that a single trade could be supported. The emerging guilds found it proper and expedient to work a range of carvable substances. Even if the regulations had been codified a century later, carvers might not willingly have confined themselves to a single material. But if custom and the statutes worked against specialization in ivory, the documents confirm what the surviving works lead us to suspect, that certain individuals developed an affinity for the exotic substance and became known for their expertise in its handling.

Notes

1. Two nineteenth-century editions exist, both containing useful introductions: Depping 1837 and Lespinasse 1879 (with an extensive glossary of terms). See also Fagniez 1877 and Coornaert 1936.

2. The holder of this important post enjoyed extensive judicial authority in the king's name.

Of Boileau, Jean de Joinville (the biographer of Louis IX) wrote: "One of the men recommended to [the king] was a certain Etienne Boileau, who subsequently maintained and upheld the office of provost so well that no wrong-doer, thief, or murderer dared to remain in Paris, for all who did were soon hanged or put out of the way;

neither parentage, nor noble descent, nor gold and silver availed to save them. So conditions in the king's domains soon began to improve, and people came to live there because of the good justice that prevailed" (Wailly 1874, §718; Shaw 1963, 341–42).

3. Lespinasse 1879, 1–2. Boileau's initiative was part of a larger program of administrative reform inaugurated by Louis IX after his return from the crusade in 1254 (see Jordan, esp. 171–81). The compendium was to have three parts: regulations of the Parisian corporations; taxes, tolls, and duties owed in Paris and its suburbs; and seigneurial jurisdictions in and around the city. The third part seems never to have been completed.

4. The Châtelet, destroyed in 1802, was the seat of the *prévôté* from the twelfth century. A stronghold with an arch and three towers, housing numerous administrative chambers and a jail, it was located at the head of the Grand Pont—the great bridge connecting the Ile de la Cité with the right bank of the Seine. See Cazelles 1972, 183–86.

5. This manuscript, called the Sorbonne copy, since it once belonged to that institution, is the most important of the surviving copies. A yet earlier transcription was destroyed in a fire at the Chambre des Comptes in 1737. On the five principal copies, see Depping 1837, xi–xviii; Lespinasse 1879, CXLVIII-CLIV.

6. Additions to MS fr. 24069 are listed in an early-eighteenth-century concordance of the copies of the *Livre des métiers* (Paris, Archives Nationales, K. 1050). Concentrated in the 1290s and 1320s, the dated additions range from the 1270s through the 1350s with a few entries in 1365, 1391, and 1421.

7. One variety of pointing finger, distinctive in shape, represents a clerk's attempt to signal all regulations dealing with the night watch (*guet;* see note 12).

8. Titre LXI, 1 (Lespinasse 1879, 127).

9. An article in the regulations of the makers of knife handles concerns unreliable apprentices: "If the apprentice leaves his trade without permission three times, because of his folly and high spirits, the master does not need to take him back the third time, nor does any other member of the said trade, either as servant or as apprentice. And this the wardens of the trade established in order to restrain the folly and high spirits of the apprentices, for they cause great damage to their master and to themselves when they take off: for, when the apprentice is beginning to learn and he disappears for a month or two, he forgets everything he has learned, and thus he wastes time and does damage to his master" (titre XVII, 4; Lespinasse 1879, 42).

10. Titre XLI, 2–5 (ibid., 127–28). When one apprentice had completed his seventh year, the *ymagier* could take on another.

11. Goldsmiths (*orfèvres*)— among the many artisans barred from night work— could work after dark if they received commissions from the king, the queen, their children, their brothers, or the bishop of Paris (titre XI, 6; Lespinasse 1879, 33). In a letter of 1322, copied into MS fr. 24069 (fol. 141r), Gilles Haquin, *prévôt* under Philip the Fair, made known that all guild members could henceforth work night and day and employ more than one apprentice (Lespinasse 1886– 97, 1:1).

12. Titre LXI, 12 (Lespinasse 1879, 129). Members of the trades formed the *guet assis,* which remained stationary through the night, while sergeants on horse and on foot made up the *guet roulant.* See Fagniez 1877, 44–49; Roger 1968, 169; Jordan 1979, 178–81.

13. Titre LXII, 5 (Lespinasse 1879, 130).

14. Titre LXI, 9 (ibid., 128).

15. Titres XVII, LXVII, LXVIII, LXI, LXII, XLIII, LXXI (ibid.). In MS fr. 24069, the central five entries are clustered on fols. 145v–150; the entry for handle makers (fol. 40v) follows that of blade makers (*fèvres couteliers);* that of the dice makers is found separately further on (fol. 175r).

16. Titre XI (ibid., 32–34).

17. Titres XXXI, XXXIII (ibid., 63–64, 65–66). The *brodeurs* and *broderesses,* producing sumptuous brocades in gold and silk, deposited their regulations in 1292 with one of Boileau's successors, Guillaume de Hangest (Lespinasse 1886– 97, 2:166-67); the text was copied into MS fr. 24069, fol. 177v.

18. The makers of gold leaf specifically sought exemption from the *guet,* which had been imposed unjustly, it was claimed, twenty years before (titre XXXIII, 7; Lespinasse 1879, 66).

19. Titres XX *(Batteurs d'archal),* XXIV *(Trefiliers d'archal);* ibid., 47–48, 53–54.

20. Titres XXXII, XII, XIV (ibid., 64–65, 34–35, 37–38). The small objects of tin included mirrors, clasps, bells, and rings.

21. Titre XLIII (ibid., 81–83). The term "patenostre," designating a rosary because *Pater noster* ("Our father") is a prayer spoken in devotions, was soon transferred to beads of all sorts. Ivory rosaries seem to have been rare. In a *lettres patentes* of 1571 confirming new statutes of *patenôtriers* of bone and horn (Lespinasse 1886–97, 2:115–16), it is

stated what forms beads could take: round, flat, olive-shaped and in the form of a skull—*teste de morte* (see nos. 78, 79).

22. Titre XXX (Lespinasse 1879, 61–63). The *cristalliers* worked rock crystal and all other kinds of natural stones. The craft was deemed so difficult that a full ten-year apprenticeship was required, and women who took up the trade upon the death of their husbands were not allowed to train apprentices.

23. The precise relation between "carvers of images" and "painters and carvers of images" is difficult to determine. Lespinasse (1886–97, 2:187) observes that the two, in fact, formed a single corporation, since the rules for internal organization, privileges, and jurors are given only once. In 1391 the two professions, merged, received a new set of regulations (ibid., 192–95).

24. Musée du Louvre, inv. OA 11113. See Gaborit-Chopin 1990, 61–62. Both rounded and carved knives are recorded, for example, among the possessions of Charles V, inventoried before his death in 1380: "ung vieil coustel à manche d'yvire, ront. . ."; "ung coutel à manche d'yvire, ouvré à ymages" (Labarte 1879, nos. 2271, 2848).

25. Musée du Louvre, inv. OA 7281 (on loan to the Musée National du Moyen Age, Thermes de Cluny). On medieval hair parters, see Koechlin 1924, 1:416–19.

26. A corporal is the square of white linen cloth on which the priest places the chalice and host in the mass. An ivory *corporalier* in the collection of Jean de France, duc de Berry, at his death in 1416, had carved images of the Passion on its cover and sides (Guiffrey 1894, 45–46, no. 98). See Gay 1887–1928, 1:432–34.

27. Clémence de Hongrie, widow of Louis X le Hutin, whose goods were inventoried and sold after her death in 1328, had in her chapel an ivory box with silver ornament containing the unconsecrated host ("une boueste d'yviere à mettre pain à chanter"), and in her chamber an ivory box with silver ornament containing another ivory box and two small silver vessels (Douët-d'Arcq 1874, 66, 46).

28. An embroidered fan with a handle of ebony and ivory with silver ferrules belonged to Notre-Dame in the later Middle Ages (see Fagniez 1874, 255, no. 44). Other ivory objects in the cathedral treasury in 1343 included a statuette of the Virgin in a tabernacle (no. 7); an "ancient" *Vierge ouvrante* (no. 8; see no. 83 here); a silver cross with a relic of the true cross in an ivory box (no. 13); a black cross with an ivory crucifix "for the dead" (*pro defunctis*) on a copper gilt foot (no. 15); and an ivory box containing miscellaneous items (no. 23).

29. Charles V possessed a round, folding fan of ivory with an ebony handle (Labarte 1879, no. 2279). See Gay 1887–1928, 1:626–27.

30. Three sumptuous whips are listed in the 1380 inventory of Charles V—two with handles of ivory, one with a handle of gold (Labarte 1879, nos. 2211, 2390, 2814). For a mid-fourteenth-century saddle decorated with bucolic scenes in precious metals and ivory, see Gay 1887–1928, 1:53.

31. An entire room in the fabulously splendid Parisian hôtel of Maistre Jacques Duchié—described by Guillebert de Metz in the early fifteenth century—was devoted to games of all sorts: "jeux d'eschez [chess], de tables [backgammon] et

d'autres diverses manieres de jeux, a grant nombre" (*Description de la ville de Paris sous Charles VI*, 25 [Le Roux de Lincy 1867, 199]).

32. Charles V possessed a guitar of ivory "où il y a un tornarement d'ivoire très bien ouvré au bout" (Gay 1887–1928, 1:805).

33. Ibid., 1:245–46.

34. Ibid., 2:97.

35. Ibid., 1:525–26.

36. On the medieval use of "mazer-wood" (often but not always maple wood), see Lightbown 1971, 20–21, pl. XVII. Charles V had many vessels of *madre*, including a drinking cup said to have belonged to Thomas Becket (Labarte 1879, no. 2200).

37. Richard 1887, 249–50. A very small cup of white *madre*, its foot enameled with the arms of "madame d'Artoys," made its way into the collections of Charles V (Labarte 1879, no. 2256).

38. Labarte 1879, nos. 2059, 2080, 2095, 2213–15, 2273, 2439, 2708, 2743, 2764, 2768, 2833, 2842, 2883, 2931, 3092, 3098, 3104.

39. Ibid., no. 2242 ("ung renart d'ybénus en guise de cordelier, assiz sur les deux piés de derrière, qui porte une coquille de perles en guise de hote").

40. Ibid., no. 2458 ("quatre grans pièces d'ybénus"). Neil Stratford (1987, 107) observes that in 1251–53 Queen Eleanor of England purchased 3 1/2 pounds of ivory for the making of images.

41. Prost 1902, 568, no. 3035; Koechlin 1924, 1:11, 534.

42. Labarte 1879, nos. 2026, 2030, 2017.

43. See Michaëlsson 1927; Baron 1968; Guerout 1972.

44. Géraud 1837.

45. Two have been edited by Michaëlsson (1958; 1962). Parisians were raising the sum of 100,000 *livres tournois,* paid in eight installments, to purchase exemption from the *maltôte*—a sales tax of one *denier* on the pound for all commercial transactions. Since 1296 is called the "fourth year," 1292 cannot be the first and the function of the list is debated (Guerout 1972, 385–89).

46. Michaëlsson 1951. The lavish festivities—including a procession in which members of various trades paraded in distinctive costume—are described in Brown and Freeman Regalado 1994.

47. On the parishes and their subdivisions *(quêtes)* in the *rôles de la taille,* see Friedmann 1959, 345–409.

48. Michaëlsson 1958, 31; Géraud 1837, 28. On the operation of this trade, see Bourlet (1992), who counts 25 individuals called *le tabletier* in 1292; 10 in 1296; 19 in 1297; 22 in 1298; 23 in 1299; 26 in 1300; 5 in 1313 (329, n. 40).

49. On surnames deriving from professions, see Michaëlsson 1927, 118 ff., 143 ff.

50. Michaëlsson 1951, 73; Baron 1968, 64.

51. Other individuals appear, over time, as both sculptors and painters: Jehan de Meaus, for example, is *ymagier* in 1297, *paintre* in 1299 (Baron 1968, 67).

52. Géraud identifies this figure (paying four sous) and a Giefroi le Cornetier (paying twelve deniers) as makers of either inkhorns or dicing horns (1837, 23, 50, 500).

53. Michaëlsson (1927, 140) assumed that Jehan de Taverni was one with the wealthy "Jehan l'imagier, le mestre" who lived at the same address in 1313 (idem, 1951, 21). The

knife maker would thus have ended his career as a master sculptor. But a document of 1309, introduced by Baron (1968, 42), establishes that the house had changed hands, passing from one Jehan to another.

54. Baron (1968, 44, 50) points out that Jean d'Arras was a mere stonecutter in 1297 *(tailleur de pierre);* but in 1298, after having been involved in the production of Philippe le Hardi's tomb at Saint-Denis, he felt able to call himself "Mestre Jehan d'Arraz, *ymagier.*"

55. Géraud 1837, 142.

56. Ibid., 55.

57. Representative accounts are published in Douët-d'Arcq 1851 and 1874. For mid-four-teenth-century accounts, see Cazelles 1966.

58. Typical categories (as summarized in Douët-d'Arcq 1851, XVI) are: wool cloth, tailoring (cutting and sewing), gold and silk fabrics, linens, furs, furnishings for the bed-chamber, tapestries, boxes and trunks, gold and silver items, wooden cups, gold and silver jewels, embroidery, cutlery, beaver hats, caps and combs, gloves and breeches, miscella-neous *(communes choses),* shoes, and furnishings for the chapel.

59. Douët-d'Arcq 1851, 133–34. Similarly, new gar-ments were acquired and royal chambers redecorated at the approach of a major feast: we read of the king's Easter chamber, the All Saints' chamber, etc. (ibid., XL–XLII, LI–LII).

60. Ibid., 174. The names of the valets were inscribed on the ferrules. In the previous year, as a fragmentary account reveals, sixteen pairs of ebony-handled knives had been given to sixteen valets (Bibliothèque Nationale,

MS fr. 20876, fol. 97v); in addition, the queen, the dauphine, and the duchess of Orléans had presented small Easter knives to their *valets de chambre* (fol. 90r).

61. Bibliothèque Nationale, MS fr. nouv. acq. 21201, fols. 22r–v. The king also gave two sets as gifts to the cardinal of Boulogne and M. Nicolas Braque.

62. MS fr. nouv. acq. 21201, fols. 69v–70r. The king and dauphin received all four sets; the queen, knives for Lent and Easter; the dauphin's eight and the queen's six companions, only knives for Easter. The *valets de chambre* of the king and the dauphin were given Easter knives with handles of *brésil.*

63. Douët-d'Arcq 1874, 205. The items, purchased from the Parisian *coustellier* Pierre Willequin, include carving knives for the first day of Lent, Easter, and Pentecost; only in the case of the Easter knives was the material of the handles indicated.

64. Titre LXVI (Lespinasse 1879, 136–38): "Des gar-niseurs de gaaines, des feiseurs de viroles. . ." Three *viroliers* appear in the 1292 tax roll; five in 1300 (Fagniez 1877, 19); and only one in 1313: Symon *l'orfevre, virolier* (Michaëlsson 1951, 24).

65. Among the many ivory statuettes of the Virgin owned by Charles V, for example, is one described as having a gem-studded crown and a brooch, standing on a silver-gilt pedestal decorated with a cut crystal, and supported by six lions (Labarte 1879, no. 3109).

66. Titre XIX (Lespinasse 1879, 45–47).

67. Four appear in the 1292 tax roll (Géraud 1837, 524). See note 20.

68. Titre XXXIV (Lespinasse 1879, 66–68); the *laceurs* became *dorelotiers* in 1327 and *rubaniers* in 1404 (Lespinasse 1886–97, 3:3, 11–19). A leather case hanging on a great silk ribbon *(pendent à un gros laz de soye)* containing three ivory combs, a hair parter, and a mirror was purchased for Charles VI from the Parisian comb maker Jehan de Coilly, for example, in 1387 (Douët-d'Arcq 1874, 214). In 1371, Colette, a Parisian silk worker *(estofferesse de soye)*, was independently commissioned to make silk ribbons for Philip of Burgundy's combs (Prost 1902, 266, no. 1463).

69. On the form of surviving writing tablets, see Koechlin 1924, 1:432–45; Lalou 1992.

70. *Tractatus de laudibus Parisius* II, 3 (Le Roux de Lincy 1867, 50–51).

71. In the early fifteenth century, La Tableterie was the street "where combs, *oeilles*, tablets, and other ivory works are made," according to Guillebert de Metz (*Description de la ville de Paris sous Charles VI* 26 [Le Roux de Lincy 1867, 203]).

72. Bibliothèque Nationale, MS fr. 2091, fol. 99r; on fol. 111r there is an image of a woman in a cutlery shop. See Egbert 1974 and Lacaze 1979.

73. Titre LXXVII (Lespinasse 1879, 166–67). Géraud (1837, 488–89) counts forty-five *boursiers* and *boursières* in the 1292 tax roll, as well as two *aumosniers* (485); twenty *boursiers* are listed in 1313. The *ouvrières d'aumosnières sarrazinoises* submitted their regulations in 1300 (Lespinasse 1886-97, 3:9–10).

74. Titre LXXV (Lespinasse 1879, 157–59). The range of goods is set forth in the *Dit d'un mercier* (Crapelet 1831, 149–56). On merciers, see Richard 1887, 198–211; Lespinasse 1886-97, 2:232–85.

75. It is stipulated in the *Livre des métiers* that makers of writing tablets cannot repair old tablets at the request of *merciers* or *gainiers*—that is, to be sold by them as if new (titre LXVIII, 9; Lespinasse 1879, 141). In 1378 we find the Parisian *mercier* Jehan Cyme selling Jean de France, duc de Berry, a "beautiful" ivory mirror and two wooden combs with cases, as well as six palettes of ivory and wood to hold candles "when reading romances"; this *mercier* also dealt in game boards and gaming pieces (Guiffrey 1894, 2:323–27; Koechlin 1924, 1:534).

76. Gay 1887–1928, 1:475.

77. Michaëlsson 1951, 30. For the texts referring to Jehan, see Richard 1887, 321–22; and Koechlin 1924, 1.10, 531 (who assumes Jehan made all the items he sold).

78. On the elegant hôtel of the counts of Artois, severely damaged by fire in 1317, see Richard 1890.

79. Douët-d'Arcq 1851, 15.

80. Marie died January 12, 1321. Mahaut purchased from her executors a statuette of the Virgin and Child in enameled silver for ninety *livres* as well as the ivory statuette, which stood on a silver pedestal: "pour une autre ymaige de Notre-Dame de yvire a piez d'argent, trente lb." (Richard 1887, 247).

81. Similarly, Mahaut's favorite sculptor, Maistre Jean Pépin de Huy—who carved tombs for Mahaut's father, husband, and sons and also a quantity of alabaster statuettes—received designations appropriate to the job at hand; he appears in her accounts both as *tombier* and as *entailleur d'alabastre* (Richard 1887, 312–18).

82. Bibliothèque Nationale, MS fr. 7391, fol. 32v; Koechlin 1924, 1:533–34. The passage is an extract from the Registre des Chartes du Regne du Roy Charles V (1871).

83. Guiffrey 1878, 204–5; Gay 1887–1928, 1:506; Koechlin 1924, 1:13, 535

84. Gay 1887–1928, 1:4; Koechlin 1924, 1:535.

85. In the late Middle Ages certain trades would amalgamate: in 1485 a set of statutes was submitted to the *prévôt*, Jacques d'Estouteville, by a group of comb makers, tablet makers, carvers of images, and turners concerned with the trade of tablet making (Lespinasse 1886–97, 2:673–75).

86. Gay 1887–1928, 1:186; Koechlin 1924, 1:12–13, 536–37. The piece was delivered to a goldsmith, Guillaume Arode, to be remade and fitted with a silver-gilt mount taken from another "spoon" of cypress.

87. Gay 1887–1928, 1:596, 132. A *gaignier* by the name of Guiot Groslet provided a leather case for "the queen's cards, the small *batonnez d'ivoire*, and the parchment rolls."

III | Symbiosis across Scale: Gothic Ivories and Sculpture in Stone and Wood in the Thirteenth Century

PAUL WILLIAMSON

TO MANY, ONE OF THE MOST STRIKING ASPECTS OF THIS EXHIBITION WILL BE THE CLOSE RELATIONSHIP BETWEEN THE IVORY CARVINGS—SOMETIMES NO MORE THAN TEN CENTIMETERS IN HEIGHT—AND CONTEMPORARY SCULPTURE IN STONE AND WOOD.

Detail, fig. III-8

Those with some knowledge of French cathedral sculpture will note the similarity of the seated Pope from the Victoria and Albert Museum (no. 3) to the same types in stone at Chartres and Reims, and the thirteenth-century Virgin and Child ivory statuettes will be seen to have many points of contact with their counterparts on a larger scale. This is hardly surprising. As long ago as 1954, Hanns Swarzenski warned against a false division of the large- and small-scale in Romanesque art, and this concern should also apply to the work of the Gothic sculptor in ivory: "It is a mistake to see in these productions mere substitutes or reflections of lost or damaged works on a grand scale, as is often done. . . the monumental quality of the art of this period is in no sense determined by size" (Swarzenski 1954, 12).

Confirmation of the interdependence of large and small Gothic sculpture is provided by the Parisian guild regulations of the middle of the thirteenth century, gathered together by Etienne Boileau in his *Livre des métiers* (see Sears essay, pp. 18–37). There the emphasis is placed not on the size of the sculptures produced but on their type, so that the *ymagier-tailleur*, for instance, was able to work in a variety of different media—"bone, ivory, wood, or any other kind of material"— in the scale that was required by the patron. Conversely, this is not to say that the stone sculptors attached to the masons' lodges of the great cathedrals were not mostly concerned with large-scale work, but it is as well not to forget the extraordinary amount of stone sculpture which required as detailed and intricate carving as ivory and wood, and that the same sculptors could turn their hand to single, smaller pieces of sculpture if necessary. Giovanni Pisano, who will be discussed in this essay, is the most famous Gothic sculptor known to have executed

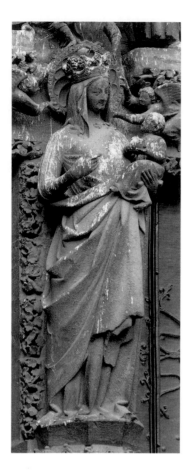

Fig. III-1. Vierge Dorée, south transept trumeau, Amiens cathedral, French, ca. 1250, stone

work in a variety of materials and sizes, but he was certainly not alone. Additionally, it would be wrong to assume that artistic innovation in every case flowed from the monumental to the miniature, as it has been demonstrated that metalwork figures influenced the development of early Gothic cathedral sculpture in the formative years around 1155–70 (Williamson 1995, 25–31). Certain Gothic ivory carvings would have the same effect in the second half of the thirteenth century.

By 1230 Paris was established as the sculptural center of western Europe, a position it was to maintain throughout the thirteenth and fourteenth centuries. It is no coincidence that the great period of Gothic ivory carving should commence at this time, as the workshops set up in the French capital were to dominate this particular trade, their products carrying the new style of the Ile-de-France to the more remote areas of Europe. It has already been mentioned that a close relationship existed between the large-scale and miniature in sculpture in the previous century, and seminal works such as the seated Virgin and Child in the tympanum of the south door of the west portal at Chartres cathedral (ca. 1150) had a profound effect on the production of Marian wood sculptures over a large area, especially in the Meuse and Lower Rhine Valleys. The conditions that lay behind the production of the polychromed wood devotional images also encouraged the manufacture of the earliest Gothic Virgin and Child groups in ivory—invariably shown seated—and on the strength of their similarity to the former, it is likely that at least some of these are Mosan rather than Parisian (Sandron, Cascio, and Levy 1993). But after about 1240, under the benign rule of Louis IX (1226–70), the French capital assumed an artistic dominance to set alongside its growing political and intellectual influence. The city acted as a magnet to the academic and ecclesiastical elite, and its new buildings—especially the churches and the cathedral of Notre-Dame—were admired by every visitor. Because they were seen by so many high-ranking dignitaries from other countries, it was inevitable that these splendid buildings would inspire emulation and that the sculptures adorning them would arouse an admiration leading to imitation.

Ivory statuettes in the same style as their monumental models provided the ideal means of obtaining a three-dimensional

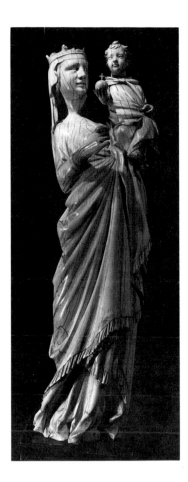

Fig. III–2. Virgin and Child by Giovanni Pisano, Italian, ca. 1298, elephant ivory, 53 cm, Pisa, Museo dell'Opera del Duomo

record of the latter. Small-scale reductions of the most celebrated stone Virgins of the second quarter of the thirteenth century—such as that on the trumeau of the south portal of the west front at Amiens cathedral (ca. 1230–35), the famous Vierge Dorée (fig. III-1) on the south side of the same building, and the Virgin and Child on the north transept doorway of Notre-Dame (fig. I-5)—were not only available for purchase in Paris but could easily be exported, taking the revolutionary Gothic style to countries not until then exposed to its influence. Three examples of this canonical mid-thirteenth-century type of Virgin are shown in the exhibition, all displaying the characteristic pose and heavy mantle drawn across the lower body in broad looping folds (nos. 4, 5, 7), and a notable instance of the transmission of style through such statuettes seems to have occurred before or during the execution of the Siena cathedral pulpit by Nicola Pisano and his workshop in around 1265–68.

In his fundamental article published in 1972, Max Seidel demonstrated the close relationship between a number of the marble figures on the Siena and Pistoia pulpits and Parisian ivory prototypes (Seidel 1972). This was not confined solely to the Virgin and Child on the Siena pulpit—which he compared to an ivory statuette of the same subject now in the North Carolina Museum of Art in Raleigh—but also included the figure of Charity, persuasively juxtaposed with the seated ivory Virgin and Child in the Art Institute of Chicago (no. 2), and the head of the Blessing Christ, which was paralleled with the head of the Dead Christ from the great Descent from the Cross group in the Musée du Louvre (ibid., 24–30; see no. 15). Ivory exemplars such as these appear to have continued to provide inspiration to Italian sculptors, so that the celebrated ivory Virgin and Child made by Nicola's son Giovanni Pisano for Pisa cathedral in 1298 (fig. III-2), for instance, could almost be mistaken for a French work were it not for the distinctive facial type and the tasseled hems found elsewhere on figures on the Tuscan marble pulpits.

It has been observed that although many ivory statuettes acted as vehicles for the transmission of a Gothic sculptural style first manifested in stone, it is possible that the particular qualities of the material played some part in the development of the late-thirteenth-century contrapposto poses seen in a

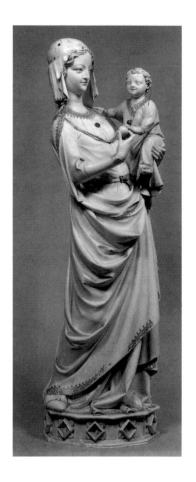

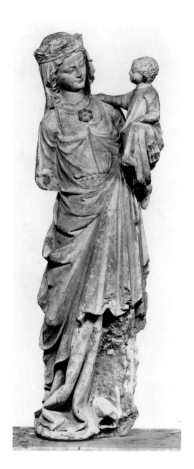

variety of media (Little 1979, 63; Williamson 1982, 18–19). When carving larger figures from ivory, it was difficult to disguise the natural curve of the tusk: many of the most talented ivory carvers maximized this feature, however, giving their Virgins a pronounced *déhanchement* not seen in larger sculpture before the middle of the thirteenth century. This is marked in the Virgin and Child of Giovanni Pisano—which is fifty-three centimeters high—and is also evident in another extremely well-known Virgin and Child once in the Sainte-Chapelle in Paris (fig. III-3). The latter, slightly smaller than the Pisa ivory at forty-one centimeters high, was probably carved around 1250–60 and might have provided a model for sculptors working on a larger scale in the years immediately after: a stone Virgin and Child of around 1270 in the church of Saint-Jacques, Compiègne, near Paris, shows all the same features (fig. III-4).

Fig. III-3. Virgin and Child from the Sainte-Chapelle, French (Paris), ca. 1250–60, elephant ivory, 41 cm, Paris, Musée du Louvre (OA 57)

Fig. III-4. Virgin and Child, church of Saint-Jacques, Compiègne, French, ca. 1270, stone

Because sculptures in an architectural context can often be dated by reference to documentary evidence and their provenance is invariably secure, they have traditionally been used as anchors for the dating and localization of the more portable ivories. This has been the case with the Paris and Amiens Virgins mentioned above, and the sculpture of Reims cathedral has also provided a fixed point to which other ivories, such as the Figure of a Pope (no. 3) and the Angel of the Annunciation (no. 16), have been linked (Little 1979, 60–61, figs. 6–7).[1] Other stone sculptures not utilized in this way until now may also give some help with the attribution of particularly idiosyncratic ivories: the exquisite and distinctive small figures of about 1260–70 in the voussoirs of the Judgment Portal at Lincoln Cathedral (fig. III-5), for instance, might with profit be compared with certain ivories in a similar style. One of these, a Virgin and Child from the center of a tabernacle (fig. III-6; Wadsworth Atheneum, Hartford, Conn.), has been described as Spanish, but, on the strength of its similarity to one of the queens at Lincoln, an attribution to England cannot be ruled out.[2]

IMAGES IN IVORY: PRECIOUS OBJECTS OF THE GOTHIC AGE

It would be shortsighted to study the relationship between stone sculpture and ivory carvings in isolation. As is clear from the excerpt from the *Livre des métiers* quoted on p. 20, it is evident that carvers of ivory statuettes also worked in wood. A rare and little-known seated Virgin and Child in boxwood, partially gilded and painted, illustrates well this connection (fig. III-7). At almost twenty centimeters, it is of about the same size as the majority of the ivory Virgins and shares the closeness to cathedral sculpture of the years 1230–50 observed elsewhere, in this case with Amiens (Williamson 1988, 56–59, no. 13). Such figures would usually have been set into tabernacles with canopies and hinged wings containing painted or relief narrative scenes, the form of which was taken over in ivory, although the earliest examples are lost.[3] It is recorded in the wardrobe accounts of Edward I of England for 1299–1300 that he owned, among other ivories, just such an "Imago beate Marie de eburn cum tabernaculo eburn"(a statuette of the Blessed Virgin of ivory within an ivory tabernacle; Williamson 1994, 197).

The emphasis so far has been placed on the affinities between ivory statuettes and larger figures in stone and wood, but the ivory reliefs of the second half of the thirteenth century are no less eloquent of the milieu of the High Gothic and Rayonnant styles. The four reliefs of this date chosen for the exhibition (nos. 9–12) may even be said to reflect the spirit of the age more strikingly than their counterparts carved in the round, as they provide a miniaturized architectural setting

Fig. III-5. Seated queen, Angel Choir, Judgment Portal, west voussoir, Lincoln Cathedral, English, ca. 1260–70, stone

Fig. III–6. Virgin and Child from a tabernacle, possibly English, ca. 1270, elephant ivory, 9.4 cm, Hartford, Conn., Wadsworth Atheneum (1949.183)

Fig. III–7. Virgin and Child, North French or Mosan, ca. 1240–70, boxwood, partially gilded and painted, approximately 20 cm, London, Victoria and Albert Museum (A200-1946)

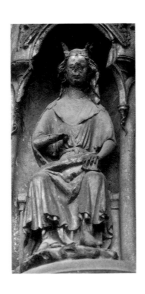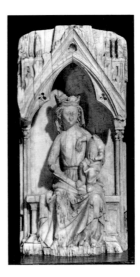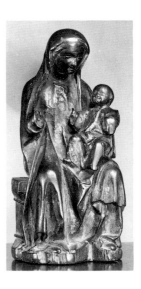

obviously missing from the statuettes. The wonderful diptych from the Cloisters of the Metropolitan Museum of Art (no. 9) is indeed a distillation—in iconography, style, and composition—of French cathedral Gothic, but the very action of miniaturizing the monumental has fundamentally changed the perception of the imagery carved into it. As Henk van Os so memorably summarized it, "The person who commissioned the Cloisters ivory around 1260, probably a French monk, brought the monumental scenes from cathedral doors into the privacy of his own living quarters. This instantly transformed their nature. Scenes that had initially had a general significance, even if they undoubtedly reminded worshippers of the salvation of their own souls, were now being made to accompany the prayers of a single individual" (Os 1994, 25).

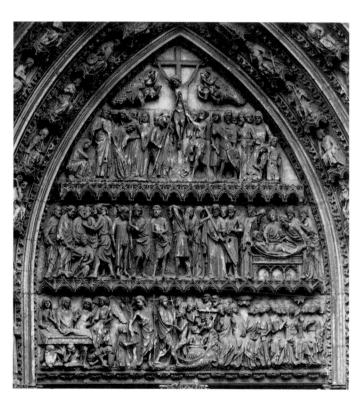

Fig. III-8. Tympanum of the Portail de la Calende, Rouen cathedral, French, ca. 1290–1305, stone

The sacred architectural setting of the scenes on the ivory diptych is lifted directly from contemporary building in Paris, the censing angels in the spandrels above the trefoil arch immediately calling to mind those occupying similar spaces in Louis IX's Sainte-Chapelle of the 1240s. Although these in turn were probably derived from small-scale angels in metalwork—the intention at the Sainte-Chapelle was, after all, to create the impression of the largest shrine ever constructed—the derivation of the diptych's angels from an architectural source is not in doubt. The inspiration of large-scale prototypes is further underlined in the scenes below: the Coronation of the Virgin is close to that above the Porte Rouge on the north side of Notre-Dame in Paris; the Christ of the Last Judgment with the kneeling interceding figures of the Virgin and Saint John and the angels holding the Instruments of the Passion may be compared to the same groups on the west facades of Notre-Dame, Amiens cathedral, and elsewhere; and the figures of the Blessed and Damned are ubiquitous features of the decoration of Judgment portals (Sauerländer 1972, pls. 147, 161, 271).

The ivory diptychs belonging to the so-called Soissons group (nos. 10–11)—named after the supposed provenance of the most celebrated piece, a diptych in the Victoria and Albert Museum (fig. VII-1)—also announce their close kinship with

monumental models. Here the inspiration was from the new Rayonnant architectural style manifested on the transept of Notre-Dame in Paris (ca. 1245–65) and characterized by rose windows, pinnacles, and high traceried gables, although the narrative sequence and crowded compositions of the ivories seem to have more in common with tympana from later in the thirteenth century, such as that of the Portail de la Calende of Rouen cathedral (fig. III-8; Williamson 1995, 151–53, pls. 224, 226; 168, pls. 251–52). The central role that contemporary architecture played among the other arts is made plain in these elegant diptychs, which are the sculptural equivalents of the colorful and refined miniatures of the Saint Louis Psalter, made in the 1260s for the French king himself (Branner 1977, 132–37, figs. 395–400).

Willibald Sauerländer has described how, with the Rayonnant facade of the transept of Notre-Dame, "Paris had created around the middle of the thirteenth century a fashionable vocabulary, which was barely less successful than the 'rocaille' in the century of Louis XV" (Sauerländer 1988, 20). This artistic language came to permeate all the media, large and small, and ivory carvings played a significant part in its diffusion throughout Europe, at the same time adding elements derived from the material's special qualities and scale. In an age without photography, they served as the principal conduits of the new sculptural style.

Notes

1. For the relations between monumental sculpture and ivories in the thirteenth century, see also Monroe 1978 and Giusti 1982.

2. For the Spanish attribution and a date of 1270–90, see Randall 1993, no. 31.

3. For a rare early (ca. 1240–50) ivory wing from such an ensemble, see Williamson 1990.

IV | The Polychrome Decoration of Gothic Ivories

DANIELLE GABORIT-CHOPIN

A PRINCIPAL SOURCE OF IVORY'S ENDURING APPEAL IS THE SILKY WHITENESS OF ITS SURFACE; IN FACT, IT HAS BEEN SUGGESTED THAT MEDIEVAL SCULPTORS PREFERRED THE MEDIUM FOR DEPICTIONS OF THE VIRGIN BECAUSE THE MATERIAL WAS VIEWED AS A SYMBOL OF PURITY AND CHASTITY.[1]

It is also known, however, that ivories have been painted, enhanced with gilding, colors, or incrustations of other decorative substances since the days of antiquity. Many Gothic ivories, for example, still bear significant remnants—or at least traces—of original gilding or paint.

These traces of gilding and polychromy on medieval ivories, which have never before been scientifically studied, have been examined by the Département des Objets d'Art at the Musée du Louvre with the help of two conservators who specialize in the polychromy of sculptures, Agnès Cascio and Juliette Lévy.[2] Both of them have systematically researched the pieces at the Louvre. Bernard Guineau, of the Centre National de la Recherche Scientifique (CNRS), has conducted the scientific analysis and physico-chemical study of pigments (see Guineau 1996). Charles Little of the Metropolitan Museum of Art in New York and Paul Williamson of the Victoria and Albert Museum in London have supervised the study of some particularly interesting pieces from those museums' collections (see Williamson 1988a; Williamson and Webster 1990). Although far from being definitive, the results of these initial studies are presented here, though much further research and verification are needed.

Although the collections of the Louvre have served as the basis for this research, it should also be said that the most significant ivories of the Victoria and Albert Museum, the British Museum in London, the Metropolitan Museum of Art in New York, the Walters Art Gallery in Baltimore, the Museo Nazionale del Bargello in Florence, and those in the most important French museums and public collections have also been taken into consideration.

Detail, no. 15

This work has encountered many difficulties. It was not possible to take as a model the type of research customarily done on panel painting or on large polychrome sculpture as the supporting material for these works—whether wood or stone, whether flat or sculpted—does not offer the perfectly polished surface of ivory. Furthermore, these surfaces have generally been primed, which is far from being the common technique for ivories. Also, gold and pigments were applied to cover completely the support as carefully as possible, whereas the decoration of ivories was never intended to fully hide the material. The polychromy of the medieval marbles and alabasters might provide a better parallel with that of ivories, if there were more fourteenth-century examples of marbles and if, in the case of alabasters, most pieces did not date as late as the very end of the Gothic period.

The Quest for Original Polychromy

Fig. IV-1. Detail showing three layers of gilding superimposed. The most recent is on a dark brown base, the second on an ocher base, and the third, the original, on a translucent base. Saint Margaret Triumphing over the Dragon (no. 27), French (Paris), ca. 1325-50, elephant ivory, London, British Museum (MLA 58,4-28,1).

Like monumental sculptures, ivories have often been subject to overpainting. It is not uncommon to observe several layers of paint on a single work. It is under the flecks of the recent layers that one must carefully look for any trace of the original pigments. This must be done while carefully avoiding attribution to the thirteenth or fourteenth century of elements that date only from the sixteenth, seventeenth, eighteenth, or nineteenth century. For instance, three layers of decoration have been detected on the leaves of the diptych from Paris and Toledo (nos. 22–23). On the small Saint Margaret at the British Museum (fig. IV-1 and no. 27), the blue and gold colors of the fourteenth century cannot be seen by the naked eye any longer because of the two layers of overpainting that cover them. Over the course of centuries, it has often seemed justified to regild or repaint ivories. The practice existed as early as the sixteenth and seventeenth centuries. Furthermore, nineteenth-century collectors knew that medieval ivories were polychromed. In order to please them, there was often little hesitation on the part of dealers to enhance or repaint any original polychromy, thus hiding what was left of the original colors. In some cases, ivories were completely stripped of all color before their "restoration." Finally, the scarcity of special-

ized restorers in this field meant that many pieces—including some of the most famous—were handled by the same small group of people. It might legitimately be asked, therefore, whether similarities observed in the polychromy of certain works are not owed to the intervention of the same "restorer" rather than to an original similarity of style.

If overpainting often has had the advantage of preserving the original decoration, radical cleaning often has completely destroyed any trace of it. On this point, the taste prevailing in the eighteenth and early nineteenth centuries, as influenced by the neoclassical movement, and the taste of the twentieth century, with its fascination for pure whiteness, have been a catastrophe. Washed, soaped, scrubbed, and bleached, some ivories have even lost their natural intrinsic patina. Others no longer reveal the slightest indication of their original decoration: for instance, the beautiful Virgin and Child by Giovanni Pisano (fig. III-2), or the Virgin of the Dukes of Tuscany at the Museo Nazionale del Bargello in Florence (see Gaborit-Chopin 1978, 154, 160–61). As noted by Paul Williamson (1988a), the systematic series of castings carried out to form reference collections is also responsible for the disappearance of some of the polychromy on medieval ivories. Thus the search for traces of polychromy requires extremely careful attention: a lock of hair can hide traces of original gilding, the folds of drapery or of a veil may retain fragments of the original orphreys, or other parts of the vestments may reveal a few square millimeters of original paint. Often only the most powerful microscopes or ultraviolet light are able to reveal the remnants of these painted or gilded decorations.

The rarity and fragility of these original traces of decoration have established the parameters of their study: their rarity generally excludes the possibility of even microscopic samplings, thus preventing a thorough identification of the pigments, of the binding mediums, or of the bole. The validity of the research is nevertheless justified by the progress of nondestructive spectroscopic methods. It was not until 1995 that it was possible to establish beyond doubt that the vivid blue in the eyes of the Virgin of the Sainte-Chapelle (fig. IV-2) was indeed lapis lazuli, and therefore almost certainly original (see Guineau 1996).

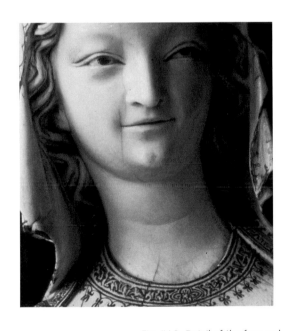

Fig. IV-2. Detail of the face and orphrey of the collar with gold leaf on a translucent red-orange base. Virgin and Child from the Sainte-Chapelle, French (Paris), ca. 1250-60, elephant ivory, Paris, Musée du Louvre (OA 57).

Documents and Formulas

We might hope that documents could make up for this lack of scientific information. In fact, they yield little information about the polychromy of ivories. We know only that in Paris, during the thirteenth and at the beginning of the fourteenth centuries, the workshops of the two corporations allowed to work on both ivory and illuminated manuscripts were established in proximity to one another. The profession of *paintres et tailleurs d'ymages* (Lespinasse 1879, titre LXII) was conducted in the same workshop—and probably also by the same person—that included painters and sculptors working on bone or ivory (see Sears essay, pp. 18–37). This had the advantage of bringing together the various phases of production under the same roof. Unless we extrapolate to a point that would eventually be contradicted by the works themselves, we can only hypothesize about the organization of labor and possible modes of cooperation and speculate on the techniques that were used. For example, the mention in Etienne Boileau's *Livre des métiers* that the *peintres-tailleurs* must always apply gold on silver is relevant only for monumental sculpture or painted panels but not for ivory. The thin application of gold on ivory is only affixed over a bole. Writing in the twelfth century, the monk Theophilus did not discuss painting on bone or ivory. He indicated only how to stain them with madder-root (Dodwell 1986, titres XCII–XCIV). He also mentioned the technique of gilding, with the gold leaf applied on a glue made of sturgeon's bladder. Other recipes suggest affixing gold leaf with glue made from animal skin or egg white. Resinous oil mixtures could also be used. These were made of oil, resin, and wax mixed with yellow ocher, stained with madder, and occasionally enhanced with a touch of garlic (see Guineau 1996).

Colors

While the gilding of Gothic ivories shows a wide variety of boles and decorative motifs, by contrast few colors were used: touches of green, sometimes used as a transparent lacquer; several kinds of red sparingly applied and occasionally glazed;

dark browns and black; a very few yellow and orange tones; but above all a large amount of blue. The latter could be obtained with various pigments: the presence of a blue derived from lapis lazuli (not the modern ultramarine but a synthetic pigment of similar composition) indicates almost certainly that the color is original. It is indeed unlikely that this very expensive pigment was ever used for overpainting or later restorations. It is lapis lazuli blue that can be identified in the original decoration of the finest ivory statuettes of the thirteenth and early fourteenth centuries, such as the Angel of the Annunciation from the Louvre (fig. IV-3 and no. 16) and on some reliefs such as the so-called Soissons Diptych (fig. VII-1) of the Victoria and Albert Museum (Koechlin 1924, 2: no. 38; Delhaye, Guineau, and Vezin 1984; Williamson 1988a; Guineau et al. 1993; Guineau 1996). The presence of azurite (natural copper carbonate), which has often left brown or greenish traces on the ivory, is reassuring but does not exclude the possibility of being an overpainting, as the pigment has been used since antiquity. On the other hand, the presence of Prussian blue or modern ultramarine implies some modern intervention; the question remains open for smalt or cobalt blue, a pigment known since antiquity but whose use in painting has not yet been confirmed before the end of the fifteenth century (see Delhaye, Guineau, and Vezin 1984; Guineau 1996). Blue pigments made from vegetal components (sunflower, woad, or indigo) do not seem to have been used for the decoration of ivories.

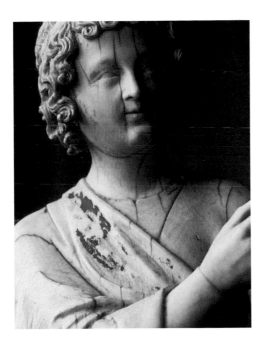

Fig. IV-3. Detail of the head and shoulders with gold leaf on a yellow base and on a translucent ocher-brown base; two lapis-lazuli blues, one on a thin white base. Angel of the Annunciation, French (Paris), ca. 1280–1300, elephant ivory, Paris, Musée du Louvre (OA 7507).

It happens occasionally that a painted decoration can now be detected only by the stain that it has left on the ivory. Sometimes the pigments have colored the ivory brown or green, as in the case already mentioned of the azurite that can be seen on the inside of the mantle of the Virgin in Glory in the Paris-Toledo diptych (nos. 22–23). At other times the decoration appears in a negative image, particularly for the orphreys in which the decorative motifs have left lighter lines, the ivory having been protected from patina or the impact of other pigments by the bole underlying the gold leaf.

The Decoration of Statuettes

In most cases, the polychromy of ivory statuettes was very carefully executed. As was the case with statues and ornamental reliefs carved in precious materials—marble or alabaster, for instance—their whole surface was not covered. Painted decoration and gilding only enhanced the beauty of ivory itself. In the case of the Sainte-Chapelle Virgin (fig. IV-2; Koechlin 1924, 2: no. 95), for instance, the perfection of the material was brought out by only a few touches of color (the vivid blue of the eyes, the red of the lips, the belt, and the apple held by the child) and the delicate gold orphreys on the border of the vestments. As is the case with most of the statuettes of the mid- and second half of the thirteenth century, these decorations deserve special attention. Here the gold leaf has been applied on a smooth bole thick enough so that it creates some relief. In order to give the gold a warmer glow, the bole itself is brown-red. The tracing of the motifs, differing according to the vestments, has been done freehand, making the decoration particularly light and delicate without a mechanical repetitiousness. Today, the gold leaf is somewhat worn and the tracings appear in the red gold remaining only within the folds of the draperies. The orphreys on the draperies of the figures of the Descent from the Cross (ca. 1260–80; fig. IV-4 and see fig. 15) from the Louvre, represented in this exhibition by the statuette of Nicodemus (no. 15), show the same quality, the same kind of clear and free drawing, traced here on a translucent orange bole, that only enhances the ivory. Besides stylistic similarities, the comparison between all the figures from the Descent has established that this Nicodemus, although it has been in many other collections through the centuries, was originally part of the ensemble (see Gaborit-Chopin 1988; Cascio and Lévy 1988, 44–45). In spite of its small size, the Virgin from the Timbal Collection, now in the Louvre (ca. 1250–70; see Koechlin 1924 2: no. 96) also exhibits exceptionally well-executed orphreys, intricate gold lace once enhanced by a bright blue line for the floral motifs along the trims of the robe and mantle (fig. IV-5). With such fine examples in mind, it is not difficult to understand that the thick gold ribbons laid on a brown bole and heavily trimmed in black of the Louvre's Coronation of the Virgin

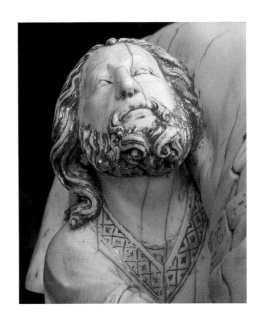

Fig. IV-4. Detail of the head of Joseph of Arimathea with gold leaf on a translucent red base. Descent from the Cross group, French (Paris), ca. 1260–80, elephant ivory, Paris, Musée du Louvre (OA 3935).

Fig. IV-5. Detail of the orphrey of the mantle with gold leaf on a translucent red-orange base. Virgin and Child, French (Paris), ca. 1250–70, elephant ivory, Paris, Musée du Louvre (OA 2583).

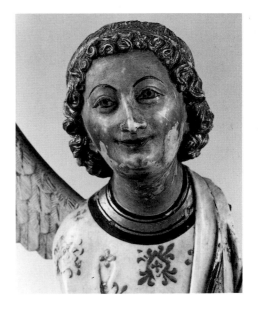

Fig. IV-6. Orphrey and polychromy postdating the Gothic period. Angel from the Coronation of the Virgin, French (Paris), ca. 1260–80, elephant ivory, Paris, Musée du Louvre (OA 3922).

(fig. IV-6; a work of the same period as the Descent from the Cross) are later additions of overpaint (see Koechlin 1924, 2: no. 16). It is ironic that the Coronation of the Virgin was acquired by the museum in the nineteenth century principally because its polychromy was believed to be original.

The few statuettes of the second half of the thirteenth century that have retained a reasonable amount of their original decoration show great restraint in the use of colors, which were always applied after the gilding: the outside of the vestments was decorated only with the orphreys along their edges. Particularly on mantles and robes, there are occasionally motifs in gold that seem strewn about in a way that recalls polychrome marbles. In each case—for example, on one of the enthroned Virgins of the Musée National du Moyen Age, Thermes de Cluny—this kind of decoration, attractive as it is, has proven to be a much later addition, at best done in the middle of the sixteenth or seventeenth century (see Koechlin 1924, 2: no. 81). The question of the so-called *claves,* those rectangular ornaments punctuating the vestments on some statuettes earlier than the middle of the thirteenth century, remains enigmatic.[3] Actually, color on Gothic ivories seems to have been reserved to specific details only. Colors were characteristically applied to large surfaces such as the linings of the mantles and robes where some faint remnants can still be detected, particularly in the deeply carved recesses or places protected from handling and overcleaning. Traces of pink on faces, hands, or the breast of the nursing Virgin might lead us to believe that flesh tones were used for those parts, but it is difficult to date these traces exactly. So far as we now know, none of the remnants of pink are original from the thirteenth or fourteenth century. Among the most telling examples are the faces of the Saint Margaret from the British Museum (no. 27), the famous figures of the Virgin at Villeneuve-lès-Avignon and San Francesco of Assisi, and of the figure of Ecclesia in the group of the Descent from the Cross in the Musée du Louvre. In all

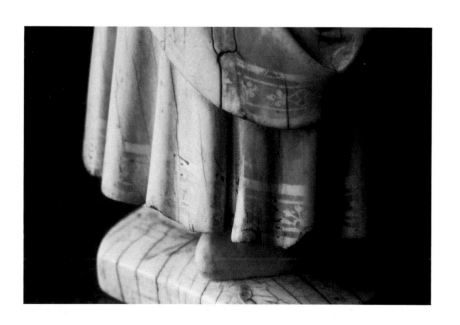

Fig. IV-7. Detail of the hem of the robe and mantle with traces of orphrey seen in negative. Angel of the Annunciation, French (Paris), ca. 1280–1300, elephant ivory, Paris, Musée du Louvre (OA 7507).

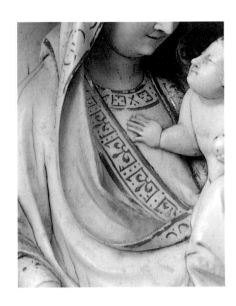

Fig. IV-8. Detail of the orphrey of the collar of the robe and part of the mantle of the Virgin and Child with recent gilding reproducing the original motif. Polyptych with the Virgin and Child, French (Paris), ca. 1320–40, elephant ivory, Musée du Louvre (OA 2587).

Fig. IV-9. Detail of orphrey of the mantle with the original motif on the upper part, which has been replaced on the lower part with a later design. Virgin and Child, French (Paris), ca. 1310–20, elephant ivory, Villeneuve-lès-Avignon.

these figures, the pink tones are either later additions or overpainted elements; not the slightest remnant of an original pink color has been found underneath them. Thus the Gothic ivory statuette was, in fact, never entirely painted. The role of gilding and polychromy was only to enhance the sheer sumptuous beauty of the ivory itself. If the extensive polychromy of the small Virgin from the Walters Art Gallery, Baltimore, happens to be original (no. 7), it would constitute a unique case.

Blue, used for the eyes and for the lining of vestments, together with red defining the lips are the colors most commonly encountered. In his recent research, Guineau has demonstrated that for the period of the thirteenth and early fourteenth centuries, lapis lazuli was the pigment of choice, yet another proof—if necessary—of the precious character of ivory sculptures and of their high value (Guineau 1996). The Angel of the Annunciation from the Musée du Louvre (no. 16) bears the remains of its original decoration. Its case is a difficult one given the fact that the polychromy has been retouched: the pink of the face, part of the blue of the mantle, and perhaps part of the thick gilding of the hair may have all been executed at a later time (fig. IV-7). Nevertheless, other parts of the brilliant blue of the mantle's lining, and probably the red on the inside of the robe, as well as the orphreys applied on a transparent ocher bole, seem to be original. The braids have remained perfectly legible. The isolated designs of lozenges with fleurs-de-lis at the edge of the mantle or the "bouquet" design at the bottom of the robe (still visible in negative) are close in size and pattern to the motifs used around 1300 and the first decades of the fourteenth century.

Indeed, the style of using polychromy on ivory changed slightly after that time. The edges of the orphreys became much wider (the width of ones executed in the third quarter of the thirteenth century varies usually between six and nine millimeters, even for the larger pieces; the width of those executed in the first third of the fourteenth century can be more than ten or fifteen millimeters; see fig. IV-8). The designs on the orphreys, even though they might still recall those of the earlier period, are more likely to be juxtaposed and centered. Most commonly, they resemble angular and stylized representations of Kufic script. The frequent repaintings of these edges

have nevertheless sometimes followed the original design. In spite of some errors—for instance, the fact that her veil has orphreys on both its inside and outside, or that some details are closely derived from Islamic models—the decoration of the large nineteenth-century Virgin at the Metropolitan Museum of Art (no. 93) shows that modern forgers could have an alarmingly accurate knowledge of the polychromy on fourteenth-century ivories.

The most remarkable example of polychromy dating to the first decades of the fourteenth century is provided by the large Virgin of Villeneuve-lès-Avignon, in spite of the fact that most of its original polychromy is now hidden and that successive layers of overpaint have made it look heavier. The very broad orphreys of the mantle have kept their original design, as evidenced by the few places where the original decoration is still visible (fig. IV-9). They are executed in gold leaf on an ocher bole and include rinceaux with lions, eagles, birds, and griffins. On the robe and the mantle of the Virgin, thin leafy scrolls follow the cracks of the ivory. This technique, also witnessed on the Descent from the Cross group in the Musée du Louvre (fig. IV-4 and see no. 15), the Virgin in the treasury of San Francesco at Assisi (Koechlin 1924, 2: no. 634), and the Saint Margaret in the British Museum (no. 27), has been deftly employed by the artists to conceal the cracks of the material—cracks that previously existed or appeared during their work—and incorporate them as part of their decorative scheme.[4]

The thrones of the seated Virgins were also embellished with color. Their moldings and windowlike detailing were highlighted in vivid blue, red, and green and were occasionally gilded. The polychromy thus enhanced the refinement of the carved architectural elements and was even able to suggest the illusion of relief on the smooth surface of the ivory.

The Decoration of Bas-Reliefs

The decoration of the thrones of the statuettes parallels that of the plaquettes, diptychs, and polyptychs about which we are far less informed, whether because painting and gilding were less commonly used for these or because the polychromy did

not adhere as securely as that of the statuettes. The few preserved documents concerning bas-reliefs attest nevertheless that the same pigments and techniques were used: gilding of architectural parts or decorative elements (leaves, moldings, or rosettes), of the hair, beards, and orphreys—often limited to one or more simple dots; highlights of red, green, and yellow for the architecture and details of the vestments; blue being largely used for the backgrounds (as, for instance, in the Soissons Diptych mentioned above; fig. VII-1) or the reverse sides of the mantles.

The traces of polychromy preserved on ivories are too few, overpainting is too frequent, studies are too limited, and the examples too widespread in time to attempt a detailed description of their modes of decoration. It is equally impossible to sketch a chronology of the polychromy of Gothic ivory bas-reliefs. Take, for instance, the example of two contemporary pieces, the Soissons Diptych and the so-called Salting Diptych of the Victoria and Albert Museum (no. 37; Koechlin 1924, 2: nos. 38, 113B).[5] In the former, the use of lapis lazuli has been detected, whereas in the latter the blue is azurite. Yet the gilding technique is similar in both cases: the gold leaf has been applied on a bole made of lead white, with a touch of vermilion and a yellow-orange earth pigment (Williamson 1988a). On the Salting Diptych a trace of the original gilding has been found in spite of the overpainting. It is a gold leaf applied on a red-brown bole reminiscent of that found on Parisian statuettes of the second half of the thirteenth century. The gilding is in this case covered with a green glaze, a technique also found on French ivories. Many plaquettes, diptychs, and polyptychs have backgrounds decorated with groups of three dots or dots forming rosettes. Even though these backgrounds are usually heavily overpainted, they may nevertheless preserve the appearance of the original decorations. Likewise, the commonly seen orphreys suggested by a double line and dots reflect a genuine Gothic fashion rather than an eighteenth- or nineteenth-century neo-Gothic fantasy. The diptych now divided between Paris and Toledo (nos. 22–23), whose leaves have had different histories, is a good example of the relative correctness of the later overpainting. Three successive interventions have been observed on these two leaves: the reverse side of the mantles and the gold of the beards and of the hair

have been "revived"; the dotted lines of the orphreys have been made heavier; the large gilded rosettes of the backgrounds (today seen in negative) are overpainted, but also visible on the leaf of the Virgin in Glory are the remnants of more delicate rosettes that may well be original to the fourteenth century.

It is, however, indisputable that beginning around 1400 the subtle highlights that had been applied to sacred and secular ivories during the thirteenth and fourteenth centuries were replaced with more invasive gilding and polychromy. They contrast sharply with the Italian "ivories" (made of bone, in fact) of the Embriachi workshops (see no. 68), which, in spite of their blue backgrounds (occasionally created with a piece of blue parchment glued behind the openwork), still exhibit lightly painted or gilded highlights and floral motifs painted freehand on the smooth surface of the bone without the definition of any relief or engraving.

Ivories and Illuminated Manuscripts

Even though the disparity of their materials might suggest different techniques, the gilding and polychromy of ivories are close to those of illuminated manuscripts, and it is tempting to find parallels for them in manuscript painting. First, however, there is a major difference in the general conception of the use of colors: painting is much less conspicuous on ivories, in the treatment of vestments in particular, whereas illuminations play fully with contrasts or nuances between parts of the vestments in order to suggest three-dimensional effects. On the other hand, the role of orphreys is much less developed in manuscript painting. The decorative motifs of the orphreys painted on ivories find counterparts in the full borders of the Parisian manuscripts of the second half of the thirteenth century and around 1300 such as the Psalter of Saint Louis (ca. 1260–70), or the Bible of Cardinal Maciejowski, or the main works of Master Honoré and his workshop, which also present scrolls of the same type (see Avril 1995, 17, 24–25). The "Somme Le Roy" illuminated by Master Honoré in about 1290–95 (London, British Museum,

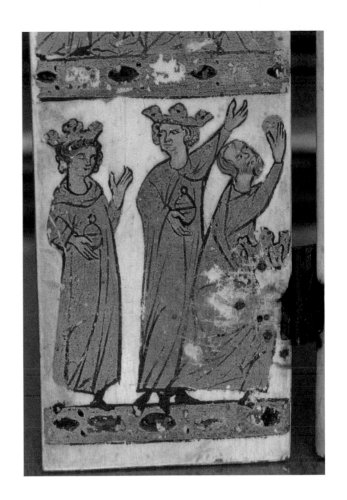

Fig. IV-10. Detail of Adoration of the Magi with gold leaf on a thin yellow base. Triptych with Adoration of the Magi, French (Paris), ca. 1270–1300, elephant ivory, Lyons, Musée des Beaux-Arts.

add. 54180; see Sterling 1987, fig. 14) displays in the borders of its full pages one of the first examples of an angular and symmetrical motif, a distant reminder of those pseudo-Kufic letters encountered so often on the ivories of the end of the thirteenth century and of the first decades of the fourteenth century. These similarities are nonetheless too vague or fortuitous to allow us to think of establishing, at least for the time being, a valid comparative chronology of the two genres. But we do know that Gothic manuscript painters painted on smooth ivory panels, whether on the reverse of sculpted plaques or on the leaves of writing tablets, such as the German tablets in the Victoria and Albert Museum (no. 40). In this very heterogeneous group of ivories painted on flat surfaces, the triptych of the Musée des Beaux-Arts in Lyons clearly shows the importance of technical analysis of polychromy (fig. IV-10). The comparison between the fragments of original polychromy remaining under the overpainted areas in the sculpted part—in particular the presence of gold leaf over a thin yellow bole found also on the two lateral wings—would

seem to prove that the painted sides are indeed of the same period as the central panel, contrary to what was once thought.[6] The style of these lateral sides, with their somewhat naïve figures broadly painted and outlined in a dark red ocher, can be compared to the style of mural paintings in northern France at the beginning of the fourteenth century and of manuscripts executed in Liège in the last decades of the thirteenth century. Thus a northern French or Mosan provenance could be deduced from that comparison, at least for some of the ivories of the so-called Soissons group.

Conclusion

Given the current state of research, several answers concerning the question of the polychromy of Gothic ivories can be suggested, with more certainty for the statuettes than for the reliefs. This is not surprising. Particularly precious and costly, the statuettes were adorned with the most carefully executed polychromy. In most cases it was also more elaborate than the polychromy used on the reliefs. The systematic identification of the pigments and their comparison with those used for illuminations and also for monumental sculpture should allow us to establish a more precise chronology of the use of these pigments and also perhaps to understand better how the work was executed. The analysis of polychromy and gilding by spectrometric absorption—a technique that allows the study of the most elusive remnants hidden in some corner of a relief, and also, most importantly, a technique that is not destructive—is full of promise. For example, the transition from lapis lazuli blue to azurite in the first half of the fourteenth century, the use of madder and cochineal for red, the role of greens and reds—apparently minor if compared to the broader use of blue and gold—until the second half of the fourteenth century will need to be confirmed (see Guineau 1996). The significance of the orphreys, their subtle design, delicate drawing, and thin relief over a light-colored, slightly raised bole is well established. On the other hand, understanding the variety of boles—with their translucent or opaque textures and their colors varying from white to light red-brown—requires further study, which is a long-term goal.

In any case, no matter what uncertainties these scientific studies may reveal, they reinforce the importance of preliminary and careful studies done under magnification. These allow us to recognize and establish the "map" of the overpainted areas that are almost always present on these works. To ignore them would lead to wrong conclusions.

Notes

1. See Monroe 1978, 24–26.

2. The photographs of details used as illustrations in this article were taken by Agnes Cascio and Juliette Lévy, conservators in the Département des Objets d'art of the Musée du Louvre, whose study of the polychromy of Gothic ivories is forthcoming. The text also owes much to the observations of Bernard Guineau, ingénieur at the Centre de la Recherche National Scientifique. I wish to thank them all for their generosity.

3. These are found, for example, on the Virgins of the Musée National du Moyen Age, Thermes de Cluny, and at the Musée du Petit Palais, Paris. See Sandron, Cascio, and Lévy 1993, 54–55.

4. In each of these three cases, the rinceaux have been overpainted but still show fragments of the original fourteenth-century foliage.

5. I owe this information on the polychromy of these two pieces to Paul Williamson, who will find here the expression of my gratitude.

6. Philippe Verdier (1982) concluded that these parts were not of the same period.

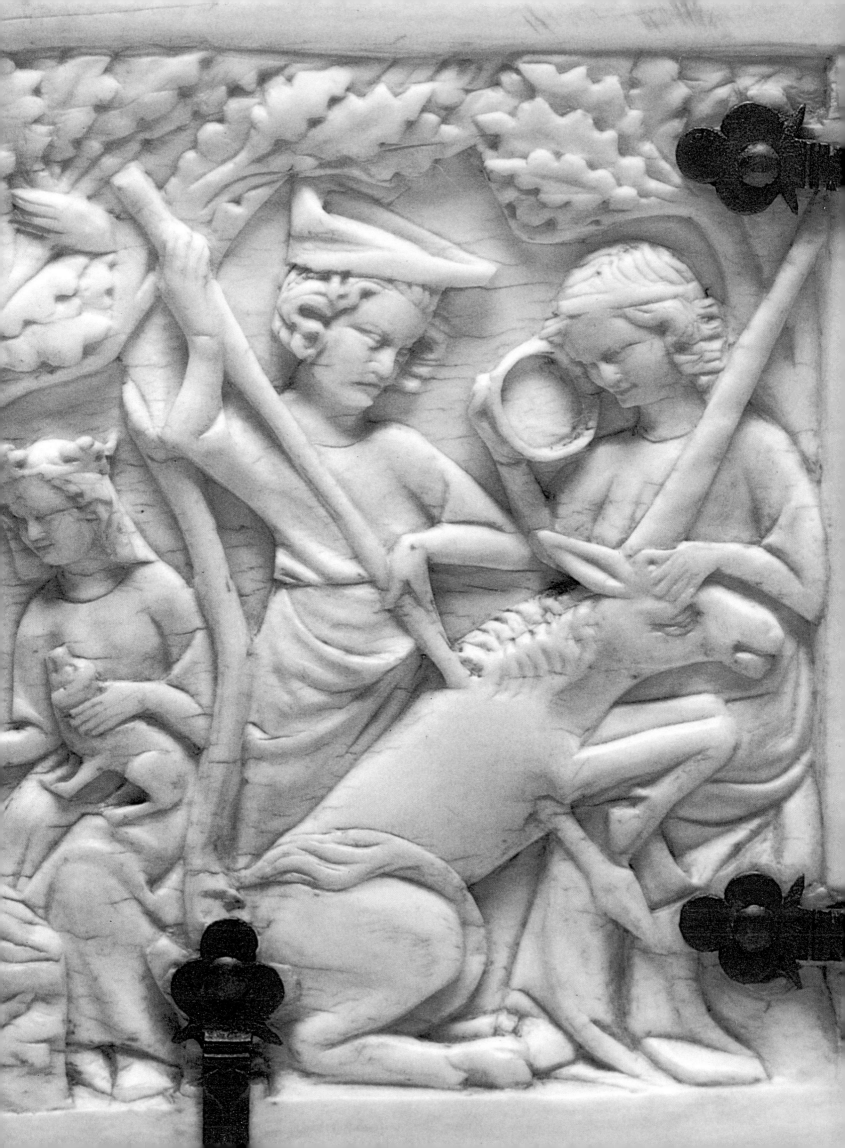

V | Popular Romances Carved in Ivory

RICHARD H. RANDALL, JR.

THE EMERGENCE OF SECULAR SUBJECT MATTER IN IVORY CARVING IN LATE MEDIEVAL EUROPE CAN BE ASCRIBED TO TWO TOTALLY DIFFERENT CURRENTS. THE FIRST WAS THE IMPORTATION OF IVORY BOXES, COMBS, AND HUNTING HORNS FROM THE ISLAMIC WORLD IN CONSIDERABLE NUMBERS IN THE TWELFTH AND THIRTEENTH CENTURIES.

Detail, no. 64

The quantity of this material is suggested by the hundreds of surviving boxes and hunting horns that have come down to us, many having been preserved in European church treasuries, in spite of their secular subject matter. The commerce was the result of the Crusades and of the exposure of Europeans to the fine glazed earthenwares, drinking glasses, and ivory objects of the Arab world. Such articles, unknown at the time in Europe, were in daily use in the Islamic countries, and their decoration consisted largely of animals, abstract patterns, and scrolls. This importation of ivories, which included, among other things, bishops' croziers made specifically for clerics in the West, continued into the middle years of the thirteenth century, when raw African elephant ivory replaced the manufactured wares in the Arab-European trade and the production of carved ivory goods was undertaken throughout continental Europe.

The second important force was the rise of vernacular literature in Europe at the end of the twelfth century, emanating from the oral traditions of the troubadours and minstrels of Brittany and southern France, whose romantic tales had attracted the attention of audiences throughout Europe. Poets such as Chrétien de Troyes began committing these oral accounts to vellum as early as 1164, and by the mid-thirteenth century, Arthurian and other romance manuscripts were in wide circulation in Europe, especially in Spain, France, Italy, and Germany.

While works of art lagged behind the literature to a certain extent, there were Arthurian knights carved on the archivolt of Modena cathedral before 1120, a mosaic of King Arthur as Christ at Otranto cathedral (Apulia) in 1166, and Tristan and Iseult portrayed on Cologne bone boxes about 1200 (Loomis 1938, figs. 7, 9, 19–23). The flowering of secular ivory

carving took place in Paris in the first quarter of the fourteenth century, and a variety of subjects from romance literature and daily life were represented on boxes, mirror cases, combs, *gravoirs* (hair parters), and knife handles for what was apparently a considerable market.

Two French ivory boxes of the late thirteenth century are the earliest examples of secular ivory production. One of these, in the Musée National du Moyen Age, Thermes de Cluny, is decorated with a series of blind trefoil arches, set on columns with floral capitals (Koechlin 1924, 2: no. 1260). There is an exterior border of roses at the top and sides but no carved figures. The second is the front of a casket formerly in the collection of Martin Le Roy, Paris, in which four pairs of lovers are shown in Gothic niches (ibid., no. 1271). The handsome architecture is simple, and the rather small figures are floating in space, suggesting that such objects were new to the world of the Gothic ivory carver.

The ivories for secular use that appeared in profusion at the end of the first quarter of the fourteenth century were carved in the sophisticated relief style of the Paris religious ivories, which had been developed over the preceding century in the production of diptychs and triptychs showing the lives of Christ and the Virgin. The new subject matter was drawn partly from the activities of daily life, including hunting, hawking, music making, courting, game playing, and jousting. Another source was romance literature—the bestiary, Arthurian romances, local tales such as *La châtelaine de Vergi,* and stories from the ancient and oriental worlds, including ones about Alexander the Great, Aristotle, Virgil, Pyramus and Thisbe, and the Fountain of Youth.

One or more of the finest Parisian ateliers produced large ivory boxes with complex subject matter, which are thought to have been made as lovers' presents. The only one of the group with a history of ownership belonged to Queen Jadwiga of Poland (1371–99), the former princess of Hungary, who married Wladyslaw Jagiello II in 1386 (Koechlin 1924, 2: no. 1285). This casket retains its engraved silver mounts, due to the fact that it was deposited as a reliquary in a chapel of Kraków cathedral at an early date and was not stripped of its silver, as has happened to nearly all the surviving examples.

It also suggests that these boxes were intended as amusing and precious containers for a lady's jewelry or other valuable objects. In subject matter, the Kraków casket is a slight variant of the example from the Walters Art Gallery (no. 64).

The lid of the Walters casket is composed of three scenes, the central one showing a tournament between two armored knights. On the left is depicted the Attack on the Castle of Love, and on the right, a mock tilt takes place between a knight and a lady with a branch of roses.

The Attack on the Castle of Love is a typical medieval allegory, enjoyed by the many generations that revered the code of chivalry. The castle would have been understood as "woman" and the attack as "courtship". The popular scene was not merely the battle between man and woman; it was understood to be fought honorably and, in this case, with the rose, the symbol of surrender, as the weapon. The Attack on the Castle of Love is first referred to in European literature in an account of a festival in Treviso in northern Italy in 1214, where it was enacted with young ladies from Padua defending the castle against a band of Venetian youths (Loomis 1919, 255). Contemporary with the theme's appearance on the ivory boxes in Paris, it is also portrayed in manuscripts of various types, including the Peterborough Psalter (see Sandler 1974, 31, fig. 57) and the Luttrell Psalter (Sandler 1986, 1: fig. 280; 2:118–21, no. 107), the Smithfield Decretals (British Library, Royal 10 E IV, fol. 18v), and the *De officiis rerum* of Walter de Milemete, all English examples of the early fourteenth century (Loomis 1919, figs. 4–6). The Peterborough Psalter is the earliest known representation of the subject, dating between 1299 and 1318.

On the Walters box, the God of Love is included among the defenders, while in other examples, ladies are seen surrendering to knights on ladders or to those who had gained entry to the castle. The subject is not often illustrated in media other than ivory, but it does appear on a French leather casket (Kohlhausen 1928, 79, no. 39, pl. 27).

The mock tilt of the third compartment suggests that in the entire program of the ivory box, humor and satire were intended, not only in such a depiction but also in the juxtaposition of the scenes and their male-female connotations.

V: POPULAR ROMANCES CARVED IN IVORY

The mock tilt also pokes fun at jousting itself, though it was considered a very serious sport in the Middle Ages.

In place of the mock tilt, as seen on the Walters casket, there is sometimes a substitute scene of an elopement with a couple riding away across a bridge, under which is a pair of lovers in a boat. This can be seen on the Jadwiga casket, and others as well, and in a more elegant portrayal in a mirror case in the Liverpool Museum (fig. V-1).

The front of the Walters box leads us even farther into the medieval mind, as the first story told there was well known as a warning about the wiles of women. It is the story of Alexander the Great being tutored by Aristotle, who warned him about women. When Aristotle meets Alexander's lady love, Phyllis, he is smitten and professes his adoration. She then rides him around the court like a horse. The story was very popular in the late Middle Ages and appears in cathedral sculpture, misericords, manuscripts, and aquamanilia. The earliest text of the story is the *Lai d'Aristote* by Henri d'Andeli of the mid-thirteenth century (Heron 1881, 1–22).

The second subject on the front of the casket is the Fountain of Youth. Here again, the subject first appeared somewhat earlier in literature in the *Romance of Alexander* by Lambert le Tort of Chateaudun, written about 1180 and based on the letter of Prester John of 1177 (Rapp 1976, 18–22). Surprisingly, the first known visual representation of the Fountain of Youth is in a Fauvel manuscript made for the French court and datable 1316–20, where it is accompanied on the folio by music and verse (ibid., fig. 1).

The first scene of the story on the ivory shows bearded and lame elders going to the fountain, and in the second panel they are bathing and youthful again. These contrasting scenes are repeated as the usual subject on the front of a number of ivory boxes. The sequence of these two stories makes its point, as the aged Aristotle showing his foolish senility is contrasted to the dream of eternal youth.

In a number of the caskets from the same atelier, there is an alternate scene used: the story of Pyramus and Thisbe, representing the ideal of young love and sacrifice, a fine contrast to the Aristotle story. The Pyramus legend also came from the

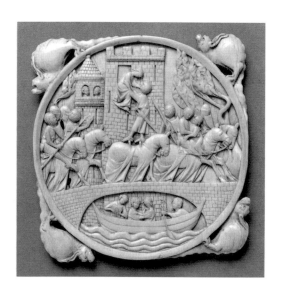

Fig. V-1. Mirror case with scene of an elopement, French (Paris), 1320–40, elephant ivory, h. 13.2 cm, Liverpool, National Museums and Galleries on Merseyside (M 8010)

IMAGES IN IVORY: PRECIOUS OBJECTS OF THE GOTHIC AGE

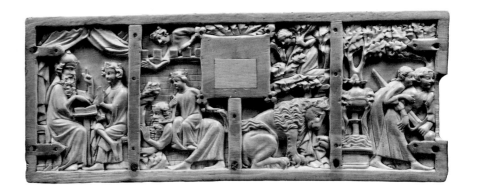

ancient world and was known to the medieval carver from Ovid's *Metamorphoses,* of which many manuscripts existed. It appears, for instance, on the Jadwiga casket in Kraków and that in the Metropolitan Museum of Art, illustrated here (fig. V-2).[1]

On the left end of the Walters box, one finds again two contrasting scenes. One is the virgin and the unicorn, a story from the medieval Bestiary, in which the unicorn is captured by the ruse of placing a virgin in the forest. The unicorn comes and lays his head in her lap, at which point the hunters kill him. This story of virginity is contrasted to the tryst beneath the tree, one of the chief episodes in the tale of Tristan and Iseult. Because of the mistake of drinking the love potion, intended for King Mark's wedding night, Tristan and Iseult are doomed to be lovers. Mark is led to suspect their treachery and hides in the tree above the fountain, where he has been told that they meet. Fortunately, they see his reflection in the fountain and converse about Tristan's potential departure from the court. Mark then forgives them, suspecting they are innocent. To the medieval mind they were the symbol of lust and adultery, a sharp contrast to the innocence celebrated in the tale of the unicorn.

On the rear of the casket are again two Arthurian stories, divided into four scenes. The first is Gawain fighting a lion followed by that of Lancelot crossing the sword bridge. Beside it is depicted Gawain on the magic bed, being showered with spears, and in the final scene he is greeted by the maidens of the castle.

The Lancelot adventures were known from the *Vulgate Lancelot,* written about 1220, and those of Gawain from the

V: POPULAR ROMANCES CARVED IN IVORY

Conte de graal, a work of Chrétien de Troyes dated between 1181 and 1190.[2] As Roger Loomis has pointed out, both scenes were illustrated for the first time on the composite caskets, as was the tryst beneath the tree. All three Arthurian scenes then became popular in manuscripts, as well as in other media, such as the capitals at the church of Saint-Pierre at Caen with Lancelot and Gawain (Loomis 1938, figs. 138–39). However, these later representations of the scenes seem never to be directly dependent on the ivories.

The final scene on the Walters box is a single one on the right end and shows Galahad, the virgin knight, receiving the keys to the Castle of Maidens so that he may rescue them. While it occupies the plaque alone on this box, it more often is paired with a second scene, that of Enyas and the wodehouse (fig. V-3). A wodehouse, or wild man, is seen in the forest with a young lady, and Enyas kills the wodehouse to rescue her. The medieval concept was that a wodehouse represented lust as the satyr did in the classical world, so it was natural for a knight to want to free the damsel. Again, one has the contrast of Galahad, the pure, with the wild and sensuous wodehouse. The scene is often shown in contemporary manuscripts, and in the marginal illustrations in the Taymouth Hours, the scribe has labeled the figures (James 1902, 60, ms. 57).

All the stories told on the box were currently popular and of interest to the recipient, but she would have been aware of the double meanings of all of them. She would also have been pleased, thinking of herself as the Castle of Love or as the object of adoration of her own noble knight, probably the donor.

There are seven complete caskets with the scenes just described and fragments of some dozen others. Only one fragment adds a story not so far mentioned. This is the side panel from a box, formerly in the collection of Baron von Hirsch, showing Ivain at the spring (Randall 1993, no. 192). The spring is guarded by a figure in the guise of a wild man, who is seated, holding a large club. The tale of Yvain, written by Chrétien de Troyes, was one of the most popular of Arthurian stories[3] and the subject of the earliest set of Arthurian frescoes in the Schloss Rodeneck in the Tyrol, which date from the opening years of the thirteenth century (Ott 1982–83, 6, fig. 1). The plaque is the only representation of the Ivain story in ivory, in spite of its literary currency at the time.

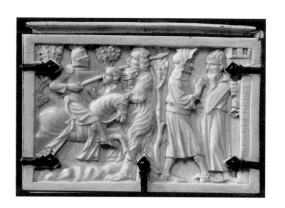

Fig. V-3. Side panel of a casket with scenes of Enyas and the Wodehouse and Galahad receiving the keys to the Castle of Maidens, French (Paris), 1320–40, elephant ivory, h. 10 cm, New York, The Metropolitan Museum of Art, Gift of J. Pierpont Morgan (17.190.173)

Besides the large group of composite caskets with their many divergent images, a number of ivory boxes were made with single stories. The first of these is the story of Perceval, based on Chrétien de Troyes's popular vernacular version of the tale in verse, written for Philippe d'Alsace, count of Champagne, between 1181 and 1190 (Poirion 1994). Only one ivory casket depicting the story survives, the example from the Musée du Louvre (no. 62). The ivory carver placed the most famous scenes of the combat with the Red Knight on the front. In an unusual departure, the lid of the box shows four saints under Gothic arches: Saint Christopher, Saint Martin, Saint George, and Saint Eustache. The question of the apparent line between secular carvers and those who produced religious work is an interesting one and will be discussed below.

A second box with a single story is one portraying the popular tale of *La châtelaine de Vergi* (no. 63). The story is one of honor, betrayal, and jealousy, as the chatelaine falls in love with a knight of the duke of Burgundy's court. Unlike most of the romances, *La châtelaine* was based on historical characters, a duke and duchess of Burgundy, though the tale is somewhat altered from historical fact. It was written in the late thirteenth century, and no fewer than fifteen manuscripts of the story exist from the period (Locey 1970, 12; Gross 1979). Its popularity is attested by mentions in texts by Jean Froissart, Eustache Deschamps, and Christine de Pisan in the following centuries. Six ivory boxes and fragments of others survive, and the fine Metropolitan Museum of Art example is shown here.

This story reveals both sides of the chivalric code, in which love and marriage have little to do with each other, but love was perceived as a goal, an ideal, and an honorable secret. As with the tales of Tristan and Iseult and Lancelot and Guinevere, the story of the chatelaine captured the medieval imagination. That it should appear on a large series of caskets is not surprising, and its choice and full presentation over other contemporary romances suggest its appeal in the second quarter of the fourteenth century. Another popular story that was carved on ivory boxes is the famous tale of the Knight of the Swan, as it was known in the north (for an English example, see Koechlin 1924, 2: no. 1310 bis); in Italy it is referred to as the story of Mattabruna and appears on the bone caskets of the Embriachi workshop of Venice (Martini 1993, 26, fig. 5).[4]

Questions have often been raised concerning the divisions of the ivory workers' guild in Paris during the fourteenth century and about the subdivisions of the trade and whether those who carved secular objects also produced religious ones (see Sears essay, pp. 18–37). Examination of the surviving boxes suggests that there was no definite line of demarcation. There is a casket, for instance, exactly in the style of the composite caskets and constructed similarly, carved with a religious subject, the history of Saint Eustache, and a lid of a second specimen with the same story (Randall 1993, no. 180). The Perceval casket (no. 62), as we have seen, has its original cover carved with four saints. The bottom of a box for weights and scales from the mid-fourteenth-century Atelier of the Boxes is carved with the Annunciation, while all other known examples from the atelier show love scenes or episodes from romances (Randall 1981, 32–33, figs. 2a–2b).

While the carved boxes were the most lavish, largest, and most expensive of secular ivory products, mirror cases and combs were the most numerous and of greater utility. The guild of *pigniers* (comb makers) sold combs and mirrors together, sometimes with a hair parter (*gravoir;* see fig. II-3) in a leather case. Many accounts survive, such as one of the duke of Burgundy in 1367:

> *Jean de Couilli, pignier, demourant à Paris, 5 fr., pour un estui garni de pignes et de mireour d'yvoire, qu'il a baillez et deliverez pour Mgr. à Guillemin Hannot, son barbier et valet de chambre."* (Jean de Couilli, comb maker, living in Paris, 5 francs for a case including combs and a mirror of ivory, which he has taken and delivered for Mgr. Guillemin Hannot, his barber and valet de chambre). (Prost 1902, 266, no. 1460)

More mirror cases have survived than any other form of secular ivory. They are thin discs carved on the face with scenes of lovers, the Attack on the Castle of Love, or other subjects, while the back was so designed that a polished metal disc could be inserted to serve as a mirror. The ivory plaque was squared off for ease of handling and stability when set on a shelf by four corner terminals, each in the form of a small, long-eared biped monster with a long tail. The creature was in standard use by mirror makers, though an occasional example

has human bipeds or lions. Many of the cases are also pierced so that they could be hung on the wall. Those from the second half of the fourteenth century usually have corner terminals with veined oak leaves.

Some of the combs may have been without carved decoration and totally utilitarian in nature, as carved examples are rare. A small number of combs with scenes of hunting and lovers are known. They have two sets of teeth, one fine and one coarse, and a central band of carving and must have often been discarded when the teeth broke (see nos. 53, 69).

The *gravoirs* are the rarest of the utilitarian ivories and were twenty-centimeter shafts of ivory, usually slightly curved, to remove tangles from long hair. The grips were carved with pairs of lovers, single figures, or animals.

The *pigniers,* it would thus appear, were the chief makers and suppliers of mirrors, combs, and *gravoirs,* sold together in cases, usually made of leather *(cuir bouilli)* but occasionally of silk. This raises the question of whether all mirrors were made by the comb makers or if some were perhaps produced by the makers of the ivory boxes.

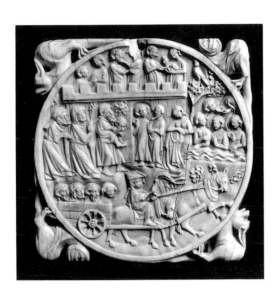

Fig. V-4. Mirror case with the Fountain of Youth, French (Paris), 1320–40, elephant ivory, h. 13 cm, Baltimore, Walters Art Gallery (71.170)

The subject represented on the carved face of a mirror case was most often a pair of lovers in a garden or lovers on horse-back, hunting or hawking. The Castle of Love was also very popular, as well as the God of Love, and many scenes of jousting are known, both serious and comic. Also frequently seen is a couple playing chess in a tent. However, it is surprising that not a single bestiary story is to be found, nor representations of Aristotle, Alexander the Great, Pyramus and Thisbe, Ivain, or Enyas. The Fountain of Youth does occur on several examples, as does the story of the tryst beneath the tree, which suggests that perhaps only a small number of mirror cases were made by the box makers and that the *pigniers* were serving a slightly different audience than the makers of the boxes with their romances and tales from antiquity.

One must consider both the subject matter and the style of a large mirror case in the Walters Art Gallery showing the Fountain of Youth as an example (fig. V-4). The broad, flat style of the carving is closely related to that of the boxes, though it is not as deep because of the nature of a mirror.

V: POPULAR ROMANCES CARVED IN IVORY

A group of elders is shown in the middle ground walking toward the fountain, in which they are returned to youth, very much in the manner of the scene on the caskets. The castle in the background with an audience witnessing the miracle of the fountain is reminiscent of the spectators at the tournament on the boxes, and in the foreground is an additional scene in which a horse-drawn cart brings other elders to the fountain.[5]

A scene that is possibly Arthurian is found on a mirror case from the Musée National du Moyen Age, Thermes de Cluny, portraying a seated king and queen between attendants (no. 54). The subject has always been thought to be royal and perhaps to represent Solomon and Sheba (Gaborit-Chopin 1978, 148, figs. 220–21). However, a Mosan gilt bronze buckle at the Cloisters of the Metropolitan Museum of Art about 1200–1220 (fig. 54a) suggests another possibility (Swarzenski 1954, no. 536, pl. 225). The buckle shows similar figures also seated with a lion and dragon underfoot. The king's adviser touches him on the shoulder as if to whisper in his ear. The queen's attendant looks down modestly, as she also looks away in the ivory. It recalls a scene not from the courtly life of France or of King Solomon but from the story of Tristan and Iseult, in which the royal couple would represent Mark and Iseult enthroned; he is indicated as noble by the lion, she as evil by the dragon. In the case of the buckle, the adviser would be the seneschal telling Mark of Iseult's affair with Tristan. In the case of the ivory, it would be both the seneschal and the dwarf pointing to the wicked Iseult. For the medieval viewer, the scene would conjure up one of the most poignant stories from romance literature, that of the fatal love potion and Iseult's unfaithfulness to King Mark. In both cases, the woman attendant would be Brangien, who served the potion and sacrificed her virginity to protect the queen.

The Attack on the Castle of Love seen on a large mirror case in the Walters Art Gallery is one of the richest versions of the subject (no. 57). It is recognizably by the same hand as the elopement mirror case in Liverpool (fig. V-1) and a third mirror case with an elaborated version of the Attack on the Castle of Love in a German collection.

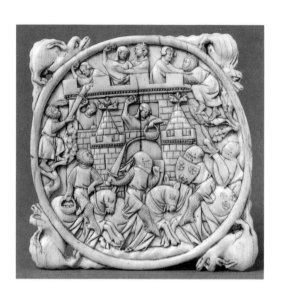

Fig. V-5. Mirror case with the Attack on the Castle of Love, French (Paris), 1320–40, elephant ivory, h. 11.5 cm, Seattle Art Museum, Donald E. Frederick Memorial Collection, (49.37)

It is worth considering the subject of the Attack on the Castle of Love and how it was handled by different carvers. The mirror case in the Seattle Art Museum (fig. V-5) is a fine and well-known ivory by an artisan who can be recognized in two other works. He uses a castle with a twin-towered gate as the frame of his composition. The Seattle example shows two knights with roses on their shields in combat, while a third rider enters with a basket of roses. In the castle, the ladies throw roses on the attackers but are overcome by knights who have climbed up ladders to the top wall of the castle and taken the ladies in their arms.

In a second example by the carver, formerly in the Sulzbach Collection in Frankfurt am Main, the setting and main figures are repeated but with interesting alterations (Koechlin 1924, 2: no. 1088). One of the two combatants now fights with a branch of roses; the third horseman now has a helmet and a branch of roses instead of a basket. The ladder to the left-hand turret has been replaced by a tree. In a third example by the same hand in the Musée Bonnat, Bayonne (ibid., no. 1086), the two horsemen have been moved to the right, and one pierces the other's shield with his sword. The third rider enters from the left, only to have a lady kindly remove his helmet, presumably to welcome him into the castle. So the ivory carver amused not only his audience but himself and varied the details of the attack from example to example.

A third workshop also depicted the Castle of Love with twin towers and a gateway with a closed portcullis (fig. V-6). Above are two levels of figures on different roofs or balconies, and in the upper one, the God of Love is central to the action. While the mirror cases differ from each other in many details, the major composition of the workshop is illustrated by the Victoria and Albert Museum example, and that ivory is very similar to the blackened and damaged but still appealing Louvre mirror case (Koechlin 1921, 291). One sees not a combat in front of the castle but a waiting charger, whose rider is boosting his companion over the wall of the castle.[6]

This workshop is easily identified, as the corner terminals of the mirror cases are crouching lions rather than biped monsters and also as the figures are arranged rather formally in layers. Yet within the boundaries of the subject and the

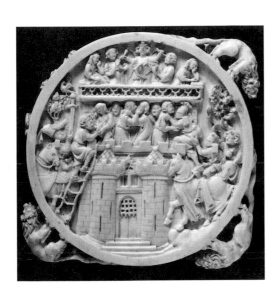

Fig. V-6. Mirror case with the Attack on the Castle of Love, French (Paris), 1350–60, elephant ivory, h. 13.5 cm, London, Victoria and Albert Museum (1617-1855)

shop, the carvers produced a variety of thoughtful changes to keep the subject fresh and the purchasers interested. Some craftsmen were more imaginative than others, and it can be easily seen in these examples that the master of the Walters and Liverpool mirror cases was a greater talent than some of his contemporaries.

The interesting mirror case with jousting knights in the Virginia Museum of Fine Arts adds new features (no. 59). Two of the knights in the foreground have roses on their shields, which are normally seen only when roses are being thrown down on them, as in the Castle of Love imagery. Here, however, they are in combat, the two at the right with crests on their helmets, while those at the left are identified with cloth streamers. One of the knights at the left knocks the helmet off his opponent, a detail seldom seen in medieval art, though it occurs frequently in the literature. It is an imaginative treatment of the popular theme.

Another image favored by the carvers of mirror cases was the God of Love. He already appeared in fables of the twelfth century and is one of the chief protagonists in the *Roman de la rose,* written by Guillaume de Lorris and Jean de Meun, and continued in popularity into the fifteenth century in the poetry of Christine de Pisan (Koechlin 1921, 280). The artistic representation is relatively straightforward and in its simplest form shows the crowned God of Love in a tree shooting or throwing arrows at a young couple below. In other compositions, there are two couples, and in some the tree is replaced with a castle or a folding chair.

In a mirror case from the Musée du Louvre, one sees a sophisticated version of the genre, probably dating from the middle of the fourteenth century (no. 56). The God of Love sits in a tree, as usual, but in an architectural context.

The God of Love also appears in many versions of the Attack on the Castle of Love, though not in all. That he was as familiar to the French populace in the fourteenth century as Eros was to the Greeks and Romans is clear, and so he becomes a favorite allegory of love and thus appropriate to decorate a mirror case or wax tablet cover, which was an intended gift from an admirer of either sex.

But like many images shown in the popular Paris ivories of the day, the figure of the God of Love is repeated in Germany in the casket of Saint Ursula in Cologne (fig. VI-7) and is crisply carved on a pair of wax tablet covers, also probably from the Rhine Valley, in the collection at Maihingen (Koechlin 1924, 2: nos. 1266, 1221).

Another medieval metaphor for love and war was the game of chess. The image occurs in many literary texts, including *Tristan and Iseult,* and became very popular with ivory carvers. The Cleveland Museum of Art mirror case (no. 58) is a typical version of the chess game, in which the man is seen lifting a chessman from the board, while the lady reaches to make her next move. While hunting and hawking were frequent subjects on mirror cases, their representation poses the possibility of a hidden iconography in the scenes (no. 54). In manuscript calendars, for instance, hawking is the usual scene for the month of May, hence suggesting spring and thoughts of love. And so the scene is most often shown on the mirror cases, with a couple on horseback either looking at one another or in some cases actually chin-chucking or kissing (Koechlin 1924, 2: nos. 1034, 1028). As love and courtship seem to have been the major subjects of mirror covers, it is possible that the season of love was thus celebrated by the ivory carvers. It is curious, however, that no other seasonal scenes were used in the ateliers.

The majority of surviving ivory combs are also carved with scenes of lovers (no. 53). One in the Museo Nazionale del Bargello shows the God of Love as well as an amusing scene of a musician accompanying a chess game (Koechlin 1924, 2: no. 1148). Only a single example illustrates stories from the *Lai d'Aristote.* This is a German comb of coarse workmanship of the late fourteenth century, showing on one face both Aristotle and Phyllis and the story of women's domination from Boccaccio of Virgil in the basket and his revenge (ibid., no. 1150). The reverse is carved with hunting scenes.

In the Museo Civico, Turin, is a *gravoir* with Tristan and Iseult standing by the fountain, in which the face of King Mark appears, though without the benefit of a tree (Koechlin 1924, 2: no. 1137). Another fine *gravoir* in the Victoria and Albert Museum shows Phyllis riding a much-compressed Aristotle

(Longhurst 1927–29, 2:49, [286-1867], pl. XLV). The subject appears once again on the handle of a dagger or *presentoir,* combined with other scenes of lovers (Koechlin 1924, 2: no. 1140). The subject was so popular that it appeared again in the fifteenth century on an ivory chalice in Münster (ibid., no. 1243a).

Close connections may be found with the poetry and literary sources among the many surviving wax tablet covers. Some fine examples were produced in the style of Paris in the first half of the fourteenth century, but the use of these little notebooks seems to have steadily increased in the middle and later years of the century, leaving us a broader spectrum of material. Wax tablets were a series of rectangular ivory leaves carved with a recessed area to receive wax on which notes could be written with a stylus. They were tied together at the top and could swivel sideways. The two outer leaves, or covers, were carved, and a set sold in a leather case with a slot for the stylus.[7]

Fig. V-7. Top and bottom of a box with castles and lovers, ascribed to the Atelier of the Boxes, North French, 1340–60, elephant ivory, h. 9.3 cm, Baltimore, Walters Art Gallery (71.283)

The set of tablets with three notebook leaves illustrates the usual size of such a little booklet (no. 61). It is English or possibly French and shows a chess game, hawking on horseback, a suitor and his lady, and two lovers observed through a door by an old man. As wax tablet notebooks were used by both the clergy and the laity, a number of covers are carved with religious subjects. A set of tablets with six leaves at the Victoria and Albert Museum (no. 40) is carved with the Coronation of the Virgin and saints and must have been made for a monastic order, as two small monks kneel in the corners. The leaves of this booklet have been painted with scenes of the Passion of Christ in a Rhenish Westphalian style of the mid-fourteenth century, suggesting that the ivory itself is German in origin.

The wax tablet covers, mirrors, and small boxes from the Atelier of the Boxes reflect a decided change of taste in the ivory ateliers toward the middle of the fourteenth century (fig. V-7). The ground plane in the carvings is pitched up so that buildings and people are seen in perspective, and the

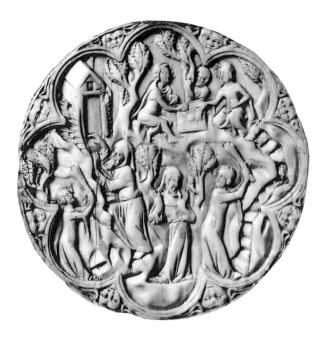

Fig. V-8. Mirror case with a lady and a hermit, ascribed to the Atelier of the Boxes, North French, 1340–60, elephant ivory, h. 9.5 cm, Baltimore, Walters Art Gallery (71.206)

Fig. V-9. Mirror case with lovers in court dress, North Italian (Savoy), ca. 1410, elephant ivory, h. 8.2 cm, Baltimore, Walters Art Gallery (71.107)

figures wear modish costumes, the men with beards and cloth chaperons, the ladies with liripipes on their sleeves and their hair braided in buns above the ears. The majority of the representations concern lovers of all ages and types, usually observed by villagers or a hermit. Because of the close connections in style to the miniatures of Guillaume de Machaut's *Remède de fortune* manuscript, it has been suggested that many of the scenes may indeed illustrate the variety of lovers in Machaut's poem *Le dit de lion* (Randall 1981, figs. 10–11). In that poem, Machaut describes lovers as true and false, bold, courtly, or boorish, just as they appear on the tablet covers and mirrors. One mirror case illustrates a narrative, not yet identified, of a couple playing chess, observed by a hermit; the lady chasing the hermit with a club; and the hermit retiring to his hut (fig. V-8). The style is of a new genre, quite different from that of the Paris boxes of the period from 1320 to 1340 but very close to that of the miniatures of the *Remède de fortune* and other romances written in northern France between 1340 and 1360.

That there was poetic inspiration behind many of the subjects is manifest by a pair of mirror cases from northern Italy, carved with couples in lavish court attire (fig. V-9). Here a line from a poem of Christine de Pisan is carved on the two mirrors: PRENEZ EN GRE taken from *Prenez en gre le don de votre amant* (Take kindly the gift of your lover). The use of the three

words implies that the intended audience had a certain familiarity with the poetry of Christine de Pisan. The ivories are attributed to the northern Italian region of Savoy, where the court language was French, and date from about 1410.

The close relationship between the secular ivories and vernacular romance literature should hardly surprise us. From the middle years of the thirteenth century, the Parisian ivory ateliers based their religious ivories on the Old and New Testaments, on the life of the Virgin, and *The Golden Legend*. That there was little transfer of artistic ideas from manuscript miniatures has been clearly shown, and when there was external influence, as in the carving of statuettes of the Virgin and Child, that influence always came from major sculpture (see Williamson essay, pp. 38–45).

The secular carvers adopted the developed style of the religious ateliers of the first quarter of the fourteenth century. There was no major sculpture of the romance subjects at the time for the carvers to refer to, but the familiarity of the artisans with the texts of Arthurian and other romances is patent. Where there are manuscript illustrations of a secular subject, such as the Castle of Love, the ivory carvers nonetheless invented their own versions of the familiar tales. The current actually flowed in the other direction, and sculpture in stone, such as that at Caen of Lancelot and Gawain, followed the example of the ivories. The profusion of representations of Aristotle and Phyllis in manuscripts came after the major ateliers in Paris had stopped producing the composite caskets.

The major period of production of ivories lasted only a little beyond the middle of the fourteenth century with a great change of style and literary influence at that time with the Atelier of the Boxes and the proliferation of wax tablets. The waning of the French ivory industry was largely due to the disastrous financial effects of the Hundred Years War between England and France (1337–1453), yet there was no immediate end of the use of ivory as a material. The center of the trade moved north to the new commercial centers of Flanders and the Netherlands, and there the major production was only of religious subjects (Randall 1994). With the exception of bone chess boxes and ivory combs with garden scenes and hunts, secular subject matter virtually disappeared from the scene.

The use of less expensive bone was adopted in Italy by the Embriachi workshops of Venice and Florence, as well as by the carvers of the Upper Rhine and Flanders. The Embriachi alone continued a literary tradition in their secular boxes, and their preference was for legends of the classical world, such as those of Jason and the Argonauts, Ameto and the Nymphs, and the life of Paris. Only the tale of Mattabruna, or the Knight of the Swan, remained popular from the medieval world and continued the tradition of romance literature as an inspiration to the carvers (Martini 1993, 26, fig. 5).

Notes

1. Other depictions of the story can be found as early as the late twelfth century on engraved copper Hansa bowls, where it is told in five or seven roundels. There are a number of bowls of the type, and each roundel of the tale is accompanied by an engraved text (Weitzmann-Fiedler 1956–57, 134–51).

2. Daniel Poirion (1994) dates the *Conte de graal* 1181–90.

3. Poirion (ibid.) dates *Yvain* 1181.

4. A third popular story is that of *Floire et Blanchefleur*, which appears on a casket in the Toledo Museum of Art (Randall 1993, no. 194). The story is presented in thirty-two scenes, placed under double gothic arches. It dates from the third quarter of the fourteenth century and, because of its brass mounts, is thought to be a product of either northern France or more likely Flanders.

5. The only example of a mirror cover with the story of Gawain on the magic bed, while coarser in workmanship than the boxes, follows the same iconography, adding a few witnesses on a balcony at the top (Koechlin 1924, 2: no. 1006). The representation was surely inspired by one of the composite boxes. The two mirror cases with the tryst beneath the tree, however, are far removed from the Parisian ateliers. One broadly rendered version in the Vatican collection is certainly northern Italian in origin, and the second in the Cluny Museum is either provincial French or northern Italian, and both date from the third quarter of the fourteenth century (Loomis 1938, figs. 123–24).

6. In one of the two examples from this shop in the Carrand Collection in the Museo Nazionale del Bargello, Florence, it is the knight himself who climbs up from his horse (Gerspach 1904, 23, fig. 82). In a second Victoria and Albert Museum example, the horsemen stand stunned by the roses thrown on them, a detail repeated in the second Bargello version (Longhurst 1927–29, 2: 48, [9-1872], pl. XLIV). In some of the covers, there are trumpeters, in others the upper platform from which the ladies throw their roses is treated with a pierced trefoil pattern.

7. The Fountain of Youth is to be found on a Parisian example of about 1340 and again on a roughly carved notebook of the second half of the century (Koechlin 1924, 2: nos. 1215, 1163–64). The matching cover of the latter shows an elopement by boat, which can be recognized from the Parisian caskets and the Liverpool mirror case. The only Arthurian scene is a tablet cover showing Gawain on the magic bed, probably northern French, where the figure is not modeled on the Paris boxes, where Gawain is correctly shown in armor beneath his shield, a detail essential to the story (Loomis 1938, fig. 141).

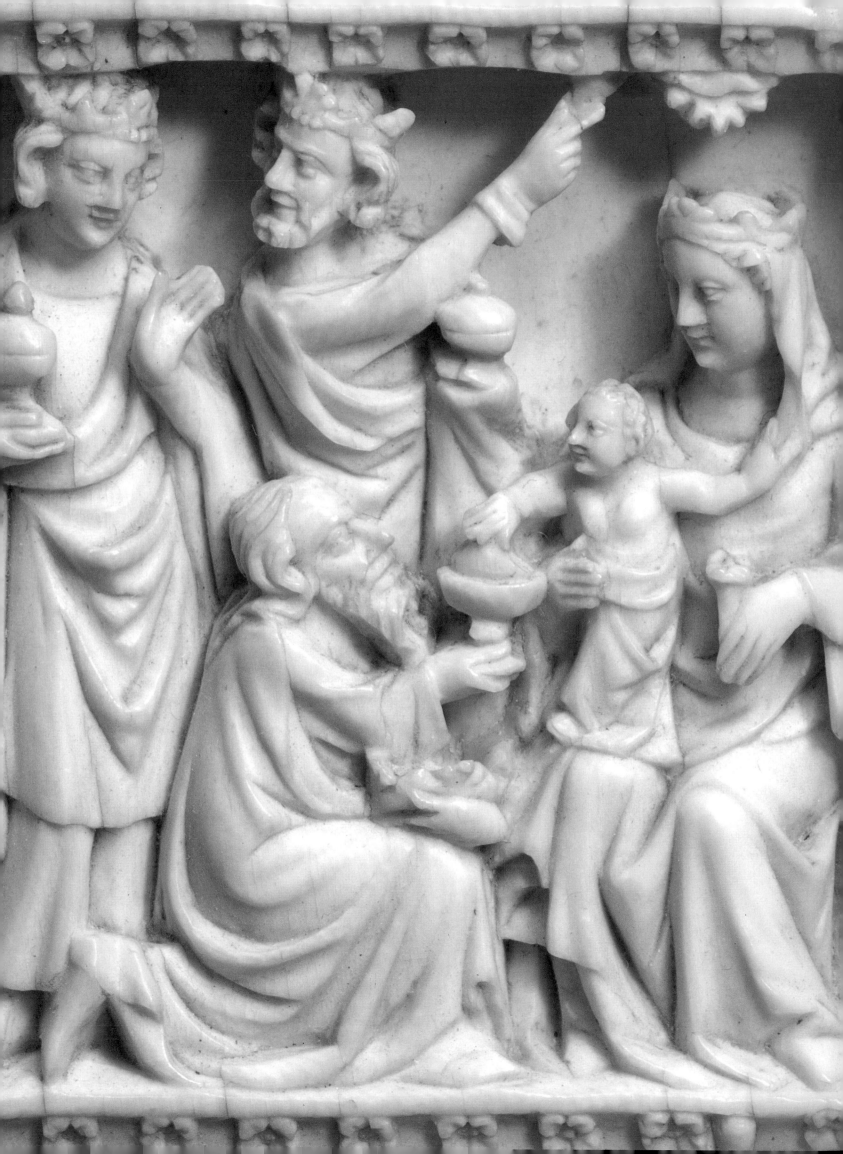

VI | Gothic Ivory Carving in Germany

CHARLES T. LITTLE

IN RECENT YEARS THE MYTH THAT ALL THE GREAT GOTHIC IVORIES ARE
FRENCH, IF NOT PARISIAN, IN ORIGIN HAS BEEN EXPOSED. THE *A PRIORI*
ACCEPTANCE OF IVORY CARVINGS, BOTH RELIGIOUS AND SECULAR, AS THE
PRODUCT OF A SERIES OF FRENCH ATELIERS CENTERED FOR THE MOST
PART IN PARIS AND NORTHERN FRANCE HAS BEEN REPEATEDLY CHALLENGED
SINCE THE AMBITIOUS STUDY PUBLISHED IN 1924 BY RAYMOND KOECHLIN,
LES IVOIRES GOTHIQUES FRANÇAIS.

Detail, no. 42

While centers outside Paris are often difficult to identify,
progress has been made toward identifying elements of the
different nationalities of Gothic ivory carvers.

For English ivories, the earlier work of Margaret Longhurst
has been updated by the dissertation by Dean Porter and
refined by Neil Stratford and most recently by Paul
Williamson.[1] While the problem of origins in France versus
Italy offers many provocative questions of transmission and
imitation, especially with the personality of Giovanni Pisano,
the study by Donald Egbert has contested many of the basic
assumptions regarding French ivories and recently Williamson
has surveyed Italian ivories.[2] For Spain, a critical study is still
in need; often it is assumed that ivories in Spanish museum
collections and church treasures are of indigenous origin
when, in fact, some were probably brought from France or
elsewhere as a result of pilgrimage, marriage, or gift-giving.[3]

Paris and/or Cologne

Is a German tradition of Gothic ivory carving recognizable?
An answer must be conditioned by the important caveats of
import versus local production and the fact that artists trav-
eled. Already by the mid-thirteenth century, the desire to own
things in the French style *(opus francigenum)* or imitate French
iconographic themes was well established. In several instances
French iconography had an early impact on German ivory
carving, such as a liturgical comb of about 1200, possibly from

Fig. VI-1. Abbot Bohuslaus's collection of ivory statuettes, French (Lorraine) or German (Rhenish), before 1258, Zwettl (Austria), abbey treasury

Bamberg, with the Tree of Jesse theme that includes an image of Bishop Fulbert of Chartres.[4] During his abbacy, Bohuslaus (1248–58) of the Cistercian order at Zwettl in lower Austria traveled to France and obtained some relics and an ivory image of the Virgin and Child with young martyr Virgins for the high altar (fig. VI-1).[5] The charming statuette is still in the abbey treasury along with seven smaller figures. The striking feature of this ensemble for the altar is its essentially non-French character—emphatically articulated eyes, flat, rounded faces, and simple drapery forms. The type of Virgin relates to no known image from the Ile-de-France, and if it were not for the reference to its acquisition in the abbey's donation book, one would never identify the group as French. This is symptomatic of the problem of identifying ivories as German in an age of widespread travel of both goods and artists. The Zwettl figures might well have been acquired in Lorraine or the Rhineland during the peregrinations of the abbot, and it may simply have been his desire to return with "something French" that inspired this acquisition, probably knowing that the monks would not have known the difference and would appreciate a new item for the altar.

Compositions, styles, and iconographic concepts traveled rapidly. As has been pointed out by Richard Randall, terra cotta impressions of ivories appear to have served as agents of transmission.[6] A terra cotta impression in Liège of the Adoration of the Magi bears a striking resemblance to an ivory of the same subject in Utrecht (figs. VI-2–3), suggesting that such terra cottas served as workshop models in the production of ivories.[7] Because the terra cotta is not a precise rendering, its function was perhaps more as an aide-mémoire for recreating the latest fashion from a main center. The fact that both pieces possess hallmarks of Cologne work—the distinctive Rhenish type of Virgin and the second king wearing a glove—emphasizes the rapid diffusion of such images to different centers.

Without specfic documents—of which, except for inventories, there are very few referring specifically to Gothic ivories in German speaking lands—isolating and defining German ivory carving is more an art than a science. Nevertheless, the role of Cologne has dominated the discussion. The Saint Martin diptych (no. 41) is often localized to Cologne. This is based, for the most part, on the presumed stylistic relationship to

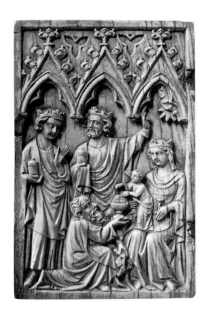

Fig. VI-2. Relief with Adoration of the Magi, 14th century, terra cotta, Liège, Musée Curtius (JB/38)

Fig. VI-3. Relief with Adoration of the Magi, German (Cologne), mid-14th century, elephant ivory, Utrecht, Aartsbisschoppelijk Museum (B759)

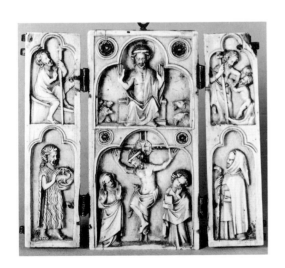

Fig. VI-4. Polyptych fragment with scenes of the Passion and saints, German (Cologne), mid-14th century, elephant ivory, Cologne, Schnütgen-Museum (B 135)

sculpture, such as a polychromed Saint Nicholas with painted scenes on the socle (Cologne, Diözesanmuseum), to a seated bishop in the church of Saint Ursula,[8] or to Cologne manuscripts.[9] Moreover, the addition of a tiled roof with pinnacles as a decorative framing device occurs on a number of ivories that have been reattributed to Cologne, suggesting that this is a localizing feature. What is interesting about the Saint Martin diptych is that the figure types with flat undulating drapery, elongated torsos, and slit eyes directly echo tendencies found in northern French ivories, especially in the so-called Soissons group (nos. 10–12 and fig. VII-1) and in its continuation in the fourteenth century in the "Saint-Sulpice-du-Tarn Group." The pervasive impact of northern French ivories on those attributed to Cologne may indicate that French works actually became models, thus perpetuating the style longer than normal. Another ivory triptych of the Crucifixion and Last Judgment with Saint John the Baptist and Saint Anthony in the wings (fig. VI-4) shares stylistic features with the Saint Martin diptych and may also be a product of Cologne.

Increasingly, the appearance of patron saints in diptychs and triptychs may suggest a regional preference for intercessing saints. Two triptychs of the Virgin and Child between Saints Clare and Francis (Copenhagen, Nationalmuseet)[10] appear to confirm the regional variety, as they both possess Virgin types that clearly evoke middle or lower Rhenish carving (figs. VI-5–6). Likewise, the elaborate diptych in New York (no. 42) with both narrative and hagiographic scenes is certainly one of the masterpieces of Cologne ivory carving.

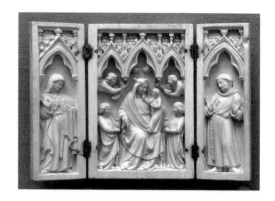

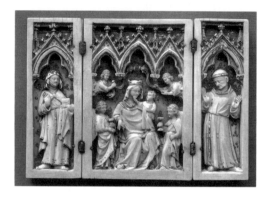

Fig. VI-5. Triptych with the Virgin and Child between Saints Clare and Francis, German (Cologne), mid-14th century, elephant ivory, Copenhagen, Nationalmuseet (2735)

Fig. VI-6. Triptych with the Virgin and Child between Saints Clare and Francis, German (Cologne), mid-14th century, elephant ivory, Copenhagen, Nationalmuseet (10359)

The Parisian or French character in ivories attributed to Cologne may be explained by the existence of Parisian carvers actually working in the German city. If the craft of wood carving can be taken as an indicator, the evidence may lie in one of the most ambitious wood sculpture projects around 1300 when the choir stalls for the cathedral were created and installed by 1311. The recent admirable study by Ulrike Bergmann distinguished several different styles in the carving, reflecting diverse backgrounds for the large project.[11] One hand could be recognized to be of Lotharingian origin, while another almost certainly came from Paris.[12]

This Paris-trained carver may have been responsible for the now-destroyed choir stalls at Notre-Dame in Paris, after 1296—known only from a seventeenth-century drawing by Israël Sylvestre—before the sculptor's arrival in Cologne.[13] His work is especially close to several ivories attributed to Cologne around 1300. The claim that it should be possible to differentiate between German and French ivories—as is done for book illumination—is rendered all the more difficult by the presence of French artists working in Cologne.[14] Most notable among ivories attributed to Cologne, and aiming at emulating the French style, is the attractive casket in the treasury of Saint Ursula depicting courtly scenes that offers paired couples engaged in games, hunting, and the triumph of love (fig. VI-7).[15] Some of the compositions and attitudes closely parallel those in the choir stall relief panels at Cologne Cathedral (fig. VI-8).[16] Significant also is the fact that there is a parallel technical correspondence between the crafts of carving wood and ivory:

Fig. VI-7. Casket with scenes from romances, German (Cologne), 14th century, elephant ivory, Cologne, treasury of the church of Saint Ursula

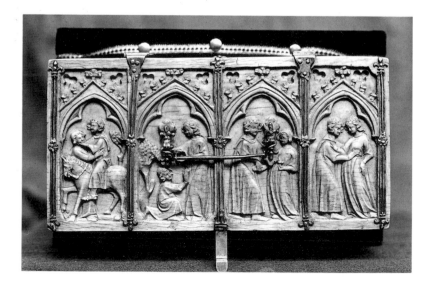

the types of tools are similar, as are the method of carving in relief and the application of polychromy. The appearance in Cologne at the same moment of works in both media further supports the hypothesis that the city was also a center of Gothic ivory carving, just as it had been an important center of ivory carving during the Ottonian and Romanesque periods.

Most characteristic of Cologne ivories is the type of Virgin and Child that they represented. In the fourteenth century the morphology of the Virgin and Child as developed in the city mirrored life, reflecting physiognomic features apparently taken from the local population: broad forehead, widely separated eyes, and small mouth with a double chin.[17] Such features are witnessed in a number of ivories, but, significantly, ones that are rarely attributed to Cologne. A magnificent triptych showing the Virgin being crowned by an angel as the Queen of Heaven between two angels with candles in the Metropolitan Museum of Art (fig. VI-9) exemplifies a grand presentation as also found in contemporary French ivories, such as a version in Angers.[18] In the nineteenth century, this triptych was in a Cologne private collection when Alexander Schnütgen published it, although he considered it a French work.[19] Retaining a significant amount of original polychromy—but "enhanced" in the nineteenth century—the figure decisively reflects a series of fourteenth-century Cologne Virgins in wood, stone, and paint, such as the Virgin from the Tongern house[20] and several other wood Virgins in the Schnütgen

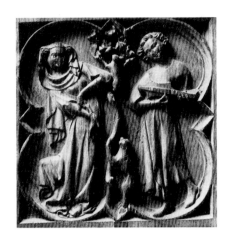

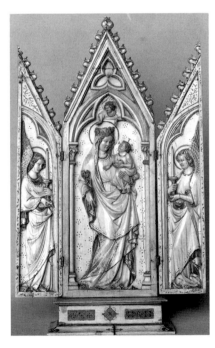

Fig. VI-8. Choir stall relief, Cologne cathedral, German, ca. 1300, wood

Fig. VI-9. Triptych with the Virgin in Glory, German (Cologne), 1325–50, elephant ivory, New York, The Metropolitan Museum of Art (17.190.211)

Museum.[21] Such types are first seen in Cologne cathedral in the Virgin of a *Sponsa-Sponsus* group (fig. VI-10) and the "Mailänder Madonna" of around 1290 in the ambulatory where the broad expanses of undulating drapery and the majestic beauty of the face conform to similar principles of form and expression.[22] In addition, the angels might be compared to those seen in Cologne glass painting in the early fourteenth century.[23] A continuation of the Cologne form of tabernacle is found in a polychromed and appliqué triptych in the Suermondt Museum, Aachen, which also has a similar

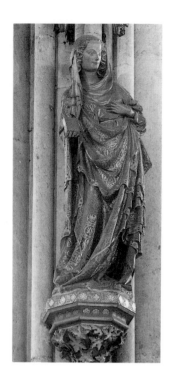

Fig. VI-10. Statue of the Virgin, choir, Cologne cathedral, ca. 1290, polychromed limestone

socle with painted panels made to imitate translucent enamels.[24] The Metropolitan Museum of Art triptych captures the essence of the Cologne style in a way that few other German Gothic ivories do.

The question must remain open whether these ivories of the earlier fourteenth century attributed to Germany were produced in Paris by carvers from Cologne or were actually made in that city. It is only in the next generation of carvers that a distinct style evolved that became the hallmark of a carver working in the Rhine Valley whose name derives from a triptych in Berlin, hence the Berlin Master (nos. 43–44). Approximately a dozen works are associated with him. He was active around the end of the century, and his works include statuettes, diptychs, triptychs, and tabernacles. The Berlin triptych itself is a masterful essay of sinuous line, restrained gestures, and expression whose economy of forms is distinctive. Features that distinguish this carver's works are the ovoid shape of the head with a high forehead and a pointed nose and chin, as well as the curvilinear effects of the drapery manifested in long sinuous folds. Danielle Gaborit-Chopin has placed this artist in the Rhine Valley, suggesting parallels both to Cologne painting and to middle Rhenish sculpture. Stylistically the refinements of the carving anticipate the International Gothic style around 1400.[25] Frequently the works include donor images such as the diptych in the Metropolitan Museum of Art (fig. VI-11). Usually localized to the middle Rhine, the Berlin Master might also have come from the Lake Constance region, where the 1361 seal for the Cistercian convent of Salem bears an enthroned Virgin and child in a nearly identical fashion as that on the Berlin triptych.[26]

The problem in attempting to localize the Berlin Master, or any other ivory carver, is that such attributions rest on comparisons in media other than ivory, but of known provenance—seals, sculpture, or manuscripts. Occasionally there is an inscription that aids in determining origin, such as the recently acquired diptych in the Rijksmuseum, Amsterdam, which bears the words "verus Possessor Albergatus Ehlen Prior Cartusie Trevirensis 1781" (The true owner is Albergatus Ehlen, prior of the Charterhouse at Trier, 1781).[27] Although this late date is no guarantee that the carving is a product of the Meuse Valley, the Virgin in the Adoration of the Magi conforms to a

IMAGES IN IVORY: PRECIOUS OBJECTS OF THE GOTHIC AGE

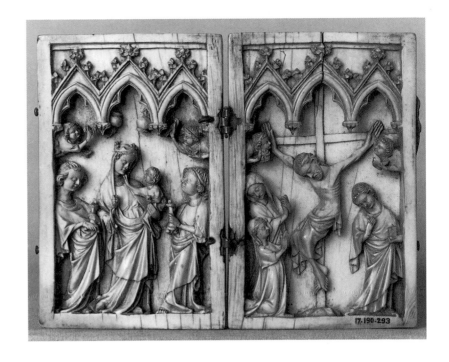

Fig. VI-11. Diptych with the Virgin and Child and the Crucifixion, German (Middle or Upper Rhine), 14th century, elephant ivory, New York, The Metropolitan Museum of Art, Gift of J. Pierpont Morgan (17.190.293)

Lotharingian type. Likewise the image of the Three Kings, especially with one king wearing a glove, is often considered an indicator of a Cologne origin, in part a result of the relics of the Magi residing in the cathedral.

Ivories and German Mysticism

Nearly all religious ivories of the later Middle Ages functioned as aids in private devotion, to assist in prayer as a means of ascending to higher levels of contemplative experience. Of paramount significance for the devotional function of images in ivory is the *Legenda maior* of Saint Hedwig (1174–1243; canonized 1267). She was the duchess of Silesia, and as a widow lived with Cistercian nuns at Trebnitz (Trzebnica). Upon her death she was buried clutching her personal ivory statuette of the Virgin and Child, an object that was the subject of both veneration and miracles. An illustrated manuscript of the *Legenda,* dated to 1353, includes several images of her holding the ivory white statuette (fig. I-7) that she "adored lovingly"; her death and burial (fol. 87r) also show her with it tightly in her grasp.[28] Because of its reputed power to heal, the statuette functioned as both relic and devotional object. Thus a piece of ivory became a clear accessory to mysticism.

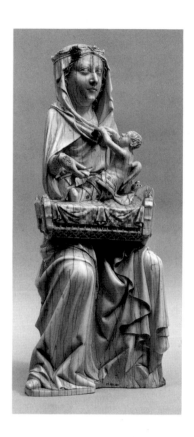

Fig. VI-12. Statuette of the Virgin and Child, German, (Upper Rhenish), second half of 14th century, elephant ivory, New York, The Metropolitan Museum of Art, Gift of J. Pierpont Morgan (17.190.182)

Hedwig's ivory statuette has not survived, but it is similar to others of the period. Intimate in character, such ivories played a key role in the development of devotional imagery. Their impact can be seen in a series of Virgin statuettes depicting the popular German theme of *Der erste Tritt* (first step of the Christ child) mostly produced in the Upper Rhine, perhaps in Basel, in the second half of the fourteenth century. One statuette has a date of 1364 inscribed on it.[29] Most exotic of these is, however, a Virgin nursing Christ wrapped in swaddling in a cradle that combines aspects of the *Virgo lactans* and the *Sedes sapientiae* (fig. VI-12). This image may be linked to German mysticism promulgated by the Dominican Norbert of Nördlingen, who guided the *Gottesfreunde,* or Friends of God. Among his followers, Margaretha Ebner (ca. 1291–1351) received a gift of a *Repos de Jésus* from Vienna in 1344 for use in her devotions, and she recorded her conversations, such as one while embracing the Christ child in his cradle.[30] The Metropolitan Museum of Art ivory would appear to be a visual corollary to these mystical revelations and might even be intended to commemorate her pious visions. Indeed the corporeal imagery of the semirecumbent Christ patently recalls the *imago pietas* theme and the whole is evocative of an *imitatio Maria,* where the nuns mimic Mary in her care of the Christ child. What is important is that these ivory statuettes, as a class of devotional objects, were created specifically for worship within conventual settings in order to nourish visionary experience. That the owners were women is confirmed by the presence of cradles, which were universally associated with convents. Such images must have been centrally produced, perhaps in the Upper Rhine or, if Richard Randall is correct in comparing them to related examples in sandstone in Simmerberg (Lindau), in the vicinity of Basel, where one also finds large-eyed Virgins and figures with heavy proportions.[31]

Two polyptychs (no. 46 and fig. VI-13) are prime examples of ivory *Andachtsbilder,* or religious images, composed in a rare form of multiple panels that fold accordion fashion. Possibly originating in the Upper Rhine, these polyptychs of the Passion, one of which retains a considerable amount of its original polychromy and gilding, are also distinctive thematically. The rarity of some episodes and the aggressiveness — even violence — of their portrayal is without precedent in

IMAGES IN IVORY: PRECIOUS OBJECTS OF THE GOTHIC AGE

Gothic ivories: the stripping and buffeting of Christ; and two Crucifixion scenes, one emphasizing the nailing of Christ to the cross, the other showing the implanting of the cross with Christ on it into the mound of Golgotha. Although many aspects of the iconography appear to be Germanic in character, the style and carving technique of indicating eyes with a slit are French, suggesting that the carver may have been a Frenchman working in the Rhineland. Also symptomatic of the French-German question is the theme of the jet of blood from Christ's side transformed into a sword piercing the heart of the Virgin, a theme frequently associated with Dominican mysticism in the Rhineland. Found primarily in German but also in French representations of the Crucifixion, the theme was first advanced by Charles Rufus Morey as an indicator of German origin of ivories of this subject.[32] These images of empathetic suffering were of widespread popularity and promulgated primarily by the Dominicans. In many instances the theme might be a logical starting point for identifying "German" Gothic ivories, but the motif is found over such a diverse geography that it cannot be confined to one locale.

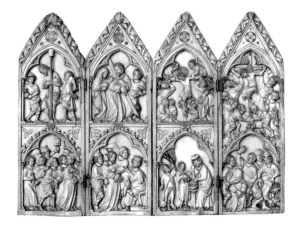

Fig. VI-13. Quadriptych with scenes of the Passion, French, 14th century, elephant ivory, New York, The Metropolitan Museum of Art, Gift of J. Pierpont Morgan (17.190.205)

Detail, fig. VI-13. The Mocking of Christ.

Such cross-fertilization of French and German artists is even more evident in two sets of carved writing tablets that also contain painted images. The Victoria and Albert Museum set with a carved Coronation of the Virgin and Saint Lawrence, a bishop, and a donor is enhanced by fourteen scenes of the Passion painted on the interior leaves (no. 40). The origin of the carvings is debated: they may be the work of a German carver trained in France, but the paintings are unquestionably from the Lower Rhine or Westphalia.[33] A similar conundrum exists with a miniature set in the Metropolitan Museum of Art, New York, that is unusual in that not only are the covers carved but also the vertical edges as well as the interior side of covers (fig. VI-14). The deluxe character of this booklet is enhanced by painted scenes that also do not correspond stylistically with the carvings. The carving technique in the New York booklet can be linked to French ivories of the

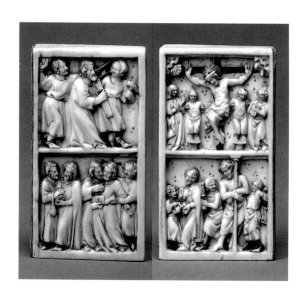

Figs. VI-14. Devotional
booklet, French (carving) and
German (painting), 1310-20,
elephant ivory, New York,
The Metropolitan Museum
of Art (1982.60.399)

Outer covers

early fourteenth century. However, the delicate paintings
laid directly on the ivory leaves correspond to Upper Rhenish
manuscript illumination, especially the Manesse Codex and the
Weingarten Liederhand-schrift, both dating to the first decades
of the fourteenth century and often related to works in the
Lake Constance region.[34] The painted images on the ivory are
composed of angelic groups of long-waisted figures, whose
simple breaking folds and doll-like faces with full wavy hair are
strikingly similar to the manuscript illumination. The stylistic
difference between the carving and painting implies that the
donors depicted adoring the Virgin are probably not the same
owners who locally commissioned the painted scenes of the
Magi, transforming the image into an Adoration with donors.
Both the New York and London writing booklets confirm the
desire of their respective German owners to possess devotional
tablets that looked "French," yet were apparently enhanced
locally in order to give them regional character.

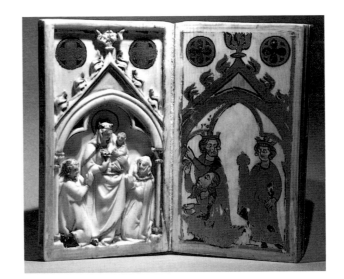

Inside of front cover

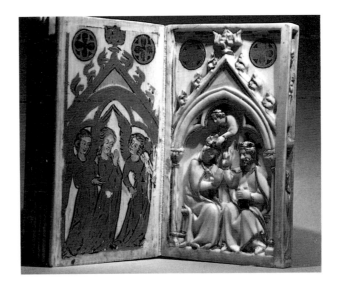

Inside of back cover

Although one assumes that statuettes were intended for devotional purposes, this is not always the case. An ivory Virgin from the former Augustinian convent of Langenhorst, Westphalia (fig. VI-15) is characteristic of the sculptural style of the Master of Kremsmünster, a prolific carver named after a diptych now in the Austrian monastery of that name (see no. 45). A study by Géza Jászai unveiled several important features about the Langenhorst figure.[35] The statuette stands on a wood and ivory socle that contains relics of Christ, John the Baptist, and Saint Priscilla of Rome, identified by *tituli* probably written in an early-fourteenth-century hand. Since the Langenhorst nunnery was dedicated to John the Baptist, it is reasonable to assume that this reliquary statuette was destined for the convent when it was made. However, it is risky to date the statuette according to the paleography of the *tituli* inscriptions, especially when the type of figure corresponds with ivories of this master whose work is normally dated

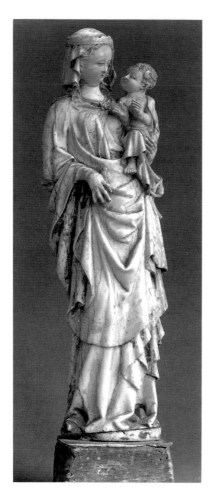

Fig. VI-15. Virgin and Child, Master of Kremsmünster, German (Mainz?), late 14th or early 15th century, elephant ivory, Ochtrup-Langenhorst, church of Saint John the Baptist

toward the end of the fourteenth century at the earliest. Whether the *tituli* are so early or whether the relics were added later when the statuette was acquired is not certain. What is certain is that its devotional function was enhanced by the inclusion of relics into the base.

Works by the Master of Kremsmünster are widespread, and they represent a flourishing of distinctive religious carving at the end of the fourteenth century. This prolific carver of high-quality works is represented in many collections.[36] Whether he was a single master or whether these works are the product of an ambitious workshop that created a characteristic "Germanic style" is uncertain. This master or workshop was probably active in the middle Rhine, possibly in Mainz, toward the end of the fourteenth and the beginning of the fifteenth century. Especially characteristic are the large head, with a small mouth and eyes clearly articulated as spheres as they are separated from the corners of the eye sockets. The decorated quality of his figures and the drama of subjects are features that Danielle Gaborit-Chopin has linked to sculpture in Mainz, especially to the Commemoration portal at the cathedral, a work of the sculptor Madern Gerthner around 1425.[37] Whether a single personality or the head of an atelier, the Master of Kremsmünster was producing ivories in homogeneous style. Representing a baroque tendency of Gothic ivory carving around 1400, few carvers surpassed his work until the Renaissance.

Notes

1. Longhurst 1926a; Porter 1977; Stratford 1987; Williamson 1994a. On the problem of attributing Gothic ivories, see also the helpful observations by Richard Randall in *The Golden Age of Ivory* (1993, 10–16).

2. Seidel 1972; Egbert 1929; Williamson 1994.

3. See Estella Marcos 1984. A useful overview is found in Randall 1993, 10–16.

4. Little 1975.

5. According to the Stiftungs Buch of the abbey dated 1311 (FRA II/3,142), "De imagine autum eburnea beate Maria Virginis gloriose que in Zwetelensi monasterio diligencius conservatur et summo altari beate Virginis in festivitatibus supponitur, sciendum quod eamdem imaginem Bouslaus abbas de superioribus partibus Francie cum aliis reliquiis attulerit. . ." See Zwettl 1981, nos. 174, 216; Koechlin 1924, 2: no. 62; Suckale 1971, 105.

6. Randall 1985, 180. See also Randall 1983–86, esp. 4.

7. For the terra cotta, see Liège 1964, no. 11. For the Utrecht relief, see Koekkoek 1987, no. 6.

8. Hilger and Willemsen 1967, pls. 12a–d; Schulten 1978, no. 24. For the seated bishop in Saint Ursula, see Bergmann 1989, fig. 39.

9. Randall 1993, no. 88, and Wixom 1972, 99.

10. Liebgott 1985, figs. 49–50.

11. Bergmann 1987.

12. On the Paris-Cologne links in sculpture, see Suckale 1979–80 and Kurmann 1977. More recently a similar study of painting by Rudiger Becksmann (1992) explores the interaction of the Rhine with Parisian court art. See also Schwarz 1986.

13. See Bideault 1984, fig. 6.

14. Haseloff 1926, 241.

15. See Koechlin 1924, 2: no. 1266; other works in this style are the mirror covers in the Victoria and Albert Museum (ibid., nos. 1034, 1044).

16. Bergmann 1989, figs. 129, 284–85.

17. See Forsyth 1936; Dieckhoff 1983. See also Cologne 1984.

18. Paris 1981, no. 140.

19. Schnütgen 1890. See also Saint Petersburg 1990, no. 44.

20. Bloch 1970, fig. 19.

21. Bergmann 1989, nos. 69, 80.

22. Bloch 1970, 15; Cologne 1984, fig. 39.

23. Becksmann 1992, figs. 20–21. On Cologne painting, see Cologne 1974.

24. Grimme 1982, no. 43.

25. Gaborit-Chopin 1978, 169. Also see Frankfurt am Main, 1975.

26. Heuser 1974, fig. 425.

27. Os 1994, pl. 1.

28. Euw and Plotzek 1982, 3: 74-81. See also Gottschalk 1983, esp. figs. 2 (fol. 12v), 33 (fol. 46v), 44 (fol. 82v). A complete "facsimile" with commentary was published by A. Ritter von Woltskron (1846).

29. There are at least seven in the group, apparently by the same carver: New York, The Metropolitan Museum of Art (Koechlin 1924, 2: no. 701); Amsterdam, Rijksmuseum (Leeuwenberg 1973, no. 768); Copenhagen, Statens Museum for Kunst (Koechlin 1924, 2: no. 696); Baltimore, The Walters Art Gallery (Randall 1985, no. 279); unknown location (sale, Gallerie Lempertz, Cologne, November 14–17, 1956, lot 940); Saint Petersburg, State Hermitage Museum (Malbork 1994, no. 42); former Georg

Schuster collection, Munich (Wilm 1937, no. 10, pl. 3).

30. Strauch 1882, esp. 90–91.

31. Randall 1985, no. 279.

32. Morey 1936a.

33. Wentzel 1962.

34. Heidelberg, Universitätsbibliothek, MS pal. germ. 848 (Walther 1988); Stuttgart, Württembergische Landesbibliothek, MS. HB XIII 1 (see Irtenkauf, Kalbach, and Kroos 1969).

35. Jászai 1979.

36. The following is a partial list of the ivories carved by the Master of Kremsmünster or his atelier:

Diptych with Adoration of the Magi and the Crucifixion, Kremsmünster, abbey treasury (Koechlin 1924, 2: no. 824)

Diptych with Virgin and Child with Saints and the Crucifixion, Paris, Musée National du Moyen Age, Thermes de Cluny (ibid., no. 825)

Diptych leaf with Crucifixion, Paris, Musée du Louvre (ibid., no. 831)

Diptych leaf with Crucifixion, Berlin-Dahlem, Staatliche Museen Preussischer Kulturbesitz (ibid., no. 832)

Diptych with Passion Scenes, Berlin-Dahlem, Staatliche Museen Preussischer Kulturbesitz (ibid., no. 833)

Diptych with Passion Scenes, Lyons, Musée des Beaux-Arts (ibid., no. 836)

Diptych leaf with scenes of the Life of the Virgin, Berlin-Dahlem, Staatliche Museen Preussischer Kulturbesitz (ibid., no. 839)

Diptych with Virgin and Child with Crucifixion, New York, The Metropolitan Museum of Art, The Cloisters Collection (1971.49.3; Schnitzler, Volbach, and Bloch 1965, S93)

Diptych leaf with Passion Scenes, Baltimore, Walters Art Gallery (no. 45)

Diptych leaf with Virgin and Child, Palermo, Gallerie Nazionali (Giusti and Leone de Castris 1981, 49)

Diptych leaf with scenes of the Life of the Virgin, Györ, cathedral treasury (Dávid 1982, pl. 13)

Diptych with Virgin and Child and Crucifixion, Munich, art market, ca. 1977

Diptych leaf with Virgin and Child, Dublin, National Museum of Ireland (inv. no. 156.1906)

Triptych with Virgin and Child and Saints, Copenhagen, Nationalmuseet (Liebgott 1985, fig. 49)

Statuette of Standing Virgin, Baltimore, The Walters Art Gallery, inv. no. 71.246 (Randall 1985, no. 284)

Statuette of Seated Virgin and Child, London, The British Museum, inv. 1980, 1-2,1 (Sotheby's, London, December 12, 1979, lot 26)

Statuette of Seated Virgin and Child, Compiègne, Musée Vivenel (Koechlin 1924, 2: no. 841)

Statuette of Seated Virgin and Child, Berlin-Dahlem, Staatliche Museen Preussischer Kulturbesitz (ibid., no. 844)

Statuette of Seated Virgin and Child, Saint Petersburg, State Hermitage Museum (ibid., no. 842; Erbach 1994, no. 11)

Statuette of Virgin and Child, Munich, Bayerisches Nationalmuseum (Koechlin 1924, 2: no. 843)

Statuette of Virgin and Child, Dijon, Musée des Beaux-Arts

Diptych leaf with Nativity and Annunciation to the Virgin, New York, The Metropolitan Museum of Art (32.100.203)

Enthroned Virgin and Child, Paris, Musée du Louvre, inv. OA 11042 (Gaborit-Chopin 1990, 62–64, no. 27).

37. Gaborit-Chopin 1978, 170.

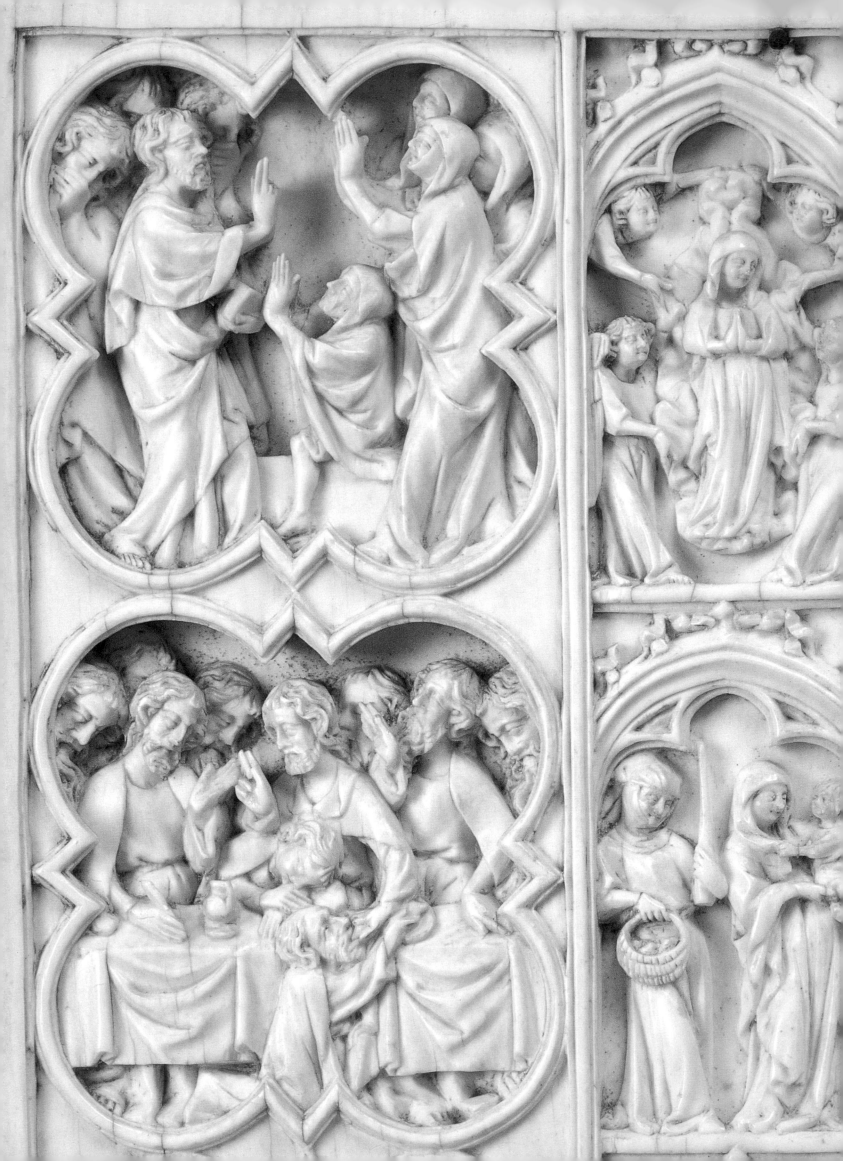

VII | Narrative Structure and Content in Some Gothic Ivories of the Life of Christ

HARVEY STAHL

GOTHIC IVORIES OF RELIGIOUS CONTENT ARE DECORATED ALMOST EXCLUSIVELY WITH SCENES FROM THE LIVES OF CHRIST AND MARY. BECAUSE SIMILAR EVENTS ARE DEPICTED IN ILLUMINATED MANUSCRIPTS AND LARGE-SCALE SCULPTURE OF THE SAME DATE, IT HAS BEEN WIDELY ASSUMED THAT IVORIES ADOPTED THE SAME REPERTORY.[1]

Yet ivories often arrange subjects in ways that no other works do; many illustrate uncommon extra-biblical events, and the properties of the ivory—the material itself—often subtlely change the way even the most familiar subjects are perceived. Although some ivories reflect works in other media, others are original and highly precocious in themselves, especially in the ways they explore various narrative structures and the expressive possibilities of the medium. These innovations result in more nuanced and dramatic readings of the life of Christ, and they reflect the devotional context in which these ivories were used. In a period that coincides with new attitudes toward religious content and with the increasingly significant role of the visual as a stimulus to prayer, these ivories were an important arena for innovation. Their history should be seen alongside that of the choir screen and the altarpiece.

Ivory plaques of religious content were normally arranged in diptychs and triptychs. The small size of many—four to six inches—makes it likely they were held in the hand and opened like a small book, while the larger ones probably stood open on a table or altar.[2] The devotional content of many of these works suggests they would have been used in a chapel or part of a room set aside for prayer or quiet reflection.[3] They would have been seen singly and at close range, the focus of attention in a context of private meditation. This kind of experience was not restricted to those possessing extreme wealth; a person able to afford an "ordinary" Book of Hours could probably have owned one of these ivories. In fact, the ready availability of ivory, the professionalization of the trade, and the standardization of many aspects of production all point to a flourishing market with a broad base of patronage in the Gothic era.[4]

Detail, no. 30

Ivory conditions its own reading in subtle ways. Such rare and costly substances as gold and ivory were understood as appropriate materials with which to revere and praise the divinity.[5] But ivory also has specific visual qualities that affect its content, such as the way it lends itself not only to precise cutting and linear detailing but also to polish and reflection and to a lush opacity in which light is diffused, its tone softened and modulated as it falls across the shallow relief. Similar effects are also found in drawing in grisaille and sculptures in alabaster, both of which became more widespread after the early fourteenth century. Like ivory, both were sometimes accented or inflected through the addition of gold and color. This luminous quality of surface became highly desirable in Gothic works after the 1260s and naturally affects the perception of space and mood.[6] By the same token, the viewer's response to the fragile and organic nature of the material informs the religious narratives, which so often dwell on the humanity of Christ.

The style of these Gothic ivories also affects the stories they tell. It is a precious style in which the points of articulation of the body—the shoulders, hips, knees, and wrists—are shifted in relation to each other, so that the body is reshaped in a composition of crossing and counterpoised forms, reversing curves, and arching silhouettes. The resulting play of gestures and of linear and undulant elements can either balance or distort the figure, suggesting a poised, ethereal beauty, a playful abandon, or an extreme emotion. When architectural elements or other figures are shaped in similar ways, compositions take on a distinctive rhythm that gives tempo to the narrative action.

A third factor affecting our perception of the stories told in ivories is their small scale, which requires that the viewer adjust to a miniaturized world. Doing so means that one must enter into its interior, accept its artifice, and become absorbed in its settings and events. These adjustments would have been familiar in an age in which paintings in manuscripts were usually of similar or even smaller scale. Whether in the context of a book or of an ivory diptych, the descriptive concentration of such works gives them a special texture and presence, and their narrow compass focuses attention and facilitates the narrative concourse of their parts. In relation to an imaginary norm, this reduced world is implicitly referential, a place of

potential figures and metaphors.[7] Thus scale can turn these
objects into talismans, reorder narrative relations, and open
up secondary levels of significance. Such changes are well
suited to meditative reflection on the life of Christ.

There can be no doubt that Gothic ivories generally func-
tioned in these ways. Most Gothic diptychs illustrate subjects
from the Infancy and the Passion of Christ and call attention
to his fate by juxtaposing scenes of his birth and adoration
with those of his death and subsequent appearances. Others
relate the events of the Passion and show a new interest in the
details surrounding the betrayal and sufferings of Christ. Both
reflect contemporary forms of private devotion that, in order
to deepen the experience of prayer and stimulate feelings
of spiritual love and compassion, emphasized meditation on
the humanity of Christ and on the promise of redemption
inherent in the events of his life.[8] By the thirteenth century,
these forms of devotion were widespread among various social
groups. They were systematized in formulas and spiritual exer-
cises and elaborated in narrative tracts, some of them in the
vernacular rather than in Latin, which retold the life of Christ,
sometimes organizing events in accordance with the canonical
hours of daily devotion. An interest in narrative accounts of
Christ's life naturally led to changes in how it was presented in
images. There was a new emphasis on the vivid details, the
reversals and ironies of his life. New types of imagery evolved
and older ones often took on a devotional character, address-
ing the viewer and eliciting a reaction more directly than
before. A few religious ivories reveal the influence of specific
devotional texts,[9] but it is no exaggeration to say that all were
made for audiences that would have expected a more vivid,
nuanced, and meaningfully structured portayal of Christ's life.

It may therefore seem odd that the most conspicuous change
we find in ivories is not the invention of new subjects or
imagery or a closer relation to the viewer but the new ways of
arranging old subjects. They are allocated in diverse ways:
ivories of the same format can read up or down, horizontally
or vertically, to the left or right, singly or in pairs, with subjects
split or whole, or even in some combination of these ways.
Because many subjects are represented in nearly identical
ways, it is likely that pictorial models were kept in the work-
place and copied by ivory cutters who presumably selected the

Fig. VII-1. The Soissons Diptych, French, ca. 1280–1300, elephant ivory, London, Victoria and Albert Museum (211-1865)

subjects and organized them as they wished.[10] When ivories based on the same model are studied together, it is clear that some omit important, telling details. This suggests that an artist did not attend to the meaning of the model but used it mechanically, so that the whole arrangement of scenes may be haphazard.[11] But an omission can also be purposeful, an opportunity for a less literal reading, and we usually do not know whether a striking detail or a dramatic juxtaposition reiterates what was seen in an impressive model or is an innovative response to a suggestive but lesser one. Was the allocation of scenes the accidental result of the mechanical way some models were copied? Or might the arrangement of scenes and how they are ordered for reading be purposeful, an opportunity to play otherwise conventional subjects against one another so as to develop a secondary level of meaning? The answer is unclear because the precise circumstances of production cannot be reconstructed, but the ivories themselves suggest that both accident and intention were the case.

The earliest ivory plaques that present these issues are those of the Soissons group, so named because of the fine ivory from Saint-Jean-des-Vignes in Soissons now in the Victoria and Albert Museum in London (fig. VII-1).[12] It is related to a diptych in Saint Louis (fig. VII-2 and no. 12), another divided between the Walters Art Gallery and the Musée National du Moyen Age, Thermes du Cluny (nos. 10–11), and several others.[13] All were probably made in the northern Ile-de-France about 1260–80, and all have panels divided into three registers, each subdivided into three scenes or sections beneath an elaborate architectural setting. Comparable architectural settings are found in contemporary Parisian illumination and similar series of events from the Passion occur in sculpted choir screens.[14] However, neither of these media grouped events in three-part sections arranged in triple registers. The series begins at the lower left with scenes pertaining to the Betrayal and then reverses direction in the middle register, resuming the normal left-to-right reading in the top register. This sequence, which enables each episode to be physically

contiguous with the succeeding one, forms a boustrophedon, a pattern of reading found in thirteenth-century stained glass and in wall decoration of both the Middle Ages and the Renaissance.[15] In these ivories, however, continuity may not have been the primary issue at all in the ordering of these events. In the Saint Louis ivory, for example (fig. VII-2), the first register narrates events from Judas's Offering to Betray Christ to the Judgment of Pilate, the second illustrates Christ's suffering and death from the Flagellation to the Three Marys at the Tomb, and the third recounts the miraculous events after the Resurrection, from the Descent into Limbo to the Ascension. The other ivories of the group differ slightly, but events are always organized into discrete dramatic phases and subphases allocated in registers and in triplets that are thematically consistent. The reversal of direction in the middle register is likely to have a larger purpose, especially since reading "backward" often has negative implications, which would be appropriate in a register that relates a history of decline, death, and absence.[16]

The subgroupings of triple scenes also have considerable thematic unity, and they sometimes include unusual subjects. For example, the Saint Louis ivory begins with the relatively rare subject of Judas Offering to Betray Christ before proceeding to Judas Receiving the Thirty Pieces of Silver and the Arrest in the Garden.[17] Most Passion cycles have only the two latter events, so that the payment to Judas leads directly to Christ's arrest. The sequence in the Saint Louis ivory personalizes the betrayal, which becomes less a matter of conspiracy or money than a part of the history of Judas, whose intentions are fulfilled in the kiss of the final scene, so that the embrace becomes narratively more central than the arrest. There are other unusual episodes, such as Christ Appearing to his Mother on the top register, an extra-biblical subject rare before the fourteenth century.[18] The episode with Mary is one of three post-Resurrection appearances that are grouped together like farewell scenes leading to Christ's Ascension, the final subject.

A still more complex and subtle level of planning is suggested by the vertical relationships between some subjects. It can be no coincidence that above the embrace of the deceitful Judas in Gethsemane is that of the faithful Joseph of Arimathea,

Fig. VII-2. Diptych with scenes of the Passion and Afterlife of Christ (no. 12), French (Paris or North France), ca. 1250–70, elephant ivory, The Saint Louis Art Museum (183:1928)

VII: NARRATIVE STRUCTURE AND CONTENT

who receives the body of Christ from the cross. Similarly, above Judas's suicide from a tree is Christ's death on the cross; above the Marys who do not find Christ in the tomb are Adam and Eve, who follow him out of the Mouth of Hell; and above Christ bearing the cross, and turning in anger to see who slaps him from behind is Thomas, to whom he freely turns and shows his wound.[19] These and other alignments of form and action direct the viewer's attention toward similarities and differences in behavior, motivation, and character that reveal the distinctive quality of specific moments in the Passion. The contrasts, reversals, and ironies inherent in these relations reflect the way the life of Christ was increasingly understood and pictured in terms of its human circumstances and dramatic implications. The same concerns are found in other subjects and contexts: Christ Appearing to his Mother probably reflects the influence of devotional texts, and Judas Offering to Betray Christ, the first subject of the ivory, is the first scene on the western or frontal face of the choir screen in the cathedral of Bourges, a powerful dramatic work that is itself influenced by extra-biblical texts.[20] These ivories are likely to have been influenced by such texts and by larger-scale sculptures, but it is their arrangement in triple registers that makes possible the vertical readings described above. It enables the ivories to multiply the possibilities of dramatic contrasts within the narrative of the Passion and to explore new meanings merely by manipulating the placement of subjects. Once the reader becomes absorbed in their content, the ivories can develop, through visual cues alone, an emotional charge not unlike that of the texts and larger scale works that may have influenced them.

The Soissons Diptych (fig. VII-1), one of the latest of the group, uses a different strategy. It drops the first subject in the Saint Louis ivory (no. 12) and adds a new one — the Descent of the Holy Spirit — at the end, so that there is a different alignment of subjects. The new scheme coincides with a different structural approach, one that focuses attention on the central vertical axis of each wing by emphasizing the main action or figure, usually the body of Christ, which is shown, moreover, in enlarged scale. Thus on the left leaf one reads up from Christ taken prisoner to the Resurrection and Noli Me Tangere; on the right leaf, the figures under the central

arch all point or look up to Christ who, in the top register, ascends to heaven. This enlargement of the central subject has the effect of de-emphasizing the lateral ones, with the result that some registers begin to read like small triptychs. These changes cause the horizontal and vertical axes of reading to drift farther apart, which forces the viewer into a double or two-tiered reading, a kind that becomes increasingly important in the fourteenth century, as we shall see below.

A similar emphasis on the central vertical axis is found in a related diptych in the Vatican in which the middle arch of each register is broader than the lateral two (fig. VII-3).[21] Here however the choice and disposition of subjects take a surprising turn. Although each leaf has four levels, the top one is not read continuously with the others. The two uppermost subjects are the Coronation of the Virgin and the Last Judgment. These events, which are specially emphasized by the elaborate superstructure of gables above them, are also central to church doctrine and commonplace at this time in French portal sculpture.[22] They are also paired in other ivories (no. 9), in which the smaller scenes below extend the theme of the Last Judgment. In the Vatican ivory, the subjects beneath begin a narrative sequence that continues downward. The left wing is devoted to scenes of the Infancy and to Mary and develops from the Nativity in the second register to the Flight into Egypt and then the Adoration of the Magi at the bottom.[23] The right wing is devoted to the Passion and to Christ and begins with the Crucifixion in the second register and continues with the Deposition and the Washing of Christ's Body. In each leaf, however, the reading does not end with the lowest register. The dead Christ in his tomb and the Magi surrounding the uncrowned Mary provide no closure. The eye must return to the top scenes, to ascend as Mary and Christ have, to draw the narrative and eschatological consequences of seeing Mary crowned and Christ returning in judgment.

Once again, sub-themes link these scenes in ways that stress the humanity of their subjects.

Fig. VII-3. Diptych with scenes of the Lives of the Virgin and Christ, French, ca. 1260–70, elephant ivory, Rome, Gallerie e Musei Vaticani

Those with Mary are notable for her intimate relation with Christ, whom she exceptionally holds before her as an infant in the Nativity, who turns to speak to her as a child during the Flight, who stands upon her knee as an adolescent in the Adoration, and who faces her as a mature man in the Coronation.[24] In the right leaf Christ's physicality is emphasized in the way his chest is always bare, first small and pierced in the Crucifixion, then embraced in the Deposition, next washed and finally, in the Last Judgment, exhibited in its largest and most robust form. Our understanding of this stern Christ, who sits enthroned like an ancient deity in a pediment, is naturally modified by the Crucifixion shown immediately below, where we see the source of his wounds and the instruments of the Passion which the angels beside him carry. In a like manner, the Coronation at the left is not an isolated ritual of state but is tied to the scenes below, which recount Mary's earlier life with Christ. The ivory presents an unusual mode of telling, one that begins at the end, with the culmination of the story, and then reverts to the beginning and develops a history that ends where it began. Although this structure finds certain echoes in the works of some Parisian rhetoricians of the mid-thirteenth century, its use in the ivory was probably inspired by sculpted portals in which the narrative sequence represented on the lintel culminates in the event monumentalized on the tympanum above it.[25] The ivory takes a wholly different tack, one that arrives at doctrine through the selective thematization of certain aspects of the lives of Christ and Mary, especially his humanity and her uniquely close relation to him. The resulting circularity of the vertical reading serves to integrate the monumental and narrative, the intimate and the eschatological. In the end the viewer compares two panels in which female and male, life and death, child and adult, flesh and spirit are poignantly bound up in a diptych richly suited for extended meditation.

The pairing of events from the Infancy and Passion is commonplace in later diptychs and may reflect the way the canonical Hours of the Virgin was often accompanied by that of the Passion.[26] Some of the most interesting and moving works juxtapose only one or two subjects from each cycle. An early and particularly fine example in ivory is a diptych in the Musée du Louvre with the Nativity on one side and the Last Judgment on the other (fig. VII-4).[27] This ivory is notable for the highly

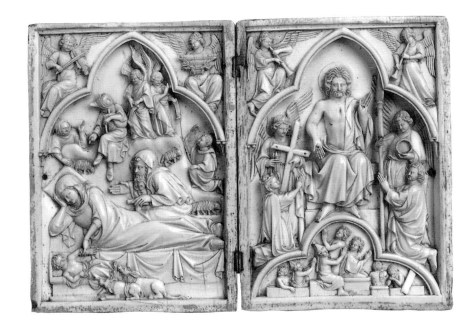

Fig. VII-4. Diptych with the Nativity and Last Judgment, French, ca. 1280–1300, elephant ivory, Paris, Musée du Louvre (OA 2755)

pictorial way it elaborates secondary events and details, such as the two angels with scrolls who announce the birth of Christ to the shepherds in the background of the left panel or the figures of the resurrected who rise from their tombs in the lower part of the right one. The Louvre ivory is not divided into registers, but its treatment of foreground and background allows for suggestive juxtapositions at several levels. Thus Christ in his crib and the resurrected rising in their tombs, each partially draped and of similar scale, present a contrast of birth and rebirth. The angels on the hillock, with their hands raised and lowered as they announce the birth of Christ, appear opposite the figure of Christ the Judge whose hands are also raised and lowered, as he pronounces judgment.[28] In the spandrels above the shepherds are angels who play musical instruments; in those above Christ the Judge, angels sound trumpets signaling the Resurrection. These formal and thematic relations are not just set against one another but are integrated into a temporal sequence that colors each one. Thus the arc of reading in the left leaf, with the angels speaking to the shepherds and Mary turning to the child, is determinedly downward, and that of the right leaf, with the resurrected rising out of their tombs and Mary and John raising their hands in prayer, is powerfully upward. As the direction of reading reverses, there is an inversion of the narrative field, one that suggests that just as the child becomes the judge, so will humanity, which has been represented by

Fig. VII-5. Diptych with scenes of the Infancy and Passion, French, 14th century, elephant ivory, The Art Institute of Chicago, Kate S. Buckingham Fund (1970.115)

Fig. VII-6. Diptych with scenes of the Lives of the Virgin and Christ, French, ca. 1375–1400, elephant ivory, Amsterdam, Rijksmuseum (BK-1992-28)

the shepherds in the fields at Bethlehem, be resurrected. The diptych does not just juxtapose events from the Infancy and Passion; it presents an inescapable eschatology within a comprehensive narrative system.

Most ivory diptychs of this kind have leaves divided into two registers and pair two events from the Infancy with two from the Passion. A mid-fourteenth-century example in the Art Institute of Chicago is typical of a group that, though later than the Louvre ivory, employs many of the same ideas and compositions (fig. VII-5). Its left leaf reads down from the Nativity, which is similar in many features to that in the Louvre ivory, to the Adoration of the Magi, and the right leaf reads down from the Crucifixion to the Entombment. Mary functions in a different way than in the Louvre diptych. Here the extremes of her life are brought sharply into contrast, for the smiling figure who tenderly plays with the child at the left will be overwhelmed with emotion under the cross at the right, fainting into the arms of those beside her.

Such differences between ivories are typical of the entire group, and it is interesting to see how a single subject, such as the Adoration of the Magi, is differently interpreted as it is juxtaposed with other subjects. In the Chicago ivory, the kings who offer gifts to the child are set against the elders who prepare his adult body for burial. An ivory in the Rijksmuseum, Amsterdam (fig.VII-6), has scenes of the Nativity and Crucifixion which are very similar to those in Chicago, but here the Adoration is juxtaposed with a Last Judgment like that in the Louvre ivory. In this case, the effect is to compare the gifts offered by the Magi

IMAGES IN IVORY: PRECIOUS OBJECTS OF THE GOTHIC AGE

to the prayers offered at the Last Judgment.[29] Another is to give new emphasis to the theme of the promise of heavenly reward, for in the Amsterdam ivory, unlike that in Chicago, Mary is shown being crowned by an angel in the Adoration. Still another point is made in the Hours of Jeanne d'Evreux, where the Adoration faces the Crucifixion (fig. VII-7). In the manuscript made for this queen of France, the nobility of the kings who adore the Christ child is strikingly contrasted with the menacing faces and gestures of the malefactors who mock Christ for being unable to save himself.[30]

Fig. VII-7. Crucifixion and Adoration of the Magi from the Hours of Jeanne d'Evreux, French, 1325–28, New York, The Metropolitan Museum of Art, The Cloisters Collection (54.1.2), fol. 68v–69

The arrangement of scenes in these double-register ivories is as variable as the choice of subjects, for when the subjects are read in chronological order, the sequence may move upward or downward or across. In this group of ivories the favored sequence seems to be across and from the lower register upward, that is, the opposite of the downward and then left to right organization of the Chicago ivory.[31] This latter arrangement turns out to be perfectly feasible, and it is interesting to see what enables it to be so and whether a difference in meaning results.

To begin, there are a number of links among the four scenes that modify the temporal sequence of events. The compositions arc upward or downward, as in the Louvre ivory, and Mary and Christ are either prone or upright (fig. VII-5). These relations create new readings, encouraging us to read across from the Nativity to the Crucifixion, as we did above, or diagonally from the Adoration to the Crucifixion, a pairing we saw in the manuscript pages, or diagonally from the Nativity, which shows Mary's and the child's bodies in a prone position, to the Entombment, where Christ is likewise prone. These prone figures bracket the series, with the Entombment providing a closure and also a way of referring back to the beginning.

It is also significant that the Crucifixion is retained in the upper register, a position it almost always has in these two-register ivories. Its superior position is in part a function of the status of the subject in the hierarchy of devotional images, that is, one would no sooner look down at a Crucifixion than one would at an image of Christ enthroned. That position is

also appropriate to the treatment of the body of the crucified Christ in Gothic art. His body hangs from the cross, but its weight is relieved by its exaggerated twist, by the way the knees are raised up and the arms outstretched, which gives the torso a certain lift. In the Chicago ivory, the proportions of the upper body are such that the figure seems buoyant, more a part of the arcades above than the events on Calvary below. As in many Crucifixions of this time, this treatment suggests the spirit in ascension. In the Chicago ivory, after following the sequence of events down to the Deposition, our eye is drawn irresistibly back up, just as it was in the Vatican ivory, though here it comes to rest not on the Last Judgment but on the Crucifixion seen now in a different aspect, its implicit promise of life.

Did the artist consciously intend these readings? In the case of the Chicago ivory, I am doubtful. Experience and intuition are likely to have guided his choice of models, and he was working for an audience and within a structure of reading in which dramatic and formal elements had so evolved that the Infancy and Passion scenes could be combined in any number of ways and still occasion lessons of thematic or moral interest. The subjects effectively become types: juxtapositions of earlier and later events imply how the seed of the Passion was already present in the Infancy, a dark shadow over these otherwise

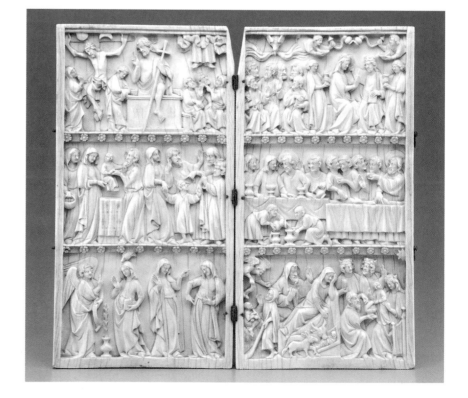

Fig. VII-8. Diptych with scenes of the Lives of Christ and the Virgin (no. 24), French (Paris), 1320–30, elephant ivory, The Detroit Institute of Arts (40.165)

IMAGES IN IVORY: PRECIOUS OBJECTS OF THE GOTHIC AGE

joyful events, and how, through the singular and tragic life of one man, the divine plan takes shape so as to make personal redemption possible.[32] Thus the narrative content of almost any juxtaposition carries profound overtones and provokes antithetical emotions. It is a flexible system geared to drama and to the production of meaning.

Similar thematic content is found on other ivories of the mid-fourteenth century, but the structures of reading become increasingly complex and sometimes take on the character of an intellectual exercise. In the fine diptych from the Detroit Institute of Arts (fig. VII-8 and no. 24) each register has two or three scenes that follow one another continuously across the leaves from left to right and from bottom to top, beginning with the Annunciation to Mary and ending with the Coronation of the Virgin. Many iconographic details recall the Soissons group discussed earlier, and there is some continuing interest in vertical alignments.[33] However, the most striking aspect of this ivory is the way the left and right scenes of each register often present narrative parallels to their counterparts on the opposing leaf. Thus the Annunciation to Mary corresponds to that to the Shepherds, and the Visitation, which shows Elizabeth pointing to Mary and Mary pointing to her womb, anticipates the Adoration of the Magi, where a king points to the star and Mary holds the child. These relations are particularly striking in the second register because of the unusual choice and treatment of subjects: in the Presentation, Christ turns to Mary just as he does in the Marriage at Cana, where they have effectively become the marriage couple; and Christ's heated exchange with the Elders is compared to that with Judas at the Last Supper.[34]

By far the most complex and pictorially sophisticated setting employed in these ivory diptychs is that of the large work in the Musée du Louvre (fig. VII-9 and no. 30).[35] The Infancy scenes involving Mary are arranged vertically in the central axis of each leaf; they read across from one leaf to the other and from the bottom to the top, beginning with the Annunciation and Visitation, continuing in the second register with the Adoration and in the third with the Presentation, and then jumping in the topmost register to the Assumption and the Coronation of the Virgin. To the left and right of

VII: NARRATIVE STRUCTURE AND CONTENT

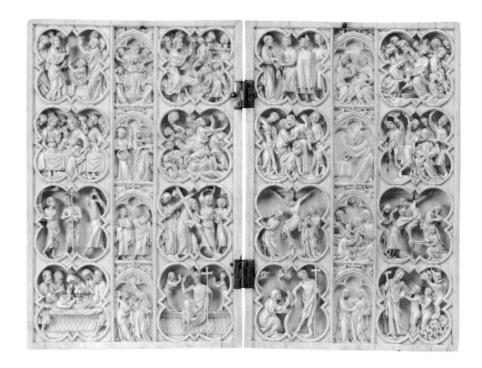

Fig. VII-9. Diptych with scenes of the Passion and the Life of the Virgin (no. 30), French (Paris), ca. 1360–80, elephant ivory, Paris, Musée du Louvre (OA 4089)

these central Infancy scenes are quatrefoils depicting events from the Passion. They read in the opposite direction—in registers from top to bottom—and are carved in higher relief. The moldings of the Passion scenes overlap with those of the Infancy, and in the second and third registers, the Passion scenes divide those of the Infancy into two parts, half in each leaf. The Infancy scenes thus seem to transpire behind the Passion scenes, to exist in a world more distant in time as well as space, one that precedes but is also simultaneously inherent in the Passion scenes that divide and supplant them. Sandwiched between the Passion scenes, with their deeper shadows and harsher content, the flatter and more remote scenes of the Infancy seem like a poignant reminder of an earlier and sweeter time. The Passion concludes with the Descent into Limbo at the lower right. The culminating events in this diptych appear, however, at the top center. To find them, the eye reenters the cycle of the Infancy scenes and rises to the joyous events of the Assumption and Coronation that complete the life of Mary.

This narrative arrangement provides rich contrasts between the Infancy and the Passion cycles, but it also divides them. Because they are read along different axes, in different directions, and almost at differing levels of illusion, it may seem that there is a less insistent relation between specific scenes.

Nonetheless, there are some familiar juxtapositions, such as the way the Nativity, which is conflated with the right part of the Adoration, is placed alongside the Crucifixion.[36] One therefore wonders whether it is a coincidence that the Annunciation, which was traditionally interpreted as the Incarnation of the Holy Spirit, is alongside the Resurrection; that next to the Noli Me Tangere is Elizabeth, who places her hand on Mary's pregnant belly; that the child who stands on Mary's lap and wears only a cloth around his waist happens to be between the Crucifixion and the Descent from the Cross, where he wears only a loincloth; that the kneeling Magus who reaches up to offer a gift to the Christ child is beside Joseph of Arimathea, who reaches up to receive Christ's body from the cross; that beside Simeon with his hands covered is Christ with his head covered; that next to the Raising of Lazarus is the Assumption of Mary; or that on the other side of the Assumption, where Mary is carried into heaven by angels, is the Entry into Jerusalem, its portal surrounded by rejoicing children. Not every Infancy scene lends itself to such associations, but that does not make the ones that do less valid. Moreover, many of these depictions, such as the Visitation or Simeon or the Assumption, turn on associations with greater dramatic nuance and finer observation than we have seen before. Making the connections requires a greater effort of visual imagination, but this would have been a familiar intellectual challenge to those brought up on the kind of sophisticated readings in other works, including manuscripts with parallel cycles and related marginalia, as we saw in the Hours of Jeanne d'Evreux. And any artist sophisticated enough to use different levels of relief for narrative effect would certainly have been capable of planning these dramatic relationships at this level of complexity.

The Louvre ivory also bears witness to an exceptional enrichment in the Passion narrative, one predicated less on juxtapositions between events in the life of Christ than on an elaboration of descriptive details, such as the swollen belly of Mary or the covered head of Christ, details that effectively reinvent certain subjects and create new ones geared to the expanded role of imagery in a devotional context. Ivories participate in this process in original ways and do so from an early date. A particularly fine example is a double-register diptych divided

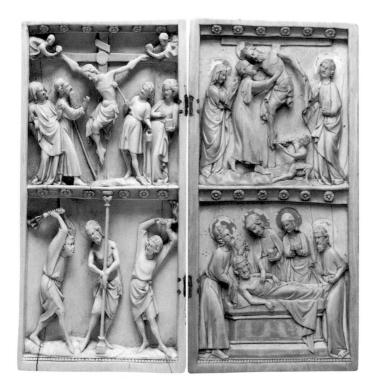

Fig. VII-10. Composite photograph, diptych with scenes of the Passion (nos. 13–14), 1280–1300, elephant ivory. Left leaf: Baltimore, Walters Art Gallery (71.124). Right leaf: London, British Museum (MLA 1943,4-1,1).

between the Walters Art Gallery and the British Museum (fig. VII-10 and nos. 13–14). The left leaf reads up from the Flagellation to the Crucifixion; the right one, downward from the Descent from the Cross to the Entombment. Together they present a sequence of particularly severe subjects moving from Christ's suffering and death down to the preparation for his burial. No less severe is the style of cutting, with its clear but stiff figures and suppression of relieving detail and rhythm. A slightly later diptych in the Cleveland Museum of Art has similar subjects on the left leaf but the right one represents the Resurrection and Noli Me Tangere (fig. VII-11).[37] In this ivory the physical suffering of the first leaf is relieved by the redemptive promise of the second, the somber mood is relieved by the rhythmic arcade, and after the final scene the viewer's attention is drawn back up to the top register, where the resurrected Christ blesses. In the British Museum leaf (no. 14), however, the Entombment is final; there is no backing up, no way out.

Two unusual elements of this now-divided diptych suggest that the artist provided other ways in, that is, a profounder kind of reading. The first involves the role of the lance-bearer at the Crucifixion. In earlier medieval art he is simply the Roman centurion, traditionally identified as Longinus, who pierces Christ's side. He is usually shown as a short, brutish figure dressed in a skirt and does not differ significantly from his counterpart on the other side of the cross, the soldier who lifts the sponge.[38] In the Soissons group and later ivories, however, Longinus is a bearded man in a long robe, the same dress sometimes used for the respectable elders who prepare Christ's body for burial. He looks up into the face of Christ as he pierces his side or, more commonly, lifts his hands in prayer after having done so.[39] Mary almost always spreads her arms, and Longinus frequently touches his forehead, both gestures that define this moment as one of amazed recognition.[40] In these works he is depicted according to the Gospel account of the centurion who recognized Christ's divinity just as he

IMAGES IN IVORY: PRECIOUS OBJECTS OF THE GOTHIC AGE

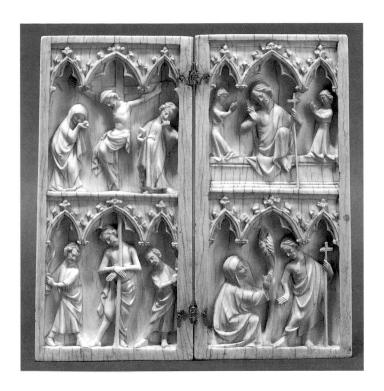

Fig. VII-11. Diptych with scenes of the Life of Christ, French, early 14th century, elephant ivory, The Cleveland Museum of Art (1975.110)

expired on the Cross.[41] The same version of the figure appears in large-scale French sculpture, such as the choir screen at the cathedral of Bourges.[42]

By the mid-thirteenth century Longinus was a familiar figure because of his association with the Holy Lance and with the blood of Christ that issues from the wound. He appears in French epics and romances, most importantly the Grail continuation of Chrétien de Troyes's *Perceval,* in popular stories connected with healing, Passion plays, and vernacular texts in Books of Hours.[43] At least briefly in these ivories, Longinus also seems to have had a certain importance as a devotional exemplar. Like Mary, whose fainting pose in other representations of the Crucifixion became a vivid model of the compassion the viewer was to feel, Longinus became a stand-in for the viewer. In some later ivories, he kneels before the cross in the manner of a patron before a holy image.[44] For Bonaventura, he represented the humility of confession.[45]

Like several other Gothic Crucifixions in ivory, the Walters leaf (no. 13) shows the lance leaning against Longinus's far shoulder, and this suggests a further thematic reference, one popularized by Jacobus de Voragine's *Golden Legend* of about 1260. According to this tradition, at the time of the Crucifixion, Longinus, who was almost blind with old age, became convinced of Christ's divinity when drops of his blood ran down the shaft of his lance and touched his eyes, restoring his vision.[46] The miracle of the blood is rarely depicted in art before the fourteenth century, and because Longinus does not point to his eyes, we cannot be certain that it is represented here.[47] In this diptych, however, unusual attention is given to vision, the second element that changes our reading of this diptych. Longinus looks up to Christ, whose head is positioned to gaze back at him in an exchange of glances so direct that Christ seems barely to look at his mother at all. This powerful visual contact with Christ would be less noteworthy except that it carries over into the British Museum leaf where, exceptionally, Christ's body is turned outward toward the viewer as it

is lowered from the cross. In the scene below in which he is anointed for burial, his head is raised and his body is again turned outward toward the viewer. The way his hand rests on the edge of the tomb makes him seem more a man attended on his deathbed than a corpse prepared for burial. The viewer is not given a harsh view of Christ's suffering and earthly end but an opportunity to recognize him as Longinus did, to join the circle of people who witness his death and attend his burial, to imaginatively make contact with him in vision and in prayer.

Such works afford us a glimpse of the real richness of invention found in Gothic ivories. In this brief essay I have not considered triptychs, tabernacles, and other forms, and I have had to ignore some of the most elaborate Parisian works of the mid- and later fourteenth century, not to mention the major innovations of ivory carvers in other countries. Yet even these few case studies show that from at least the third quarter of the thirteenth century, Gothic ivories represent a field of far-reaching artistic innovation in content as well as in form, in structures of reading as well as in the thematic elaboration of subjects both old and new. While some artists no doubt borrowed ideas from works in other media, many of the most significant ideas arose from formats and shop practices that are distinctive of this medium. The streamlining of procedures could lead either to uninspired copies or to savings in time that were reinvested in experimentation and a search for a richer and more dramatic language of form. The juxtapositions and other structures of reading we have seen are as old as medieval art, but they were given new life in the particular qualities of this medium and in the ways it was shaped for viewing in a devotional context. In this essay I could only hint at the texts and other works of art and at the religious and social practices that together provide a real context for the works. But the ivories themselves describe that context when they are read with care.

Notes

1. Louis Grodecki (1947, 68) correctly emphasizes that they are not copies.

2. I know of no carrying cases for ivory diptychs, although leather ones for carved plaques, mirrors, and combs would suggest they existed; see Randall 1993, 123, no. 183; 1985, 179.

3. It is possible that some of the larger works were carried in procession and used in the liturgy; see Foley 1995, 199 ff.

4. For payments for works in ivory and other media as well as for the larger changes in the market, the most detailed overview is still Koechlin 1924, 1:7–26. See also Gaborit-Chopin 1978, 131–32.

5. The classic statement remains that of Suger; see Panofsky 1979, esp. 64–67.

6. The dry and grainy surface that some of these ivories now have is the result of aging and would not have been the case with the young ivory imported to France in the thirteenth century.

7. Stewart 1993, ch. 2.

8. For an excellent summary on this and what follows, see Marrow 1979, esp. 8–27, and, more recently, Belting 1994, esp. ch. 19; and Os 1994.

9. Os 1994, 12–13.

10. Koechlin 1924, 1:20–21, 26; Randall 1985, 182–83; Walsh 1984a. Patrons' preferences must also have played a role, at least in those ivories representing specific saints, but one can only speculate on what their role was in the ivories of the life of Christ.

11. Os 1994, 74.

12. Longhurst 1927–29, 2: no. 211-1865; Koechlin 1924, 2: no. 38.

13. E.g., Koechlin 1924, 2: no. 39; see also the four-register diptychs, such as Koechlin 1924, 2: no. 57.

14. For the architectural "proscenia" in the royal psalters made for Louis IX and Isabella of France, for which see Grodecki 1947, 88, and Branner, 132–37; other forms are common in sculptural relief, such as the fragment from a late-thirteenth-century choir screen, possibly from Normandy, now in the Art Institute of Chicago, for which, see Krohm 1971, 133. Paul Williamson (1995, 168) notes the similar relation between figures and architectural settings that is found in church portals and ivories of about 1280 and suggests that the ivories may have occasionally provided iconographic models for monumental sculptures. For choir screens with Passion scenes, see that from the cathedral of Bourges, notes 20, 42.

15. Deuchler 1981; Lavin 1990, 8, 21, 53–54, 75–76, and passim.

16. In general, reversal of field is a device to call attention to a fundamental change in narrative. As far as I know, our negative interpretation, which depends upon associations common in magic and ritual, has been applied to medieval art only by Meyer Schapiro, whose interest, however, was in art's tolerance for reversals of field; see Schapiro 1969, repr. 20. But it certainly has wider applicability, such as in the vexing and still unresolved issue of narrative reversals in the Bayeux Tapestry; see the recent discussion by Wolfgang Grape (1994, 70–71).

17. For Judas Offering to Betray Christ, see Luke 22: 3–4, and Matthew 26: 14–15.

The subject is rare as an independent scene that precedes Judas Receiving the Thirty Pieces of Silver. See, however, Hamann 1955, 81–82, pl. 54, and especially Laborde 1911–27, pl. 519.

18. These ivories are apparently the earliest known occurrence of the subject. Although best known from Pseudo-Bonaventura's *Meditations on the Life of Christ,* it is not surprising to find the subject represented earlier, given its currency in texts by Rupert of Deutz, Honorius of Autun, Peter of Celle, and, most importantly for these ivories, *The Golden Legend* of about 1260; see Ryan 1993, 1:221–22. For other sources and iconography, see Kirschbaum 1968–76, 1: cols. 667–71, and Breckenridge 1957.

19. In figure VII-1 and in Koechlin 1924, 2: no. 39, the Descent into Limbo precedes rather than follows the Three Marys at the Tomb and is reversed in direction. The artist of the Saint Louis ivory may have wanted to locate the Mouth of Hell over the tomb of Christ as well as Adam and Eve over the Marys.

20. Joubert 1991, 53 54, 91 n. 94. For Christ Appearing to his Mother, see note 18.

21. New York 1982, 107, no. 44.

22. Katzenellenbogen 1959, 56–65, 82–87; Sauerländer 1970, 24–32.

23. The Nativity is combined with the Annunciation and the Massacre of the Innocents with the Flight into Egypt. The Adoration of the Magi normally precedes rather than follows the Flight into Egypt; I have no explanation for the change in order.

24. On Christ and Mary as *Sponsus* and *Sponsa,* husband and wife, in scenes of the Coronation of the Virgin, see Katzenellenbogen 1959. Because the Christ child in the Adoration turns toward the Virgin rather than to the kneeling king, the latter also seems to be adoring her.

25. For rhetoric, see Lawler 1974, 54–55; for sculpture, see, for example, the lintel and tympanum of Villeneuve-l'Archêveque in Sauerländer 1970, 149–50, pl. 178.

26. The narrative cycles were sometimes illustrated in tandem or Passion scenes illustrate the Hours of the Virgin; see Wieck 1988, 66–71. See figure VII-7 and note 30.

27. Gaborit-Chopin 1978, 145–46, 206–7.

28. I have no explanation for the exceptional reversal of Christ's gestures—usually his right hand is raised and his left lowered—unless it is to create a link to Mary who kneels beneath his lowered right hand. The traditional sides for the lance and cross are also switched, so that the cross appears to link Mary and Christ, whose pierced hand is just before her. In contrast to the leaf opposite, where she reaches to the child in the crib, Christ seems to reach toward her in a vivid evocation of her role beneath the cross. Considering the very high quality of the ivory, these reversals are not likely to be a result of incompetence.

29. Os 1994, 10–13.

30. New York, Metropolitan Museum of Art, The Cloisters Collection, 54.1.2. See Hoffeld 1971; Paris 1981, 292-93, no. 239.

31. The more common sequence is found, for example, in figure VII-6 and in Koechlin 1924, 2: nos. 237, 292, 320, 782, 813.

32. These readings both forward and backward in time operate as many Old and New Testament typologies do; see Chenu 1968, esp. 146–48.

33. For examples of these alignments, see the way a dramatically enlarged figure of Christ emerges from his tomb in the Resurrection (see figure VII-1) or the play of pointing gestures in the Visitation, Christ Debating the Elders, and the Ascension.

34. The highly unusual scene of Christ seated next to Mary at Cana has precedents in Byzantine works, such as the mosaics of Monreale; see Demus 1949, fig. 66a. For a related ivory with different subjects but a similar structure of reading, see Koechlin 1924, 2: no. 240, and Paris 1981, 187–88, no. 146.

35. Gaborit-Chopin 1978, 165–68, 211; Paris 1981, 199–200, no. 160.

36. Rather than a standing king, the Adoration depicts Joseph, normally a part of the Nativity, beside the kneeling Magus.

37. Randall 1993, 73, no. 69.

38. Kirschbaum 1968–76, 7: col. 410–11.

39. For example, figures VII-2–3, and Koechlin 1924, 2: nos. 34, 47, 434.

40. See Koechlin 1924, 2: nos. 43, 194, 203, 435; Randall 1993, no. 50.

41. Matthew 27: 54; Mark 15: 39; Luke 23: 47. On the lance-bearer's subsequent identification with Longinus and canonization, see *Acta Sanctorum,* March II, pp. 376–90.

42. Joubert 1994, 57–59.

43. The basic references are found in the still-useful survey by Rose Jeffries Peebles (1911) and in Burdach 1974, esp. 409–47. The texts are conveniently collected and quoted by Carl Kröner (1899). Among recent studies, see especially Doner 1993, in which interest in Longinus and the miracle of the blood in the *Continuation-Gauvain* is associated with the use of symbols promoted by the Franciscans.

44. See Koechlin 1924, 2: nos. 39, 43, 61 bis, 220.

45. Bonaventura, *Commentarius in Evangelium Lucae* (1882–1902, 7:167-68 and 582, no. 13.)

46. Koechlin (1924, 1:26) associated the gesture with Jacobus de Voragine's text; see Ryan 1993, 1:184.

47. Longinus points to his eye in many fourteenth-century miniatures of the Crucifixion, such as the Hours of Jeanne de Navarre (Paris, Bibl. Nat. MS n. a. lat. 3145 fol. 113), but earlier representations of the miracle are rare. See, however, Berg 1957.

THE FIRST GOTHIC

IVORIES

Enthroned Virgin and Child

ca. 1210–30

English or North German under English influence

Elephant ivory with traces of polychromy

Height 11.8 cm

Hamburg Museum für Kunst und Gewerbe (1893.199)

PROVENANCE

Collection of Frédéric Spitzer, Paris.

REFERENCES

Goldschmidt 1914–26, 3: no. 133

New York, 1970, no. 55

Sauerländer 1971, 511

Gaborit-Chopin 1978, 132, no. 193

Little 1979, 58–67, esp. 59 and 66 n. 9

Klack-Eitzen 1985, 16

London, 1987, no. 248

Sauerländer 1988a, esp. 151

Braunschweig 1995, no. G115

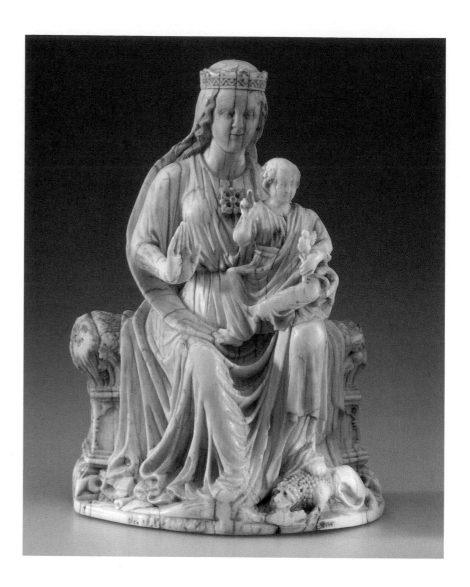

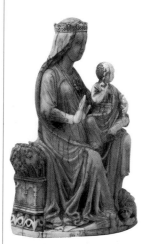

Side view

Few works of Gothic art as *materia meditandi* have achieved as much cause for admiration as this regal statuette. Enthroned upon an elaborate bench, decorated with blind trefoil arcades surmounted by stiff leaf acanthus, the Virgin tramples a crouching lion under her left foot and an asp under her right, a visual reference to Psalm 90:13: "Thou shalt walk upon the asp and the basilisk: thou shalt trample under foot the lion and the dragon." The lion together with the asp is rarely depicted in images of the Virgin, but this motif occasionally occurs in English images such as the Amesbury Psalter, a Salisbury work of about 1250 (Oxford, All Souls College, MS 6, fol. 4; Marks and Morgan 1981, fig. V). More frequently it is reserved for Christ (e.g., the "Beau Dieu" at Amiens cathedral). Imbued with a regal elegance, the composition is, in fact, a humanized version of the Romanesque throne of wisdom *(Sedes Sapientiae)*. Its meaning is further enhanced by the blossoming flowers in Christ's left hand, certainly a visual allusion to the Tree of Jesse theme and the genealogy of Christ.

Its classicizing character, perhaps a consequence of early Byzantine influence (New York 1970, no. 55), reveals organically integrated figures enveloped in rhythmic folds of drapery that lyrically veil the bodies and generate a sense of life within. Whatever the artistic impulses that

Fig. 1a. Virgin and Child,
English, ca. 1230, stone, west
front, central tympanum,
Wells Cathedral

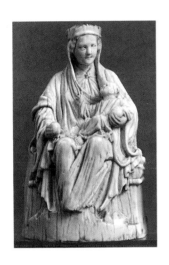

Fig. 1b. Virgin and Child,
German, Lower Saxony or
Westphalia, ca. 1230–40,
elephant ivory, formerly Berlin,
Kaiser Friedrich Museum

inspired this statuette, its serene beauty has elicited widespread discussion concerning its provenance and, depending on its attribution, been considered the harbinger of the Gothic style in ivory in the Meuse Valley, the Rhineland, France, England, and Germany. At once symptomatic of both the diffusion and imitation of the *opera francigeno*, it is a pivotal work of the Gothic style in northern Europe precisely because its fluid sculptural lines and noble bearing were widely admired.

Recently there has been a growing consensus that this statuette origi-0nated in England. In favor of the attribution is the expansive throne decorated with a blind trefoil arcade surmounted by stiff acanthus leaf foliage that is very similar to the sculpture at Wells Cathedral, as are its relationship to sculptural representations of the Virgin and Child at Wells (fig. 1a) and Glastonbury Abbey. Close correspondence of the composition—especially the relaxed attitude of the blessing child—also can be seen on the 1241 seal of Merton Priory (London 1987, no. 283).

The type of Virgin wearing a veil inspired by classical sculpture that balloons out around the figure and Christ, who wears a *clavium* and offers a corresponding blessing, however, conforms to a variety widespread in northern European wood sculpture; for example, the early-thirteenth-century Enthroned Virgin in Nienburg, Lower Saxony (Braunschweig 1995, no. G117). On more than one occasion, the Hamburg statuette has been compared to the ivory Virgin and Child, formerly in the Kaiser Friedrich Museum, Berlin, but destroyed in World War II (fig. 1b; Volbach 1923, no. 1958), whose noble features are connected to the silver Virgin in Minden cathedral, Westphalia. The Englishness of the present Virgin seems less definite with regard to the physiognomy, which can also be compared with sculpture of Lower Saxony and Westphalia, such as the Virgin on the tympanum at Freiberg cathedral (Klack-Eitzen 1985, pl. 26). Although the English origin is likely, the possibility that the Hamburg Virgin and Child was produced in northern Germany in the first decades of the thirteenth century under English influence cannot be excluded.

The projections of the crown are broken, and the right arm of the Virgin has been replaced. **CTL**

1240–50

North French

**Elephant ivory with traces
of polychromy**

Height 22.4 cm

**Chicago
The Art Institute of Chicago
Kate S. Buckingham Fund
(1971.786)**

PROVENANCE
Collections of Octave Homberg,
Paris; anonymous owner,
Paris; E. and M. Kofler-Truniger,
Lucerne; purchased from
Leopold Blumka, New York,
1971.

REFERENCES
Koechlin 1924, 2: no. 11

Paris 1931, lot 128

Grodecki 1947, 82, pl. 21

Schnitzler, Volbach, and Bloch
1964, no. S-31

Suckale 1971

Seidel 1972, 29, 50, fig. 31

Monroe 1978

Little 1979

Randall 1993, 34, no. 1

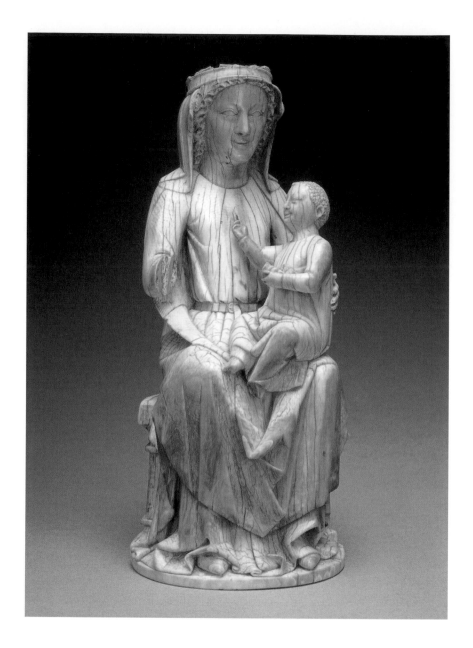

While the Enthroned Virgin and Child statuette from Hamburg (no. 1) is consistent with Romanesque images of the subject, this example from the Art Institute of Chicago reveals significant changes in attitudes toward the Virgin that occurred during the thirteenth century. The Virgin and Child both grin broadly in this mid-thirteenth-century statuette. The child turns to his right while the Virgin smiles down upon him in a relaxed pose. Consistent with the more humanized view of the Virgin at this time, the Chicago group conveys a new intimacy between mother and child.

The simplified geometric approach to form in this sculpture conveys a sense of monumentality. The broad unbroken planes of the upper portion of the group break into nested V-folds of drapery below. The Virgin holds her child with her left arm while much of her right arm is missing. The child holds a bird (its head is now missing) in his left

hand while he makes a gesture of benediction with his right. Small areas of loss can be seen in the child's feet, the Virgin's veil, and her crown. The carving is masterful, with sharp, thin areas such as the fold beneath the Virgin's broken right arm. The simple throne was formerly decorated with painted tracery best seen in the arcade on the proper left side. A hole in the back of the group suggests that the piece might have originally been secured to a tabernacle. The nerve cavity of the tusk can be seen on the underside.

The Chicago statuette is best understood in the context of northern French architectural sculpture produced in the second quarter of the thirteenth century (see Monroe 1978). The densely decorated portals of

Fig. 2a. Archivolt Figures, French, 1230s, stone, west facade, central portal, Amiens cathedral

the west facade of Amiens cathedral provide some of the most useful comparisons (fig. 2a). Sometimes disparaged as dry or formulaic, the Amiens sculptures are characterized by a simplified and geometric approach to the figure, planar rather than linear. The most stylistically homogeneous of the great thirteenth-century cathedrals, the west portals of Amiens were completed in a relatively short period of time during the 1230s (see Williamson 1995, 142-45). The masons active at Amiens introduced an expedient method of stone carving with less experienced and presumably younger members of the workshop roughly carving the uniform limestone blocks, leaving details and the most significant areas to be completed by the masters. In both style and iconography, the west facade of Amiens derives from Notre-Dame in Paris and the Chartres cathedral transept portals.

As Monroe has shown (1978) the sculpture of the priory church of Villeneuve-l'Archevêque (Yonne), stylistically similar to the Amiens west facade, can also be related to the Chicago statuette. These affinities with monumental sculpture suggest that the ivory should be attributed to northern France. The statuette might have been carved in Paris, but the planar conception of the figure seen here is found in a broad area, including Amiens to the north of Paris and Villeneuve-l'Archevêque to the south. Only a few ivory sculptures can be closely related to this statuette, suggesting that a small workshop or a local center of production was responsible. Among the most comparable ivories are two Virgin and Child groups in the Walters Art Gallery, one standing and one seated (Randall 1985, nos. 261–62), and a standing Virgin and Child in the Ognies treasury of Notre-Dame, Namur, Belgium (Monroe 1978, figs. 15–16). These figures all share similar approaches to hair and drapery in addition to the geometric conception of form. **PB**

3 | Figure of a Pope

ca. 1240–50

French (probably Paris)

Elephant ivory

Height 16.4 cm

**London
Victoria and Albert Museum
(A.8-1914)**

PROVENANCE
J. H. Fitzhenry Collection,
London; purchased from the
executors of the estate of
J. H. Fitzhenry, 1914.

REFERENCES
Koechlin 1924, I:258,
2: no. 716, 3: pl. CXVI

Longhurst 1927-29, 2:32,
pl. XXIV

Little 1979, 60–61, fig. 8

Williamson 1982, 44, pl. 28

The seated pope, dressed in an amice, alb, chasuble, stole, and conical tiara, holds a book in his left hand and would originally probably have made a gesture of blessing with his right. The figure is not carved in the round: the reverse, entirely smooth but angled and with scored lines running across the surface, still retains the remains of an iron dowel and pin exactly half way up the figure, which would have attached the relief to a separate background.

Notwithstanding its small size, the figure has a monumentality that immediately links it with High Gothic cathedral sculpture, its elegant elongation calling to mind the figures of the transepts at Chartres and

Reims cathedrals. Popes in similar attire are to be found on the so-called Confessors' doorway of the south transept at Chartres, of about 1215–20, and in the outer archivolt of the Calixtus portal on the north transept of Reims cathedral of about 1225–30 (Sauerländer 1972, pls. 120–21 and 243 right), but there are also stylistic points of contact with sculptures of the middle years of the century, such as the fragmentary jamb figures from the south transept of Notre-Dame in Paris of about 1260 (Erlande-Brandenburg and Thibaudat 1982, 97–104).

The figure's original context remains unclear. Small individual appliqué figures of a lesser quality are sometimes attached to the wings of tabernacle polyptychs, such as on the late-thirteenth-century example in the Museo della Cattedrale, Trani (see Giusti and Leone de Castris 1981, 46), but these are usually iconographically connected to the Virgin and Child at the center of the composition. A stylistically related but slightly larger appliqué figure of this type is the Saint Simeon and the Christ child now in the Walters Art Gallery (Randall 1985, no. 265). Although it has been suggested that both pieces emanated from the same ensemble (Little 1979, 67 n. 28), the Baltimore figure, which was almost certainly originally mounted on the wing of a polyptych or triptych, is probably a little later in date. Ivory reliefs of individual saints are extremely rare, and it may be that the present figure was mounted in a niche on a reliquary shrine. Shrines of this sort, with seated or standing figures ranged along the sides, were commonplace from the late twelfth to the early fourteenth century; two of the grandest were the late-twelfth-century Shrine of the Three Magi by Nicholas of Verdun in Cologne cathedral and the late-thirteenth-century Shrine of Saint Gertrude in Nivelles, Belgium, and although the figures on such shrines were usually of gilt-copper or silver, ivory might equally have been deemed an appropriate and worthy material.

The identity of this particular pope-saint must also remain a mystery. A number of the early popes were venerated in the thirteenth century: at Chartres and Reims alone sculptures representing Popes Clement, Leo, Gregory, Calixtus, and others may be found, so their presence in smaller ensembles, whether shrines, altars, or tabernacles, is entirely to be expected. **PW**

1225–75

French (Paris)

Elephant ivory

Height 52 cm

**Paris
Musée National du
Moyen Age, Thermes de
Cluny (inv. 1954)**

PROVENANCE
Barroux Collection; acquired by
the museum in 1851.

REFERENCES
Du Sommerard 1883, no. 1087

Koechlin 1924, 1:107,
2: no. 106

Paris 1950

Tardy 1966, 58, illus.

Gaborit-Chopin 1978

Taburet-Delahaye 1980, pl. 13

Cologne/Paris 1996, 348-49,
no. 36

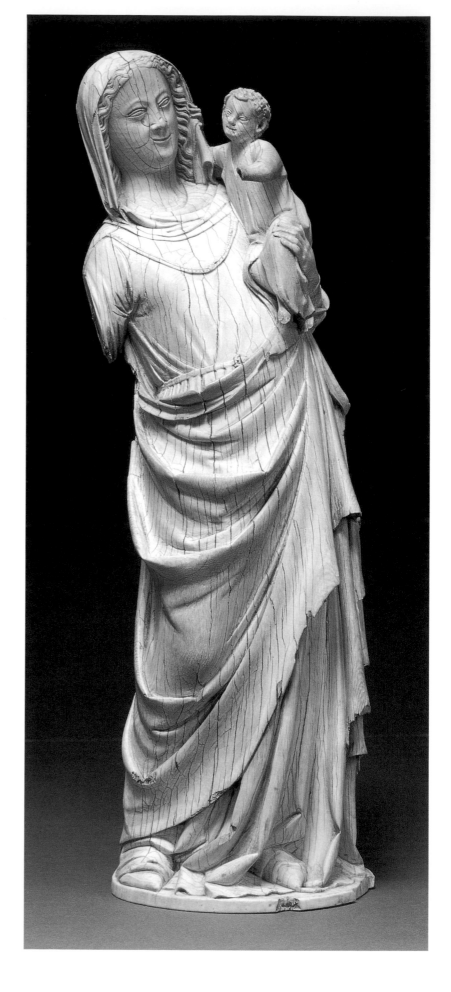

The standing Virgin holds the child high on her left arm. Her carefully molded round face has a cold, slightly haughty, expression. Her wavy hair is covered with a veil, which wraps around her neck. She wears an ample mantle held by a clasp; her robe is held by a belt at the waist. Its abundant deep folds fall freely to her feet, underlining the movement of the body. Close to his mother, the child firmly holds her veil. His full, round, smiling face is framed by carefully executed locks of hair.

The dimensions of the statue are exceptionally large. It is carved from a single piece of elephant tusk. It has, however, suffered from alterations. Its surface is damaged with cracks, and parts are missing: the right arm of the Virgin, the left hand and foot of the child, and a piece of the Virgin's veil. There is also a loss on the base, and a flaw is visible on the face of the Virgin. The ivory appears very white and dry and all traces of polychromy have disappeared.

This figure is one of a group of ivory statuettes that display common characteristics with French monumental sculpture of the middle of the thirteenth century. The Virgin (fig. I-5) on the northern section of the portal of the transept at the cathedral of Notre-Dame, Paris, displays the same sense of monumentality as does the more finely executed Vierge Dorée at the cathedral of Amiens, which also exhibits similarities with the face of this ivory Virgin. The carving of the draperies with rows of large folds forming deep recessions and projections, the facial type with the elongated, almondlike eyes and subtle smile are even more directly connected to the most important sculpture of that group of ivories: the Virgin of the Sainte-Chapelle, mentioned in an inventory of 1265-79, and now at the Musée du Louvre (figs. I-4, III-3, IV-2).

"Of monumental conception but precious execution," this type of ivory Virgin has been studied by Charles Little (1979); he has noted the same elegance in the Virgin of the Metropolitan Museum of Art (17.190.191), also from the last years of the thirteenth century, and in the famous Virgin of Saint-Denis (no. 5).

The long and graceful pose of the body, dictated by the material and for technical reasons, became a decisive element in the sculpture of the middle of the thirteenth century. This statue is a signature of the Parisian style, itself synonymous with classical elegance. **V H**

1250–75

French (Paris)

Elephant ivory with traces of gold and polychromy

Height 34.8 cm

**Cincinnati
The Taft Museum
Bequest of Mr. and
Mrs. Charles Phelps
Taft (1931.319)**

PROVENANCE
Abbey of Saint-Denis (until 1793); on deposit at the museum (Louvre; until 1802); Notre-Dame, Paris (until 1811); Edouard Delacour (1889); Gaston Lebreton (sale at Galeries Georges Petit, Paris, 1921, lot 196); Charles Phelps Taft Collection, Cincinnati (acquired from Duveen, New York, 1924).

REFERENCES
Félibien 1706

Paris 1889, no. 111

Molinier 1896b, 88

Paris 1921, lot 196

Koechlin 1924, 2: no. 97

Montesquiou-Fezensac 1956

Paris 1965, no. 209

Ottawa 1972, no. 71

Seidel 1972, fig. 53

Montesquiou-Fezensac and Gaborit-Chopin 1973-76, 1-2: nos. 10-11, 3:30-32, pls. 13-15

Gaborit-Chopin 1978, fig. 200

Little 1979, 62, fig. 9

Randall 1988

Gaborit-Chopin 1991

Paris 1991, 231-37

Randall 1993, 34-35, no. 3

Randall 1995

Cologne/Paris 1996, 356-57, no. 40

5 | VIRGIN AND CHILD

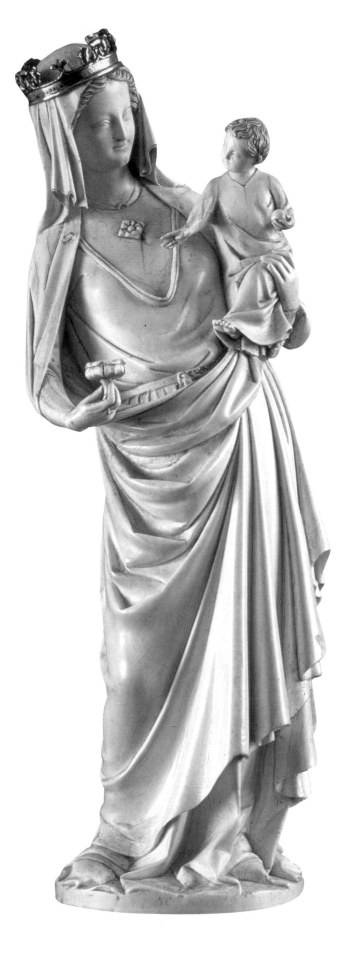

Part of an ivory group representing the Virgin in Glory, the statuette, now in the Taft Museum, was originally surrounded by three adoring angels. In 1973 Blaise de Montesquiou-Fezensac identified this Virgin and Child as the lost Virgin of the abbey of Saint-Denis, known from inventories of the treasury of the royal abbey since the early sixteenth century. The most descriptive inventory entry for the ivory group dates from 1534:

> An image of Our Lady of large scale in ivory, holding a child in the left hand and in the other a little double rose attached to a wand, as in a bouquet. Two angels of ivory holding two little candlesticks, also of ivory, which should be beside the said image of Our Lady, and a little angel, also of ivory, which should hold from behind the crown of the statue. It would appear that these figures of the Virgin and angels should have some sort of base, and to have there a column on which to place the little angel, because the feet of all three have signs of holes to attach them to a base. (quoted in Randall 1995, 463)

It is clear from this sixteenth-century description that the original ensemble had already been disassembled. We know from later inventories that by 1625 the pair of angels holding candlesticks had been separated from the group and incorporated into a reliquary of Saint Clou, and sometime before 1634 the "little" angel had disappeared entirely. With the dissolution of the churches in 1793 following the French Revolution, the Virgin and Child and the reliquary statue were placed in the Musée du Louvre, newly founded as the state museum. The gold crown on the Virgin was sold soon thereafter. In 1802, by an agreement between Pope Pius VII and the French government, all items of a religious nature were returned to the churches. The Virgin statuette was given to the archbishop of Paris, and the reliquary with the pair of angels was given to the archbishop of Rouen. The Saint Clou reliquary was restored, with the addition of new wings for the angels. It was rededicated to Saint Romain, the patron saint of Rouen, where it is now kept in the cathedral treasury. The Virgin and Child statuette was sold by the canons of the cathedral of Notre-Dame, Paris, in 1811, and after passing through the hands of several private collectors, it was acquired for the Taft Collection in 1924.

Virgin and Child with Two
Angels from Saint-Denis

The Taft statuette is representative of the enthusiastic patronage of the arts during the reign of Louis IX (1226–70). The statuette can be compared with newly carved Virgin and Child statues that adorned the portals of several Gothic cathedrals. Like the sculptors of the north transept portal of Notre-Dame in Paris and the Virgin of the south transept portal of Amiens cathedral, the artist of the Taft ivory conveys the intimate communication between the Virgin and her child. The Virgin sways slightly, her right leg bent and her weight on her left leg. Cloaked about her shoulders and held in place by cords across her chest, her mantle gathers in sweeping folds to her left hip and then cascades to the ground in deeply cut folds. The mantle falls in long, shallow folds down the back of the statuette, gracefully suggesting the

THE FIRST GOTHIC IVORIES

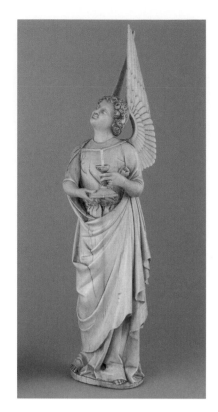

Elephant ivory with traces of gold and polychromy

Height 25 cm

Rouen Cathedral Treasury

PROVENANCE
Abbey of Saint-Denis (until 1793); on deposit at the museum (Louvre; until 1802); Cathedral of Rouen.

Virgin's contrapposto stance. Under the mantle she wears a simple robe, with a narrow belt at her waist. The child, perched on the Virgin's left arm, reaches with his right arm for a rose that the Virgin holds out for him. He kicks his left foot and tilts his head, glancing at his mother, while still clutching a small apple in his left hand.

One of the best preserved thirteenth-century ivories, the statuette is in remarkable condition. Traces of gold are still evident in the hair of both figures, while a pattern of color is visible on the belt. The right arm of the child was broken and repaired in the seventeenth century. The silver crown now adorning the Virgin was added in the early nineteenth century. Likewise, the carved brooch was added in the nineteenth century to replace an emerald and gold brooch, which had been removed before 1634.

No similar ivory ensemble of this period survives intact, and one can only speculate on the original disposition of the figures from Saint-Denis. The early inventories, the Saint-Denis statuettes themselves, and surviving examples of metalwork provide clues to the original appearance. In addition to the holes around the Virgin's brow to hold the crown in place, there are remains of five ivory pins in the top of her head implying that the small flying angel might have been supported by stays connecting it to the Virgin, rather than by a column, as suggested in the 1534 inventory. Danielle Gaborit-Chopin has postulated that the Saint-Denis group was probably intended to be seen inside a miniature Gothic structure that would have allowed the ivories to have been anchored from above and below (Paris 1991, 234). The polyptych in the Toledo Museum of Art (no. 17) also can provide some insight into the possible appearance of the half-length angel placing a crown on the Virgin's head. **PB**

7 | Virgin and Child

ca. 1250–70

French (Paris)

Elephant ivory with polychromy and traces of gilding

Height 19 cm

Baltimore Walters Art Gallery (71.236)

PROVENANCE
Purchased from Léon Gruel, Paris, before 1925; collection of Henry Walters; collection of the Walters Art Gallery, 1931.

REFERENCES
Providence 1977, no. 13

Randall 1985, 200, no. 264

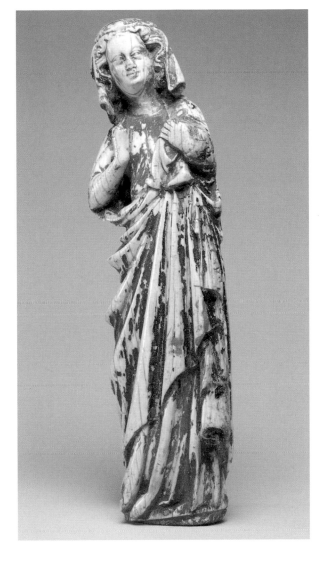

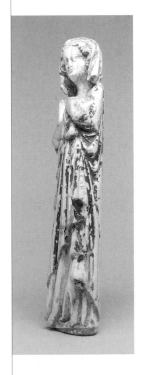

The Virgin stands in a slightly curved posture, holding the Christ child in her left arm and offering him a flower with her right hand as she looks into his face. The skirt of her robe is caught up at the waist, creating a series of deep folds over the right hip and a triangle of vertical folds in front.

The statuette follows the often-copied Virgin of the trumeau of the north porch of the cathedral of Notre-Dame, Paris (see fig. I-5), datable about 1250. As Max Seidel pointed out in his study of the Pisa ivory Virgin, the ivory copies of that stone figure spread its influence far and wide (Seidel 1972). The ivory in the North Carolina Museum of Art, Raleigh, is close in treatment to the Walters example, though not by the same sculptor (Randall 1993, 34, no. 2).

The polychromy is unusually well preserved and shows that the group was completely painted. The Virgin's gown *(cotte)* is dark red with traces of gilt details, and her head cloth and robe are dark blue. Her hair has traces of gilding and is bound with a fillet without any indications of a crown. The child's robe is dark blue with traces of gilt ornament. The upper torso and head of the child are missing, as are the flower and the fingers of the Virgin's right hand. The base has been trimmed, and there is considerable wear on the front and head of the figure from use. **RHR**

THE FIRST GOTHIC IVORIES

ca. 1260–80

French (Paris?)

**Elephant ivory with traces
of polychromy**

Height 16.5 cm

**New York
The Metropolitan
Museum of Art
Gift of Mr. and Mrs. Maxime
L. Hermanos (1978.521.3)**

PROVENANCE
Unknown

REFERENCES
New York 1979, 24

Little 1979, esp. 59–60

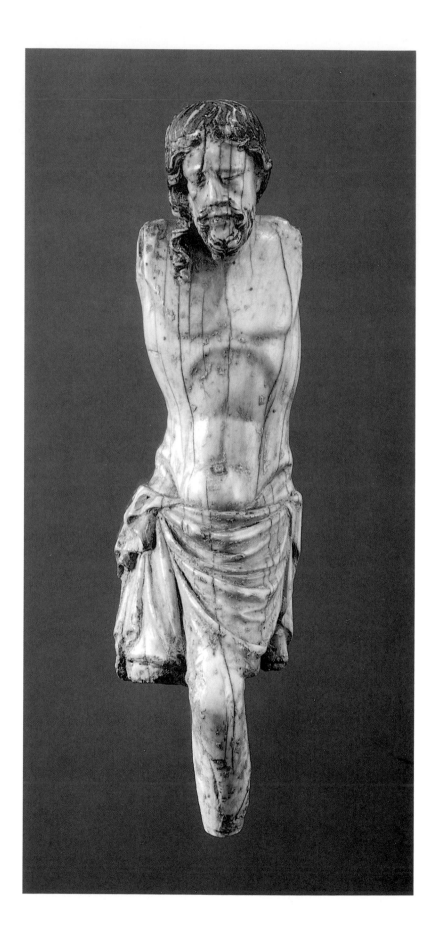

The suffering of Christ on the cross is a central theme in Gothic art. So significant was the subject that the mid-thirteenth century statute of the Parisian corporations (see Sears essay, pp. 18-37) defined an entire guild authorizing the carving of such images, including ivory (Lespinasse 1879, 127, title LXI). Unfortunately, few of these crucifixes have survived.

Carved in the round and certainly intended for an altar cross, the figure beautifully conveys the pathos and agony of Christ. In spite of the losses of arms and legs (which originally were pegged into the body), the figure reveals a profound sensitivity to form and expression. The powerful anatomical structure—portraying naturally the corporeality of the dying figure—is remarkable for crucifixes of the period. The short loincloth is not fastened by a knot but tucked in on both sides. It closely follows the shape of the body, clinging to it in front in thin, rhythmic folds, while the cloth at the sides is more fully draped. The face is carved with as much sensitivity as the torso. The closed eyes and the long hair falling down the back and right side of the head reveal the emotional impact of death. A subtle twist in the torso was produced, in part, by the legs, which were crossed and mounted on a cross with a single nail.

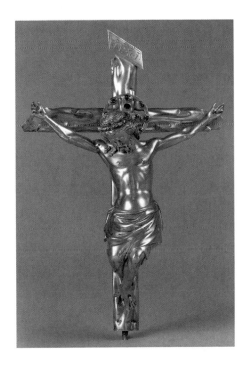

Fig. 8a. Crucifixion, French, after 1272, silver, from the shrine of Saint Gertrude, abbey of Sainte-Gertrude, Nivelles, Belgium

The important place this magnificent corpus occupies within the development of Gothic sculpture can be determined by comparing it to works in stone, wood, and ivory produced in the Ile-de-France around the middle of the thirteenth century. Something of the spirit of this ivory and its sculptural presence is found in the wooden crucifix from Cérisiers, dated about 1260, now in the cathedral of Sens (Sauerländer 1972, pl. 63). The short loincloth has a close parallel in the Crucifixion and Deposition of the cathedral of Bourges choir screen or the Saint Honoratus portal at Amiens cathedral (ibid., pls. 294, 279). However, the strong articulation of the torso and the realization of the perizonium bear a striking resemblance to the great silver crucifix on the shrine of Nivelles, created after 1272 (fig. 8a; Cologne/Paris 1996, fig. 5).

Some aspects of the physiognomy—especially the closely trimmed beard and short mustache that leaves the middle of the upper lip bare and curves down at the corner of the mouth—can be compared to the celebrated ivory Deposition in the Musée du Louvre (Gaborit-Chopin 1988, figs. 6, 33). The retrospective tendencies of the New York corpus, such as the thin, clinging folds of the loincloth—which are reminiscent of the classicizing trends of the early thirteenth century—become evident in its refined style and pathos. These features also become revitalizing components of the mature Gothic style in the second half of the thirteenth century. **CTL**

THE FIRST GOTHIC IVORIES

9 | Diptych with the Last Judgment and Coronation of the Virgin

ca. 1250–70

French (Paris)

Elephant Ivory

Height 12.7 cm
Width 6.5 cm (each panel)

New York
The Metropolitan
Museum of Art
The Cloisters Collection
(1970.324.7a-b)

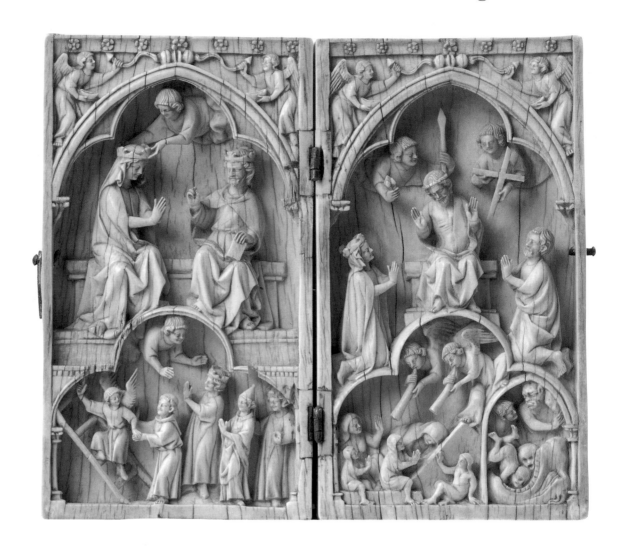

PROVENANCE
Collection of Ernst Kofler,
Lucerne.

REFERENCES
Schnitzler, Volbach, and Bloch
1964, no. S-57

Little 1979, esp. 64–65, fig. 21

Verdier 1980, 10, pl. 88

Hamburger 1990, 49, fig. 111

Os 1994, 25–26, no. 6

Diptychs in ivory emerge as an important class of devotional objects around the middle of the thirteenth century, as exemplified by this masterful carving, which stands at the beginning of this tradition in the Latin West. Conceived as sculpture in high relief, the diptych telescopes the two leading programmatic themes of the Gothic era: the Last Judgment and the Coronation of the Virgin. Each scene is presented in two zones. Above on the right is Christ Enthroned in Judgment displaying his wounds with angels holding instruments of the Passion and the Virgin and Saint John kneeling in prayer. Below angels trumpet the fate of the risen while the damned are pitched into the Mouth of Hell. On the left is the Coronation of the Virgin by an angel in the presence of Christ, while below a retinue of the saved souls, including a mendicant friar, a king, a pope, and possibly a deacon, is ushered up a ladder to the celestial paradise by an angel who points the way. Although these themes frequently are juxtaposed on the portals of French cathedrals, rarely are they presented on ivories (see, for example, Koechlin 1924, 2: no. 524).

Historically, the Coronation immediately follows the Last Judgment; this is elucidated by the heavenly ladder reserved for the Elect who ascend to paradise. Functioning as a visual metaphor, the ladder is linked to

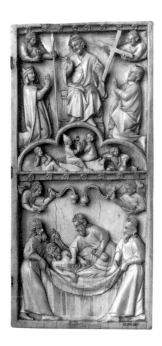

Fig. 9a. Diptych leaf with Christ Enthroned in Judgment and the Entombment, French, ca. 1275-1300, elephant ivory, New York, The Metropolitan Museum of Art (17.190.280)

that in the dream of Jacob. Hymns and sermons on the Virgin exegetically associated her with the *scala coeli*. This idea is expressed by many theologians, such as Saint Augustine, Saint Bernard of Clairvaux, and Richard of Saint Laurent, canon of Rouen cathedral who died in 1260, in his influential *De laudibus Beatus Mariae Virginis*. In Saint Bernard's *Sermo de Beata Maria Virgina* (Migne 1859, col. 1016), she is celebrated as the ladder and "through the steps (of humility) the angels climb and elevate men who rise up." Significant also is the mendicant friar preceding the king and pope to eternal salvation. Both Blanche of Castille and Louis IX supported and encouraged the monastic orders within the royal domain, and they played an active educational and religious role within the court circle. The inclusion of a friar along with an idealized king may be an indication of royal patronage, although this cannot be proved.

The diptych is the earliest representative of the "rose-decorated diptychs" and certainly a Parisian work, but it relates to few other Gothic ivories: a later variant of the Judgment scene is depicted on a diptych leaf (fig. 9a; Koechlin 1924, 2: no. 234). The precision of forms with deeply undercut figures produces an exceptional degree of sculptural projection, the noble gestures of veneration and the supple, full draperies are characteristic of the courtly tendencies of Paris during the middle and second half of the thirteenth century. The pronounced projection of the figures is unusual for Gothic ivories and may be an attempt to evoke the qualities of goldsmith work as seen on the silver gilt repoussé Coronation scene on the book casket (fig. 9b) made for Abbot Arnold II of Saint Blasien in the Black Forest (1247–76; Cologne/Paris 1996, no. 34) and monumental sculpture, such as the tympanum of the north door of Notre-Dame in Paris or the cenotaph of Dagobert at Saint-Denis (Sauerländer 1972, pl. 271, fig. 100). Thus, the interaction of different media contributed significantly to the beginning of the ivory tradition in Paris. **CTL**

Fig. 9b. Coronation scene (detail), Book Casket for Abbot Arnold II of Saint Blasien in Schwarzwald, French, (Strasbourg?), 1260-70, silver gilt repoussé, Benedictine monastery of Saint-Paul-en-Lavanttal

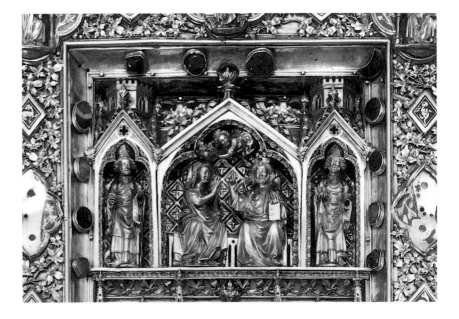

THE FIRST GOTHIC IVORIES

1250-70

French (Paris or North France)

Elephant ivory

Height 33 cm
Width 13 cm

**Baltimore
Walters Art Gallery
(71.157)**

PROVENANCE
Collection of Frédéric Spitzer; sale Paris, 1893, bought in; sale of Spitzer heirs, New York, 1929, purchased by Henry Walters; collection of the Walters Art Gallery, 1931.

REFERENCES
Molinier 1890, no. 43

Paris 1893, lot 78, pl. 3

Koechlin 1924, 2: no. 40

New York 1929, lot 544

Morey 1939, 184, no. 4

Verdier 1963, 32, no. 3

Randall 1969, 1–2

Randall 1985, 200, no. 266

10 | LEFT LEAF OF A DIPTYCH WITH SCENES OF THE PASSION OF CHRIST

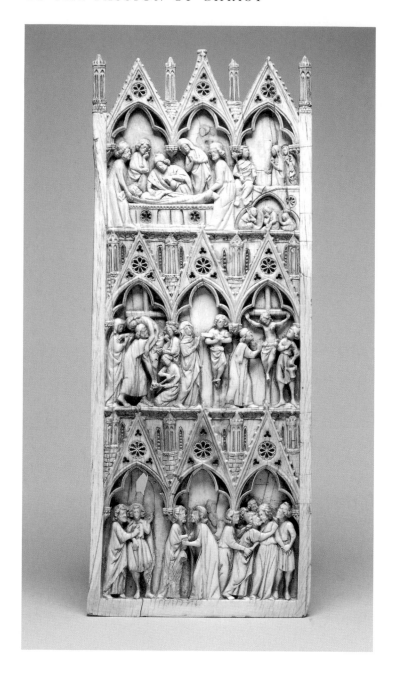

The so-called Soissons group of thirteenth-century ivories is named for the most famous example that came from the church of Saint-Jean-des-Vignes in Soissons. That diptych (fig. VII-1) is now in the Victoria and Albert Museum, London (Koechlin 1924, 2: no. 38). While the architectural details and ordering of the scenes are generally similar within the group of diptychs and triptychs, there is a wide range of experimentation with all these elements, and some scholars have argued that these were among the earliest Parisian ivories, while others suggest that they may have been produced in northern France. The date span of 1250–70 is based on the architectural details, as well as the figural style of related sculpture, such as the portal sculpture of 1235–40 from Thérouanne in northern France (Sauerländer 1972, 468, pls. 176–77).

Elephant ivory

Height 19 cm
Width 8 cm

Paris
Musée National du
Moyen Age, Thermes de
Cluny (cl. 417)

PROVENANCE
Collection of Alexandre Du
Sommerard; purchased for the
Cluny Museum, 1843.

REFERENCES
Du Sommerard 1883, no. 1062

Molinier 1896b, 184

Koechlin 1924, 2: no. 42

Randall 1969, 1–2

Taburet-Delahaye 1980, 13

Erlande-Brandenburg 1993, 130

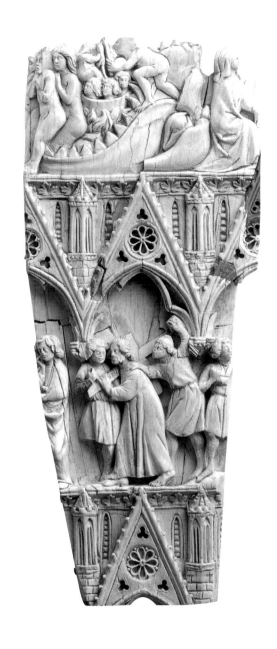

The Walters leaf (no. 10) and the Cluny fragment (no. 11; the Musée
National du Moyen Age, Thermes de Cluny, in Paris was formerly known
as the Cluny Museum) once formed part of the same diptych. The
Walters plaque reads from left to right across the bottom and from right
to left in the second tier, then left to right in the uppermost. The scenes
commence with the Temptation of Judas, Judas Receiving the Thirty
Pieces of Silver, and the Arrest of Christ. The second tier shows Christ
between Stephaton and Longinus with the Good Thief and the Virgin to
his right; the balance of the Crucifixion scene is on the Paris fragment.
The Deposition also is on the second level; while the upper level pre-
sents the Entombment and the Three Marys at the Tomb.

The Cluny fragment has been badly broken; all that survive are, at the top, the Mouth of Hell with Adam and Eve emerging, beside which is the Magdalen kneeling in the Noli Me Tangere. The middle tier centers the Carrying of the Cross, with Saint John from the Crucifixion scene at the left and a figure from the Flagellation at the right. The Crucifixion was divided between the two leaves of the diptych, and the figure of the Bad Thief has been broken away in the Cluny fragment. A complete Crucifixion scene, filling the width of an entire tier, can be seen on a diptych in the State Hermitage Museum, Saint Petersburg (Koechlin 1924, 2: no. 34), and on one in the Wallace Collection, London (Mann 1992, 37, fig. 11).

While the figural style of these two leaves is somewhat drier and probably later than the Soissons Diptych, these pieces resemble that ivory in the treatment of the architectural frame. At each level, the scenes are placed between three pierced tympana, separated by buttress towers flanked by single pointed window embrasures. The horizontal moldings separating the tiers are also carved with ivy leaves, as in the Soissons diptych. The figural style of the Walters-Cluny diptych is closer to that of the diptych in the Hermitage and an example in the Vatican (Koechlin 1924, 2: no. 37), where the formats of the Entombment and Deposition scenes are also similar.

The Descent into Limbo and its relationship to the Magdalen in the adjoining Noli Me Tangere is handled similarly in the Walters-Cluny work and the piece from Saint Louis (no. 12), in spite of the addition of columns to define the space. A similar Mouth of Hell appears in the Hermitage example.

Within the Soissons group, the architectural treatment of the Saint Louis diptych (no. 12) forms an interesting contrast to the Walters-Cluny diptych, which reflects a system of exterior tympana springing from corbels. In the Saint Louis diptych, the eighteen scenes are contained under trefoil arches set on columns with simple floral capitals, representing interior architecture with its stately procession of bays. This arrangement caused the ivory carver to make each scene of the Passion into a composition with two or three figures. In some cases, this created a problem of scale between scenes: for instance, the large Christ in the Carrying of the Cross is seen between a tiny Christ in the Crucifixion and the two small torturers in the Flagellation. Only in the Descent into Limbo does the artist allow himself two intercolumniations for a single subject, and here he sensibly made it into two related subjects: Christ leading Adam and Eve from the inferno and the Mouth of Hell itself.

The scenes in the Saint Louis diptych read from left to right in the bottom level: the Temptation of Judas, Judas Receiving the Thirty Pieces of Silver, the Arrest of Christ, the Hanging of Judas, Christ before Pilate, and Pilate washing his hands; from right to left in the middle level: the Flagellation, the Carrying of the Cross, Crucifixion, Deposition, Entombment, and Three Marys at the Tomb; in the upper level, the

Elephant ivory

Height 20.4 cm
Width 17.3 cm

Saint Louis
The Saint Louis Art
Museum (183:1928)

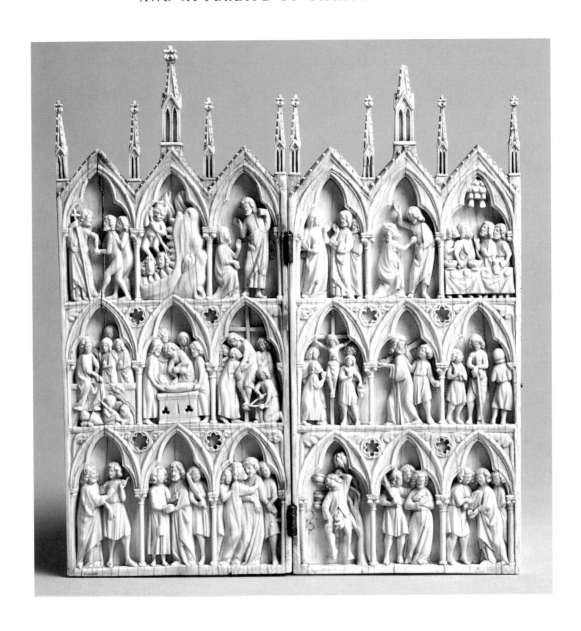

Descent into Limbo, Noli Me Tangere, Christ Appearing to His Mother, Doubting Thomas, and the Ascension. The rich effect of the arrangement is visually pleasing and easier to read than the diptychs of the Soissons group where the scenes run into one another or overlap.

The crowning row of trefoil arches develops into a roofline of crockets and pinnacles. One of the larger pinnacles is missing its top and has been broken off and reattached. There is an inset piece in the back to reinforce an age crack. While much of the original polychromy has been rubbed away, there are traces of color, including red on the Mouth of Hell, blue on the Tomb, and green on the foliage of the architectural frames. **RHR**

1280–1300

French (Paris)

Elephant ivory

Height 22.2 cm
Width 10.6 cm

Baltimore
Walters Art Gallery
(71.124)

PROVENANCE
Collections of George R.
Harding (purchased anonymous
sale, London, June 10, 1897,
Lot 70); Octave Homberg, Paris
(Homberg sale, May 12, 1908,
Lot 468); purchased from
Jacques Seligmann, Paris, 1908.

REFERENCES
Koechlin 1924, 2: no. 235

Randall 1985, no. 288

13 | FLAGELLATION AND CRUCIFIXION

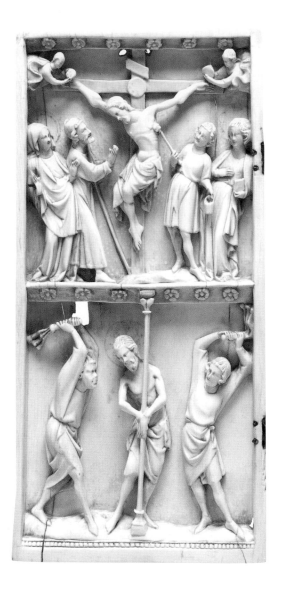

These two plaques certainly formed a diptych, since their silver hinges
match exactly. The left leaf (no. 13) is said to have been painted purple
in 1907 and reddish traces remain, as well as some gilding of the halos
and vestiges of a diaper-patterned background. The right leaf (no. 14)
has traces of green on the draperies and on the horizontal bands of
rosettes above each scene; the halos are gilded, with a black outline, and
there is a pattern of gilded dots on the background. Alternating lancets
and circles decorate the sarcophagus of the Entombment. The scenes
are carved with unusual freedom and monumentality, each zone being
isolated against a plain background as on the lintels of many thirteenth-
century portals. A discreet frieze of six small rosettes runs across above
each scene, and there is a beaded lower border. Koechlin grouped sever-
al ivories as the products of a single workshop on the basis of the motif
of these rosette borders. But his group (the so-called Rose Group) is
stylistically too diverse to be accepted. The present diptych is closest in
style to a diptych divided between the Ashmolean Museum, Oxford,

Elephant ivory

Height 22.2 cm
Width 10.6 cm

London
British Museum
(MLA 1943, 4-1, 1)

PROVENANCE
Purchased from F. E. Teusch
of Gosport (Lancashire), 1943;
said to have been found by
the vendor in a secondhand
shop in Gosport.

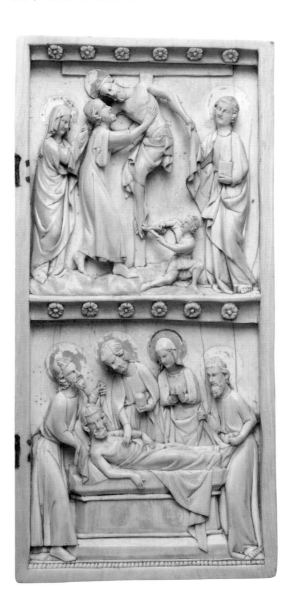

(1685, [cat. A 580]) and the Metropolitan Museum of Art (MMA 17.190.280; Koechlin 1924, 2: no. 234); a diptych in the Gulbenkian Collection, Lisbon, is a later production (ibid., no. 256).

Other members of the Rose Group show such a variety of styles that the hypothesis of a workshop production must be abandoned. Here there is a clarity and massive quality to some of the figures that are reminiscent of the best French monumental sculpture of the period of about 1280; for instance, the reliefs of the north door of the west facade of Auxerre cathedral (Quednau 1979, fig. 89ff.). With other figures, the language of forms is more refined, the silhouettes are already elongated. The undercutting of the two ivory leaves is superficially similar to the Paris ivories with colonnettes of about 1300, but their style is again very different. This diptych therefore represents a unique blend of the "monumental" and the "mannered" at the turn of the thirteenth and fourteenth centuries. It is a small masterpiece, among the most precious ivories to survive from the reign of Philippe le Bel. **NS**

15 | Nicodemus

ca. 1260-80

French (Paris)

**Elephant ivory with traces
of gilding and polychromy**

Height 19.8 cm

**Paris
Musée du Louvre
(OA 9443)**

PROVENANCE
Costa de Beauregard; Gustave
de Rothschild; Robert de
Rothschild; given in 1947 by
the children of Baron and
Baroness Robert de Rothschild.

REFERENCES
Darcel 1878, 287

Molinier 1896a, 121-35

Koechlin 1924, 1:59-60,
2: nos. 18-19, 3: pl. VII-VIII,
no. 20

Grodecki 1947

Verlet 1947

Paris 1968, no. 353

Gaborit-Chopin 1988

Cascio and Lévy 1988

Williamson 1995, 150, fig. 209

Guineau 1996

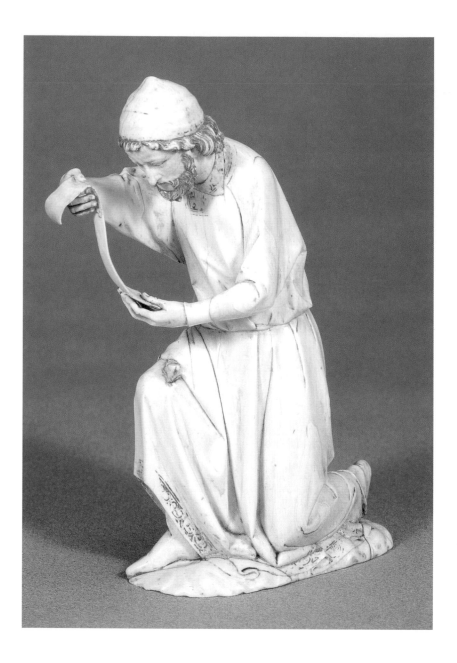

This kneeling figure leans forward and appears to be reading the long scroll that he holds. In fact, if the piece is seen without the modern additions of the left wrist, right forearm, hands, and scroll (all covered with a patina to make them look original), the small sculpture can be seen to represent Nicodemus. Kneeling at the foot of the cross, he was originally represented removing nails from the feet of Christ, raising his right arm in order to hold a pair of long pliers, the ends of which are still visible near his right knee.

Nicodemus was one of the figures from a group representing the Descent from the Cross (fig. 15a). When it was bought from Charles Mannheim for the Musée du Louvre in 1896, this group included a figure of Joseph of Arimathea supporting the dead body of Christ, another of the Virgin raising his hand to her lips, and an additional figure of a woman holding a chalice, of which only the foot remains, meant as Ecclesia, an allegorical representation of the Church.

There are several indications that all these figures belonged originally to the same group: their uniform style, the similar plinths on which the figures stand (with the exception of the one under Joseph, which is very thick), and the similar orphreys executed in gold leaf over red-orange translucent bole. These decorations repeat fairly simple motifs from one figure to the other with certain variations. There is some evidence of later overpainting. The blue, made of lapis lazuli for the figure of Christ, is made of smalt for Nicodemus and therefore dates later than the fifteenth century. Likewise, the pink on the cheeks of the figure of Ecclesia is not original.

The figures were originally set on different levels. Thus the Virgin would have been placed at the same level as Nicodemus and lower than Joseph, so that the hand of Christ reaches the desired position. A figure of Saint John probably stood on the other side of the cross. Smaller in size, the figure of Ecclesia was set lower on the side. It is not clear if there was a pendant allegorical figure of the Synagoga. An ivory diptych of about 1250, now in the Vatican, shows a Descent from the Cross similar in composition but with all the figures lined up on the same level (see fig. 15b and New York 1982, no. 44).

The setting of the figures at different heights indicates that they were placed in a complex structure that included several steps and allowed the ivories to be seen from all sides. Given the refined and precious character of these ivories, it is likely that this structure was the work of a goldsmith, as it is similar in some ways to the gilded silver reliquary of the Holy Sepulcher in Pamplona made in Paris about 1290 (see Gauthier 1983, 154–55).

The dating of Nicodemus and of the other figures from this group has varied between the middle of the thirteenth century (Williamson 1995)

Fig. 15a. Descent Group, Paris, ca. 1260-80, elephant ivory, 29 cm, Paris, Musée du Louvre (OA 57)

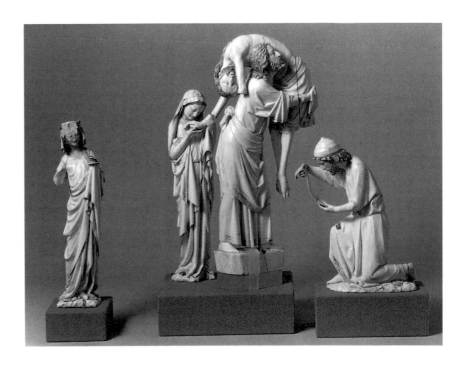

THE FIRST GOTHIC IVORIES

and the years 1270–80 (Gaborit-Chopin, 1988). The similarity of the Virgin and of the Ecclesia figure, especially as seen from the back, with the ivory Virgin of the Sainte-Chapelle, Paris (figs. I-4, III-3, IV-2) is evident, in spite of the latter's more ample and powerful silhouette. It is also true that the faces of both Nicodemus and Joseph are firmly and delicately carved, their long almond-shaped eyes, straight noses, and sensitive mouths recalling the figure of Christ (and also sharing his thick, curly beard) on the north tower of the western portal at the cathedral of Reims (ca. 1260). Yet other comparisons suggest a later date: the slender silhouettes of the Virgin and of Ecclesia and the many falls of conical folds of their mantles stress their similarity with the wooden angels of Saudemont, for instance, of about 1270 or the last third of the thirteenth century (Arras, Musée Municipal). A date around 1260-80 is thus more plausible. This connection with monumental sculpture demonstrates clearly that, in any case, the carver of this group must have been one of the most gifted *tailleurs d'ymage* allowed to work on ivory. The extraordinary quality and refinement of the figures such as Nicodemus also suggests that this Descent from the Cross was intended for an exacting patron, whether a member of the Church or a layman. **DGC**

Fig. 15b. Diptych with Descent from the Cross (detail), French, ca. 1250, elephant ivory, h. 30.5 cm, Rome, Gallerie e Musei Vaticani

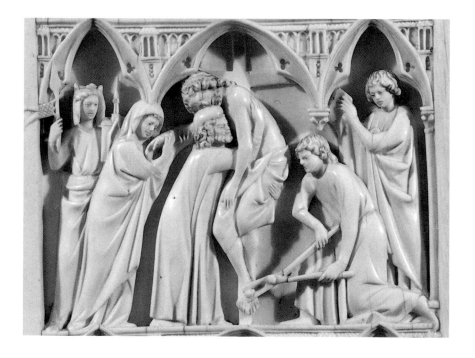

IMAGES IN IVORY: PRECIOUS OBJECTS OF THE GOTHIC AGE

ca. 1280–1300

French (Paris)

**Elephant ivory with traces
of polychromy and gilding**

Height 31.8 cm

**Paris
Musée du Louvre
Given in 1922 by Georges
Chalandon, in memory
of Ferdinand Chalandon
(OA 7507)**

PROVENANCE
Laforge, Lyons (?); Albin
Chalandon; Georges Chalandon.

REFERENCES
Giraud 1877, pl. V

Lyons 1877, no. 806

Molinier 1896b, 187

Paris 1900, no. 59

Migeon 1900, 457–58

Migeon 1905, 22

Aubert 1922

Koechlin 1924, 2: no. 20

Grodecki 1947, 84–85

Natanson 1951, no. 12

Gaborit-Chopin 1978, 146–47,
no. 217

Little 1979, 60, figs. 6-7

Koekkoek 1987, 22, figs. 7a–b

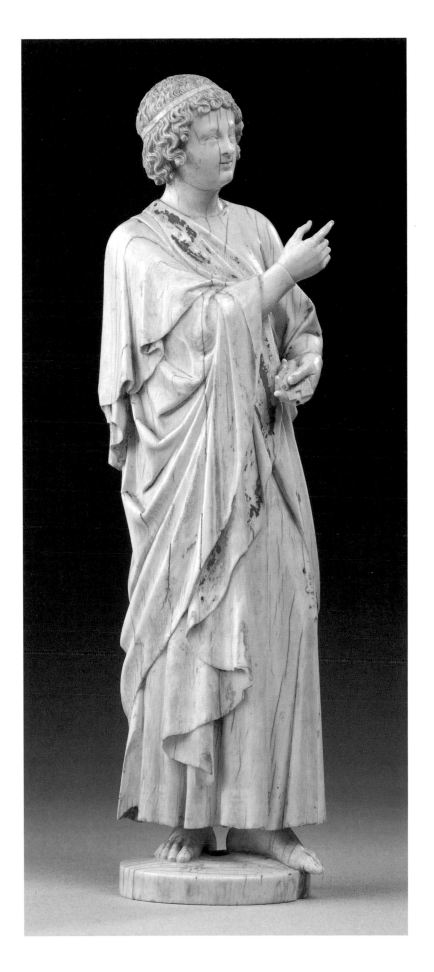

One of the most famous Gothic ivories, this angel was originally part of an Annunciation group. Barefoot, he stands on a base on which traces of a painted inscription are still visible. He originally turned toward the Virgin in a movement accentuated by the projection of his knee and the position of the right arm (the lower part of the forearm and the hand have been replaced). His left hand holds the upper part of a scroll that fell to the level of his knee, as attachments for it are still visible. His tight curls are held together by a diadem. His face is full, with a short nose, barely smiling small mouth, and double chin. The angel wears a long robe with fluted folds that stops at the ankles. Contrary to Koechlin's opinion (1924), careful examination reveals that the base

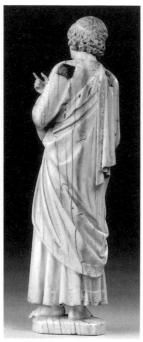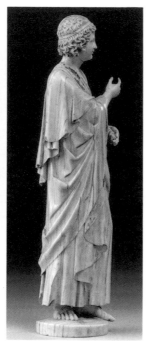

and the front part of the feet are made of the same block of ivory as the rest of the sculpture. Only the heels have been reworked. A long mantle is thrown over the angel's robe. A flap goes over the angel's chest and falls down in the back, creating the illusion of a short cope in a fashion that can be seen on other angels of the second half of the thirteenth century. Here, this is executed in a more exaggerated manner. In the back, two open cavities were originally used to affix the wings. The back itself displays carefully executed draperies with the vertical folds of the robe contrasting strongly with the curiously triangular shape of the mantle. Under this triangle, the V-folds of the sides do not drastically affect the shape of the statue, as is often the case in the works of the third quarter of the thirteenth century.

The traces of polychromy, in spite of some overpainting, are part of the original decoration (see pp. 51, 55). The magnificent orphreys at the edge of the vestments are particularly sumptuous. Their complexity and width recalls those of the ivories of the end of the thirteenth and beginning of the fourteenth centuries.

In 1900, the angel was considered to be the pair to the Annunciate Virgin of the Garnier collection, now at the Musée du Louvre (fig. 16a). Louis Grodecki (1947) first mentioned the differences between the two ivories, suggesting doubt that they could not have been part of the same original group, even though they may have been brought together as a pair at a later date. Differences in height (the Virgin is 29.5 cm) and in the shape of the bases, as well as the differences of style between the two pieces, are further arguments. The Virgin is austere and recalls the monumental sculptures of the central and left west portal at the cathedral of Reims, suggesting a date around the middle of the century (see Gaborit-Chopin 1978, 139). The ephebelike appearance of the angel has triggered comparisons with the archaizing sculptures of the central

Fig. 16a. Annunciate Virgin, French, ca. 1250, elephant ivory, h. 29.5 cm, Paris, Musée du Louvre (OA 7007)

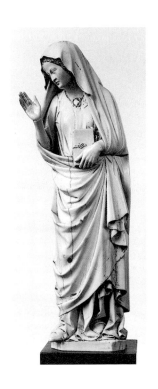

west portal at Reims, while his full face has been compared to the one of the young deacon on the left portal of the same facade. This would suggest a date around 1240-50 (see Little 1979). His face has even been compared to that of the "Smiling Angel" at Reims (Koekkoek 1987). However, this resemblance is not as strong as it may appear to be at first. The baby face of the ivory angel, his short nose, and ornamental frizzy hair belong to a different aesthetic and can be compared more convincingly to works executed around 1300 or in the first decades of the fourteenth century. The ivories of the group of the Christ in Judgment (ca. 1300; see Gaborit-Chopin 1978, 145–48), the goldsmith work on the angels of the reliquary of Saint Louis in Bologna (ca. 1300; see Lüdke 1983, no. 228), the angel of the reliquary of the Holy Sepulcher in the treasury of the cathedral at Pamplona (ca. 1290; see Gauthier 1983, 154–55), or some of the angels on the Reliquary of Saint Gertrude at Nivelles (1272-98; see Cologne/Paris 1996) all belong to this same aesthetic. In terms of monumental sculpture, comparisons with the head of the wooden angel holding the nails of the Passion (ca. 1300) at the Metropolitan Museum of Art, New York; the head of the statue of Isabelle of France at Poissy; and the heads of the recumbent tomb sculptures of Robert d'Artois by Jean Pépin de Huy and of the infant Jean I at Saint-Denis (1316) are also striking (fig. 16b). Jean I's head—that of a baby with fully round cheeks, a small mouth, wide open eyes, and curly hair held together by a band—is particularly close. The design of the folds of the ivory angel's vestment confirms a date around 1300, the flattening of the large folds, and the weightless arabesques of the mantle's border are typical of Parisian art of the time. The fluted folds of the robe can also be seen in another sculpture of about 1300 from Poissy, the statue of Pierre d'Alençon at the Musée National du Moyen-Age, Thermes de Cluny (see Erlande-Brandenburg 1988, fig. 18). **DGC**

Fig. 16b. Tomb Sculpture of Jean I, French, 1316, marble, abbey church of Saint-Denis, and detail of the Angel of the Annunciation

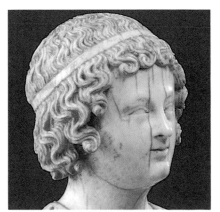

1280–90

North French (probably Paris)

Elephant ivory with traces of polychromy and gilding, metal hinges

Height 29.4 cm
Width 28 cm (open)

Toledo
The Toledo Museum of Art
Purchased with funds from the Libbey Endowment Gift of Edward Drummond Libbey (50.304)

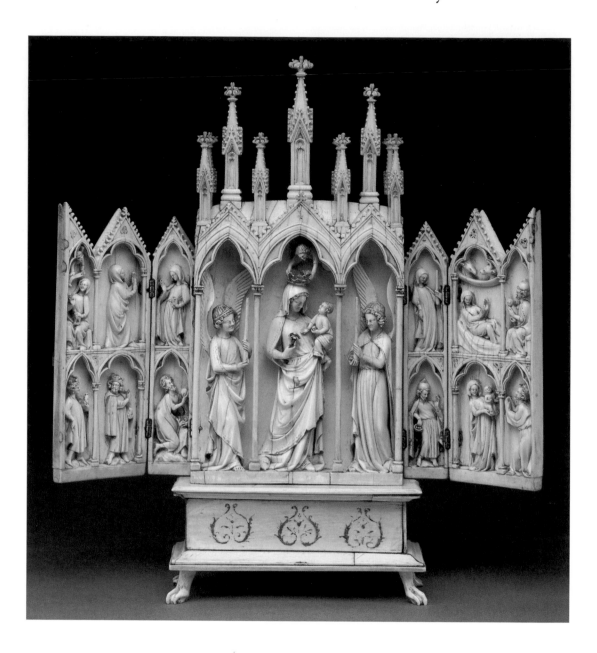

PROVENANCE
Collections of Frédéric Spitzer, Paris (sale Paris, 1893); Oscar Hainauer, Berlin (until 1906); Emile Baboin, Lyons, purchased from Raphael Stora, New York, 1950.

REFERENCES
Molinier 1890, no. 84

Bode 1897, no. 138

Koechlin 1905a, 467

Koechlin 1912, no. 21

Apollo 1967, 440

Little 1979, 61

Randall 1993, 50–51, no. 32, pl. 6

Toledo 1995, 58

The tabernacle is remarkable for its high quality and its excellent state of preservation. Only the eleven pinnacles appear to be modern restorations. The figures and the three arcades of the center section are deeply carved out of a single block of ivory. Angels bearing candles flank the Virgin as she holds the Christ child in her left arm and a flower in her right hand. The child holds a globe in his left hand as he gazes up at the Virgin while a half-length angel appears framed in the trefoil arch above and places a crown upon her head. The figures are carved in three-quarter relief to suggest free-standing sculptures. The sloping bottom of the central block is cleverly disguised from the front by a separate ivory wedge placed beneath the figures. The irregular shape of the central block is due perhaps to an effort to make maximum use of the tusk and the wedge allows the block to sit squarely on the base, which is in turn supported by claw-and-ball feet. Each wing is composed of two hinged sections so that the tabernacle closes securely. The sequence of scenes in relief from the infancy of Christ is read across the top from left to right

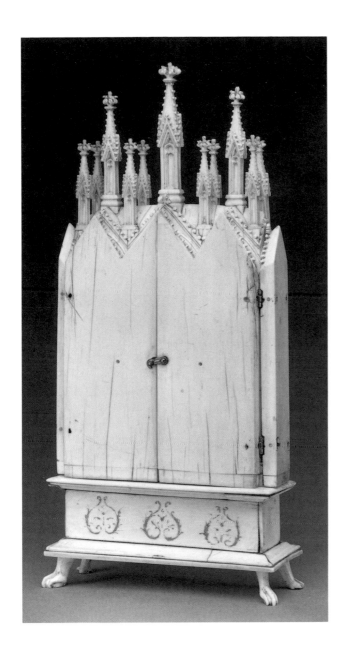

and then across the bottom beginning again on the left. Above on the left are the Annunciation and Visitation and on the right is the Nativity (the woman bearing a candle to the left of the Nativity is an unusual feature). Below, from left to right are the Adoration of the Magi and Presentation in the Temple. In addition to the foliate decoration of the base, traces of gilding and red and blue polychromy can be seen throughout. The gilding appears primarily in the hair, the crown, and the borders of some garments. Blue and red appear on the garments of the deeply carved figures in the central section as well as on some of the architectural elements.

We have already seen that the Virgin from the treasury of Saint-Denis (no. 5), holding a flower in her right hand, was originally the central element in a tabernacle in which she was flanked by angels bearing candles while a small angel placed a crown upon her head from above. The central portion of the Toledo polyptych conforms in these details to the description of the lost monument from Saint-Denis, suggesting that the importance of the royal abbey might have inspired this reflection of its great ivory. While the Toledo polyptych is a smaller, more portable version of the Saint-Denis monument, it is grander in conception with its triple arcade and deeply carved figures than most of the surviving Virgin and Child triptychs and polyptychs in ivory (see Koechlin 1924, 3: pls. XXXIV-XLIV).

As Charles Little has noted, thirteenth-century ivory tabernacles devoted to the Virgin can be viewed in a broader context (Little 1979, 61-62). While the new popularity of the devotional diptych in the thirteenth century was confined to ivory, folding tabernacles were made in a variety of materials. Silver gilt was a particularly popular medium. It is possible that some tabernacles might have used mixed materials, such as ivory reliefs on a metal ground, although none such have survived. The central portion of another lost ivory tabernacle survives in the Metropolitan Museum of Art, New York (17.190.197; Koechlin 1924, 2: no. 167). It is iconographically and stylistically similar enough to the Toledo ivory to suggest that they might have been produced by the same workshop. A third closely related, but larger, polyptych in the State Hermitage Museum, Saint Petersburg, (Koechlin 1924, 2: no. 172) is more complex, with Christ Enthroned in Judgment above the standing Virgin and Child in the

central section. The Saint Petersburg tabernacle is similar to the Toledo ivory in style and decorative details. Furthermore, the Saint Petersburg piece includes the same rare iconographic detail of the candle-bearing woman adjacent to the Nativity scene. The Toledo polyptych and its close relatives are indicative of the elegance and high quality seen in Parisian art toward the end of the thirteenth century during the reign of Philippe le Bel (1285–1314). This milieu produced, for example, such works as the well-known manuscript illuminations of Master Honoré (d. ca. 1318). **PB**

Detail, no. 17. Coronation of the Virgin.

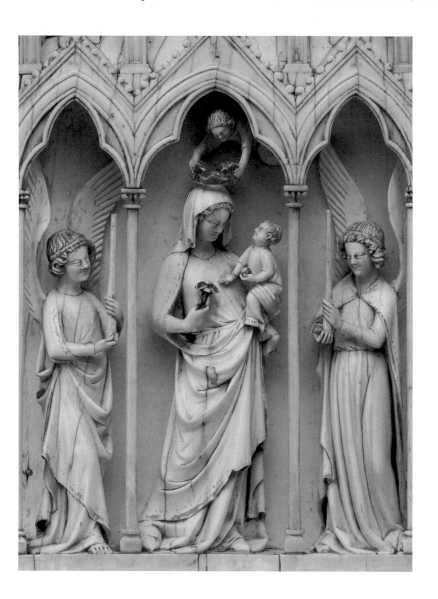

PARIS AND OTHER CENTERS:

DEVOTIONAL
OBJECTS

ca. 1300

French (Paris)

Elephant ivory

Height 20.1 cm

London
Victoria and Albert Museum
(200-1867)

PROVENANCE
Possibly to be identified with
an ivory in the Sommesson
Collection, Paris, until 1848
(sale, January 24, 1848, lot 123:
*"Ivoire. Vierge assise tenant
l'Enfant Jésus qui joue avec un
oiseau. Quatorzième siècle.
Charmante statuette pleine
d'expression et de finesse,
parfaitement conservée";* I am
grateful to Danielle Gaborit-
Chopin for supplying me with
this and the following reference);
Rattier Collection, Paris, until
1859 (sale, March 21-24,
1859, lot 192, bought by John
Webb); purchased from John
Webb, London, in 1867.

REFERENCES
Koechlin 1924, 1: 103,
2: no. 86, 3: pl. XXVIII

Longhurst 1927-29, 2:29-30,
pl. XXVIII

Randall 1974a, 291, fig. 8

Gaborit-Chopin 1978, 139,
205, no. 204

Paris 1981, 176, no. 130

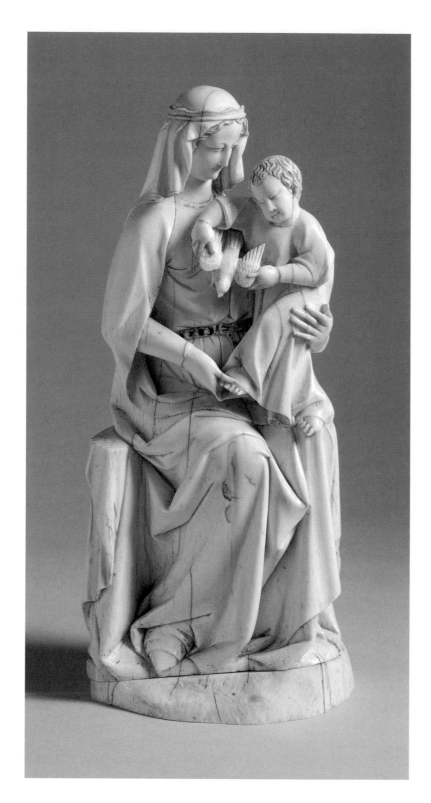

The Virgin, seated on a low throne, supports the Christ child on her left knee. The child is shown playing with a bird, holding it by its open wings. The small bird (usually a goldfinch) often held by the child in such groups alludes to Christ's future Passion because of that bird's fondness for thistle seeds, thus linking it to the Crown of Thorns. Here there is a possible allusion to Christ's Crucifixion in the outstretched wings of the bird. There are considerable remains of paint and gilding on the ivory: the hair of both the Virgin and Child is gilded, the borders of the Virgin's robe retain extensive traces of a gilded pattern, and her belt is decorated with green and gilt bands. The inside of the Virgin's robe was originally painted, but of this only a faint staining remains, and the inside of the child's tunic is red. The curved reverse of the throne upon which the Virgin sits was once painted with tracery designs of tall lancets, only the ghost of one still being visible (for similar tracery designs on the throne of a Virgin and Child in the Yale University Art Gallery, see Bucher 1957 and Randall 1993, 38, no. 10). The later base (presumably of the mid-nineteenth century) has been made separately from two pieces of ivory to replace the original wedge, the latter being necessary to counter the natural curve of the tusk and to allow the figure to stand straight.

This statuette may be related to a classic group of slightly later seated Virgins, the primary pieces being those in the Walters Art Gallery, the British Museum, the Victoria and Albert Museum (a larger example), the Thyssen-Bornemisza Collection, the treasury of the Collégiale at Villeneuve-lès-Avignon, and San Francesco in Assisi (see Williamson 1987, 188–21, no. 22). While the date of these ivories has been fixed at around 1320–30, it is likely that the present Virgin and Child was made somewhat earlier, probably about 1300. It would seem to represent a transitional point between the first High Gothic Virgins of the third quarter of the thirteenth century, such as the standing examples from the Sainte-Chapelle (figs. I-4, III-3a, IV-2) and from Saint-Denis (no. 5) and the seated "Frigolet Virgin" in Paris (Gaborit-Chopin 1978, 205 and fig. 203), and the later group, which testifies to the longevity of the basic type of Virgin and Child between about 1260 and 1340. Once this type had been established, only minor changes took place to the carving of the drapery and the poses of the Christ child and the Virgin. **PW**

| Appliqué Plaques with Scenes of the Passion of Christ

ca. 1320–40

North French (Paris?)

These appliqué plaques—all carved in a similar, but not identical style—depict scenes from the Passion of Christ and are now in collections in Antwerp and Oslo, as well as Paris, New York, and London. The fragment of the Arrest of Christ (no. 19) portrays both the taking of Christ, with Judas drawing him close amid the tumult of soldiers, and the almost marginal scene of Peter cutting off the ear of Malchus, who is often shown as a dwarf. The pictorial drama is heightened by the compression of composition and the agitation of the protagonists as well as by the emphatic gestures.

In the Deposition scene (no. 20) the body of Christ is lowered from the cross by Joseph of Arimathea, while the kneeling figure of Nicodemus removes the nail with a pair of pliers. The Virgin and Saint John frame the scene. At the foot of the cross is a schematized representation of the

19 | THE ARREST OF CHRIST

Elephant ivory with traces of polychromy and gilding

**Height 18.6 cm
Width 10 cm**

**Paris
Musée du Louvre
(OA 9961)**

PROVENANCE

Charles Mège collection, Paris.

REFERENCES

Florence 1880, no. 41

Koechlin 1906a, 67–75

Kann 1907, no. 18

Koechlin 1924, 2: nos. 227–28

Longhurst 1927–29, 2:15–16

Rorimer 1931, 29, fig. 18 and frontis

Ottawa 1972, no. 66

Porter 1977, 111, fig. 51

Paris 1981, nos. 137–38

Gaborit-Chopin 1988, esp. 42

skull of Adam. Studied physiognomies, distorted anatomies, and broad passages of drapery broken by linear folds distinguish this panel and its companion, the fragment of a scene depicting the Two Marys at the Tomb holding their ointment jars (no. 21). The high foreheads, narrow eyes, and pointed chins suggest that both originated from the same ensemble of Passion scenes. The Arrest scene is different enough from these to suggest that it may be the work of another hand; but nevertheless Koechlin believed they all may have originally belonged together.

The Deposition panel is composed of multiple pieces of elephant ivory mounted on a large flat sheet of whalebone. The photograph of 1880 in the Possenti de Fabriano catalogue (Florence 1880) reflects the original state of the piece with a different titulus on the cross and the hem and right foot of the Virgin absent. The reproduction in the Kann catalogue (1907) gives the present appearance of the ivory.

20 | THE DEPOSITION OF CHRIST

Elephant ivory and whalebone with traces of polychromy and gilding

Height 23.1 cm
Width 18.2 cm

**New York
The Metropolitan
Museum of Art
Gift of J. Pierpont Morgan
(17.190.199)**

PROVENANCE
Count Girolamo Possenti de Fabriano, Florence; Rodolphe Kann, Paris; Bligny, Paris; Georges Hoentschel, Paris; J. Pierpont Morgan, New York.

The appliqué composition is secured to the ground not by dowels but by an adhesive. Whalebone, either the jaw or the scapula, was used often for earlier medieval objects, but rarely in Gothic works. However, the material is attested in the 1302 will of Raoul de Nesle that cites "an image in ivory on a whale bone tabernacle" (Paris 1981, no. 137)

An overall impression of the original setting of these Passion scenes placed within an architectural support may be gained from the carved wood retable with thirty-six scenes of the Passion still located in the church of Mareuil-en-Brie, Marne (fig. 19-21a; Didier 1979, esp. 89ff). Dating from the second half of the thirteenth century, the retable includes the same episodes represented here but forming a narration of the Passion of Christ. Although the presentation is more naïve, it demonstrates the close relationship between the working methods of wood and ivory carvers.

21 | TWO MARYS AT THE TOMB

Elephant ivory with traces of polychromy and gilding

Height 11 cm
Width 9 cm

London
Victoria and Albert Museum
Gift of H. B. Harris
(A.99-1927)

PROVENANCE
H. B. Harris, London.

Fig. 19-21a. Retable with scenes of the Passion of Christ, French, ca. 1250–1300, wood, church of Mareuil-en-Brie (Marne)

The Parisian provenance of this group is based primarily on the compositional verisimilitude between the Deposition scene in the New York ivory (no. 20) and that in the triptych from Saint-Sulpice-du-Tarn (fig. 22–23a; Gaborit-Chopin 1988, fig. 223), a pivotal Parisian work of the early fourteenth century. Also, the related triptych of the Passion in the Thyssen-Bornemisza Collection, Madrid, affords a parallel with the nearly identical Deposition scene (Williamson 1987, no. 23; Koechlin 1924, 2: no. 220). The large Crucifixion panel in the Wallace Collection, London (Gaborit-Chopin 1978, fig. 222), closely associated to the Saint-Suplice work, offers a possible model for the Christ figure in the New York relief. Although Paris has been repeatedly cited as the origin for this ivory group, the hardness of the forms in the Deposition and the Two Marys seems more removed from the Saint-Suplice group. Reflections of the Deposition plaque may be seen in a smaller appliqué version in the Victoria and Albert Museum that is sometimes claimed to be English (A. 38-1940; Porter 1977, no. 44). Residual effects of this style are also evident in the contemporary ivories made for John de Grandisson, bishop of Exeter (see no. 38), and in the wood Annunciation group at Wells Cathedral (London 1987, nos. 526–27, 594–95). Thus, the fundamental question of whether all these large appliqués are purely Parisian in origin or are inspired by works produced there and made elsewhere is an issue not easily resolved. **CTL**

22 AND 23 | Diptych with the Virgin in Glory and the Crucifixion

1300-1325

French (Paris)

Elephant ivory with traces of polychromy

Height 24 cm
Width 12.5 cm

Paris
Musée du Louvre
(OA 11097)

PROVENANCE
Léopold Goldschmidt (1924);
Paris, Musée du Louvre,
acquired in 1986.

REFERENCES
Koechlin 1924, 1:199,
2: no. 414, 3: pl. LXXXVI

Gaborit-Chopin 1990a, no. 20

Randall 1993, 63–64, no. 52

22 | THE VIRGIN IN GLORY

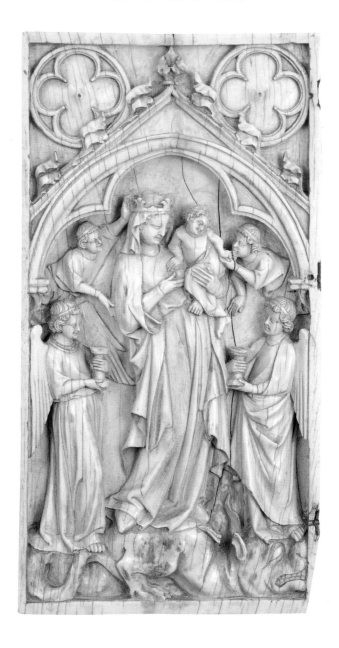

The reunification in this exhibition of the two leaves of this diptych, which is one of the most remarkable productions of the Parisian ivory workshops, is an exceptional event. Their unusual thickness of about 0.15 cm, similar dimensions, composition, and style, and the alignment of the marks left by the original hinges and clasp are proof that they belong together. Furthermore, the break at their lower corners indicates that they were carved from the same piece of ivory (as can also be seen in no. 24). The traces of polychromy that remain are also an indication of their history as a single object.

Each leaf depicts a single scene topped by a trilobate arch and a spandrel adorned with foliated crockets, with two quatrefoils above. The high relief of the figures, the energy of the carving, as well as the extreme refinement and sophistication of the draperies, the harmonious com-

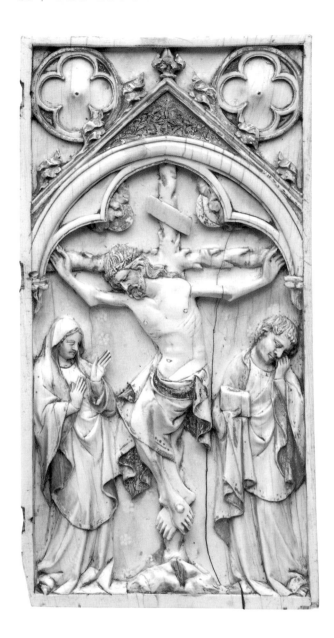

Elephant ivory with many
traces of polychromy

Height 24.2 cm
Width 12.5 cm

Toledo
Toledo Museum of Art
Purchased with Funds from
the Libbey Endowment
Gift of Edward Drummond
Libbey (50.301)

PROVENANCE
John Malcolm of Poltalloch
(County Argyll, Scotland);
exhibited in Leeds (1868); col-
lections of Baron Malcolm of
Poltalloch and Colonel Edward
Donald Malcolm (sale,
Christie's, London, May 1,
1913, lot 19); purchased from
Raphael Stora, New York, 1950.

REFERENCES
London 1879, no. 282

London 1913, lot 19

Riefstahl 1964, 15

Gaborit-Chopin 1990a, no. 20

Randall 1993, 63–64, no. 52

position, and the originality of the iconography all contribute to the exceptional quality of these ivories.

In this diptych, several iconographic traditions are brought together: the Virgin in Glory, the Virgin trampling the dragon, and the image of angels entertaining the Christ child. The Virgin is standing on a large dragon. The two angels, holding candelabras, stand perilously on the head and back of the dragon. In the upper part, an angel holds the arm of the Virgin and steadies the crown over her head, while another entertains the child, kissing his hand. The theme of the Virgin with the dragon—an allusion to the defeat of the dragon by the Woman of the Apocalypse—had already been used in thirteenth-century statuettes of the Enthroned Virgin, but the representation of the Virgin standing on top of the dragon is rarely seen: an ivory plaquette at the Musée des

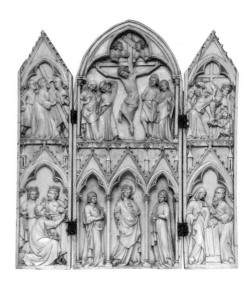

Fig. 22–23a. Triptych from
Saint-Sulpice-du-Tarn, French,
ca.1300, elephant ivory,
h. 32 cm, Paris, Musée National
du Moyen Age, Thermes de
Cluny (cl. 13101)

Beaux-Arts in Lyons shows, however, that this image was known in Paris around 1300. The angel kissing the hand of the child and, above all, his nudity are allusions to the incarnation of Christ, a theme already well in place in the Christian iconography of the first half of the thirteenth century (see Steinberg 1983).

The monumental style of these two reliefs is striking. The depth of the carving and the massive volumes of the figures find few parallels elsewhere: the modeling of Christ's torso and the transverse drapery of the Virgin's dress in the Crucifixion panel can be compared to features found in the Crucifixion group in the triptych of Saint-Sulpice-du-Tarn (fig. 22–23a). The refined carving of the head of Christ is closer yet to the Crucifixion in the Wallace Collection, London (see Gaborit-Chopin 1978, nos. 222–24). On the leaf representing the Virgin in Glory, the angels are still closely related to works of the second half of the thirteenth century (see no. 6), but the curving and sinuous figure of the Virgin and the long arching folds of her robe can be compared to those of the angels in the silver-gilt reliquary of San Domenico in Bologna made in Paris about 1300 (Lüdke 1983, no. 228). **DGC**

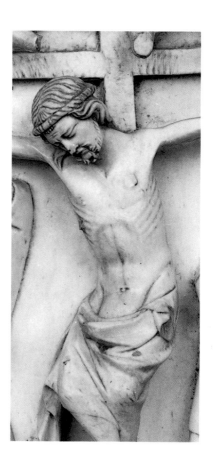

Detail, fig. 22–23a. Crucifixion.

Detail, no. 23. Crucifixion.

Diptych with Scenes of the Lives of Christ and the Virgin

ca. 1320–30

French (Paris)

Elephant ivory with traces of polychromy

Height 24.9 cm
Width 26.3 cm

Detroit
The Detroit Institute of Arts
Gift of Robert H. Tannahill
(40.165)

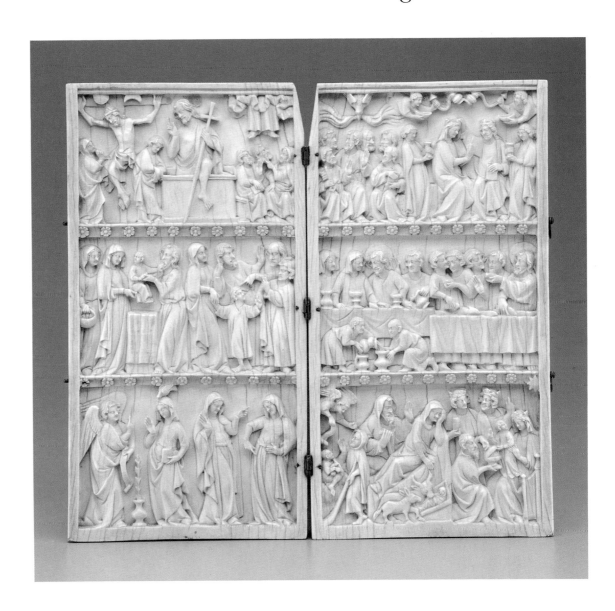

PROVENANCE

Maurice Sulzbach, Paris (until 1922); New York art market (1929); Robert H. Tannahill, Grosse Pointe, Michigan.

REFERENCES

Robinson 1941

Walsh 1984, 5

Barnet 1986, 39

Randall 1993, 67, no. 57

The inside upper corner of each leaf of this diptych, which still bears many traces of the original polychromy, is cut at an angle. This corresponds to the original shape of the ivory block before it was cut in half in order to make these two leaves (as was also the case with nos. 22–23). Moldings with rosettes divide the different scenes. These read from bottom to top and from left to right across both leaves. At the bottom are the Annunciation and Visitation, Annunciation to the Shepherds, Nativity, and Adoration of the Magi. In the middle register are the Presentation in the Temple and Christ among the Doctors, the Wedding at Cana and Last Supper. At the top are the Crucifixion, Resurrection, and Ascension; Pentecost and Crowning of the Virgin. These various scenes are deftly juxtaposed, and their skillful composition makes them easily readable in spite of the large number of figures. Their slender proportions, the ample and flowing folds of their vestments, their smiling expressions, their long, well-shaped eyes, and the fine execution of their wavy hair and beards are common to many Parisian ivories of this period.

This diptych can be compared in particular to the triptychs of the "Death of the Virgin" at the Bibliothèque Municipale at Amiens and the one at the Musée du Louvre (see no. 25) or also to the diptych (fig. 24a) with bands of rosettes illustrating scenes from the life of Christ and the Virgin from the Musée des Beaux-Arts, Lille (these diptychs were, however, executed in another workshop; see Paris 1981, nos. 143-44). These similarities point to a common origin in the Parisian workshops and a date around 1320-30. The close connection between the iconography of the diptychs in Detroit and Lille has already been noticed (see Robinson 1941): the composition of the two ivories is indeed similar and some of the scenes, although placed differently, are comparable but not identical. The iconography of the Detroit diptych is closer yet to that of the Louvre diptych (see no. 25). Though stylistically different, the Louvre diptych repeats the same composition punctuated by bands of rosettes; its iconography is identical, and the scenes are in the same order as in the Detroit diptych. The comparison of the two works, fortunately shown together in this exhibition, allows us to note some minute changes in the iconography, and also to understand that common models existed that were interpreted freely by the different workshops. Thus on both Lille and Detroit diptychs, the disciples watching the Ascension of Christ are represented seated, whereas they are standing on the one in the Louvre. In the case of the Resurrection, Christ covered with his mantle is surrounded by two angels in Lille and Paris. In Detroit, he is instead represented alone, with a bare leg rising from the grave.

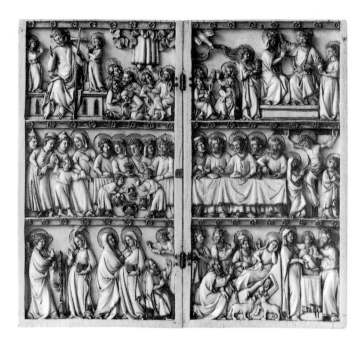

Fig. 24a. Diptych with scenes of the Life of the Virgin and Christ, French, 1320–30, elephant ivory, Lille, Musée des Beaux-Arts

The two diptychs with bands of rosettes in Detroit and at the Louvre are telling examples of the interpretation of subjects, already partly in place on the ivories of the Soissons group (see nos. 10–12), by the Parisian craftsmen, or *ivoiriers*, of the first half of the fourteenth century. Diptychs with blind arcade friezes (see nos. 31-33) give a later interpretation of these same subjects. Contrary to what is generally thought, the fact that the composition is underlined by bands of rosettes is no indication of chronology: this motif is found on many ivories before 1300 and again on ivories of the second half of the fourteenth century. **DGC**

ca. 1325–35

French (Paris)

Elephant ivory with traces of polychromy

Height 25.5 cm
Width 28.2 cm

Paris
Musée du Louvre
(OA 9959)

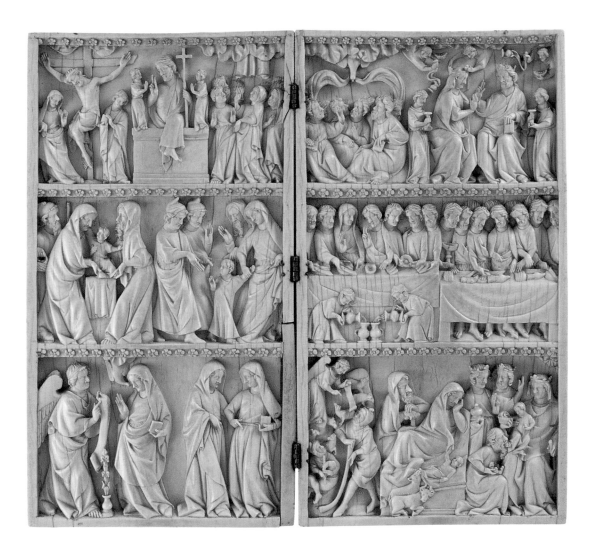

PROVENANCE
Collection of Charles Mège; bequeathed to the museum by Mlle. Elisabeth Mège, 1958.

REFERENCES
Paris 1889, no. 115

Migeon 1909, 8

Koechlin 1924, 2: no. 251

Robinson 1941, 77

Paris 1981, no. 115

Mexico City 1993, 134, no. 54

This diptych with bands of rosettes follows the same composition and the same order of scenes as the Detroit diptych (no. 24). Its iconography is therefore similar, but to a lesser degree, to the iconography of the diptych at the Musée des Beaux-Arts, Lille (fig. 24a). A careful comparison between this ivory and the Detroit diptych shows that some variations have been introduced in the number of figures, details of their attributes, costumes, and accessories, while its figure style is completely different. The figures of the Louvre diptych are less harmonious and less elegant than the figures in Detroit. This is somewhat compensated for by its more generous treatment of the draperies, with some conical folds in the Crucifixion and Visitation, and by a more simplified treatment of the volumes, particularly in the faces that feature long and prominent noses, and by the treatment of the hair in striated scrolls that replace the sophisticated undulations of the Detroit ivory. Furthermore, the figure's gestures emphasize drama over sinuous elegance. This difference in style becomes obvious, for instance, if one compares the Annunciation and Visitation scenes in each diptych, although their iconography, with the exception of some minute details, is identical.

Detail, no. 25. Marriage at Cana.

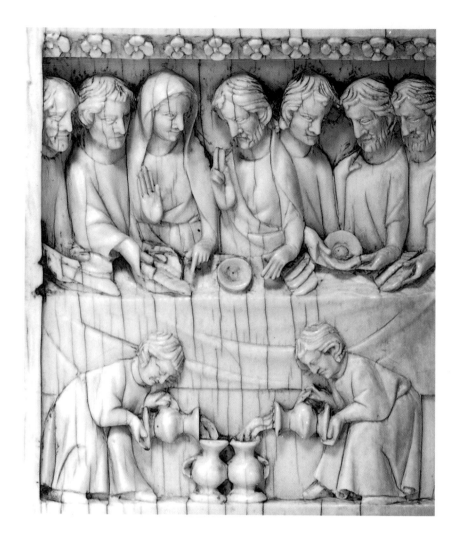

Fig. 25a. Diptych with scenes of the Passion of Christ, French, 1325–35, elephant ivory, Amiens, Bibliothèque Municipale

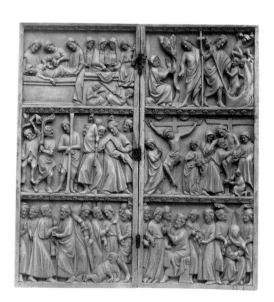

The powerful execution of the Louvre ivory prefigures the style of the group by the "Master of Mège" (see Randall 1980) and points to a slightly later date, around 1325–35. This energetic style can be seen on other Parisian ivories from the same workshop, for instance, the two diptychs with bands of rosettes illustrating scenes from the Passion at the Bibliothèque Municipale, Amiens (fig. 25a), and in the State Hermitage Museum, Saint Petersburg (see Koechlin 1924, 2: nos. 240–41).

The comparison between the Louvre and Detroit ivories, both similar in subject and different in style, is particularly significant as it sheds light on the existence of common models that could be used by different workshops. The variations brought to the representation of the same scene or subject illustrate the limits of dependency of the sculptors on those models and their freedom to express themselves.

The framing edge has been replaced from the middle left to the bottom. **DGC**

Triptych with Scenes of the Life of the Virgin

ca. 1320–30

French (Paris)

Elephant ivory with many traces of polychromy

Height 24.6 cm
Width 18.5 cm

Paris
Musée du Louvre
(OA 6932)

PROVENANCE
Bouvier collection, Amiens; Foulc collection; Arconati Visconti collection; given to the Musée du Louvre by the Marquise Arconati-Visconti in 1916.

REFERENCES
Marquet de Vasselot 1903, 12

Koechlin 1906

Koechlin 1924, 2: no. 218, 3: pl. LV

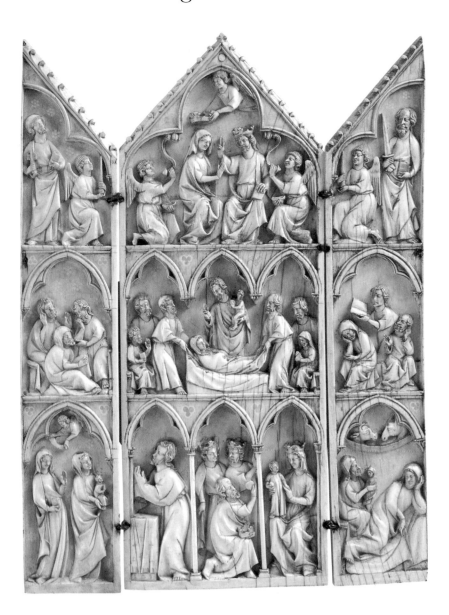

Scenes from the childhood of Christ and from the life of the Virgin are represented under large trilobate arches topped by simple crockets. The scenes read continuously across the three leaves and from bottom to top, culminating in the Coronation of the Virgin. Identifiable on the lower right is the Nativity; in the center the Adoration of the Magi; in the center and on the left, the Presentation in the Temple. Above, on the side leaves in the center, two groups of three apostles surround the Dormition of the Virgin, a scene attended by two other groups of three apostles. Christ, making the gesture of Benediction, carries in his arms the soul of his mother in the form of an infant. At the top, the Coronation of the Virgin is represented; she is surrounded by angels and flanked by Saint Peter holding a key and Saint Paul holding a sword.

The style and iconography of this triptych are close to those of tabernacles with representations of the Virgin in Glory, such as the one in Toledo (no. 17) and to the ivory groups of the so-called Death of the Virgin group (see Koechlin 1924, 2: nos. 210-19). The distribution of the scenes under broad arches and the iconography of the central part

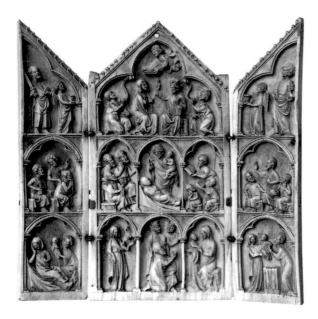

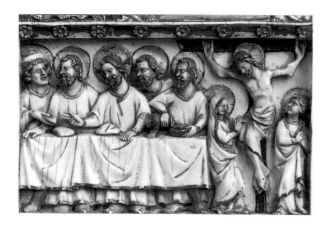

recall in fact the two triptychs representing scenes of the Death of the Virgin (according to the tradition established by *The Golden Legend* by Jacobus de Voragine), formerly in the collection of Martin Le Roy, Paris, for one, and in the Bibliothèque Municipale, Amiens, for the other (see Koechlin 1924, 2: nos. 210–11).

The Louvre triptych, however, is but a modest version of these other works: it is less deeply carved, the iconography is made simpler and its composition is occasionally awkward: for instance, the "overflowing" of the Presentation in the Temple, or the overly reduced proportions of the apostles seated in the foreground next to the body of the Virgin. A still more simplified version with the same composition and distribution of the scenes under the arches can be seen on another triptych at the Musée du Louvre (fig. 26a). It is of the same period but from a different workshop.

This ivory embodies the grace of the Parisian ivories of the first third of the fourteenth century. The proportions of the figures are slender, the draperies deftly executed, the gestures harmonious, the faces smiling. The eyes are oblong, and great care has been brought to the execution of wavy hair and beards. It recalls the style of the Toledo polyptych and Detroit diptych (see nos. 17, 24).

A date of about 1315–30 can be assigned to this triptych on the basis of the marked elongation of the seated figures' torsos in the Virgin in the Adoration of the Magi and in Christ in the Coronation of the Virgin. The proportions of these figures, their characteristic facial features, including smiles and upturned noses—perhaps slightly exaggerated— seem to be trademarks of the workshop that produced it. To the same workshop must be attributed the triptych of the Amiens Bibliothèque already mentioned and above all the diptych with bands of rosettes at the Musée des Beaux-Arts, Lille (fig. 26b; see Koechlin 1924, 2: no. 250) and the triptych of the Thyssen-Bornemisza Collection, Lugano (see Williamson 1987, no. 23). The latter, of composition similar to the Louvre triptych, as both ivories display the various scenes under arches, is dedicated to scenes of the Passion. Thus a particular workshop could use the same architectural frame for different images, just as it could use bands with roses or arches.

This triptych formerly rested on a rectangular ivory base to which it was glued and bolted. The small columns have been replaced. **DGC**

Fig. 26a. Triptych with scenes of the Life of the Virgin, French, 1320–30, elephant ivory, Paris, Musée du Louvre (OA 6931)

Fig. 26b. Diptych with the Last Supper (detail), French, 1320–30, elephant ivory, h. 24.2 cm, Lille, Musée des Beaux-Arts

27 | Saint Margaret Triumphing over the Dragon

1325–50

French (Paris)

Elephant ivory with traces of original polychromy and gilding beneath two later layers of paint

Height 14.5 cm

London British Museum (MLA 58, 4-28, 1)

PROVENANCE
Purchased in 1858 from Karl Reeve, Neuss-am-Rhein, Germany.

REFERENCES
London 1858

Dalton 1909, no. 340

Koechlin 1924, 2: no. 709

Paris 1981, no. 142

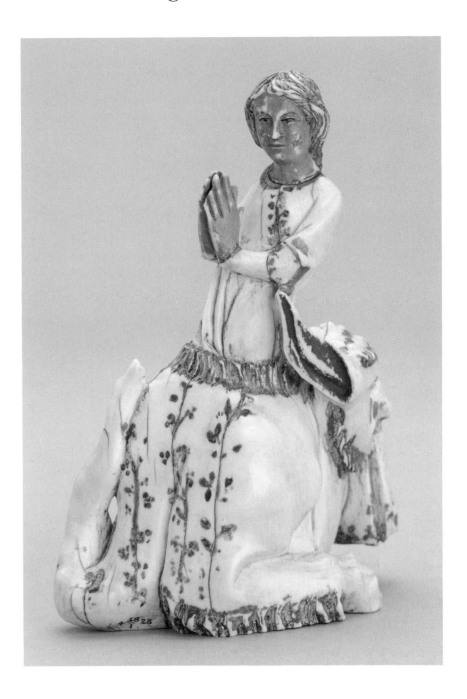

Saint Margaret of Antioch is shown at the moment when, having been swallowed by the dragon that represents the powers of evil, she invokes the cross and bursts out of the dragon's body; the dragon still has part of the saint's dress hanging from his jaws. This iconography is found frequently in fourteenth-century France, where devotion to Saint Margaret was widespread (Weitzmann-Fiedler 1966; Stones 1990, esp. 205–8). Given that the tips of the fingers of the saint's right hand are not original, it is possible that she was holding the stem of a cross (perhaps in metal), as she does in other contemporary representations (such as the one found in the British Library [Royal MS 19 B XVII, fol. 167v], a French translation of *The Golden Legend,* illuminated in Paris and dated 1382; see also Stones 1990, figs. 76–79, 81). The bottom of the ivory is crosshatched and covered with remains of glue; there was a mount

beneath the statuette. By analogy with other representations of the period, it is tempting to suggest that this was one of the side groups of a large devotional tabernacle. On the other hand, an entry in the 1379–80 inventory of Charles V of France—"Item, une ymage d'yvire de saincte Marguerite sur ung serpent"—proves that such groups could exist as single devotional images (Labarte 1879, no. 1970). The Saint Margaret ivory was in the king's study in the château at Melun when the inventory was made, and it was still there in 1400 but disappeared from view in the surviving royal French inventories after that date. Danielle Gaborit-Chopin tentatively suggested that the present sculpture could even be the "ivory image" at Melun; there is another ivory version of Saint Margaret and the dragon in the Carrand Collection (Museo Nazionale del Bargello, Florence; Supino [1898], inv. no. 94), even if it is of second-rate quality.

Here all is exquisite refinement, from the delicate cutting of the features of the saint to her elegant tresses and close-fitting dress to the boldly conceived head of the dragon. Microscopic examination of the polychromy by Juliette Lévy and Agnès Cascio has revealed that beneath two thick layers of repainting, mostly in gold, dark red, pink and blue, there exist traces of the original beautifully executed polychromy: delicate plant and trefoil forms in gold followed the lines of the original cracks in the ivory (a fashion also known from the Assisi and Villeneuve-lès-Avignon Virgins; see Gaborit-Chopin 1978, figs. 229–30; Koechlin 1924, 2: no.103), while a pattern of crescents in gold decorated the border of Saint Margaret's dress. It is probable that the present distribution of the polychromy reflects the original coloring. For remarks on the polychromy of this superb sculpture, see the essay by Danielle Gaborit-Chopin (pp. 54-56). **NS**

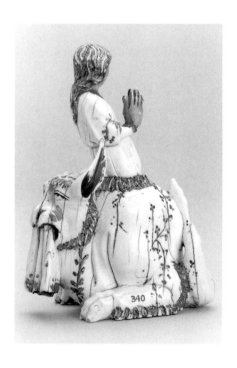

Side view, no. 27

Head of a Crosier with the Crucifixion and the Virgin between Angels

1350–60

French (Paris)

Elephant ivory

Height 13.1 cm

**Baltimore
Walters Art Gallery
(71.231)**

PROVENANCE
Collection of John Edward
Taylor, London; purchased
from Seligmann Brothers,
New York, 1913.

REFERENCES
London 1912, lot 82

Koechlin 1924, 2: no. 757

Randall 1966, 16

Wixom 1967, no. 17

Randall 1969a, no.15

Randall 1985, 208, no. 286

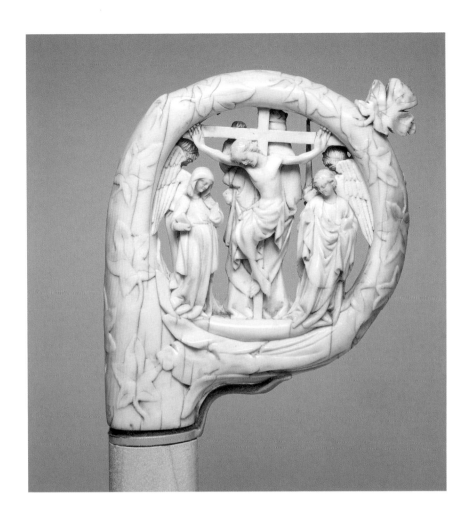

The two subjects are adroitly carved back to back, so that each seems to be an openwork relief. On one face, the Crucifixion is placed between the Virgin and Saint John, who stand with downcast eyes. On the second face, the Virgin holds a globe that the Christ child touches; she stands between two candle-bearing angels. The figures are placed within a volute carved with bryony leaves, one of which projects into the air at an upper corner. The socket of the shaft and the knop are missing, and the hands and candle are lost from the right-hand angel.

The figures are particularly graceful in this example, especially the undulating body of Christ in the Crucifixion and the candle-bearing angels. The tender interplay between the Virgin and Child is also notable and indicates a date after the middle of the fourteenth century.

While no other Parisian ivory crosier approaches this example in the quality of the figures, several seem related to it through the treatment of the volute. While some volutes are supported by angels, the present example must have had a simple socket, such as that of the monster with an open mouth on an example in the Victoria and Albert Museum (Longhurst 1927–29, 2: no. 297-1867, pl. XXIII). The bryony leaves are in very slight relief, as they cover the surface of the volute, unlike those

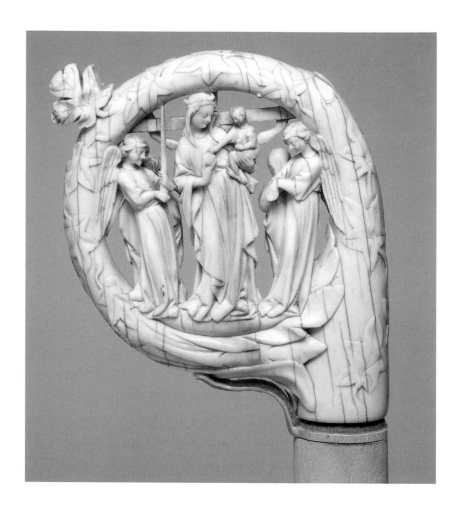

on other ivories carved in projecting relief or even undercut. Two other examples are treated in exactly the same way, though the figures are by different hands, suggesting that the three are possibly by the same leaf carver and come from the same atelier. One of these is the Victoria and Albert crosier with the single subject of the Virgin between angels, just referred to. In that example, the Virgin figure is strikingly different, but the angels are closely similar to the Walters crosier. The second is a crosier in Metz cathedral (Paris 1965, no. 843, pl. 143, where the text describes a different crosier of the twelfth century), on which the leaves are again treated similarly, and the drapery of the Virgin in the Crucifixion is nearly identical to that of the Virgin between angels in the Walters example.

In addition to the similarity of the leafage, the three volutes end in exactly the same way with a plain area of long leaves on the base of the volute, which splay outward where they meet the shaft of the crosier.

Margaret Longhurst (1927-29, vol. 1) suggested that the Victoria and Albert crosier is somewhat earlier than the other two examples. The S-type stance of the Virgin, however, could also be seen as a mid-century interpretation of a late-thirteenth-century model. **RHR**

29 | Angel

ca. 1350–75

French (Paris)

Elephant ivory with traces of polychromy

Height 15 cm

**New York
The Metropolitan
Museum of Art
Gift of G. and F. P.
Blumenthal
(41.100.164)**

PROVENANCE
Vicomte Baré de Comogne,
Ghent; Demotte collection
by 1920.

REFERENCES
Liège 1905, no. 1460

Ghent 1913, 7

Casier and Bergmans 1913,
pl. VII

Koechlin 1924, 2: no. 852,
3: pl. CLIII

New York 1943

Paris 1981, no. 158

This angel is a sculpture that was conceived in the round: even though its back is relatively flat, the angel was meant to be seen from all sides. It may have been originally integrated into an architectural composition that partially concealed the flatness of its back, particularly when wings were attached to it.

Standing on a plinth, the angel wears a floor-length robe that reveals his bare toes. The frontal aspect of the sculpture is softened by the

naturalistic folds of the robe, the slight protrusion of the knee, and the movement of the head, projecting forward and turning slightly. The hood of the cope has rounded tassels of a type that had already appeared before 1300 on one of the angels of the reliquary at Nivelles in Belgium (see Cologne/Paris 1996). On either side of the hood, near the shoulder blades, an abraded surface indicates the original placement of the wings: from the reworked areas it can be concluded that the wings were carved from the same block as the statue itself. It is also clear that they were set on either side of the angel's head so that the hood was visible. The slightly hard execution of the mantle's folds in the back enhances by contrast the subtlety and sophisticated simplicity of the front and sides and reveals a sculptor of exceptional talent. His talent can also be witnessed in many details of the angel's head. An incised line makes the eyes more oblong; a slight depression on the surface of the ivory creates a delicate shadow over them. The nose is pointed and well drawn; the mouth is elongated and the chin strong, in a manner typical of fourteenth-century French art; the youthful cheeks are imbued with an almost humorous expression of curiosity; the thick curls are held together by a diadem. Originally a lock of curled hair, now unfortunately broken, fell over his forehead. This type of hairstyle was common in the second half of the fourteenth century and at the beginning of the fifteenth.

Fig. 29a. Flavigny Angel, French, 1375-1400, marble, h. 61 cm, New York, The Metropolitan Museum of Art (17.190.390)

Fig. 29b. "Ange aux burettes" from the abbey of Maubuisson, French, ca. 1340, marble, h. 52.7 cm, Paris, Musée du Louvre

The large central hole above the waist was used to affix a cross or a reliquary that the angel presumably held. The two holes on the sides at the level of the elbows allowed the insertion of the angel's forearms and hands, which had been carved separately in order to simplify the placement of the reliquary. Most likely another angel, with his head turned in the opposite direction, held the other side of the cross of the reliquary, according to a type well established in Gothic art since the second half of the thirteenth century.

The attribution advanced by Koechlin (1924) of the Metropolitan Museum angel to the Annunciation group from Langres of the beginning of the fifteenth century is not convincing. The Langres angel appears to be a late caricature of the New York one. The Metropolitan Museum angel can be compared more closely to examples of French sculpture from the second half of the fourteenth century. The hairstyle, facial details, and its general quality are comparable to two works of the last quarter of the century: the Flavigny angel of the Metropolitan Museum of Art (fig. 29a) and the head of the angel in the Musée d'Evreux (see this author's discussion in Paris 1981, no. 82). The head of the ivory angel is, however, more sharply angular. The delineation of his elongated eyes is still a clear reference to the art of the first half of the century. Likewise, the folds of his vestments are austere if compared to those of the Flavigny angel and are closer to earlier works such as the

IMAGES IN IVORY: PRECIOUS OBJECTS OF THE GOTHIC AGE

funerary groups of the tomb of Clement VI at the Chaise-Dieu (Haute-Loire, ca. 1347–51) and above all to the "Ange aux burettes" from the abbey of Maubuisson, attributed to Evrard of Orleans (ca. 1340; fig. 29b). The long, straight folds of the Maubuisson angel's vestments are rendered in a similar manner, with a slight fold at the bottom (see another example in Paris 1981, no. 47).

Obviously executed by a first-rate artist, this ivory of high quality can be considered an innovative work belonging to the very beginning of the artistic movement that dominated the second half of the fourteenth century. This style appeared around 1330–55 at the court of Jean le Bon, as illustrated, for example, by the illumination of the "Maître du remède de Fortune" (fig. 29c; see Avril 1982). The work of that painter exhibits profiles with pointed noses and strong chins and the same kind of thick curls observed on the angel. Given the angel's ties with earlier works of the middle of the century, such as the "Ange aux burettes," its date could therefore be as early as about 1350.

Fig. 29c. *Le remède de fortune* (detail), French, 1350–55, Paris, Bibliothèque Nationale, MS Fr. 1586

While there are some ivory statuettes representing angels dating from the thirteenth century (see nos. 5, 16), fewer fourteenth-century examples are known. The inventory of the treasury of Charles V included, however, the "jewel" made in 1351 for Jean le Bon on the occasion of the "fête de l'Ordre de l'Etoile." It was composed of a cross and a star adorned with precious stones held by two ivory angels (see Labarte 1879, no. 131). It was made by one of the two goldsmiths entrusted with the making of the works specially ordered for the occasion, Guillaume de Vaudétar, or more likely Jean le Braelier (who was also known for carving ivory; see Gaborit-Chopin 1987, 49). If we consider the original function of the Metropolitan Museum angel, who certainly held a cross or a reliquary and whose position with a turned head strongly suggests that a pendant figure originally existed, and if we also consider the remarkable quality of this sculpture and the compatibility of its style with the production of sculpture around the middle of the century, it is not impossible to think that it was one of the angels that supported Jean le Bon's "Joyau de l'Etoile." **DGC**

ca. 1360–80

French (Paris)

Elephant ivory

Height 21 cm
Width 27.4 cm

Paris
Musée du Louvre
(OA 4089)

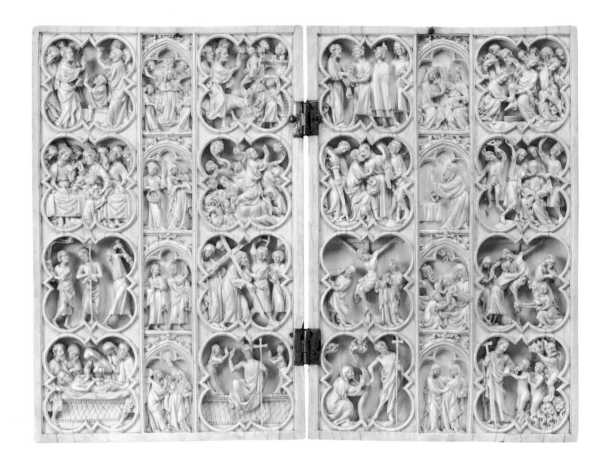

PROVENANCE
Collection of Justin Bousquet, Rodez; acquired by the Musée du Louvre in 1889.

REFERENCES
Koechlin 1924, 2: no. 819, 3: pl. CXLII

Grodecki 1947, 105

Vienna 1962, no. 345

Paris 1981, no. 160

The composition of this superb diptych is highly uncommon: on each leaf, two vertical rows of four quatrefoils devoted to the story of the Passion of Christ are separated by a column upon which scenes from the life of the Virgin are represented under arches. The story of the Passion is intended to be read across both leaves, from left to right and from top to bottom: the Raising of Lazarus; Entrance into Jerusalem; Betrayal of Judas; Washing of the feet; Last Supper; Agony in the Garden; Kiss of Judas; Mocking of Christ; Flagellation; Carrying of the Cross; Crucifixion; Descent from the Cross; Burial of Christ; Resurrection; Noli Me Tangere; Descent into Limbo. By contrast the scenes from the life of the Virgin unfold from left to right, occasionally on both leaves simultaneously, but from bottom to top: the Annunciation; Visitation; Adoration of the Magi; Presentation in the Temple; Assumption; and Coronation of the Virgin. This diptych presents one of the most complete repertories of images in ivory of the fourteenth century (see Stahl essay, pp. 107-9).

Quatrefoils were rarely used in religious ivories. The general composition recalls here the illuminations of the *Heures de Jeanne de Navarre* by Jean le Noir (ca. 1336-40, Bibliothèque Nationale de France, Paris, ms. Nouv. Acq. lat. 3145) and the *Petites Heures de Jean de Berry*, also in part by Jean le Noir (Bibliothèque Nationale de France, Paris, MS lat. 18014; see Avril 1978, 20-22, 35, 37). The iconography of this ivory also refers to the works by Jean le Noir although the artist responsible for the

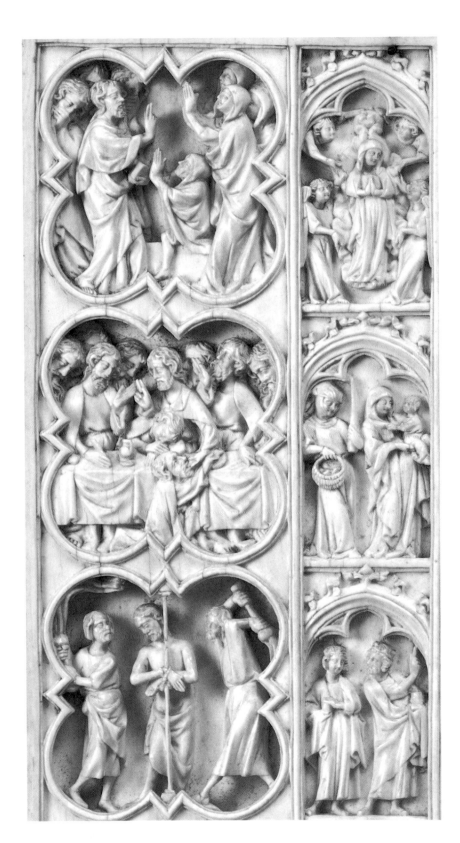

Detail, no. 30. Top to bottom, left side: the Raising of Lazarus, Last Supper, Flagellation; right side: the Assumption of the Virgin, Presentation in the Temple, Adoration of the Magi.

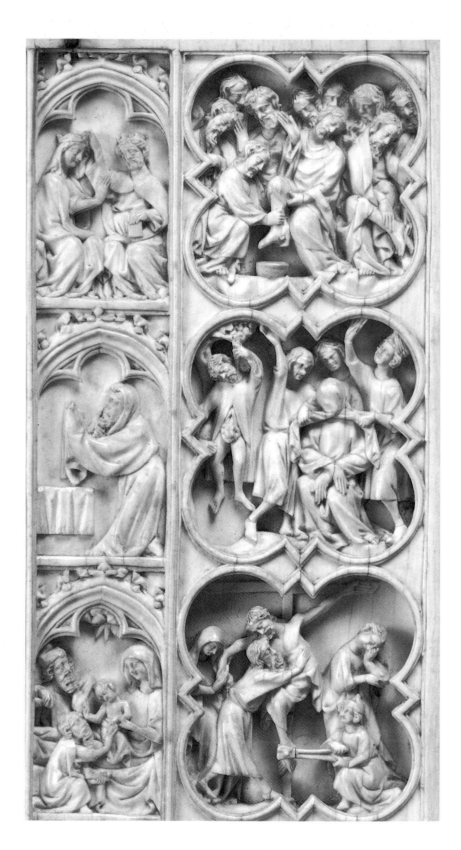

Detail, no. 30. Top to bottom, left side: the Coronation of the Virgin, Presentation in the Temple, Adoration of the Magi; right side: Washing of the Feet, Mocking of Christ, Descent from the Cross.

ivory occasionally resorted to more traditional elements. For instance, he did not represent his subjects in the kind of tight-fitting garments one sees in the later illuminations (such as the Arrest of Christ and the Mocking of Christ in the *Petites Heures de Jean de Berry* or the Adoration of the Magi in the *Heures de Jeanne de Navarre*). The representation of the Crucifixion follows the traditional image found on Parisian ivories. The influence of Jean le Noir can be sensed also in the way the ivory carver created long, silky drapery topped by slightly exaggerated heads with bony noses, high cheekbones for the men, and pointed noses and rounded cheeks with double chins for the women. The ivory is also characterized by rather exaggerated poses and very animated movement.

No less remarkable than its composition, style, and rich iconography is the skillfulness of its execution. This can be seen in particular, in spite of the small dimension of the figures, in the high relief of the sculpture in the quatrefoils, full of nuances and extraordinary precision in the rendering of the details (for instance, the veiled face of Christ in the Mocking scene). The diptych ranks among the greatest of the so-called Passion Ivories. To this group belong, among others, a diptych in Berlin (Koechlin 1924, 2: no. 788), the diptychs in Baltimore (no. 31), Toledo (no. 32), Minneapolis (no. 33), and the small diptych of the Ascension and Pentecost at the Louvre (fig. 30a), which can be identified with an ivory described in the inventory of the treasury of Charles V written in 1380 (see Paris 1981, no. 161). The Germanic features that have been noticed in that group (Randall 1985, no. 309) can easily be explained by the international milieu of the court of Charles V and of the beginning of the reign of Charles VI. **DGC**

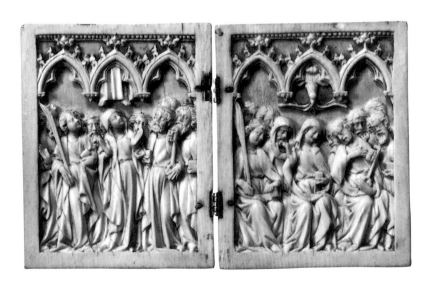

Fig. 30a. Diptych with the Ascension and Pentecost, French, ca. 1360–80, elephant ivory, h. 7.1 cm, Paris, Musée du Louvre (OA 2599)

31 | DIPTYCH WITH SCENES OF THE PASSION OF CHRIST

ca. 1350–65

French

Elephant ivory

Height 24.8 cm
Width 11.4 cm (each leaf)

Baltimore
Walters Art Gallery
(71.179)

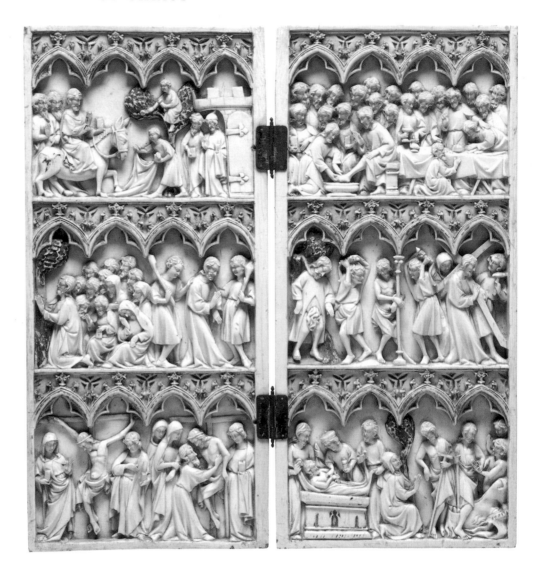

REFERENCES

Vich 1893, no. 176

Koechlin 1924, 2: no. 814

Baltimore 1962, no. 116

Verdier 1963, 30, fig. 4

Randall 1985, no. 299

In the third and fourth quarters of the fourteenth century, the ivory ateliers of Paris created diptychs of large scale, comparable to the Soissons group of ivories of the thirteenth century (nos. 10–12), but a number of new scenes were added to the Passion cycle. Koechlin felt that the ivories must all have emanated from a single workshop and praised the new conceptions of the group. He named the innovative mind behind this group of works the "Passion Master" and attributed a large number of ivories to this Parisian workshop (Koechlin 1924, 2: nos. 284–98). The earliest ivory of the group that appears in a document is a Passion diptych in the 1380 inventory of the estate of Charles V. Jean de France, duc de Berry also owned a Passion diptych in 1416, and others belonged to lady Marie de Sully in 1409 and a Monsieur de Coucy, who willed his to Noyon cathedral in 1402 (ibid., 285).

The Walters diptych (no. 31) is a large and early example of a Passion diptych made by an atelier that may be slightly earlier than the Passion

Elephant ivory

Height 24.6 cm
Width 24.8 cm. (open)

Toledo
The Toledo Museum of Art
Purchased with funds from
the Libbey Endowment
Gift of Edward Drummond
Libbey (50.300)

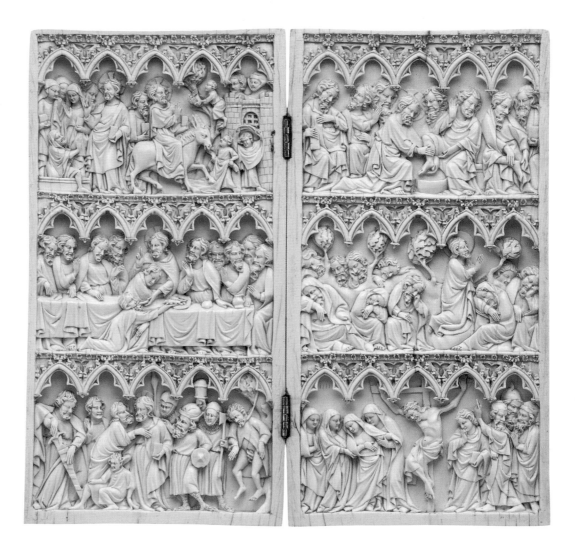

PROVENANCE
Collections of Frédéric Spitzer,
Paris, until 1893; Julius Campe,
Hamburg; Emile Baboin, Lyons,
before 1912; purchased from
Raphael Stora, New York, 1950.

REFERENCES
Molinier 1890, 50

Koechlin 1906, 49

Koechlin 1912, no. 19

Koechlin 1924, 2: no. 792

Riefstahl 1964, 15

Wixom 1967, 214-15, no. V 24

Apollo 1967, 440, fig. 7

Randall 1993, no. 103

Master's workshop. There are a number of pieces from this workshop, mostly diptychs with four scenes, and only the left wing of a three-tier diptych in Liverpool is conceived in as grand a scale (Gibson 1994, no. 32).

The Walters example shows thirteen scenes of the Passion beneath arcades of four trefoil arches. Reading from top to bottom and left to right, the scenes include the Entry into Jerusalem, Washing of the Feet, Last Supper, Garden of Gethsemane, Arrest of Christ, Hanging of Judas, Flagellation, Way to Calvary, Crucifixion, Deposition, Entombment, Noli Me Tangere, and Descent into Limbo. It follows the program of the Liverpool ivory, which lacks the trefoil decoration above the arches and has a band of beading on its inner edge, suggesting that it is perhaps an earlier work from the shop. Certain details, such as the broad underbelly of the donkey in the Entry scene and the hat on the central figure in the Entombment are nearly identical and indicate the use of the same model in the workshop.

All of the other related works, a triptych in the Fitzwilliam Museum, Cambridge (Koechlin 1924, 2: no. 286); a diptych, half in the Victoria and Albert Museum and half in the Liverpool Museum (ibid., no. 290); and a diptych in the Musée du Louvre (OA 10006) share the same architectural format as well as the treatment of certain scenes, especially the Virgin aiding Christ in the Way to Calvary, and the details of the Deposition, Flagellation, and Entombment. The Arrest of Christ by two men with clubs in this ivory is unusual in that it omits the Kiss of Judas.

There are unusually rich remains of the polychromed scheme of the diptych. The arches were painted red and blue with green used on the crockets and incised trefoils, and all the colors exhibit traces of gold highlights. The green of the trees is particularly well preserved, again picked out with gold details. The figures also were fully painted, and there are many traces of color on the garments, including red on Christ's robe in several scenes and gilt and brown in the hair of many figures. The surface mounted hinges are replacements.

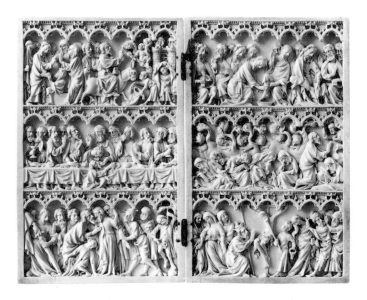

Fig. 31-33a. Diptych with scenes of the Passion of Christ, French, 1360–65, elephant ivory, h. 20.7 cm, Staatliche Museen zu Berlin, Preußischer Kulturbesitz

Recent study has confirmed that the very productive Passion Atelier was working for thirty-five or forty years and created two series of works. The earlier Passion cycle begins with the Raising of Lazarus and the Entry into Jerusalem and ends with the Crucifixion. The later group adds three scenes of the Infancy and two of the Afterlife of Christ.

However, within the Paris ivory industry, there was a considerable overlap of designs and much copying of what the atelier across the street was producing. Drawings and models of the latest scene were moved from one place to another, as clay models of Paris ivories found in Liège (see fig. V1-2) and in the Scheldt River attest (Randall 1985, 180–82), and a number of workshops are now thought to have carved Passion diptychs. Some of these were very individual and created different compositions for the scenes and different characters as part of the drama; others merely copied the major workshops but produced diptychs of lesser quality. One interesting provincial example follows a Passion diptych exactly but in a small size with the tiers divided with rows of huge roses in the manner of the first quarter of the fourteenth century (the Metropolitan Museum of Art, 17.190.289). German carvers also imitated work of the group, as the Walters-Lyons diptych (no. 45 and fig. 45a) illustrates, where the Master of Kremsmünster follows the tradition of the Passion diptychs and adds his own cast of characters and a baroque play of light and shade (see Little essay, pp. 91–92).

The sources of the Passion Atelier's iconographic programs, and even minor details of the compositions, are traceable to earlier monumental sculpture. The scene of the Arrest of Christ, which was used continually throughout the production of the workshop, is based on the tympana

ca. 1375–1400

French (Paris)

Elephant ivory

Height 21.4 cm
Width 22.3 cm

Minneapolis
The Minneapolis
Institute of Arts
The Centennial Fund
(83.72)

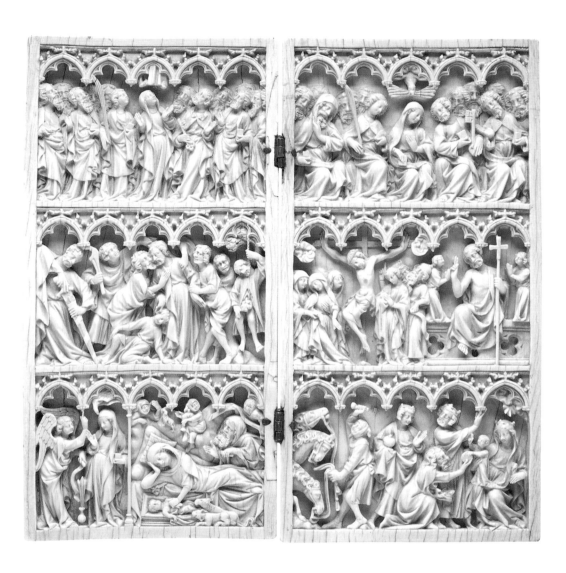

PROVENANCE

Collections of Felix Ravaisson-
Mollien, Paris, until 1903; Paul
Garnier, Paris, until 1917;
Jacques Seligmann, Paris;
Cranbrook Academy of Art,
Bloomfield Hills, Michigan, until
1972; purchased from Ruth
Blumka, New York, 1983.

REFERENCES

Paris 1900, 19, no. 133

Migeon 1900, 460

Migeon 1906, 13

New York 1972, lot 97

Randall 1983–86

Randall 1993, 106, no. 147

of the right west portal of the cathedral of Mantes and the Portail de la
Calende at the cathedral of Rouen (both about 1300; see fig. III-8). The
scene of the Adoration of the Magi and the Angel of the Annunciation
are also based on those tympana, and the subjects used later in the ate-
lier of the Ascension and Pentecost follow the program of the Portail de
la Calende. The figure style also reflects observation of the monuments
of the beginning of the century, including Saint Jacques l'Hôpital in
Paris (1332–35) and the abbey of Jumièges (1326–27), both by the
atelier of Robert de Lannoy and Guillaume de Nourrich.

The Toledo diptych (no. 32) is one of those that follows the iconogra-
phy of the Passion Atelier exactly but exhibits a greater density in its
compositions and a crisper delineation of faces and drapery. The archi-
tectural frame is more complex, with a greater play of light on the
deeper, steeply pointed arcades and bands of tiny roses on the lintels
that divide the episodes. The scenes follow the model of the diptych in

the Staatliche Museen, Berlin (fig. 31-33a), which is a classic example of work from the Passion Atelier and thought to date about 1360-65. The upper tier begins with the Raising of Lazarus and the Entry into Jerusalem on the left wing and the Washing of the Feet on the right. At the next level are the Last Supper and the Agony in the Garden, while the Arrest of Christ, Hanging of Judas, and Crucifixion complete the bottom level of the diptych.

Comparing the Toledo ivory to that from Berlin, one discerns various compositional changes to emphasize the figure of Christ. The Crucifixion is the most altered scene, and the centurion and sponge bearer have been eliminated, Christ made the size of the other figures, the group of Marys increased to four, and the figure of Saint John made far more dramatic.

These subtle changes are combined with a crisp carving technique, as opposed to the soft, undulating forms of the Berlin ivory, which are typical of early work from the Passion Atelier. The scenes of the Toledo work are strengthened with more attention to the heads of the figures and their facial expressions, and the figures are more tightly packed, both laterally and against the overhanging arcade.

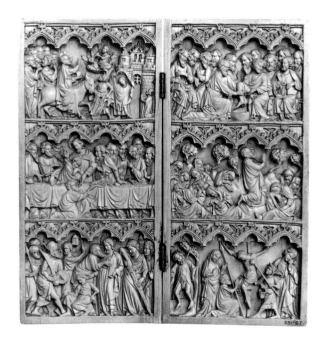

Fig. 31–33b. Diptych with scenes of the Passion of Christ, French, 1360–70, elephant ivory, h. 25.5 cm, London, Victoria and Albert Museum (291-1867)

A second work by the master of the Toledo diptych is one in the Victoria and Albert Museum (fig. 31–33b), somewhat less synthesized and, therefore, perhaps a little earlier, but with many of the same features. In both the Toledo and Victoria and Albert Museum diptychs, the Christ figure is designated with a cruciform halo, a feature generally found only in German ivories. This raises the difficult question of the origin of the carver and where he was working, as such a halo is a detail that the artist could have borrowed from a German source; he could also have been a German working in Paris or a Paris-trained artisan working in Germany. It is clear, however, that he thoroughly understood the program of the Parisian Passion ivories.

The Minneapolis diptych (no. 33) is an example of the perfected program of the Passion Atelier for its second group of works. It should be noted at once that the diptychs in the British Museum and the Petit Palais (Dutuit Collection; see Randall 1983–86, figs. 7–8) are virtually identical to that in Minneapolis and that it is the arrangement with the Afterlife scenes at the top of the ivories that seems to have been the final scheme preferred by the workshop.

The changes in the program from the Walters diptych (fig. 31-33c) that are reflected in all three of the ivories of the second design are, first, to place the Afterlife scenes at the top and those of the Infancy at the bottom. Next, it was considered necessary to place a column between the Annunciation and the Nativity. The scale of the Crucifixion was

increased and the space of the Resurrection reduced, while the upper scenes of the Ascension and Pentecost remained rather consistent. The general changes in the Arrest scene have been thoroughly discussed with reference to the Minneapolis ivory and need not be repeated here (Randall 1983–86, 12–14).

There are minor changes in composition in each of the diptychs, as might be expected. Most occur in the Adoration scene, where a stable is provided for the horses in the Petit Palais example, and the positions of the standing kings are changed in each ivory. The patterning of the sarcophagus in the Resurrection scenes also changes and so does the arrangement of the Three Marys at the Crucifixion.

To fully understand the Passion Atelier, one must examine all of its works. A very informative tiny diptych in the Musée du Louvre (fig. 30a) shows scenes of the Ascension and Pentecost. At a slightly reduced scale, this is identical to the scenes on the larger diptychs and reminds us that all customers were not equally wealthy and did not require exactly the same thing in their lives. This small diptych, of the same quality of larger works from the atelier, suggests that its output was both flexible and large. Many of the smaller diptychs have undoubtedly been lost, as the larger ones are more likely to have survived. This remarkable Parisian atelier not only produced works over a long period but has left far more works than any other. Its output was more copied than any other, as far away as the Rhine Valley, and perhaps even farther. **RHR**

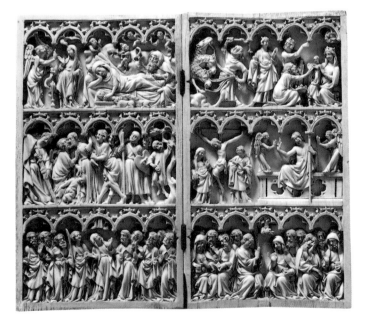

Fig. 31–33c. Diptych with scenes of the Passion of Christ, French, ca. 1375–1400, elephant ivory, h. 19.7 cm, Baltimore, Walters Art Gallery (71.272)

ca. 1300

Giovanni Pisano
(ca. 1250–after 1314)

**Italian
(Pisa or Siena)**

Elephant ivory

Height 15.5 cm

**London
Victoria and Albert Museum
(212-1867)**

PROVENANCE
Purchased from John Webb,
London, in 1867.

REFERENCES
Pope-Hennessy 1965, 9–16
(with older literature)

Lisner 1970, 44, n. 39

Seidel 1972, 1

Carli 1977, 67–69, pls. 73–74

Gaborit-Chopin 1978, 160, 211,
figs. 250–51

Marques 1980, 17, fig. 8

Williamson 1982, 46, pl. 30

Gaborit-Chopin 1984, 58, fig. 3

Seidel 1984, 222

Florence 1987, 24

Williamson 1994, 293, fig. 1

Williamson 1995, 260–61,
pl. 383

Williamson 1996a, 56

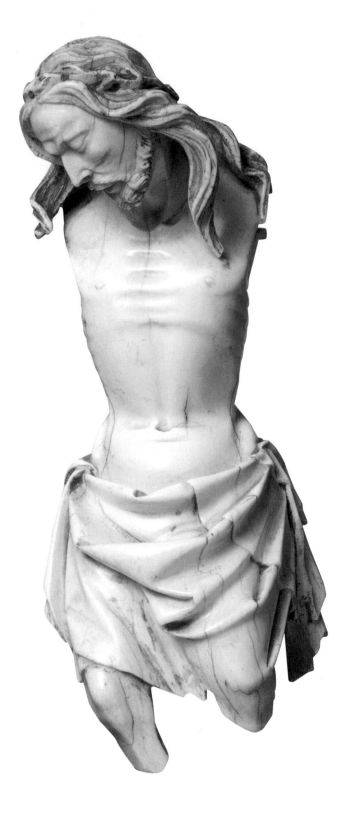

John Pope-Hennessy was the first to attribute this figure of the crucified Christ to Giovanni Pisano, on the strength of its close similarities to sculpture on the Pisa cathedral pulpit of about 1302–10 and to the sculptor's wooden crucifix in the Museo dell'Opera del Duomo in Siena (Pope-Hennessy 1965). Given these persuasive comparisons and the sublime quality of the carving, there can be little doubt that it is indeed his work. Pope-Hennessy tentatively suggested that the present figure belonged to the same complex—a large tabernacle—as the only documented work in ivory by Giovanni Pisano, the great Virgin and Child now in the Museo dell'Opera del Duomo in Pisa, which formed the centerpiece of the ensemble and was completed in 1298 (fig. III-2). It is more likely, however, that it was intended to stand alone, in the manner of Giovanni's larger polychrome wood crucifixes (for a summary of the arguments, see Williamson 1995, 260 61). It is of interest that in the first inventory of the Pisa cathedral treasury drawn up in around 1313 there is mention of "crux una parva cum imaginibus de ebore" (one small cross with a figure of ivory), although it is of course impossible conclusively to associate the present figure with that reference (see Barsotti 1956, 524).

Two further ivory carvings have been attributed to Giovanni Pisano. The first, another fragmentary crucifix figure, is anatomically less well understood than the London Christ but has been related by Max Seidel to Giovanni's youthful work on the Siena cathedral pulpit of 1265–68,

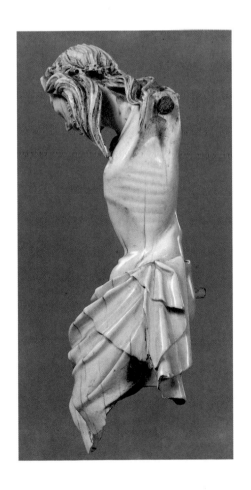

leading him to propose a date for it of about 1270 (Seidel 1984). The second is a copy of the marble Madonna della Cintola in Prato cathedral and does not appear to be medieval (Marques 1980).

The Corpus of Christ, carved fully in the round, is now missing its arms and legs below the knees. The latter have been roughly broken off, perhaps when the figure was torn from its cross, while the arms were made from separate pieces of ivory and doweled into position at the shoulders in the same way as the Victoria and Albert figure from a crucifix (no. 36). Wooden plugs of later date fill the holes. The body was originally attached to the vertical shaft of the cross with a dowel set into a hole at the center of the reverse of the loincloth, now plugged with an ivory peg. There are considerable traces of red bole in the hair and beard and red paint in the wound in Christ's side. The crown of thorns on Christ's head had separately made thorns of ivory set into it: most of these are now broken or missing, but two complete thorns survive at the back. **PW**

ca. 1300

English (London?)

**Elephant ivory with
dark brown patina**

Height 27.3 cm

**New York
The Metropolitan
Museum of Art
The Cloisters Collection
(1979.402)**

PROVENANCE
Said to have been offered to
Jean III de Dormans at the time
he was made bishop of Lisieux
in 1359; G. J. Demotte, New
York; John and Getrude Hunt,
Dublin.

REFERENCES
Detroit 1928, no. 69

Porter 1977, 96–102, no. 33

Wixom 1980, 23

Stratford 1983

Wixom 1987, 337–58

London 1987, no. 518

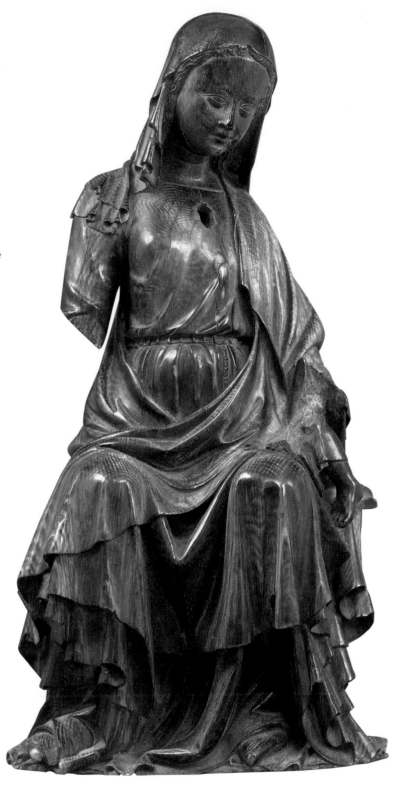

Few Gothic images of the Virgin and Child accomplish the grandeur of presentation—despite the loss of the child—as this ivory. From the fragment of a leg of the child it is evident he was standing, but nothing more can be said of the physical relationship of the two figures

The enigmatic assertion that the ivory was offered to Jean III de Dormans on the occasion of his installation as bishop of Lisieux in 1359 may have been based on some truth. It is known that Jean III de Dormans was bishop-elect in 1359, was elected bishop of Beauvais, not Lisieux, in 1360, and was shortly thereafter made chancellor of France by Charles V (Deshays 1872). Independent confirmation of the claim of its provenance made by the antiquarian and dealer G. J. Demotte has yet to yield fruit (see Wixom 1987, 351–52, n. 32). Perhaps of significance is the existence of another contemporary seated Virgin, also stained brown and with a broken-off child, that was in the Baudry Collection in Rouen, which is in the same diocese as Lisieux (Rouen 1932, 64). The possible presence of two related statuettes in the same region may support the reputed provenance.

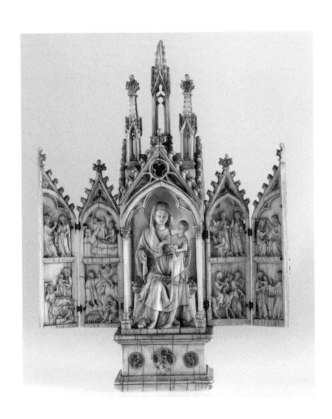

Fig. 35a. Polyptych with scenes of the Infancy of Christ, English, 1325-50, elephant ivory, h. 21.3 cm, Pittsburgh, The Carnegie Museum of Art (56.3.1)

Clearly the figure originated from a tabernacle setting as seen in a more complete example on a smaller scale, also attributed to England (fig. 35a; Randall 1993, no. 33). The English attribution of the Virgin has been established on the basis of a comparative analysis with known English sculpture, especially by Wixom. The geometry of the ovoid face punctuated by a high forehead and pinched eyes and mouth compares generally to the Virgin in the leaves of a polyptych made for John de Grandisson, bishop of Exeter (1327-69), in about 1330-40 (London 1987, nos. 594–95). The deep lyrical folds of the mantle have been related both to the sculpture of Glastonbury Abbey and another ivory of a seated Virgin at Yale University Art Gallery (Stratford 1983, 213) and to contemporary works in London, such as the gilt bronze effigies at Westminster Abbey (Wixom 1987, 356), or the mid-fourteenth-century altarpiece from Saint Mary's, Sutton Valence, Kent (London 1987, no. 698). The persistent links to French works are evident, yet it is difficult stylistically to isolate French and English features given the constant courtly exchanges between Paris and London. Whether this elegant carving can be associated with the court of Edward I at Westminster, as suggested by Wixom, or is a later manifestation of this refined style, closer to the time of John de Grandisson, must remain open.

Only a fragment of the lower part of the child remains on the left knee of the Virgin; her right arm and left hand are missing; the cavity in the upper chest may have contained a jewel or a relic; the throne, made separately and probably of a different material, is missing. The dark reddish-brown patina of the statuette is possibly the result of a stain, such as walnut oil, applied to the surface, which is recommended by Theophilus in his *De diversis artibus* (Dodwell 1986, ch. XCIV). The darkest areas on the back may have been caused by exposure to heat. CTL

ca. 1300

**French (Paris)
or English (London)**

Elephant ivory

Height 24.3 cm

**London
Victoria and Albert Museum
(A.2-1921)**

PROVENANCE
Collection of Thomas Gambier-
Parry (d. 1888), Highnam
Court, Gloucestershire;
purchased by the Victoria
and Albert Museum in 1921.

REFERENCES
London 1987, 112, no. 310,
328–29 (with older literature)

Gaborit-Chopin 1990,
51–52, no. 19

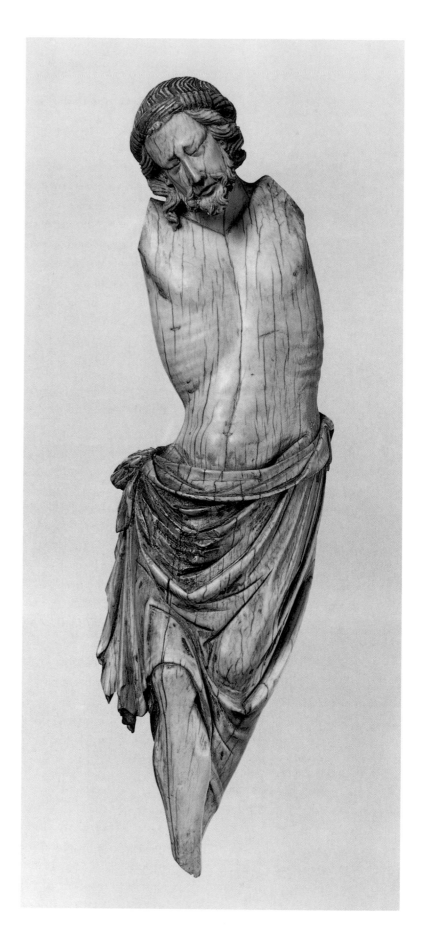

This extremely fine and moving crucifix figure is a rare surviving example of what must have been one of the most common types of medieval small-scale sculpture. Christ is shown at the moment of death, his eyes closed and his head slumped to one side. The carving of the skin and musculature of the torso are masterly, the rib cage shown pressing through the tightly drawn flesh of Christ's chest. Although there can be no denying the surpassing quality of the figure, it has not proved possible to establish beyond doubt its place of production, despite claims for an English provenance. It was certainly made in either France or England, but the problem of separating the style of one from the other in the years around 1300 is here highlighted. The ivory carvings closest to the present figure are a recently acquired head of Christ from a crucifixion figure, now in the Musée du Louvre in Paris (Gaborit Chopin 1990a), and a smaller Christ of a Deposition group in the Kunstindustrimuseet in Oslo (Paris 1981, no. 136): the former is probably slightly earlier in date than the London figure, the latter perhaps a few years later. While the Oslo group can be associated with other indubitably French ivories of the early fourteenth century, both the London and Paris ivories might be seen as part of a continuing tradition established by such figures as the great Herlufsholm (Denmark) Crucified Christ of about 1250, which appears to take its stylistic lead from English works of the middle of the thirteenth century (Williamson 1995, 220–21, pls. 326–27). Some idea of the typical Parisian ivory crucifix figure of around 1300 may be gained by reference to a lower-quality example now in the Germanisches Nationalmuseum in Nuremberg (Cologne/Paris 1996, 360–61, no. 42).

At the time of its acquisition by the Victoria and Albert Museum, the figure's arms and feet had been restored, probably in the nineteenth century; these additions have since been removed (for an early photograph, see Longhurst 1927–29, 2: pl. III). The original arms would have been made separately and attached to the body at the shoulders in the same way as the later restorations, but the feet were almost certainly carved from the same piece of ivory as the body. The drapery folds at the front of the loincloth have been damaged and recarved, and microscopic traces of discolored pigmentation remain both here and in the hair and beard. Under magnification it can be seen that the latter were originally gilded, the lips of Christ were red, and the underside of the loincloth was blue. The main surface of the loincloth has been stained brown, presumably by the painting medium used in the lost colored decoration, and there is the ghost of a border running along the lower edge of the cloth. The sculpture is carved in the round, although flattened at the back in the manner of an appliqué figure, and was attached to a narrow cross by means of a large dowel that would have been inserted into the circular hole behind Christ's right hip. In the center of Christ's back are four short parallel lines scored into the surface of the ivory. **PW**

ca. 1310–20

English (Westminster?)

Elephant ivory with gilding and polychromy

Height 21.4 cm
Width 7.9 cm (each leaf)

London
Victoria and Albert Museum
(A.545-1910)

PROVENANCE
Collection of Francis Douce
(d.1834); Doucean Museum
at Goodrich Court, Hereford
and Worcester (Collection of
Sir Samuel Meyrick), by 1836;
Frédéric Spitzer Collection,
Paris, by 1890; Spitzer Sale,
Paris, 17 April 1893, lot
no.145; Salting Collection,
London, 1893-1910; Salting
Bequest, 1910.

REFERENCES
London 1987, 425–26, no. 520
(with older literature)

Pächt 1987, 181–90

Williamson 1996, 200–201

Williamson 1996a, 57

The Virgin and Child and the Blessing Christ stand in deep niches below trefoil ogee arches with foliate crockets. The Christ child, holding an apple in his left hand, reaches out to touch the bunch of flowers in the Virgin's right hand, while the adult Christ holds an open book in his left hand in which is inscribed EGO SU(M)/D(OMI)N(U)S D(EU)S/TUUS/I(HSOU)C XP(ISTO)C/Q(UI) CREA/VI REDE/MI ET SAL/VABO TE (I am the Lord thy God, Jesus Christ, who made, redeemed, and saved you). The two hinges (and probably the clasp on the outer edge of the right panel) are not original; they replace three earlier hinges, the positions of which are indicated by later ivory insertions and the remains of pinholes along the inner edge of each leaf. There is thus no reason to doubt that the panels were always intended as a diptych, rather than belonging to some larger ensemble (for the latter view, see London 1987). Presumably when the original hinges were taken out, the inner edges were slightly cut back and the newer hinges inserted. The leaves were also at one time sunk into a base for display, being secured by four pins underneath and further pins at the bottom of the outer sides. The gilded decoration of the hair, beard, borders of draperies, and small rosettes of the frame is not original but overlays a similar scheme, thus giving an accurate impression of the original appearance. It is worth noting that the border decoration of the draperies is delicately incised in addition to being painted.

This diptych, known as the Salting Diptych, is, along with the Grandisson ivories (see no. 38), among the most celebrated English Gothic ivory carvings. It has been universally accepted as English because of its distinctive style and unusual monumental format, although its exact date is less clear. Comparisons have been drawn between the style of the figures and that of the sculptures from the Eleanor Crosses and royal tombs in Westminster Abbey of the early 1290s, and parallels made with the sculpture and paintings of the Westminster Abbey sedilia of about 1308 (Stone 1972, 148-49). This elegant, rather austere, style continued to be employed until the middle of the fourteenth century, and similarities have also been noted with the sculptures of the Percy tomb at Beverley Minster, Yorkshire, of about 1340 (London 1987, nos. 494, 520). The uniqueness of the diptych, both in type and facture (it is probably the thickest ivory relief from the Gothic period), suggests strongly that it was a special commission, made as a precious object of private devotion for an important patron close to the court circle, and it is likely that it represents the work of one of the leading small-scale sculptors in London in the first quarter of the fourteenth century. When closed, the diptych forms a compact—if solid—shape and would have fitted neatly into a leather carrying-case for safe travel. It stands apart from the majority of Gothic diptychs in the quality of its carving and in the ambition of its conception, inhabiting a world between small-scale relief sculpture and the free-standing statuette. As such, it would seem to occupy an innovatory position toward the beginning of the chronological sequence outlined above, probably in the years around 1310–20. **PW**

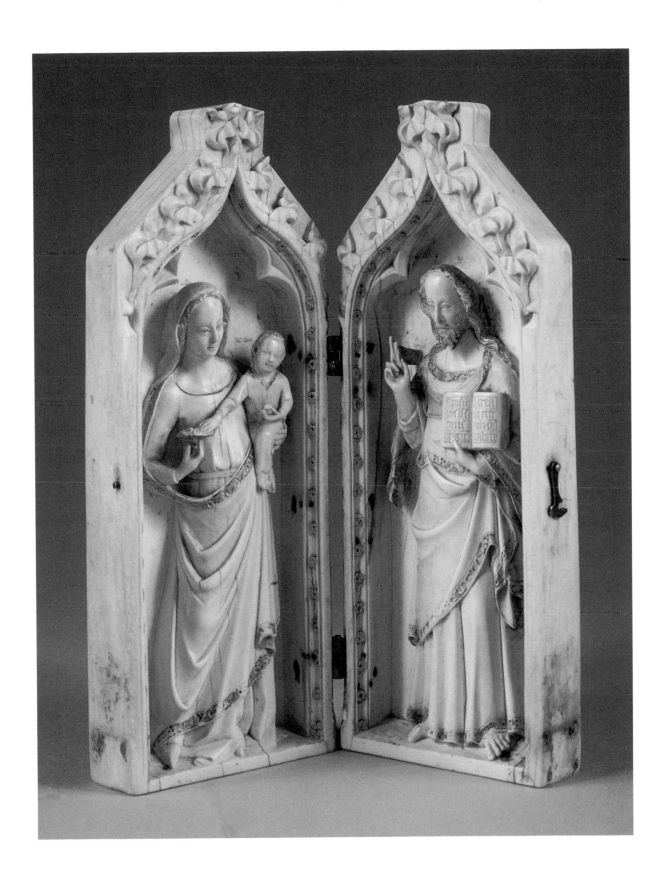

ca. 1340s–50s

English (probably Exeter)

Elephant ivory

Height 24 cm
Width 20.2 cm (open)

London
British Museum
(MLA 61,4-16,1)

PROVENANCE
Collections of Debruge-
Dumenil, 1847 (no. 164); Juste;
Prince Soltykoff; purchased
Soltykoff sale, Paris, 1861,
Lot 238, by the dealer Webb
for the British Museum.

REFERENCES
Franks 1861

Dalton 1909, no. 245

Dalton 1926, 74–83

Rose-Troup 1928, 239–75

Paris 1968, no. 363

Porter 1977, no. 49–51

Randall 1974

Gaborit-Chopin 1978, no. 247

London, 1987, no. 593–96

Stratford 1991, 144–55

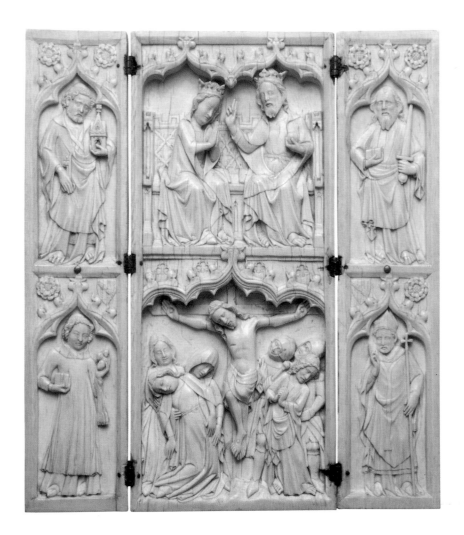

Cut from a very thick leaf of ivory, the two central scenes with densely packed compositions are more deeply carved than the figures of Saints Peter, Paul, Stephen, and Thomas Becket on the wings, which form a marked contrast in depth of relief. The format is reminiscent of contemporary Italian painted altarpieces rather than French Gothic triptychs. Identified by the coat of arms carved on the inner spandrels above the lower saints, the triptych must have been made for John de Grandisson, bishop of Exeter (1327-69). His arms (paly of six argent and azure on a bend gules a mitre between two eaglets displayed or) also occur on a boss of the nave vaults of Exeter Cathedral, on a misericord in the choir of his collegiate foundation at Ottery Saint Mary (Devon), and on certain textiles and manuscripts. A second ivory triptych in the British Museum (MLA 1926,7-12,1) and two leaves divided between the British Museum (MLA 61,4-16,2) and the Musée du Louvre (OA 105) are also carved with the same arms. Taken as a group, the Grandisson ivories display a number of iconographic features that suggest strong, even direct influence from near-contemporary Italian, particularly Sienese, painting.

Here, for instance, the incident-packed Crucifixion is a representation that first appears in Italian art in the third quarter of the thirteenth century, although by the mid-fourteenth century it was established to some extent north of the Alps. It is possible that John de Grandisson acquired Italian works of art, perhaps panel paintings, during his youth.

The English branch of the Grandisson family had risen to a position of major influence under Edward I, but their roots remained cosmopolitan, the family base being Grandson on Lake Neuchâtel. Educated in Oxford and Paris, John spent some years in the 1320s at the papal court at Avignon, where the latest Italian artistic fashions were in vogue. Certain details are personal to John: he held a lifelong devotion to the cult of the Blessed Virgin Mary, and the relief carved in his funerary chapel in Exeter Cathedral also depicts the same scene of the Coronation of the Virgin. The four saints carved on the wings all had altars at Exeter, and John's devotion to Saint Thomas Becket led him to write a life of the martyred archbishop. The Italian elements of the ivories by no means extend to their style. If comparisons with surviving sculptures at Exeter and Oxford are not direct, the sculptor was nevertheless English. There is above all a close parallel for the depressed crocketed ogee arches, with the niches on the upper zone of the choir screen at Exeter from the 1330s; the elegant cusped lattice pattern on the throne of the Coronation scene of the triptych is exactly replicated on the wooden doors of John's funerary chapel inside the west screen facade at Exeter (ca. 1329). Only certain avant-garde iconographic features of the ivories would suggest a somewhat later date, since the carver seems to have had knowledge of Sienese painting of the 1330s and 1340s.

John's lifelong passion for putting his personal coat of arms on every available object has here bequeathed us a rare certainty, almost unique within the whole range of Gothic ivories: that of a group of works that can be localized, dated, and given a named patron.

There is no evidence that England saw a vigorous production of Gothic ivories; most of the ivories that are attributed to England seem to have been one-time commissions, carved in a recognizably insular style. The Grandisson ivories belong in the same category and represent a stylistic and iconographic contrast to contemporary Paris ivories, which needs no further emphasis. **NS**

ca. 1320

**German
(Mainz or Cologne)**

**Elephant ivory
with traces of red ground
and gilding**

**Height 13.7 cm
(without base)**

**London
Victoria and Albert Museum
(A.28-1939)**

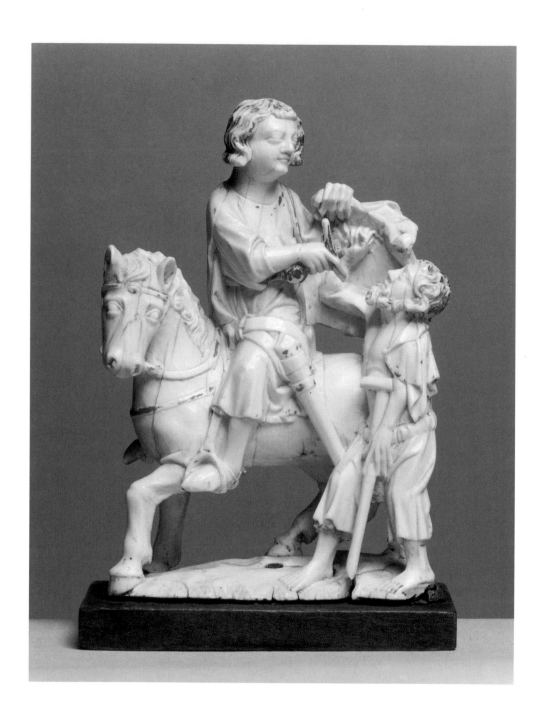

PROVENANCE
Private collection, East Anglia;
sold in Norwich prior to
1939; purchased at Sotheby's,
London, June 29, 1939, lot
142 (illustrated).

REFERENCES
Tardy 1966, 85

Burton and Haskins 1983, 22

Saint Martin is shown on horseback, dividing his cloak and covering the beggar, who stands supporting himself with a crutch. The ivory, carved in the round, retains considerable traces of gilding and its red ground, especially in the hair of both figures and on the edges of the garments, and is in good condition, although there are a number of long surface cracks and the blade of the saint's sword has been broken off. The group is mounted on a later wooden block, fixed with discolored plaster at the back and a wooden dowel through a hole in the center of the base, and at the time of acquisition by the Victoria and Albert Museum it was set on an Empire-style metal base.

The episode represented is narrated in the thirteenth-century *Golden Legend* of Jacobus de Voragine, following the account written by Saint Martin's disciple Sulpicius Severus:

> It chanced one winter day that Martin was passing through the gate of Amiens, and came upon a poor and almost naked beggar. The poor man had received no alms that day, and Martin considered that he was reserved to himself; wherefore he drew his sword, divided his cloak in two parts, gave one part to the beggar, and wrapped himself in the other. On the following night, in a vision, he saw Christ wearing the part of his cloak with which he had covered the beggar, and heard him saying to the angels who surrounded him: "Martin, while yet a catechumen, has clothed me with this garment!" Hence the holy man, not puffed up with pride, but acknowledging the goodness of God, had himself baptised.
> (Ryan and Ripperger 1941, 664)

This scene was translated into visual form by the eleventh century, becoming one of the most popular individual images of the Middle Ages. Groups of Saint Martin and the Beggar were especially popular in sculpture on a larger scale, and numerous examples survive from the thirteenth to fifteenth centuries (for a representative sample of French pieces, see Paris 1961).

Despite the scene's ubiquity in wood and stone, no other ivory figures of Saint Martin and the Beggar appear to survive. This may partly be an accident of fate, as the episode is sometimes shown in reliefs (see no. 41), but ivory statuettes from the thirteenth and fourteenth centuries other than of the Virgin and Child are rare. A few remain, such as that of Saint Margaret in the British Museum (no. 27), and there are occasional references to small figures of saints in contemporary inventories, as in the will drawn up in 1319–22 of Humphrey de Bohun, earl of Hereford and Essex, where a "petite ymage de yvor de Seinte Katerine" is listed (Turner 1846, 348; Williamson 1994a, 200). It seems likely that such pieces were primarily intended for private devotion and mostly belonged to wealthy individuals rather than to churches.

An extremely similar ivory carving—presumably of the same date but with the composition reversed—was attached to a small casket in the Hallesches Heiltum, the extraordinary collection of reliquaries gathered

together in Halle by Albrecht von Brandenburg, archbishop of Mainz (1490–1545). This ensemble was later broken up and dispersed, but fortunately the archbishop commissioned a set of watercolors to record the contents of the treasury, bound up in the so-called Hallesches Heiltumsbuch in the Hofbibliothek, Aschaffenburg, and therein the box with Saint Martin is illustrated (fig. 39a) and described as "Eyn Schwartz beynenn ledleyn mitt silber beschlagenn Vff der deckenn eyn weysz beynenn Sanct Martins bilde. Inhalt 3 Partikel" (A small black bone box with silver mounts with on the lid a white bone sculpture of Saint Martin. Inside three particles; see Halm and Berliner 1931, 30, pl. 13a). These "particles" were presumably relics connected with Saint Martin, but it is also worth noting that small groups of Saint Martin and the Beggar were used on objects connected with works of charity, such as alms boxes, until the seventeenth century, a particularly fine silver-gilt example topping the cup of Saint Martin's Guild of Haarlem, made by the van Vianen workshop in 1604 (Amsterdam 1993, no. 108).

The style also points toward a Lower or Middle Rhenish origin. The broad facial types have close connections with early-fourteenth-century sculpture at Cologne, most notably the marble figures from the high altar of the cathedral and the Adoration of the Magi group from Sankt Maria im Kapitol, both groups executed in about 1315-20 (Cologne 1984, figs. 48–54, 62). Saint Martin was the patron saint of Mainz cathedral, at the heart of the biggest and most powerful archbishopric in the Holy Roman Empire, and it is to be expected that devotional sculptures of the saint would have enjoyed an especially strong local popularity. The ivory Saint Martin group of the Hallesches Heiltum was almost certainly acquired by Albrecht von Brandenburg in Mainz, and images of Saint Martin and the Beggar abound in the cathedral: on the baptismal font of 1328, in the volutes of the crosiers held by a number of the fourteenth-century archbishops on their memorial slabs (such as that of Matthias von Bucheck, who died in 1328), and as individual reliefs and sculptured groups scattered about the building (Kautzsch 1925, esp. pls. 58, 67). **PW**

Fig. 39a. Saint Martin and the Beggar, Hallesches Heiltumsbuch, Aschaffenburg, Hofbibliothek, MS 14, fol. 70v, German, 1525–30, watercolor

ca. 1330–40

German (Lower Rhine or Westphalia)

Elephant ivory with painted and gilded leaves

Height 10.5 cm
Width 5.9 cm (each leaf)

London
Victoria and Albert Museum (11-1872)

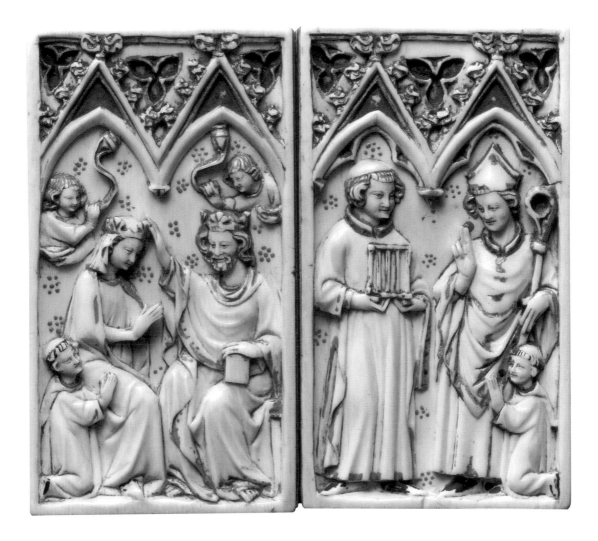

PROVENANCE
Purchased from John Webb, London, in 1872.

REFERENCES
Koechlin 1924, 1:194, 198, 207, 210, 2: no. 526, 3: pl. XCIV

Longhurst 1927-29, 2:24–25, fig. 3, pl. XIX

Berliner 1955, 51, figs. 6–7

Martin 1961, 17, fig. 6

Wentzel 1962, 193–212

Wixom 1972, 96–99, figs. 25–26

Hamburger 1989, 30, figs. 4–5

Os 1994, 114–15, 182, pl. 35

Williamson 1996, 212–13, pl. 21

The booklet is made up of two outer ivory leaves (0.75 cm thick), both carved, and six considerably thinner panels inside (each 0.2 cm), held together with a glued parchment spine. The front cover shows the standing figures of Saint Lawrence and a bishop or archbishop with a kneeling monk (perhaps an abbot) at his feet; the back is carved with the Coronation of the Virgin with two censing angels above and the same kneeling monk—undoubtedly the owner of the booklet—as on the front. The insides of the two outer panels and both sides of each of the six internal leaves are painted with ten scenes of the Passion of Christ and four showing the Instruments of the Passion (*Arma Christi*), in the following order: the Last Supper, the Betrayal, Christ before Pilate, Christ before Herod, the Flagellation, Pilate Washing His Hands, the Carrying of the Cross, the Crucifixion, the Resurrection, and the Veronica (or *Vera icon*). The first of the final four panels shows Christ with one of his tormentors and the hand that struck him; the second has the Crown of Thorns, the wound in Christ's side, the bucket of vinegar and the staff with the sponge that was offered to Christ to drink on the cross; the third depicts the cloth with which Christ was blindfolded, the hammer and three nails by which he was fastened to the cross, the pincers for removing the nails, the thirty pieces of silver for which he was betrayed by Judas (the silver, here as elsewhere, has tarnished, and

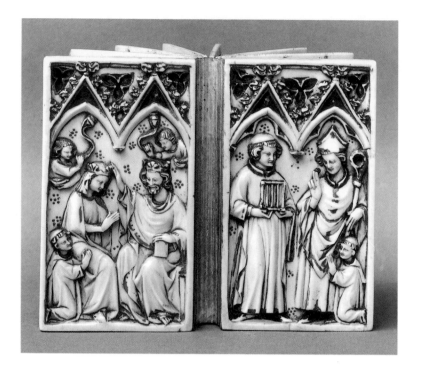

Booklet splayed open

The Last Supper and Betrayal

one of the pieces on the bottom row has been lost, leaving only a slight trace), and three bloody footprints from Christ's journey to Golgotha; the final panel shows a stick, the scourge, the ladder, Christ's cloak and the three dice with which the soldiers gambled for it, the spear, and a view of Christ's tomb from above. The three holes at the top of every other leaf may have been made for the attachment of small silk curtains to protect the miniatures.

The attribution of the paintings inside the booklet to a German workshop has been accepted since 1961, when Kurt Martin suggested an origin around Lake Constance on the Upper Rhine (Martin 1961, 17).

Christ before Pilate and Christ before Herod

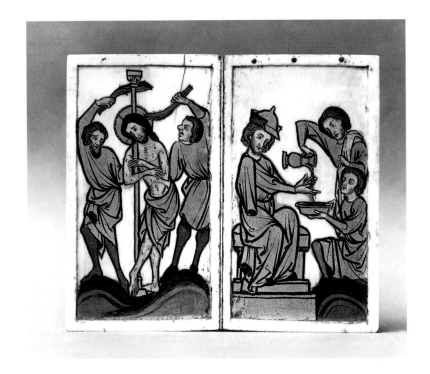

The Flagellation and Pilate washing his hands

Their exact place of execution remains a matter of debate, but it seems most likely that they are products of the Lower Rhine given their similarity to painting in Cologne of the first half of the fourteenth century (see Budde 1986, 21–37, 196–203). Although it has been proposed that the covers were carved in Paris and the booklet exported to Germany before painting took place, there is actually no reason to doubt that the whole booklet—carving and paintings—was made in Cologne at the same time, probably around 1330–40. The fact that the covers were custom-made for the monastic patron shown kneeling on the front and back precludes the possibility that the paintings reflect a secondary use,

PARIS AND OTHER CENTERS: DEVOTIONAL OBJECTS

Carrying of the Cross and
Crucifixion

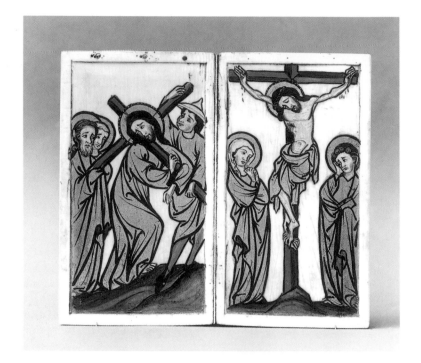

The Resurrection and Veronica
(or *Vera icon*)

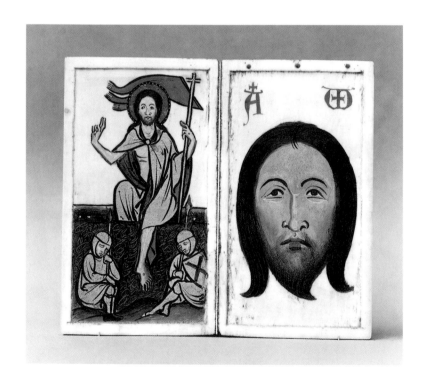

and the close adherence to Parisian style in the carving merely reflects the preeminent influence of the ivory workshops of the French capital.

The booklet exemplifies the growing use of devotional aids throughout Europe in the fourteenth century. It would have been utilized as a spur to meditation and prayer, encouraging the owner to personally experience and share Christ's Passion. This intensely private approach to worship, wherein a bridge was built between personal feeling and the suffering of Christ and the Virgin, grew in popularity from about 1300 onward and was embraced with special enthusiasm in convents (Os 1994).

Christ with one of his tormentors, the hand that struck him, the Crown of Thorns, wound in Christ's side, bucket of vinegar, and staff with the sponge that was offered to Christ to drink on the cross

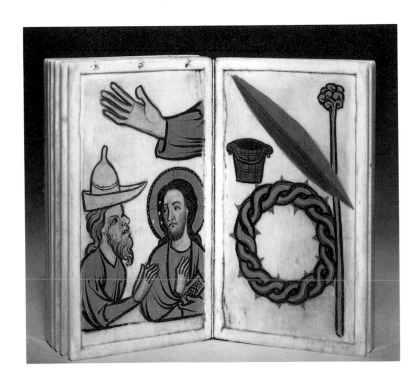

The cloth with which Christ was blindfolded, hammer and three nails by which he was fastened to the cross, pincers for removing the nails, thirty pieces of silver for which he was betrayed by Judas, three bloody footprints from Christ's journey to Golgotha, stick, scourge, ladder, Christ's cloak and three dice with which the soldiers gambled for it, spear, and view of Christ's tomb from above

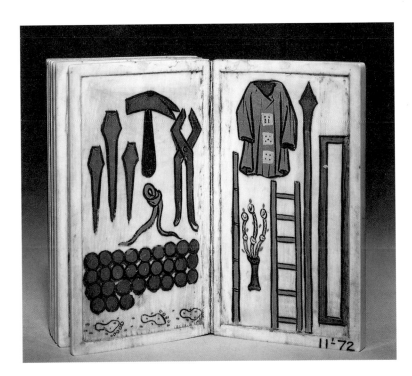

It is unfortunately not possible at present to link the booklet with a particular individual, although the diminutive monk shown on its covers presumably belonged to a religious house dedicated to Saint Lawrence and the (arch)bishop saint alongside perhaps represents an illustrious precursor. A similar juxtaposition of monastic patron, archbishop, the Virgin, and the Instruments of the Passion is to be seen in the illuminated parchment charter of the Cistercian monastery of Marienstatt, of about 1325, now in the Rheinisches Landesmuseum in Bonn (Budde 1986, 26, 197–98). **PW**

ca. 1340–50

German (Cologne)

Elephant ivory with polychromy and gilding; silver

**Height 9.1 cm
Width 10.2 cm**

**Cleveland
The Cleveland Museum of Art
J.H. Wade Fund
(71.103)**

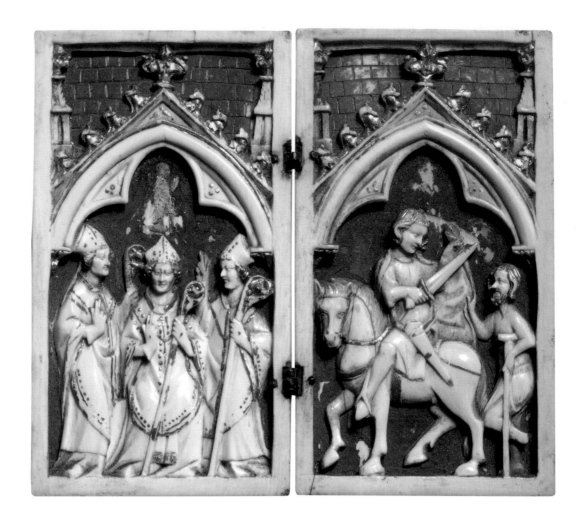

PROVENANCE
Formerly in the collections of Ozenfant, Lille; Julius Böhler, Munich.

REFERENCES
Wixom 1972, 95–101

Gaborit-Chopin 1978, 159–58, 210

Randall 1993, no. 88

This precious ivory depicts scenes rarely encountered on Gothic diptychs; on the right, Saint Martin on horseback divides his cloak for a naked beggar, the saint's most celebrated act of charity. This popular episode occasionally appears in combination with scenes of the Passion, as seen on diptych leaves in London and Darmstadt (Koechlin 1924, 2: nos. 379, 590). However, here it is juxtaposed with a scene that has been identified as the consecration of Martin as bishop of Tours, an event that occurred in 371 (Wixom 1972, 95). One of the bishops is probably his companion, Saint Hillary, bishop of Poitiers. All three bishops wear identical vestments, hold crosiers, and offer a blessing. Martin's ordination, rather than his consecration, was more frequently depicted in the Middle Ages, as seen in a thirteenth century relief in the cathedral of Lucca (Martin 1917, 19 illus.) or in a miniature in a fifteenth-century Benedictine breviary (Grammont, Maredsous Abbey Library, fol. 140v; Liège 1994, fig. 27). However, since none of the three bishops on the ivory is nimbed, the event may be a contemporary consecration of a church being dedicated to Saint Martin. The meaning of the kneeling figure painted in gold just above Saint Martin is uncertain. He wears a chasuble, is without nimbus, but is tonsured. Perhaps he is the

donor-patron of the diptych. The polychromy appears to be original and enhances our conception of how such devotional objects were decorated. The lapis lazuli background and red roof tiles add a sumptuous quality to the work, as do the gilt details of the hair, chasubles, and horse trappings.

Both scenes are set under a trefoil arch with floral crockets and towers. The field behind the arches is tiled, a feature William Wixom and Richard Randall regarded as characteristic of Cologne work (Wixom 1972, 99; Randall 1993, no. 88) In fact, this feature also occurs on a leaf of a diptych in Berlin that Volbach attributed to Cologne, in part because it came from there in 1845 (Volbach 1923, no. 670; Koechlin 1924, 2: no. 622 bis). Closer in type and style to the bishops on the diptych is the bishop depicted on the Passion booklet in London (no. 40), also a contemporary Cologne or Lower Rhenish work, which contains a nearly identical figure. A Cologne provenance can also be confirmed by comparing the bishops on the ivory to a series of polychromed sculptures of bishops made around the middle of the fourteenth century and originating in Cologne for its churches, such as that in Saint Ursula, or others (fig. 41a; Bergmann 1989, nos. 55, 76, fig. 39).

Saint Martin, who was the father of monasticism in France, was also widely venerated elsewhere. In Cologne, the Benedictine abbey of Gross Sankt Martin and the cathedral of Mainz were dedicated to him, so its likely German origin is not unusual. However, the specific hagiographic subject of such a devotional ivory suggests that the patron must have commissioned it for a special occasion to commemorate an event, a namesake, or the saint's feast day. CTL

Fig. 41a. Saint Nicholas, German, ca. 1300–50, polychromed wood, Cologne, Erzbischöfliches Diözesan Museum

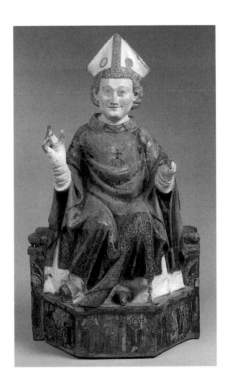

ca. 1350

German (Cologne)

Elephant ivory

Height 25.6 cm
Width 21 cm

New York
The Metropolitan
Museum of Art
The Cloisters Collection
(1970.324.8)

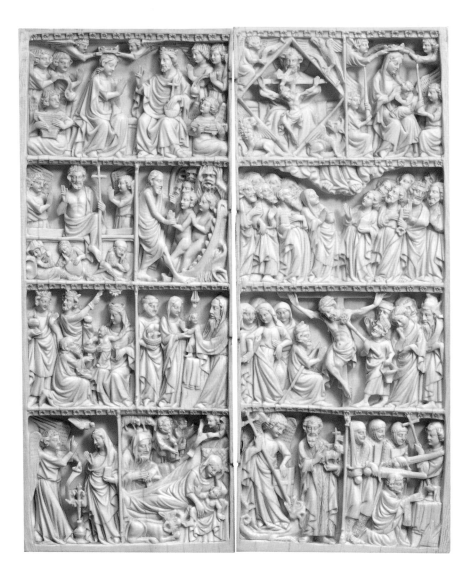

This resplendent diptych, carved in exceptional detail, contains one of the most unusual combinations of Christian scenes to be found on Gothic ivories. The program is organized in an ascendent or anagogical manner, moving from the earthly realm to heavenly or symbolic. Rarely are patron saints incorporated into comprehensive narrative cycles of the life of Christ and the Virgin. Here, Saint Michael triumphant over the dragon and John the Baptist with the sacrificial lamb are strategically placed next to the martyrdom of Thomas Becket, an event that took place at Canterbury Cathedral on December 29, 1170. Even the attempt by Becket's secretary, Edward Grim, to intercede and protect him is included in the image. Because of Becket's high position and the horror of his murder in the church, the rapid development of his cult and its diffusion throughout Europe was one of the most remarkable events of the High Middle Ages.

The lower registers portray key episodes in the life of Christ: the Annunciation, Nativity with the Annunciation to the Shepherds, Adoration of the Magi, Presentation of Christ in the Temple, the Crucifixion

between Mary, John, Longinus and Stephaton, Resurrection of Christ, Descent into Limbo, and Ascension. These scenes comprise the core iconographic program most frequently found on many Gothic ivory diptychs.

The ascendent program culminates with the heavenly realm at the top and the vision of the Trinity in a diamond-shaped mandorla surrounded by the symbols of the Evangelists. It is framed on the left side by the symbolic image of the Coronation of the Virgin by angels in the presence of musical and censing angels. On the right, it is complemented by the Virgin nursing the Christ child adored by two angels who hold tapers while two others crown her.

Since the order of the scenes is not strictly narrative, the governing principle of the arrangement might have been dictated by meditations for each of the canonical hours of the Virgin. The complexity of the imagery also suggests that the diptych could have been destined for monastic rather than private use.

The triple dedication to Saints Michael, John the Baptist, and Thomas Becket may be a clue to the origin of the diptych. However, the widespread veneration of Becket does not aid in specifically localizing the ivory. A number of compositional and stylistic features of this work can be related to other ivories in the Vatican (Koechlin 1924, 2: no. 812) and formerly in the Granjean Collection, Paris (Koechlin 1924, 2: no. 807). Charles Rufus Morey believed these ivories were southern German works and compared the figure types and style to sculpture at the cathedral of Freiburg in Breisgau, while the authors of the Kofler-Truniger catalogue found analogies of the carving in the portals at Swäbish Gmünd (Morey 1936a, 200; Schnitzler, Volbach, and Bloch 1964, 22).

While the robust, naturalistic style of these sculptures is generally similar to the ivory, the compositions, gestures, physiognomies, and idiosyncratic iconography relate more specifically to sculptures from Cologne around the middle of the fourteenth century. Often displaying a strong Mosan influence (compare the Christ of the Coronation to a marble of the same subject in the Victoria and Albert Museum [Williamson 1988, no. 23], the scenes on the diptych can be related in style and type to the marble reliefs of the high altar in Cologne cathedral, before 1322. Both the Adoration of the Magi from the high altar (fig. 42a) and a series of wood Virgins produced in Cologne around mid-century (see Bergmann 1989, no. 89) are evidence of this interdependence of various media. A number of ivories that were certainly created in Cologne but often erroneously attributed to France are also linked to this diptych. For example, a diptych leaf with the Adoration of the Magi in Hannover (fig. 42b) or a diptych in the Kunstgewerbemuseum, Cologne (inv. B276, 277Cl; see Cologne 1982, nos. 7–8) are evidence of ivory production in Cologne, only now beginning to be recognized. As one of the key works of German ivory carving, this devotional diptych is clear evidence that Cologne rapidly came into competition with Paris for preeminence (see Little essay, pp. 80–93). **CTL**

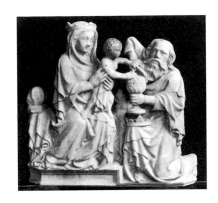

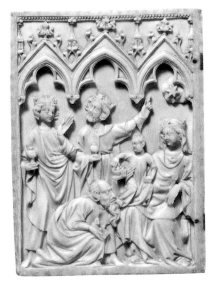

Fig. 42a. Adoration of the Magi from the high altar of Cologne Cathedral, German, before 1322, alabaster, Cologne, Schnütgen Museum

Fig. 42b. Leaf of a diptych with the Adoration of the Magi, German, ca. 1350, Hannover, Kestner Museum

ca. 1350–75

German (Cologne)

Elephant ivory

Height 14.2 cm
Width 9.2 cm (left leaf)

Height 14.3 cm
Width 9.4 cm (right leaf)

Baltimore
Walters Art Gallery
(71.214 a, b)

43 | DIPTYCH WITH THE VIRGIN AND ANGELS
AND THE CRUCIFIXION

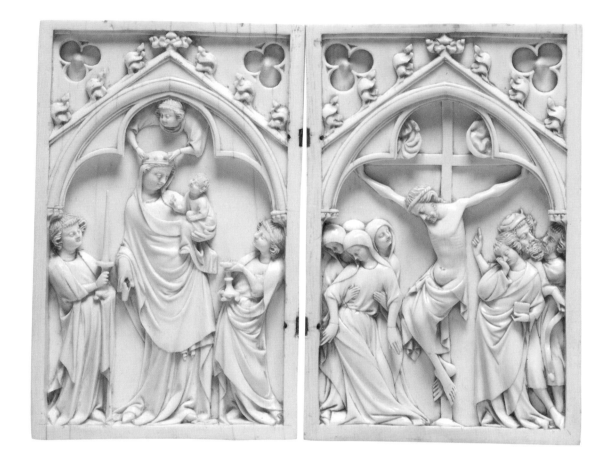

PROVENANCE
Purchased by Henry Walters
prior to 1931.

REFERENCES
Randall 1985, 214, no. 301,
pl. 73

The carver of this diptych and triptych is called the Berlin Master because of a notable triptych in the Staatliche Museen, Berlin, that has long been thought to be German (Gaborit-Chopin 1978, 168–69, no. 257). In the Berlin work the style is mannered and the detailing of every figure and crocket is elegant. The Virgin is seated and being crowned, with the Christ child striding in her lap, while the wings contain two candle-bearing angels.

The Walters diptych (no. 43) repeats the subject of the Berlin piece, with the Virgin standing and with certain common details. The Virgin is frontal with her face in three-quarter view, and her veil falls in a sweeping curve, creating a shadow on the right side of her face. This last feature is repeated in a number of works from the hand of this carver, such as the Virgin in the Museum of Fine Arts, Houston (fig. 43–44a), where the angels closely resemble those in the Berlin wings.

In the Walters leaf, the Crucifixion contrasts admirably with the Virgin wing, where the gently S-curved Virgin stands between angels that curve away from her, while in the Crucifixion the opposing S-shape of Christ's

torso is framed by the containing forms of the Virgin and Saint John, curving inward. There are three Holy Women, one of whom looks up at the Cross, as the Virgin faints, counterbalanced by a broad frontal figure of Saint John with two Jews. The Virgin in her twisted skirt is a characteristic feature of the Berlin Master's atelier.

The architectural frames are strong, crisp, and sober. Both scenes are placed beneath trefoil arches under a tympanum decorated with undulating crockets. In the upper corners of the plaques are deep trefoils with a rising point in their centers. The trefoils are emphasized by three diamonds incised at their edges. The hinges are lacking in this diptych, as is the candle from the right-hand angel.

The triptych in the Art Institute of Chicago (no. 44) shows additional features of the workshop of the Berlin Master. The Crucifixion scene is based on the same model as the Walters diptych (no. 43). The Saint John, however, is totally changed, as the triptych form required a different series of compositional relationships. This Saint John is similar, but with modest drapery changes, to the Saint John in a fourth work by the Berlin Master: a diptych in the Musée du Louvre from the Mège Collection (0A 9960; Koechlin 1924, 2: no. 533; Paris 1981, no. 152), where the figures of Saint John and Christ are also similar but not identical to the Chicago triptych.

Fig. 43 44a. Leaf of diptych with the Virgin in Glory, German, 1325–50, elephant ivory, Houston, The Museum of Fine Arts, Houston (71.7)

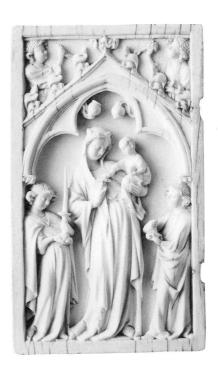

ca. 1350–75

German (Cologne)

Elephant ivory

Height 25.7 cm
Width 17.6 cm (open)

Chicago
The Art Institute of Chicago
Mr. and Mrs. Martin
A. Ryerson Collection
(1937.827)

PROVENANCE
Collections of Frédéric Spitzer,
Paris; Mr. and Mrs. Martin
A. Ryerson, Chicago.

REFERENCES
Molinier 1890, 47, no. 60

Paris 1893, lot 95

Koechlin 1924, 2: no. 208

Randall 1993, no. 43

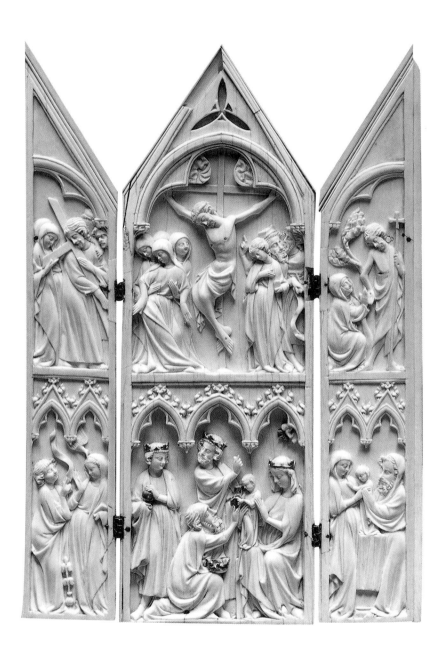

Below the Crucifixion in the Chicago triptych is an Adoration of the Magi with an unusual feature: the Three Kings are divided from the Virgin and Child by a vertical fall of the folds of the garment of the second king. The figures are placed beneath three trefoil arches, framing the heads of two magi and isolating the Virgin in a niche with the star appearing from the arch.

The leaves of the triptych show the Carrying of the Cross, to the left of the Crucifixion, and the Noli Me Tangere to the right. Flanking the Adoration are the Annunciation and Presentation in the Temple. It is quite apparent that the wings are by a second hand, a more modest carver from the Berlin Master's atelier. The figures are less deeply carved and

are more elongated. The head of Simeon at the lower right is large and out of proportion to the others. However, the effect of these differences is perhaps intentional, as the reduced chiaroscuro of the wings emphasizes the center panel.

The upper edges of the gable of the triptych most probably resembled those of the Berlin triptych with the characteristic undulating crockets of the atelier. Both wings have applied modern moldings on their upper edges, while the center panel has a replaced molding on the right and a missing section on the left and new edges. The triptych has lost its original hinges and has been repaired where they were broken away. Modern mounting holes in the base have been plugged with ivory. The discoloration on Christ's chest in the Crucifixion was caused by the original silver pin for the hook on the outside of the right wing.

The variety of the Berlin Master's workshop is notable and also allows one to see that certain models were repeated, some intact, and some with minor changes. For instance, the angels flanking the Virgin are similar in the Houston diptych and Berlin triptych but quite different facially and in the handling of drapery in the Walters diptych and that in the Louvre. The bowed head of Saint John in the Chicago triptych is a variant of that in the Louvre example. Certain features of the Berlin Master's style are repeated with great variation and imagination, particularly the treatment of the Virgin's drapery in Berlin, Baltimore, and Houston, where the manner in which the veil is used to frame the face and upper figure is similar. The drapery of those figures is otherwise totally different, as is the strongly mannered apron-style drapery of the Virgin in the Louvre example. The Louvre and Walters Virgins share the technique of creating sharp linear folds on the robes to emphasize the S-posture of the figures.

The atelier used various devices to accent the architecture. The trefoils of circles of the Walters diptych are used on the Berlin triptych, while trefoils of lozenges decorate the Chicago and the Louvre examples. The Houston panel shows both a different iconography and treatment above the architecture. There two angels are placed above the Virgin's head, and their censers fall below the arch, while in the Walters panel, the Virgin is crowned by an angel below the arch, as she is in the Berlin triptych.

The variety and control of the Berlin Master are the earmarks of the atelier. They are, like the works of the Passion Atelier (nos. 31-33) and the Master of Kremsmünster (no. 45), clear signs that the ivory industry was producing some of its greatest works at the end of the fourteenth century and before the Hundred Years War ceased. **RHR**

45 | Right Leaf of a Diptych with Scenes of the Passion of Christ

ca. 1375–1400

Master of Kremsmünster

German (Mainz)

Elephant ivory

Height 26.2 cm
Width 12.5 cm

Baltimore
Walters Art Gallery
(71.156)

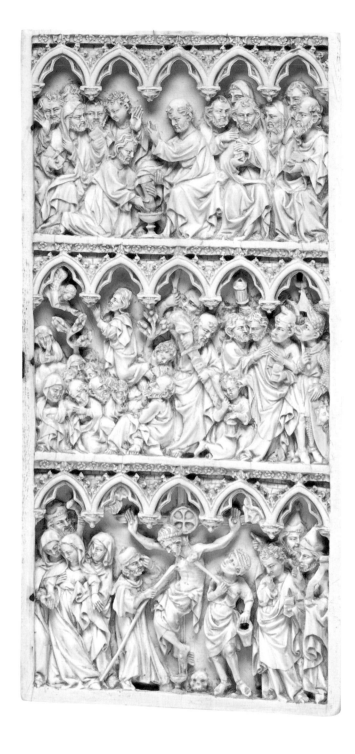

This panel is the right leaf of a diptych of the Passion by the Master of Kremsmünster, a carver named for a diptych of the Adoration and Crucifixion in the abbey of Kremsmünster in Austria. His works are to be found in many German collections, and all those with histories have been found east of the Rhine River. His style is thought to be that of Mainz in the Rhine Valley, based on similar carving on the Memorial Portal of Mainz cathedral, where the violent motion of the figures and the heavy drapery are similar to the diptych in Kremsmünster (Gaborit-Chopin 1978, 169–70, figs. 260–61).

The master specialized in swerving drapery folds, crowded compositions, and a play of light and shade on his figures. The present panel is typical of his mature work and shows, from top to bottom, the Washing of the Feet, Christ at Gethsemane, and the Arrest of Christ, and in the lowest tier, the Crucifixion with the Marys at the left and Saint John and the Jews at the right. The curly haired and youthful Saint John is a type invented by the Master of Kremsmünster and appears in the majority of his works.

The original left leaf of the diptych survives and was given to the Musée des Beaux-Arts in Lyons in 1850 (fig. 45a). It shows the usual scenes preceding those of the Walters leaf. In the upper tier is the Entry into Jerusalem in a very busy version of the scene, including the baby ass accompanying Christ's mount. In the second tier is the Last Supper, combined with the Judas Receiving the Thirty Pieces of Silver. In the bottom level is the Hanging of Judas, Flagellation, and Carrying of the Cross. In this last scene, the Virgin aids Christ with the Cross, a concept of Rhenish mysticism that later became standard in Dominican iconography and was repeated frequently in France as well as Germany.

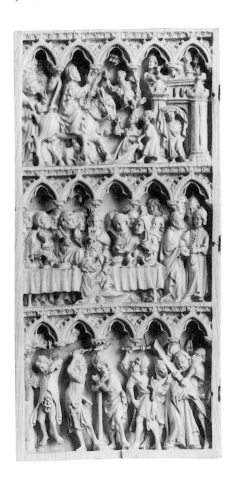

Fig. 45a. Left leaf of a diptych (no. 45), German (Mainz), 1375–1400, elephant ivory, Lyons, Musée des Beaux-Arts

The architectural enframement of the diptych is composed of a series of five pointed trefoil arches above each scene, with a molding decorated with roses above. The depth of the carving behind the arches creates an area of shade above each scene while the roses add a band of reflected light. The entire composition is typical of German Gothic baroque with its play of light and shade. Other German features to be noted are the carved cruciform halo of Christ and the monster-faced soldier in the Arrest of Christ.

When the ivory was in the collection of Frédéric Spitzer, the left wing had already been separated from it, and Spitzer had a replacement wing created. That wing appears in this catalogue in the final section (no. 89), where it is shown with the real wing to emphasize the contrast of the stiff nineteenth-century carving and the fluid baroque carving of the original. **RHR**

46 | Quadriptych with Scenes of the Passion of Christ

1370–80

German

**Elephant ivory
with gilt and polychromy**

**Height 18.7 cm
Width 5.9 cm (each leaf)**

**Baltimore
Walters Art Gallery
(71.200)**

PROVENANCE
Purchased from Arnold
Seligmann, Rey and Company,
Paris, 1923; Henry Walters,
1923–31; The Walters Art
Gallery, Baltimore, 1931.

REFERENCES
Morey 1936, 41, pl. 20

Morey 1936a, 203, fig. 6

Baltimore 1962, 117–18,
no. 119

Randall 1985, 216, no. 305

One of the most unusual types of folding altarpieces is the quadriptych form, of which only a few examples are known. The earliest shows an unusual series of scenes from the infancy of Christ and is French from the early fourteenth century. It is in the Victoria and Albert Museum (Longhurst 1927–29, 2:[237abc-1867], 23, fig. 2) and was questioned by Koechlin, who proposed that it was two diptychs that were later joined. It is very small in size, the panels being three inches tall.

The Walters example and a quadriptych in the Metropolitan Museum of Art (fig. VI-13) are both large in scale and are composed of four leaves. Both show scenes of the Passion but are quite different in date, that in the Metropolitan Museum from near the middle of the century or perhaps a bit later, and the Walters example datable 1370–80. Both are currently attributed to Germany.

The Walters quadriptych reads from left to right across the top and similarly across the lower tier. The scenes are the Raising of Lazarus, Entry into Jerusalem, Washing of the Feet, Last Supper, Christ at Gethsemane, the Arrest of Christ, Carrying of the Cross, and Crucifixion. The halos carved with a cross are more frequently a German feature.

The basic iconography shows a familiarity with the Parisian diptychs of the Passion, which date from about 1370 to 1390 but follow the large-scale sculptural formulae of the 1320s and 1330s at Jumièges, Rouen, and Mantes (Randall 1983–86).

The atelier that produced the quadriptych was following French tradition carefully, which suggests that one or more of the carvers may have been trained in Paris or that the shop was conscious of the latest developments in carved ivories. It is interesting, in this regard, to observe that three of the panels are by one hand, while the fourth panel with the Washing of the Feet and Carrying of the Cross is by a different carver. The treatment of the architecture in the third panel, for instance, is less crisp, particularly in the treatment of the corner trefoils, another Germanic feature. The crockets are handled differently, and the crowning fleuron is much wider and flatter. The figures also vary from the other three leaves and are much larger in scale and have more exaggerated heads than in similar scenes in the diptychs of the Passion.

There are considerable traces of polychromy on the landscape, bowl, and halos. That on the trees in the Gethsemane scene is dark green with gilt highlights, while the halos are black-brown with a gold cross, and the bowl in the Washing of the Feet, as well as the nails in the Carrying of the Cross, are black-brown.

There are a few minor chips on the corners of the ivory panels, and the lower right corner of the Crucifixion leaf has been broken and repaired. The silver hinges are original, allowing the quadriptych to be stood either with the two central panels flat and the outer ones acting as wings or in a zigzag like a screen.

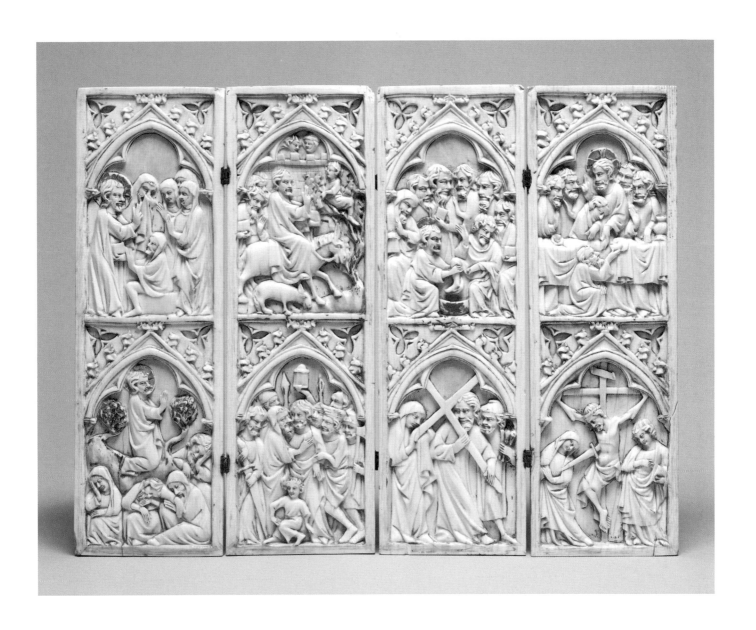

It should be noted that Morey (1936a) confused the discussion of quadriptychs by introducing the detached wings of polyptychs as comparisons, a complication that has continued in all writing on the subject. He correctly identified this ivory as German, however, basing his thought on the iconography of Rhenish mysticism, including the sword in the Crucifixion and the Virgin in the Carrying of the Cross. The detail of the Virgin with the cross, however, appears in French work as early as the Portail de la Calende at the cathedral of Rouen of about 1300, and the sword can be found in the Evangelary of the Sainte-Chapelle of about 1270 (Paris, Bibliothèque Nationale, Lat. 8892 and 17326) and in the Psalter and Hours of Yolande de Soissons of about 1275 (New York, Pierpont Morgan Library, MS 729). **RHR**

47 | Virgin and Child

1370–90

Mosan

Elephant ivory

Height 32.4 cm

**Kansas City, Missouri
The Nelson-Atkins
Museum of Art
Nelson Fund (34.139)**

PROVENANCE
Purchased from the Brummer
Gallery, New York, 1934.

REFERENCES
Kansas City 1949, 110

Randall 1993, 45, no. 25, pl. 4

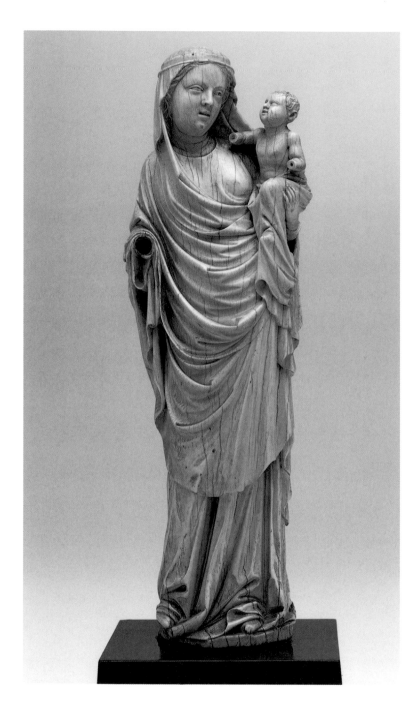

The Christ child looks into his mother's face, as she stares into the
distance, her mouth slightly open. She holds the child in her left arm,
and while he is naked to the waist, his drapery is unusually long and falls
below the Virgin's hip. Her veil and overmantle fall in a busy series of
curved transverse folds across the body, contrasting with the vertical
folds of her gown. Her head is carved to accommodate a crown, which
fitted over the veil. She is lacking her right hand, and both arms of the
child have been cut at the forearm for earlier restorations. The scale
of the group is impressive, and it is undoubtedly the work of a sculptor

rather than an ivory workshop, as was common in the latter part of the fourteenth century. An ivory Virgin in a private collection in Belgium is treated much the same way (photo A.C.L.-Bruxelles, no. 154976) with the veil and overmantle creating a waterfall of transverse folds. Again, in that work, the child's drapery is unusually long, and the chest bare, which suggests that they are by the same sculptor. The right hand of the second statuette points downward and holds the stem of a flower, while the child's right hand reaches for his mother's chin (Didier 1970, fig. 15).

The love of small repeated transverse folds is illustrated by many works from Liège and the Meuse Valley, including the silver statue of Saint Blasius in the church of Notre-Dame, Walcourt, dated before 1300, and the famous stone Virgin of the church of Saint Servais in Liège of about 1330 (Devigne 1932, figs. 47, 49). **RHR**

48 | Appliqué with the Virgin and Child

Fig. 48a. Triptych with Virgin and Child, French, late 14th century, elephant ivory, The Cleveland Museum of Art, Purchase from the J. H. Wade Fund (51.450)

This statuesque figure of the standing Virgin and Child appears massive due to the disproportionately small head of the Virgin. Moreover, the broad breaking folds of the tunic and mantle contribute to this impression of monumentality. The Virgin holds the stem of a flower in her left hand and in her right supports the Christ child, who gazes at her.

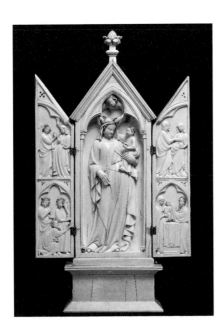

The ivory was originally intended to be mounted on a ground, as evidenced by an irregular hole on the reverse, probably for a dowel in order to set the figure into a tabernacle. A similar broadly proportioned Virgin can be seen in a complete tabernacle in the Cleveland Museum of Art, also probably from eastern France (fig. 48a; Randall 1993, no. 400). Despite its reputed provenance from a church in the Ile-de-France, nothing about the style of the figure points to that region for its artistic origin. The style and type of figure are consistent with other images of the Virgin around 1400,

ca. 1380–1400

French (Lorraine)

**Elephant ivory
with traces of polychromy**

Height 21.1 cm

**Worcester, Massachusetts
Worcester Museum of Art
(1940.27)**

PROVENANCE
Said to come from the church of
Lagny-sur-Marne, near Meaux,
around 1860; private collection,
Nancy; Louis Carré, New York.

REFERENCES
Randall 1993, no. 24

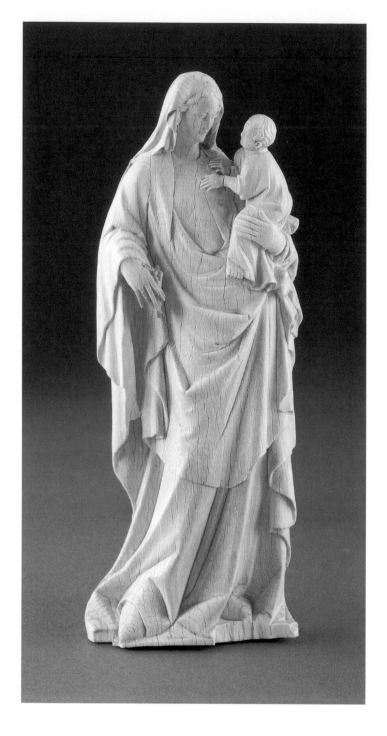

as seen in limestone sculpture of the Lorraine (Paris 1981, no. 6) or
the series related by William Forsyth to the Virgin of the cathedral at
Saint-Dié, Vosges (Forsyth 1936). Variations are also found in the Upper
Rhine, such as that in Hollogne sur Geer (Geisler 1957, fig. 32). Also
contemporary Netherlandish boxwoods often portray the Virgin in
a similar way, such as fine figure in the Victoria and Albert Museum
(Williamson 1988, no. 49). CTL

49 | Triptych with the Coronation of the Virgin

ca. 1360–70

Italian (Venice)

Elephant ivory with painting and gilding

Height 26.6 cm
Width 16.5 cm

London
Victoria and Albert Museum
(143-1866)

PROVENANCE
Purchased from John Webb, London, in 1866.

REFERENCES
Maskell 1872, 61–62

Longhurst 1927-29, 2:61, pl. LIII

Natanson 1951, fig. 62

Giusti and Leone de Castris 1981, 35–36

Randall 1985, no. 351

Williamson 1994, 293, fig. 3

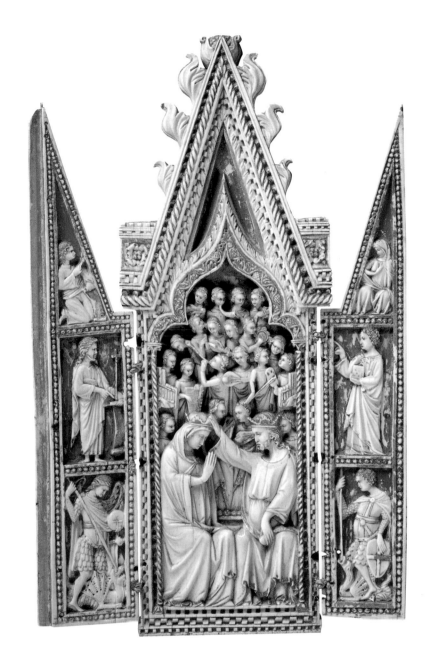

In the central panel, under a trefoil ogee arch, the Coronation of the Virgin takes place beneath a choir of twenty musician angels. On the wings of the triptych are the Archangel Michael, Saint John the Baptist, and the Angel of the Annunciation (on the left), and Saint George, Saint John the Evangelist, and the Virgin of the Annunciation (on the right). On the outside of the wings, extensive remains of incised cross-hatching indicate that two standing figures of angels with upstretched wings, perhaps of ivory but possibly of gilt metal, were once glued to the surface (see fig. 49a and Randall 1985, 237, no. 356, for a directly comparable pair of angels painted in grisaille on the outer wings of a triptych from the early-fifteenth-century Embriachi workshop). The reverses of both leaves have gilded borders, and that on the left has a thin strip of gilded ivory pinned to its outer edge to seal the triptych

Triptych with the Coronation of the Virgin, no. 49, closed

Fig. 49a. Triptych with painted angels, closed, Embriachi workshop, Venice, Italian, early 15th century, bone, wood, and intarsia, h. 60 cm, Baltimore, Walters Art Gallery (71.98)

when shut. The back of the central panel is completely plain, with no traces of decoration. The present simple wire hinges replace the three original hinges on each side, the slots for which are still visible. Small holes in the tops of the buttresses to each side of the central gable indicate that separately made elements—possibly small towers or standing prophets—were once attached, and holes in the central crockets and crowning finial likewise suggest the presence of further additions, possibly a bust-length figure of God the Father at the apex of the gable (see no. 50 and below, and Merlini 1991, 51, fig. 3, for small standing prophets on an Embriachi triptych). Three holes on the underside of the central panel presumably held dowels, fastening the triptych to a separate base. The triptych is fully painted and gilded, and although this is unlikely to be original, it is possible that it follows the original color scheme.

The form of the foliate ogee arch, supported on thin spiral colonnettes, the luxuriant crockets, the rich surface decoration, the iconographic type, and the figure style all point toward a Venetian provenance for the triptych. The design of the arch closely follows that on the so-called Porta dei Fiori on the north side of San Marco in Venice (Demus et al. 1995, 46–49, 48 illus.), of the thirteenth century, but the iconography reflects the type of the *Coronation of the Virgin* with musician angels seen most commonly in Venetian paintings of the third quarter of the fourteenth century by Paolo Veneziano and others (see, for example, Nepi Sciré and Valcanover 1985, 111, 146, 172; for Paolo Veneziano's famous *Coronation of the Virgin* of 1358 in the Frick Collection, New York, see Verdier 1980, fig. 62). Furthermore, the general form of the triptych, with crocketed gable, standing figures at the sides and richly patterned borders, calls to mind the late-fourteenth-century Holy Sacraments tabernacle in San Marco, the finials on both sides of which are topped by half-length figures of God the Father (Wolters 1976, 1: no. 137, 2: figs. 397–98). On a smaller scale the closest comparisons for the figure style are with the painted ivory low reliefs on a group of crosiers also associated with Venice, which appear to date from the third quarter of the fourteenth century (see no. 50).

Two further triptychs in the Walters Art Gallery, Baltimore, and formerly in the Gibson Carmichael Collection, Castle Craig, of a lower quality and carved from bone, were probably made in Venice as cheaper versions of this type of object, prefiguring the mass production of bone triptychs by the Embriachi workshop at the beginning of the following century (see no. 68); the wings of the example in Baltimore are directly copied from those on the London triptych (Randall 1985, no. 351; London 1902, lot 149, illus.). That the Embriachi workshop took prototypes such as the present triptych—with its elongated proportions, tall, pointed wings, and crocketed gable—as models is confirmed by the presence of the painted angels on the backs of the wings of the later triptych in the Walters Art Gallery (fig. 49a), which seem to be copied from those once on the wings of the present example or a closely related triptych. **PW**

ca. 1370

Italian (Venice)

Elephant ivory with polychromy and leather case

Height (including staff) 188 cm; diameter of volute 12.3 cm; case height 46 cm, case width 25 cm (at top)

London Victoria and Albert Museum (A.547 and 547a-1910)

PROVENANCE
Museo Civico, Volterra, until 1880; Frédéric Spitzer Collection, Paris, 1880–93; Spitzer Sale, Paris, April 17, 1893, lot 125, the case sold separately as lot 799; Salting Collection, London, 1893–1910; Salting Bequest, 1910.

REFERENCES
Florence 1880a, lot 4

Watts 1924, 32, no. 28, pl. 15

Longhurst 1927-29, 2: 60-61, pl. LII

Lesley 1936, 477–78, fig. 15

Cott 1939, 57–58, no. 179, pl. 66

Natanson 1951, fig. 61

Gaborit-Chopin 1978, 211

Williamson 1994, 293, fig. 2

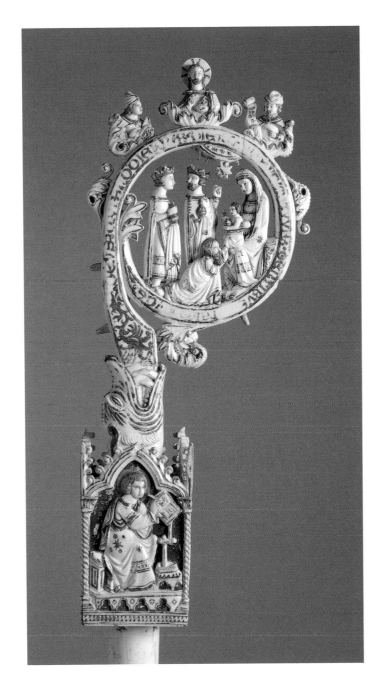

The volute, which issues from the mouth of a dragon, is surmounted by half-length figures of Christ between David and Solomon. It encloses an openwork representation of the Adoration of the Magi with the star above and is decorated with the following inscription, a portion of the Collect for the Epiphany: DEVS.QVI.HODIERNA DIE.VNIGENITVM. TVVR.GENTIBVS.STELLA.DVCE on the front side, and REVELASTI. CONCEDE.PROPITIVS.VT.QVI.IAM.TE.EX FIDE. COGNO[vimus...] on the back (O God, who on this day by the leading of a star didst manifest thine only-begotten son to the gentiles; mercifully grant that we who know thee now by faith, [... may be brought to the contemplation of the beauty of thy majesty]). The knop is carved on each face with a writing Evangelist seated beneath a trefoil arch. The volute and knop retain the original paint and are in good condition, although four foliate shoots or

additional prophets are now missing around the lower part of the former: three ivory pegs remain. The heads of Christ and Solomon and the two foliate shoots are either late-nineteenth-century replacements or were broken off before 1880 and subsequently restored (see the photograph reproduced in Florence 1880a). The stem, divided into four sections that screw together, is painted with dragons, birds, and faded leafy stems. The *cuir bouilli* case is decorated with various animals amid leafy scrolls and with the arms of the Aldobrandini family (azur a bend counter-embattled or between six mullets of the same ranged in orle). The interior is divided into five compartments, a central one for the head of the crosier and four circular ones for the sections of the staff.

The coat of arms on the case identifies the crosier as having belonged to Giovanni Benci Carrucci Aldobrandini, bishop of Gubbio between 1370 and 1375 (Pesci 1918, 87); the earlier date of 1331 given to the crosier by Sambon in 1880 and followed by Longhurst, Lesley, Cott, and others was based on the incorrect assumption that an earlier member of the Aldobrandini family had been bishop of Gubbio in that year. This adjustment to the dating affects not only the present crosier but also the small group of about ten crosiers related to it, most of which have a single narrative scene (the Baptism of Christ, Annunciation or Dormition of the Virgin) contained within the volute. Only one of these—that now in the Museo Nazionale del Bargello in Florence, which has a kneeling bishop, a warrior saint, and Saint Peter before the Virgin and Child at its center, and which is closest in style and facture to the present crosier—has been dated by reference to a known individual: it has been associated with Pietro di Monte Caveoso, bishop of Acerenza in Basilicata in 1334–43 (Gaborit-Chopin 1988a, 73–75, no. 20). This connection has not been established beyond doubt, however, and the stylistic similarities to the London crosier might suggest a later date for it.

Disassembled crosier and leather case, no. 50

Parker Lesley was the first to note the Venetian elements in the crosier, most conspicuously the half-length figures of Christ and prophets in foliate shoots (Lesley 1936, 474–78). The present crosier shares this feature with a number of others in the group, including those in Florence (already mentioned), the Walters Art Gallery (Randall 1985, no. 344), and that now in a private collection in New York (Randall 1993, no. 205; this was sold as lot number three at the same Volterra auction in 1880 as the London crosier and was then recorded as coming from the abbey of San Giusto alle Balze). The figure style and painting of the crosiers also link them with the Venetian triptych of about 1360–70 (no. 49). **PW**

SECULAR OBJECTS AND THE

ROMANCE

TRADITION

ca. 1250

English (London?)

Walrus ivory

Height 7.9 cm

**New York
The Metropolitan
Museum of Art
Gift of
J. Pierpont Morgan
(17.190.231)**

PROVENANCE
Formerly in the collections of
Georges Hoentschel, Paris;
J. Pierpont Morgan, London
and New York.

REFERENCES
Pératé 1911, no. 18

Koechlin 1924, 2: no. 18

Longhurst 1927–29, 2: 39

Porter 1977, 64–75, no. 18

Ottawa 1972, 2: 66

London 1987, no. 147

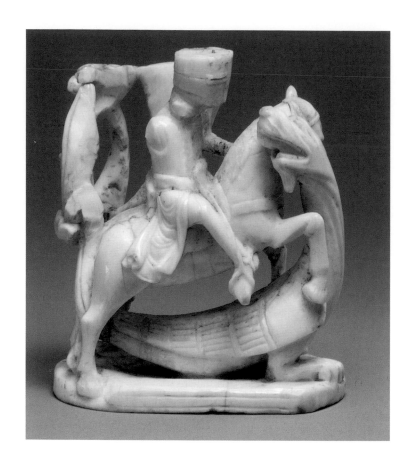

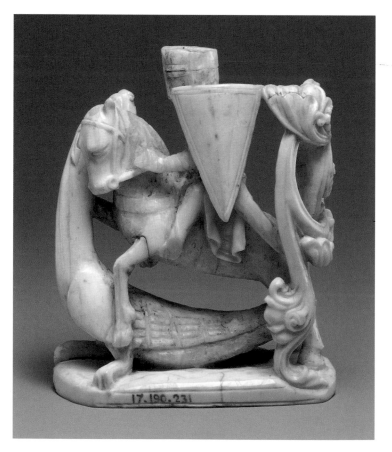

London, like Paris, was an important artistic center for courtly goods, including chess pieces. Chrétien de Troyes's celebrated romance *Perceval*, written in the 1180s, and its later continuation, includes an intriguing prelude to a chess match in the Chessboard Castle:

Ou je vos ferai anvoier	And I shall send you
Et les eschés et l'eschaquiér	both chessmen and board.
Il sont molt bel et bien ovré	It is very fine and decorated with
Et de fin or et anluminé,	fine gold and painted.
Si furent fait par grant devise	They were made with great device
A Londres qui siet sus Tamise.	in London that is on the Thames.

(Roach 1971, lines 27961–66)

Although without a specific mention of ivory here, chess pieces were customarily made of ivory and "decorated with fine gold and painted." This knight and two others, perhaps from the same set in Oxford and Compiègne (fig. 51a and London 1987, 254, no. 148), are the finest of the Gothic examples, and perhaps symptomatic of the pieces "made with great device in London."

The knight on horseback is engaged in combat with a dragon in a powerful composition of forms twisting in space, becoming a rare example of medieval sculpture as an independent object. Dressed in shirt and leggings of chain mail beneath a windblown surcoat, the knight wears a helmet *(héaume)* with narrow slots for the eyes. As he charges the dragon, his sword (now broken off) plunges into its mouth. A triangular shield is attached to his left arm, and rich foliage frames the hindquarters. While echoing images of Saint George and the dragon, this theme is unknown in chess sets.

The English origin of these chess pieces has been established both on grounds of provenance—the Oxford figure was in a local collection by 1685—and style. Images of combatant knights also occur on contemporary seals, especially that of the Great Seal of Henry III of 1259 where he is depicted on his charger in similar manner with a windblown surcoat (Binski 1995, fig. 122). Related depictions also appear on glazed tiles and in manuscript illumination (London 1987, nos. 16, 144, 151). Because of the close style parallels to the bestiary produced at Saint Albans, Porter believed the workshop to be located there (Porter 1977, 70). However, the spiral acanthus forms may also be compared to contemporary sculpture at Westminster Abbey, such as the arcades of the Edmund's Chapel or the chapter house door, completed by 1253 (Binski 1995, figs. 55, 243). **CTL**

Fig. 51a. Chessman, English, ca. 1240–50, walrus ivory, Oxford, Ashmolean Museum of Art and Archaeology (1685.A587)

ca. 1300–1320

**French (Paris)
or German (Cologne?)**

Elephant ivory

**Height 13.5 cm
Width 7.5 cm**

**London
Victoria and Albert Museum
(278-1867)**

PROVENANCE
Purchased from John Webb,
London, in 1867.

REFERENCES
Rohde 1921–22, 156, fig. 3

Koechlin 1924, 1:422,
2: no. 1141, 3: pl. CXC

Longhurst 1927–29, 2:50,
pl. XLV

Beigbeder 1965, fig. 61

Müller 1975, 203–7, figs. 5–6

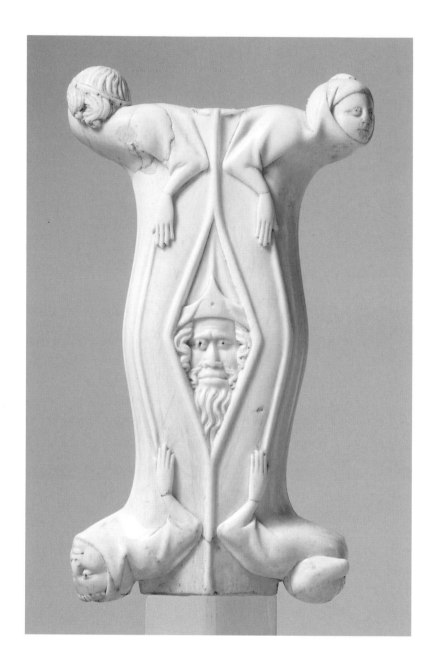

The corners of the handle are formed by busts of two women, a monk, and a youth whose hair is bound with a fillet. In the center of each side is a lozenge containing the head of a bearded man.

Four other dagger handles of a similar type are known. The first and the closest to the present example is still attached to its blade and was in the Rothschild Collection in 1922. It had come from the town hall of Coesfeld in Westphalia and the ivory sheath is embellished with enameled heraldic shields of the Westphalian von Graes family (see Rohde 1921-22, fig. 2). That handle also has a bearded male head in a lozenge on each side and four small heads (one is now missing) on each corner. The other three handles, now in the State Hermitage Museum, Saint Petersburg, the Bayerisches Nationalmuseum, Munich (this piece retains

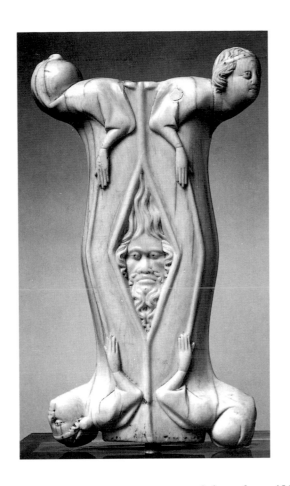

its ivory sheath), and the Museum für Kunst und Gewerbe, Hamburg, have small busts at the corners (the Munich handle only has two busts on the corners nearest the blade), but instead of lozenges on the sides there are medallions with younger heads (all are illustrated in Müller 1975). The handles in Saint Petersburg and Hamburg are carved from walrus ivory, suggesting that they were not made in Paris, where elephant ivory was plentiful in the fourteenth century, and the Munich handle has a provenance in the South Tyrol (Giessbach near Bruneck). A fifth ivory dagger handle, of a similar shape but not carved with figures, is in the cathedral treasury at Aachen and has an ivory sheath with male and female figures under arcades similar to that in Munich.

The provenance of three of these pieces in Germany and the Tyrol and the use of walrus ivory for two of them might suggest a German origin for at least some of the daggers. The Hamburg dagger is clearly of a lower quality and is probably a provincial reflection of a well-known type, but it is at present not possible to be categorical about the place of origin of the others, if indeed they were all carved in the same center. The bearded heads on the London and Coesfeld handles may be compared with similar heads on the Cologne cathedral choir stalls of 1308-11 (Bergmann 1987, 2: figs. 174, 231, 238–39), and the type of jeweled fillet *(bandeau gemmé)* worn on the heads of the youthful figures on the London, Munich, and Saint Petersburg pieces is also seen on ivories that have been attributed to Cologne, including the so-called casket of Saint Ursula (see Gaborit-Chopin 1978, 209-10). But here the difficulties of separating the work of Paris from that produced in other centers strongly influenced by it are once again apparent.

Daggers with decorated handles, probably more ceremonial than functional, must have been made in good numbers in France and Germany in the Gothic period, and it is to be expected that a popular type, once established, would be copied in different countries. René of Anjou (1409-80) seems to have possessed an identical dagger handle to the present example, possibly handed down to him, which is described in a 1471-72 inventory of Angers castle: "ung manche de couteau d'yvoire, auquel a IV petites testes aux IV bouts, et aux deux costes deux Barbarins" (a dagger handle of ivory, which has four small heads at the four extremities, and on two sides two Barbarians; Koechlin 1924, 1:423).

The blade of the dagger was missing before acquisition in 1867, but the handle is in good condition; the head of the youth has been broken off and mended with a pin through the shoulder. **PW**

ca. 1320–30

French (Paris)

Elephant ivory

Height 11.5 cm
Width 14.5 cm

London
Victoria and Albert Museum
(A.560-1910)

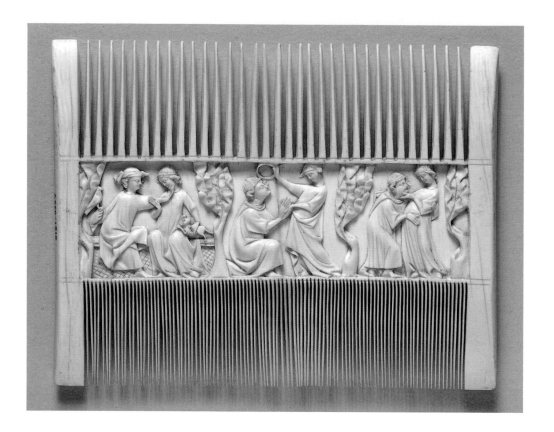

The comb has three scenes of courting on each side, separated by small trees. On one side the lovers on the left are seated on a bench, the man with a hawk, the lady holding a small dog; in the center the lady crowns her kneeling lover; and on the right the couple embrace. On the other side, on the left the man fondles the lady, who holds a small dog in her left hand; in the center the kneeling lover picks a flower for the lady standing above him, who holds a crown; and on the right the couple hold a crown between them. The comb is in perfect condition; not a single tooth is broken and the double incised lines made by the carver to mark out the surface between the teeth and central narrative section are still visible at the sides.

Ivory combs, together with mirror cases and *gravoirs* for parting the hair, formed an essential part of the *trousse de toilette* or *étui* (dressing case) of the typical wealthy lady or gentleman in the Gothic period. Just such a set is detailed in the French royal accounts of 1316: "1 pingne et 1 mirouer, une gravouère et 1 fourrel de cuir, achaté de Jehan le Scelleur" (1 comb and 1 mirror, a gravoir and 1 leather case, purchased from Jehan le Scelleur; Koechlin 1924, 1: 531). Typical examples of these leather cases are preserved in the Deutsches Ledermuseum, Offenbach, and the Musée des Beaux-Arts, Dijon (see Randall 1985, 179, fig. 35;

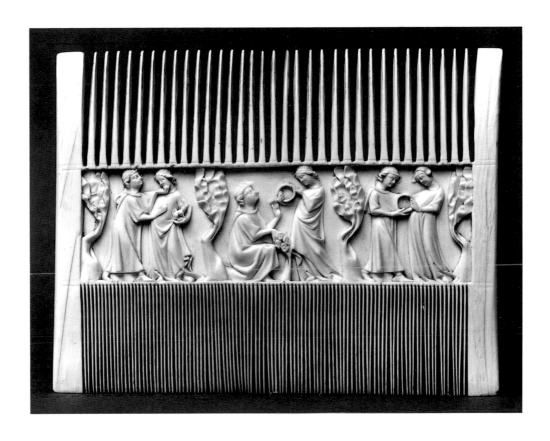

Krueger 1990, figs. 15–17). The sale of ivory combs by specialist *pigniers,* who also made combs in other materials, is well documented, and Koechlin published a good number of the names of such craftsmen, mentioned in the accounts of the French aristocracy (Koechlin 1924, 1:423–25, 531–39); these accounts and other references in inventories do not, however, give any details as to the decoration of the combs mentioned therein.

Considering the original ubiquity of such combs and in comparison with ivory mirror cases, a surprisingly small number survive from the fourteenth century. Koechlin catalogued just four examples (plus a fragment in the British Museum), and of these only one—that in the Museo Nazionale del Bargello, Florence—has a related subject matter of paired lovers engaged in courting (Koechlin 1924, 2: no. 1148, 3: pl. CXCI). In details, however, the latter is somewhat different, with the four scenes on each side taking place under an arcade. In iconography and style the London comb is closest to a mirror case in the Musée du Louvre that shows four sets of courting lovers, the individual scenes divided by spindly trees (Koechlin 1924, 2: no. 1007, 3: pl. CLXXVII): both were probably made at the beginning of the second quarter of the fourteenth century. **P W**

Mirror Case with a Royal Couple and Courtly Figures

1300–1320

French (Paris)

Elephant ivory

Diameter 14 cm

Paris
Musée National du
Moyen Age, Thermes de
Cluny (cl. 404)

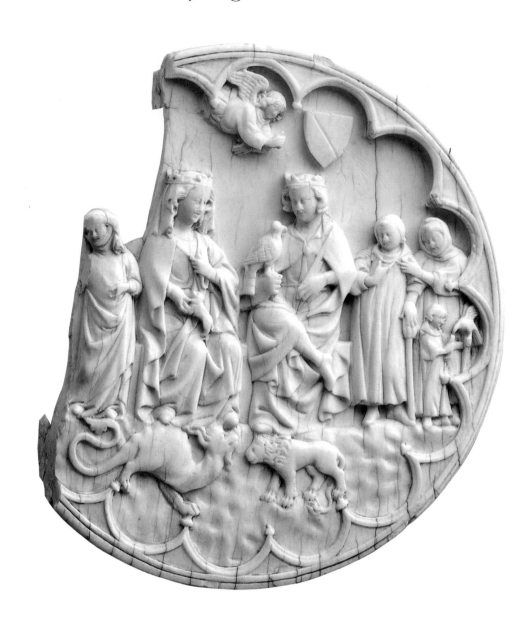

REFERENCES
Du Sommerard 1883, no. 1055

Koechlin 1924, 2: no. 1057

Grodecki 1947, 117

Beigbeder 1965, 47, no. 45

Ottawa 1972, no. 78

Gaborit-Chopin 1978, 148,
figs. 220–21

Cologne/Paris 1996, no. 47

One of the largest of all medieval ivory mirror cases, this example with a seated king and queen and attendants has been interpreted in many different ways. It was for many years thought to come from either the treasury of the Sainte-Chapelle or that of Saint-Denis, both of which have been shown to be incorrect. An entry in the records of the Garde Meuble of 1788 (Paris, Archives Nationales de la Couronne, 0 3370) most likely describes the piece (Gaborit-Chopin 1978, 207).

The subject has been interpreted as a portrait of a royal couple, and a number of kings and queens have been suggested, but without any convincing arguments. There is no doubt that it is a royal couple, and only one other mirror case, that of a hunting scene in the Fogg Art Museum, Cambridge, (Randall 1993, 124, no. 185) shows a king and queen.

However, there is a parallel to the subject in a gilt-bronze buckle of the early thirteenth century at the Metropolitan Museum of Art, the Cloisters Collection, the subject of which has been interpreted as

Solomon and Sheba (fig. 54a; the figures have also been identified as Esther and Ahasuerus [Broderick 1977]). However, the figures at the sides of the royal couple and the beasts beneath their feet suggest that this is possibly wrong. The king in both works has his feet on a lion, a symbol of nobility and resurrection, while the queen places hers on a dragon, the symbol of evil. The king in the ivory is further designated by a shield with his coat of arms above his head, undoubtedly originally painted, and with an angel pointing to it.

The figures at the sides in the bronze buckle are a bearded man touching the king on his shoulder, as though to tell him a secret, while the king looks directly at the queen. She, in turn, looks away and appears distressed, while her female attendant sits loyally beside her. The buckle was made at the high point of the early interest in romance literature in the early thirteenth century after Chrétien de Troyes and other authors had written the Arthurian and romance tales that became well known throughout the European continent. The facade of the Modena cathedral shows Arthurian knights in 1120, Tristan and Iseult are shown on Cologne bone boxes of about 1200, and King Arthur is portrayed in a mosaic at Otranto cathedral (Apulia) in 1166. So it would appear that the logical identification of the subject would be romantic rather than biblical or royal. None of the attendant figures supports the identification of Solomon and Sheba.

The couple on the buckle suggest an immediate identification with King Mark and his queen, Iseult. Because the love potion, which was intended for Mark, was drunk by Tristan, while escorting Iseult to her wedding, Tristan and Iseult were doomed to be lovers. The figure touching Mark on the shoulder could then be identified as Mark's seneschal, who warned Mark about Iseult's infidelity. The queen, presumably Iseult, looks guiltily away, and beside her sits Brangien, who mistakenly gave Tristan and Iseult the love potion

The ivory mirror case was made early in the fourteenth century in the court circles of Paris, where caskets and mirrors of ivory reflected the revived interest in romance literature. The subject is the same but it is slightly more elaborated than the buckle. The king has three attendants: a seneschal resting his hand on the top of his mace, his badge of office; a second figure pointing toward the queen, perhaps the dwarf who also told Mark of Iseult's infidelity; and a youth attending the king's hawk.

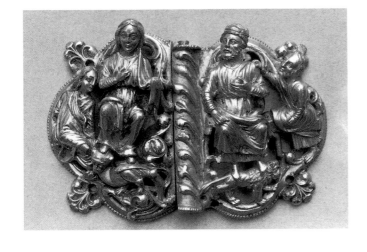

Fig. 54a. Buckle with Seated Couple, Mosan, ca. 1200, gilt bronze, h. 5.1 cm, New York, The Metropolitan Museum of Art, The Cloisters Collection (47.101.48)

On the queen's side there remains only one figure, a woman looking away from the scene, who could again be Brangien. There were probably two other attendants, but they have been broken away.

The interpretation of the couple as King Mark and Queen Iseult tallies with the western European interest in romance literature, which became widely known in the twelfth and early thirteenth centuries, the date of the buckle. This literature was revived in the fourteenth century, as is

shown by the Paris romance caskets with stories of Perceval, Gawain, Lancelot, and other Arthurian figures, of whom the most important were Tristan and Iseult. The tryst beneath the tree occurs on the composite Parisian ivory caskets and on many mirror cases and *gravoirs*, as well as in manuscripts of the period.

The ivory mirror case is not only of large scale, but it is elaborately designed with a border of cusped arches and a roughened ground plane, but without details of grass and plants. The drapery of the figures is complex and handsomely handled, as are the details of the dog in the queen's lap, the king's hawk, the faces, and the beasts.

The case has lost its corner terminals and was broken, so that much of the left side is missing. **RHR**

55 | Mirror Case

A lady crowns her lover, who kneels before her and offers his heart in covered hands. On the left a hooded groom raises his whip to control their two horses, whose muzzles only protrude into the picture; the rim is decorated with four crawling monsters. The mirror case has three small holes drilled through it around the kneeling lover, and a further hole below the top of the rim; all are secondary and connected with post-medieval use. There are substantial remains of gilding in the hair of both principal figures. The back has been shaved down to fit into a later setting, so that the raised rim, although still visible, shows no sign of the usual screw thread and there is no trace of the original mirror.

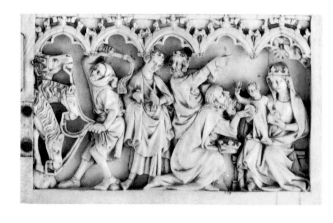

Fig. 55a. Diptych with the Adoration of the Magi (detail), French, 14th century, elephant ivory, London, British Museum (MLA 55,12-1,34)

Danielle Gaborit-Chopin has associated the mirror case with another showing two lovers engaged in a game of chess, now in the Musée du Louvre, and suggested that both were made in the same atelier in around 1300 (Gaborit-Chopin 1978, 207). Only two other French ivory mirror cases, now in the Museo Nazionale, Ravenna, and the Walters Art Gallery, Baltimore, show the single scene of a kneeling suitor being crowned by a lady, but these do not include the horses and groom on the left (see Koechlin 1924, 3: pl. CLXXVI, no. 999; Martini and Rizzardi 1990, 86–87, no. 17; and Randall 1985, 222, no. 320).

This is one of the finest of the earlier mirror cases, exemplyifing the world of courtly romance in the thirteenth-century *Roman de la Rose*. It has been observed, however, that its iconography, far from being purely secular, seems to have been derived pointedly from religious imagery,

ca. 1300–1320

French (Paris)

Elephant ivory

Height 10.5 cm
Width 10.2 cm

London
Victoria and Albert Museum
(217-1867)

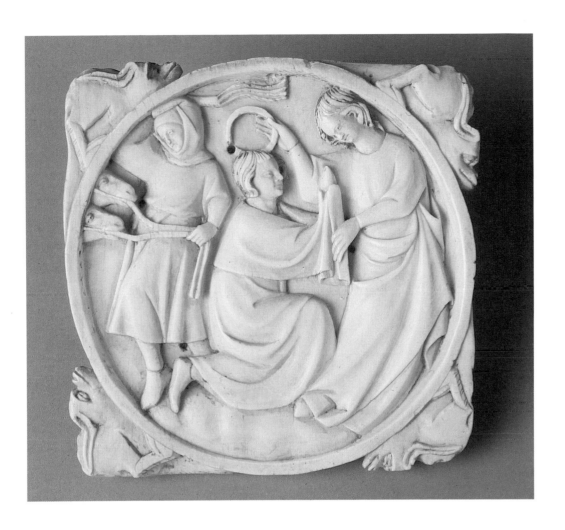

PROVENANCE

Préaux Collection, Paris, until 1850 (sale, January 9–11, 1850, lot 148); Rattier Collection, Paris (sale, March 21–24, 1859, lot 103); purchased from John Webb, London, in 1867.

REFERENCES

Du Sommerard 1846, 110, album: 5th series, pl. XI,3

Koechlin 1924, 1:378, 2: no. 1002, 3: pl. CLXXVI

Longhurst 1927–29, 2:44–45, pl. XLII

Grodecki 1947, 116

Ottawa 1972, 1: no. 76; 2: pl. 101

Gaborit-Chopin 1978, 148, 207, no. 219

Williamson 1982, 44, pl. 27

Camille 1989, 308–10, fig. 167

Blamires 1988, 18–21, fig. 2

Campbell 1995, 14–15, fig. 6

in particular the scene of the Adoration of the Magi (fig. 55a). Blamires has succinctly summarized the relationship by noting that the ivory carver

> challenges us to perceive the suitor as a Magus, his heart as a substitute gift of gold; hence the detail of the covered hands, which appears intermittently in Magi iconography during the Middle Ages. However, if the lover has yielded sovereignty to this "Virgin Queen" (there being no infant Monarch in question), paradoxically she inverts Adoration convention by making ready to crown him monarch of her heart. We are in the sphere of literary parlance concerning the voluntary capitulation of one's heart. The mirror both embraces the religious archetype and alters it, to enrich quite remarkably the sentiment of reverence and self-surrender in love. (Blamires 1988, 20–21)

Despite the fact that the feature of the horse-whipping also sometimes takes place in the scene of the Adoration of the Magi, it is possible that its presence on the mirror back should be interpreted in a different way in relation to the two lovers, signifying the restraining of their mutual passion, especially as it also appears on two other mirror backs in Florence and Naples that show two lovers embracing (Gaborit-Chopin 1988a, 64–65, no. 17; Giusti and Leone de Castris 1981, 98-99, no. II,3; and Kolve 1984, 244). **P W**

Mirror Case with the Court of the God of Love

ca. 1310–30

French (Paris)

Elephant ivory with traces of gilding and polychromy

Diameter 13.5 cm

Paris Musée du Louvre (MR R 195)

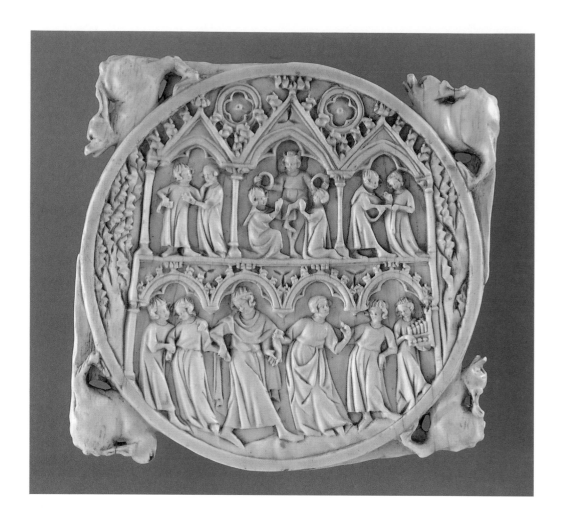

REFERENCES

Migieu and Boullemier 1779, pl. III

Molinier 1896, no. 23

Koechlin 1921, 285

Koechlin 1924, 2: no. 1080, 3: pl. CLXXXIV

Carra 1966, 128–29

Leningrad/Moscow 1980–81

Paris 1981, no. 125.

Several secular ivories, in particular mirror covers, are carved with scenes illustrating amorous encounters and glorifying romantic love. The example shown here is exceptional in that its various love scenes are intended to celebrate the triumph of the God of Love in his palace. Its dimensions are large and, as with the mirror case kept in the Victoria and Albert Museum, London (no. 55), it is framed by four monsters with elongated ears. These monsters derive from the grotesque figures or *drôleries* seen in manuscripts of the same period. As in other mirror covers illustrating the triumph of Love, its surface is divided in half by a horizontal line. Here, the line corresponds to the division between the two stories of a Gothic palace seen in section and surrounded by two large trees. At the top, three arches resting on small columns support spandrels decorated with leaves surmounted by two quatrefoils with protruding centers. This design can also be found on religious ivories (see nos. 22-23). In the center, the God of Love—a winged youth—is enthroned on a tree of which only the trunk can be seen. This well-established representation of the god may seem surprising in an interior scene. Love places crowns on the heads of two lovers who kneel at his feet and implore him. This completely secular image derives in fact

from religious models, such as Christ crowning the imperial couple (diffused by Byzantine prototypes of the tenth century) or that of the Virgin and Saint John kneeling before Christ during the Last Judgment and interceding for mankind. Two love encounters, part of the traditional imagery of the *amour courtois*, are represented on either side: the lover fondling his lady's chin and the lady giving her lover a crown. The charm of this ivory and its originality can be found in the scene represented on the ground floor of the palace: there under a gallery with four arches, a dance—the so-called *carole*—is taking place. Five youths are shown holding hands, but the two lovers are represented in the center, each holding the end of a glove. They dance gaily and lovingly to the sound of a portable organ, played by a young girl sitting on the side.

The seductive character of these representations is enhanced by their extraordinary quality. The faces are round and smiling, with wavy hair. Some of the ladies sport their hair *en cornes* (with their hair heaped over their ears). The robes are long and floating or else held by a thin belt. The gracefulness of the figures and the subtlety of the carving relate this ivory also to the London mirror case (see no. 55); it can be dated within the first third of the fourteenth century.

The reverse, covered at a later date with dark blue paint, shows the mechanism known as *pas-de-vis* that allowed this case to be affixed to its mate (now lost) in order to encase a round mirror.

A mirror case in London (Victoria and Albert Museum, no. 210, 1815; see Longhurst 1927-29, 2: 47, pl. XLIV) is closely related to this one, but the *carole* is replaced with three love scenes. The London ivory is bordered with rosettes; its execution is more mannered and it is slightly smaller than the Louvre's. It cannot therefore be considered as its match. The authenticity of the mirror case from the State Hermitage Museum, Saint Petersburg, which also represents amorous couples in a Gothic palace, is doubtful. **DGC**

1320–40

French (Paris)

Elephant ivory

Diameter 12.9 cm

Baltimore
Walters Art Gallery
(71.169)

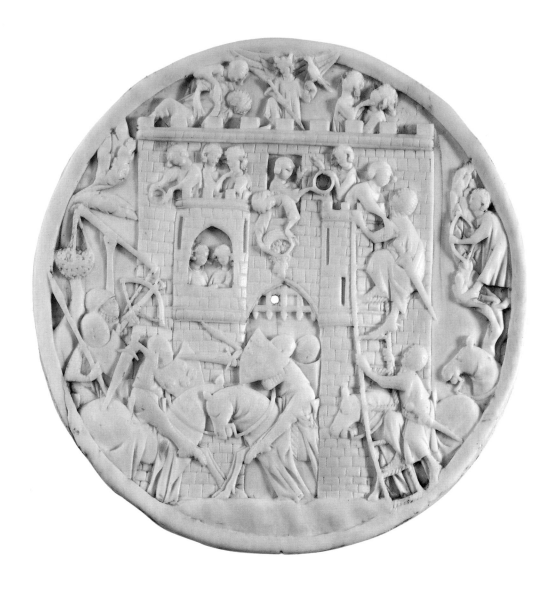

PROVENANCE
Treasury of the Cistercian
Abbey of Rein, Styria; sold
1928; purchased from Jacques
Seligmann, Paris, December 1,
1928, by Henry Walters.

REFERENCES
Lind 1873, pl. 22

Westwood 1876, 468

Schultz 1889, 577

Koechlin 1924, 2: no. 1097

Randall 1985, no. 322, pl. 71

The theme of the Attack on the Castle of Love is richly depicted on this large mirror case. There are twenty-two figures, including the God of Love on the top of the battlements, and four horses. The castle itself is handsomely portrayed with its portcullis, oriel window, and different levels of battlements.

The attacking force of knights includes crossbowmen and catapult operators throwing roses into the castle. In the foreground, two horsemen fight in front of the portcullis, while two others ascend a ladder from their horses. The defending ladies pour baskets of roses on the attackers, while one lady welcomes the knight ascending the ladder. The knights who have entered the castle are embraced by the ladies, including the couple in the oriel window. There is one tree at the left behind the catapult, and one at the right in which a bowman stands. The panorama, though complex, is clearly readable in every detail, and the knights and bowmen are distinguished by their helmets or mail. The combatant horsemen are seen to have roses on their shields.

The carver of the Walters mirror case with the Attack on the Castle of Love can be recognized by his treatment of figures in three works. There is the fine mirror in the National Museums and Galleries on Merseyside, Liverpool, with an elaborate elopement (fig. V-1). The careful rendering of the bridge and castle parallels the Walters mirror, as does the rendering of the horse trappings and other details. The subject is one often seen on the composite Parisian romance caskets, in which a couple ride away across a bridge in front of a castle, while a figure or figures are seen in a boat below, as in the Kraków and Boulogne-sur-Mer coffrets (Koechlin 1924, 2: nos. 1285, 1293). The scene shows mounted knights on a bridge, a knight lifting a lady down from the castle tower, and a group riding away with a lady in the arms of one of the protagonists. Below the bridge is a couple in a boat, with a musician playing the psaltery, and an oarsman.

Mirror Case with the Attack on the Castle of Love, back

Margaret Gibson and Kathleen Scott have interpreted the scene, as did Koechlin before them, as a sequence of events involving the same people (Gibson 1994, 94–95). They believe, as did Koechlin, that the knights arriving on the bridge, the knight with the lady, and the group riding away are three moments in the elopement, and, further, that the figures in the boat are again the same pair of lovers. It is more likely that the couple in the boat with the musician were thought by the carver to be love symbols and no more, since such figures appear in other versions of the elopement on a bridge. The direct relationship of the imagery of the Castle of Love and the elopement is made explicit by the lid of the Metropolitan Museum of Art's composite casket (New York 1975, 26–27, no. 10) where the elopement on a bridge takes place before the Castle of Love, including the God of Love and rose-throwing ladies, and the couple in the boat beneath the bridge are framed by rose decoration on the bridge itself.

A third work by the same carver is a mirror case in a German private collection with a completely different approach to the Attack on the Castle of Love, but where the figure style and treatment of the architecture show the same individual characterization (Koechlin 1924, 2: no. 1095).

The mirror case originally had four corner terminals in the shape of monsters, like those on the Liverpool mirror by the same carver, and the remains of their tails can be seen on the rim of the ivory. There is a chip out of the rim at the upper right. **RHR**

1325–50

French (Paris)

Elephant ivory

Diameter 9.8 cm

**Cleveland
The Cleveland Museum
of Art
J. H. Wade Fund (40.1200)**

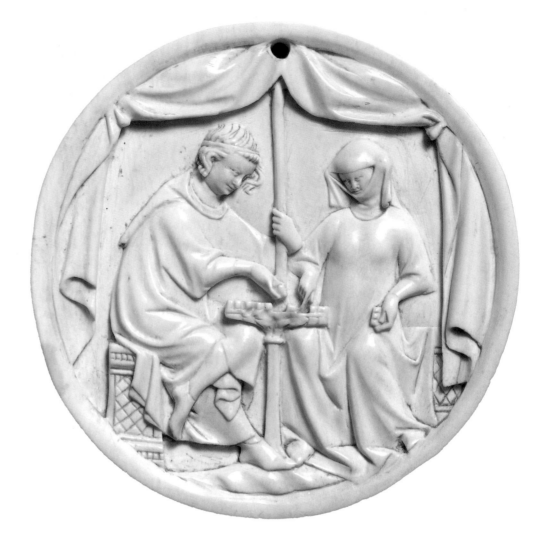

REFERENCES
London 1923, no. 144

Longhurst 1926, 262–63

London 1936, no. 109, pl. XXV

Williamson 1938, 163

Cheney 1941, 124–25

Wixom 1967, no. V-18

Randall 1993, no. 184

The game of chess represented both love and war in the Middle Ages, and the contest is mentioned in many of the romances of the period, including the story of Tristan and Iseult. It appears on caskets, combs, plaques, and mirror covers throughout the fourteenth century in both France and Germany, and the three finest examples appear to come from the same Paris atelier, and perhaps from the hand of the same carver. The Cleveland mirror case is one of these three.

The figures are depicted playing chess in a tent, with the tent pole placed just behind the table, and the tent flaps tied back and draped at the sides. The male player holds the tent pole firmly in his left hand while making a move on the board with his right. The lady points to the chessboard and holds a captured piece in her left hand. Both figures wear simple gowns (*cottes*), the lady with a wimple and with a deep drapery fold between her knees.

The two comparable pieces are to be found in the Victoria and Albert Museum (Longhurst 1927–29, 2: no. 803–1991, pl. XLII) and the Musée du Louvre (Koechlin 1924, 2: no. 1053). In the Victoria and Albert Museum example, the lady raises her right hand in surprise at her opponent's move, and other details are similar, such as the oddly cocked left hand holding a chessman. In the Louvre example, two witnesses have been added in the background, but all other details are perceptibly the same. The carver, whose composition was nearly perfect, amused himself in different mirror cases with portraying variant reactions to the game and making slight changes in the costume and curtains. A very similar depiction can also be seen on the English writing tablet cover in the exhibition (no. 61).

The Cleveland mirror case has lost its corner terminals, which would have been monsters, as seen on the other two. The surface of the ivory is highly polished and shows no traces of polychromy. It has been drilled at the top with a hole for hanging. RHR

59 | Mirror Case with Jousting Knights

This mirror case with jousting knights is unusual in two respects. First of all, one of the tilting knights at the left has knocked the helmet off his opponent, an event seldom represented, and second the knights at the right have roses on their shields, indicating that the ivory atelier was familiar with the details of the Attack on the Castle of Love, where roses are thrown down on the attackers. The format of the mirror is very similar to those depicting the Attack on the Castle of Love, in that two levels of spectators witness the jousting knights, as the ladies in the attack look down at the male besiegers. The castle is represented with two towers with barred windows, framing the two levels of battlements with their crenelations. In trees at either side are trumpeters signaling the event, and the knights are seen in the foreground. Those on the left have cloth streamers from their helmets; those on the right have crests of a bird and a flower.

The mirror has a simple rim adorned with four biped monsters with long tails, three of which are restorations, while the one at the lower right is original. The reverse side of the mirror is unusual, as there is no socket for inserting a metal mirror, and the smooth-sided opening is surrounded with a band of rosettes, a feature not otherwise known.

1330–50

French (Paris)

Elephant ivory

Diameter 12 cm

Richmond
Virginia Museum of Fine Arts
The Williams Fund (69.45)

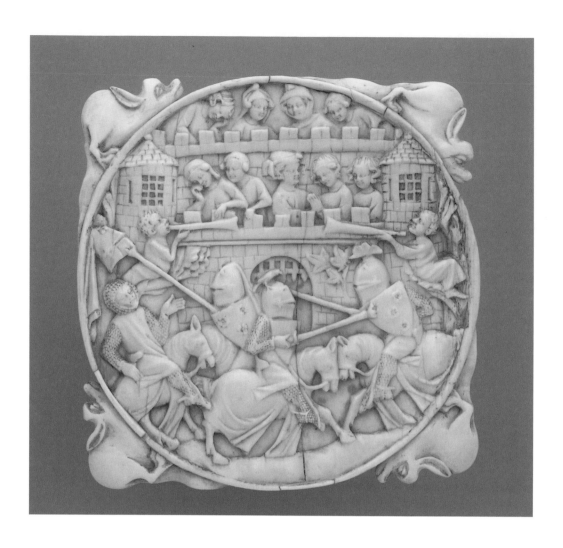

PROVENANCE
Purchased from John Hunt,
Dublin, April 1969.

REFERENCES
Chronique 1970, 51, no. 244

Glasgow 1977, 18, no. 12

A mirror case in the Burrell Collection, Glasgow, is perhaps from the same atelier, but not by the same carver. It shows the Castle of Love with two knights jousting in the foreground. One of the knights hits the other's helmet, which is occasionally depicted, but the scene in the Virginia mirror in which the helmet is actually seen knocked off by the lance is even rarer. Curiously, in the Burrell mirror two knights scale the castle, one with a ladder, and the God of Love crowns the battlements, but there are no roses thrown by either side (Glasgow 1977, 18, no. 12). **RHR**

1350–75

French (Paris?)

Elephant ivory

Diameter 10.1 cm

New York
The Metropolitan
Museum of Art
Gift of George Blumenthal
(41.100.160)

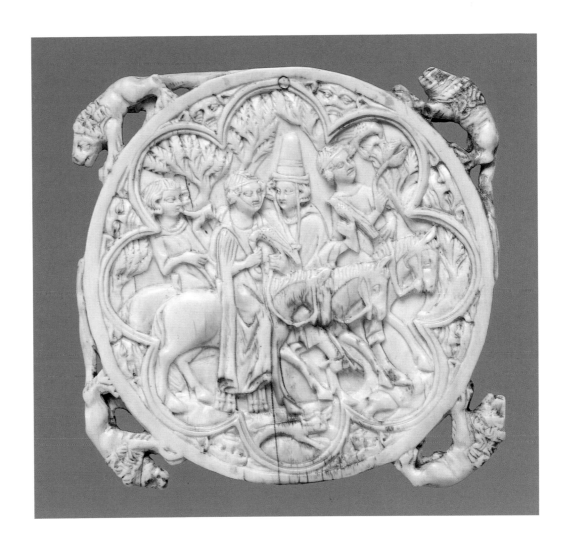

REFERENCES
Spitzer 1890-92, no. 69, pl. XIX

Bode 1897, no. 131, illus. 83

Koechlin 1924, 2: no. 1032

Rubinstein-Bloch 1926–30,
3: no. 139

Detroit 1928, no. 65

Boston 1940, no. 139

Los Angeles 1970, no. 74

Ann Arbor 1976, no. 70

Ivory mirror cases or covers were usually carved in pairs to protect a polished metal disk within, which was opened by means of a *closure à bayonette* mechanism. As forerunners of the modern compact, they were destined primarily for a courtly or mercantile audience. Often mentioned in inventories and wills, very few complete pairs survive and none with its protective leather case.

Set in a forested landscape, the falcon party is depicted within an eight-lobed frame with grotesques in the spandrels. The aristocratic couple on horseback hold falcons and are accompanied by two attendants, one blowing a hunting horn, the other with a lure to train the falcons. The man's amorous intentions are made clear by his glance and his arm placed around the woman's shoulder. He wears a distinctive conical felt hat corded around the neck, unknown in hunting scenes but found, for example, in the fresco of the Three Living and the Three Dead, possibly painted by Buffalmacco in about 1336, in the Campo Santo in Pisa. Four lions mount the corners, of which the upper right is modern.

Themes of falconry were popular in medieval art and literature even before Frederick II wrote his influential *De arte venandi cum aribus* in the early thirteenth century. In the fourteenth century Henri de Ferrierère's treatise on the art of the chase called *Le livre du roi Modus et la reine Ratio* illustrated similar episodes. Closely related representations on ivory mirror backs can be found on examples in Saint Petersburg, State Hermitage Museum, (inv. 2917), London, British Museum, (Koechlin 1924, 2: no. 1026), and New York, the Metropolitan Museum of Art (inv. 17.190.248; Koechlin 1924, 2: no. 1030 bis). Frequently these mirror backs are attributed to Paris, but stylistically they do not form a homogeneous group.

However, what is certainly the companion to this case was also originally in the Parisian collection of Frédéric Spitzer (fig. 60a; Koechlin 1924, 2: no. 1014). The other half is of corresponding dimensions, with four lions on the corners, but, instead of a single episode, it depicts four stages of love laid in foliate quadrants. The theme culminates with the man offering his heart to his lover. Both compositions are set within similar eight-lobed frames with grotesque masks in the spandrels. Reunited, the lions on the two valves would have confronted each other in pairs.

The link between the sport of falconry and courtly love is frequently manifested in romance and wedding iconography of the period; thus the imagery on the mirror back can also be read as a *caccia amorosa* (see Seidel 1994). **CTL**

Mirror Case with Falconing Party, no. 60, back

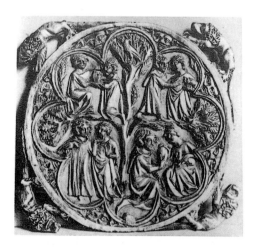

Fig. 60a. Mirror case with the Four Stages of Love, French (Paris?), ca. 1350–75, elephant ivory, formerly Frédéric Spitzer Collection, present location unknown.

ca. 1330–40

English or French (Paris)

Elephant ivory

Height 10 cm
Width 5.4 cm

Leather case

English or French (Paris)

Height 10 cm
Width 7.2 cm

Switzerland
Dr. Ernst and Sonya Boehlen

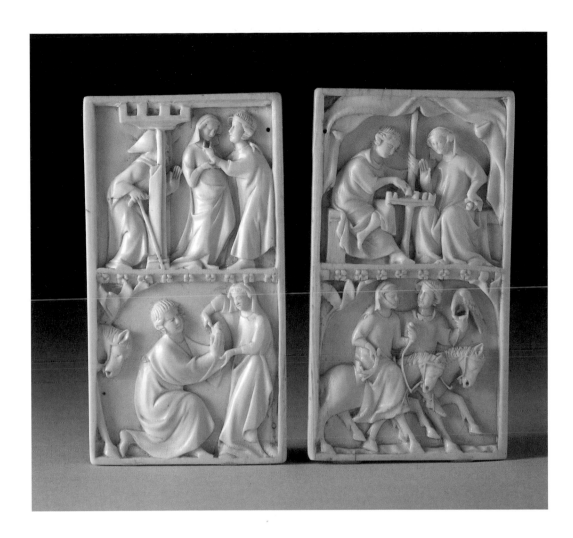

PROVENANCE
Said to have been found "in the thatched eaves of a cottage… in the English countryside" by Robert Darnaid (1752–1810); by descent to Lucia B. Hollerwith, Washington, D.C.

REFERENCES
Randall 1993, 123, no. 183
New York 1995, lot 13

Of the several dozen decorated secular ivory writing tablets that survive from the Gothic era only two are complete with their leather case, one in the Museé Archéologique, Namur, Belgium, (Koechlin 1924, 2: no. 1161-62), and the present set. In fact, this set of exceptional quality is the finest and clearly was destined for aristocratic use. Its charming scenes on the front and back feature the theme of the pursuit of love. From the allegorical chess game to the offering of the heart of true love, the scenes evoke popular courtly pastimes rather than literary accounts. Both utilitarian and beautiful in form, such tablets epitomize the courtly life of the High Middle Ages.

The presentation of the courtly love themes is conveyed with economy and artistic sensitivity. In the upper register of the front panel, two lovers play a game of chess within a tent where the woman appears to conceal in her garment some of the pieces she has already won. In the lower register below a border of rosettes the man embraces the lady as they ride through the woods. The man feeds a falcon, while the woman holds a crop.

On the back panel, in the upper register a cowled man with a staff emerges through a doorway to admonish or observe an embracing couple as the man chucks the chin of his lover. Below a rosette-filled

divide, the man kneels before his lover and offers his heart, while his steed waits behind him under a tree. The reverse sides of both tablets have recesses for wax, as do the other three panels. Originally the ensemble would have been linked by means of a thong running through the two holes along the edge of each.

The indoor and outdoor encounters of the lovers is striking. Each composition rhythmically balances figures and setting with counterbalanced elements such as trees or horses emerging into the vignette. The drapery style of large folds and the emphatic gestures of the lovers is characteristic of the finest Gothic ivories created for the aristocracy.

Although the style of the figures, the compositions, and the rosette borders are emblematic of the courtly Paris style of the first half of the fourteenth century, some features suggest a strong English element. Specifically, these include the figures emerging through a doorway suggestive of a stage set, supporting a crenelated wall section above. This can be observed, as recognized by Richard Randall (1993, no. 183), in English manuscripts of the 1320s and 1330s, such as the Holkham Picture Bible (fig. 61a). Yet the courtly style of Paris is evident throughout and several of the scenes are directly linked to such Parisian works as the Cleveland Museum of Art mirror back with the chess game (Randall 1993, 123–24, no. 184). Whether the tablets are products of England or France, or London as opposed to Paris, cannot be established with certainty given the mobility of labor and the preeminence of Paris as a center of ivory carving and the clear evidence of export.

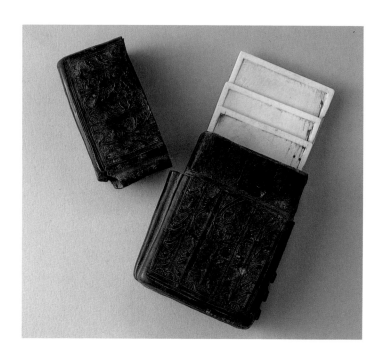

Writing Tablets with leather case, no. 61

The leather *(cuir bouilli)* case consists of two parts that are decorated with raised and engraved floral patterns in addition to geometric designs. Incorporated into one side of the case is a scabbard for the stylus, now missing. The case is certainly of the fourteenth century and was made to accommodate these writing tablets along with a metal or ivory stylus. It probably is the original but, perhaps due to water damage, now fits poorly. Some elements of the rinceau and other patterns can be related to such English works as a circular box in the Yorkshire Museum (Cherry 1991, 313, fig. 159).

The other set of writing tablets decorated with courtly scenes in Namur has eight leaves, a leather case with scenes from the story of Tristan and Iseult, and a metal stylus. Both sets have a recessed area on the plain leaves, which would have been coated with a mixture of wax and pitch or resin on which a text or message could be inscribed with the stylus. By smoothing the wax the writer could erase or correct the message. Since the scenes on the covers are patently romantic, it is tempting to surmise that these tablets were created for a campaign of love.

The episodes of courtship on the tablets do not illustrate a specific text, but rather they evoke the rituals entailed by courtly love. They are thus generic or universal in nature. Aside from the indoor/outdoor juxtaposition, the scenes shift from allegorical—as in the chess games where the lady attempts to conceal some of the pieces in her garment while she admonishes or encourages her lover—to an almost voyeuristic witness of lovers embracing when the old man comes upon the youth chucking his lover's chin, gestures considered in the Middle Ages to be charged with erotic overtones. Playfulness is extended in the falcon hunt where the lovers embrace while they ride. The man offering the heart is the final act of fidelity and acceptance of love. Such themes were popular in poems such as Guillaume de Lorris and Jean de Meun's *Roman de la Rose*, the widely known allegory of courtly love written about 1237–77. **CTL**

Fig. 61a. *Holkham Picture Bible*, England, ca. 1320–50, London, British Library, Add MS 4782, fol. 39v

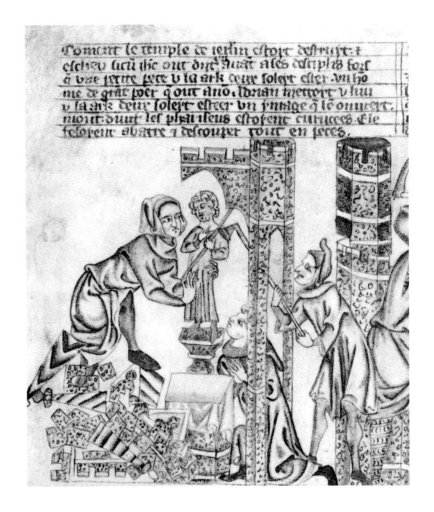

SECULAR OBJECTS AND THE ROMANCE TRADITION

62 | Casket with the Story of Perceval and Saints

ca. 1310–30

French (Paris)

**Elephant ivory
with modern silver mounts**

**Height 7.4 cm
Width 22.5 cm
Depth 11.3 cm**

**Paris
Musée du Louvre
(OA 122)**

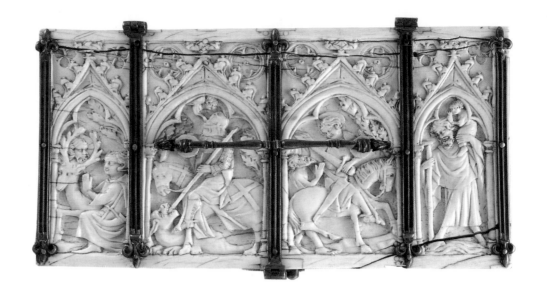

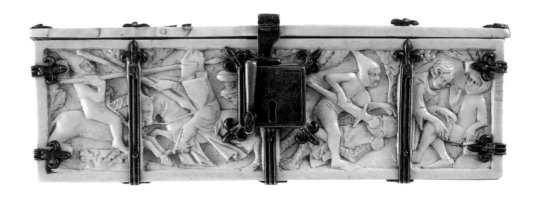

PROVENANCE

Collection of Charles Sauvageot, Paris; given to the museum in 1856.

REFERENCES

Molinier 1896, no. 62

Loomis 1917

Koechlin 1924, 1: 513-16, 2: no. 1310, 3: pl. CCXXLLL-IV

Grodecki 1947, 117

Fouquet 1971, 237–44

Mexico City 1993, 136

The subjects illustrated on secular caskets are often borrowed from contemporary literature. Whereas in the first decades of the fourteenth century "composite" caskets—that is, caskets with scenes taken from different stories—are relatively common, those illustrating a single theme are rare. The one exhibited here is the only known example to take for its subject the story of Perceval. The scenes unfold on the side panels and follow closely the original text of the first episodes of Chrétien de Troyes's novel. The cycle begins on one of the short sides with the encounter between Perceval (wearing tights with a hood, and holding a bow) and three knights that Perceval believes to be angels. It is followed by scenes representing the conversation between Perceval and his mother, her fainting as Perceval leaves her, the ride of Perceval, and the description of the kiss he steals from a young girl asleep under a tent. On the other short side, Perceval on horseback enters the room where King Arthur, Guinevere, and the Knights of the Round Table are

seated around a table. In the background, the young maid he had kissed is being treated roughly by his friend. Finally Perceval is depicted fighting the knight with the vermilion coat of arms who has stolen the cup from the Queen. He kills the knight and puts on his adversary's suit of armor.

These scenes are not set in architectural frames but are separated from one another by the moldings intended to accommodate the iron mounts. Their style is narrative and quite vivacious. The soft and flowing execution is typical of the style of the first decades of the century.

By contrast, the subjects represented on the lid are different both in composition and iconography. Four saints, all subjects of devotion in the Middle Ages, are represented under large arches with hooks and topped with trefoils and quatrefoils: Saint Christopher, Saint Martin, Saint George, and Saint Hubert. Their style is identical to that of the figures in the story of Perceval (see, for instance, the kneeling Perceval and Saint Hubert). From the time of its conception, secular and religious scenes were thus associated on this casket. It is indeed most likely that there is a link between these images of the life of young Perceval—the first episodes in the story of the Grail—and these religious figures, in particular those of the saints who were also knights, Martin, George, and Hubert. Nevertheless this rare pairing of religious and secular subjects on a Gothic casket proves clearly that the same craftsmen could produce either secular or religious ivories (other examples are the Gotha casket and the casket formerly in the Watelin collection, now at the Musée Dobrée, Nantes; see Koechlin 1924, 2, nos. 1312, 1270 bis). **DGC**

Casket, right and left short sides

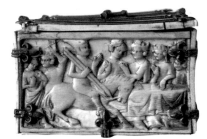

Casket, back

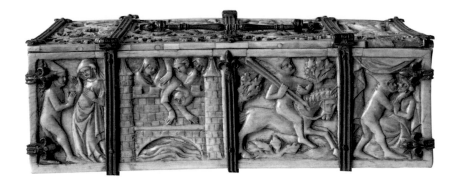

SECULAR OBJECTS AND THE ROMANCE TRADITION

ca. 1320–40

French (Paris)

Elephant ivory

Height 8 cm
Width 21.6 cm
Depth 10.2 cm

New York
The Metropolitan
Museum of Art
Gift of J. Pierpont Morgan
(17.190.177)

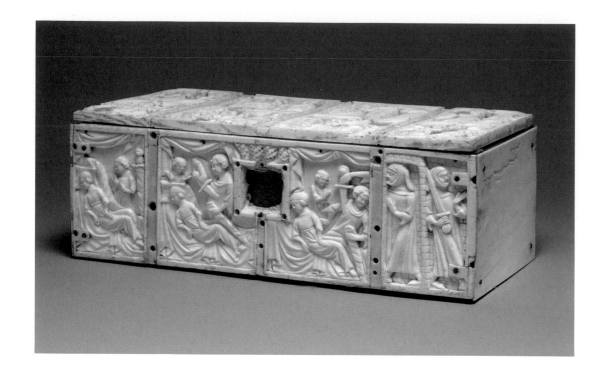

REFERENCES
Koechlin 1924, 2: no. 1305

Erffa 1954

Locey 1970

Gross 1979

Bruckner 1995

Written toward the middle of the thirteenth century, *La châtelaine de Vergi* illustrates a classic story of love and death, caused by conflicting loyalties. Perhaps based on a scandal at the Burgundian court, the story became a widely praised narrative poem. It is ironic that only ivory caskets, such as this one, offer a visual synopsis of the poem. A lost manuscript model has been proposed, but the surviving medieval texts only occasionally illuminate a single scene. The images closely follow the narrative of the poem and are arranged in pairs, beginning on the lid at the top left and reading in a serpentine fashion to the right: the knight, who serves the duke of Burgundy, declares his love for the chatelaine (lady). She employs a small dog to signify to him her availability for the secret affair; the lovers enjoy each other in her chamber. The duke's wife, who wears a crown, also attempts to seduce the knight, but he rejects her in favor of the lady. The duchess falsely tells the duke (who is identified by a hood) that the knight propositioned her. In the last scene on the lid, the knight pleads for mercy before the furious duke and reveals his secret love for the lady to the duke.

On the back of the casket, the duke promises to keep the secret and then, as visual proof of the affair, witnesses the meeting of the lovers with the dog in attendance. Next, in their bedchamber, the duchess coaxes the secret from the duke, while in the last scene a messenger invites the duchess to a court feast held at Pentecost. The duchess whispers the secret to the lady, revealing her knowledge of the lady's love for the knight, and in so doing seals her own fate, that of the lady, and even that of the knight.

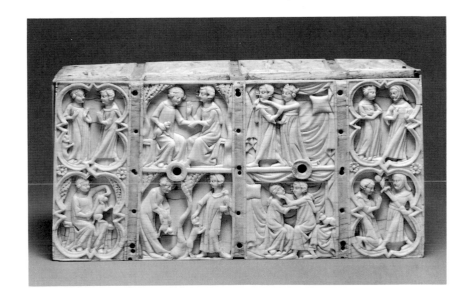

Casket, top

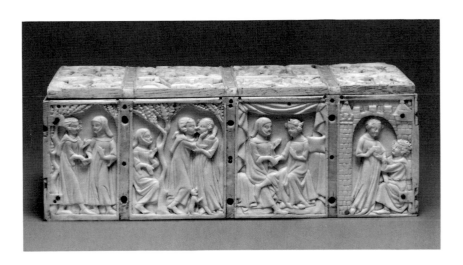

Casket, back

On the front of the casket, the distraught chatelaine dies and is discovered by her maid. In anguish the knight joins her in death. The gruesome finale shows the duke pulling out his sword and going in search of the duchess who caused the treachery. The missing end must have displayed the execution of the duchess amid the court.

The visual drama is enhanced with a range of gestures indicating intimacy, trust, loyalty, astonishment, grief, and death. As demonstrated by Gross (1979, 318–19) these gestures and postures have a symmetry that enlarge the ironies of the relationship. In a similar way the settings become instruments of meaning, especially the bed, which is the locus

of both love and death. The sword likewise foreshadows key scenes and serves as a symbol of death.

This casket is one of six narrating the theme of *La châtelaine de Vergi* (others are in New York, the Metropolitan Museum of Art; Paris, Musée du Louvre; Milan, Castello Sforzesco; Vienna, Kunsthistorisches Museum; and London, the British Museum [Koechlin 1924, 2: nos. 1301-9]. Two end plaques in the British Museum depicting the dance and the execution of the duchess are similar in design and style but are of different dimensions to those missing spaces on the present example (figs. 63a–b). All the caskets appear to be contemporary and of related, but not identical, style, and most follow the story similarly. However, a lid in the Musée du Louvre (A 10012; Koechlin 1924, 2: no. 1304) is analogous in design and style to this one, suggesting that both are the work of the same Parisian atelier. The function of such caskets is uncertain. They are usually thought to be for jewels, but they may also have been presented as tokens of affection or marriage.

The mounts are lost, and the ends of the casket are missing. **CTL**

Fig. 63a. Casket panel with ladies dancing, French (Paris), 1320–40, elephant ivory, h. 6.9 cm, London, British Museum (MLA 1958,4-2,1)

Fig. 63b. Casket panel with execution scene, French (Paris), ca. 1320–40, elephant ivory, h. 10.7 cm, London, British Museum (MLA 92,8-1,47)

1330–50

French (Paris)

Elephant ivory

Height 11.5 cm
Width 24.6 cm
Depth 12.4 cm

Baltimore
Walters Art Gallery
(71.264)

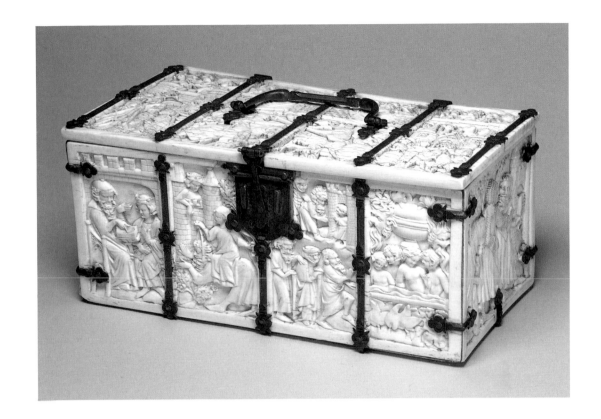

PROVENANCE

Collections of Rev. John Bowle (1725–88), Wiltshire, about 1780; Gustavus Brander, Christchurch, Hampshire, 1787; Francis Douce (1757–1824), London, until 1824; Sir Samuel Rush Meyrick (1783–1848), Goodrich Court, Herefordshire, until 1848; Lt. Col. Augustus Meyrick; Frédéric Spitzer, Paris, until 1893; Oscar Hainauer, Berlin, 1897; H. Economos, London 1913; purchased from Arnold Seligmann, Rey, and Company, Paris, 1923.

REFERENCES

Carter 1780, 49, pl. CXIII, CXIV

Meyrick 1836, 382–83, no.10

Bode 1897, 142

Koechlin 1911, 398–99

Ricci 1913, pl. 44

Koechlin 1924, 2: no. 1281

Loomis 1938, 60, 70, 76

Wixom 1967, V 20

Randall 1969a, no. 18

Frühmorgen-Voss 1975, 132–36

Randall 1985, 224, no. 324

The most lavish products of the Paris ivory ateliers for secular use were the large caskets, which averaged seven to ten inches in length, richly carved on five faces with stories from popular romances. Some of these elaborate jewelry or document boxes represented a single story, such as that of Perceval (no. 62) or *La châtelaine de Vergi* (no. 63), but by far the largest number of surviving caskets were of a composite nature, with ten or eleven stories from Arthurian romances, the bestiary, the ancient world, or the Near East.

The Walters Art Gallery box in this exhibition is a typical example of the composite casket, and the tenor of its subject matter is set by the scenes of jousting on the lid, as well as a mockery of jousting, and the Attack on the Castle of Love, a favorite allegory of chivalric love. Jousting was the public exhibition of male prowess and offered a festive opportunity for a varied audience. It is portrayed on the casket with two knights in helms and partial plate armor, with ailettes on their shoulders, charging one another in the tilt yard. In the trees sit two trumpeters, and above in a gaily draped balcony stand nine spectators pointing and remarking on the event. Their social classes are indicated by the costume, and one elegant youth carries his hawk, while at the side an old man in a hood with a pet bird is a witness.

To the right of the tilting scene is another of the same subject. But this one is a humorous mockery of the sport, where two women joust with armored knights using branches of roses, the symbols of surrender in medieval love imagery, while the men hold branches of oak leaves, age-old symbols of fertility.

At the left is the Attack on the Castle of Love, where knights assault the fortress of love with roses thrown by crossbows and catapults. The ladies energetically throw roses on the attackers, aided by the bow and arrows of the God of Love. One knight ascends a ladder to reach the battlements. As a visual bond between the scenes, one of the knights in the central joust is seen to have roses on his shield. Thus is the tone of the subject matter set with allegory, humor, and heroism.

The stories on the front of the casket come from the ancient world and from the East. The first of two scenes is that of Aristotle teaching the young Alexander the Great to be careful of women and attend to his lessons. Aristotle, as every medieval reader was aware, had learned that Alexander was smitten by a young beauty named Phyllis (or Campaspe in some versions of the story), but the tutor had never seen the young woman. Shortly thereafter, Aristotle met Phyllis and was so astonished at her beauty that he got down on his knees and offered her his love. She spurned him but asked if he would let her ride him around the court like a horse. He agreed, and as he carried Phyllis on his back, Alexander looked out and saw his famous tutor on all fours making an idiot of himself.

As the story of Aristotle is one of old age, it is followed by one whose theme is youth. Again in two scenes, one reads the story of the Fountain of Youth, an oriental legend made popular in Europe by the letter of Prester John, in which the bearded elders in the first scene approach the fountain on crutches. In the second panel, they have bathed in the fountain and are young again and eyeing the pretty maiden in their midst.

This contrast of subjects is carried onto the left short side of the box, where the scenes, combined in a single panel, represent Tristan and Iseult at the fountain and the capture of the unicorn. The first is an Arthurian tale, usually called the tryst beneath the tree, where Tristan and Iseult often met secretly. King Mark, having been informed of this by his seneschal, hid in the tree to witness a meeting. Mark's face, however, was reflected in the fountain, and when Tristan and Iseult saw it, they talked of King Mark and of Tristan's thoughts of leaving the court, and Mark, hearing this, considered them innocent of the adultery that he had been informed about.

The adjoining story of the unicorn, from the bestiary, is one based on virginity. A maiden is brought to the forest, and the unicorn surrenders to her, laying his head in her lap. Only then can the hunter come and kill the unicorn, as it is too swift and wary to be trapped by any other means.

The back of the box continues the Arthurian stories, and in four panels shows Gawain fighting the lion, Lancelot crossing the sword bridge, Gawain on the magic bed, and the ladies of the Castle Merveille witnessing this scene. In the Gawain bed scene, spears rain down on him from the ceiling, and he survives the ordeal by sleeping in his armor and under his shield. The paw of the lion is embedded in the shield, refer-

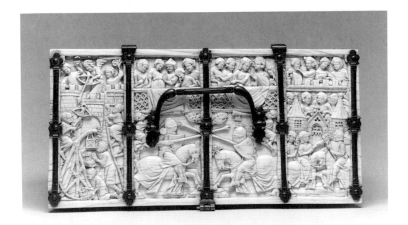

Casket, top

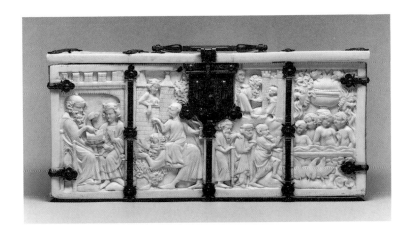
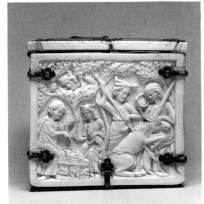

Casket, front and left short side

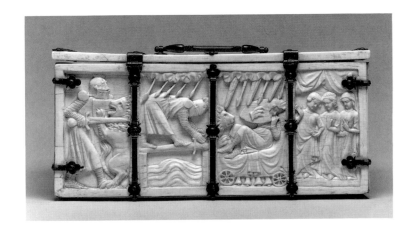
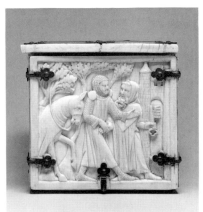

Casket, back and right short side

SECULAR OBJECTS AND THE ROMANCE TRADITION

ring back to the first panel. However, the carver placed spears above the Lancelot scene, where they do not belong, but this error must have been perpetuated by a drawing or model in the workshop, since it occurs on a half dozen boxes and is never corrected.

On the right short side of the box is yet another Arthurian story, that of Galahad receiving the keys to the Castle of Maidens. It is given great prominence in this casket and allowed to fill the entire panel. The figures are large and finely detailed, the keeper with the key, Galahad in his mail and surcoat with an ailette on his shoulder, and his horse in a trapper, tied to an oak tree. On other caskets this scene is often combined with the story of Enyas and the Wodehouse (or wild man; see p. 68). In that case, the contrasts continue as Galahad was the virgin knight and the wodehouse the symbol of carnal sin.

There exist more than one half dozen complete composite boxes, and fragments of a dozen more, suggesting that this was the most popular model for a Parisian casket. While the workmanship varies with the artisan, it is interesting and perhaps indicative of a single major workshop that the error of the spears in the Lancelot scene is continually repeated. There is one non-Parisian version of the box, an example in the Musée Municipale, Boulogne-sur-Mer, that, while very different in style and quality, has captured the essence of the stories (Koechlin 1924, no. 1293).

The box was originally mounted in silver, as can be seen from the Jadwiga casket in Kraków with its original mounts (Koechlin 1924, 2: no. 1285). The Walters box was in dismounted pieces when in the Douce Collection in 1836 and was remounted in iron when in the collection of Frédéric Spitzer in Paris in 1890. There are several age cracks occasioned by the iron mounts. **RHR**

NEW
DEVELOPMENTS

IN IVORY AND BONE CARVING

Late 14th or
early 15th century

French (Burgundy)

Elephant ivory

Height 24.7 cm

**Houston
Museum of Fine Arts
Houston
Edith A. and Percy S.
Straus Collection
(44.581)**

PROVENANCE
Collection of Henry Garnier,
Lyons; purchased by Edith A.
and Percy S. Straus from Joseph
Brummer, New York, January,
1935.

REFERENCES
Houston 1945, no. 57

Verdier 1975

Gaborit-Chopin 1978, 171,
212–13, fig. 267

Erlande-Brandenburg 1983,
no. 634

Randall 1985, 184, 188

Dupin 1990, 35–65, figs. 1–20

Morand 1991, 327, 329, fig. 57

Randall 1993, 45, no. 26, pl. 5

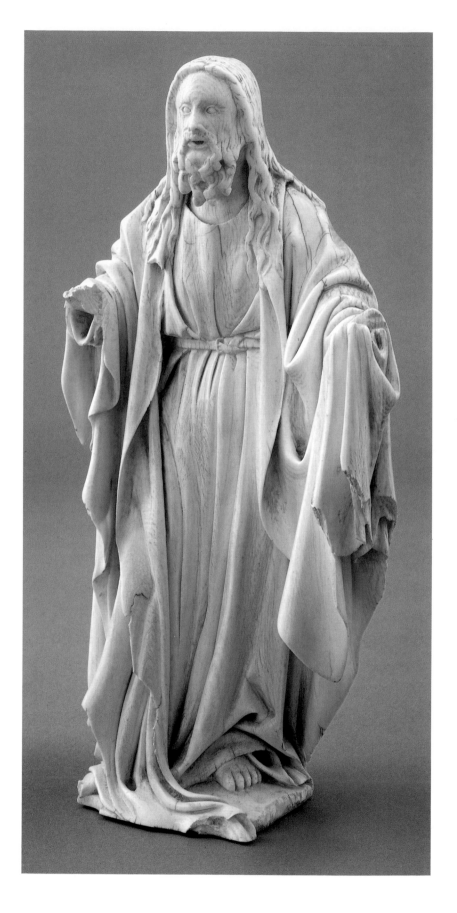

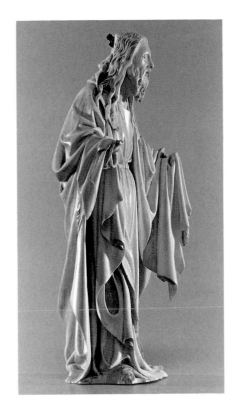

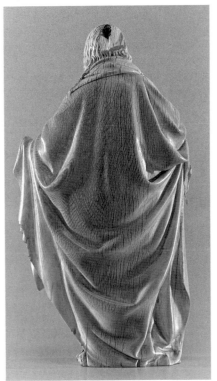

Carved in the round, this magisterial figure of God the Father stands with his arms raised before him. His long, wavy hair falls over his shoulders, and his beard grows in layers of curls. His eyes are open wide, and his mouth is partially open. His simple robe is gathered at the waist by a narrow belt which is buckled and then looped over on itself. Below the waist the robe falls to his bare feet in soft vertical folds. The mantle, draped over the figure's shoulders and open arms, hangs gracefully in voluminous, soft folds. At the back, the mantle falls from the shoulders to the ground in wide, soft arcs. A section of ivory is missing from the back of the head where a bolt has been inserted. There is a small loss to the base by the right foot, and the right hand is broken.

The statuette is clearly the major figure from a group representing the Trinity. The iconography was first explored by Philippe Verdier (1975) and more recently by Isabelle Mosneron Dupin (1990). The standing representation of the Trinity, in contrast to the seated depiction, is a rare iconography localized to the Burgundian court. The original appearance of the ivory group can be reconstructed from surviving examples, such as the sculpture in the church at Genlis near Dijon (Dupin 1990, fig. 10). In the Genlis sculpture and in other Burgundian representations, the figure of God the Father stands holding the crucifix, which reaches to his feet, in his outstretched hands. The dove of the Holy Spirit flies down toward the cross, occupying the space between the open mouth of God the Father and the top of the cross. The Trinity was a theme of particular importance for the Burgundian court. The Chartreuse de Champmol in Dijon was dedicated jointly to the Virgin and to the Trinity, and sculptures of both images were commissioned for the church there.

It is not, however, iconography alone that allows us to place the Houston statuette in the milieu of the dukes of Burgundy. Associated generally with the followers of Claus Sluter (d. 1406) from the time of its acquisition by the Museum of Fine Arts, Houston, Dupin has demonstrated that the ivory can be related intimately to the history of sculpture in Burgundy. She observed a remarkably close relationship between the Houston God the Father and a mourner from the tomb of John the Fearless (figs. 65a–b; see Dupin 1990, 63–65). The ivory and marble figures differ significantly only in the treatment of the heads and necks due to the cowl worn by the mourner. The two figures are posed in the same way, their soft drapery falls in identical patterns, front and back, and the narrow belt is knotted identically. The tomb of John the Fearless and his wife, Margaret of Bavaria, is the work of Juan de la Huerta (active 1443–62), who was commissioned in 1443 to make the

tomb for the Chartreuse de Champmol in Dijon. Dupin has shown, how-ever, that models played a key role in the development of Burgundian sculpture. Juan de la Huerta based the form of his tomb on the seminal tomb of Philip the Bold begun by Jean de Marville (d. 1389) and completed by Claus Sluter. As Danielle Gaborit-Chopin first observed, the calm drapery of the ivory is closer to the style of sculpture in Dijon before the arrival of Sluter in Marville's workshop (Gaborit-Chopin 1978, 171).

The Houston ivory is generally consistent with the sculptures of Jean de Marville, and it should be remembered that rare documents inform us that Marville actually worked in ivory and wood as well as stone. A document of 1377 relates the purchase by Philip the Bold of twenty-six "livres" of ivory from a Parisian "tabletier" for twenty-six francs to be used by Jean de Marville (see Verdier 1975, 67–68). While it cannot be proven that the Houston statuette was produced by Marville's workshop, it is demonstrably a masterwork in ivory produced in the late fourteenth or early fifteenth century, and it preserves a figure type used as a model in the ducal court over approximately fifty years. **P B**

Fig. 65a. Mourner number 78 from the tomb of John the Fearless and Margaret of Bavaria, Jean de la Huerta and Antoine Le Moiturier, French, 1443, alabaster, Dijon, Musée des Beaux-Arts

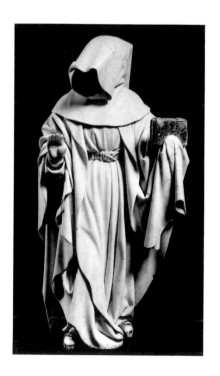
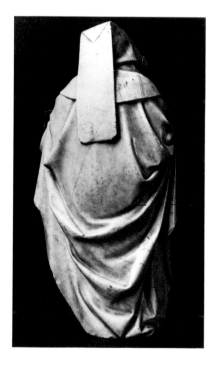

ca. 1400–1420

French (Burgundian) or South Netherlandish

Elephant ivory

Virgin: height 10.2 cm

Saint John: height 9.9 cm

Boston Museum of Fine Arts William Francis Warden Fund (Virgin 49.486 and Saint John 49.487)

PROVENANCE
Gabriel Dereppe, Paris; purchased at the Joseph Brummer sale, New York, 1949.

REFERENCES
New York 1949, no. 683

Calkins 1968, 163–64, no. 90

Randall 1993, 46, no. 27

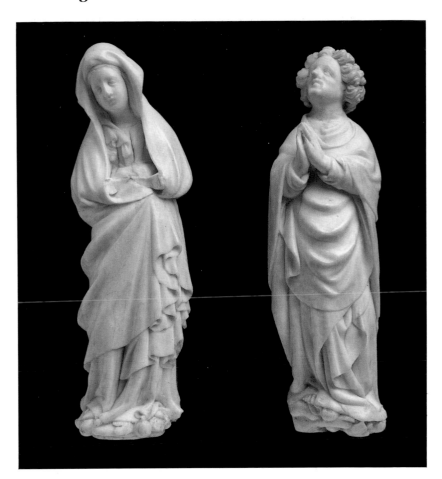

The two statuettes, carved in the round, were undoubtedly made to flank a crucifix. In such representations, the image of the Virgin is traditionally placed to the right of the cross. Here, the Virgin's head is tilted to her right in a gesture of sorrow, so that originally she would have looked away from the cross. Saint John gazes up to his right with his hands clasped before him in a gesture of prayer. The Virgin's hands are missing. Both figures are draped in heavy mantles that break into soft folds. They are both drilled for attachment underneath, and each has an additional hole at the side of the base.

The voluminous drapery of these statuettes and the thick, curly hair of Saint John reveal the influence of late Gothic stylistic developments at the Burgundian court around 1400. Robert Calkins has drawn comparisons to illuminations in the Turin-Milan Hours (Calkins 1968). In sculpture, the so-called Well of Moses at the Chartreuse de Champmol, Dijon, created by Claus Sluter as the base for a monumental cross no longer extant, provides some general comparisons for the Boston ivory figures. The six figures of angels placed between the large prophets in the Dijon monument were installed by 1403. In the treatment of their hair, drapery, and facial types they are consistent with these ivories (see Morand 1991, figs. 74–79). The sculpture workshop assembled in Dijon was Netherlandish in origin, and it is, therefore, difficult to determine whether the ivories should be assigned to a location in the southern Netherlands or Burgundy. The Boston statuettes can, however, be understood in the context of new developments in sculpture attributable to Claus Sluter and his contemporaries. **PB**

ca. 1410–20

French (probably Paris)

**Elephant ivory <u>à jour</u> relief,
painted, set under
rock crystal in a silver-gilt
and nielloed frame**

**Height 8 cm
Width 5.7 cm**

**Boston
Museum of Fine Arts
Helen and Alice Colburn
Fund (54.932)**

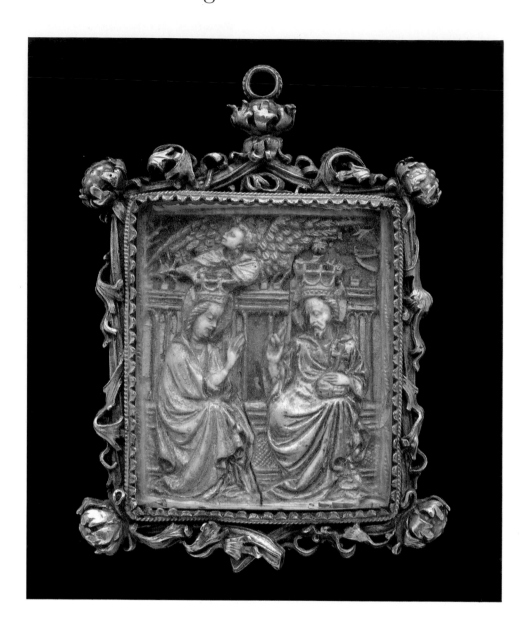

PROVENANCE
Martin Heckscher Collection,
Vienna, until 1898 (sale,
Christies, London, May 6, 1898,
lot 242, illustrated); Staatliche
Museen, Berlin (inv. no. 98,
220); Hinrichsen, Berlin;
purchased in 1954.

REFERENCES
Volbach 1923, 41

New York 1975, 90, no. 100a

Rasmussen 1977, 130, n. 409,
no. 6

Randall 1993, 111-12, no. 161

The small ivory relief shows the Virgin and Christ sitting turned toward one another on a high-backed bench. An angel, with outstretched wings filling the space above the figures, places a crown on the Virgin's head while Christ—not God the Father, as previously described—blesses her with his right hand and holds an orb with his left. Because the fragile *à jour* relief has been protected under rock crystal, the polychromy is well preserved and gilding remains in the hair of the figures. The relief is set into a silver-gilt frame embellished with curling leaves around the edge and poppy heads (?) at the corners, and the ring through which a cord would have been fed is fixed to a fifth poppy head. The back of the frame has been engraved and nielloed with a design of strawberries and other plants.

The relief shares the style, small scale, detailed micro-carving, and bright polychromy of a group of early-fifteenth-century ivories often described as "Franco-Flemish," but that were probably made in Paris (for a summary of the literature, see Williamson 1987, 134-37, no. 27, and

Hildesheim 1991, 81–82, no. 6). More than fifty reliefs in this style survive, some of which—like the present example—are set into pendants or lockets, while others would have formed part of larger ensembles, such as reliquaries or liturgical vessels (for a list of thirty-one pieces, see Rasmussen 1977, 129–30 n. 409). A particularly impressive group of eighteen polychrome ivory reliefs of this type, showing scenes from the infancy and Passion of Christ and single saints, is now mounted on a gilt-copper processional cross in the treasury of Burgos cathedral in northern Spain.

The style of the group can be compared with goldsmiths' work and manuscript illumination produced in the Parisian courtly milieu at the time of Jean de France, duc de Berry. Several of the most notable manuscript illuminators of the first quarter of the fifteenth century in the French capital—such as the Boucicaut Master, the Limbourg Brothers, and Jacquemart de Hesdin—hailed from northern France, Flanders, or Holland, and the art of their homelands was assimilated into a metropolitan style that linked great technical accomplishment with advanced expressiveness. The same traits are identifiable in the ivory reliefs, which in many respects—particularly the figure style and the range of colors employed—are especially comparable to the illuminations of the so-

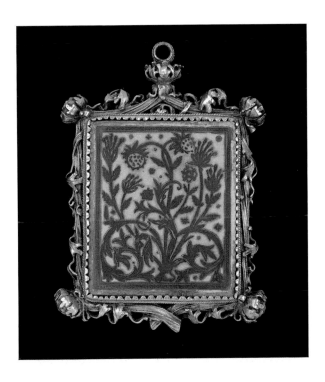

Back of frame

called Rohan Master of about 1410–30 (see Meiss and Thomas 1973 and Meiss 1974, 1:256–77). One of the closest ivories of the group is a relief of Christ as the Man of Sorrows supported by an angel, recently acquired by the Musée du Louvre, where the head types of the figures (especially that of the angel), the way of depicting the angel's wings, and the crosshatching and moldings on Christ's tomb can be paralleled with the same features on the Boston plaque (Gaborit-Chopin 1990a). The iconographic type of the Coronation of the Virgin on the present ivory is similar to that found in the Giac Hours in Toronto (Royal Ontario Museum), probably a youthful work of the Rohan Master of about 1410, where, as Meiss has pointed out, Christ "wears, as usual in Rohan miniatures, the white hair and beard of God the Father" (Meiss 1974, 1: 262, 2: fig. 820).

The decoration of the frame is also consonant with a date at the beginning of the fifteenth century, and there thus seems no reason to assume that the relief was inserted into it at a later date (for a different view, see Randall 1993, 112). The borders of coeval manuscript illuminations were invariably decorated with similar flowers and leaf forms to those found on the back of the frame (see Meiss 1974, vol. 2), and comparable contemporary work in precious metal is not difficult to find (see most conveniently Müller and Steingräber 1954 and Munich 1995). **PW**

Late 14th to early
15th century

Italian (Venetian, probably
workshop of Baldassare
degli Embriachi)

Bone, horn, hoof,
and wood
with gilt metal hardware

Height 28.4 cm
Width 33.1 cm
Depth 19.1 cm

Los Angeles
Los Angeles County
Museum of Art
William Randolph Hearst
Collection (47.8.25)

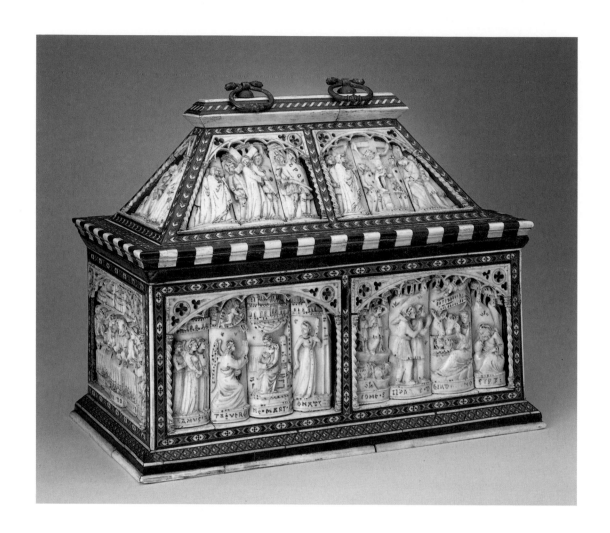

PROVENANCE
Collection of William Randolph
Hearst.

REFERENCES
Randall 1993, 141, no. 217

The well-preserved casket is decorated with carved bone plaques on all four sides and on the hip roof. The six scenes from the life of Christ that appear on the sides of the casket are composed of four or five bone plaques each. The four scenes on the long sides of the roof are made up of three plaques, and those on the ends are made of two each. All of the twelve scenes are framed by a wide, cusped arch supported by spiral colonnettes, and the spandrels are decorated with pierced trefoils and quatrefoils. The wood borders are decorated with intarsia of wood, horn, and bone. The edge of the hinged lid box is decorated with strips of bone and hoof. Two gilt metal bail handles appear on top of the lid, and a central piece of hardware is now lost. The interior is lined with red silk, giving no clue about the original function of the box, and the underside is painted brown with foliate decoration.

Six scenes from the life of Christ appear on the sides of the box and each is accompanied by an inscription placed beneath it. They are the Annunciation (ANNUNCIATA: VERGINE: MARI: PLENA[?]IGA); the Adoration of the Shepherds (COME: SILPA ... C: DEIAD ... NOSTRA); the Adoration of the Magi (COME: IMAGI: OFERA A SIGNO GIESV:); the Baptism (COME: SAM GIOVANI: BAPESA: GIEXV CHRISTO); the Entry into Jerusalem (COME: GIESV: VA: IGERUSIEME: ISVLAS[?]);

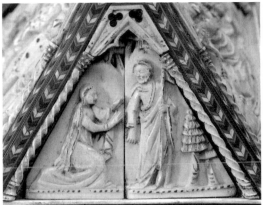

Noli Me Tangere

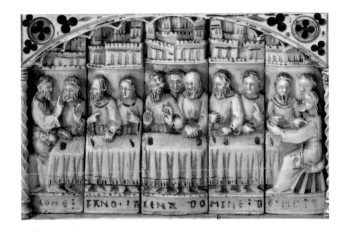

The Last Supper

Christ before Pilate

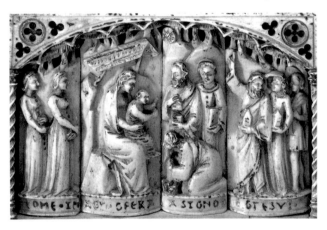

Adoration of the Magi

NEW DEVELOPMENTS IN IVORY AND BONE CARVING

and the Last Supper (COME [?]ANO: [?] A CENA DOMINE DE NOS:). The narrative continues on the lid with the Agony in the Garden, Arrest of Christ, Christ before Pilate, Christ Carrying the Cross, Crucifixion, and Noli Me Tangere. There are no inscriptions on the lid except SPQR, which appears on shields of the Roman soldiers. The figures in nearly all of the scenes appear in relief against a steep, relatively flat background, and each scene is surmounted by a decorative border. The interior scenes, such as the Last Supper, are surmounted by a cityscape of crenelated buildings and the exterior scenes, such as the Baptism of Christ, are provided with a border of stylized trees. All of the scenes are decorated with polychromy and gilding.

Many bone caskets produced by Venetian workshops in the late fourteenth and fifteenth centuries survive. Rectangular, hexagonal, and octagonal in shape, they are frequently decorated with themes from classical literature and medieval romance and sometimes with scenes taken from the Old Testament. The extensive christological program found on the Los Angeles casket is highly unusual among Italian late Gothic caskets. The imagery does, however, compare closely to the great altarpieces produced by the same workshops. One of these was made for the Certosa of Pavia (see Merlini 1985), and another example was commissioned for the abbey of Poissey by Jean de France, duc de Berry. In the style of its carving and decoration, the Los Angeles casket is close to the casket in the Certosa of Pavia, which is a documented product of the workshop of Baldassare degli Embriachi (d. 1406; see Merlini 1988). Another stylistically related casket is in the Museo Nazionale in Ravenna (see Martini 1993a, 63–65, no. 12). **PB**

Casket with Scenes of the Life and Passion of Christ, no. 68, opposite side

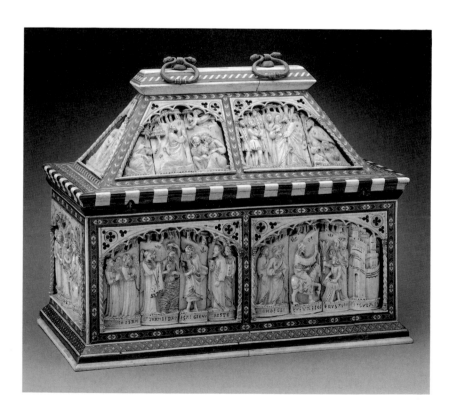

IMAGES IN IVORY: PRECIOUS OBJECTS OF THE GOTHIC AGE

First third of the
15th century

North Italian (Lombardy?)

**Elephant ivory
with polychromy
and gilding**

**Height 11.5 cm
Width 14 cm**

**Baltimore
Walters Art Gallery
(71.215)**

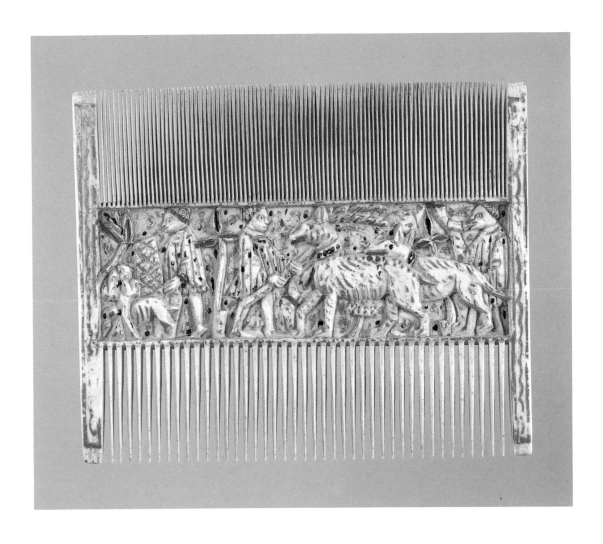

PROVENANCE
Collection of Richard Forrer,
Strasbourg; purchased from
Leon Gruel, Paris, before 1931,
Walters Art Gallery, 1931.

REFERENCES
Randall 1985, 234, no. 349,
pl. 77

On one face of the central band of the comb is an unusual deer hunt in which the stag wears a collar. One huntsman blows his horn, while the second holds his spear at the ready while a hound chases the stag. The comb is of the usual form with a set of fine teeth on one side of the carved band and a set of coarser teeth on the other. On the reverse side, two couples holding hands are represented dancing in a garden to the music of a portable organ, played by a seated lady. The figures are richly dressed and are separated by stylized trees.

The polychromy is very well preserved, and both costumes and landscape are accented with dots of red, blue, and gilt, while the trees are painted dark green and red. The hair of the figures is gilded. The borders of the comb were also painted with a pattern of wavy lines and dots within a border, but only the brown underpainting survives. The comb illustrates one of the many choices that a decorator of carved ivory might use to enrich the effect of the carving. Often only certain details, such as garment borders and hair, were gilded, as in the Virgin of Saint-Denis (no. 5), and sometimes the entire figure was painted, garments and face, as in the Paris Virgin in the Walters Art Gallery (Randall 1985, no. 264, pl. 69). Where the polychromy is well preserved, as in

this comb, it must certainly have been kept in its original case over the years and seldom touched.

A large number of Italian combs have survived, many with garden scenes, figures surrounding a well, an attack on a castle, and the God of Love. There are many minor variations in style, and none can be attributed with certainty to a particular center. Occasional features, such as the figure of Frau Minne (Lady Love) on a comb in the Victoria and Albert Museum, suggest that some of them may come from the Tyrol or the Germanic parts of northern Italy (Longhurst 1927–29, 2: no. 151-1879, pl. LVI). **RHR**

Comb, no. 69, opposite side

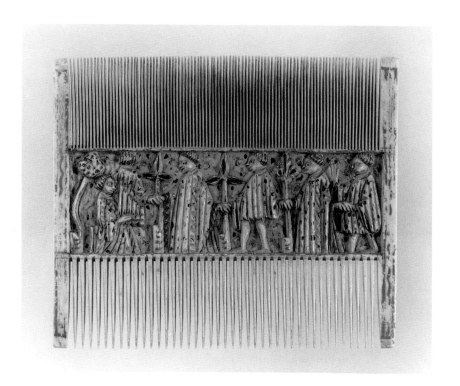

ca. 1430–60

Central European (probably Tyrol)

Bone on wood core with leather, hide, bark, and polychromy

Height 36.2 cm
Width 54.6 cm
Depth 37.1 cm

Boston Museum of Fine Arts Centennial Acquisition Fund (69.944)

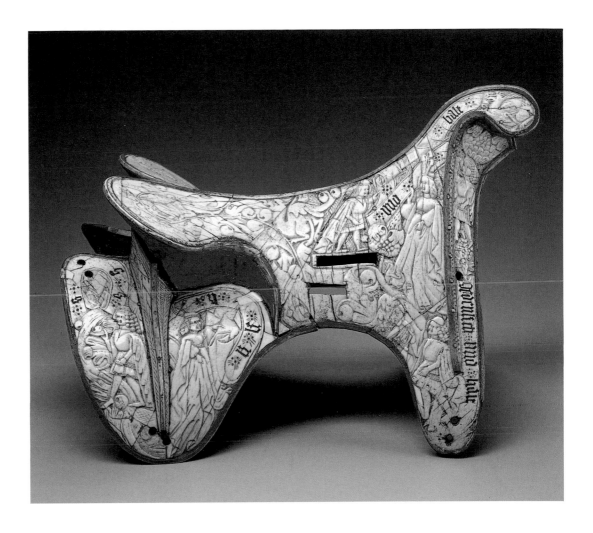

PROVENANCE
Collections of Princes Batthyani-Strattman, castles of Rohancz and Kormend, Hungary, 1520–1966.

REFERENCES
Schlosser 1894

Kárdsz 1894

Gaborit-Chopin 1978, 213

Eisler 1977–79, pt. 2: 205–44

Randall 1993, 130, no. 199, pl. 18

The exterior of the saddle is decorated with bone plaques carved in low relief. In the upper left quadrant on the proper left side of the saddle, Saint George is represented standing over the vanquished dragon as the saint thrusts a lance into its mouth. Another dragon (or possibly a griffin) appears behind the saint at the center of the same side. Saint George is the only identifiable figure on the saddle. Courtly men and women appear throughout, frequently with banderoles bearing initials. They are surrounded by vine scrolls and animals, such as a third dragon on the right side and a monkey that appears at the left side of the pommel. The inscription GEDENKCH UND HALT appears vertically below the pommel on both sides of the saddle, and the incomplete inscription UND HALT is seen again on the proper right roughly opposite Saint George. The words can be literally translated as "think and stop" but perhaps should be interpreted as a motto related to "look before you leap."

The wide plaques, probably from the pelvic bones of large animals, are attached to the core with bone pins as well as glue. The underside is lined with a layer of hide to which birch bark is adhered. The surface of the bark has darkened, apparently through use. Some of the areas between the upper and lower sections of the saddle are decorated with leather that has been painted red. The inscriptions are in black paint,

and traces of red and green can also be found in the carved areas. Fourteen holes are placed around the perimeter of the saddle. There is a horizontal slot on each side for the girth and another, smaller slot for the stirrup leathers.

Twenty-one related saddles are known. They share common form and construction and were undoubtedly used for parade (see Eisler 1977–79). The decoration of the saddles varies, but some motifs are common throughout the group. Three of the others depict Saint George standing on the dragon as he appears on the Boston saddle, and another four examples represent Saint George differently. Wild men and unicorns are depicted on other examples, and courtly ladies and gentlemen in similar costumes to those seen here are found throughout the group (see Eisler 1977–79, pt. 2: 232).

In his extensive discussion of a saddle in the Magyar Nemzeti Múzeum, Eisler places it within the context of art produced during the time of the German emperor Sigismund I (1368–1437). Of special interest is the tradition that such saddles were given by the emperor to knights in the Order of the Dragon upon their induction. In addition to the appearance of Saint George on several examples, at least one saddle bears the emblematic representation of a dragon associated with the order, which was founded by Sigismund. Stylistically, the saddles have been related to southern German, northern Italian, Franco-Flemish, Bohemian, and Hungarian works. A possible Tyrolian origin was first discussed by von Schlosser (1894). Late Gothic wall painting of the Tyrol offers useful comparisons for the imagery found on the saddles, and that region still seems the most likely place of origin. It is possible, however, that not all of the related saddles were made in the same center. **P B**

Saddle, no. 70, top and opposite side

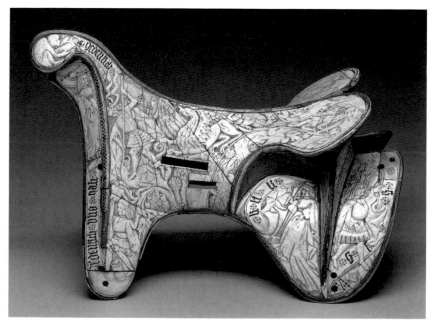

71 | Virgin and Child

1450–60

French (Touraine)

Elephant ivory

Height 29.5 cm

**Baltimore
Walters Art Gallery
(71.188)**

PROVENANCE
Collection of Chanoine Sauvé
of Laval cathedral, sold 1892;
purchased from Jacques
Seligmann, Paris, 1913; collec-
tion of Henry Walters, 1913–31;
Walters Art Gallery, 1931.

REFERENCES
Farcy 1898, 290, pl. XIV, XV

Koechlin 1924, 2: no. 982

Randall 1969a, no. 25

Gaborit-Chopin 1978, 171,
173–74, 213, no. 268

Randall 1985, 208, no. 285,
pl. 75

Munich 1995, 234–35

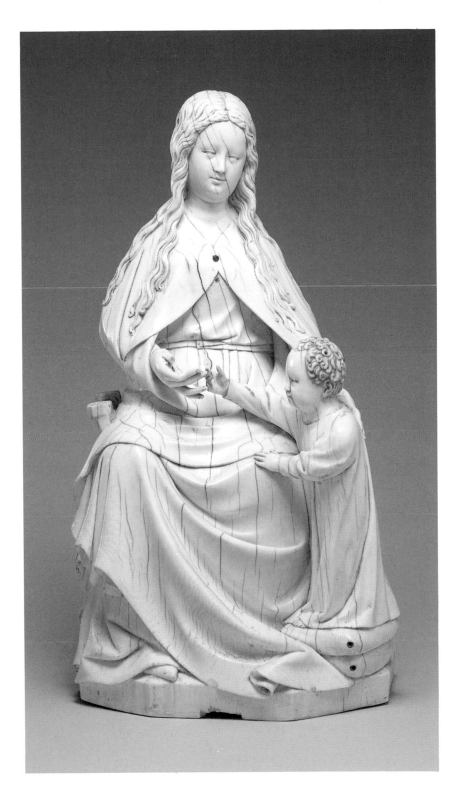

The seated Virgin is a gently idealized image of a young mother with her
realistically round-faced Christ child reaching for an object in her hand.
She sits on a folding chair, her loose hair falling over her shoulders, and
her gown and mantle are modeled with large, gentle folds. The curly
haired child wears a simple chemise. The figure is fully finished in the
round. The Virgin's ample hair falls in wavy strands down her back, and
the folding stool on which she sits is ornamented at the center with a
large rose.

NEW DEVELOPMENTS IN IVORY AND BONE CARVING

The statue is grand in scale, over ten inches tall, and was originally ornamented with gold or silver-gilt details, including a crown on the Virgin's head, a jeweled breast ornament, and an object, probably a bird or an apple, in the Virgin's hand. The two cushions on which the Christ child stands were decorated at the corners with either pearls or gilt tassels, as indicated by the drilled holes.

Danielle Gaborit-Chopin has convincingly attributed the work to Touraine, based not only on its history, as it was owned by Chanoine Sauvé of Laval cathedral, but on the style of the figure, its monumental calm, and the lack of square folds in the drapery, so frequent in works from Flanders and northern France (1978, 171). Similar treatment of the drapery can be seen, for instance, in the miniatures of Jean Fouquet, especially in the Annunciation figures in the Pierpont Morgan Library Hours (M. 834). The book was painted in Tours and is datable about 1460 (Plummer 1982, pl. 42a).

A related treatment of the Virgin is to be found in the earlier *Goldene Rössl* of 1404, a comparison recently pointed out by Rainer Kahsnitz (Munich 1995, 234–35). The gold and enamel Virgin is a rare survival of the court art of Paris at the beginning of the fifteenth century and is more elegant than the realistic young mother depicted in the ivory.

Gaborit-Chopin noted that the right hand of the Virgin was slightly misaligned and assumed that it was a replacement (1978, 213). It is, however, the original hand, which was cut and reglued at a slightly incorrect angle. It is drilled for the attachment of the apple or bird that it held, and the carving of the fingernails matches the child's hands. The thumb has been broken off. There is an old, but perhaps not original, cut in the front of the base, as if for attachment at some time. **RHR**

Virgin and Child, no. 71, three-quarter view and back

Pax with the Virgin and Child, Saint John the Baptist, and Saint Catherine

ca. 1450–75

North Netherlandish (Utrecht)

Elephant ivory

Height 12.1 cm
Width 8.6 cm

Detroit
The Detroit Institute of Arts
Gift of Mrs. Lillian Henkel Haass (25.91)

PROVENANCE
Unknown

REFERENCES
Koch 1958

Randall 1985, no. 363

Randall 1993, 114, no. 167, pl. 15

Randall 1994

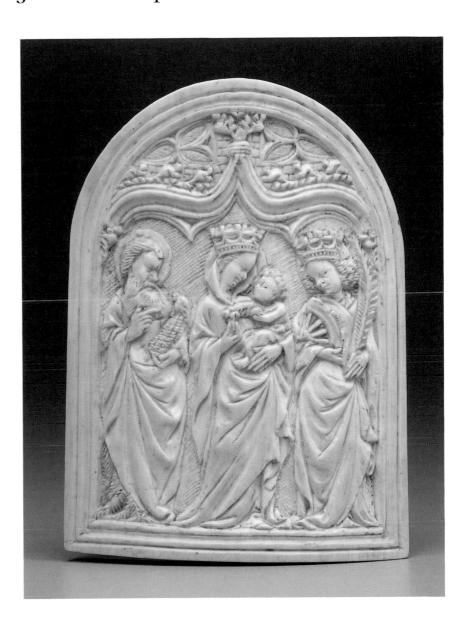

Most often made of precious metals, the pax (or *osculatorium*) was kissed during Mass by the celebrating priest, then by other clerics, and finally by the congregation. This replaced the kiss of peace *(osculum sanctum or osculum pacis)* of the earlier church, which was given by bishops to priests before communion. Although first used liturgically in the thirteenth century, paxes are not found in substantial numbers before the fifteenth century. They are most frequently decorated with the Crucifixion, but images of the Virgin and Child, the Annunciation, and saints are not uncommon.

The crowned Virgin stands at the center of the convex pax. She gazes down upon her child as he reaches for the flower held in her right hand. She is flanked on her right by the bearded figure of Saint John the Baptist, who gestures with his right hand to the lamb held in his left. Both the Virgin and Saint John are nimbed. To the Virgin's left is the crowned figure of Saint Catherine of Alexandria, who holds the broken wheel in her right hand while she bears the martyr's palm in her left.

The three figures are surmounted by an ogee arch decorated with crockets and a floral finial. A trefoil of blind tracery fills each spandrel. The background throughout is decorated with crosshatching, and the edge is distinguished by a simple, molded frame. The handle that was originally set into a chamfered slot in the back has been lost.

This pax is nearly identical to a less sensitively carved example in the Walters Art Gallery, Baltimore (Randall 1985, no. 363). The Walters example depicts the same three figures in the same disposition. The crosshatching and the ogee arch are similar, as is the molded frame. In the Baltimore example, however, a rope border appears inside the molding.

Fig. 72a. Box cover with the Virgin and Child, North Netherlandish (Utrecht), ca. 1450–75, elephant ivory, Stuttgart, Württembergisches Landesmuseum (1992.221)

Robert Koch was the first to associate the Detroit pax with other ivory carvings and to propose a northern Netherlandish origin for the group (Koch 1958). Focusing on a diptych in the Princeton University Art Museum (Randall 1993, no. 169), Koch convincingly assigned a cohesive group of ivory diptychs and paxes to Utrecht based primarily on comparisons to wood sculptures made in and around that center. More recently Richard Randall expanded Koch's group to include ten ivory reliefs: seven paxes and three diptychs (see Randall 1994). These form a stylistically uniform group with crosshatched grounds, ogee arches, and similar frames. To this group can now be added an eleventh relief, recently acquired by the Württembergisches Landesmuseum in Stuttgart (fig. 72a; see Meurer 1994). The Stuttgart ivory is the top from a circular box, now lost. The standing Virgin and Child appear in the center against a crosshatched ground while an angel at the top center places a crown on the Virgin's head. The remaining space is filled by flowering plants (perhaps roses), and the frame is decorated with a rope similar to the border of the Baltimore pax.

Randall has based his dating of the Utrecht group about 1440-70 on the dependence of the Princeton diptych upon a lost model by Jan van Eyck (see Randall 1981, 39-48). This argument is plausible, but more importantly the ivories are stylistically consistent with the wood reliefs first cited by Koch that can be dated to the middle of the fifteenth century. Furthermore, the crosshatching that appears in all of the ivories of this group is consistent with engraved backgounds seen in metalwork and contemporary Netherlandish prints. **PB**

ca. 1450–75

North Netherlandish (Utrecht)

Elephant ivory statuette; polyptych of wood with carved bone panels and bone and wood intarsia with traces of polychromy and gilding

Height 48.3 cm

Detroit The Detroit Institute of Arts Founders Society Purchase (23.149)

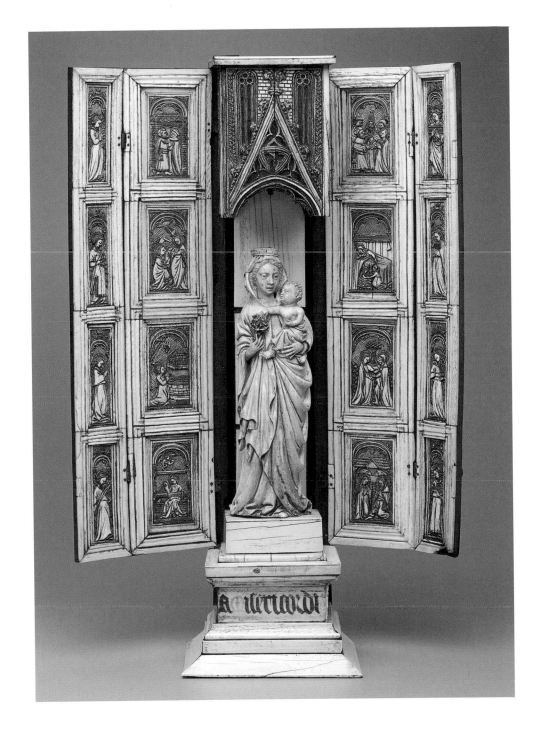

Back view

PROVENANCE
Purchased from Max Heilbronner, Berlin.

REFERENCES
Randall 1993, 52–53, no. 35, pl. 7

An ivory statuette representing the Virgin and Child stands at the center of this polyptych. She holds the child in her left arm, and he reaches out to touch the flower in her right hand while he holds a globe in his left hand. The Virgin wears a veil on her head over which is placed a small crown. The Virgin's heavy mantle, gathered at her waist, falls in deep V-folds below her left arm. She stands on a square block that surmounts a simple base on which is inscribed DME REGINA MISERICORDI [?]ITA DULCED. Projecting above the Virgin's head is a square canopy decorated on three sides with ashlar masonry, lancet windows, and a gable

decorated with blind tracery. The underside of the canopy takes the form of a ribbed cross vault. The three plain panels behind the statuette are probably modern replacements.

Inside, the hinged wings are decorated with four bone plaques each with crosshatched backgrounds carved in low relief. On the narrow outside wings, music-making angels appear under round arches while the wider inner wings depict scenes from the Life of the Virgin, each under a trilobed arch. Beginning at the upper left is the Meeting of Joachim and Anna, Annunication, Virgin praying in the Temple, and Virgin weaving. Resuming at the upper right are the Marriage of the Virgin, Birth of the Virgin, the Visitation, and the Nativity. This arrangement is out of proper narrative sequence, suggesting that the plaques have been reassembled. The carved plaques are framed by molded strips of bone, some of which have been restored. The outside of the wings and the back of the shrine are decorated with geometric intarsia of bone and wood. There are some losses in the intarsia. The tabernacle is designed so that the wings fold around the Virgin and Child creating an easily portable oblong shape.

Significant amounts of gilding and polychromy survive. The Virgin's mantle is blue, and her flower is green. The reliefs on the wings are decorated with gilding, and there are traces of red, brown, and green. The canopy has brown paint and gilding on the outside and blue paint in the vault.

The generally well-preserved polyptych is one of six similar tabernacles, each with a central statuette of the Virgin and Child, which were presumably made in the same place. The other examples are in the church of Saint-Jean in Bruges (see Randall 1993, 13, fig. 4); formerly in Karlsruhe (see Baden-Baden 1995, no. 253); in the cathedral treasury at Monza (see Egbert 1929, fig. 46); and two in the cathedral treasury at the Museo d'Arti Applicate, Milan (ibid., figs. 44–45). Wings of a lost tabernacle are in the Museo Christiano of the Vatican (ibid., fig. 42). All but the tabernacles in Detroit and Bruges have pinnacles on top and it is possible that this element has been lost from the Detroit example. A group of caskets decorated with bone plaques of the life of Christ and the life of the Virgin are closely related to the tabernacles and were probably made in the same center (see Randall 1985, 238–39, no. 359).

At the time of its acquisition in 1923, the Detroit polyptych was catalogued as a northern Italian product of the Embriachi workshop. In 1929 Egbert studied this group, and while acknowledging "Flemish" characteristics and even accepting a Flemish origin for the Bruges tabernacle, he argued that the others had a Milanese origin (see Egbert 1929, 191-98). It is difficult not to conclude that Egbert was unduly influenced by the modern location of these objects, for he accepted the Bruges tabernacle as Flemish and argued that the Karlsruhe tabernacle "seems to form a transition between the Flemish group… and the Italian group" pointing out that Karlsruhe "is geographically located half way between the two main centers" (ibid., 195).

More recently, Randall has attributed the entire group of tabernacles and caskets to Flanders, based in part on the example in Bruges (Randall 1993, 52-53, no. 35). He has noted that many of the bone reliefs in the group depend on print sources in the *Biblia pauperum* (Randall 1985, 239, no. 359), observing that the Detroit tabernacle and a casket in the Victoria and Albert Museum in London share a common source (Randall 1993, 53, no. 35). While Randall's observations are generally convincing, there is strong evidence for an attribution to the northern Netherlands. The *Biblia pauperum* was produced in several centers, including Utrecht, at about the middle of the fifteenth century (see Henry 1987). The bone reliefs with crosshatched backgrounds in this group are generally similar to the group of paxes and diptychs discussed here previously (see no. 72). Furthermore, the style of the ivory statuette of the Virgin and Child at the center of the Detroit tabernacle can be compared to sculpture from Utrecht. An oak Virgin in Utrecht (fig. 73a) is similar in the treatment of the drapery and the Virgin's facial type to the Detroit ivory (see Steyaert 1994, no. 81), and the Christ child in the Detroit ivory can be compared to an example in Kortrijk, Belgium (ibid., no. 82). Both of the wood sculptures have been dated to the second quarter of the fifteenth century, and it is likely that the tabernacle was produced then or, in keeping with the date of the *Biblia pauperum*, during the third quarter of the century. **PB**

Detail, no. 73. Virgin and Child.

Fig. 73a. Virgin and Child, North Netherlandish, ca. 1425–34, oak, 130 cm, Utrecht, Museum Catharijneconvent (ABM494)

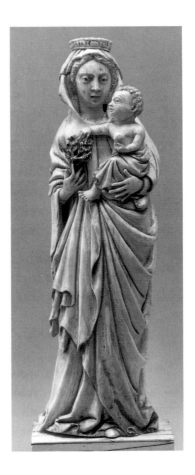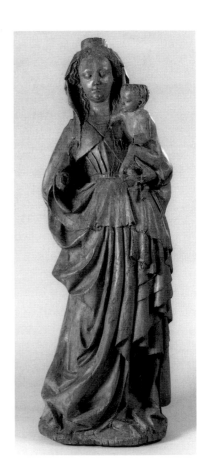

Bone and walnut
on wood core
with metal hinges

Length 27.6 cm
Width 24.8 cm

Detroit
The Detroit Institute of Arts
Gift of Mrs. William Clay
(41.2)

PROVENANCE
Count Wilczek of Kreuzenstein
(?); Silberman Galleries, Vienna
(paper label #832 on edge);
purchased from E. and A.
Silberman Galleries, New York,
1941.

REFERENCES
Bassani and Fagg 1988, 104

Randall 1993, 130, no. 198

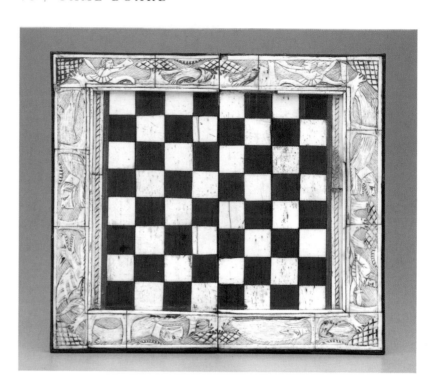

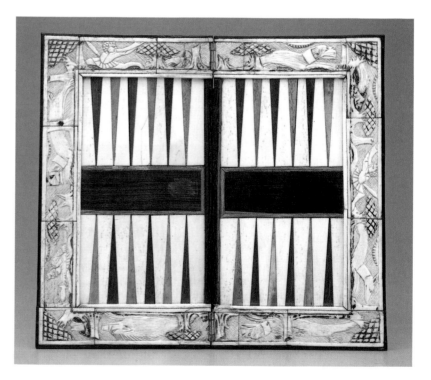

It is difficult to localize this large group of objects, and many suggestions
have been offered. The Detroit game board, like many similar examples,
was attributed to Italy at the time of its acquisition. Koechlin saw north-
eastern France as the most likely source (see Koechlin 1924, 1:528) of
the group. A box with heraldic decoration in the Burrell Collection in
Glasgow suggests that the center that produced the boxes and related
pieces was most likely in the Upper Rhine (see Beard 1935). **PB**

ca. 1460–80

German (Upper Rhine)

Elephant ivory

Diameter 7.1 cm

Cleveland
The Cleveland Museum
of Art
Andrew R. and Martha
Holden Jennings Fund
(71.7)

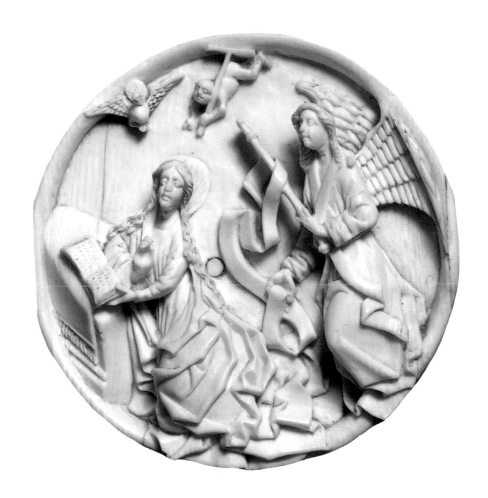

PROVENANCE
Collection of E. and M. Kofler-Truniger, Lucerne; purchased from Blumka Gallery, New York, 1971.

REFERENCES
Schnitzler, Volbach, and Bloch 1964, no. S-133

Smith 1968

Wixom 1972, 106

Randall 1993, 115, no. 170

This piece appears to have been carved as a devotional roundel rather than as a mirror back or other utilitarian object. On the left the Virgin kneels before a prie-dieu covered with a cloth. The Archangel Gabriel, who appears on the right with wings spread, appears to have interrupted the Virgin at her reading. She holds an open book in her left hand as she looks up. The angel carries a scepter in the left hand, and in the right is an unrolled banderole that loops over the scepter. Both figures have long hair and narrow faces. The Virgin's hair flows in curls over her shoulders and down her back. The dove of the Holy Spirit appears above the Virgin and the figure of an infant carrying a tau cross appears above the space between the Virgin and Gabriel. The Virgin and the dove are both given halos. The drapery falls in complex sharp, angular folds. The edge of the roundel is incised, and there are two holes in the ivory. Behind the Virgin there is a hole now plugged with ivory, and a hole at the top was presumably made for suspension.

Beginning in the fifteenth century, prints became valuable models for carvers in many materials, including wood and mother-of-pearl. In 1968 Graham Smith was the first to recognize that the carver of this ivory medallion was indebted for the composition to the prolific Upper Rhenish engraver Master E. S. (active ca. 1450–67). Master E. S. was the

hatchings, herringbone patterns, or guilloches. The early provenance of these belts, whenever known, points to the north of France or Flanders. Three Parisian collectors in the nineteenth century owned five of them, three of which were owned by Victor Gay alone. Three other belts are found today in Bruges, the Diocesan Museum; Liège, the Curtius Museum; and Ghent, Archeological Museum, originally from the convent of Saint Barbe of Jerusalem. The comparisons that can be made (in particular with paxes or in the secular realm with caskets and combs) confirm that northern origin as well as the later date toward the end of the fifteenth or even the beginning of the sixteenth century proposed for these objects by Koechlin, particularly because of the presence of a skull on the belt in Ghent.

Detail, no. 77. Pendant, reverse.

Koechlin's surprise at finding principally religious iconography on objects he believed to be secular is hard to understand. This would be not uncommon at the end of the Middle Ages, but also nothing indicates that these belts belonged to lay people. The exclusivity of religious subjects and the provenance of the belt in Ghent allow us instead to suppose that these belts were intended for clerics. Indeed, they may have been part of their habits. Besides the representation of the Holy Face that can be seen on many other examples (Cologne, Dublin, New York, and Paris, formerly Beurdeley Collection), the pendant of the belt presented here bears iconography that refers specifically to the Dominican order. It can only come from a convent of that order, as already noted by Alfred Darcel at the time of the gift of the object to the museum in 1889.

There are old inscriptions which may be owner's marks: on the buckle, O D COL and on the pendant, N. **PYLP**

1500–1525

**North French
or South Netherlandish**

**Elephant ivory with
traces of polychromy**

Height 7 cm

**Detroit
The Detroit Institute of Arts
Founders Society Purchase,
European Sculpture and
Decorative Arts Insurance
Recovery Fund, European
Sculpture and Decorative
Arts General Fund, General
Art Purchase Fund, Henry
Ford II Fund, Mr. and Mrs.
Robert Hamilton Fund,
and contributions from
Mr. and Mrs. Robert
Hamilton and the
David L. Klein Jr. Memorial
Foundation (1990.315)**

PROVENANCE
Purchased from Blumka II
Gallery, New York, in 1990.

REFERENCES
New York 1990

Barnet 1991

78 | PENDANT TO A ROSARY OR CHAPLET

These small ivory carvings convey one of the most profound themes of the late Middle Ages. The death mask and pair of embracing lovers joined to skulls serve as *memento mori*, reminders of the transitory nature of life and the inevitability of death (for a general discussion of attitudes about death in the Middle Ages, see Aries 1981). The Latin inscription found across the collarbone of the Detroit example reads: O MORS QUAM AMARA EST MEMORIA TUA (O Death, how bitter it is to be reminded of you).

The repetition of prayers and liturgical texts was an important part of late medieval devotion. The rosary, which became popular by the fourteenth century, is a collection of these texts devoted particularly to the Virgin Mary. Strings of beads to assist those saying the long sequences of recitations also came to be known as rosaries (see especially Colgone 1975). Saint Hedwig holds such a string of beads in a fourteenth-century illuminated manuscript (fig. I-7). These carvings are pierced vertically for suspension, consistent with their original function as pendants to rosaries or chaplets (shorter strings of devotional beads). The New York example retains its metal mounts and the decorative emerald terminal while the Detroit example has lost its mount.

Dating from the late Middle Ages through the seventeenth century, there are many surviving *memento mori* pendants from rosaries. Frequently double sided, the pendants are often decorated with a skull on one side and a youthful face on the other (see especially Dieckhoff 1981, 39–46, and Forrer 1940). These stylistically related pendants are among the finest examples to survive. Similar foliage decorates the underside of each one. The magnificently detailed carving of these

NEW DEVELOPMENTS IN IVORY AND BONE CARVING

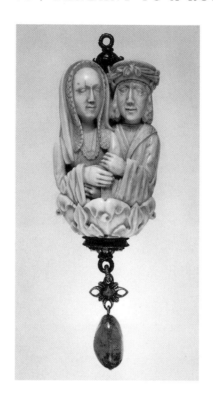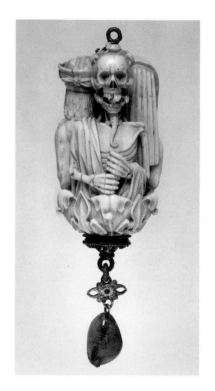

Elephant ivory and
uncut emerald

Height 13.3 cm
(with attachments)

New York
The Metropolitan
Museum of Art
Gift of
J. Pierpont Morgan
(17.190.305)

PROVENANCE
J. Pierpont Morgan Collection,
New York.

REFERENCES
Providence 1974, nos. 41–42

New York 1975, no. 254

Ann Arbor 1976, 116–17,
no. 82

pieces, evoking compassion by the slack-jawed death mask of the New York pendant and horror by the gruesome skull of the Detroit one, for example, make them miniature masterpieces.

The New York pendant shows the upper part of a skeleton on one side joined to a pair of elegantly dressed lovers on the other, dramatically contrasting the grim reality of death with the vitality of youth. The skull on the skeleton of the New York pendant and the head of the young male lover are so close in style to the Detroit example that it is possible that they were carved in the same workshop or even by the same hand. The style of the two ivories, as well as the costume details of the New York piece, suggest that they were carved in northern France or the southern Netherlands during the first quarter of the sixteenth century.

A closely related example (Museum of Fine Arts, Boston, 57.589; see Providence 1974, no. 41-1) must be regarded with caution. The Boston *memento mori* depicts a pair of lovers and a skeleton much like the New York bead, but it has an ivory stand, or base, that appears to have been carved out of the same piece of ivory as the bead, a format not consistent with late medieval usage. The base of the Boston ivory bears a slightly abbreviated version of the inscription that appears on the Detroit bead (MORS QUAM AMARA EST MEMORIA). Furthermore, the pair of lovers in the Boston example are uncharacteristically separated from the skeleton by a wall. Nor is the Boston example pierced for suspension like most other examples but rather has an ivory loop for suspension carved at the top that would be unlikely to survive hard use. It is therefore possible that the Boston ivory is a modern conflation of the composition of the New York example and the inscription from the Detroit example. **PB**

EPILOGUE

PASTICHES, REVIVALS,
FORGERIES, AND OPEN

QUESTIONS

Fragment of a Mirror Case with Knights and Foot Soldiers

ca. 1350–1400
or ca. 1800–1850

French (Paris?)

**Elephant ivory with
traces of discolored paint**

Diameter 14 cm

**London
British Museum
(MLA 1902,4-23,4)**

PROVENANCE
Collection A. C. Kirkmann,
1851; purchased in 1902
from F. G. Smith,
46 Parliament Street,
London.

REFERENCES
Kirkmann 1851

Read 1902

Dalton 1909, no. 380

London 1990, no. 193

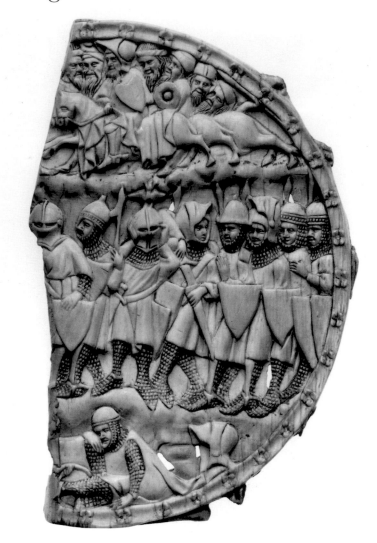

In the opinion of Claude Blair and Richard Randall, the repertory of helmets on this mirror case is anachronistic for the fourteenth century; perhaps an illustrated manual of helmet design acted as a source to the forger, who was catering to the nineteenth-century taste for medieval warfare. Since the early 1980s, the ivory has been consigned to the museum reserve collection, and it was included in the 1990 exhibition "Fake?" at the British Museum. Recently, however, a small-sample accelerator radiocarbon date from the Research Laboratory for Archaeology and the History of Art, Oxford, has placed the ivory tusk from which the mirror case was carved with 95 percent confidence in the period 1160-1300. It would indeed be stretching coincidence to postulate that a nineteenth-century faker happened to employ a medieval tusk so close to the right date to carve a pastiche fourteenth-century ivory. It may be that the apparently anachronistic details of the armor are the product of the imagination of a Gothic ivory carver who knew little about how contemporary armor looked and was worn. The back of the ivory has the normal grooves for slotting into a second mirror case and encourages the view that piece is medieval. Whatever the status of this enigmatic mirror case, it illustrates perfectly the fragile state of our knowledge about Gothic ivory fakes, whose authenticity is almost invariably questioned on the basis of stylistic or iconographic criteria that are themselves questionable. NS

ca. 1390–1400
assembled
at a later date

Italian (Venetian, related to the workshops of Baldassare degli Embriachi)

Bone, cow horn and hoof, wood, metal hardware

Height 33 cm
Width 28.6 cm

Chicago
The Art Institute of Chicago
Bequest of
Mrs. Gordon (Hanis H.)
Palmer (1985.112)

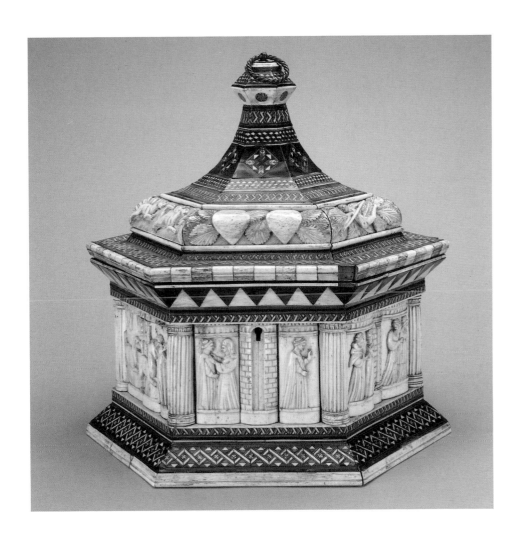

PROVENANCE
Mrs. Gordon Palmer.

REFERENCES
Randall 1993, 148, no. 236

Like a three-dimensional puzzle in which the pieces have been shifted from their proper places, this hexagonal casket presents a pastiche of carved elements. Each side is composed of three bone panels flanked by large, fluted columns. Geometric patterns of horn and hoof inlay decorate the sloping base and projecting cornice as well as the lid. Carved bone segments with nude figures, a dog chasing a group of rabbits, vegetation, and a pair of blank crests form the shoulder of the lid. The scale and carving style of the casket relate it to the Embriachi workshop of fourteenth-century Florence and Venice (nos. 49–50), yet close examination of the scenes reveals that the casket was reassembled at a later date.

Randall has suggested that the casket includes scenes illustrating three different stories: *Il pecorone* (The Golden Eagle) by Giovanni Fiorentino; the myth of the Judgment of Paris; and the story of Mattabruna, a medieval legend of an evil mother-in-law who steals seven princes, replacing them with seven puppies (Randall 1993, 148). In fact, the scenes are not so easily divided into three coherent themes. As Suzanne Merz notes (DIA curatorial files, March 1996), the scenes of *Il pecorone* and the Judgment of Paris are incomplete, interrupted by other panels, and out of order, and none of the scenes correlates well with the story of Mattabruna. A brief look at the six sides of the casket, beginning at the side with the keyhole and moving to the right around the casket,

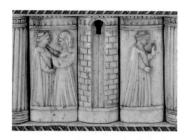

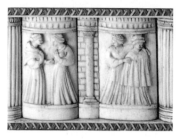

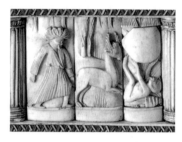

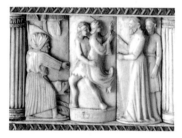

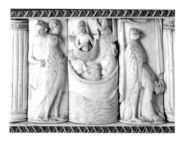

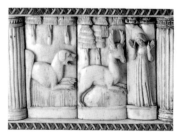

Details, no. 81, Marriage Casket.

reveals the composite quality of the bone panels. The first two sides, characterized by panels of paired figures flanking a gateway on the first side and a column on the second side, are perhaps the most enigmatic. The pairing of figures leads one to compare these panels with several caskets that have paired male and female figures such as the Embriachi caskets in the Detroit Institute of Arts (41.86) and the Museum of Art at the Rhode Island School of Design (85.075.8; Randall 1993, nos. 232, 235). These panels with paired figures are most frequently identified as "scenes of lovers." The activities depicted in the Chicago example, the female fixing the male's robe, the departing male, the two figures talking together (both male?) and the two figures standing nearby, all indicate a more complex narrative than would simply paired lovers. Yet without further iconographic hints, the story to which they allude remains unidentifiable.

The quality of the casket as a pastiche is fully realized in the next several sides. On the third side, the third panel with an ape holding an empty crest originally was placed horizontally across the lid of a casket, whereas here it is squeezed between a base and fragments of trees above. The two left panels—a man in Middle Eastern dress of a turban and light robe and a stag—relate to the first panel of the fourth side, in which the man appears again, this time as a hunter encouraging his dog to the chase. But the central and right panels of this side seem to come from entirely different stories. Merz (forthcoming) has noted the similarity of the central panel to a panel depicting the kidnapping of Helen by Paris seen on a casket in the Kunsthistorisches Museum, Vienna (inv. 8020), on which the Judgment of Paris is depicted. Based on similarities of costume, the right panel of the fourth side should be grouped with the three panels of the fifth side of the casket. These three scenes—the standing bird, the bird in a boat, and a man emerging from a bird—all relate to the story of *Il pecorone*, which relates this casket to a group of Embriachi panels in the Metropolitan Museum of Art collection (17.190.490) that depict the entire story (Merz forthcoming). The first two panels of the sixth side, depicting a dog chasing a stag, relate back to the hunter of the third and fourth sides. The final panel, a woman raising her arms in surprise, may or may not be connected to the hunting scene.

The disjointed and confusing juxtaposition of scenes raises the question of whether this casket is composed of incorrectly arranged pieces from a damaged or dismantled casket or whether various pieces, perhaps all intended for another casket, were haphazardly placed together on this one. Whatever the origin of these elements, it seems likely that the casket itself is a post-medieval combination of medieval carvings. **RPW**

17th–18th century

Italian

Elephant ivory

Height 17.2 cm

Detroit
The Detroit Institute of Arts
Gift of
Robert H. Tannahill
(F70.51)

PROVENANCE
Unknown

REFERENCES
Unpublished

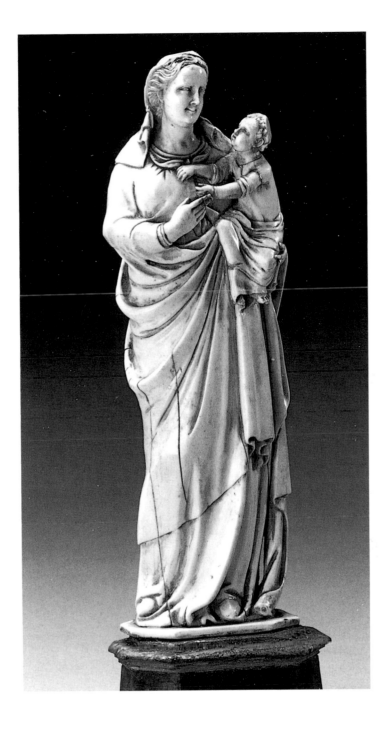

Representing a long tradition of copies of the much-venerated marble statue of the Virgin in the convent of Santissima Annunziata in Trapani, Sicily, this statuette recalls the tall proportions, the treatment of the hair and veil, and the relationship of the mother and child of the original statue (fig. 82a). The Virgin stands slightly swayed with her weight on her left leg and her robe gathered above her left hip. The Christ child, held in the Virgin's left arm, reaches out for her and gazes up into her face. She responds quietly, smiling and touching his left hand. Numerous details of the statuette, such as the Virgin's long face with high, rounded forehead and hair swept back in loose waves, the shoulder-length veil placed far back on her head, and the treatment of her cloak wrapped over her right shoulder and arm and falling in wide

arcs over her right hip indicate the close connection of this statuette with the original statue. Likewise, Christ's drapery falling around his legs as he turns to his mother, his reaching arms and imploring gaze, as well as the reassuring touch of the Virgin's right hand, are copied directly from the original statue. The back of the statuette and its base, which is painted gold and red, is rough and unfinished, indicating that it was meant to be seen only from the front.

As Hanno-Walter Kruft has noted, little art historical attention has been paid to the Trapani Virgin, although she was the object of much devotion based on a rich legend that tells of the statue's origin in Cyprus and its miraculous recovery from the sea by fishermen of Trapani (Kruft 1970, 302–4). From the late nineteenth century, suggestions have been made regarding the date and authorship of the original statue. Early attributions placed the statue before 1291 and posited that it was the creation of a follower of Tino da Camaino (1280/85–1337), while more recently scholars have attributed it to Nino Pisano (active ca. 1343–68; ibid., 298). While acknowledging its connection to the style of Nino, Anita Moskowitz has attributed the Trapani Virgin to the Master of the Santa Caterina Annunciation pair in the church of Santa Caterina, Pisa (Moskowitz 1986, 156).

Because of the miraculous properties associated with the original statue, pilgrimages to Trapani became popular, and numerous copies were made from the fifteenth through the nineteenth centuries. The copies fall into two groups: small-scale statuettes intended for personal devotion and lifesize statues intended for church altars. The strong stylistic similarity of this ivory statuette with the original statue supports Kruft's point that the statuettes tend to be more faithful to the original and thus should be considered "copies" in the modern sense, whereas more liberties were taken by the artists of the life-size statues (Kruft 1970, 321). **RPW**

Fig. 82a. Virgin and Child, Italian, mid-14th century, marble, Trapani, Santissima Annunziata

Probably 1750–80

**French
(Ile-de-France or Paris)**

Elephant ivory

Height 43.5 cm

**Baltimore
Walters Art Gallery
(71.152)**

PROVENANCE

Said to come from the priory of
Boubon, Cussac (Haute Vienne);
collections of Abbé A. Lecler;
Baron de Verneilh; M. Sailly;
Jacques Seligmann; Sir Thomas
Gibson Carmichael until 1902;
Henry Walters, 1903–31;
Walters Art Gallery, 1931.

REFERENCES

Didron 1870–72, 108–9

Lecler 1888, 241

Verneilh 1898, 254

London 1902, lot 20

Maskell 1905, 171, 384

Clément 1909, 39

Fabre 1911, 54ff

Sarrète 1913, 40, 85–87

Koechlin 1924, 2: no. 9

Vloberg 1963, 25ff

Blancher and Blancher 1972

Baumer 1977, 237ff

Gaborit-Chopin 1978, 134

Sandron, Cascio, and Lévy 1993

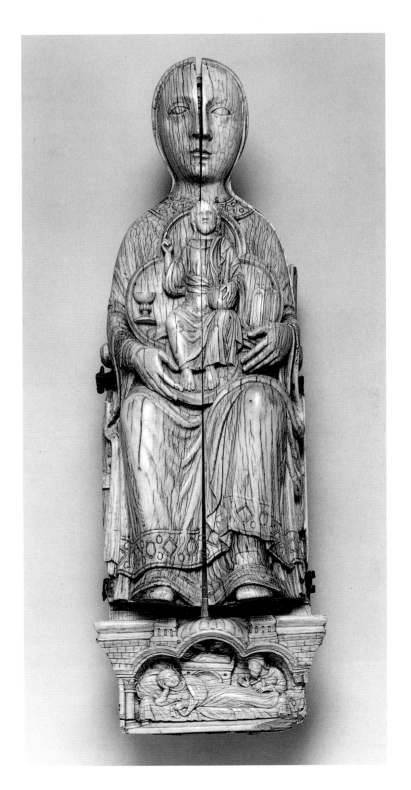

This interesting statue is the "Vierge ouvrante de Boubon," supposed
to have come from the priory of Boubon, Cussac (Haute Vienne), at the
time of the French Revolution. There are no documents to prove this
contention, and the evidence is based on attestations of various owners
in the nineteenth century.

The statuette, when closed, is in the form of a seated Virgin holding a
quatrefoil with the image of Christ in Majesty between the chalice and
the tablets of the new and old law. It separates down the center and
is hinged so that, when open, it becomes a carved triptych, showing the

Passion of Christ. The Virgin sits on a low throne decorated with a band of incised ovals. She wears a veil that closely frames her head, and her wavy hair falls down her back. Her robe, or surcot, is carved to represent embroidery at the neck and hem with alternating ovals and diamonds, and her cuffs are crosshatched. Her feet protrude below the folds of her gown *(cotte)*. The base is a separate piece of ivory with the scene of the Nativity, set within a domical stone building.

The wings, when open, show on the left Christ before Pilate, the Carrying of the Cross, and Flagellation; and on the right the Resurrection, Three Marys at the Tomb, and Noli Me Tangere. Across the base are four arched spaces with the Evangelists writing. At the top, and therefore on the reverse of the Virgin's head, are two standing angels flanking the figure of Christ in Majesty, holding a book.

The central panel of the triptych has a Crucifixion with Mary and Saint John and the figures of Ecclesia with her chalice and Synagogia with the tablets of the old dispensation. Above the cross, which has an unusually long upper arm, are four angels, two mourning over Christ and two holding a quatrefoil with the Lamb of God with cross and pennant. Below the Crucifixion is the Entombment, enacted on a bridge of masonry with a trefoil opening.

The trefoil and lozenge frames of the scenes are crisply cut with a double-molded edge. The quatrefoil for the lamb is recessed and that for the Christ on the exterior has an incised edge. There are ten circular depressions filling the open areas of the ivory interior, and the sun and moon are similarly recessed above the lamb.

The iron hinges are broken but original, and the wings can be seen to have been cut from the same block of ivory as the back. The left side of the head of the Virgin is a restoration, including the carved angel inside, and the right half of the head has been broken off and reattached. The left portion of the head of Christ on the exterior is also a restoration.

The type of the Virgin may be noted in three related examples, the closest being the seated Virgin and Child in the Musée National du Moyen Age, Thermes de Cluny, Paris, which entered with the Du Sommerard Collection in 1883 (Koechlin 1924, 2: no. 8). There is the same facial type, the hair tight to the head, which is crowned, the crown being patterned with diamonds and ovals like the embroidery on the Vierge de Boubon. The Virgin of Ourscamp (ibid., no. 7) and that in the Hermitage (ibid., no. 6) are of the same form but with more movement in the drapery and with the child turning in his mother's lap. Both of these statues were acquired in the mid-nineteenth century. The iconography of the Vierge de Boubon is, however, unusual, with the figure holding the risen Christ, instead of an infant, in a quatrefoil.

The figure style of the scenes of the interior is studied and stiff, totally lacking in dynamism, and there are certain questionable details. The upper arm of the cross, for instance, is not only unusually tall, but it lacks the *titulus* that one would expect. The lamb held above the cross

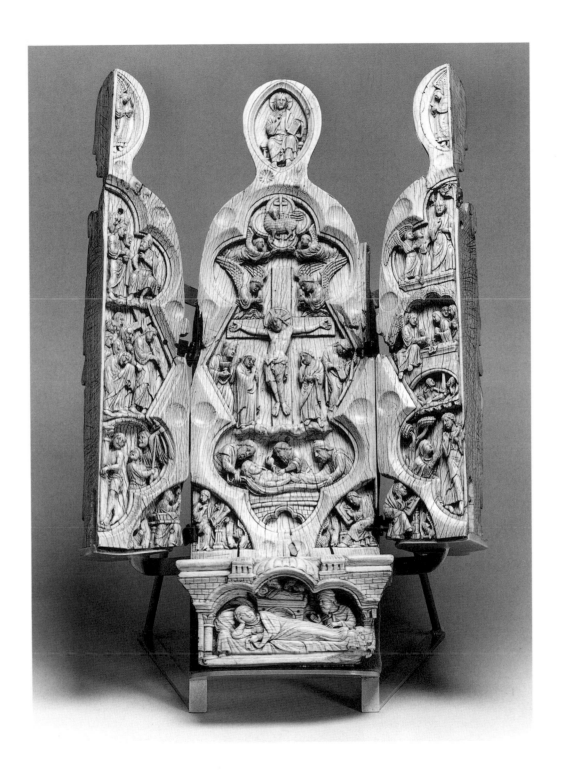

Vierge Ouvrante, no. 83, open

is also unknown except in this group of four *Vierges ouvrantes*. The stiff geometry of the spaces is also not found in other Romanesque or transitional Gothic sculpture, and the use of blind circular depressions to fill the voids is known only in metalwork. The depressions, incidentally, on the Rouen *Vierge ouvrante* are even more unusual and are treated as incised eight-petaled flowers.

In seeking parallels or sources, one must refer to Ottonian ivories of the tenth century for the concept of four angels above the cross and the inclusion of Ecclesia and Synagogia with the Crucifixion, for instance, the book cover in the Bibliothèque Nationale, Paris, from

Metz Cathedral (Goldschmidt 1914–26, 1: fig. 86). The Evangelists across the bottom of the triptych are also similar to Ottonian representations. But closer at hand are the two stone sculptures of the Nativity at the cathedral of Chartres, where the Virgin reclines on a bed, head supported by her right arm, while the left arm falls across the body (Favier

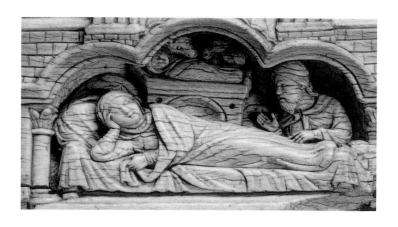

Detail, no. 83. *Vierge Ouvrante.*

1988, 131, 134). Also, there are close parallels in the stained glass of Chartres to the figure of the Crucified Christ in a roundel in bay XVIII, and the Entombment in bay III (Delaporte 1926, pls. I, bay XVIII and bay III, color pl. IX). In fact, there seem to be a number of possible sources, together with the unusual or unique elements, which suggest to most scholars that the Vierge de Boubon is not a medieval work but a concept of the Gothic revival.

Jaap Leeuwenberg, when studying the Paris forgeries of a carver he named the Master of the Agrafe Forgeries, discovered that many of these neo-Gothic works were already known and in collections or museums in the early nineteenth century. He surmised, therefore, that many of them had been made at least as early as the last decades of the eighteenth century. It is possible that the *Vierges ouvrantes* are earlier specimens of the Gothic revival in France (Leeuwenberg 1969).

One knows that the collecting of historical materials had a long history in France, the proof of which is shown in the drawings of historical monuments by Roger de Gaignières (1642–1715; Buchot 1891) and the volumes of Bernard de Montfaucon (1655–1741) on both antiquities and French sculpture (Montfaucon 1729–33). That there was an active market in antiquities is shown by the many seventeenth- and eighteenth-century collectors in France. In Arles, for instance, Antoine Agard collected both Limoges enamels and ivories as early as 1609. François Filhol in Toulouse collected "statues d'ivoire" about 1658, while Philibert de la Mare of Dijon owned a wing of a consular diptych. The cardinal archbishop of Bordeaux owned a "Vierge en ivoire," which he donated to the Chartreuse de Bordeaux (Bonaffé 1966, 3, 108, 153, 195).

In addition, there was an active ivory industry in France in the seventeenth and eighteenth centuries. Workshops in Dieppe produced many ivory products, such as snuffboxes, mantle garnitures, ship models, and other ivories à la mode. But Paris and many other areas were also known for their ivory carving.

What the combination of production and demand suggests is that the revival or survival subjects, such as medieval Virgins, were produced to satisfy collectors and to replace outdated or damaged church ornaments.

In 1836, the *Vierge ouvrante* of Rouen was the first of the group to enter a museum and is said to come from the town of Bosc-Guérard. The Louvre statue was acquired in 1844, and that of Lyons was donated in

1850 by the collector A. Lambert. The first part, the back, of the Vierge de Boubon was discovered only in 1872, and the wings were recovered by 1897.

It would appear, therefore, that these four objects were made in a single atelier prior to the French Revolution. The other three passed through various collections and into museums and are now admitted to be Gothic revival forgeries. This ivory (no. 83) may have actually been in the priory of Boubon before the Revolution, and its history in local families suggests that this was so. However, it must have been there as a replacement for an earlier work and made in the second half of the eighteenth century. This agrees with Leeuwenberg's conclusions on the Agrafe Master that ivory forgeries were already in circulation and collected in the eighteenth century.

The dating of the *Vierges ouvrantes* in the eighteenth century has recently been brought into question by a carbon dating of the Walters ivory. The test was done by the Research Laboratory for Archaeology and the History of Art, Oxford, and produced a date for the demise of the elephant as 1020–1220 A.D. in calibrated years (95 percent possibility) or, more narrowly, 1030–1150 A.D. (68 percent possibility). The early or even the median date would be too early stylistically for the object. The latest date, 1220, might be possible to consider if the object were medieval, which it does not appear to be.

Other examples of unusually early datings have resulted from carbon 14 tests; for instance, the Cloisters Cross, where the walrus ivory has been dated in the seventh century, though the cross is a carving of the twelfth century (Parker and Little 1994, 17–19). However, many laboratories feel that the very low carbon content of ivory makes testing difficult in our present state of knowledge and that the large plus or minus factors in the dating must be considered (Bowman 1990, 24–25).

The second problem is our total lack of knowledge of the ivory trade and the sources from which the tusks actually came and whether some of them may have been old treasure that was sold at a later date. Until a larger body of knowledge is gathered, it will be difficult to assess these datings.

It would, of course, be interesting to test the three related *Vierges ouvrantes* to see whether they were made of ivory of a similar date. These are in the Musée du Louvre, the Musée des Beaux-Arts, Lyons; and the Musée des Antiquités, Rouen. They are all similar to the present statue and have been shown to be forgeries. Arguments in favor of the authenticity of the Vierge de Boubon suggest that it must be the prototype, yet it was discovered long after the others were already in their museums. Its reconstructed history is based on the fact that some of the families that owned some of the parts of the statue were connected with the priory in the eighteenth century. **RHR**

Master of the Agrafe Forgeries

ca. 1800–1839

wood frame 1850–1912

Probably French

Elephant ivory in hinged wood frame with bone and wood intarsia

Height 25.5 cm
Width 37.5 cm

**Washington, D.C.
National Gallery of Art
Widener Collection
(1942.9.285)**

84 | DIPTYCH WITH SCENES OF THE LIFE OF CHRIST

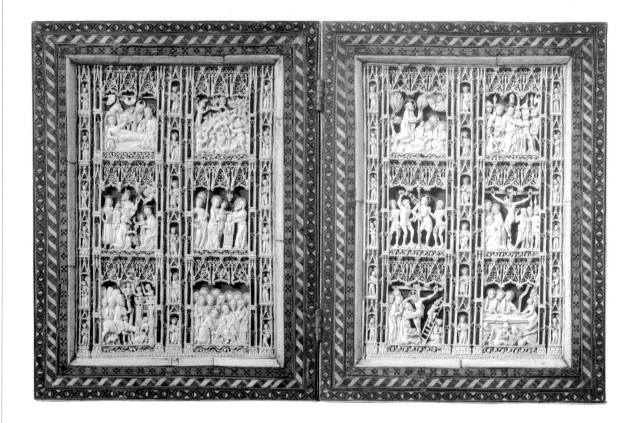

PROVENANCE
Alexandre Du Sommerard (1779–1842), Paris, before 1839; government of France, July 14, 1843–before 1847; Debruge Duménil family, Paris, before 1850; M. Issac (by sale at Hôtel des Ventes Mobilières, Paris, January 23–March 12, 1850, no. 159); George Field, Ashurst Park, England, before 1857–93; John Edward Taylor, after 1893–1912 (sale Christie, Manson, and Woods, London, July 1–3 and 9–10, 1912, no. 81, first reference to inlaid case); Joseph Duveen, 1912; purchased by Peter A. B. or Joseph Widener, Elkins Park, Pennsylvania, November 11, 1912, as Milanese, fifteenth century; by inheritance from the estate of Peter A. B. Widener, by gift through power of appointment of Joseph E. Widener, Elkins Park.

REFERENCES
Manchester 1857, 22, pl. V

Leeuwenberg 1969

Washington 1993

In the late eighteenth century, antiquarian interests in the ancient and medieval past brought about a fascination and a demand for ivories in the Gothic style that intensified in the nineteenth century with the increasingly romantic idealization of the Middle Ages. While many ivories were intentionally carved merely to evoke the Gothic era, some were carved as forgeries intended to be sold as authentic medieval works of art. Such is the case with the National Gallery of Art diptych (no. 84) and the Metropolitan Museum of Art fragment (no. 85), which have been attributed to the same forger.

The diptych is composed of two ivory leaves set within a frame of wood with wood and bone inlay. The ivory leaves were carved prior to 1839, the date they were acquired by Alexandre Du Sommerard. In the mid-nineteenth century the leaves were bought by an American collector and eventually sold in 1912 to Peter or Joseph Widener of Pennsylvania. It is at this time that the inlaid wood frame is first mentioned, suggesting that it dates to the latter half of the nineteenth century. Although originally considered a genuine medieval work, in 1969 the diptych was attributed to the Master of the Agrafe Forgeries, who worked in France during the late eighteenth and early nineteenth centuries (Leeuwenberg 1969).

The ivory panels are organized into an elaborate architectural framework of pierced niches and gables, lending a lightness to the diptych. Angels singing and playing musical instruments stand in gabled niches

along the outer edges of each leaf, while the central niches are occupied by the twelve apostles. Like the text of a book, the twelve scenes from the life of Christ that decorate the two leaves of the diptych begin at the upper left corner and proceed from left to right and top to bottom. The first four scenes illustrate events from the infancy of Christ, beginning with the Nativity and Annunciation to the Shepherds. The story of Christ's childhood continues on the next register with the Adoration of the Magi and Presentation at the Temple. Completing the left leaf are scenes from the Passion of Christ: the Entry into Jerusalem and Washing of the Disciples' Feet. The Passion continues on the right leaf with scenes of the Agony in the Garden, Arrest of Christ, Flagellation, Crucifixion, Deposition, and Three Marys at the Tomb. While the ivory leaves are in particularly good condition, there is some warping of the lower frame and some loss of ivory inlay surrounding the frame. Some of the checkerboard patterns are inlaid, while others are painted on. Composed of parchment over a wood core, the backgrounds of the narrative scenes are blue with gold decoration and the backgrounds of the niches are a brownish-yellow. There are traces of gilding throughout the piece, especially on the halos.

The group of three standing figures represents Saint John and the two Jews at the base of the cross (no. 85), thus indicating that it is to be understood as a fragment of a larger Crucifixion composition. Saint John holds a small book with a diaper-patterned cover in his left hand. The two Jews, identifiable by their caps, stand behind him; one holds a leather-wrapped sword at his side. Although acquired by J. Pierpont Morgan as an authentic ivory, the group's strong facial features, stunted proportions, and other stylistic similarities with other such groups led Koechlin in 1924 to identify this piece along with several others as forgeries (Koechlin 1924, 1:308). His detective work of identifying and grouping fakes was continued by Jaap Leeuwenberg, who suggested that the National Gallery diptych represents a late work by the master of these fragment groups (Leeuwenberg 1969, 142).

Leeuwenberg called the master who carved these works the "Master of the Agrafe Forgeries" because of his frequent use of an agrafe (a broochlike clasp) on the cloaks of his figures. In fact, agrafes are rarely seen in medieval sculpture, and then only on the robe of the Virgin. As both Koechlin and Leeuwenberg have pointed out, there are a number of ivories that one can group by their clumsy and agitated figures with earnest, self-assured facial expressions, small books with diaper-patterned decorations on the covers, leather-swathed swords, and hats with upturned brims, in addition to various iconographic inconsistencies. Also typical of the style of the Master of the Agrafe Forgeries is the predominent use of openwork in the ivory carving, a characteristic rarely adopted by medieval ivory carvers. In the National Gallery diptych not only is the architectural framework pierced, but also details such as the halos, features that would have been painted on an authentic medieval ivory. Because the first ivories attributable to the Agrafe Master were acquired in Paris and Lyons, a French provenance is assumed.

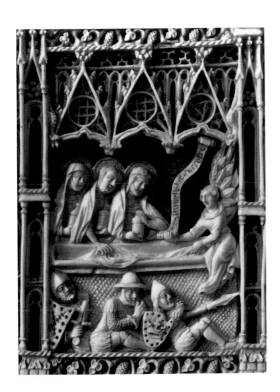

Detail, Three Marys at the Tomb

Elephant ivory

Height 12 cm
Width 5.5 cm

New York
The Metropolitan
Museum of Art
Gift of J. Pierpont Morgan
(17.190.206)

PROVENANCE
G. Hoentschel Collection, Paris;
J. Pierpont Morgan.

REFERENCES
Koechlin 1906

Koechlin 1924, 1:306

Leeuwenberg 1969

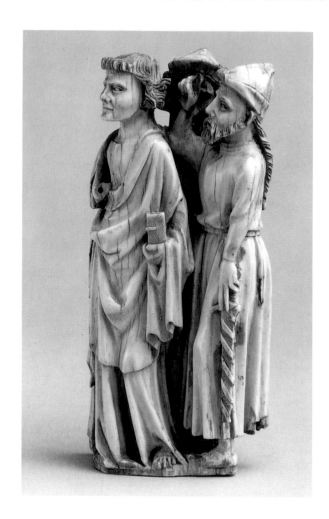

Leeuwenberg suggested that, owing to his apparent knowledge of medieval ivories, the Master of the Agrafe Forgeries began his career as a restorer and then turned to forgery, perhaps for economic gain or artistic freedom (Leeuwenberg 1969, 143).

Our awareness of the Master of the Agrafe Forgeries highlights some of the problems that come with the study of ivories carved in the Gothic style. Dealing with artists who had authentic models at hand, who worked as restorers of medieval ivories, or who based their work on graphic models of the Middle Ages, which were also available to the medieval artist, complicates the identification of modern ivories. Questioning whether some of the ivories attributed to the Master of the Agrafe Forgeries are in fact medieval, Danielle Gaborit-Chopin has argued that Leeuwenberg casts his net too widely in his claim that there are at least 110 objects that can be attributed to the Master or his workshop (Gaborit-Chopin 1970a, 128). She calls for more careful and thorough identification of the characteristics that determine authenticity, noting that one stylistic or iconographic inconsistency alone cannot confirm a modern origin. **RPW**

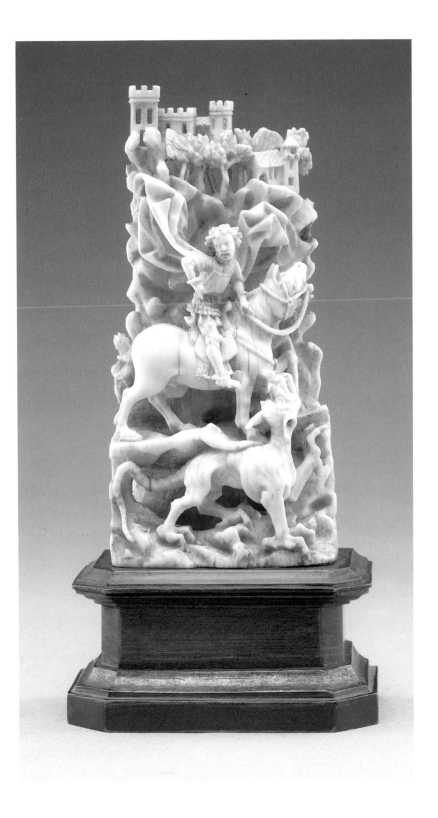

ca. 1850–70

French?

Elephant ivory

Height 8.25 cm

Toledo
The Toledo Museum of Art
Purchased with funds from
the Libbey Endowment
Gift of Edward Drummond
Libbey (69.296)

PROVENANCE
Heugel Collection, Paris,
in 1924; gift of Edward
Drummond Libbey in 1969.

REFERENCES
Koechlin 1924, 1:351; 3:
no. 985E, pl. CLXXIV

The high relief depicts Saint George on horseback dressed in armor and with a billowing mantle. He holds a lance in his right hand (now missing) and attacks the dragon, which is seen struggling beneath the horse. The scene is set before a rocky background with the cave of the dragon clearly distinguished and surmounted by a castle that is surrounded by trees.

This relief can be associated with a number of reliefs in ivory with the same subject, clearly divided into two groups. The first group consists of the following reliefs, which are preserved in:

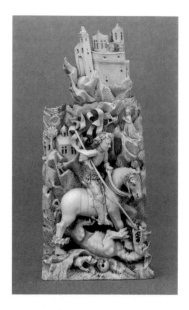

Fig. 86a. Saint George and the Dragon, German? probably 1400–20, elephant ivory, Hamburg, Museum für Kunst und Gewerbe (1876.210)

Fig. 86b. Saint George and the Dragon, German? probably 1400–20, elephant ivory, formerly Jakob Goldschmidt Collection, Berlin

1. Hamburg, Museum für Kunst und Gewerbe, inv. no. 1876.210; height 15.3 cm (fig. 86a; Volbach 1917, 57, pl. IIc)

2. London, Wallace Collection, inv. no. S 256; height 17.5 cm with socle (Mann 1931, 95, pl. 62)

3. Nuremburg, Germanisches Nationalmuseum, inv. no. pl. 397; height 11.4 cm (Stafski 1965, 241, no. 218)

4. Saint Petersburg, State Hermitage Museum, inv. no. 2923; height 15.5 cm (Berlin-Köpenick 1972, no. 7)

5. Formerly in Berlin in the collection of Jakob Goldschmidt, present location unknown; height 13 cm (fig. 86b; Frankfurt am Main 1936, no. 29, pl. 35)

6. Formerly in London in the possession of H. Baer, present location unknown; height 10 cm (London 1962, no. 640, pl. 324, possibly reversed).

In contrast to the present ivory, these six pieces show the king and queen of the city of Selina in Libya, the parents of the princess Sabra or Cleodolinda, who is generally shown kneeling above Saint George, and a skull or a skeleton beneath the dragon. They also differ markedly from the present example in the quality of facture and in the treatment of the armor, which is correctly rendered (fig. 86a).

A second group of three can be established, although some of these have in the past often been mixed up with the reliefs of the first group (Koechlin 1924, 1: 351). This group includes the present relief; one in the Victoria and Albert Museum, London (inv. no. A.547-1910; height 14.5 cm; Longhurst 1927–29, 2: 56, pl. LI); and another one formerly in a private collection in London, which was sent in 1934 for inspection to the Victoria and Albert Museum (height about 20 cm; photograph in Sculpture Department files). These reliefs are obviously derived from pieces of the first group. The present relief, for instance, is loosely based on the ivory in the former Jakob Goldschmidt Collection in Berlin (fig. 86b) although the carver seems to have known one of the other reliefs of the first group, which show the tail of the horse bound up. He certainly misunderstood the function of the hinges of the leg harness, the correctly upward-turned spurs that are clearly shown in the first group, and the somewhat peculiar physiognomy that has nothing in common with the distinctive face of the saint as shown in the first group.

Most of these reliefs have traditionally been dated to the first half of the fifteenth century; for the present one Koechlin (1924, 1:351) suggested a Westphalian provenance. More recently doubts have been expressed about an early date for the whole ensemble. The second group is certainly derived from examples of the first and is undoubtedly of the nineteenth century; the origins of the first group are still unclear. **NJ**

Late 19th century

Spanish

Wood with elephant ivory, bone, and wood inlay, and iron hardware

Height 35.5 cm
Width 30.5 cm

Bloomfield Hills, Michigan
Cranbrook Art Museum
Gift of George G. Booth
(CAM 1922.2)

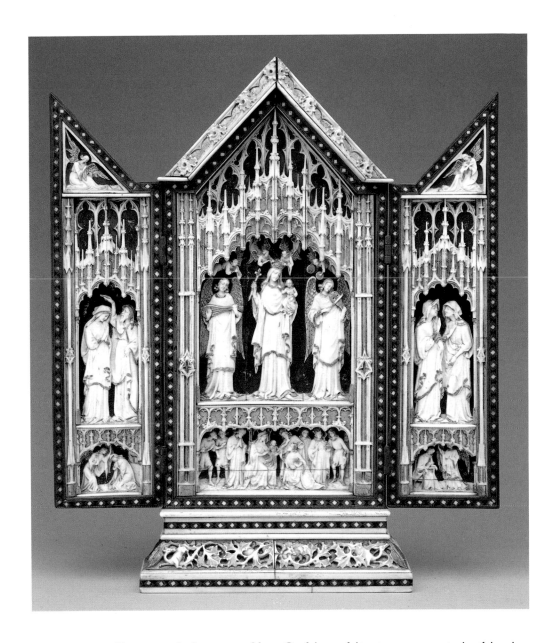

Triptych, closed

PROVENANCE
Purchased by G. G. Booth at Museo-Paseo de Los Martires, Alhambra, Granada, January 5, 1922.

REFERENCES
Unpublished

Forms and elements of late Gothic architecture resonate in this nineteenth-century gabled triptych, creating an elaborate stage set for scenes glorifying the Virgin. Sharp pinnacles and elegant, lobed arches articulate the composition and divide the scenes. The Virgin and Child stand in the center flanked by two angels playing musical instruments. Four small angels hover in the shadows of the lobed arcade above the group. The two outer angels play a horn and cymbals, while the two in the center place a crown on the Virgin's head. The Adoration of the Magi is portrayed in the lower portion of the central panel. Joseph stands behind the enthroned Virgin and Child, while the three Magi attend the family from the right. Several animated figures in short tunics, perhaps shepherds, stand in the background.

The scenes of the wings are enigmatic in their unusual iconography. The upper scene of the left wing depicts a man with his hand raised in blessing above the Virgin's head. While in medieval iconography the Virgin is presented at the temple as a child, there is no scene comparable to that

portrayed here. The lower scene depicts the angel of the Annunciation. The scenes of the right wing portray the Visitation above and the Annunciation of the Virgin's death below. An adoring angel, with wings spread, sits in the triangular space at the top of each wing. The hems of all the garments are banded with gilding, while the robe of Christ in the Adoration scene is entirely gilded, drawing attention to his central position. A wood frame inlaid with small, diagonally set bone squares surrounds the central panel and each wing. The central panel stands on a layered pedestal of ivory, wood, and bone. Decorating the base is a rinceau of prickly vegetation inhabited by fantastic beasts.

The elegant, lithe figures, their affected gestures and the attenuated architectural setting place this triptych within a group of pseudo-Gothic triptychs carved in Spain in the late nineteenth century. In 1943 Adolf Goldschmidt identified a group of triptychs, several of which had been acquired by Henry Walters of the Walters Art Gallery (Goldschmidt 1943). In addition to strong stylistic similarities between the Cranbrook triptych and the Walters triptychs, they share the lack of an iconographic program and a tendency to contain scenes that have no iconographic parallel in medieval images. At the time of his article, Goldschmidt had found four other triptychs that he believed to be by the same sculptor; the Cranbrook triptych was not included in his list. While there are similarities in figure style with the Embriachi ivories from Italy (see no. 68), he suggests that the artist is more likely to have been Spanish. This attribution is based on the close stylistic relationship of the architectural features with Spanish rood screens and altarpieces of about 1500, as well as the use of Spanish armorials and portrait heads in many of the triptychs (Goldschmidt 1943, 55).

Goldschmidt suggests that the carver of these triptychs may be Francisco Pallas y Puig (1859–1926) of Valencia, an artist responsible for two other groups of forged Spanish ivories. The two groups of ivories, one in the Mozarabic style and one in the Romanesque style of southern France, were also carved in the late nineteenth century. In comparing the Romanesque and Gothic ivories, Goldschmidt notes that there is a similarity of treatment of drapery and carving style and concludes that their authorship by a single carver is plausible (ibid., 58). Ivories from all three groups were originally sold and purchased as authentic, leading one to suppose that Pallas y Puig was a forger. Nonetheless, Goldschmidt generously suggests that Pallas y Puig was carving "in the style of the fifteenth century," rather than deliberately trying to deceive his audience (ibid., 49). Whatever the case, the artist responsible for the Cranbrook triptych had a capacity for invention as seen in the liberties taken with conventions of medieval sculpture and in his rather personal interpretation of medieval iconography. **RPW**

19th century

French?

Elephant ivory, wood

Height 42 cm (without base)
Width 23 cm

Paris
Musée du Louvre
(OA 3291)

PROVENANCE
Gift of the Marquise Arconati
Visconti in 1892

REFERENCES
Molinier 1892, 182

Molinier 1896, no. 116

Koechlin 1924, 2: no. 1252,
3: pl. CCIX

Grodecki 1947, 111

Leeuwenberg 1969, 135

Homo 1986

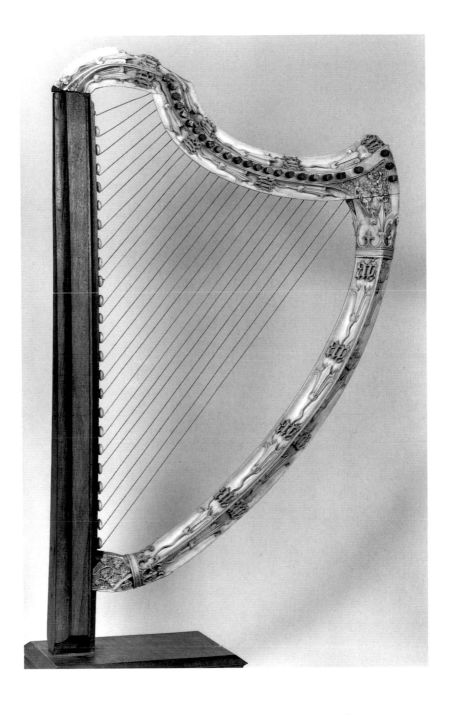

The interest in daily life in the Middle Ages often led nineteenth-century collectors to acquire objects that fit their idealized vision of the Middle Ages. This vision was informed by sometimes fanciful drawings and watercolors illustrating the books they consulted (see Arquié-Bruley 1980–81; 1990). This ivory harp, given to the Musée du Louvre by the Marquise Arconati Visconti at the request of curator Emile Molinier (1857–1906), who had found it at a dealer, was enthusiastically accepted by everyone as genuine at the time of its acquisition. It was considered to be a rare musical instrument of the fifteenth century, the more admired because it was made of ivory, a costly material that seemed to indicate a royal or princely provenance. The harp was discussed in many studies on medieval life and especially on medieval music.

This instrument does not have a sounding box and consists only of a console and column. These are decorated with fleur-de-lis with undulating stems alternating with the letters *A* and *Y* in Gothic script. At the junction of the crossbar and the console, bas-reliefs represent the Nativity with the inscription EN BETHLEAN (in Bethlehem?); to the left, the Adoration of the Magi, to the right, the Massacre of the Innocents. Molinier thought the letters *A* and *Y* referred to the motto of Philip the Good after his marriage to Ysabella of Portugal ("Aultre n'auray" [I will not have another]); others saw in it an allusion to Yolanda of France and her consort, Amedeus of Savoy. Koechlin's entry (1924) shows that this object had already aroused his doubt. This suspicion was confirmed by Leeuwenberg (1969).

In 1986 a study by Catherine Homo revealed some unconventional aspects of the instrument: first, the harp appears to be too small for the period to which it is meant to belong; second, it has twenty-five strings, which is too many; and, above all, one cannot imagine how such ivory elements could be attached to a sounding box in the fifteenth century (Homo 1986). These observations, as well as the extraordinary stylistic differences between the dryly executed scenes representing the infancy of Christ and the fleur-de-lis, whose gracefulness foreshadows Art Nouveau, led scholars to believe that the Louvre harp is a forgery; a more generous explanation might suggest that this is a neo-Gothic accessory for a sculpture representing David or Saint Cecilia. **DGC**

Opposite side and details,
no. 88

Before 1893

French (Paris)

Elephant ivory

Height 26.2 cm
Width 12.5 cm

Baltimore
Walters Art Gallery
(71.156)

PROVENANCE
Collections of Frédéric Spitzer, Paris, until 1893; Sigismond Bardac, Paris; purchased from Jacques Seligmann, Paris, 1912; collection of Henry Walters, 1912–31; Walters Art Gallery, 1931.

REFERENCES
Paris 1900, no. 132

Rosen 1952–53, figs. 2, 3

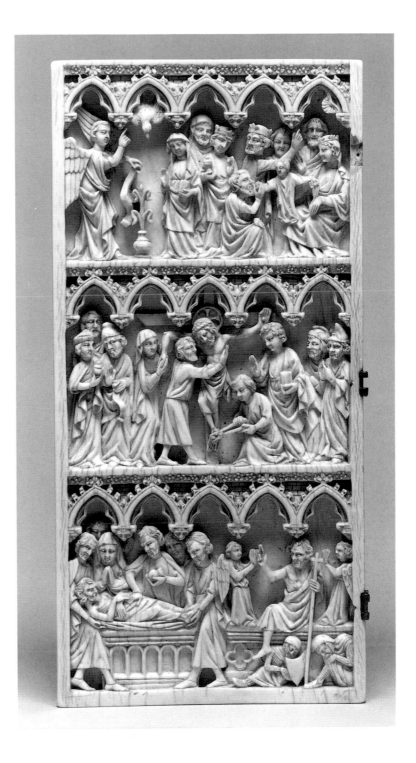

The panel is the false leaf created to complete a diptych by the Master of Kremsmünster (no. 45) made by a carver for Frédéric Spitzer before 1893, when it appeared in the Spitzer sale. The original left leaf is in the collection of the Musée des Beaux-Arts, Lyons, and represents an entirely different series of scenes from those the forger invented.

The carver of the false leaf clearly knew little of medieval iconography and was unaware that the original wing existed. He could have followed the many precedents of Passion diptychs in which the scenes would have been in logical order, but he preferred to create scenes based vaguely

on other ivories, but, in large part, imaginary. In the top tier one sees the Annunciation, followed by the Adoration of the Magi. The second scene illustrates how little the carver had studied existing models, as he placed Joseph and a woman as witnesses to the Adoration, a depiction that does not occur in any medieval ivory. In the second tier, one sees a Deposition with ten figures, unusual in itself, and again unknown in other ivories. The carver has, however, carefully imitated the Germanic carved cruciform halo of Christ. In the lowest tier are shown the Entombment of Christ and his Resurrection.

The carving style is stiff and studied, and it is apparent that the ivory carver did not understand the Gothic baroque style of the Kremsmünster leaf. His figures are formal and dry and somewhat elongated. While the original panel shows directed glances, the false one shows both the Virgin in the Annunciation and the second king staring into space. In the Entombment the figures are crammed in at the left, while the Resurrection has too much open space, a feature never allowed by the Master of Kremsmünster. That the carving is inept may be seen best by studying the figure of Nicodemus at the head of Christ in the Entombment, the Magdalen in the Crucifixion, and both figures in the Annunciation. The carver almost caught the flow of the garments of the two Jews witnessing the Crucifixion in the original leaf.

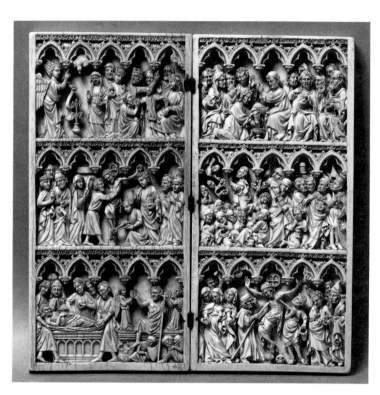

Diptych with original right leaf, no. 45, and 19th-century left leaf, no. 89

When compared to the original left leaf with its dynamic Entry into Jerusalem, the crowded Last Supper, and the three scenes compressed into the lowest tier, the replacement leaf appears rigid and inarticulate. In the original leaf, the compositional motion leads one's eye across to the next scene, while in the replacement, all the scenes terminate with the backs of figures facing the right panel (fig. 89a).

It should be noted that this carver was one of the lesser men available to Frédéric Spitzer in Paris in the 1890s. A number of copies and forgeries have emerged from the Spitzer Collection, some of which are of very superior quality. In the case of the Kremsmünster panel, the carver understood neither its style nor the proper iconography of the leaf he intended to create. **RHR**

90 | Mirror Cases with Scenes of Lovers in Gardens

Late 19th or
early 20th century

Austrian?

Elephant ivory

Diameter 13.1 cm

Detroit
The Detroit Institute of Arts
Founders Society
Purchase (23.137)

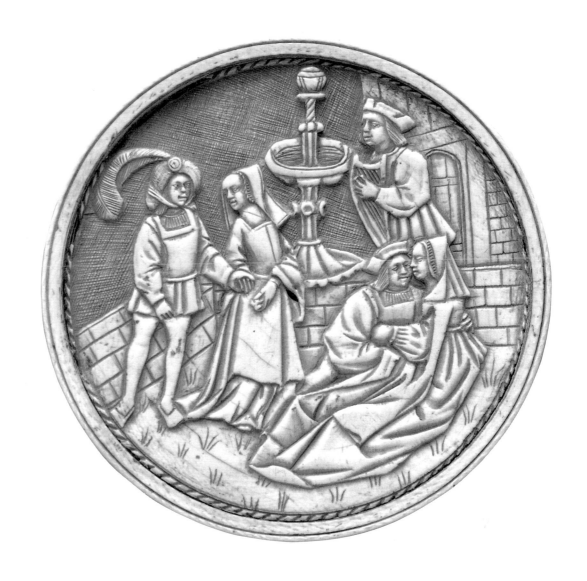

PROVENANCE
Purchased from A. Satori,
Vienna, September 1923.

REFERENCES
Unpublished

The Garden of Love, a favorite theme among engravers of the late Middle Ages, provides the inspiration for the scenes of lovers serenaded by musicians on each of the pair of mirror cases. On one, the couples are enclosed within a garden wall, while a musician standing behind the seated couple plays a harp for the lovers. A stone building fills the back right portion of the image and a polygonal fountain, perched precariously on the garden wall, fills the center. The second mirror case depicts two couples standing in a tree-filled, grassy area. One couple walks together, the other leans against a stone or brick wall, while the musician, playing a recorder, sits on the ground near the brick wall. A dog reclines in the foreground. The angular drapery of the female figures, the costumes of the male figures, and the treatment of the architectural features and trees, as well as the crosshatched background, all recall a style of engraving of the late fifteenth century. A detail, for example, from *The Large Garden of Love*, an engraving by the Master of the Gardens of Love (fig. 90a) provides a useful comparison. Similarities

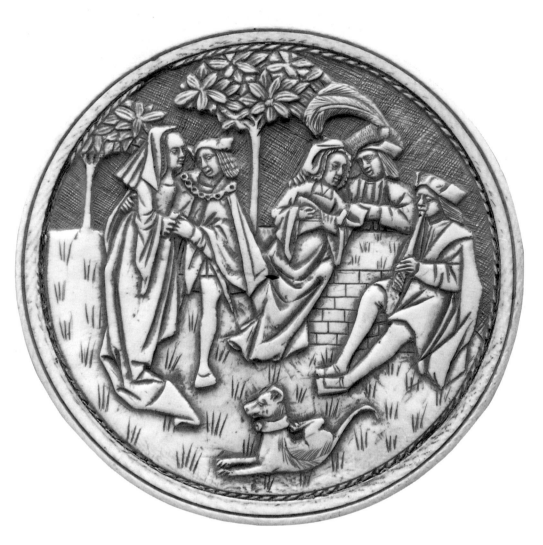

Fig. 90a. The *Large Garden of Love*, detail, Master of the Gardens of Love, German, 1460, engraving, Kupferstichkabinett, Staatliche Museen zu Berlin-Preußischer Kulturbesitz

between the mirror cases and the engraving include the voluminous, angular drapery of the women; the short, pleated tunics of the men; the amorous interaction of the couples; and the tilted perspective of the walls and fountain.

While the figure style and subject of the mirror cases evoke the second half of the fifteenth century, the construction of these mirror cases provides a clue to their modern origin. The outer rim of each is glued onto the circular disk of the mirror case, rather than being carved all from one piece. Though the unusual construction belies the late date of their carving, this pair of mirror cases does bring up the issue of prints as sources for medieval ivories. As seen in several ivories previously discussed here (nos. 72, 73, 76), the connection between ivory carving and the graphic arts, such as woodcuts and engravings, was relatively close in the fifteenth century. This existing connection provided the forger of the nineteenth and early twentieth centuries with a ready source of inspiration for new ivories. **RPW**

91 | Diptych with the Virgin in Glory and Crucifixion

19th or 20th century

French?

Elephant ivory and silver

Height 12.2 cm
Width 12.2 cm

Detroit
The Detroit Institute of Arts
Gift of Robert H. Tannahill
(43.456)

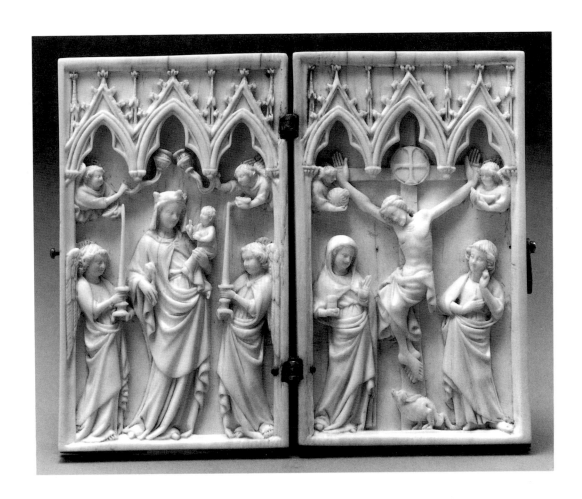

PROVENANCE
Collection Professor A. Gilbert, Paris; sale, Hôtel Drouot, Paris, December 1, 1927.

REFERENCES
Unpublished

Each scene of the diptych takes place under a trilobed arcade set on corbels. Trefoil moldings and foliate gables decorate each arch, and spikey turrets rise between each gable. The Virgin in Glory is portrayed on the left leaf. She stands with her left hip swayed to support the weight of the Christ child, whom she holds in her left arm. Christ is animated, sitting upright with his attention focused on the bird he holds in his right hand. Flanking the Virgin and Child are two angels, each holding a footed candlestick, while two angels hover above the group swinging censers and holding crescent-shaped bowls that seem to contain grapes or berries. The right leaf, on which the Crucifixion is depicted, is organized into a similar composition with Christ on the cross in the center. The Virgin and Saint John the Evangelist flank the cross, and two angels hover in the sky, one holding the sun and the other the crescent moon. Christ hangs heavily from the cross, his head inclined to his right and his legs bent and twisted under him. He wears a loincloth draped in generous folds over his thighs. The drapery of the standing figures is notable in its texture and weight as it is drawn in sweeping folds across their bodies and falls smoothly to their feet. The leaves are joined by two slot and pin hinges and can be held together by a silver latch. Silver corner mounts, the style of which suggest a seventeenth-century origin, decorate and protect the four corners of each leaf.

EPILOGUE: PASTICHES, REVIVALS, FORGERIES, AND OPEN QUESTIONS

The scenes depicted on this diptych are frequently portrayed in ivory in the mid-fourteenth century as seen in the diptych shared by the Musée du Louvre and the Toledo Museum of Art (nos. 22 and 23) and a diptych in the Walters Art Gallery (no. 43). In addition, Koechlin illustrates several similar diptychs, including one in the Metropolitan Museum of Art (1924, no. 566) and one in the British Museum (ibid., no. 542). The style and treatment of the figures also lead one to compare this ivory with work of the mid- to late fourteenth century. In particular, the simplified compositions and the large hands and feet and the shortened, contorted body of Christ relate the Crucifixion scene to a group Randall has identified as Parisian in origin and dating to 1340–60 (Randall 1993, 78–79). The use of the cruciform nimbus on the cross relates the diptych to various ivories from the Middle Rhine by the Master of Kremsmünster (no. 45 and fig. 45a). This juxtaposition of elements with conflicting origins, in addition to unusual elements of the portrayals themselves, casts doubt on the diptych's authenticity. For instance, the position of the angels carrying the sun and the moon beneath the arms of the cross is highly unusual, as they typically appear above the cross's arms. In addition, the extremely thin proportions of the turrets that punctuate the spaces between the gables are not consistent with medieval practice. Another unsettling addition is the basilisk at the foot of the cross where one would expect to find a small mound symbolizing Calvary or the skull of Adam symbolizing Golgotha. Although the carving of this diptych is seductively beautiful, the compilation of these atypical features and treatments can only lead one to the conclusion that it is a modern forgery of a medieval ivory. **RPW**

92 | Writing Tablets with Scenes of Lovers

These scenes of lovers standing under trilobed arches recall typical expressions of courtly love of the early to mid-fourteenth century (compare nos. 53 and 55). On the left tablet, a woman crowns her lover as he presents her with his heart, a token of his love and devotion. The scene on the right tablet depicts an embracing couple; he holds a falcon and, as on the left leaf, she holds a small dog at her hip. The two men wear hooded, ankle-length robes, while the women wear robes with simple, rounded necklines. In each scene, the woman gathers her robe up at her left hip, from which it falls to the ground in smooth, vertical folds. A crudely carved tree, growing from the left frame of each tablet, fills the background of each scene. The arches, springing from small corbels, are foliated, and long-eared dragons fill the spandrels above. Hinges once held the two tablets together as a diptych, as attested by the three pierced holes along the right edge of the left tablet and the left edge of the right tablet. In addition, there is a pierced hole at the top of each tablet so that the tablets could perhaps be hung from a belt. A sunken

19th or early 20th century

French?

Elephant ivory

Height 10.1 cm
Width 6.3 cm (each)

Detroit
The Detroit Institute of Arts
Gift of Robert H. Tannahill
(42.136, 42.137)

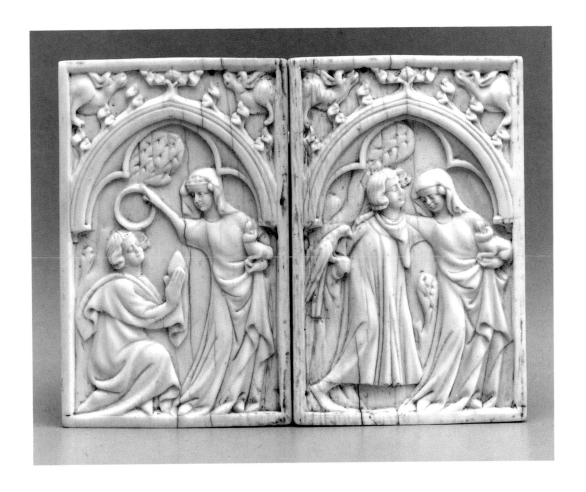

PROVENANCE
Purchased from Goldschmidt
Galleries, New York, 1929.

REFERENCES
Robinson 1943

Ann Arbor 1976, 112, pl. IV

rectangular area with raised frame allowed the back of each to be filled with wax for inscribing with a stylus. There are traces of polychromy on the frame.

Until recently these tablets were considered authentic Parisian ivories from the first half of the fourteenth century (Ann Arbor 1976, 112). A comparison of these tablets with secular Gothic ivories reveals that the artist has, unusually, combined secular iconography with the arcaded framing typical of religious scenes. Except for panels used in the construction of caskets, secular scenes are rarely portrayed in arcaded settings. Taken alone, this characteristic does not confirm a modern origin, yet close examination of each scene reveals several other anomalous characteristics. While the spandrels above arches of Gothic diptychs are often filled with foliate ornament or polyfoil blind tracery, they are not decorated with monsters as one finds here. The monsters derive from the corners of mirror backs, such as can be found on the mirror case from the Victoria and Albert Museum (no. 55) and another from the Virginia Museum of Fine Arts (no. 59). Furthermore, as Randall has observed (DIA curatorial files, December 1995), the man on the right leaf is missing his left leg and atypically the woman embraces the man, instead of the reverse, which is more common in Gothic imagery. These innacurate quotations of fourteenth century ivories suggest that the tablets should be viewed as modern forgeries. **RPW**

19th century

French

Elephant ivory

Height 30.5 cm

New York
The Metropolitan
Museum of Art
The Friedsam Collection
Bequest of
Michael Friedsam, 1931
(32.100.407)

PROVENANCE
Formerly in the collection of
Wyndam Francis Cook, London;
the Friedsam Collection.

REFERENCES
Skinner 1904, no. 510

London 1881, no. 474

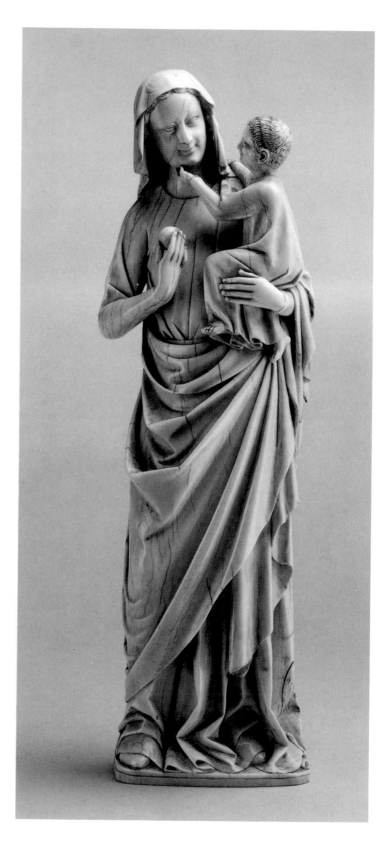

The standing Virgin and Child ultimately developed from the Byzantine image of the Hodegetria and became the classic image of the Virgin and Child in Western Europe. In ivory, the Virgin and Child of the Sainte-Chapelle in Paris, (figs. I-4, III-3, IV-2), and the contemporary Virgin for Saint-Denis (no. 5) became prototypes for many contemporary variants. The present example, with its completely vacuous expression, appears to be a direct copy of a late-thirteenth-century statuette formerly in the Benoît Oppenheim Collection in Berlin (fig. 93a; Koechlin 1924, 2: no. 75). Although the Oppenheim figure has extensive craquelure and originally possessed a crown, probably of metal, it is consistent with ivory Virgins of the late thirteenth century. More than double the size of the original, the copy's monumental composition was made to impress. As a workmanlike reproduction, it successfully deceived at least one collector.

Fig. 93a Virgin and Child, French, late 13th century, elephant ivory, 14.7 cm, formerly Benoît Oppenhcim Collection, Berlin

The motif of the Christ child chucking the chin of the Virgin develops from the Eastern tradition *Eleousa*, or Virgin of Tenderness, and appears in western Europe in monumental sculpture, metalwork, and ivories in the course of the thirteenth century. The nineteenth-century revival of the Gothic created a climate for such images of the Virgin and Child in ivory, unprecedented since the Middle Ages. Perhaps honestly made as a revival-style object modeled on a genuine ivory of around 1300, such a work was allowed to masquerade as something other than what was intended because of the taste for such objects at the time. Ironically, when the ivory was exhibited in 1881 it was mounted in a shrine that was known to be modern and no question was asked about the age of the Virgin and Child within. **CTL**

Bibliography

In addition to references to books and articles cited in the essays and catalogue entries, the bibliography includes material intended to provide a wider background to the Gothic period.

Aldrich 1995
Aldrich, M. "Gothic Sensibility: The Early Years of the Gothic Revival," in *A. W. N. Pugin: Master of Gothic Revival*, exh. cat., New Haven, Conn., The Bard Graduate Center for Studies in the Decorative Arts, 1995.

Amsterdam 1993
Dawn of the Golden Age: Northern Netherlandish Art, 1580–1620, exh. cat., Amsterdam, Rijksmuseum, 1993.

Ann Arbor 1976
Images of Love and Death in Late Medieval and Renaissance Art, exh. cat., Ann Arbor, University of Michigan Museum of Art, 1976.

Apollo 1967
"Medieval Art at Toledo: A Selection," *Apollo* 86, no. 70 (December 1967): 438–43.

Aries 1981
Aries, P. *The Hour of Our Death*, trans. H. Weaver, New York, 1981. Originally published as *L'homme devant la mort* (Paris, 1977).

Arquié-Bruley 1980–81
Arquié-Bruley, F. "Un précurseur: Le comte de Saint-Morys (1782–1817), collectionneur d'antiquités nationales,'" parts 1 and 2, *Gazette des beaux-arts* 96, no. 1341 (October 1980): 109–18; 97, no. 1345 (February 1981): 61–77.

Arquié-Bruley 1990
Arquié-Bruley, F. "Debruge-Duménil (1778–1838) et sa collection," *Annali della Scuola normale superiore di Pisa: Classe di lettere e filosofia*, 3rd ser., 20 (1990): 211–48.

Aubert 1922
Aubert, M. "L'Ange de la Collection Chalandon au Musée du Louvre," *Revue de l'art ancien et moderne* 41 (1922): 387–90.

Avril 1978
Avril, F. *L'enluminure du XIVe siècle à la cour de France*, Paris, 1978.

Avril 1982
———. "Les manuscrits enluminés de Guillaume de Machaut," in *Guillaume de Machaut: Colloque—Table ronde organisé par l'Université de Reims*, Paris, 1982.

Avril 1995
———. *L'enluminure à l'époque gothique, 1200–1420*, Paris, 1995.

Babelon 1970
Babelon, J., et al. *Le siècle de Saint Louis*, Paris, 1970.

Baden-Baden 1995
Sotheby and Co., Baden-Baden, *Die Sammlung der Markgrafen und Grossherzöge von Baden*, sale cat., vol. 2, October 5, 1995.

Baekeland 1975
Baekeland, F. "Two Kinds of Symbolism in a Gothic Ivory Casket," *The Psychoanalytic Study of Society* 6 (1975): 20–52.

Baldwin 1986
Baldwin, J. *The Government of Philip Augustus: Foundations of French Royal Power in the Middle Ages*, Berkeley, Calif., 1986.

Baltimore 1962
The International Style: The Arts of Europe around 1400, exh. cat., Baltimore, The Walters Art Gallery, 1962.

Barnet 1986
Barnet, P. "From the Middle Ages to the Victorians," *Apollo* 124, no. 298 (December 1986): 38–45.

Barnet 1991
———. *Bulletin of the Detroit Institute of Arts* 66, no. 4 (1991): 50.

Baron 1968
Baron, F. "Enlumineurs, peintres et sculpteurs parisiens des XIIIe et XIVe siècles d'après les rôles de la taille," *Bulletin archéologique du Comité des travaux historiques et scientifiques*, n.s., 4 (1968): 37–121.

Baron 1987
———. "La Vierge à l'Enfant dite 'de Maisoncelles,' au Musée du Louvre: Un chef d'oeuvre de l'art normand du XIVe siècle," in *Art, objets d'art, collections: Études sur l'art du moyen âge et de la Renaissance sur l'histoire du goût et des collections. Hommage à Hubert Landais*, Paris, 1987.

Barsotti 1956
Barsotti, R. "Gli antichi *Inventari* della Cattedrale di Pisa: *L'Inventario* di Gioanni Sacrista," *Critica d'arte*, no. 18 (November–December 1956): 501–25.

Bassani and Fagg 1988
Bassani, E., and W. B. Fagg. *Africa and the Renaissance: Art in Ivory*, exh. cat., New York, The Center for African Art, 1988.

Baumer 1977
Baumer, C. "Die Schreinmadonna," *Marian Library Studies*, n.s., 9, (1977).

Beard 1935
Beard, C. "Heraldry: Arms on a Fifteenth-Century Box," *Connoisseur* 96, no. 410 (October 1935): 238–39.

Becksmann 1992
Becksmann, R. "Die Bettelorden an Rhein, Main und Neckar und der höfische Stil der Pariser Kunst um 1300," in *Deutsche Glasmalerei des Mittelalters: Bildprogramme, Auftraggeber, Werkstätten*, Berlin, 1992.

Beckwith 1966
Beckwith, J. "A Rhenish Ivory Noli Me Tangere," *Victoria and Albert Museum Bulletin* 2 (1966): 112–16.

Beigbeder 1951
Beigbeder, O. "Le château d'amour dans l'ivoirerie et son symbolisme," *Gazette des beaux-arts* 38 (1951): 65–76.

Beigbeder 1965
———. *Ivory*, London, 1965.

Belting 1994
Belting, H. *Likeness and Presence: A History of the Image before the Era of Art*, trans. E. Jephcott, Chicago, 1994. Originally published as *Bild und Kult: Eine Geschichte des Bildes vor dem Zeitalter der Kunst* (Munich, 1990).

Berg 1957
Berg, K. "Une iconographie peu connue du Crucifiement," *Cahiers archéologiques* 9 (1957): 319–28.

Bergmann 1987
Bergmann, U. *Das Chorgestühl des Kölner Domes*, 2 vols., Neuss, 1987.

Bergmann 1989
———. *Die Holzskulpturen des Mittelalters (1000–1400)*, Cologne, Schnütgen Museum, 1989.

Berlin-Köpenick 1972
Westeuropäische Elfenbeinarbeiten aus der Eremitage Leningrad, exh. cat., Berlin Köpenick, Kunstgewerbemuseum, 1972.

Berliner 1926
Berliner, R. *Die Bildwerke des Bayerischen Nationalmuseums*, vol. 4, *Die Bildwerke in Elfenbein, Knochen, Hirsch- und Steinbockhorn*, Munich, 1926.

Berliner 1955
———. "Arma Christi," *Münchner Jahrbuch der bildenden Kunst*, 3rd ser., 6 (1955): 35–152.

Bideault 1984
Bideault, M. "Les croix triomphales de Notre-Dame de Paris et de la cathédrale de Chartres: Un document inédit," *Bulletin monumental* 142, no. 1 (1984): 7–17.

Binski 1995
Binski, P. *Westminster Abbey and the Plantagenets: Kingship and the Representation of Power, 1200–1400,* New Haven, Conn., and London, 1995.

Blamires 1988
Blamires, A. "The `Religion of Love' in Chaucer's Troilus and Criseyde and Medieval Visual Art," in *Word and Visual Imagination: Studies in the Interaction of English Literature and the Visual Arts*, ed. K. J. Höltgen, P. M. Daly, and W. Lottes, Erlangen, 1988.

Blancher and Blancher 1972
Blancher, M., and R. Blancher. *Recherches sur la Vierge de Boubon*, Paris, 1972.

Blindheim 1952
Blindheim, M. *Main Trends in East Norwegian Wooden Figure Sculpture in the Second Half of the Thirteenth Century*, Oslo, 1952.

Bloch 1970
Bloch, P. *Kölner Madonnen*, Mönchengladbach, 1970.

Bloch 1977
———. "Neugotische Statuetten des Nikolaus Elscheidt," in *Festschrift für Otto von Simpson zum 65. Geburtstag*, ed. L. Grisebach and C. Reuger, Frankfurt am Main, 1977.

Bloch 1983
———. "Eine Muttergottes im Liebieghaus," *Städel-Jahrbuch*, n.s., 9 (1983): 221–26.

Bloch 1993
———. "Alexander Schnütgen und die neugotische Skulptur," in *Alexander Schnütgen: Colligite fragmenta ne pereant. Gedenkschrift des Kölner Schnütgen-Museums zum 150. Geburtstag seines Gründers*, Cologne, 1993.

Bode 1897
Bode, W. von. *Die Sammlung O. Hainauer*, Berlin, 1897.

Bonaffé 1966
Bonaffé, E. *Dictionnaire des amateurs français au XVIIe siècle*, Amsterdam, 1966.

Bonaventura 1882-1902
Bonaventura, Saint. *Opera omnia*, 10 vols., Quarracchi, 1882–1902.

Boston 1940
Arts of the Middle Ages, exh. cat., Boston, Boston Museum of Fine Arts, 1940.

Bourlet 1992
Bourlet, C. "Les tabletiers parisiens à la fin du moyen âge," in *Les tablettes à écrire de l'antiquité à l'époque moderne*, Bibliologia, vol. 12, Turnhout, Belgium, 1992.

Bowman 1990
Bowman, S. *Radiocarbon Dating*, Interpreting the Past, London, 1990.

Branner 1965
Branner, R. *Saint Louis and the Court Style in Gothic Architecture*, London, 1965.

Branner 1977
———. *Manuscript Painting in Paris during the Reign of Saint Louis*, California Studies in the History of Art, vol. 18, Berkeley, 1977.

Braunschweig 1995
Heinrich der Löwe und seine Zeit: Herrschaft und Repräsentation der Welfen, 1125–1235, exh. cat., Braunschweig, Herzog Anton Ulrich-Museum, vol. 1, 1995.

Breckenridge 1957
Breckenridge, J. D. "*Et prima vidi*: The Iconography of the Appearance of Christ to his Mother," *Art Bulletin* 39 (1957): 9–32.

Broderick 1977
Broderick, H. "Solomon and Sheba Revisited," *Gesta* 16, no. 1 (1977): 45–48.

Brown and Freeman Regalado 1994
Brown, E. A. R., and N. Freeman Regalado. "*La grant feste*: Philip the Fair's Celebration of the Knighting of His Sons in Paris at Pentecost of 1313," in *City and Spectacle in Medieval Europe*, ed. B. A. Hanawalt and K. L. Reyerson, Minneapolis, 1994.

Bruckner 1995
Bruckner, M. T. "Reconstructing Arthurian History: Lancelot and the Vulgate Cycle," in *Memory and the Middle Ages*, exh. cat., Chestnut Hill, Mass., Boston College Museum of Art, 1995.

Bruzelius 1987
Bruzelius, C. "The Construction of Notre-Dame in Paris," *Art Bulletin* 69 (1987): 540–69.

Bucher 1957
Bucher, F. "A Gothic Ivory Virgin and Child," *Bulletin of the Associates in Fine Arts at Yale University* 23 (1957): 4–9.

Buchot 1891
Buchot, H. *Inventaire des dessins de Roger de Gaignières*, 2 vols., Paris, 1891.

Budde 1986
Budde, R. *Köln und seine Maler, 1300–1500*, Cologne, 1986.

Burdach 1974
Burdach, K. *Der Gral: Forschungen über seinen Ursprung und seinen Zusammenhang mit der Longinuslegende*, 2nd ed., Darmstadt, 1974.

Burton and Haskins 1983
Burton, A., and S. Haskins. *European Art in the Victoria and Albert Museum*, London, 1983.

Calkins 1968
Calkins, R. *A Medieval Treasury*, exh. cat., Ithaca, N.Y., Andrew Dickson White Museum of Art, Cornell University, 1968.

Camille 1989
Camille, M. *The Gothic Idol: Ideology and Image-Making in Medieval Art*, Cambridge, England, 1989.

Campbell 1995
Campbell, C. J. "Courting, Harlotry, and the Art of Gothic Ivory Carving," *Gesta* 34, no. 1 (1995): 11–19.

Carra 1966
Carra, M. *Gli avori in occidente*, Milan, 1966.

Carli 1977
Carli, E. *Giovanni Pisano*, Pisa, 1977.

Carter 1780
Carter, J. *Specimens of Ancient Sculpture*, vol. 2, London, 1780.

Cascio and Lévy 1988
Cascio, A., and J. Lévy. "Etude de la polychromie de la Descente de Croix du Louvre," *Revue de l'art* 81 (1988): 45–46.

Casier and Bergmans 1913
Casier, J., and P. Bergmans. *L'art ancien dans les Flandres: Memorial de l'exposition retrospective*, vol. 1, Ghent, 1913.

Cazelles 1966
Cazelles, R. "L'argenterie de Jean le Bon et ses comptes," *Bulletin de la Société nationale des antiquaires de France* (1966): 51–62.

Cazelles 1972
———. *Nouvelle histoire de Paris, de la fin du règne de Philippe Auguste à la mort de Charles V, 1223–1380*, Paris, 1972.

Cheney 1941
Cheney, T. L. "A French Ivory Mirror-Back of the Fourteenth Century," *Bulletin of the Cleveland Museum of Art* 28 (October 1941): 124–25.

Chenu 1968
Chenu, M. D. *Nature, Man, and Society in the Twelfth Century: Essays on New Theological Perspectives in the Latin West*, ed. and trans. J. Taylor and L. K. Little, Chicago, 1968.

Cherry 1991
Cherry, J. "Leather," in *English Medieval Industries: Craftsmen, Techniques, Products*, ed. J. Blair and N. Ramsay, London, 1991.

Chestnut Hill 1995
Memory and the Middle Ages, exh. cat., ed. N. Netzer and V. Reinburg, Chestnut Hill, Mass., Boston College Museum of Art, 1995.

Chronique 1970
La chronique des beaux-arts, supplement to *Gazette des beaux-arts*, no. 1213 (February 1970).

Clément 1909
Clément, J. *La représentation de la Madone à travers les âges*, Paris, 1909.

Cologne 1972–73
Rhein und Maas: Kunst und Kultur, 800–1400, 2 vols., exh. cat. Cologne, Schnütgen Museum, 1972–73.

Cologne 1974
Vor Stefan Lochner: Die Kölner Maler von 1300 bis 1430, exh. cat., Cologne, Wallraf-Richartz Museum, 1974.

Cologne 1975
Fünfhundert Jahre Rosenkranz: 1475 Köln 1975, exh. cat., Cologne, Erzbischöfliches Diözesan-Museum, 1975.

Cologne 1978
Die Parler und der schöne Stil 1350–1400: Europäische Kunst unter den Luxemburgern, 3 vols., Cologne, 1978.

Cologne 1982
Die Heiligen Drei Könige: Darstellung und Verehrung, exh. cat., Cologne, Kunsthalle, 1982.

Cologne 1984
Verschwundenes Inventarium: Der Skulpturenfund im Kölner Domchor, exh. cat., Cologne, Schnütgen Museum, 1984.

Cologne/Paris 1996
Un trésor gothique: La châsse de Nivelles, exh. cat., Cologne, Schnütgen-Museum, and Paris, Musée national du Moyen Age, Thermes de Cluny, 1996.

Coornaert 1936
Coornaert, E. "Notes sur les corporations parisiennes au temps de Saint Louis d'après le `Livre des métiers' d'Etienne Boileau," *Revue historique* 177 (1936): 343–52.

Cott 1939
Cott, P. B. *Siculo-Arabic Ivories*, Princeton, N.J., 1939.

Crapelet 1831
Crapelet, G. A. *Proverbes et dictons populaires avec les dits du mercier et des marchands, et les crieries de Paris, aux XIIIe et XIVe siècles*, Paris, 1831.

Cust 1910
Cust, A. M. *The Ivory Workers of the Middle Ages*, London, 1910.

Cutler 1985
Cutler, A. *The Craft of Ivory: Sources, Techniques, and Uses in the Mediterranean World, A. D. 200–1400*, Byzantine Collection Publications, vol. 8, Washington, D.C., 1985.

Cutler 1987
Cutler, A. "Prolegomena to the Craft of Ivory Carving in Late Antiquity and the Early Middle Ages, " in *Artistes, artisans et production artistique*, vol. 2, ed. X. Barral i Altet, Paris, 1987.

Cutler 1994
———. *The Hand of the Master: Craftsmanship, Ivory, and Society in Byzantium (9th–11th Centuries)*, Princeton, 1994.

Dalton 1909
Dalton, O. M. *Catalogue of the Carvings of the Christian Era with Examples of Mohammedan Art and Carvings in Bone in the Department of British and Mediaeval Antiquities and Ethnology of the British Museum*, Oxford and London, 1909.

Dalton 1912
———. *Fitzwilliam Museum, McClean Bequest. Catalogue of the Medieval Ivories, Enamels, Jewellery…* Cambridge, England, 1912.

Dalton 1926
———. "A Fourteenth-Century English Ivory Triptych," *Burlington Magazine* 68 (1926): 74-83.

Darcel 1878
Darcel, A. "Le moyen âge et la Renaissance au Trocadéro," *Gazette des beaux-arts* 2 (1878): 274–91, 520–75.

Dávid 1982
Dávid, K. *Treasures in Hungarian Ecclesiastic Collections*, Budapest, 1982.

Davis 1929
Davis, C. P. "Fourteenth Century Ivory Diptych," *Bulletin of the City Art Museum of St. Louis* 14, no. 3 (July 1929): 31–32.

Delaporte 1926
Delaporte, Y. *Les vitraux de la cathédrale de Chartres*, Chartres, 1926.

Delhaye, Guineau, and Vezin 1984
Delhaye, M., B. Guineau, and J. Vezin. "Application de la microsonde Raman-Laser à l'étude des pigments," *Courrier du Centre national de la recherche scientifique* (November–December 1984): 23–25.

Demus 1949
Demus, O. *The Mosaics of Norman Sicily*, London, 1949.

Demus et al. 1995
Demus, O., L. Lazzarini, M. Piana, and G. Tigler. *Le sculture esterne di San Marco*, Milan, 1995.

Depping 1837
Depping, G. B., ed. *Réglemens sur les arts et métiers de Paris rédigés au XIIIe siècle, et connus sous le nom du Livre des métiers d'Etienne Boileau*, Paris, 1837.

Deshays 1872
Deshays, N. *Mémoires pour servir à l'histoire des évêques de Lisieux*, 1754, pub. 1763, in vol. 2 of H. de Formeville, *Histoire de l'ancien évêché comte de Lisieux*, 1872, 128–29.

Detroit 1928
Gothic Art, exh. cat., Detroit, The Detroit Institute of Arts, 1928.

Deuchler 1981
Deuchler, F. "Le sens de la lecture: A propos du boustrophédon," in *Etudes d'art médiéval offertes à Louis Grodecki*, ed. S. M. Crosby et al., Paris, 1981.

Devigne 1932
Devigne, M. *La sculpture mosan au XIIe du XVIe siècle*, Brussels, 1932.

Didier 1970
Didier, R. "Contribution à l'étude d'un type de Vierge français du XIVe siècle: A propos d'une réplique de la Vierge de Poissy à Herresbach," *Revue des archéologues et historiens d'art de Louvain* 3 (1970): 49–72.

Didier 1979
———. "A propos de quelques sculptures français en bois du XIIIe siècle," *Revue des archéologues et historiens d'art de Louvain* 12 (1979): 81–103.

Didier 1990
———. "Sculptures, style et faux," in *Festschrift für Peter Bloch*, Mainz, 1990.

Didron 1870–72
Didron, E. "Les images ouvrantes," *Annales archéologiques* 27 (1870–72): 107–9.

Dieckhoff 1981
Dieckhoff, R. "Klappernd Gebein und nagend Gewürm: Memento mori im Schnütgen-Museum," in *Kleine Festschrift zum dreifachen Jubiläum*, Cologne, 1981.

Dieckhoff 1983
———. "`Kölsche Mädcher, jot jelunge…': Madonnen und Heiligenfiguren des 14. Jahrhunderts," *Köln* 4 (1983): 22–25.

Dodwell 1986
Dodwell, C. R., ed. and trans. *De diversis artibus*, by Theophilus, Oxford, 1986.

Doner 1993
Doner, J. R. "The Knight, the Centurian, and the Lance," *Neophilologus* 77 (1993): 19–29.

Dorr 1962
Dorr, G. H. "Marriage Casket of Bone, Wood and Ivory," *Minneapolis Institute of Arts Bulletin* 51 (1962): 20–21.

Douët-d'Arcq 1851
Douët-d'Arcq, L. *Comptes de l'argenterie des rois de France au XIVe siècle*, Paris, 1851.

Douët-d'Arcq 1874
———, ed. *Nouveau recueil de comptes de l'argenterie des rois de France*, Paris, 1874.

Dupin 1990
Dupin, I. M. "La Trinité debout en ivoire de Houston et les Trinités bourguignonnes de Jean de Marville à Jean de la Huerta," *Wiener Jahrbuch* 43 (1990): 35–65.

Du Sommerard 1846
Du Sommerard, A. *Les arts au moyen âge*, vol. 5, Paris, 1846.

Du Sommerard 1883
Du Sommerard, E. *Catalogue et descriptions des objects d'art de l'antiquité, du moyen-âge et de la Renaissance*, Paris, 1883.

Egbert 1929
Egbert, D. D. "North Italian Gothic Ivories in the Museo Cristiano of the Vatican Library," *Art Studies* 7 (1929): 168–207.

Egbert 1974
Egbert, V. W. *On the Bridges of Mediaeval Paris: A Record of Early Fourteenth-Century Life*, Princeton, N.J., 1974.

Eisler 1977–79
Eisler, J. "Zu den Fragen der Beinsättel des Ungarischen Nationalmuseums," parts 1 and 2, *Folia archaeologica* 28 (1977): 189–209; 30 (1979): 205–44.

Enlart 1916
Enlart, C. *Manuel d'archéologie française depuis les temps mérovingiens jusqu'à la Renaissance française*, vol. 3, *Le Costume,* Paris, 1916.

Erbach 1994
Christliche westeuropäische Elfenbeinkunst 13.–18. Jahrhundert aus der Eremitage Sankt Peterburg, exh. cat., Erbach, Deutsches Elfenbeinmuseum, 1994.

Erffa 1954
Erffa, H. M. von. "Chastelaine von Vergi," in *Reallexikon zur deutschen Kunstgeschichte,* vol. 3, Stuttgart, 1954.

Erlande-Brandenburg 1983
Erlande-Brandenburg, A. *L'art gothique,* Paris, 1983.

Erlande-Brandenburg 1987
———. *Le monde gothique: Le conquête de l'Europe, 1260–1380,* Paris, 1987.

Erlande-Brandenburg 1988
———. "Statue d'anges provenant de la priorale Saint-Louis de Poissy," *Monuments et mémoires. Foundation Eugène Piot* 69 (1988): 43–60.

Erlande-Brandenburg 1993
———. *Musée National du Moyen-Age—Thermes de Cluny,* Paris, 1993.

Erlande-Brandenburg and Thibaudat 1982
Erlande-Brandenburg, A., and D. Thibaudat. *Les sculptures de Notre-Dame de Paris au Musée de Cluny,* Paris, 1982.

Estella Marcos 1983
Estella Marcos, M. "Esculturas de marfil medievales en España," *Archivio español de arte* 56 (1983): 89–114.

Estella Marcos 1984
———. *La escultura barroca de marfil en España: Las escuelas europeas y las coloniales,* 2 vols., Madrid, 1984.

Euw 1976–77
Euw, A. von. *Elfenbeinarbeiten von der Spätantike bis zum hohen Mittelalter,* exh. cat., Frankfurt am Main, 1976–77.

Euw 1993
———. "Alexander Schnütgen und der Bildhauer Nikolaus Elscheidt," in *Alexander Schnütgen: Colligite fragmenta ne pereant. Gedenkschrift des Kölner Schnütgen-Museums zum 150. Geburtstag seines Gründers,* Cologne, 1993.

Euw and Plotzek 1982
Euw, A. von, and J. M. Plotzek. *Die Handschriften der Sammlung Ludwig,* 4 vols., Cologne, 1982.

Fabre 1911
Fabre, A. "Les Vierges ouvrantes," *Notre-Dame* 1 (1911): 24–39.

Fagniez 1874
Fagniez, G. "Inventaires du trésor de Notre-Dame de Paris de 1343 et de 1416," *Revue archéologique* 27 (1874): 157–65, 249–59, 389–400; 28 (1874): 83–102.

Fagniez 1877
———. *Etudes sur l'industrie et la classe industrielle à Paris au XIIIe et au XIVe siècle,* Paris, 1877.

Falke 1922
Falke, O. von. "Die Marcy-Fälschungen," *Belvedere* 1 (1922): 8–13.

Farcy 1898
Farcy, L. de. "Epaves," *Revue de l'art chrétien,* 4th ser., no. 9 (1898): 287–92.

Favier 1988
Favier, J. *The World of Chartres,* New York, 1988.

Félibien 1706
Félibien, M. *Histoire de l'abbaye royale de Saint-Denys en France,* Paris, 1706.

Fingerlin 1971
Fingerlin, I. *Gürtel des hohen und späten Mittelalters,* Munich and Berlin, 1971.

Florence 1880
Raphael Dura, auctioneer, Florence, *Catalogue d'objets d'art et de curiosité formant la collection Girolamo Possenti di Fabriano,* sale cat., April 1, 1880.

Florence 1880a
Florence, *Description des ivoires de la ville de Volterra,* sale cat. by J. Sambon, December 2, 1880.

Florence 1987
Scultura dipinta: Maestri di legname e pittori a Siena, 1250–1450, exh. cat., Florence, 1987.

Florence 1989
Arti del medio evo e del Rinascimento: Omaggio ai Carrand, 1889–1989, Florence, Museo Nazionale del Bargello, 1989.

Foley 1995
Foley, E. "The Treasury of Saint-Denis according to the Inventory of 1234," *Revue Bénédictine* 105 (1995): 167–99.

Forrer 1940
Forrer, R. von. "Memento mori—Kleinkunstwerke," *Zeitschrift für Schweizerische Archaeologie und Kunstgeschichte* 2 (1940): 129–33.

Forsyth 1936
Forsyth, W. H. "Mediaeval Statues of the Virgin in Lorraine Related in Type to the Saint-Dié Virgin," *Metropolitan Museum Studies* 5, pt. 2 (1936): 235–58.

Forsyth 1968
———. "A Group of Fourteenth-Century Mosan Sculptures," *Metropolitan Museum Journal* 1 (1968): 41–59.

Forsyth 1972
Forsyth, I. H. *The Throne of Wisdom: Wood Sculptures of the Madonna in Romanesque France,* Princeton, 1972.

Fouquet 1971
Fouquet, D. "Das Elfenbein-kästchen der Sammlung Monheim, Aachen," *Aachener Kunstblätter* 40 (1971): 237–44.

Frankfurt am Main 1936
Hugo Helbing, Frankfurt am Main, *Kunstbesitz eines Berliner Sammlers,* sale cat., June 26, 1936.

Frankfurt am Main 1975
Kunst um 1400 am Mittelrhein: Ein Teil der Wirklichkeit, exh. cat., Frankfurt am Main, Liebieghaus Museum alter Plastik, 1975.

Franks 1861
Franks, A. W. In *Proceedings of the Society of Antiquaries of London,* 2nd ser., 1 (April 18, 1861): 376–77.

Friedmann 1959
Friedmann, A. *Paris, ses rues, ses paroisses du moyen âge à la Révolution,* Paris, 1959.

Frühmorgen-Voss 1975
Frühmorgen-Voss, V. H. *Text und Illustration im Mittelalter,* Munich, 1975.

Gaborit-Chopin 1970
Gaborit-Chopin, D. "Mélanges: Les ivoires gothiques à propos d'un article récent," *Bulletin monumental* 128 (1970): 127–33.

Gaborit-Chopin 1972
———. "La Vierge à l'Enfant d'ivoire de la Sainte-Chapelle," *Bulletin monumental* 130 (1972): 213–24.

Gaborit-Chopin 1973
——. "Faux ivoires des collections publiques," *Revue de l'art* 21 (1973): 94–101.

Gaborit-Chopin 1978
——. *Ivoires du moyen âge*, Fribourg, 1978.

Gaborit-Chopin 1983
——. "Une Vierge d'ivoire du XIIIe siècle," *Revue du Louvre* 33, no. 4 (1983): 270–79.

Gaborit-Chopin 1984
——. "Un Christ en bronze doré du Trecento au Musée du Louvre," *Revue de l'art* 64 (1984): 57–64.

Gaborit-Chopin 1987
——. "Les collections d'orfèvrerie des princes français au milieu du XIVe siècle d'après les comptes et inventaires," in *Art, objets d'art, collections: Etudes sur l'art du moyen age et de la Renaissance sur l'histoire du goût et des collections. Hommage à Hubert Landais*, Paris, 1987.

Gaborit-Chopin 1988
——. "Nicodème travesti: La *Descente de Croix* d'ivoire du Louvre," *Revue de l'art* 81 (1988): 31–44.

Gaborit-Chopin 1988a
——. *Avori medioevali: Museo Nazionale del Bargello*, Florence, 1988.

Gaborit-Chopin 1990
——. *Nouvelles acquisitions du Département des Objets d'art, 1985–89. Musée du Louvre*, Paris, 1990.

Gaborit-Chopin 1990a
——. "Une 'Pitié Nostre Seigneur' d'ivoire," in *Festschrift für Peter Bloch*, ed. H. Krohm and C. Theuerkauff, Mainz, 1990.

Gaborit-Chopin 1990b
——. "Le sculture in avorio del Louvre," *Casa Vogue Antiques*, no. 7 (March 1990): 112–15.

Gaborit-Chopin 1991
——. "La *Vierge à l'enfant* et les *anges* d'ivoire du trésor de Saint-Denis," *Revue du Louvre* 41, no. 4 (1991): 26–27.

Gaborit-Chopin 1994
——. "Orfèvres et émailleurs parisiens au XIVe siècle," in *Les orfèvres français sous l'Ancien Régime. Actes du Colloque, Nantes, 1989*, Cahiers de patrimoine, vol. 39, Paris, 1994.

Gardner 1967
Gardner, J. "The Ivories of the Gambier-Parry Collection," *Burlington Magazine* 109 (1967): 139–44.

Garmier 1980
Garmier, J.-F. "Le goût du moyen âge chez les collectionneurs Lyonnais du XXe siècle," *Revue de l'art* 47 (1980): 53–61.

Gauthier 1983
Gauthier, M.-M. *Les routes de la foi*, Fribourg, 1983.

Gay 1887–1928
Gay, V. *Glossaire archéologique du moyen âge et de la Renaissance*, 2 vols., Paris, 1887–1928. Reprint, Nendeln, Liechtenstein, 1967.

Geisler 1957
Geisler, I. *Oberrheinische Plastik um 1400*, Berlin, 1957.

Gengaro 1960
Gengaro, M. L. "La bottega degli Embriachi," *Arte Lombarda* 5 (1960): 221–28.

Géraud 1837
Géraud, H., ed. *Paris sous Philippe-le-Bel, d'après des documents originaux, et notamment d'après un manuscrit contenant le rôle de la taille imposée sur les habitants de Paris en 1292*, Paris, 1837. Reprint, Tübingen, 1991.

Gerspach 1904
Gerspach, E. "La Collection Carrand au Musée National de Florence, II," *Les arts* 3, no. 32 (1904): 2–32.

Ghent 1913
L'art ancien dans les Flandres, Ghent, 1913.

Gibson 1994
Gibson, M. *The Liverpool Ivories: Late Antique and Medieval Ivory and Bone Carving in Liverpool Museum and the Walker Art Gallery*, London, 1994.

Giraud 1877
Giraud, J. B. *L'exposition rétrospective de Lyon*, Lyons, 1877.

Giusti 1982
Giusti, P. "Una Madonna in avorio nel Museo Duca di Martina: Plastica minore e scultura monumentale nella Francia del XIII secolo," *Bollettino d'arte* 67, no. 14 (1982): 77–86.

Giusti and Leone de Castris 1981
Giusti, P., and P. Leone de Castris. *Medioevo e produzione artistica di serie: Smalti di Limoges e avori gotici in Campania*, exh. cat., Florence, 1981.

Glasgow 1977
Rarer Gifts than Gold: Fourteenth Century Art in Scottish Collections, exh. cat., Glasgow, Burrell Collection Touring Exhibition, 1977.

Goldschmidt 1914–26
Goldschmidt, A. *Die Elfenbeinskulpturen aus der Zeit der karolingischen und sächsischen Kaiser und der romanischen Zeit*, 4 vols., Berlin, 1914–26. Reprint, Berlin, 1969–75.

Goldschmidt 1943
——. "Pseudo-Gothic Spanish Ivory Triptychs of the Nineteenth Century," *Journal of the Walters Art Gallery* 6 (1943): 49–59.

Gottschalk 1983
Gottschalk, J. "Die älteste Bilderhandschrift mit den Quellen zum Leben der hl. Hedwig," *Aachener Kunstblätter* 34 (1983): 61–161.

Grape 1994
Grape, W. *The Bayeux Tapestry: Monument to a Norman Triumph*, trans. D. Britt, Munich and New York, 1994.

Grimme 1982
Grimme, E. G. "Die Schenkung Peter und Irene Ludwig für das Suermondt Museum," *Aachener Kunstblätter* 51 (1982).

Grodecki 1947
Grodecki, L. *Ivoires français*, Paris, 1947. Reprint, Paris, 1982.

Gross 1979
Gross, L. "'La Chastelaine de Vergi' Carved in Ivory," *Viator* 10 (1979): 311–21.

Guerout 1972
Guerout, J. "Fiscalité, topographie et démographie à Paris au moyen âge," *Bibliothèque de l'Ecole des Chartes* 130 (1972): 33–129, 383–465.

Guiffrey 1878
Guiffrey, J. J. "Peintres, ymagiers, verriers, maçons, enlumineurs, écrivains et libraires du XIVe et du XVe siècle," *Nouvelles archives de l'art français* (1878): 157–220.

Guiffrey 1894
Guiffrey, J. *Inventaire de Jean, Duc de Berry (1401–1416)*, 2 vols., Paris, 1894.

Guineau 1996
Guineau, B. "Etudes des couleurs dans la polychromie des ivoires médiévaux," *Bulletin de la Société nationale des Antiquaires de France (séance du 17 avril 1996)*, paper presented at conference, publication forthcoming.

Guineau et al. 1993
Guineau, B., L. Dulin, J. Vezin, and M.-T. Gousset. "Analyse, à l'aide de méthodes spectrophotométriques, des couleurs de deux manuscrits du XVe siècle enluminés par Francesco Antonio del Chierico," in *Ancient and Medieval Book Materials and Techniques*, vol. 2, ed. M. Maniaci and P. F. Munafò, Studi e testi, vol. 358, Vatican City, 1993.

Guldan 1965
Guldan, E. *Eva-Maria*, Cologne, 1965.

Halm and Berliner 1931
Halm, P. M., and R. Berliner. *Das Hallesche Heiltum*, Berlin, 1931.

Hamann 1927
Hamann, R. "Die Salzwedeler Madonna," *Marburger Jahrbuch für Kunstwissenschaft* 3 (1927): 77–144.

Hamann 1955
Hamann, R. *Die Abteikirche von St. Gilles und ihre künstlerische Nachfolge*, Berlin, 1955.

Hamburger 1989
Hamburger, J. "The Use of Images in the Pastoral Care of Nuns: The Case of Heinrich Suso and the Dominicans," *Art Bulletin* 71, no. 1 (1989): 20–46.

Hamburger 1990
——. *The Rothschild Canticles: Art and Mysticism in Flanders and the Rhineland circa 1300*, New Haven, Conn., 1990.

Hartford 1948
Seaver, E. D. *The Life of Christ*, exh. cat., Hartford, Conn., Wadsworth Atheneum, 1948.

Haseloff 1926
Haseloff, G. Review of *Les ivoires français*, by R. Koechlin, *Repertorium für Kunstwissenschaft* 47 (1926): 241.

Hassig 1995
Hassig, D. *Medieval Bestiaries: Text, Image, Ideology*, Cambridge, England, 1995.

Hawthorne and Smith 1976
Hawthorne, J. G., and C. S. Smith, trans. *On Divers Arts: The Treatise of Theophilus*, Chicago, 1963. Reprint, Chicago, 1976.

Henry 1987
Henry, A. *Biblia Pauperum: A Facsimile and Edition*, Ithaca, N.Y., 1987.

Heron 1881
Heron, A. *Oeuvres de Henri d'Andeli*, Paris, 1881.

Heuser 1974
Heuser, H. J. *Oberrheinische Goldschmiedekunst im Hochmittelalter*, Berlin, 1974.

Hildesheim 1991
Schatzkammer auf Zeit: Die Sammlungen des Bischofs Eduard Jakob Wedekin, 1796–1870, Hildesheim, 1991.

Hilger 1990
Hilger, H. P. "Eine spätgotische Statue der hl. Helena aus Utrecht," in *Festschrift für Peter Bloch*, Mainz, 1990.

Hilger and Willemsen 1967
Hilger, H. P., and E. Willemsen. *Farbige Bildwerke des Mittelalters im Rheinland*, Düsseldorf, 1967.

Hoffeld 1971
Hoffeld, J. M. "An Image of St. Louis and the Structuring of Devotion," *Bulletin of the Metropolitan Museum of Art* 29 (1971): 261–66.

Homo 1986
Homo, C. "Un faux instrument médiéval: La harpe en ivoire du Louvre," *Bulletin d'archéologie musicale* 6 (1986): 25–27.

Horton 1987
Horton, M. "The Swahili Corridor," *Scientific American* 257, no. 3 (1987): 86–93.

Horton forthcoming
——. *Shanga: The Archaeology of a Muslim Trading Community on the Coast of East Africa*, Nairobi, forthcoming.

Houston 1945
Catalogue of the Edith A. and Percy S. Straus Collection, Houston, Museum of Fine Arts, Houston, 1945.

Irtenkauf, Kalbach, and Kroos 1969
Irtenkauf, W., K. H. Kalbach, and R. Kroos, *Die Weingartner Liederhandschrift*, vol. 1, *Textband*, Stuttgart, 1969.

James 1902
James, M. R. *A Descriptive Catalogue of the Second Series of Fifty Manuscripts in the Collection of Henry Yates Thompson*, Cambridge, England, 1902.

Jászai 1979
Jászai, G. "Nordfranzösisch oder mittelrheinisch? Zur Elfenbein-Madonna der Kirche des ehemaligen Augustinerinnenklosters in Langenhorst," *Westfalen* 57 (1979): 16–23.

Jolly 1991
Jolly, P. H. "Crosscurrents in the Mid-Trecento: French Medieval Ivories and the Camposanto, Pisa," *Gazette des beaux-arts* 133 (1991): 161–70.

Jones 1992
Jones, M., ed. *Why Fakes Matter*, London, 1992.

Jordan 1979
Jordan, W. C. *Louis IX and the Challenge of the Crusade: A Study in Rulership*, Princeton, N.J., 1979.

Joubert 1994
Joubert, F. *Le Jubé de Bourges*, Les dossiers du Musée du Louvre, vol. 44, Paris, 1994.

Kann 1907
Kann, R. *Catalogue of the Rodolphe Kann Collection: Objets d'art*, vol. 1, Paris, 1907.

Kansas City 1949
The William Rockhill Nelson Collection, Kansas City, Mo., 1949.

Kárdsz 1894
Kárdsz, L. "Elefántcsont-Nyergek A N. Múzeumban," *Archaeologiai Ertesito* 14, no. 1 (1894): 53–59.

Katzenellenbogen 1959
Katzenellenbogen, A. *The Sculptural Programs of Chartres Cathedral*, Baltimore, 1959.

Kautzsch 1925
Kautzsch, R. *Der Mainzer Dom und seine Denkmäler*, vol. 1, Frankfurt am Main, 1925.

Kinney 1994
Kinney, D. "A Late Antique Ivory Plaque and Modern Response," *American Journal of Archaeology* 98 (1994): 457–80.

Kirkmann 1851
Kirkmann, A. C. "On an Ivory Carving of the Thirteenth Century; with Observations on the Prick Spur," *Journal of the British Archaeological Association* 6 (1851): 123–24.

Kirschbaum 1968–76
Kirschbaum, E., ed. *Lexikon der christlichen Ikonographie*, 8 vols., Rome, 1968–76.

Klack-Eitzen 1985
Klack-Eitzen, C. *Die thronenden Madonnen des 13. Jahrhunderts in Westfalen*, Bonn, 1985.

Koch 1958
Koch, R. "An Ivory Diptych from the Waning Middle Ages," *Record of the Art Museum*, Princeton University 17 (1958): 55–64.

Koechlin 1905
Koechlin, R. "Quelques ateliers d'ivoiriers français aux XIIIe et XIVe siècles: L'atelier du diptyque du trésor de Soissons," *Gazette des beaux-arts*, pt. 2 (1905): 361–79.

Koechlin 1905a
——. "Quelques ateliers d'ivoiriers français aux XIIIe et XIVe siècles: L'atelier des tabernacles de la Vierge," *Gazette des beaux-arts*, pt. 2 (1905): 453–71.

Koechlin 1906
——. "Quelques ateliers d'ivoiriers français aux XIIIe et XIVe siècles: L'atelier des diptyques de la Passion," *Gazette des beaux-arts*, pt. 1 (1906): 49–62.

Koechlin 1906a
——. "Les retables français en ivoire du commencement du XIVe siècle," *Monuments et mémoires. Fondation Eugène Piot* 13 (1906): 67–75.

Koechlin 1911
——. "Quelques ivoires gothiques français connus antérieurement au XIXe siècle," *Revue de l'art chrétien* 61 (1911): 281–92, 387–402.

Koechlin 1912
——. *Ivoires gothiques: Collection Emile Baboin*, Lyons, 1912.

Koechlin 1918
——. "Quelques groupes d'ivoires gothiques français: Les diptyques à décor de roses," *Gazette des beaux-arts* 60 (1918): 225–46.

Koechlin 1921
——. "Quelques groupes d'ivoires français: Le dieu d'Amour et le château d'Amour sur les valves de boîtes à miroirs," *Gazette des beaux-arts*, 63, no. 721 (November 1921): 279–97.

Koechlin 1924
——. *Les ivoires gothiques français*, 3 vols., Paris, 1924. Reprint, Paris, 1968.

Koechlin 1924a
——. "Essai de classement chronologique d'après la forme de leur manteau des Vierges du XIVe siècle portant l'Enfant," in *Actes du Congrès d'Histoire d'Art*, 1924.

Koechlin and Marquet de Vasselot 1900
Koechlin, R., and J.-J. Marquet de Vasselot. *La sculpture à Troyes et dans la Champagne méridionale au seizième siècle*, Paris, 1900.

Koekkoek 1987
Koekkoek, R. *Gotische Ivoren in het Catharijneconvent*, Utrecht, 1987.

Kohlhausen 1928
Kohlhausen, H. *Minnekästchen im Mittelalter*, Berlin, 1928.

Kolve 1984
Kolve, V. A. *Chaucer and the Imagery of Narrative*, London, 1984.

Krohm 1971
Krohm, H. "Die Skulptur der Querhausfassaden an der Kathedrale von Rouen," *Aachener Kunstblätter* 40 (1971): 40–153.

Kröner 1899
Kröner, C. *Die Longinus-legende, ihre Entstehung und Ausbreitung in der franzö-sischen Literatur*, Münster, 1899.

Krueger 1990
Krueger, I. "Glasspiegel im Mittelalter: Fakten, Funde und Fragen," *Bonner Jahrbücher* 190 (1990): 233–313.

Kruft 1970
Kruft, H.-W. "Die Madonna von Trapani und ihre Kopien. Studien zur Madonnen-Typologie und zum Begriff der Kopie in der sizilianischen Skulptur des Quattrocento," *Mitteilungen des Kunst-historischen Institutes in Florenz* 14 (1970): 297–322.

Kurmann 1977
Kurmann, P. "La sculpture allemande du XIIIe siècle: A propos des influences français," in *Les sculptures médiévales allemandes dans les collections belges*, exh. cat., Societé général de Banque, Brussels, 1977, lii–lxi.

Kurz 1967
Kurz, O. *Fakes: A Handbook for Collectors and Students*, 2nd and rev. ed., New York, 1967.

Labarte 1879
Labarte, J. *Inventaire du mobilier de Charles V, roi de France*, Collection des documents inédits sur l'histoire de France, 3rd ser., Archéologie, Paris, 1879.

Laborde 1911–27
Laborde, A. de. *Etude sur la Bible Moralisée illustrée conservée à Paris, Oxford, et Londres*, Société Française de Reproductions de Manuscrits à Peinture, Paris, 1911–27.

Lacaze 1979
Lacaze, C. *The "Vie de St. Denis" Manuscript (Paris, Bibliothèque Nationale, Ms. fr. 2090–2092)*, New York, 1979.

Lalou 1992
Lalou, E. "Inventaire des tablettes médiévales et présentation générale," in *Les tablettes à écrire de l'antiquité à l'époque moderne*, Bibliologia, vol. 12, Turnhout, Belgium, 1992.

Lavin 1990
Lavin, M. A. *The Place of Narrative: Mural Decoration in Italian Churches, 431–1600*, Chicago, 1990.

Lawler 1974
Lawler, T. *The Parisiana Poetria of John of Garland*, Yale Studies in English, vol. 182, New Haven, Conn., 1974.

Lawrence 1969
The Waning Middle Ages: An Exhibition of French and Netherlandish Art from 1350-1500, exh. cat., Lawrence, Kansas, University of Kansas Museum of Art, 1969.

Lecler 1888
Lecler, A. "La Vierge ouvrante de Boubon," *Bulletin de la Société archéologique et historique de Limousin* 36 (1888): 204–41.

Leeuwenberg 1969
Leeuwenberg, J. "Early Nineteenth-Century Gothic Ivories," *Aachener Kunstblätter* 39 (1969): 111–48.

Leeuwenberg 1973
———. *Beeldouwkunst in het Rijksmuseum*, Amsterdam, 1973.

Leff 1968
Leff, G. *Paris and Oxford Universities in the 13th and 14th Centuries: An Institutional History*, New York, 1968.

Lehrs 1910
Lehrs, M. *Geschichte und kritischer Katalog des deutschen, niederländischen und französischen Kupferstichs im XV. Jahrhundert*, vol. 2., Vienna, 1910.

Leningrad/Moscow 1980–81
Chefs-d'oeuvre du Louvre, de Cluny et d'Ecouen, exh. cat., Leningrad/Moscow, 1980–81.

Le Roux de Lincy 1867
Le Roux de Lincy, ed. *Paris et ses historiens aux XIVe et XVe siècles*, Paris, 1867.

Lesley 1936
Lesley, P. "Two Triptychs and a Crucifix in the Museo Cristiano of the Vatican Library," *Art Bulletin* 18, no. 4 (1936): 465–79.

Lespinasse 1879
Lespinasse, R. de, and F. Bonnardot, eds. *Les métiers et corporations de la ville de Paris. XIIIe siècle. Le livre des métiers d'Etienne Boileau*, Paris, 1879.

Lespinasse 1886–97
Lespinasse, R. de. *Les métiers et corporations de la ville de Paris*, 3 vols., Paris, 1886–97.

Lewis 1987
Lewis, S. *The Art of Matthew Paris in the "Chronica Majora,"* Berkeley, 1987.

Liebgott 1985
Liebgott, N.-K. *Elfenben fra Danmarks Middelalder*, Copenhagen, 1985.

Liège 1905
Exposition universelle, Liège, 1905.

Liège 1964
La Nativité au Musée Curtius, exh. cat., Liège, 1964.

Liège 1994
Martin de Tours: Du légion-naire au Saint Evêque, exh. cat., Liège, Musée d'Art religieux et d'Art mosan, 1994.

Lightbown 1971
Lightbown, R. W. *Secular Goldsmiths' Work in Medieval France: A History*, London, 1971.

Lind 1873
Lind, K. "Die österreich-ische kunsthistorische Abtheilung auf der Wiener Weltausstellung," *Mittheilungen der K. K. Central-Commission zur Erforschung und Erhaltung der Baudenkmale* 18 (1873): 149–220.

Lisner 1970
Lisner, M. *Holzkruzifixe in Florenz und in der Toskana von der Zeit um 1300 bis zum frühen Cinquecento*, Munich, 1970.

Little 1975
Little, C. T. "An Ivory Tree of Jesse from Bamberg," *Pantheon* 33, no. 4, (1975): 292–300.

Little 1979
———. "Ivoires et art gothique," *Revue de l'art* 46 (1979): 58–67.

Locey 1970
Locey, M. "La Chastelaine de Vergi," *The Register of the Museum of Art* (Lawrence, Kans.) 4, no. 2 (1970): 4–23.

London 1858
Proceedings of the Society of Antiquaries of London, 1st ser., 4 (April 14, 1858): 188–89.

London 1879
Catalogue of Bronzes and Ivories, London, Burlington Fine Arts Club, 1879.

London 1881
Spanish and Portuguese Ornamental Art, exh. cat., London, Victoria and Albert Museum, 1881.

London 1902
Christie, Manson and Woods, London, *Catalogue of the Well-Known Collection of Works of Art of the Classic, Mediaeval, and Renaissance Times, formed by Sir Thomas Gibson Carmichael, Bart. of Castle Craig, N.B.*, sale cat., May 12–13, 1902.

London 1912
Christie, Manson and Woods, London, *Catalogue of the Highly Important Collection of Drawings by J. M. W. Turner, Works by Old Masters and Modern Pictures and Drawings, formed by the Late John Edward Taylor*, sale cat., July 1912.

London 1913
Christie, Manson and Woods, London, Malcolm sale, sale cat., May 1, 1913

London 1923
Catalogue of Carvings in Ivory, exh. cat., London, Burlington Fine Arts Club, 1923.

London 1936
Gothic Art in Europe, exh. cat., London, Burlington Fine Arts Club, 1936.

London 1962
Third International Art Treasures Exhibition, exh. cat., London, Victoria and Albert Museum, 1962

London 1987
Age of Chivalry: Art in Plantagenet England, 1200–1400, exh. cat., ed. J. Alexander and P. Binski, London, Royal Academy of Arts, 1987.

London 1990
Fake? The Art of Deception, exh. cat., London, British Museum, 1990.

Longhurst 1926
Longhurst, M. H. "The Eumorfopoulos Collection: Western Objects—II," *Apollo* 3, no. 17 (May 1926): 260–64.

Longhurst 1926a
———. *English Ivories*, London, 1926.

Longhurst 1927–29
———. *Catalogue of Carvings in Ivory*, 2 vols., London, Victoria and Albert Museum, 1927–29.

Loomis 1917
Loomis, R. S. "The Tristan and Perceval Caskets," *Romantic Review* 8, no. 2 (1917): 41–54.

Loomis 1919
———. "The Allegorical Siege in the Art of the Middle Ages," *American Journal of Archaeology* 23, no. 3 (1919): 255–69.

Loomis 1938
———. *Arthurian Legends in Medieval Art*, London, 1938.

Los Angeles 1970
Treasures from the Cloisters and the Metropolitan Museum of Art, exh. cat., Los Angeles, Los Angeles County Museum of Art, 1970.

Lüdke 1983
Lüdke, D. *Die Statuetten der gotischen Goldschmiede*, vol. 2, Munich, 1983.

Lyons 1877
Exposition rétrospective de Lyon, Lyons, 1877.

MacGregor 1985
MacGregor, A. *Bone, Antler, Ivory and Horn: The Technology of Skeletal Materials since the Roman Period*, London and Totowa, N.J., 1985.

Malbork 1994
Rzemiosło artystyczne zachodniej Europy od XI do XVI wieku: Ze zborów Państwowego Ermitażu w Sankt Peterburgu, exh. cat., Malbork, Muzeum Zamkowe w Malborku, 1994.

Mallé 1969
Mallé, L. *Smalti-avori del Museo d'Arte Antica, Museo Civico di Torino*, Turin, 1969.

Manchester 1857
Art Treasures of the United Kingdom from the Art Treasures Exhibition, exh. cat., Manchester, 1857.

Mann 1931
Mann, J. G. *Wallace Collection Catalogues: Sculptures, Marbles, Terracottas and Bronzes, Carvings in Ivory and Wood, Plaquettes, Medals, Coins and Wax-Reliefs*, London, 1931.

Mann 1992
Mann, J. W. "Medieval Art," *The Saint Louis Art Museum Bulletin*, n.s., 20, no. 3 (winter 1992): 35–38.

Marks and Morgan 1981
Marks, R., and N. Morgan. *The Golden Age of English Manuscript Painting*, New York, 1981.

Marques 1980
Marques, L. C. "Un avorio di Giovanni Pisano," *Antichità viva* 19, no. 5 (1980): 16–22.

Marquet de Vasselot 1903
Marquet de Vasselot, J.-J. "La Collection Arconati-Visconti," *Les arts*, no. 20 (1903): 2–14.

Marquet de Vasselot 1914
———. *Catalogue sommaire de l'orfèvrerie, de l'émaillerie et des gemmes, Musée du Louvre*, Paris, 1914.

Marquet de Vasselot 1914a
———. *Les émaux à fond vermiculé (XIIe et XIIIe siècles)*, Paris, 1914.

Marquet de Vasselot 1941
———. *Les crosses limousines du XIIIe siècle*, Paris, 1941.

Marrow 1979
Marrow, J. *Passion Iconography in Northern European Art of the Late Middle Ages and Early Renaissance: A Study of the Transformation of Sacred Metaphor into Descriptive Narrative*, Ars Neerlandica, vol. 1, Kortrijk, 1979.

Martin 1917
Martin, H. *Saint Martin*, Paris, 1917

Martin 1961
Martin, K. "Zur oberrheinischen Malerei im beginnenden 14. Jahrhundert," in *Eberhard Hanfstaengl zum 75. Geburtstag*, ed. E. Ruhmer, Munich, 1961.

Martini 1993
Martini, L. "Alcune osservazione sulla produzione di confanetti 'embriacheschi' e sulla loro storiografia," in *Oggetti in avorio e osso nel Museo Nazionale di Ravenna. Sec. XV–XIX*, ed. L. Martini, Ravenna, 1993.

Martini 1993a
———, ed. *Oggetti in avorio e osso nel Museo Nazionale di Ravenna. Sec. XV–XIX*, Ravenna, 1993.

Martini and Rizzardi 1990
Martini, L., and C. Rizzardi. *Avori bizantini e medievale nel Museo Nazionale di Ravenna*, Ravenna, 1990.

Maskell 1872
Maskell, W. *A Description of the Ivories Ancient and Mediaeval in the South Kensington Museum*, London, 1872.

Maskell 1905
Maskell, A. *Ivories*, New York and London, 1905.

McNairn 1968
Mcnairn, A. "The Entry of Christ into Jerusalem," *Muse: Annual of the Museum of Art and Archaeology, University of Missouri, Columbia* 2 (1968): 25–32.

Meiss 1974
Meiss, M. *French Painting in the Time of Jean de Berry: The Limbourgs and Their Contemporaries*, vol. 1, New York, 1974.

Meiss and Thomas 1973
Meiss, M., and M. Thomas. *The Rohan Master: A Book of Hours*, New York, 1973.

Merlini 1985
Merlini, E. "Il trittico eburneo della Certosa di Pavia: Iconografia e committenza—Parte I," *Arte cristiana* 73 (1985): 369–84.

Merlini 1986
———. "Il trittico eburneo della Certosa di Pavis: Iconografia e committenza—Parte II," *Arte cristiana* 74 (1986): 139–54.

Merlini 1988
———. "La 'Bottega degli Embriachi' e i cofanetti eburnei fra Trecento e Quattrocento: Una proposta di classificazione," *Arte cristiana* 76 (1988): 267–82.

Merlini 1991
———. "I trittici portatili della `Bottega degli Embriachi,'" *Jahrbuch der Berliner Museen* 33 (1991): 47–62.

Merz forthcoming
Merz, S. *The Secular Production of the Embriachi Workshop: Thirty-Two Secular Panels in the Metropolitan Museum of Art in New York*, Ph.D. dissertation, University of Bonn, forthcoming.

Meurer 1994
Meurer, H. "Maria mit dem Kind," *Jahrbuch der Staatlichen Kunstsammlungen in Baden-Württemberg* 31 (1994): 254–55.

Mexico City 1993
Tesoros medievales del Louvre, exh. cat., Mexico, City, 1993.

Meyrick 1836
Meyrick, S. R. "The Doucean Museum," *Gentleman's Magazine* (April 1836): 380–84.

Michaëlsson 1927
Michaëlsson, K. *Etudes sur les noms de personne français d'après les rôles de taille parisien: Thèse pour le doctorat*, Uppsala, 1927.

Michaëlsson 1951
———, ed. *Le livre de la taille de Paris l'an de grâce 1313*, Göteborg, 1951.

Michaëlsson 1958
———, ed. *Le livre de la taille de Paris l'an 1296*, Göteborg, 1958.

Michaëlsson 1962
———. *Le livre de la taille de Paris l'an 1297*, Göteborg, 1962.

Michel 1906
Michel, A. *Histoire de l'art depuis les premiers temps*, vol. 2, bk. 2, Paris, 1906.

Migeon 1900
Migeon, G., "L'exposition rétrospective de l'art français," *Revue de l'art ancien et moderne* 7 (1900): 369–78, 453–62.

Migeon 1905
———. "La collection de M. G. Chalandon," *Les arts* 4, no. 42 (1905): 17–29.

Migeon 1906
———. "La collection de M. Paul Garnier," *Les arts* 5, no. 53 (1906): 13–24.

Migeon 1909
——. "Collection de M. Ch. Mège," *Les arts* 8, no. 86 (1909): 2–19.

Migieu and Boullemier 1779
Migieu, Marquis de, and C. Boullemier. *Recueil des sceaux du moyen âge dits sceaux gothiques*, Paris, 1779.

Migne 1859
Migne, J. P., ed. *Patrologiae cursus completus ... Series latina*, vol. 184, Paris, 1859.

Milan 1976
Avori gotici francesi, exh. cat., Milan, Museo Poldi-Pezzoli, 1976.

Molinier 1890
Molinier, E. *La collection Spitzer*, vol. 1, Paris, 1890.

Molinier 1892
——. "Un don récent au Musée du Louvre," *L'art* 53 (1892): 182.

Molinier 1896
——. *Catalogue des ivoires du Musée du Louvre*, Paris, 1896.

Molinier 1896a
——. "La Descente de croix," *Monuments et mémoires. Fondation Eugène Piot* 3 (1896): 121–35.

Molinier 1896b
——. *Histoire générale des arts appliqués à l'industrie du Ve àla fin du XVIIIe siècle*, vol. 1, *Ivoires*, Paris, 1896.

Monroe 1978
Monroe, W. H. "An Early Gothic French Ivory of the Virgin and Child," *Museum Studies* (The Art Institute of Chicago) 9 (1978): 6–29.

Montesquiou-Fezensac 1956
Montesquiou-Fezensac, B., "Le reliquaire de Saint Romain," *Les monuments historiques de France*, no. 2 (April–June 1956): 137–141.

Montesquiou-Fezensac and Gaborit-Chopin 1973-76
Montesquiou-Fezensac, B., and D. Gaborit-Chopin. *Le trésor de Saint-Denis*, 3 vols., Paris, 1973–76.

Montfaucon 1729–33
Montfaucon, B. *Les monumens de la monarchie françoise*, Paris, 1729–33.

Morand 1991
Morand, K. *Claus Sluter: Artist at the Court of Burgundy*, Austin, Tex., and London, 1991.

Morey 1936
Morey, C. R. *Gli oggetti di avorio e di osso del Museo Sacro Vaticano*, Vatican City, 1936.

Morey 1936a
——. "A Group of Gothic Ivories in the Walters Art Gallery, " *Art Bulletin* 18, no. 2 (1936): 199–212.

Morey 1939
——. "Italian Gothic Ivories," in *Medieval Studies in Memory ot A. Kingsley Porter*, ed. W. Koehler, vol. 1, Cambridge, Mass., 1939.

Mortari 1960
Mortari, L. "Un avorio gotico francese nel Lazio," *Bollettino d'arte* 45 (1960): 313–19.

Moskowitz 1986
Moskowitz, A. F. *The Sculpture of Andrea and Nino Pisano*, Cambridge, England, 1986.

Müller 1975
Müller, T. "Ein früher gotischer Prunkdolch," *Pantheon* 33 (1975): 203–7.

Müller and Steingräber 1954
Müller, T., and E. Steingräber. "Die französische Goldemailplastik um 1400," *Münchner Jahrbuch der bildenden Kunst*, 3rd. ser., 5 (1954): 29–79.

Munich 1995
Das goldene Rössl: Ein Meisterwerk der Pariser Hofkunst um 1400, exh. cat., Munich, Bayerisches Nationalmuseum, 1995.

Natanson 1951
Natanson, J. *Gothic Ivories from the XIIIth and XIVth Centuries*, London, 1951.

Nepi Sciré and Valcanover 1985
Nepi Sciré, G., and F. Valcanover. *Accademia Galleries of Venice*, Milan, 1985.

New Brunswick 1989
St. Clair, A., and E. P. McLachlan. *The Carver's Art: Medieval Sculpture in Ivory, Bone, and Horn*, exh. cat., New Brunswick, N.J., Jane Voorheis Zimmerli Art Museum, Rutgers, the State University of New Jersey, 1989.

New York 1929
Anderson Galleries, New York, *Medieval and Renaissance Art: Paintings, Sculpture, Armor... Collection of Frédéric Spitzer*, sale cat., January 9–12, 1929.

New York 1943
Masterpieces in the Collection of G. Blumenthal: A Special Exhibition, exh. cat., New York, The Metropolitan Museum of Art, 1943.

New York 1949
Parke-Bernet Galleries, New York, *Part II of the Notable Art Collection Belonging to the Estate of the Late Joseph Brummer...*, sale cat., May 11 14, 1949.

New York 1970
The Year 1200, exh. cat., New York, The Metropolitan Museum of Art, 1970.

New York 1972
Parke-Bernet Galleries, New York, *Medieval, Renaissance and Later Tapestries, Works of Art, and Furniture, Property of the Albany Institute of Art, Cranbrook Academy of Art, and Other Sources*, sale cat., March 25, 1972.

New York 1975
The Secular Spirit: Life and Art at the End of the Middle Ages, exh. cat., New York, The Metropolitan Museum of Art, 1975.

New York 1979
Notable Acquisitions, 1975–1979, New York, The Metropolitan Museum of Art, 1979.

New York 1982
The Vatican Collections: The Papacy and Art, exh. cat. New York, The Metropolitan Museum of Art, 1982.

New York 1990
Medieval Masterworks, 1200–1520, exh. cat., New York, Blumka II Gallery, 1990.

New York 1995
Sotheby's, New York, *European Works of Art: Arms and Armor, Furniture and Tapestries*, sale cat., May 31, 1995.

Oakley 1979
Oakley, F. *The Western Church in the Later Middle Ages*, Ithaca, N.Y., 1979.

Os 1994
Os, H. van. *The Art of Devotion in the Late Middle Ages in Europe, 1300-1500*, exh. cat., trans. M. Hoyle, Princeton, 1994.

Ott 1982–83
Ott, N. "Geglüchte Minne-Aventure," in *Jahrbuch der Oswald von Wolkenstein Gesellschaft*, vol. 2, 1982–83.

Ottawa 1972
Art and the Courts: France and England from 1259 to 1328, exh. cat., 2 vols. Ottawa, National Gallery of Canada, 1972.

Pächt 1987
Pächt, O. "Der Salvator Mundi des Turiner Stundenbuches," in *Florilegium in honorem Carl Nordenfalk octogenarii contextum*, Stockholm, 1987.

Panofsky 1979
Panofsky, E., ed. and trans. *Abbot Suger on the Abbey Church of St.-Denis and Its Art Treasures*, 2nd ed. by G. Panofsky Soergel, Princeton, N.J., 1979.

Paris 1889
Exposition rétrospective de l'art français au Trocadéro, Paris, 1889.

Paris 1893
P. Chevallier, commissaire-priseur, Paris, *Catalogue des objets d'art et de haute curiosité: Antiques du moyen-âge et de la Renaissance, composant l'importante et précieuse Collection Spitzer*, sale cat., vol. 1, April 17-June 16, 1893.

Paris 1900
Exposition rétrospective de l'art français des origines à 1800, Paris, Petit Palais, 1900.

Paris 1921
Galerie Georges Petit, Paris, Lebreton sale, sale cat., December 6, 1921.

Paris 1931
Galerie Georges Petit, Paris, *Catalogue des tableaux anciens, objets d'art et de haute curiosité européens et orientaux, objets d'Extrême-Orient, meubles et sieges, sculptures et bronzes du XVIIIe siècle, composant la collection de Octave Homberg*, sale cat., June 4–5, 1931.

Paris 1950
La Vierge dans l'art gothique, exh. cat., Paris, 1950.

Paris 1961
Charité de Saint Martin, exh. cat., Paris, 1961.

Paris 1965
Trésors des églises de France, exh. cat., Paris, Musée des arts décoratifs, 1965.

Paris 1968
L'Europe gothique XIIe-XIVe siècles, exh. cat., Paris, Musée du Louvre, 1968.

Paris 1981
Les fastes du gothique: Le siècle de Charles V, exh. cat., Paris, Galeries nationales du Grand Palais, 1981.

Paris 1989
Les donateurs du Louvre, exh. cat., Paris, Musée du Louvre, 1989.

Paris 1991
Le trésor de Saint-Denis, exh. cat., Paris, Musée du Louvre, 1991.

Paris 1993
Dictionnaire de biographie française, vol. 107, Paris, 1993.

Parker and Little 1994
Parker, E., and C. T. Little. *The Cloisters Cross: Its Art and Meaning*, New York, 1994.

Peebles 1911
Peebles, R. J. *The Legend of Longinus in Ecclesiastical Tradition and in English Literature, and Its Connection with the Grail*, Bryn Mawr College Monographs, vol. 9, Baltimore, 1911.

Pératé 1911
Pératé, A. *Collections Georges Hoentschel*, Paris, 1911.

Pesci 1918
Pesci, U. *I vescovi di Gubbio*, Perugia, 1918.

Plummer 1982
Plummer, J. *The Last Flowering: French Painting in Manuscripts, 1420–1530, from American Collections*, exh. cat., New York, Pierpont Morgan Library, 1982.

Poirion 1994
Poirion, D., ed. *Chrétien de Troyes: Oeuvres complètes*, Paris, 1994.

Polacco and Traversari 1988
Polacco R., and G. Traversari. *Sculture romane e avori tardo-antichi e medievali del Museo Archeologico di Venezia*, Rome, 1988.

Pope-Hennessy 1965
Pope-Hennessy, J. "An Ivory by Giovanni Pisano," *Victoria and Albert Museum Bulletin* 1, no. 3 (1965): 9–16.

Pope-Hennessy 1986
———. *Italian Gothic Sculpture*, 3rd ed., Oxford, 1986.

Porter 1977
Porter, D. A. *Ivory Carving in Later Medieval England, 1200–1400*, Ann Arbor, Mich.: University Microfilms, 1977.

Prost 1902
Prost, B. *Inventaires mobiliers et extraits des comptes des Ducs de Bourgogne de la Maison de Valois (1363–1477)*, vol. 1, Paris, 1902.

Providence 1974
Europe in Torment: 1450–1550, exh. cat., Providence, R.I., Museum of Art, Rhode Island School of Design, 1974.

Providence 1977
Transformations of the Court Style: Gothic Art in Europe, 1270 to 1330, exh. cat., Providence, R.I., Museum of Art, Rhode Island School of Design, 1977.

Quednau 1979
Quednau, U. *Die Westportale der Kathedrale von Auxerre*, Wiesbaden, 1979.

Randall 1966
Randall, R. H., Jr. "The Medieval Artist and Industrialized Arts," *Apollo* 84, no. 58 (December 1966): 434–41.

Randall 1969
———. "A Passion Diptych," *Bulletin of the Walters Art Gallery* 21, no. 7 (1969): 1–2.

Randall 1969a
———. *Medieval Ivories*, Baltimore, 1969.

Randall 1974
———. "A Fourteenth-Century Altar-Frontal," *Apollo* 100, no. 153 (November 1974): 368–71.

Randall 1974a
———. "A Monumental Ivory," in *Gatherings in Honor of Dorothy Miner*, Baltimore, 1974.

Randall 1980
———. "A Parisian Ivory Carver," *Journal of the Walters Art Gallery* 38 (1980): 60–69.

Randall 1981
———. "Jan van Eyck and the St. George Ivories," *Journal of the Walters Art Gallery* 39 (1981): 39–48.

Randall 1983
———. "New Scholarship on Ivories," *Apollo* 118, no. 260 (October 1983): 292–95.

Randall 1983-86
———. "An Ivory Diptych," *Minneapolis Institute of Arts Bulletin* 5, no. 66 (1983–86): 2–17.

Randall 1985
———. *Masterpieces of Ivory from the Walters Art Gallery*, New York, 1985.

Randall 1988
———. "The Ivory Virgin of St-Denis," *Apollo* 128, no. 322 (December 1988): 394–98.

Randall 1989
———. "Medieval Ivories in the Romance Tradition," *Gesta* 28 (1989): 30–40.

Randall 1993
———. *The Golden Age of Ivory: Gothic Carvings in North American Collections*, New York, 1993.

Randall 1994
———. "Dutch Ivories of the Fifteenth Century," in *Beelden in de late Middeleeuwen en Renaissance* (Late Gothic and Renaissance Sculpture in the Netherlands), ed. R. Falkenburg et al., Nederlands Kunsthistorisch Jaarboek (Netherlands Yearbook for History of Art), vol. 45, Zwolle, 1994.

Randall 1995
———. "The Saint-Denis Virgin," in *The Taft Museum: Its History and Collections*, 2 vols., ed. E. J. Sullivan, New York, 1995.

Rapp 1976
Rapp, A. *Der Jungbrunnen in Literatur und bildender Kunst des Mittelalters*, Zurich, 1976.

Rasmussen 1977
Rasmussen, J. "Untersuchungen zum Halleschen Heiltum des Kardinals Albrecht von Brandenburg, II," *Münchner Jahrbuch der bildenden Kunst*, 3rd ser., 28 (1977): 91–132.

Ratkowska 1974
Ratkowska, P. "Le feuillet de diptyque à décor de roses au Musée national de Varsovie," *Bulletin du Musée national de Varsovie* 15 (1974): 21–27.

Read 1902
Read, C. H. In *Proceedings of the Society of Antiquaries of London*, 2nd ser., 19 (January 30, 1902): 44.

Ricci 1913
Ricci, S. de. *Album, Palais Sagan*, Paris, 1913.

Richard 1887
Richard, J.-M. *Une Petite-nièce de Saint Louis: Mahaut, comtesse d'Artois et de Bourgogne (1302–1329)*, Paris, 1887.

Richard 1890
———. "Documents des XIIIe et XIVe siècles relatifs à l'hôtel de Bourgogne (ancien hôtel d'Artois) tirés du trésor des chartes d'Artois," *Bulletin de la Société de l'histoire de Paris et de l'Ile-de-France* 17 (1890): 137–47.

Richie 1975
Richie, C. *Bone and Horn Carving*, New York, 1975.

Riefstahl 1964
Riefstahl, R. M. "Medieval Art," *Toledo Museum News*, n.s., 7, no. 1 (1964): 3–22.

Ritter von Wolfskron 1846
Ritter von Wolfskron, A. *Die Bilder der Hedwigs Legende*, Leipzig, 1846.

Roach 1971
Roach, W., ed. *The Continuations of the Old French Perceval of Chrétien de Troyes*, vol. 4, Philadelphia, 1971.

Robinson 1941
Robinson, F. W. "A French Gothic Ivory Diptych," *Bulletin of the Detroit Institute of Arts* 20, no. 8 (May 1941): 74–77.

Robinson 1943
———. "Notes on a French Gothic Writing Tablet," *Bulletin of the Detroit Institute of Arts* 22, no. 8 (May 1943): 84–87.

Rochester 1929
"A Loan Exhibition of Gothic Art," *The Bulletin of the Memorial Art Gallery* (Rochester, N.Y.) 2, no. 2 (1929): 2–10.

Roger 1968
Roger, J.-M. "La prévôté de Paris de sa réforme sous Saint Louis à la suppression de la prévôté des marchands (vers 1262-1383)," *Ecole nationale des Chartes. Positions des thèses* (1968): 167–74.

Rohde 1921–22
Rohde, A. "Ein Dolchmesser des 14. Jahrhunderts im Hamburgischen Museum für Kunst und Gewerbe," *Zeitschrift für historische Waffen- und Kostümkunde* 9 (1921–22): 156.

Rorimer 1931
Rorimer, J. J. *Ultra-Violet Rays and Their Use in the Examination of Works of Art*, New York, 1931.

Rose-Troup 1928
Rose-Troup, F. "Bishop Grandisson: Student and Art Lover," *Transactions of the Devonshire Association* 61 (1928): 239–75.

Rosen 1952–53
Rosen, D. "Photomacrographs as Aid in the Study of Decorative Arts," *Journal of the Walters Art Gallery*, 15–16 (1952–53): 83–87.

Ross 1939
Ross, M. "A Gothic Mirror Case," *Journal of the Walters Art Gallery* 2 (1939): 109–11.

Rouen 1932
Exposition d'art réligieux ancien, exh. cat., Rouen, Musée de Peinture, 1932.

Rouse and Rouse 1990
Rouse, R. H., and M. A. Rouse. "The Commercial Production of Manuscript Books in Late-Thirteenth-Century and Early-Fourteenth-Century Paris," in *Medieval Book Production: Assessing the Evidence*, ed. L. L. Brownrigg, Los Altos Hills, Calif., 1990.

Rubinstein-Bloch 1926-30
Rubinstein-Bloch, S. *Catalogue of the Collection of George and Florence Blumenthal*, 6 vols., New York, 1926–30.

Ryan 1993
Ryan, W. G., trans. *The Golden Legend: Readings on the Saints*, by Jacobus de Voragine, 2 vols., Princeton, N. J., 1993.

Ryan and Ripperger 1941
Ryan, G., and H. Ripperger, trans. *The Golden Legend of Jacobus de Voragine*, 2 vols., London and New York, 1941.

Saint Louis 1991
The Saint Louis Art Museum, Handbook of the Collections, Saint Louis, 1991.

Saint Petersburg 1990
Medieval Art from Late Antique through Late Gothic from the Metropolitan Museum of Art and the Art Institute, Chicago, exh. cat., Saint Petersburg, State Hermitage Museum, 1990.

Sandler 1974
Sandler, L. F. *The Peterborough Psalter in Brussels and Other Fenland Manuscripts*, London, 1974.

Sandler 1986
———. *Gothic Manuscripts, 1285–1385*, 2 vols., A Survey of Manuscripts Illuminated in the British Isles, vol. 5, Oxford, 1986.

Sandron, Cascio, and Lévy 1993
Sandron, D., A. Cascio, and J. Lévy. "La sculpture en ivoire au début du XIIIe siècle, d'un monde à l'autre," *Revue de l'art* 102 (1993): 48–59.

Sarrète 1913
Sarrète, J. *Vierges ouvertes, Vierges ouvrantes, et la Vierge ouvrante de Palau-del-Vidre*, Lézignan-Corbières, France, 1913.

Sauerländer 1970
Sauerländer, W. *Gotische Skulptur in Frankreich, 1140–1270*, Munich, 1970.

Sauerländer 1971
———. Review of *The Year 1200* (New York, 1970), *Art Bulletin* 53, no. 4 (December 1971): 505–16.

Sauerländer 1972
———. *Gothic Sculpture in France, 1140–1270*, London, 1972.

Sauerländer 1972a
———. *La Sculpture gothique en France, 1140–1270*, Paris, 1972.

Sauerländer 1988
———. "Medieval Paris, Center of European Taste. Fame and Realities," in *Paris: Center of Artistic Enlightenment*, ed. G. Mauner et al., Papers in Art History from the Pennsylvania State University, vol. 4, University Park, 1988.

Sauerländer 1988a
———. Review of *The Age of Chivalry* (London, 1987), *Burlington Magazine* 130, no. 1019 (February 1988): 149–51.

Sauerländer 1989
———. *Le monde gothique: Le siècle des cathédrales, 1140–1260*, Paris, 1989.

Schapiro 1969
Schapiro, M. "On Some Problems in the Semiotics of Visual Art: Field and Vehicle in Image-Signs," *Semiotica* 1, no. 3 (1969): 223–42. Reprinted in *Theory and Philosophy of Art: Style, Artist, and Society*, by M. Schapiro, New York, 1994.

Schlosser 1894
Schlosser, J. von. "Elfenbeinsättel des ausgehenden Mittelalters," *Jahrbuch der kunsthistorischen Sammlungen des allerhöchsten Kaiserhauses* 15 (1894): 260–94.

Schlosser 1899
———. "Die Werkstatt der Embriachi in Venedig," *Jahrbuch der kunsthistorischen Sammlungen der allerhöchsten Kaiserhauses* 20 (1899): 220–82.

Schmidt 1981
Schmidt, G. "Zu einigen Stifterdarstellungen des 14. Jahrhunderts in Frankreich," *Etudes d'art médiéval offertes à Louis Grodecki*, Paris, 1981.

Schnitzler, Volbach, and Bloch 1964
Schnitzler, H., F. Volbach, and P. Bloch. *Sammlung E. und M. Kofler-Truniger, Luzern*, vol. 1, *Skulpturen—Elfenbein, Perlmutter, Stein, Holz—Europäisches Mittelalter*, Stuttgart, 1964.

Schnitzler et al. 1965
———. *Mittelalterliche Elfenbein- und Emailkunst aus der Sammlung E. und M. Kofler-Truniger, Luzern*, Düsseldorf, 1965.

Schnütgen 1890
Schnütgen, A. "Elfenbein Triptychon des XIV. Jahrhunderts im Privatbesitz zu Köln," *Zeitschrift für christliche Kunst* (1890): 233–36.

Schulten 1978
Schulten, W. *Kostbarkeiten in Köln: Erzbischöfliches Diözesan- Museum*, Cologne, 1978.

Schultz 1889
Schultz, A. *Das höfische Leben zur Zeit der Minnesinger*, vol. 1, Leipzig, 1889.

Schwarz 1986
Schwarz, M. V. *Höfische Skulptur im 14. Jahrhundert: Entwicklungsphasen und Vermittlungswege im Vorfeld des Weichen Stils*, Worms, 1986.

Seidel 1972
Seidel, M. "Die Elfenbeinmadonna im Domschatz zu Pisa. Studien zur Herkunft und Umbildung französischer Formen im Werk Giovanni Pisanos in der Epoche der Pistoieser Kanzel," *Mitteilungen des Kunsthistorischen Institutes in Florenz* 16 (1972): 1–50.

Seidel 1984
———. "'Opus heburneum': Die Entdeckung einer Elfenbeinskulptur von Giovanni Pisano," *Pantheon* 42 (1984): 219–29.

Seidel 1994
———. "Hochzeitsikonographie im Trecento," *Mitteilungen des Kunsthistorischen Institutes in Florenz* 38 (1994): 1–47.

Shaw 1963
Shaw, M. R. B., trans. *Joinville & Villehardouin: Chronicles of the Crusades*, Harmondsworth, England, 1963.

Skinner 1904
Skinner, A. B. *Catalogue W. F. Cook Collection*, vol. 1, *Carvings in Ivory and Bone*, London, 1904.

Smith 1968
Smith, G. "Reflections of a Pattern Print by Master E.S.—Passion Cycles in Mother-of-Pearl," *Pantheon* 26 (1968): 430–39.

Spitzer 1890–92
Spitzer, F. *La Collection Spitzer: Antiquité, moyen-âge, Renaissance*, vol. 1, 1890–92.

Stafski 1965
Stafski, H. *Die Bildwerke in Stein, Holz, Ton und Elfenbein bis um 1450*, Die mittelalterlichen Bildwerke, vol. 1, Nuremberg, 1965

Steinberg 1983
Steinberg, L. *The Sexuality of Christ in Renaissance Art and Modern Oblivion*, New York, 1983.

Steingräber 1973
Steingräber, E. "Ein hochgotisches Elfenbeinkruzifix," in *Festschrift Klaus Lankheit*, Cologne, 1973.

Sterling 1987
Sterling, C. *La peinture médiévale à Paris, 1300–1500*, Paris, 1987.

Stewart 1993
Stewart, S. *On Longing: Narratives of the Miniature, the Gigantic, the Souvenir, the Collection*, Durham and London, 1993.

Steyaert 1994
Steyaert, J. W. *Late Gothic Sculpture: The Burgundian Netherlands*, exh. cat., Ghent, Museum voor Schone Kunsten, 1994.

Stone 1972
Stone, L. *Sculpture in Britain: The Middle Ages*, 2nd ed., Pelican History of Art, Harmondsworth, 1972.

Stones 1990
Stones, M. A. In *Wace. La Vie de Sainte Marguerite*, ed. H.-E. Keller, Tübingen, 1990.

Stratford 1983
Stratford, N. "Glastonbury and Two Gothic Ivories in the United States," *Studies in Medieval Sculpture*, ed. F. H. Thompson, Society of Antiquaries of London, Occasional Papers, n.s., vol. 3, London, 1983.

Stratford 1987
——. "Gothic Ivory Carving in England," in *Age of Chivalry: Art in Plantagenet England, 1200-1400*, London, 1987.

Stratford 1991
——. "Bishop Grandisson and the Visual Arts," in *Exeter Cathedral: A Celebration*, ed. M. Swanton, Exeter, 1991.

Strauch 1882
Strauch, P., ed. *Margaretha Ebner und Heinrich von Nördlingen: Ein Beitrag zur Geschichte der deutschen Mystik*, Freiburg im Breisgau, 1882.

Suckale 1971
Suckale, R. *Studien zu Stilbildung und Stilwandel der Madonnenstatuen der Ile-de-France zwischen 1230 und 1300*, Ph.D. dissertation, Universität München, 1971.

Suckale 1979–80
——. "Die Kölner Domchorstatuen. Die Kölner und Pariser Skulptur in der zweiten Hälfte des 13. Jahrhunderts," *Kölner Domblatt* 44-45 (1979–80): 223–54.

Swarzenski 1954
Swarzenski, H. *Monuments of Romanesque Art: The Art of Church Treasures in Northwestern Europe*, Chicago and London, 1954.

Taburet-Delahaye 1980
Taburet-Delahaye, E. *Les ivoires du Musée de Cluny*, Petits guides des grands musées, Paris, 1980.

Tardy 1966
Tardy. *Les ivoires: Evolution décorative du 1er siècle à nos jours*, Paris, 1966.

Texier 1857
Texier, J. R. *Dictionnaire d'orfevrerie, de gravure et de ciselure chrétienne*, Paris, 1857.

Toledo 1995
Toledo Treasures: Selections from the Toledo Museum of Art, Toledo, 1995.

Török 1985
Török, G. von. "Beiträge zur Verbreitung einer niederländischen Dreifaltigkeitsdarstellung im fünfzehnten Jahrhundert," *Jahrbuch der Kunsthistorischen Sammlungen in Wien* 81 (1985): 7–31.

Turner 1846
Turner, T. H. "The Will of Humphrey de Bohun, Earl of Hereford and Essex, with Extracts from the Inventory of His Effects, 1319-1322," *The Archaeological Journal* 2 (1846).

Utrecht 1987
Gotische Ivoren, exh. cat., Utrecht, Rijksmuseum het Catharijneconvent, 1987.

Verdier 1963
Verdier, P. "Les ivoires de la Walters Art Gallery," *Art international* 7, no. 4 (1963): 28–36.

Verdier 1975
——. "La Trinité debout de Champmol," in *Etudes d'art français offertes à Charles Sterling*, Paris, 1975.

Verdier 1980
——. *Le couronnement de la Vierge: Les origines et les premiers développements d'un thème iconographique*, Montreal, 1980.

Verdier 1982
——. "Le triptyque d'ivoire à volets peints au Musée des Beaux-Arts de Lyon," *Bulletin des Musées et monuments Lyonnais* 7, no. 2 (1982): 17–30.

Verlet 1947
Verlet, P. "Le prophète d'ivoire de Robert de Rothschild," *Bulletin des Musées de France* 12, no. 4 (1947): 8–10.

Verneilh 1898
Verneilh, Baron de. "La Vierge ouvrante de Boubon: Découverte de la seconde partie," *Bulletin de la Société archéologique et historique du Limousin*, Limoges 46 (1898).

Vich 1893
Catalogo, Museo arqueólogico artistico episcopal, Vich, 1893.

Vienna 1962
Europäische Kunst um 1400, exh. cat., Vienna, Kunsthistorisches Museum, 1962.

Vloberg 1963
Vloberg, M. "Vierges ouvrantes: Sanctuaires et pèlerinages," *Bulletin du Centre national de la recherche scientifique* 30 (1963).

Volbach 1917
Volbach, W. F. *Der heilige Georg: Bildliche Darstellung in Süddeutschland mit Berücksichtigung der norddeutschen Typen bis zur Renaissance*, Studien zur Deutschen Kunstgeschichte, no. 199, Strasbourg, 1917.

Volbach 1923
Volbach, W. F. *Die Elfenbeinbildwerke: Die Bildwerke des deutschen Museums*, vol. 1, Berlin and Leipzig, 1923.

Wainwright 1994
Wainwright, C. "The Antiquary and Collector," in *Pugin: A Gothic Passion*, New Haven, Conn., and London, 1994.

Wailly 1874
Wailly, N. de. *Histoire de Saint Louis*, by Jean de Joinville, Paris, 1874.

Walsh 1984
Walsh, D. A. "Notes on the Iconography of a Fourteenth-Century Ivory," *Porticus: The Journal of the Memorial Art Gallery of the University of Rochester* 7 (1984): 1–7.

Walsh 1984a
——. "A Late Medieval Sculpture of the Annunciation," *Porticus: The Journal of the Memorial Art Gallery of the University of Rochester* 7 (1984): 8–16.

Walther 1988
Walther, I. *Codex Manesse: Die Miniaturen der grossen Heidelberger Liederhandschrift*, Frankfurt am Main, 1988.

Washington 1993
Western Decorative Arts, part 1, *Medieval, Renaissance, and Historicizing Styles, including Metalwork, Enamels, and Ceramics*, Washington, D. C., The National Gallery of Art, 1993.

Watts 1924
Watts, W. W. *Catalogue of Pastoral Staves, Victoria and Albert Museum*, London, 1924.

Weitzmann-Fiedler 1956–57
Weitzmann-Fiedler, J. "Romanische Bronzeschalen mit mythologischen Darstellungen: Ihre Beziehungen zur mittelalterlichen Schulliteratur und ihre Zwecksbestimmung," parts 1 and 2, *Zeitschrift für Kunstwissenschaft* 10 (1956): 109–52; 11 (1957): 1–34.

Weitzmann-Fiedler 1966
——. "Zur Illustration der Margaretenlegende," *Münchner Jahrbuch der bildenden Kunst*, 3rd ser., 17 (1966): 17–48.

Wentzel 1962
Wentzel, H. "Ein Elfenbein-büchlein zur Passionsandacht," *Wallraf-Richartz-Jahrbuch* 24 (1962): 193–212.

Westwood 1876
Westwood, J. O. *A Descriptive Catalogue of the Fictile Ivories in the South Kensington Museum*, London, 1876.

Wieck 1988
Wieck, R. S. *Time Sanctified: The Book of Hours in Medieval Art and Life*, exh. cat., New York, 1988.

Williamson 1938
Williamson, G. C. *The Book of Ivory*, London, 1938.

Williamson 1982
Williamson, P. *An Introduction to Medieval Ivory Carvings*, London, 1982.

Williamson 1987
——. *The Thyssen-Bornemisza Collection: Medieval Sculpture and Works of Art*, London, 1987.

Williamson 1988
——. *Northern Gothic Sculpture, 1200–1450*, London, Victoria and Albert Museum, 1988.

Williamson 1988a
——. "The Polychrome Decoration of the Salting Diptych and Other Gothic Ivories," paper presented at the Academic Symposium, London, February 1988, in conjunction with the exhibition "The Age of Chivalry."

Williamson 1990
——. "An English Ivory Tabernacle Wing of the Thirteenth Century," *Burlington Magazine* 132, no. 1053 (December 1990): 863–66.

Williamson 1994
——. "Avori italiani e avori francesi" in *Il gotico europeo in Italia*, ed. V. Pace and M. Bagnoli, Naples, 1994.

Williamson 1994a
——. "Ivory Carvings in English Treasuries before the Reformation," in *Studies in Medieval Art and Architecture Presented to Peter Lasko*, eds. D. Buckton and T. A. Heslop, Dover, N.H., and London, 1994.

Williamson 1995
——. *Gothic Sculpture, 1140-1300*, Pelican History of Art, New Haven, Conn., 1995.

Williamson 1996
——, ed. *The Medieval Treasury: The Art of the Middle Ages in the Victoria and Albert Museum*, 2nd ed., London, 1996.

Williamson 1996a
——, ed. *European Sculpture at the Victoria and Albert Museum*, London, 1996.

Williamson and Webster 1990
Williamson, P., and L. Webster. "The Coloured Decoration of Anglo-Saxon Ivory Carvings," in *Early Medieval Wall Painting and Painted Sculpture in England*, ed. S. Cather, D. Park, and P. Williamson, London, 1990.

Wilm 1937
Wilm, H. *Die Sammlung Georg Schuster*, Munich, 1937.

Wixom 1967
Wixom, W. D. *Treasures from Medieval France*, exh. cat., Cleveland, The Cleveland Museum of Art, 1967.

Wixom 1972
——. "Twelve Additions to the Medieval Treasury," *Bulletin of the Cleveland Museum of Art* 59 (April 1972): 87–111.

Wixom 1979
——. "Romance Casket," in "Eleven Additions to the Medieval Collection," *Bulletin of the Cleveland Museum of Art* 66 (March and April 1979): 110–26.

Wixom 1980
——. "Virgin and Child," in *Notable Acquisitions, 1979–80*, New York, The Metropolitan Museum of Art, 1980.

Wixom 1987
——. "A Late Thirteenth-Century English Ivory Virgin," *Zeitschrift für Kunstgeschichte* 50 (1987): 337–58.

Wolters 1976
Wolters, W. *La scultura veneziana gotica (1300–1460)*, 2 vols., Venice, 1976.

Wright 1989
Wright, C. M. *Music and Ceremony at Notre-Dame of Paris, 500–1550*, Cambridge, England, 1989.

Wunsch 1968
Wunsch, A. "Two Fragments from the Embriachi Workshop," *University of Michigan Museum of Art Bulletin* 3 (1968): 2–8.

Wyman 1936
Wyman, M. A. "The Helyas Legend as Represented on the Embriachi Ivories at the Metropolitan Museum of Art," *Art Bulletin* 18 (1936): 4–24.

Young 1977
Young, P. "The Origin of the Herlufsholm Ivory Crucifix Figure," *Burlington Magazine* 119 (1977): 12–19.

Zastrow 1978
Zastrow, O. *Museo d'arte applicate: Gli avori*, Milan, 1978.

Zwettl 1981
Die Kuenringer: Das Werden des Landes Niederösterreich, exh. cat., Zwettl, Osterreichisches Museum für Volkskunde, 1981.

Index

A

Aachen, Suermondt Museum:
Triptych, 85

Abelard, Peter, 9

Adoration of the Magi, Diptych,
leaf of (Kestner Museum,
Hannover), 201, 201

Adoration of the Magi,
Diptych with (British
Museum, London), 226

Adoration of the Magi, High
Altar, Cologne Cathedral
(Schnütgen Museum,
Cologne), 201, 201

Adoration of the Magi, Relief
with (Musée Curtius, Liège),
82, 83

Adoration of the Magi, Triptych
with (Musée des Beaux-
Arts, Lyons), 59, 59–60

Adoration of the Magi and
Crucifixion, from the
Hours of Jeanne d'Evreux
(Metropolitan Museum
of Art, New York), 105,
105, 109, 114n47

Agard, Antoine, 288

Agrafe, Master of the
Forgeries. See Master of
the Agrafe Forgeries

Aldobrandini, Giovanni Benci
Carrucci, 216

Amesbury Psalter, 116

Amiens, Bibliothèque
Municipale: Diptych
with Scenes of the Passion,
160, 160, 162; Triptych
of the Death of the Virgin,
158, 162

Amiens Cathedral, 11, 43;
Archivolt Figures (west
facade, central portal), 119,
119; Beau Dieu, 116; Saint
Honoratus portal, 129;
Vierge dorée (south transept
trumeau), 40, 41, 123, 125

Amsterdam, Rijksmuseum:
Diptych, 86–87; Diptych
with Scenes of the Lives
of Mary and Christ, 104,
104–5

Angel from the Abbey of
Maubuisson ("Ange aux
burettes") (Musée du
Louvre, Paris), 168, 169

Angel (Metropolitan Museum
of Art, New York), 167,
167–69

Angel (Musée d'Evreux), 168

Angel of Flavigny (Metropolitan

Museum of Art, New York),
168, 168

Angel of the Annunciation
(Musée du Louvre, Paris),
42, 51, 51, 54, 55, 141,
142, 142–43, 143

Annunciate Virgin (Musée du
Louvre, Paris), 142, 143

Annunciation, Master E. S.
(British Museum, London),
274, 274

Annunciation Group (Wells
Cathedral), 153

Annunication Group (Langres
Cathedral), 168

Appliqué Plaques with Scenes
from the Life of Christ
(Musée du Louvre, Paris,
Metropolitan Museum
of Art, New York, and
Victoria and Albert
Museum, London),
150, 150–53, 151, 152

Appliqué with the Virgin and
Child (Worcester, Mass.,
Worchester Museum of
Art), 211–12, 212

Archivolt Figures (west facade,
central portal, Amiens
Cathedral), 119, 119

Aristotle Teaching Alexander,
Casket (Metropolitan
Museum of Art, New
York), 67, 67

Aristotle Teaching Alexander,
Casket (Walters Art Gallery,
Baltimore), 66

Arode, Guillaume, 37n86

Arras, Musée Municipal:
Saudemont, Wooden
Angels of, 140

Arrest of Christ, from Appliqué
Plaques with Scenes
from the Life of Christ
(Musée du Louvre, Paris),
150, 150, 151

Atelier of the Boxes, 70, 76, 78

Attack on the Castle of Love,
Casket (Walters Art Gallery,
Baltimore), 65

Attack on the Castle of Love,
Mirror case (Seattle Art
Museum), 72, 73

Attack on the Castle of Love,
Mirror case (Victoria and
Albert Museum, London),
73, 73

Attack on the Castle of Love,
Mirror case (Virginia
Museum of Fine Arts), 74

Attack on the Castle of Love,
Mirror Case (Walters
Art Gallery, Baltimore),
72, 230, 230–31, 231

Augustine, Saint, 131

Auxerre Cathedral, 137

B

Baden-Württemberg,
Staatliche Kunstsammlung:
Box cover with the Virgin
and Child, 266, 266

Baltimore, Walters Art Gallery:
Casket with Aristotle
Teaching Alexander, 66;
Casket with Attack on the
Castle of Love, 65; Casket
with Castles and Lovers,
Atelier of the Boxes, 76,
76; Casket with Scenes
from Romances, 65–68,
245, 245–48, 247; Casket
with Scenes of Fountain
of Youth, 66; Casket with
Scenes of Gawain Fighting
a Lion, 67; Casket with
Scenes of Gawain Greeted
by the Maidens of the
Castle, 68; Casket with
Scenes of Gawain on the
Magic Bed, 67; Casket
with Scenes of Gawain
Receiving the Keys to the
Castle of Maidens, 68;
Casket with Scenes of
Lancelot Crossing the
Sword Bridge, 67; Casket
with Scenes of Mock Tilt,
65–66; Casket with Scenes
of Phyllis and Aristotle, 66;
Casket with Scenes of
Tristan and Iseult, 67;
Casket with Scenes of
Virgin and the Unicorn, 67;
Comb with Scenes of
Courtly Life, 259, 259–60,
260; Crosier, head of with
the Crucifixion and the
Virgin between Angels,
165, 165–66, 166; Diptych
with Christ's Passion, 174,
174–75, 178; Diptych with
Scenes of the Passion, left
leaf (1250-70), 132, 133;
Diptych with Scenes of
the Passion, left leaf
(1280-1300), 98, 109–10,
110, 111, 136, 136–37;
Diptych with Scenes of the
Passion, left leaf (before
1893), 299, 299–300;
Diptych with Scenes of the
Passion, right leaf, Master
of Kremsmünster, 206,

206–7; Diptych with Scenes of the Passion (ca. 1375–1400), 178, *179;* Diptych with the Virgin and Angels and the Crucifixion, Berlin Master, *202,* 202–3, 205; Flagellation and Crucifixion from Diptych with Scenes of the Passion, 98, 109–10, *110,* 111, 136, 136–37; Mirror Case, 226; Mirror Case with Attack on the Castle of Love, 72, *230,* 230–31, *231;* Mirror Case with Fountain of Youth, *71,* 71–72; Mirror Case with Lady and Hermit, Atelier of the Boxes, 77, *77;* Mirror Case with Lovers in Court Dress, 77, 77–78; Pax with the Virgin and Child, Saint John the Baptist, and Saint Catherine, 266; Quadriptych with Scenes of the Passion, 208–9, *209;* Saint Simeon and the Christ Child, 121; Triptych with Painted Angels, exterior panels, 214, *214;* Vierge *Ouvrante* de Boubon, *35n, 285,* 285–89, *287, 288;* Virgin and Child groups, 119; Virgin and Child (seated), *263,* 263–64, *264;* Virgin and Child (standing), 55, 127, *127*

Bayeau Tapestry, 113n16

Bayonne, Musée Bonnat: Mirror Case with Attack on the Castle of Love, 73

Beau Dieu (Amiens Cathedral), 116

Becket, Thomas, 35n36, 200, 201

Beckwith, John, 15

Belting, Hans, 13

Belt with Ivory Fittings (Musée National du Moyen Age, Thermes de Cluny, Paris), *275,* 275–76, *276*

Bergmann, Ulrike, 84

Berlin, Benôit Oppenheim Collection: Statuette, Virgin and Child, 307

Berlin, Jakob Goldschmidt Collection (formerly): Saint George and the Dragon, 294, *294*

Berlin, Kaiser Friedrich Museum: Virgin and Child (destroyed), 117

Berlin, Staatliche Museen zu Berlin-Preussischer Kulturbesitz, Diptych with Scenes of the Passion, *176,* 177–78; The Large Garden of Love, Master of the Gardens of Love, 301–2, *302;* Triptych with the Virgin and Angels, Berlin Master, 86, 202

Berlin Master, 86; Diptych with the Life of Christ (Musée du Louvre, Paris), 203, 205; Diptych with the Virgin and Angels and the Crucifixion (Walters Art Gallery, Baltimore), *202,* 202–3, 205; Triptych with the Life of Christ (Art Institute of Chicago), 203–5, *204;* Triptych with the Virgin and Angels (Staatliche Museen, Berlin), 86, 202, 205; Virgin in Glory, leaf of a diptych (Museum of Fine Arts, Houston), 202, *203,* 205

Bernard of Clairvaux, Saint: *Sermon on the Virgin,* 131

Bible of Cardinal Maciejowski, 58

Biblia Pauperum, 269

Bibliothèque Nationale (Paris), 20

Blair, Claude, 280

Blanche of Castille, 9, 10, 131

Blessed and Damned, 44

Bloomfield Hills, Michigan, Cranbrook Academy of Art: Triptych with the Virgin in Glory, *295,* 295–96

Bohun, Humphrey de, 191

Bohuslaus, Abbot, 82

Boileau, Etienne, 33n2, 34n3; *Livre des métiers* (Book of Trades), 10, *19,* 19–24, *20,* 27, 34n6, 34n9, 37n75, 39, 43, 50

Bologna: Reliquary of Saint Louis, 143; Reliquary of San Domenico, 156

Bonn, Rheinisches Landesmuseum: Cistercian Monastery, Marienstatt, illuminated parchment charter, 197

Book Casket for Abbot Arnold II of Saint Blaisen in Schwarzwald, with Coronation Scene (Benedictine monastery of Saint-Paul-en-Lavanttal), 131

Book of Hours, 13, 14, 111

Boston, Museum of Fine Arts: Mourning Virgin and Saint John, 253, *253;* Pendant with the Coronation of the Virgin, *254,* 254–55, *255;* Saddle, *261,* 261–62, *262*

Boubon, Cussac, Priory of (Haute Vienne), 285

Boucicaut Master, 255

Bourges Cathedral, 100, 111; Crucifixion and Deposition (choir screen), 129

Box cover with the Virgin and Child (Staatliche Kunstsammlung, Baden-Württemberg), 266, *266*

Bruges: Church of Saint-Jean, 268

Buckle with Seated Couple (scenes from Tristan and Iseult) (Metropolitan Museum of Art, New York), 72, 224–25, *225*

Burgos Cathedral, 255

C

Calkins, Robert, 253

Canterbury Cathedral, 200

Cascio, Agnès, 47, 61n1, 164

Casket, Jadwiga (Kraków Cathedral), 64–65, 66, 67, 248

Casket, Marriage, with Scenes from Classical and Vernacular Literature (Art Institute of Chicago), *281,* 281–82, *282*

Casket (Musée Dobrée, Nantes), 241

Casket of Gotha, 241

Casket Panel with Execution Scene (British Museum, London), 244, *244*

Casket Panel with Ladies Dancing (British Museum, London), 244, *244*

Casket with Attack on the Castle of Love (Walters Art Gallery, Baltimore), 65

Casket with Castles and Lovers, Atelier of the Boxes (Walters Art Gallery, Baltimore), 76, *76*

Casket with Scenes from Romances (Treasury of church of Saint Ursula, Cologne), 75, 84, *84,* 221

Casket with Scenes from Romances (Walters Art Gallery, Baltimore), 65–68, *245,* 245–48, *247*

Casket with Scenes of Aristotle Teaching Alexander, Phyllis and Aristotle, Thisbe and the Lion, Pyramus and Thisbe's Suicides (Metropolitan Museum of Art, New York), 67, *67*

Casket with Scenes of La *Châtelaine de Vergi* (Metropolitan Museum of Art, New York), 69, *242,* 242–44, *243*

Casket with Scenes of Elopement and the Castle of Love (Metropolitan Museum of Art, New York), 231

Casket with Scenes of Enyas and the Wodehouse and Galahad Receiving the Keys to the Castle of Maidens (Metropolitan Museum of Art, New York), 68, *68*

Casket with Scenes of the Fountain of Youth (Walters Art Gallery, Baltimore), 66

Casket with Scenes of Ivain at the Spring (formerly in Baron von Hirsch Collection), 68

Casket with Scenes of the Life and Passion of Christ (Los Angeles County Museum of Art), *256,* 256–58, *257, 258*

Casket with Story of Perceval and Saints (Musée du Louvre, Paris), 69, 70, *240,* 240–41, *241*

Caveoso, Pietro di Monte, 216

Cenotaph of Dagobert (Abbey of Saint-Denis), 131

Certosa of Pavia, 258

Charity (Art Institute of Chicago), 41

Charles V, 25, 28, 32, 35n24, 35n29, 35n30, 35n32, 35n36, 164, 173

Charles VI, 29

Chartres Cathedral, 11, 39, 288; Pope (Confessors' doorway, south transept), 121; Virgin and Child (tympanum, south door, West Portal), 40

Chartreuse de Champmol (Dijon), 251, 252

La Châtelaine de Vergi, 64

La Châtelaine de Vergi, scenes of, Casket (Metropolitan Museum of Art, New York), 69, 242, 242–44, 243

Châtelet, 19, 20, 34n4

Chess Game, Mirror Case with Scenes of (Cleveland Museum of Art), 75, 232, 232–33, 238

Chessman (Ashmolean Museum of Art and Technology), 219, 219

Chessman (Metropolitan Museum of Art, New York), 218, 219

Chicago, Art Institute of Chicago: Casket, Marriage, with Scenes from Classical and Vernacular Literature, 281, 281–82, 282; Charity, 41; Diptych with Scenes of the Infancy and Passion, 104, 104, 105, 106–7; Enthroned Virgin and Child, 118, 118–19; Triptych with the Life of Christ, Berlin Master, 203–5, 204

Choir screen (Bourges Cathedral), 100, 111

Choir stall relief (Cologne Cathedral), 84, 85

Chrétien de Troyes, 63, 68, 69, 225; Conte de graal, 63, 68, 79n2; Perceval, 111, 219, 240

Christ as the Man of Sorrows, Relief (Musée du Louvre, Paris), 255

Christine de Pisan, 69, 74, 77–78

Cincinnati, Taft Museum: Virgin and Child with Two Angels from Saint-Denis, 123, 124, 124–26, 125, 126, 145, 307

Cistercian Monastery, Marienstatt, illuminated parchment charter (Rheinisches Landesmuseum, Bonn), 197

Clémence de Hongrie, 35n27

Clement VI, 169

Cleveland, Cleveland Museum of Art: Diptych with Saint Martin of Tours, 82, 83, 198, 198–99; Mirror Case with a Couple Playing Chess, 75, 232, 232–33,

238; Roundel with the Annunciation, 273, 273–74; Triptych with Virgin and Child, 211, 211

Cloisters Cross, 289

Coesfeld, Westphalia, 220; Dagger Handle, 220, 221

Cologne, 82

Cologne, Schnütgen Museum: Adoration of the Magi, High Altar, Cologne Cathedral, 201, 201; Polyptych fragment with Scenes of the Passion and Saints, 83, 83; Virgin from the Tongern house, 85

Cologne Cathedral, 221; Adoration of the Magi, High Altar (Schnütgen Museum, Cologne), 201, 201; Choir stall relief, 84, 85; Shrine of the Three Magi (Nicholas of Verdun), 121

Comb with the God of Love (Museo Nazionale del Bargello, Florence), 75, 223

Comb with Scenes of Courting (Victoria and Albert Museum, London), 222, 222–23, 223

Comb with Scenes of Courtly Life (Walters Art Gallery, Baltimore), 259, 259–60, 260

Commemoration portal, Madern Gerthner (Mainz Cathedral), 92, 206

Conte de graal (Chrétien de Troyes), 68, 79n2

Cornée, Jean, 32

Cornet, Pierre, 26

Coronation of the Virgin (Musée du Louvre, Paris), 44, 52, 53, 54

Coronation Scene, Book Casket for Abbot Arnold II of Saint Blaisen in Schwarzwald (Benedictine monastery of Saint-Paul-en-Lavanttal), 131

Corpus of Christ, Giovanni Pisano (Victoria and Albert Museum, London), 180, 181, 181

Corpus of Christ (Metropolitan Museum of Art, New York), 128, 129

Corpus of Christ (Victoria and Albert Museum, London), 184, 185

Crosier, head of with the Crucifixion and the Virgin between Angels (Walters Art Gallery, Baltimore), 165, 165–66, 166

Crosier, head of with the Crucifixion and the Virgin (Metz Cathedral), 166

Crosier, head of with the Virgin between Angels (Victoria and Albert Museum, London), 165, 166

Crosier and Case (Victoria and Albert Museum, London), 215, 215–16, 216

Crosier (Museo Nazionale del Bargello, Florence), 216

Crucifix from Cérisiers (Sens Cathedral), 129

Crucifixion, from Diptych with the Virgin in Glory and the Crucifixion (Toledo Museum of Art, Toledo), 155, 156

Crucifixion, shrine of Saint Gertrude (Abbey of Sainte-Gertrude, Nivelles, Belgium), 129, 129

Crucifixion and Adoration of the Magi from the Hours of Jeanne d'Evreux (Metropolitan Museum of Art, New York), 105, 105, 109, 114n47

Crucifixion and Deposition, choir screen (Bourges Cathedral), 129

Crucifixion Figure (Germanisches Nationalmuseum, Nuremberg), 185

Crucifixion Figure (Musée du Louvre, Paris), 185

Crucifixion Panel (Wallace Collection, London), 153, 156

D

Dagger Handle (Bayerisches Nationalmuseum, Munich), 220, 221

Dagger Handle (Coesfeld, Westphalia), 220, 221

Dagger Handle (Museum für Kunst und Gewerbe, Hamburg), 221

Dagger Handle (State Hermitage Museum, Saint Petersburg), 220, 221

Dagger Handle (Victoria and Albert Museum, London), 220, 220–21, 221

Darcel, Alfred, 276

Death of the Virgin, Triptych of the (Bibliothèque Municipale, Amiens), 158, 162

Demotte, G. J., 183

Deposition and Entombment from Diptych with Scenes of the Passion (British Museum, London), 98, 109–10, 110, 111–12, 137

Deposition Group (Musée du Louvre, Paris), 41, 129

Deposition of Christ, Appliqué Plaque (Victoria and Albert Museum, London), 153

Deposition of Christ, from Appliqué Plaques with Scenes from the Life of Christ (Metropolitan Museum of Art, New York), 150–52, 151

Descent from the Cross group (Musée du Louvre), 54, 56, 138, 138–40, 140

Deschamps, Eustache, 69

Detroit, Detroit Institute of Arts: Diptych with Scenes from the Lives of Christ and the Virgin, 157, 157–58, 159, 162; Diptych with Scenes of the Life of Christ, 106, 107; Diptych with the Virgin in Glory and the Crucifixion, 303, 303–4; Game Board, 271–72, 272; Mirror Case with Scenes of Lovers in Gardens, 301, 301–2; Pax with the Virgin and Child, Saint John the Baptist, and Saint Catherine, 265, 265–66; Memento Mori Pendant to a Rosary or Chaplet, 277, 277–78; Polyptych with the Virgin and Child and Scenes from the Life of the Virgin, 267, 267–69, 269; Virgin and Child, 283, 283–84; Writing Tablets with Scenes of Lovers, 304–5, 305

De Vasselot, J.-J. Marquet, 14

Devotional Booklet (Metropolitan Museum of Art, New York), 89–90, 90, 91

Devotional Booklet (Victoria and Albert Museum, London), 89, 90, 193–97, 193–97, 199

Dijon: Chartreuse de Champmol, 251, 252, 253

Dijon, Musée des Beaux-Arts: Tomb of John the Fearless and Marguerite of Bavière, Mourner Number 78 from, 251–52, *252*

Diptych, leaf of, with Adoration of the Magi (Kestner Museum, Hannover), 201, *201*

Diptych (Ashmolean Museum, Oxford, and Metropolitan Museum of Art, New York), 136–37

Diptych (Gulbenkian Collection, Lisbon), 137

Diptych (Rijksmuseum, Amsterdam), 86–87

Diptych with the Adoration and Crucifixion, Master of Kremsmünster (Kremsmünster Abbey, Austria), 206

Diptych with the Adoration of the Magi (British Museum, London), 226

Diptych with the Ascension and Pentecost (Musée du Louvre, Paris), 173, *173*

Diptych with Christ Enthroned and the Entombment (Metropolitan Museum of Art, New York), *131*

Diptych with Christ's Life and Passion (Minneapolis Institute of Arts, Minneapolis), *177*, 178

Diptych with Christ's Passion (Walters Art Gallery, Baltimore), *174*, 174–75, 178

Diptych with Descent from the Cross (Gallerie e Musei Vaticani, Rome), 139, *139*

Diptych with the Last Judgment and the Coronation of the Virgin (Metropolitan Museum of Art, New York), 44, *130*, 130–31

Diptych with the Last Supper (Musée des Beaux-Arts, Lille), 162, *162*

Diptych with the Life of Christ, Berlin Master (Musée du Louvre, Paris), 203

Diptych with the Nativity and Last Judgment (Musée du Louvre, Paris), 102–4, *103*, 105

Diptych with the Passion of Christ (Toledo Museum of Art), *175*, 177–78

Diptych with Saint Martin of Tours (Cleveland Museum of Art), 82, 83, *198*, 198–99

Diptych with Scenes from the Life of Christ, Master of the Agrafe Forgeries (National Gallery of Art, Washington, D.C.), 288, 289, 290, 290–92, 291

Diptych with Scenes from the Life of the Virgin and Christ (Musée des Beaux-Arts, Lille), 158, *158*, 159

Diptych with Scenes from the Lives of Christ and the Virgin (Detroit Institute of Arts), *157*, 157–58, 159, 162

Diptych with Scenes from the Lives of the Virgin and Christ (Musée du Louvre, Paris), 158, *159*, 159–60, *160*

Diptych with Scenes from the Passion and from the Life of the Virgin (Musée du Louvre, Paris), *170*, 170–73, *171*, *172*

Diptych with Scenes of the Ascension and Pentecost (Musée du Louvre, Paris), 179

Diptych with Scenes of the Infancy and Passion (Art Institute of Chicago), 104, *104*, 105, 106–7

Diptych with Scenes of the Life of Christ (Cleveland Museum of Art), 110, *111*

Diptych with Scenes of the Life of Christ (Detroit Institute of Arts), *106*, 107

Diptych with Scenes of the Lives of Mary and Christ (Gallerie e Musei Vaticani, Rome), *101*, 102

Diptych with Scenes of the Lives of Mary and Christ (Rijksmuseum, Amsterdam), 104, 104–5

Diptych with Scenes of the Passion, left leaf of, Master of Kremsmünster (Musée des Beaux-Arts, Lyons), 207, *207*

Diptych with Scenes of the Passion, left leaf of (before 1893) (Walters Art Gallery, Baltimore), *299*, 299–300

Diptych with Scenes of the Passion, left leaf (1250-70) (Walters Art Gallery, Baltimore), *132*, 133

Diptych with Scenes of the Passion, left leaf (1280-1300) (Walters Art Gallery, Baltimore), 98, 109–10, *110*, 111, *136*, 136–37

Diptych with Scenes of the Passion, right leaf, Master of Kremsmünster (Walters Art Gallery, Baltimore), *206*, 206–7

Diptych with Scenes of the Passion, right leaf (British Museum, London), 98, 109–10, *110*, 111–12, *137*

Diptych with Scenes of the Passion, right leaf (Musée National du Moyen Age, Thermes de Cluny, Paris), 98, *133*, 133–34

Diptych with Scenes of the Passion and Afterlife of Christ (Saint Louis Art Museum), 134–35, *135*

Diptych with Scenes of the Passion and the Life of the Virgin (Musée du Louvre, Paris), *94*, 107–9, *108*

Diptych with Scenes of the Passion (Bibliothèque Municipale, Amiens), 160, *160*, 162

Diptych with Scenes of the Passion (ca. 1375–1400) (Walters Art Gallery, Baltimore), 178, *179*

Diptych with Scenes of the Passion (Saint Louis Art Museum), 98, *99*, 99–100, 113n19

Diptych with Scenes of the Passion (Staatliche Museen zu Berlin-Preussischer Kulturbesitz, Kupferstichkabinett), *176*, 177–78

Diptych with Scenes of the Passion (State Hermitage Museum, Saint Petersburg), 134, 160

Diptych with Scenes of the Passion (Victoria and Albert Museum, London), 178, *178*

Diptych with Scenes of the Passion (Wallace Collection, London), 134

Diptych with Symbolic Images, Scenes of the Life of Christ and the Virgin (Metropolitan Museum of Art, New York), 83, *200*, 200–201

Diptych with the Virgin and Angels and the Crucifixion, Berlin Master (Walters Art Gallery, Baltimore), *202*, 202–3, 205

Diptych with the Virgin and Child and Christ Blessing (Salting Diptych) (Victoria and Albert Museum, London), 57, 186, *187*

Diptych with the Virgin and Child and the Crucifixion (Metropolitan Museum of Art, New York), 86, *87*

Diptych with the Virgin in Glory and the Crucifixion (Detroit Institute of Arts), *303*, 303–4

Diptych with the Virgin in Glory and the Crucifixion (Musée du Louvre, Paris, Toledo Museum of Art, 51, 57–58, *154*, 154–56, *155*, *156*, 304

Dupin, Isabelle Mosneron, 251, 252

E

Ebner, Margaretha, 88

Ecclesia, Descent from the Cross group (Musée du Louvre, Paris), 54, 56, 138, 139

Edward I (England), 43

Egbert, Donald, 81, 268

Eleanor Crosses, 186

Eleousa (Virgin of Tenderness), 307

Embriachi workshops, 14, 58, 70, 79, 213, 214, 258, 268, 281

Enthroned Virgin and Child (Art Institute of Chicago), *118*, 118–19

Enthroned Virgin and Child (Metropolitan Museum of Art, New York), *182*, 183

Enthroned Virgin and Child (Museum für Kunst und Gewerbe, Hamburg), *116*, 116–17

Enthroned Virgin and Child (Victoria and Albert Museum, London), *148*, 149

Enthroned Virgin and Child (Yale University Art Gallery, New Haven), 149

Enthroned Virgin (Musée National du Moyen Age, Thermes de Cluny, Paris), 54

Enthroned Virgin (Nienburg, Lower Saxony), 117

Enyas and the Wodehouse, Scenes of, Casket (Metropolitan Museum of Art, New York), 68, *68*

Evrard of Orleans, 169

Evreux, Musée d'Evreux: Angel, 168

Exeter Cathedral, 188, 189

F

Ferrierère, Henri de: *Le livre du roi Modus et la reine Ratio*, 236

Fienvillier, Thomas de, 28, 29

Figure of a Pope (Victoria and Albert Museum, London), 39, 42, *120*, 120–21

Filhol, François, 288

Fiorentino, Giovanni: *Il pecorone* (The Golden Eagle), 281, 282

Flagellation and Crucifixion from Diptych with Scenes of the Passion (Walters Art Gallery, Baltimore), 98, 109–10, *110*, 111, *136*, 136–37

Floire et Blanchefleur, 79n4

Florence, Museo Nazionale del Bargello: Comb with the God of Love, 75, 223; Crosier, 216; Saint Margaret Triumphing over the Dragon, 164; Virgin of the dukes of Tuscany, 49

Forsyth, William, 212

Fountain of Youth, Mirror Case (Walters Art Gallery, Baltimore), *71*, 71–72

Fountain of Youth, Scenes of, Casket (Walters Art Gallery, Baltimore), 66

Fouquet, Jean, 264

Fragment from a Crucifixion Group, Master of the Agrafe Forgeries (Metropolitan Museum of Art, New York), 290, 291–92, *292*

Fragment of a Mirror Case with Knights and Foot Soldiers (British Museum, London), 280, *280*

Frederick II: *De arte venandi cum aribus*, 236

Freiburg Cathedral: 201, Virgin (tympanum), 117

Frigolet Virgin, 149

Froissart, Jean, 69

Fulbert, Bishop, of Chartres, 82

G

Gaborit-Chopin, Danielle, 7, 126, 164, 292; *Ivoires du Moyen-Age*, 15, 86, 226, 252, 264

Gaignières, Roger de, 288

Galahad Receiving the Keys to the Castle of Maidens, Scenes of, Casket (Metropolitan Museum of Art, New York), 68, 68

Game Board (Detroit Institute of Arts), *271–72*, *272*

Gardens of Love, Master of the: The Large Garden of Love (Staatliche Museen zu Berlin-Preussischer Kulturbesitz, Kupferstich-kabinett), 301–2, *302*

Gawain Fighting a Lion, Scenes of, Casket (Walters Art Gallery, Baltimore), 67

Gawain Greeted by the Maidens of the Castle, Scenes of, Casket (Walters Art Gallery, Baltimore), 68

Gawain on the Magic Bed, Scenes of, Casket (Walters Art Gallery, Baltimore), 67

Gawain Receiving the Keys to the Castle of Maidens, Scenes of, Casket (Walters Art Gallery, Baltimore), 68

Gay, Victor, 276

Genlis, Church of, 251

Gerthner, Madern: Commemoration portal (Mainz Cathedral), 92

Gibson, Margaret, 231

Gilles Haquin, 34n11

Glasgow, Burrell Collection: Mirror Case with Jousting Knights, 234

God of Love, Casket of Saint Ursula (Treasury of church of Saint Ursula, Cologne), 75, 84, *84*, 221

God of Love, Comb (Museo Nazionale del Bargello, Florence), 75

God of Love, Mirror case (Musée du Louvre, Paris), 74

God of Love, Wax tablet covers (Maihingen), 75

God the Father (Museum of Fine Arts, Houston), *250*, 250–52, *251*

Goldene Rössl, 264

Golden Legend (Jacobus de Voragine), 111, 113n18

Goldschmidt, Adolf, 296

Gotha Casket, 241

Gottesfreunde (Friends of God), 88

Grandisson, John de, Bishop of Exeter, 153, 183, 188, 189

Grandisson Ivories, 186, 188

Grand Pont (Paris), 30, 34n4

Gravoir with Phyllis and Aristotle (Victoria and Albert Museum, London), 75–76

Great Seal of Henry III, 219

Grim, Edward, 200

Grodecki, Louis, 142

Groslet, Guiot, 37n87

Gross Sankt Martin Benedictine Abbey, Cologne, 199

Guillaume de Lorris, 239; *Roman de la rose*, 74

Guillaume de Machaut: *Le dit de lion*, 77; *Le Remède de fortune* (Bibliothèque Nationale, Paris), 77, 169, *169*

Guillaume de Nourrich, 177

Guillaume de Vaudétar, 169

Guillebert de Metz, 35n31, 37n71

Guineau, Bernard, 47, 55

H

Hallesches Heiltum, 191–92

Hallesches Heiltumsbuch, Aschaffenburg, Hofbibliothek: Saint Martin and the Beggar, 191, *191*

Hamburg, Museum für Kunst und Gewerbe: Dagger Handle, 221; Enthroned Virgin and Child, *116*, 116–17; Saint George and the Dragon, 294, *294*

Hangest, Guillaume de, 34n17

Hannover, Kestner Museum: Diptych, leaf of, Adoration of the Magi, 201, *201*

Harp (Musée du Louvre, Paris), *297*, 297–98, *298*

Head of a Crosier with the Crucifixion and the Virgin between Angels (Walters Art Gallery, Baltimore), *165*, 165–66, *166*

Henri d'Andeli: *Lai d'Aristote*, 66, 75

Henry des Grès, 33

Herlufsholm Crucified Christ, 185

Hillary, Bishop of Poitiers, 198

Hollogne sur Geer, 212

Holy Sepulcher, reliquary of (Pamplona Cathedral, Treasury), 139, 143

Homo, Catherine, 298

Honoré, Master, 146; "Somme Le Roy," 58–59

Horton, Mark, 3–4

Hours of Jeanne d'Evreux, Crucifixion and Adoration of the Magi from (Metropolitan Museum of Art, New York), 105, *105*, 109, 114n47

Houston, Museum of Fine Arts: God the Father, 250, 250–52, *251*; Virgin in Glory, leaf of a diptych, Berlin Master, 202, *203*, 205

Hundred Years War, 78

I

Ile-de-France, 8, 15, 40, 98, 129, 211

Ile de la Cité, 11, 34n4

Isabelle of Bavaria, 32

Isabelle of France, statue of (Poissy), 143

Ivain at the Spring, Scenes of, Casket (formerly in Baron von Hirsch Collection), 68

Ivory box (Musée National du Moyen Age, Thermes de Cluny, Paris), 64

J

Jacobus de Voragine: *Golden Legend,* 111, 113n18, 162, 191

Jacquemart de Hesdin, 255

Jadwiga, Queen of Poland (1371-99), 64

Jadwiga casket (Kraków Cathedral), 64–65, 66, 67, 248

Jaszai, Géza, 15

Jean d'Arras, 36n54

Jean de France, Duc de Berry, 35n26, 37n75, 255, 258

Jean de Jandun, 30

Jean de Los Angeles Huerta, 251–52

Jean de Marville, 25, 252

Jean de Meun, 239; *Roman de la rose,* 74

Jean de Roëm, 26

Jean Girart, 25

Jean III de Dormans, 183

Jean le Bon (1350-64), 24, 28, 29, 169

Jean le Braelier, 169

Jean le Noir: *Heures de Jeanne de Navarre,* 170–71; *Petites Heures de Jean de Berry,* 170–71

Jeanne d'Evreux, Hours of, Crucifixion and Adoration of the Magi from (Metropolitan Museum of Art, New York), 105, *105,* 109, 114n47

Jehan Aubert, 32–33

Jehan Cyme, 37n75

Jehan de Coilly, 37n68

Jehan le Seelleur, 31, 32

Jehan de Taverni, 27

Jehan le Mestre, 28

Joseph of Arimathea, Descent from the Cross group (Musée du Louvre, Paris), *53,* 138, 139, 140

Judgment of Paris, 281, 282

Jumièges, Abbey of, 177

K

Kahsnitz, Rainer, 264

Kansas City, Missouri, Nelson-Atkins Museum of Art: Virgin and Child, *210,* 210–11

Kenya, 3

Kiss of Judas, detail from Diptych with Scenes from the Passion and from the Life of the Virgin (Musée du Louvre, Paris), *172*

Knife with elephant ivory handle (Musée du Louvre, Paris), 24

Knight of the Swan, 69, 79

Koch, Robert, 266

Koechlin, Raymond: *Les ivoires gothiques français,* 14–15, 16, 81, 136, 142, 151, 168, 174, 208, 223, 231, 272, 276, 291, 298, 304; Rose Group, 136, 137

Kofler-Truniger catalogue, 201

Kraków Cathedral: Jadwiga casket, 64–65, 66, 67, 248

Kremsmünster Abbey, Austria, 206

Kremsmünster Master. See Master of Kremsmünster

Kruft, Hanno-Walter, 284

L

Lai d'Aristote (Henri d'Andeli), 66, 75

Lake Constance, 86, 90, 194

Lambert, A., 289

Lambert le Tort of Chateaudun: Romance of Alexander, 66

Lancelot Crossing the Sword Bridge, Scenes of, Casket (Walters Art Gallery, Baltimore), 67

Langres Cathedral: Annunication Group, 168

Lannoy, Robert de, 177

The Large Garden of Love, Master of the Gardens of Love (Staatliche Museen zu Berlin-Preussischer Kultur-besitz, Kupferstichkabinett), 301–2, *302*

Leeuwenberg, Jaap, 288, 291, 292, 298

Lefrison, Jehan, 31

Left Leaf of a Diptych with Scenes of the Passion, Master of Kremsmünster (Musée des Beaux-Arts, Lyons), 207, *207,* 299, 300

Left Leaf of a Diptych with Scenes of the Passion (before 1893) (Walters Art Gallery, Baltimore), *299,* 299–300

Kenya, 3

Legend of Theophilus (tympanum, north transept, Notre-Dame cathedral, Paris), *12,* 12–13

Le remède de fortune, Guillaume de Machaut (Bibliothèque Nationale, Paris), 169, *169*

Le Roy, Martin, 64

Les Halles (Paris), 30

Lesley, Parker, 216

Lévy, Juliette, 47, 61n1, 164

Liège, 60, 211

Liège, Musée Curtius: Relief with Adoration of the Magi, 82, *83*

Li Establissement des mestiers de Paris. See Livre des métiers (Book of Trades)

Lille, Musée des Beaux-Arts: Diptych with the Last Supper, 162, *162;* Diptych with Scenes from the Life of the Virgin and Christ, 158, *158,* 159

Limbourg Brothers, 255

Lincoln Cathedral: Seated queen (Judgment Portal, west voussoir, Angel Choir), 424343

Lisbon, Gulbenkian Collection: Diptych, 137

Little, Charles T., 15, 47, 123, 145

Liverpool, National Museums and Galleries on Merseyside: Mirror Case with Scene of Elopement, 66, 72, 231

Livre des métiers (Book of Trades), 10, *19,* 19–24, *20,* 27, 34n6, 34n9, 37n75, 39, 43, 50

London, British Library: Holkham Picture Bible, 238, *239*

London, British Museum: *Annunciation,* Master E. S., 274, *274;* Casket Panel with Execution Scene, 244, *244;* Casket Panel with Ladies Dancing, 244, *244;* Deposition and Entombment from Diptych with Scenes of the Passion, 98, 109–10, *110,* 111–12, *137;* Diptych with Adoration of the Magi, 226; Diptych with Scenes of the Passion, right leaf, 98, 109–10, *110,* 111–12, *137;* Fragment of a Mirror Case with Knights and

Foot Soldiers, 280, *280;* Saint Margaret Triumphing over the Dragon, 48, *48,* 54, 56, *163,* 163–64, *164,* 191; Triptych with the Arms of John de Grandisson, Bishop of Exeter, *188,* 188–89

London, H. Baer collection (formerly): Saint George and the Dragon, 294

London, Victoria and Albert Museum: Appliqué Plaques with Scenes from the Life of Christ (also Paris, Musée du Louvre, and New York, Metropolitan Museum of Art), *150,* 150–53, *151, 152;* Comb with Scenes of Courting, *222,* 222–23, *223;* Corpus of Christ, *184,* 185; Corpus of Christ, Giovanni Pisano, *180,* 181, *181;* Crosier, head of with the Virgin between Angels, 165, *166;* Crosier and Case, *215,* 215–16, *216;* Dagger Handle, *220,* 220–21, *221;* Deposition of Christ, Appliqué Plaque, 153; Devotional Booklet, 89, *90,* 193–97, *193–97,* 199; Diptych with Scenes of the Passion, 178, *178;* Diptych with the Virgin and Child and Christ Blessing (Salting Diptych), 57, 186, *187;* Enthroned Virgin and Child, *148,* 149; German tablets, 59; *Gravoir* with Phyllis and Aristotle, 75–76; Mirror Case, 226–27, *227,* 228, 229, 305; Mirror Case with Attack on the Castle of Love, 73, *73;* Mirror Case with Couple Playing Chess, 233; Quadriptych with Scenes of the Infancy of Christ, 208; Figure of a Pope, 39, 42, *120,* 120–21; Saint George and the Dragon, 294; Saint Martin and the Beggar, *190,* 191–92; Soissons Diptych, 44, 51, 57, 60, 83, 98, *98,* 100–101, 110, 132, 134, 135; Triptych with the Coronation of the Virgin, *213,* 213–14, *214,* 216; Two Marys at Tomb, from Appliqué Plaques with Scenes from the Life of Christ, *152,* 153; Virgin and Child (boxwood), 43, *43;* Wax tablet with Coronation of the Virgin, 76

IMAGES IN IVORY: PRECIOUS OBJECTS OF THE GOTHIC AGE

London, Wallace Collection: Crucifixion Panel, 153, 156; Diptych with Scenes of the Passion, 134; Saint George and the Dragon, 294

Longhurst, Margaret, 81, 166, 216

Longinus, 110–11, 114n43, 114n47

Loomis, Roger, 68

Los Angeles, Los Angeles County Museum of Art: Casket with Scenes of the Life and Passion of Christ, 256, 256–58, 257, 258

Lost Virgin, Abbey of Saint-Denis, 125, 145

Louis IX (1226-70), 5, 9, 10–11, 19, 40, 131

Louis VII (1137-80), 7

Louis X le Hutin (1314-16), 26

Lower Rhine Valley, 40

Lower Saxony, Nienburg: Enthroned Virgin, 117

Lucca Cathedral, 198

Lugano, Thyssen-Bornemisza Collection: Triptych, 162

Ludwig I (Liegnitz and Brieg), 13

Luttrell Psalter, 65

Lyons, Musée des Beaux-Arts: Diptych with Scenes of the Passion, left leaf of, Master of Kremsmünster, 207, 207; Triptych with Adoration of the Magi, 59, 59–60; Vierge Ouvrante, 288, 289; Virgin, plaquette, 155–56

M

Maciejowski, Cardinal, Bible of, 58

Madonna della Cintola (Prato Cathedral), 181

Madrid, Thyssen-Bornemisza Collection: Triptych with Scenes of the Passion, 153

Mahaut, Countess of Artois, 25, 31, 37n80

Maihingen: Wax tablet covers with the God of Love, 75

Mailänder Madonna (Cologne Cathedral), 85

Mainz Cathedral, 92, 199; Commemoration portal (Madern Gerthner), 92, 206

Maistre Jean Pépin de Huy, 37n81, 143

Malibu, J. Paul Getty Museum: Hedwig Codex (Legenda maior) (Silesia), 13, 13, 87, 277

Manesse Codex, 90

Mannheim, Charles, 138

Mantes Cathedral, tympana of right west portal, 176–77

Mareuil-en-Brie, Church of (Marne): Retable with Scenes of the Passion, 152, 153

Marriage Casket with Scenes from Classical and Vernacular Literature (Art Institute of Chicago), 281, 281–82, 282

Martin, Kurt, 194

Master E. S., 273–74; Annunciation (British Museum, London), 274, 274

Master of Kremsmünster, 91, 92, 93n36, 205, 304; Diptych with Scenes of the Passion, left leaf of (Musée des Beaux-Arts, Lyons), 207, 207, 299, 300; Diptych with Scenes of the Passion, right leaf of (Walters Art Gallery, Baltimore), 206, 206–7; Diptych with the Adoration and Crucifixion (Kremsmünster Abbey, Austria), 206; Virgin and Child, Church of Saint John the Baptist, Ochtrup-Langenhorst, 92

Master of Mège, 160

Master of the Agrafe Forgeries: Diptych with Scenes from the Life of Christ (National Gallery of Art, Washington, D.C.), 288, 289, 290, 290–92, 291; Fragment from a Crucifixion Group (Metropolitan Museum of Art, New York), 290, 291–92, 292

Master of the Gardens of Love: The Large Garden of Love (Staatliche Museen zu Berlin-Preussischer Kulturbesitz, Kupferstich-kabinett), 301–2, 302

Mattabruna legend, 69, 79, 281

Maubuisson, Abbey of, Angel ("Ange aux burettes") (Musée du Louvre, Paris), 168, 169

Maurice de Sully, Bishop, 9

Mediations on the Life of Christ (Meditationes Vitae Christi), 13–14

Mège, Master of, 160

Memento Mori Pendants (Detroit Institute of Arts and Metropolitan Museum of Art), 277, 277–78, 278

Merz, Suzanne, 281

Meuse Valley, 40, 211

Milemete, Walter de: De Officiis Rerum, 65

Minneapolis, Minneapolis Institute of Arts: Diptych with Christ's Life and Passion, 177, 178

Miracle at the Wedding of Cana, detail from Diptych with Scenes from the Lives of the Virgin and Christ (Musée du Louvre, Paris), 160

Mirror Case, fragment of, with Knights and Foot Soldiers (British Museum, London), 280, 280

Mirror Case, Tristan and Iseult (Musée National du Moyen Age, Thermes de Cluny, Paris), 72

Mirror Case (Museo Nazionale, Ravenna), 226

Mirror Case (Victoria and Albert Museum, London), 226–27, 227, 228, 305

Mirror Case with a Couple Playing Chess (Cleveland Museum of Art), 75, 232, 232–33, 238

Mirror Case with a Royal Couple and Courtly Figures (Musée National du Moyen Age, Thermes de Cluny, Paris), 224, 224–26

Mirror Case with Attack on the Castle of Love (Musée Bonnat, Bayonne), 73

Mirror Case with Attack on the Castle of Love (Seattle Art Museum), 72, 73

Mirror Case with Attack on the Castle of Love (Victoria and Albert Museum, London), 73, 73

Mirror Case with Attack on the Castle of Love (Virginia Museum of Fine Arts, Richmond), 74

Mirror Case with Attack on the Castle of Love (Walters Art Gallery, Baltimore), 72, 230, 230–31, 231

Mirror Case with Couple Playing Chess (Musée du Louvre, Paris), 226, 233

Mirror Case with Couple Playing Chess (Victoria and Albert Museum, London), 233

Mirror Case with Falconing Party (Metropolitan Museum of Art, New York), 235, 235–36, 236

Mirror Case with the Fountain of Youth (Walters Art Gallery, Baltimore), 71, 71–72

Mirror Case with Hunting Scene (Fogg Art Museum, Cambridge), 224

Mirror Case with Jousting Knights (Burrell Collection, Glasgow), 234

Mirror Case with Jousting Knights (Virginia Museum of Fine Arts, Richmond), 233–34, 234, 305

Mirror Case with Lady and Hermit, Atelier of the Boxes (Walters Art Gallery, Baltimore), 77, 77

Mirror Case with Lovers in Court Dress (Walters Art Gallery, Baltimore), 77, 77–78

Mirror Case with Scene of Elopement (National Museums and Galleries on Merseyside, Liverpool), 66, 72, 231

Mirror Case with Scenes of Lovers in Gardens (Detroit Institute of Arts), 301, 301–2

Mirror Case with the Court of the God of Love (Musée du Louvre, Paris), 74, 223, 228, 228–29

Mirror Case with the Four Stages of Love (formerly Frédéric Spitzer Collection), 236, 236

The Mocking of Christ, from quadriptych with scenes of the Passion (Metropolitan Museum of Art, New York), 88–89, 89

Mock Tilt, Scenes of, Casket (Walters Art Gallery, Baltimore), 65–66

Modena Cathedral, 63, 225

Moiturier, Antoine Le, 252

Molinier, Emile, 297

Montesquiou-Fezensac, Blaise de, 125

Montfaucon, Bernard de, 288

Morey, Charles, 89, 201, 209

Morgan, J. Pierpont, 291

Moskowitz, Anita, 284

Mourning Virgin and Saint John (Museum of Fine Arts, Boston), 253, *253*

Mozambique, 3

N

Namur, Belgium, Museé Archéologique: Writing Tablets with Case, 237, 238

Namur, Belgium, Trésor d'Ognies des Soeurs de Notre-Dame: Virgin and Child, 119

Nesle, Raoul de, 152

New Haven, Yale University Art Gallery: Enthroned Virgin and Child, 149

New York, Metropolitan Museum of Art: Adoration of the Magi and Crucifixion, from the Hours of Jeanne d'Evreux, 105, *105*, 109, 114n47; Angel, *167*, 167–69; Angel of Flavigny, 168, *168*; Appliqué Plaques with Scenes from the Life of Christ (also Paris, Musée du Louvre, and London, Victoria and Albert Museum), *150*, 150–53, *151*, *152*; Buckle with Seated Couple (scenes from Tristan and Iseult), 72, 224–25, *225*; Casket, Aristotle Teaching Alexander, 67, *67*; Casket with Scenes of *La Châtelaine de Vergi*, 69, *242*, 242–44, *243*; Casket with Scenes of Elopement and Castle of Love, 231; Casket with Scenes of Enyas and the Wodehouse, 68, *68*; Casket with Scenes of Enyas and the Wodehouse and Galahad Receiving the Keys to the Castle of Maidens, 68, *68*; Casket with Scenes of Galahad Receiving the Keys to the Castle of Maidens, 68, *68*; Casket with Scenes of Phyllis and Aristotle, 67, *67*; Casket with Scenes of Pyramus and Thisbe's Suicides, 67, *67*; Casket

with Scenes of Thisbe and the Lion, 67, *67*; Chessman, *218*, 219; Corpus of Christ, *128*, 129; Crucifixion and Adoration of the Magi from the Hours of Jeanne d'Evreux, 105, *105*, 109, 114n47; Deposition of Christ, from Appliqué Plaques with Scenes from the Life of Christ, 150–52, *151*; Devotional Booklet, 89–90, *90*, 91; Diptych (also Oxford, Ashmolean Museum), 136–37; Diptych with Christ Enthroned and the Entombment, *131*; Diptych with the Last Judgment and the Coronation of the Virgin, 44, *130*, 130–31; Diptych with Symbolic Images, Scenes of the Life of Christ and the Virgin, 83, *200*, 200–201; Diptych with the Virgin and Child and the Crucifixion, 86, *87*; Enthroned Virgin and Child, *182*, 183; Fragment from a Crucifixion Group, Master of the Agrafe Forgeries, 290, 291–92, *292*; Memento Mori Pendant, 277–78, *278*; Mirror Case with Falconing Party, *235*, 235–36, *236*; The Mocking of Christ, from quadriptych with scenes of the Passion, 88–89, *89*; Quadriptych with Scenes of the Passion, 88–89, *89*, 208; Statuette of the Virgin and Child, 88, *88*; Tabernacle (fragment), 145; Triptych with the Virgin in Glory, 85, *85*, 86; Virgin and Child, 56, *306*, 307, *307*

Nicholas of Verdun: Shrine of the Three Magi (Cologne Cathedral), 121

Nicodemus, Descent from the Cross group (Musée du Louvre, Paris), 52, 138, *138*, 139, 140

Nivelles, Belgium: Crucifixion, Shrine of Saint Gertrude, 129, *129*; Reliquary of Saint Gertrude, 121, 129, *129*, 143, 168

Noli Me Tangere; Descent into Limbo, detail from Diptych with Scenes from the Passion and from the Life of the Virgin (Musée du Louvre, Paris), *171*

Norbert of Nördlingen, 88

Notre-Dame, Church of, Walcourt, 211

Notre-Dame Cathedral, Paris, 8–9, 35n28, 40, 44; choir stalls, 84; jamb figures (south transept), 121; Virgin (northern section, portal of the transept), 123

Nuremberg, Germanisches Nationalmuseum: Crucifixion Figure, 185; Saint George and the Dragon, 294

O

Ochtrup-Langenhorst, Church of Saint John the Baptist: Virgin and Child, Master of Kremsmünster, 92

Oslo, Kunstindustrimuseet: Deposition Group, 185

Otranto Cathedral (Apulia), 63, 225

Ottery Saint Mary, Devon, 188

Oxford, Ashmolean Museum of Art and Technology: Chessman, 219, *219*; Diptych (also New York, Metropolitan Museum of Art), 136–37

P

Pallas y Puig, Francisco, 296

Pamplona, Pamplona Cathedral Treasury: Reliquary of the Holy Sepulcher, 139, 143

Paris, Bibliothèque Nationale: *Le remède de fortune*, Guillaume de Machaut, 169, *169*

Paris, Matthew: *Chronica Majora*, 5–6, *6*

Paris, Musée du Louvre: Angel ("Ange aux burettes"), Abbey of Maubuisson, *168*, 169; Angel of the Annunciation, 42, 51, *51*, 54, 55n41, *142*, 142–43, *143*; Annunciate Virgin, 142, *143*; Appliqué Plaques with Scenes from the Life of Christ (also Metropolitan Museum of Art, New York, and Victoria and Albert Museum, London), *150*, 150–53, *151*, *152*; Arrest of Christ, from Appliqué Plaques with Scenes from

the Life of Christ, 150, *150*, 151; Casket with Story of Perceval and Saints, 69, 70, *240*, 240–41, *241*; Christ as the Man of Sorrows, Relief, 255; Coronation of the Virgin, 44, 52, *53*, 54; Crucifixion Figure, 185; Deposition Group, 41, 129; Descent from the Cross group, 54, 56, *138*, 138–40, *140*; Diptych with the Ascension and the Pentecost, 173, *173*; Diptych with the Life of Christ, Berlin Master, 203; Diptych with the Nativity and Last Judgment, 102–4, *103*, 105; Diptych with Scenes from the Lives of the Virgin and Christ, 158, *159*, 159–60, *160*; Diptych with Scenes from the Passion and from the Life of the Virgin, *170*, 170–73, *171*, *172*; Diptych with Scenes of the Ascension and Pentecost, 179; Diptych with Scenes of the Passion and the Life of the Virgin, *94*, 107–9, *108*; Diptych with the Virgin in Glory and the Crucifixion (also Toledo Museum of Art, Toledo), 51, 57–58, *154*, 154–56, *155*, *156*, 304; Ecclesia, Descent from the Cross group, 54, 56, 138, 139; Harp, *297*, 297–98, *298*; Joseph of Arimathea, Descent from the Cross group, *53*, 138, 139, 140; Kiss of Judas, detail from Diptych with Scenes from the Passion and from the Life of the Virgin, *172*; Knife with elephant ivory handle, 24; Miracle at the Wedding of Cana, detail from Diptych with Scenes from the Lives of the Virgin and Christ, 160; Mirror Case with Couple Playing Chess, 226, 233; Mirror Case with the Court of the God of Love, 74, 223, *228*, 228–29; Nicodemus, Descent from the Cross group, 52, 138, *138*, 139, 140; Noli Me Tangere; Descent into Limbo, detail from Diptych with Scenes from the Passion and from the Life of the Virgin, *171*; Triptych with Scenes from the Life of the Virgin (ca. 1300-30), 162, *162*;

Triptych with Scenes from the Life of the Virgin (ca. 1320-30), *161*, 161–62, *162; Vierge Ouvrante,* 288, 289; Virgin, Descent from the Cross group, 138, 139, 140; Virgin and Child, Polyptych with the Virgin and Child, *55;* Virgin and Child, Timbal Collection, 52, *53;* Virgin and Child (Sainte-Chapelle, Paris), *3, 11,* 11–12, 42, *42,* 49, *49,* 52, 123, 140, 307

Paris, Musée National du Moyen Age, Thermes de Cluny: Belt with Ivory Fittings, *275,* 275–76, *276;* Diptych with Scenes of the Passion, right leaf, 98, *133,* 133–34; Enthroned Virgin, 54; Ivory box, 64; Mirror Case with a Royal Couple and Courtly Figures, *224,* 224–26; Mirror Case with Scenes of Tristan and Iseult, 72; Pierre d'Alençon, Statute of, 143; Triptych with the Crucifixion, from Saint Sulpice-du-Tarn, 153, *156,* 156; Virgin and Child, *122,* 122–23

Passion Atelier, 174, 176, 177, 178, 179, 205

Passion Diptychs, 173, 174–79

Pax with the Virgin and Child, Saint John the Baptist, and Saint Catherine (Detroit Institute of Arts), *265,* 265–66

Pax with the Virgin and Child, Saint John the Baptist, and Saint Catherine (Walters Art Gallery, Baltimore), 266

Pendant with the Coronation of the Virgin (Museum of Fine Arts, Boston), *254,* 254–55, *255*

Pendants to a Rosary or Chaplet, *Memento Mori* Pendants (Detroit Institute of Arts and Metropolitan Museum of Art), *277,* 277–78, *278*

Perceval, Scenes of, Casket (Musée du Louvre, Paris), 69, 70, *240,* 240–41, *242*

Percy tomb, Beverley Minster, Yorkshire, 186

Peterborough Psalter, 65

Petit Pont (Paris), 30Philibert de la Mare, 288

Philip le Bel, 26, 137, 146

Philippe Auguste, 8

Philippe d'Alsace, count of Champagne, 69

Philippe de Long (King), 30, 31

Philip the Bold (Burgundy), 25, 252

Phyllis and Aristotle, *Gravoir* (Victoria and Albert Museum, London), 75–76

Phyllis and Aristotle, Scenes of, Casket (Metropolitan Museum of Art, New York), 67, *67*

Phyllis and Aristotle, Scenes of, Casket (Walters Art Gallery, Baltimore), 66

Pisa, Campo Santo: The Three Living and the Three Dead, 235

Pisa, Church of Santa Caterina: Annunciation, 284

Pisa Cathedral, 181

Pisano, Giovanni, 39–40, 81; Corpus of Christ (Victoria and Albert Museum, London), *180,* 181, *181;* Virgin and Child (Museo dell'Opera del Duomo, Siena), 41, *41,* 42, 49, 181; Wooden crucifix (Museo dell'Opera del Duomo, Siena), 181

Pisano, Nicola, 41

Pisano, Nino, 284

Pistoia, 41

Pittsburgh, Carnegie Museum of Art: Polytych with scenes of the Infancy of Christ, *183*

Poissey Abbey, 258

Polyptych fragment with scenes of the Passion and Saints (Schnütgen-Museum, Cologne), 83, *83*

Polyptych (State Hermitage Museum, Saint Petersburg), 145–46

Polyptych with the Virgin and Child and Scenes from the Life of the Virgin (Detroit Institute of Arts), *267,* 267–69, *269*

Polyptych with Virgin and Child and Scenes from the Infancy of Christ (Toledo Museum of Art), 126, *144,* 144–46, *145, 146,* 161, 162

Polytych with scenes of the Infancy of Christ (Carnegie Museum of Art, Pittsburgh), *183*

Pontarlier, 25

Poor Clares, 14

Pope, Figure of a (Victoria and Albert Museum, London), 42, *120,* 120–21

Porta dei Fiori (San Marco Cathedral, Venice), 214

Portail de la Calende (tympanum), Rouen Cathedral, 38, *44,* 45, 209

Porter, Dean, 81, 219

Prato Cathedral: Madonna della Cintola, 181

Prester John, 66

Princeton, N. J., Princeton University Art Museum: Game Box, *270,* 270–72, *271*

Psalter and Hours of Yolande de Soissons, 209

Psalter of Saint Louis, 45, 58

Pyramus and Thisbe's Suicides, Scenes of, Casket (Metropolitan Museum of Art, New York), 67, *67*

Q

Quadriptych with Scenes of the Infancy of Christ (Victoria and Albert Museum, London), 208

Quadriptych with Scenes of the Passion (Metropolitan Museum of Art, New York), 88–89, *89,* 208

Quadriptych with Scenes of the Passion (Walters Art Gallery, Baltimore), 208–9, *209*

R

Raleigh, North Carolina Museum of Art: Virgin and Child, 127

Randall, Richard H. Jr., 16, 82, 88, 199, 238, 266, 269, 280, 281, 304, 305

Reims Cathedral, 11, 39, 42, 142, 143; Pope (outer archivolt, Calixtus portal, north transept), 121; "Smiling Angel," 143Relief, Christ as the Man of Sorrows (Musée du Louvre, Paris), 255

Relief with Adoration of the Magi (Aartsbisschoppelijk Museum, Utrecht), 82, *83*

Relief with Adoration of the Magi (Musée Curtius, Liège), 82, *83*

Reliquary of San Domenico (Bologna), 156

René of Anjou, 221

Retable with Scenes of the Passion (Church of Mareuil-en-Brie, Marne), 152, *153*

Rhine Valley, 86, 89

Richard of Saint Laurent: *De laudibus Beatus Mariae Virginis,* 131

Richmond, Virginia Museum of Fine Arts: Mirror Case with Attack on the Castle of Love, 74; Mirror Case with Jousting Knights, 233–34, *234,* 305

Rohan Master, 255

Roman de la rose (Guillaume de Lorris and Jean de Meun), 74, 239

Rome, Gallerie e Musei Vaticani: Diptych with Descent from the Cross, 139, *139;* Diptych with Scenes of the Lives of Mary and Christ, *101,* 102

Rose Group, 136, 137

Rouen Cathedral: Portail de la Calende (tympanum), 38, 44, 45, 177; Two Angels, 125, *126*

Roundel with the Annunication (Cleveland Museum of Art), *273,* 273–74

S

Saddle (Museum of Fine Arts, Boston), *261,* 261–62, *262*

Saint Albans, 219

Saint Blasius (Church of Notre-Dame, Walcourt), 211

Saint Clou reliquary, 125

Saint-Denis, Abbey Church of, 7–8, 9; Cenotaph of Dagobert, 131; Lost Virgin, 125, 145; Tomb Sculpture of Jean I, 143, *143;* Virgin and Child with Two Angels (Taft Museum, Cincinnati), 123, *124,* 124–26, *125, 126,* 145, 259

Sainte-Chapelle, 11, 12, 44; Evangelary, 209; Virgin and Child (Musée du Louvre, Paris), *3, 11,* 11–12, 42, *42,* 49, *49,* 52, 123

Saint George and the Dragon (formerly in Jakob Goldschmidt Collection, Berlin), 294, *294*

Saint George and the Dragon (Germanisches National-museum, Nuremburg), 294

Saint George and the Dragon (Museum für Kunst und Gewerbe, Hamburg), 294, *294*

Saint George and the Dragon (State Hermitage Museum, Saint Petersburg), 294

Saint George and the Dragon (Toledo Museum of Art), *293*, 293–94

Saint George and the Dragon (Victoria and Albert Museum, London), 294

Saint George and the Dragon (Wallace Collection, London), 294

Saint Gertrude, Reliquary of (Abbey of Sainte-Gertrude, Nivelles, Belgium), 121, 129, *129*, 143, 168

Saint Honoratus portal (Amiens Cathedral), 129

Saint Jacques l'Hôpital, Paris, 177

Saint-Jean, Church of (Bruges), 268

Saint-Jean-des-Vignes (Soissons), 98, 132

Saint Louis, Reliquary of (Bologna), 143

Saint Louis, Saint Louis Art Museum: Diptych with Scenes of the Passion, 98, *99*, 99–100, 113n19; Diptych with Scenes of the Passion and Afterlife of Christ, 134–35, *135*

Saint Louis Psalter, 45, 58

Saint Margaret Triumphing over the Dragon (British Museum, London), 48, *48*, 54, 56, *163*, 163–64, *164*, 191

Saint Margaret Triumphing over the Dragon (Museo Nazionale del Bargello, Florence), 164

Saint Martin and the Beggar (Hallesches Heiltumsbuch, Aschaffenburg, Hofbiblio-thek), 191, *191*

Saint Martin and the Beggar (Victoria and Albert Museum, London), *190*, 191–92

Saint Martin of Tours, Diptych with (Cleveland Museum of Art, Cleveland), 82, 83, *198*, 198–99

Saint Martin's Guild of Haarlem, 192

Saint Mary's, Sutton Valence, Kent, 183

Saint Nicholas (Diözesan-museum, Cologne), 83

Saint Nicholas (Erzbischö-fliches Diözesan Museum, Cologne), 199

Saint Petersburg, State Hermitage Museum: Dagger Handle, 220, 221; Diptych with Scenes of the Passion, 134, 160; Polyptych, 145–46; Saint George and the Dragon, 294

Saint-Pierre (Caen), 68

Saint-Servais, Church of, Liège, 211

Saint Simeon and the Christ Child (Walters Art Gallery, Baltimore), 121

Saint-Sulpice-du-Tarn, Triptych with the Crucifixion (Musée National du Moyen Age, Thermes de Cluny, Paris), 153, 156, *156*

Saint-Sulpice-du-Tarn group, 83

Saint Ursula, Casket of, with Scenes from Romances (Treasury of church of Saint Ursula, Cologne), 75, 84, *84*, 221

Salem (Swabia), Cistercian convent: Virgin with the Child, 86

Salting Diptych (Diptych with the Virgin and Child and Christ Blessing) (Victoria and Albert Museum, London), 57, 186, 187

Sambon, 216

San Domenico, Reliquary of (Bologna), 156

San Giusto alle Balze Abbey, 216

San Marco Cathedral, Venice: Holy Sacraments tabernacle, 214; Porta dei Fiori, 214

Santa Caterina Annunciation (Church of Santa Caterina, Pisa), 284

Saudemont, Wooden Angels of (Musée Municipal, Arras), 140

Sauerländer, Willibald, 45

Schloss Rodeneck, Tyrol, 68

Schnütgen, Alexander, 85

Scott, Kathleen, 231

Sears, Elizabeth, 10

Seated Queen (Judgment Portal, west voussoir, Lincoln Cathedral, Angel Choir), 42, *43*, 43

Seidel, Max, 41, 127, 181

Sens Cathedral: Crucifix from Cérisiers, 129

Shrine of the Three Magi, Nicholas of Verdun (Cologne Cathedral), 121

Siena, Museo dell'Opera del Duomo: Virgin and Child, Giovanni Pisano, 41, *41*, 42, 49

Siena Cathedral, 41; Virgin and Child (pulpit), 41

Sigismund I, 262

Simmerberg (Lindau), 88

Sluter, Claus, 251, 252, 253

Smith, Graham, 273

Smithfield Decretals, 65

Soissons Diptych (Victoria and Albert Museum, London), 44, 51, 57, 60, 83, 98, *98*, 100–101, 110, 132, 134, 135

"Somme Le Roy" (Master Honoré), 58–59

Sommerard, Alexandre Du, 290

Spitzer, Frédéric, 207, 236, 299, 300

Sponsa-Sponsus group (Cologne Cathedral), 85

Stahl, Harvey, 14

Statue of the Virgin (Cologne Cathedral), 85, *86*

Statuette, Virgin and Child (Benoit Oppenheim Collection, Berlin), 307

Statuette of the Virgin and Child (Metropolitan Museum of Art, New York), 88, *88*

Statuette of the Virgin and Child (Museum Catharijne-convent, Utrecht), 269, *269*

Statuette of the Virgin (Convent of Langenhorst, Westphalia), 91–92, *92*

Statue of Pierre d'Alençon (Musée National du Moyen Age, Thermes de Cluny, Paris), 143

Stratford, Neil, 15, 81

Suger, Abbot, 7, 8

Sulpicius Severus, 191

Sulzbach Collection, Frankfort am Main, 73

Swäbish Gmünd, 201

Swahili corridor, 3–4

Swarzenski, Hanns, 39

Sylvestre, Israël, 84

T|

Tabernacle (fragment) (Metropolitan Museum of Art, New York), 145

Tablets, German (Victoria and Albert Museum), 59

Tanzania, 3

Taymouth Hours, 68

Theophilus, 6–7, 50; *De diversis artibus*, 183

Thérouanne Cathedral, 132

Thisbe and the Lion, Scenes of, Casket (Metropolitan Musuem of Art, New York), 67, *67*

Three Living and the Three Dead (Campo Santo, Pisa), 235

Tino da Camaino, 284

Toledo, Toledo Museum of Art: Diptych with the Passion of Christ, 175, 177–78; Diptych with the Virgin in Glory and the Crucifixion (also Paris, Musée du Louvre), 51, 57–58, *154*, 154–56, *155*, *156*, 304; Saint George and the Dragon, *293*, 293–94

Tomb of John the Fearless and Marguerite of Bavière, Mourner Number 78 from (Musée des Beaux-Arts, Dijon), 251–52, *252*

Tomb Sculpture of Jean I (Abbey Church of Saint-Denis), 143, *143*

Toronto, Royal Ontario Museum: Giac Hours, 255

Touraine, 264

Trapani, Sicily, Santissima Annunziata: Virgin and Child, 283, 284, *284*

Tree of Jesse, liturgical comb, 82

Triptych, Virgin and Child between Saints Clare and Francis (Nationalmuseet, Copenhagen), 83, *84*

Triptych of the Death of the Virgin (Bibliothèque Municipale, Amiens), 158, 162

Triptych (Suermondt Museum, Aachen), 85

Triptych (Thyssen-Bornemisza Collection, Lugano), 162

Triptych with Adoration of the Magi (Musée des Beaux-Arts, Lyons), *59,* 59–60

Triptych with the Crucifixion, from Saint Sulpice-du-Tarn (Musée National du Moyen Age, Thermes de Cluny, Paris), 153, 156, *156*

Triptych with Painted Angels, exterior panels (Walters Art Gallery, Baltimore), 214, *214*

Triptych with Scenes from the Life of the Virgin (ca. 1300-30) (Musée du Louvre, Paris), 162, *162*

Triptych with Scenes from the Life of the Virgin (ca. 1320-30) (Musée du Louvre, Paris), *161,* 161–62, *162*

Triptych with Scenes of the Passion (Thyssen-Bornemisza Collection, Madrid), 153

Triptych with the Arms of John de Grandisson, Bishop of Exeter (British Museum, London), *188,* 188–89

Triptych with the Coronation of the Virgin (Victoria and Albert Museum, London), *213,* 213–14, *214,* 216

Triptych with the Life of Christ, Berlin Master (Art Institute of Chicago), 203–5, *204*

Triptych with the Virgin in Glory (Cranbrook Academy of Art, Bloomfield Hills, Michigan), *295,* 295–96

Triptych with the Virgin in Glory (Metropolitan Museum of Art, New York), 85, *85,* 86

Triptych with Virgin and Child (Cleveland Museum of Art), 211, *211*

Tristan and Iseult, *Gravoir* (Museo Civico, Turin), 75

Tristan and Iseult, Mirror Case (Musée National du Moyen Age, Thermes de Cluny, Paris), 72

Tristan and Iseult, Scenes of, Buckle (Metropolitan Museum of Art, New York), 72, 224–25, *225*

Tristan and Iseult, Scenes of, Casket (Walters Art Gallery, Baltimore), 67

Turin, Museo Civico: Tristan and Iseult, *Gravoir,* 75

Turin-Milan Hours, 253

Two Angels (Rouen Cathedral Treasury), 125, *126*

Two Marys at the Tomb, from Appliqué Plaques with Scenes from the Life of Christ (Victoria and Albert Museum, London), *152,* 153

U

Utrecht, Aartsbisschoppelijk Museum: Relief with Adoration of the Magi, 82, *83*

Utrecht, Museum Catharijineconvent: Statuette of the Virgin and Child, 269, *269*

Utrecht Group, 266

V

van Eyck, Jan, 266

van Os, Henk, 44

van Vianen workshop, 192

Veneziano, Paolo, 214

Venice, San Marco Cathedral: Holy Sacraments tabernacle, 214; Porta dei Fiori, 214

Verdier, Philippe, 251

Vie de Saint-Denis, 30

Vierge dorée (south transept trumeau, Amiens Cathedral), *40,* 41, 123

Vierge Ouvrante de Boubon (Walters Art Gallery, Baltimore), 35*n,* 285, 285–89, *287, 288*

Vierge Ouvrante (Musée des Antiquités, Rouen), 287

Vierge Ouvrante (Musée des Beaux-Arts, Lyons), 288, 289

Vierge Ouvrante (Musée du Louvre, Paris), 288, 289

Villeneuve-l'Archevêque, church of (Yonne), 119

Virgin, Descent from the Cross group (Musée du Louvre, Paris), 138, 139, 140

Virgin, Plaquette (Musée des Beaux-Arts, Lyons), 155–56

Virgin and Child, Box Cover (Staatliche Kunstsammlung, Baden-Württemberg), *266, 266*

Virgin and Child, Giovanni Pisano (Museo dell'Opera del Duomo, Siena), 41, *41,* 42, 49

Virgin and Child, Master of Kremsmünster (Church of Saint John the Baptist, Ochtrup-Langenhorst), 92

Virgin and Child, Polyptych with the Virgin and Child (Musée du Louvre, Paris), 55

Virgin and Child, Timbal Collection (Musée du Louvre), 52, *53*

Virgin and Child (boxwood) (Victoria and Albert Museum, London), 43, *43*

Virgin and Child (Detroit Institute of Arts), *283,* 283–84

Virgin and Child (Glastonbury Abbey), 117, 183

Virgin and Child groups (Walters Art Gallery, Baltimore), 119

Virgin and Child (Kaiser Freidrich Museum, Berlin, destroyed), 117

Virgin and Child (Metropolitan Museum of Art, New York), 56, *306,* 307, *307*

Virgin and Child (Minden Cathedral Treasury), 117, *117*

Virgin and Child (Musée National du Moyen Age, Thermes de Cluny, Paris), *122,* 122–23

Virgin and Child (Nelson-Atkins Museum of Art, Kansas City), *210,* 210–11

Virgin and Child (North Carolina Museum of Art, Raleigh), 127

Virgin and Child (pulpit, Siena Cathedral), 41

Virgin and Child (Sainte-Chapelle, Paris) (Musée du Louvre, Paris), *3, 11,* 11–12, 42, *42,* 49, *49,* 52, 123, 140, 307

Virgin and Child (Saint-Jacques, Compiègne), 42, *42*

Virgin and Child (Santissima Annunziata, Trapani, Sicily), 283, 284, *284*

Virgin and Child (1241 seal, Merton Priory), 117

Virgin and Child (seated) (Musée National du Moyen Age, Thermes de Cluny, Paris), 286

Virgin and Child (seated) (Walters Art Gallery, Baltimore), *263,* 263–64, 264

Virgin and Child (standing) (Walters Art Gallery, Baltimore), 55, 127, *127*

Virgin and Child (tabernacle) (Wadsworth Atheneum, Hartford), 42, *43*

Virgin and Child (Trésor d'Ognies des Soeurs de Notre-Dame, Namur, Belgium), 119

Virgin and Child (trumeau, north transept, Notre Dame cathedral, Paris), 12, *12,* 41, 125, 127

Virgin and Child (tymanum, south door, West Portal, Chartres cathedral), 40

Virgin and Child (Villeneuve-lès-Avignon), 54, 55, 56

Virgin and Child (west front, central tympanum, Wells Cathedral), 117, *117*

Virgin and Child with Two Angels from Saint-Denis (Taft Museum, Cincinnati), 123, *124,* 124–26, *125, 126,* 145, 307

Virgin and Child with Young Martyr Virgins, Abbot Bohuslaus collection (Abbey treasury, Zwettl, Austria), 82

Virgin and the Unicorn, Scenes of, Casket (Walters Art Gallery, Baltimore), 67

Virgin from the Tongern house (Schnütgen Museum, Cologne), 85

Virgin in Glory, from Diptych with the Virgin in Glory and the Crucifixion (Musée du Louvre, Paris), *154,* 155, 156

Virgin in Glory, leaf of a diptych, Berlin Master (Museum of Fine Arts, Houston), 202, *203,* 205

Virgin of Ourscamp, 286

Virgin of Tenderness *(Eleousa),* 307

Virgin of the dukes of Tuscany (Museo Nazionale del Bargello, Florence), 49

Virgin (San Francesco at Assisi), 56

Virgin (tympanum, Freiberg Cathedral), 117

Visconti, Marquise Arconati, 297

von Brandenburg, Albrecht, 191–92

von Glogau, Agnes, 13

von Hirsch, Baron, Collection (formerly): Casket with Scenes of Ivain at the Spring, 68

Vosges: Saint-Dié Cathedral, 212

Vulgate Lancelot, 67

W

Walcourt, Church of Notre-Dame: Saint Blasius, 211

Walters, Henry, 296

Washington, D.C., National Gallery of Art: Diptych with Scenes from the Life of Christ, Master of the Agrafe Forgeries, 288, 289, *290,* 290–92, *291*

Wax tablet with Coronation of the Virgin (Victoria and Albert Museum, London), 76

Weingarten Liederhandschrift, 90

Wells Cathedral: Annunciation group, 153; Virgin and Child (west front, central tympanum), 117, *117*

Westminster Abbey, 183, 186, 219

Westphalia, 89

Westphalia, Coesfeld: Dagger Handle, 220, 221

Westphalia, Convent of Langenhorst: Statuette of the Virgin, 91–92, *92*

Widener, Peter (or Joseph), 290

Willequin, Pierre, 36 n. 63
Williamson, Paul, 12, 15, 47, 49, 81

Wixom, William, 15–16, 183, 199

Wladyslaw Jagiello II, 64

Worcester, Mass., Worcester Museum of Art: Appliqué with the Virgin and Child, 211–12, *212*

Writing Tablets with Case (Museé Archéologique, Namur, Belgium), 237, 238

Writing Tablets with Case (Switzerland, Private Collection), *237,* 237–39, *238*

Writing Tablets with Scenes of Lovers (Detroit Institute of Arts), 304–5, *305*

Y

Yonne: Church of Villeneuve-l'Archevêcque, 119

Z

Zwettl Abbey, Austria: Virgin and Child, with young martyr Virgins (Abbot Bohuslaus collection), *82*

PHOTO CREDITS

In most cases, photographs were provided by the owners of the works of art and are published with their permission; their courtesy is gratefully acknowledged. Additional information on photograph sources follows.

Réunion des Musées Nationaux, 11, 42, 156 (fig. III-3), 173, 275

James Austin, 12 (figs. I-5–6), 40, 119

Soprintendenza ai Monumenti e Gallerie, Pisa, 41

Photographer: E. Irving Blomstrann, 43 (fig. III-6)

Roger-Viollet, 44

Paul Macapia, 72

Rheinisches Bildarchiv, 83 (fig. VI-4), 84 (fig. VI-7)

Westf. Amt für Denkmalpflege, 92

Rijksmuseum-Stichting Amsterdam, 104 (fig. VII-6)

Courtauld Institute of Art, with the compliments of the Conway Library, 117 (fig. 1a)

Staatliche Museen zu Berlin, Skulpturen-Sammlung, 117 (fig. 1b)

RMN – H. Lewandowski, 122

The Taft Museum, Cincinnati, Ohio, 125–26

RMN/Ojeda – El Majd, 133, 224

Photographer: Hilda Deecke, 176

Tom Barr, 183

Photographer: Katherine Wetzel, 234

Staatliche Kunstsammlung, Baden-Württemberg, Stuttgart, 266

Photographer: Ruben de Heer, 269 (fig. 73a)

Photographer: Bruce M. White, 270

Photographer: Robert Hashimoto, 281

Aurelio Amendola, 284

Photographer: Jörg P. Anders, 302 (fig. 90a)